THE CIVIL WAR
AND *American Art*

THE CIVIL WAR AND American Art

Eleanor Jones Harvey

Smithsonian American Art Museum, Washington, D.C.,
in association with Yale University Press, New Haven, Connecticut

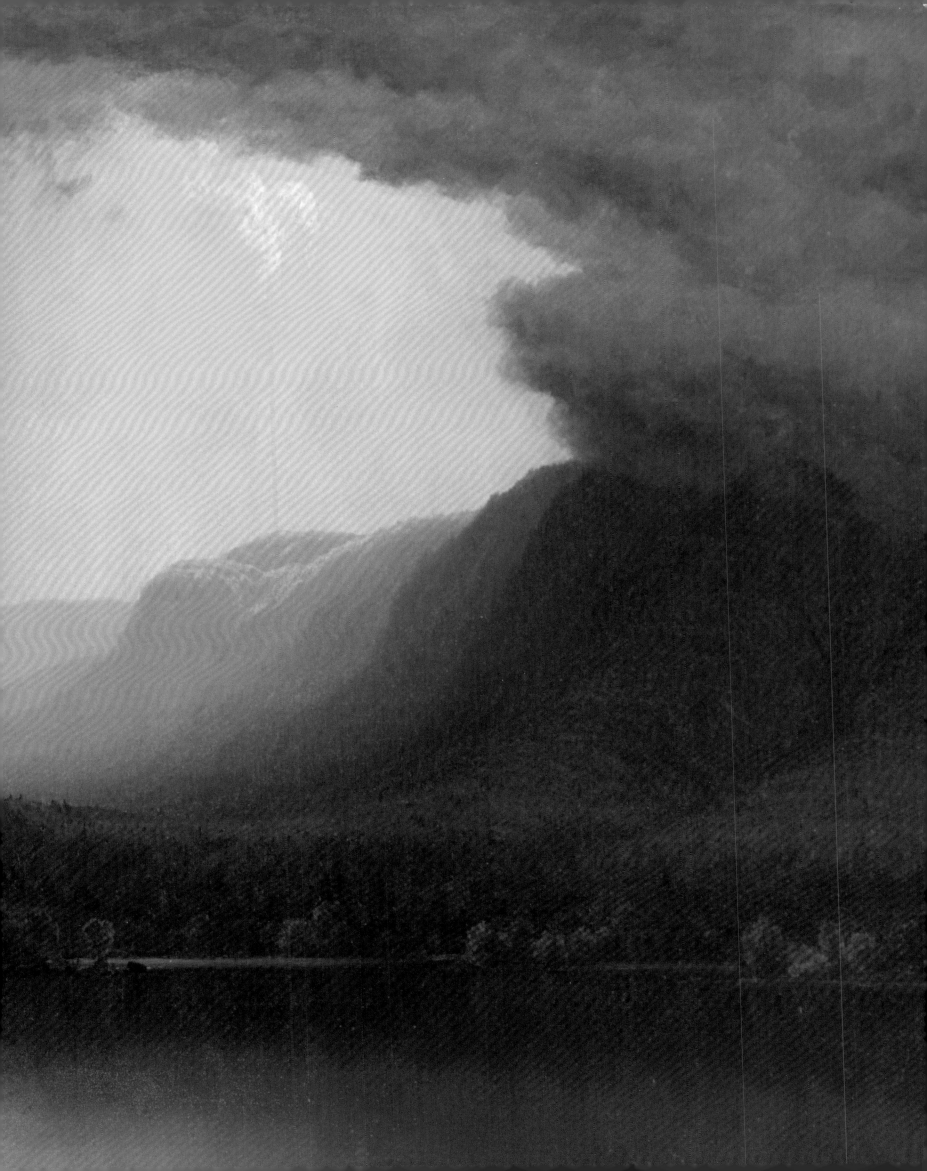

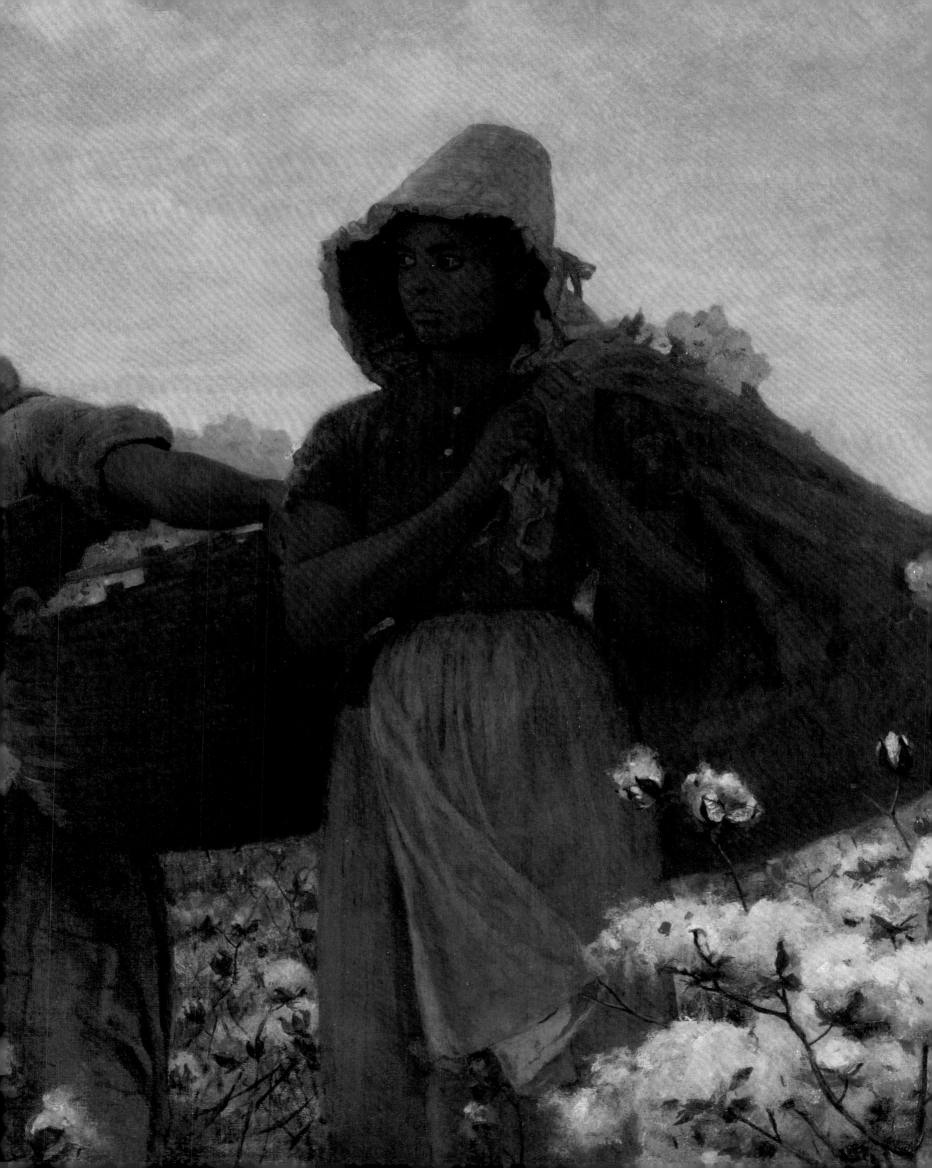

is organized by the Smithsonian American Art Museum
with generous support from:

Anschutz Foundation
Ludmila and Conrad Cafritz
Christie's
Sheila Duignan and Mike Wilkins
Tania and Tom Evans
Norma Lee and Morton Funger
Dorothy Tapper Goldman
Raymond J. and Margaret Horowitz Endowment
Mr. and Mrs. Raymond J. Horowitz
 Foundation for the Arts
Wolf Kahn and Emily Mason Foundation
Joffa and Bill Kerr
Thelma and Melvin Lenkin
Henry Luce Foundation
Paula and Peter Lunder
Margery and Edgar Masinter
Barbro and Bernard Osher
Walter and Lucille Rubin Foundation
Patricia Rubin and Ted Slavin
Holly and Nick Ruffin

The C. F. Foundation in Atlanta supports the museum's
traveling exhibition program, *Treasures to Go*.

This exhibition is supported by an indemnity from the
Federal Council on the Arts and the Humanities.

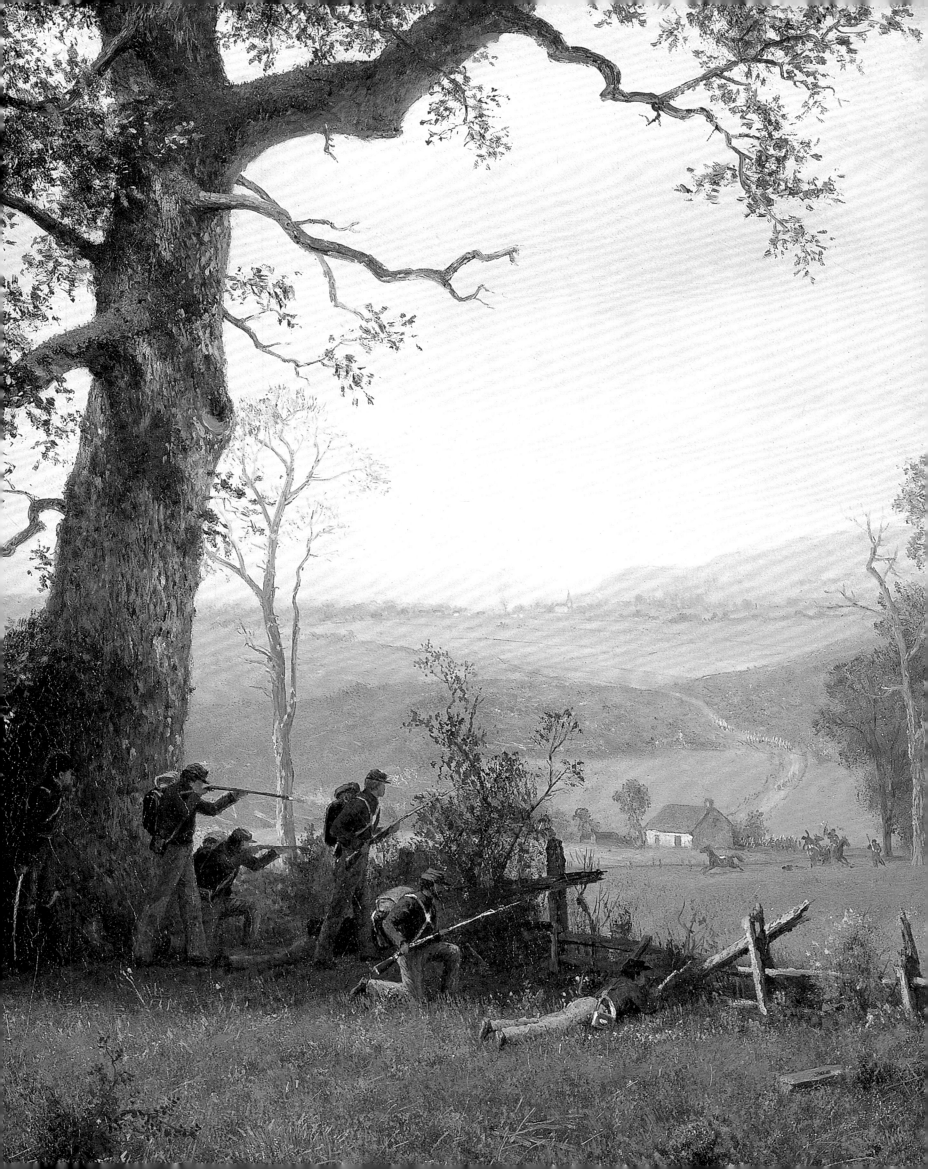

LENDERS TO THE EXHIBITION

Amon Carter Museum of American Art
Birmingham Museum of Art
The Century Association
Chrysler Museum of Art
The Cleveland Museum of Art
Corcoran Gallery of Art
Dallas Museum of Art
Detroit Institute of Arts
Fine Arts Museums of San Francisco
The Fralin Museum of Art at the
 University of Virginia
Frank M. Gren
Judith Filenbaum Hernstadt
Joslyn Art Museum
Fred Keeler
Los Angeles County Museum of Art
The Metropolitan Museum of Art
Mount Vernon Ladies' Association
The Museum of the Confederacy
National Gallery of Art
The Nelson-Atkins Museum of Art
New Britain Museum of American Art
The New-York Historical Society
New York State Military Museum
Newark Museum
Philadelphia Museum of Art
Philbrook Museum of Art
Portland Museum of Art, Maine
Smithsonian American Art Museum
The Union League Club of New York
Virginia Museum of Fine Arts
Yale University Art Gallery

And several Anonymous Private Collectors

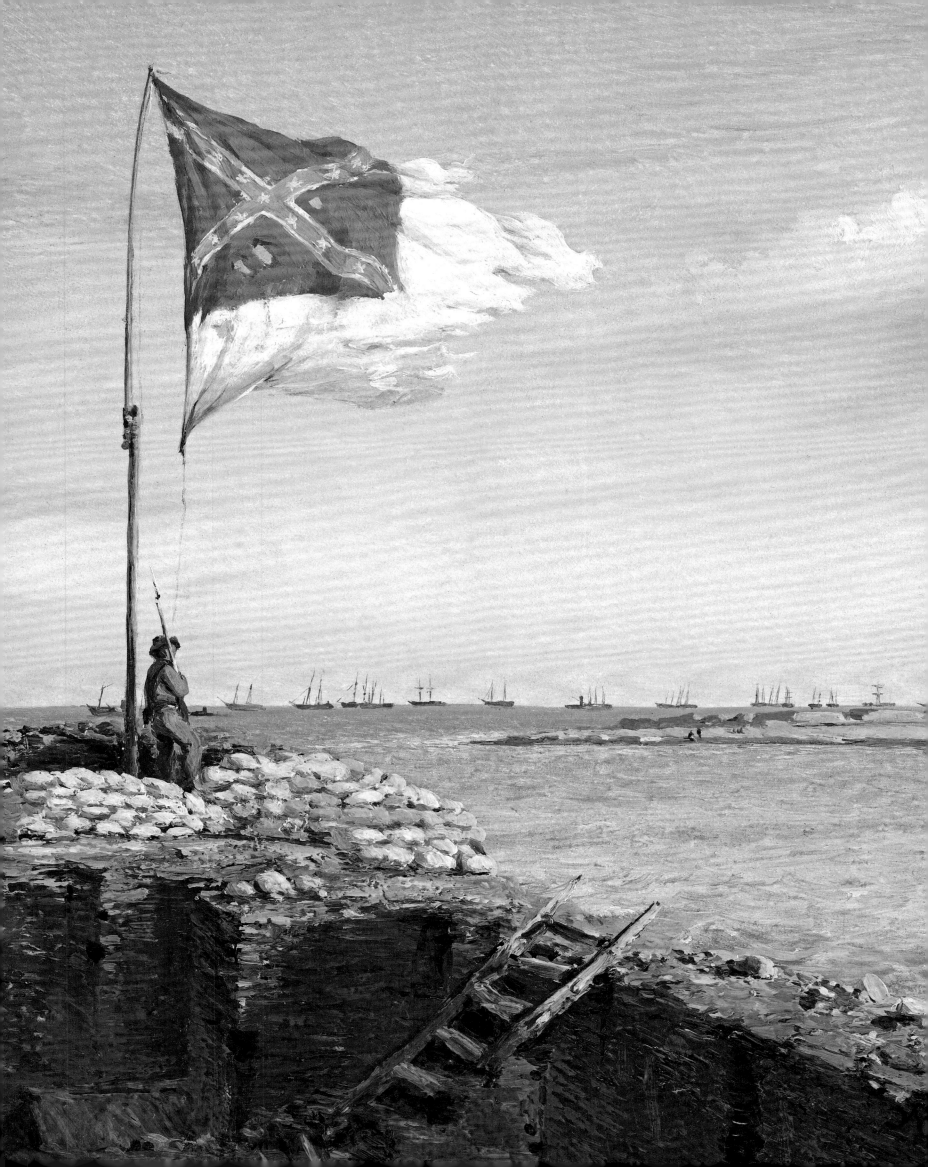

CONTENTS

DIRECTORS' FOREWORD

The Civil War redefined America in every way imaginable. Yet, while this war remains the most deeply researched event in our history, surprisingly little has been written about its impact on art and on the artists who experienced it firsthand. The works presented in *The Civil War and American Art* provide eloquent testimony to the ravages of the conflict on the land, the cities, and the people who endured it.

Dr. Eleanor Jones Harvey, the organizing curator of the exhibition and the author of this book, has delved into the intersection of American artists and the Civil War, particularly the transformation of landscape and genre painting during this profoundly turbulent period. While battlefield photographs offered visceral shock and destroyed Americans' romantic views of the war as a gallant adventure, the paintings associated with the war are more allusive, often envisioning the future of a reunited nation that had been grievously divided. Dr. Harvey proposes deeper readings and significant new interpretations of many familiar masterworks: sixty major paintings created between 1852 and 1877 and a selection of key photographs.

Our two museums are well positioned to undertake this reevaluation. The Smithsonian American Art Museum is housed in the former Patent Office Building—Washington's largest public space at the time of the Civil War—where Union troops were billeted to defend the capital when war broke out. The building served as a hospital for the wounded in July 1861, after the first major land battle at Manassas, Virginia. President Lincoln held his inaugural ball in its ornate halls in March 1865, just six weeks before his tragic assassination. The Metropolitan Museum of Art is also linked to the Civil War. In 1864, members of the Union League Club—artists, writers, politicians, generals—and others from New York's cultural elite organized a huge art display at the Metropolitan Fair to raise money for medical aid and relief for the Union army. Six years later, some of the gentlemen who had helped to shape the Metropolitan Fair became founding trustees of the Metropolitan Museum, thus creating a permanent home for the arts in the city. Together our two museums' vast collections of American art testify to the endurance of the American spirit. That endurance lies at the heart of *The Civil War and American Art*.

The Smithsonian American Art Museum organized this exhibition under Dr. Harvey's leadership, with early and sustained interest from Dr. H. Barbara Weinberg and her colleagues at The Metropolitan Museum of Art. Each of our museums has contributed five major paintings to the exhibition, in each case precipitating the reinstallation of some of its galleries. We appreciate the mutually beneficial relationship that has developed between our institutions, which has ensured a beautiful and riveting experience for our visitors.

Projects such as this one require immense resources to achieve fruition. The Smithsonian American Art Museum would like to recognize and thank the following individuals and foundations for their generous support: The Anschutz Foundation, Denver; Ludmila and Conrad Cafritz; Christie's, New York; Sheila Duignan and Mike Wilkins; Tania and Tom Evans; Norma Lee and Morton Funger; Dorothy Tapper Goldman; the Raymond J. and Margaret Horowitz Endowment; the Mr. and Mrs. Raymond J. Horowitz Foundation for the Arts; the Wolf Kahn and Emily Mason Foundation; Joffa and Bill Kerr; Thelma and Melvin Lenkin; the Henry Luce Foundation; Paula and Peter Lunder; Margery and Edgar Masinter; Barbro and Bernard Osher; the Walter and Lucille Rubin Foundation; Patricia Rubin and Ted Slavin; and Holly and Nick Ruffin. We also thank the Smithsonian Institution for program support from the Grand Challenges grant.

At the Metropolitan Museum, we would like to recognize an anonymous foundation for its outstanding generosity and engagement in this project. We are also grateful for the support provided by the Gail and Parker Gilbert Fund and the Enterprise Holdings Endowment.

An exhibition of this magnitude requires the generosity of numerous museums, organizations, and individuals willing to share their works for almost a year. The paintings and photographs included are among the finest made by American artists during this period. In many cases they are signature works in collections that rarely allow them to travel. We are deeply indebted to each lender for recognizing the significance of this project and profoundly grateful to each for agreeing to be a part of this landmark exhibition. Simply put, we could not have realized this exhibition without them.

Elizabeth Broun
The Margaret and Terry Stent Director
Smithsonian American Art Museum

Thomas P. Campbell
Director
The Metropolitan Museum of Art

ACKNOWLEDGMENTS

The Civil War left its mark on every aspect of American life and culture. To address that impact in its entirety is an impossible task. Presently more than 75,000 books on the Civil War have been published; that averages more than one book per day since the war ended at Appomattox. My own thinking about this topic has been shaped over many years, especially from reading deeply and consulting with colleagues as I navigated the path leading to this book. Pioneering scholars in art history and Civil War history have left their mark on these pages, as have numerous recent works that have expanded my understanding of the nuances of both the war and the arts in America. Several books left a distinct impression. Drew Gilpin Faust's groundbreaking study, *This Republic of Suffering*, convinced me that comprehending the reaction to death was the key to understanding the long-term impact of the war. Her conclusions gave me insight into Walt Whitman's desire to tend wounded and dying soldiers in the Old Patent Office Building, now home to the Smithsonian American Art Museum and the National Portrait Gallery. Eric Dean's *Shook over Hell* similarly peeled away the fog surrounding post-traumatic stress during the Civil War, reinforcing the point that no one escaped the war unscathed. Terrie Dopp Aamodt's *Righteous Armies, Holy Cause* made clear how much religion inflected contemporary understanding of the war in both the North and the South and reinforced how much of that rhetoric was grounded in landscape imagery.

I am indebted to numerous colleagues in American history and American art who helped me navigate the mountain of material on the Civil War. Edward Ayers

offered me sage advice so many years ago I doubt he remembers dispensing it, but his suggested readings gave me a solid foundation for this project. Adam Goodheart's book, *1861*, confirmed how personal stories often illuminated larger truths about the war. His work on the *New York Times'* blog *Disunion!* encouraged all of us to consider what we think we know about the Civil War and how we talk about it today. Peter H. Wood's stellar work *Near Andersonville* underscored the point that there is still more to learn and more to write about Winslow Homer. His incisive responses to some of my ideas sharpened my thinking and led me to historical sources not often applied to American art. Will Stapp proved to be an indefatigable source on Civil War photography and, more than that, a sharp critic whose pointed questions made me ask better ones. Frank Goodyear and Toby Jurovics read early drafts of the manuscript, and their insights on photography immeasurably strengthened my arguments. Randy Griffin's book, *Homer, Eakins, & Anshutz: The Search for American Identity in the Gilded Age*, placed Homer in a postwar context far less sanguine than Twain's ironic moniker might suggest. Beyond his superb scholarship, Randy has always been my most fervent advocate and ruthless critic. His close reading of the manuscript pushed me to ask more complicated questions and led me to conclusions that became the soul of this book. Each of these scholars, directly or indirectly, has shaped my perceptions of the Civil War and influenced my decisions about which artists and artworks to explore and what material to set aside.

My choice to focus on landscape painting owes much to Barbara Novak and Harold Holzer, each of

whom influenced my belief that landscape painting was the key to understanding the impact of the Civil War on American art. My approach to genre painting owes much to Steven Conn, who has written with great insight about the ways in which history painting came up short when faced with the Civil War. His article "Narrative Trauma: Why Are these Paintings So Bad?" confirmed my thinking about the inadequacies of the venerable genre to cope with the war and clarified why this project needed to look elsewhere for its subject. I chose not to address portraiture, as its conventions and appearance did not change as a result of the war, varying little in substance and symbolism from the work of earlier American artists. Kirk Savage did such a marvelous job considering Civil War-era sculpture in his book *Standing Soldiers, Kneeling Slaves* that I found I had nothing to add. I leave for others the examination of latent and outright war-related meaning in still life, where it is becoming more apparent that food carried political overtones in the manner in which it was grown and harvested, its point of origin, and its commercial path to the American table. I look forward to reading another generation of scholars' work on American art and the Civil War, as there are still many areas to mine.

My debts are many, and I gratefully acknowledge them here. This book may have a sole author, but it took a small army of people to assist with its development and production. I owe a tremendous debt to my editor, Tiffany Farrell, who helped shape and clarify my ideas and has worked tirelessly to bring this manuscript into sharp focus. It is a much stronger book thanks to her efforts. I have benefited immensely from having Barbaranne Liakos as my curatorial assistant for the last three years. As a fellow scholar and able coordinator, she has juggled ideas, research, and exhibition logistics with equal facility and aplomb. Curatorial Assistant Jennifer Bauman provided essential help with early logistical support and critical research on literary figures of the period. Emma Stratton handled rights and reproductions with skill and good humor and a sharp eye for detail. Jessica Hawkins has designed an elegant book, making it a visual pleasure to navigate this material. I have had a number of talented interns who contributed to the research and ideas in this book, and it is with gratitude that I thank

Allison Dietz Hicks, Emily Guth, Catherine Homsey, Katherine Hughes, Gretchen Martin, Mary McMahon, Laura Groves Napolitano, Lauren Staub, Randi Stead, and Julia Trechsel.

Archivists, librarians, and researchers across the country assisted with research queries. Marisa Bourgoin at the Archives of American Art provided access to countless primary documents. Smithsonian librarians tracked down obscure references and provided superb research support, and I would like to thank Patricia Lynagh, Doug Litts, Anne C. Evenhaugen, and especially Mary Wassum for their unflagging efforts. Librarians and researchers elsewhere provided timely assistance, particularly Paul Carnahan, Vermont Historical Society; Lynda Claassen, Mandeville Special Collections Library, University of California San Diego; Teresa Roane, The Museum of the Confederacy, Richmond, VA; and Autumn Simpson, research assistant, Valentine Richmond History Center, VA.

Several scholars read early versions of this manuscript, and their comments made my thinking measurably better and my prose significantly stronger. I am especially grateful to Lonnie Bunch, director of the Smithsonian's National Museum of African American History and Culture; Frank Goodyear, assistant curator of photography at the Smithsonian's National Portrait Gallery; Randy Griffin, professor of art history, Southern Methodist University, Dallas, TX; Toby Jurovics, chief curator, Joslyn Art Museum, Omaha, NE; Barbaranne Liakos, Smithsonian American Art Museum; Will Stapp, independent scholar; Peter H. Wood, professor of history emeritus, Duke University, Durham, NC; and my anonymous peer reviewers. In addition, I would like to thank David C. Ward, historian at the National Portrait Gallery; Scott Winterrowd, curator of education, Southern Methodist University; and Adam Goodheart, director of the C. V. Starr Center for the Study of the American Experience, Washington College, Chestertown, MD. I have benefited greatly from your help and your encouragement.

Many of my colleagues at lending institutions provided critical help in securing loans and providing information on their works of art. I would like to thank Becky Lawton, Amon Carter Museum of

American Art, Fort Worth, TX; Gail Andrews and Graham Boettcher, Birmingham Museum of Art, AL; Terry Carbone, Brooklyn Museum; Jonathan Harding, Century Association, NY; Bill Hennessey, Chrysler Museum of Art, Norfolk, VA; Mark Cole, Cleveland Museum of Art, OH; Sarah Cash, Corcoran Gallery of Art, Washington, DC; Bonnie Pitman, Olivier Meslay, and Sue Canterbury, Dallas Museum of Art, TX; Ken Myers, Detroit Institute of Art, MI; Tim Burgard, the late John Buchanan, and Julian Cox, Fine Arts Museums of San Francisco, CA; Toby Jurovics and Sarah Burt, Joslyn Art Museum, Omaha, NE; Ilene Fort and Austen Bailey, Los Angeles County Museum of Art, CA; H. Barbara Weinberg, Metropolitan Museum of Art, NY; Emily Dana Shapiro, George Washington's Mount Vernon Estate, Museum, and Gardens, Alexandria, VA; S. Waite Rawls III and Cathy Wright, The Museum of the Confederacy, Richmond, VA; Franklin Kelly, Charles Brock, Sarah Fisher, Anne Halpern, Jay Krueger, and Doug Lachance, National Gallery of Art, Washington, DC; Keith Davis, Margi Conrads, and April Watson, Nelson-Atkins Museum of Art, Kansas City, MO; Douglas Hyland, New Britain Museum of Art, CT; Mary Sue Sweeney Price and Holly Pyne Connor, The Newark Museum, NJ; Linda Ferber, Kimberly Orcutt, and Christina Charuhas, New-York Historical Society; Courtney Burns, New York State Military Museum, Saratoga Springs, NY; Mark Mitchell, Philadelphia Museum of Art, PA; James Peck, Philbrook Art Museum, Tulsa, OK; Tom Denenberg, Portland Museum of Art, ME; David K. Ray and Duncan Burns, Union League Club, NY; Bruce Boucher, Fralin Museum of Art at the University of Virginia, Charlottesville; Alex Nyerges and Sylvia Yount, Virginia Museum of Fine Arts, Richmond; and Jock Reynolds, Helen Cooper, and Keely Orgeman, Yale University Art Gallery, New Haven, CT.

Numerous art dealers were helpful in tracking down key works of art and making research materials available to me. I would like to thank Alex and Loie Acevedo, Alexander Gallery, NY; Joe Caldwell, Caldwell Gallery, Manlius, NY; John Driscoll and Lyle Dawson, Driscoll Babcock Galleries, NY; Stuart Feld, M. P. Naud, and Eric Baumgartner, Hirschl & Adler Galleries, NY; Howard Godel and Katherine Baumgartner, Godel and Company Fine Art, NY; Steve Good, Steve Good Inc., Denver, CO; Alfred C. Harrison Jr., North Point Gallery, San Francisco, CA; Rob Hicklin Jr. and Jane Harper Hicklin, Charleston Renaissance Gallery, SC; Frederick D. Hill, Collisart, NY; Allan and Colleen Kollar, A. J. Kollar Fine Art, Seattle, WA; Mary Lublin, Mary Lublin Fine Art, NY; James Maroney, James Maroney, Inc., Leicester, VT; Craig Nannos, The Sentry Post, Villanova, PA; Richard Rossello and Nicole Amoroso, Avery Galleries, Bryn Mawr, PA; Louis Salerno, Questroyal Fine Art, NY; and Paul Worman, Paul Worman Fine Art, NY.

So many individuals have provided enthusiastic support for this exhibition and book, among them colleagues at museums and the academy, private collectors, and independent scholars. I am grateful to Parker Agelasto; Nan Altmayer; Ed Ayers, University of Richmond, VA; P. J. Brownlee and Annelise Madsen, Terra Foundation, Chicago, IL; Ludmila and Conrad Cafritz; Gerald L. Carr; Lisa Darlington; John Davis, Smith College, Northampton, MA; Marie-Stephanie Delamaire; Kathleen Diffley, University of Iowa; Joseph Fogg; David and Linda Gray; Adam Greenhalgh; Randall Griffey, Mead Art Museum, Amherst, MA; Nina Gray, Seventh Regiment Armory, NY; Frank Gren; Bill and Abigail Gerdts; Bart Hacker and Margaret Vining, National Museum of American History, Washington, DC; Judith Filenbaum Hernstadt; Harmony Haskins and David Henderson, The Johnson Collection, Spartanburg, SC; Fred Keeler; Lisa Koenigsberg; Thelma and Melvin Lenkin; Angela Mack, Gibbes Museum of Art, Charleston, SC; Kenneth Maddox, Newington-Cropsey Foundation, Hastings on Hudson, NY; Joyce Mandeville, T. W. Wood Gallery & Arts Center, Montpelier, VT; Leo Mazow, University of Arkansas; Maurie McInnis, University of Virginia; Charlotte Emans Moore; James McPherson; the late Merl J. Moore, Jr.; Emily Neff, Museum of Fine Arts, Houston, TX; Burn Oberwager; Estill Curtis Pennington; Col. Mary L. Purdue, USAF; David Purvis; Bruce Robertson, University of California at Santa Barbara; William Keyse Rudolph, Milwaukee Art Museum, WI; Julia Sienkowicz; Craig L. Symonds; Mark Thistlethwaite, Texas Christian University; Evelyn Trebilcock and Valerie Balint, Olana State Historic Site,

Hudson, NY; Jane Wald, Emily Dickinson Museum, Amherst, MA; Jim Warehime; Glenn G. Willumson, University of Florida; Robert Wilson, editor of the *American Scholar*; and Susan Powell Witt.

Support across the Smithsonian American Art Museum has been essential to the success of this endeavor. Director Betsy Broun made it possible for me to focus exclusively on this project for two years. Deputy Director Rachel Allen supervised the budget and with Chief Registrar Melissa Kroning handled contract negotiations with the Metropolitan Museum of Art. Marie Elena Amatangelo, former head of exhibitions, provided early logistical support. Jenni Lee, registrar for this exhibition, has done an admirable job of tracking loans and securing indemnification for them. My curatorial colleagues George Gurney and Virginia Mecklenburg stepped up to take on my supervisory responsibilities while I was writing. Debbie Earle and Jean Lavery provided office support while I was immersed in writing. Theresa Slowik, publications chief, negotiated the arrangements with Yale University Press. Jo Ann Gillula, Laura Baptiste, and Nona Martin handled press queries, the marketing campaign, and public programs. Suzannah Niepold and Sally Otis developed outstanding educational programs for local and distance learning audiences. Georgina Goodlander and Carlos Parada developed the podcast and the exhibition's web presence. David Gleeson has designed a compelling installation, using light, color, and space to feature each work of art as an essential part of the viewer's experience.

Taking this exhibition on tour turned out to be a considerable challenge, and I am grateful to all of the lenders who made it possible. We could not have accomplished this without the help of our colleagues at the Metropolitan Museum of Art, in particular Dr. H. Barbara Weinberg, Alice Pratt Brown curator of American art, whose early and unwavering interest steered this exhibition to the Met. I am also grateful for the help of Harold Holzer, senior vice president for external affairs; Jennifer Russell, associate director for exhibitions; Jeff Rosenheim, curator in charge of photography; Nina Maruca, registrar; Barbara Bridgers, head of photo services; and Catherine Mackay and Sean Farrell in the American Wing.

Projects like this require immense resources. The Smithsonian American Art Museum's development staff did an outstanding job generating support for this exhibition. I would like to thank Catie Anchin, Michelle Atkins, Ross Randall, and Elaine Webster for all of their efforts. I am especially grateful to Ludmila and Conrad Cafritz and Thelma and Melvin Lenkin for providing critical support both for the early stages of research and again for this book, and to the Henry Luce Foundation, NY, for awarding this project a very generous grant. Support like this facilitates more than an exhibition and a book—it makes in-depth research and writing possible.

Finally, I could not have written this book or organized this exhibition without the constant support of my family. My heartfelt thanks go to my husband Steve, our children, Caroline and Duncan, and my mother, Peggy Jones. All of them stood by me, offered support and advice, put up with long hours at the computer, and endured numerous conversations that I hijacked into a disquisition about the Civil War. They have been there and back again with me, and for that I am forever grateful.

Eleanor Jones Harvey
Smithsonian American Art Museum
November 2012

INTRODUCTION

*I*n April 1861 America went to war with itself. At stake was the viability of the republic and the premises upon which it had been founded. The war's causes were multiple and interwoven into the fabric of American society. From 1859, when it was clear war was imminent, through 1876, when the nation sought closure to the conflict at the Centennial, the Civil War was never far from anyone's thoughts. Walt Whitman bemoaned that the "real war" would never make it into the books. By the "real war" he meant the story of the war as it was experienced by those who fought it and by those whose lives were forever altered by it. The history books have told and retold the stories of the war as it unfolded on the battlefield; contemporary poets and authors narrated it from various perspectives. However, most artists could not agree on how best to capture the universal qualities of the conflict in the moment. The moral ambiguities over the war's causes and the often brutal tactics used to advance the conflict undermined the expectations of history painting, based as it was on heroic action conducted for a righteous cause.[1] But what do you paint during the war when there is no way of knowing who was winning, how long it might last, and what might happen next?

This book focuses on the effects of the Civil War on American landscape and genre painting, and on the new medium of photography, considering what artists chose or avoided as their war-related subjects. By looking closely at specific works of art, we can better understand how Americans grappled with the impact of the war in the moment, without the benefit of hindsight. My purpose is to tease out the war-inflected layer of meaning in some of the most powerful paintings and photographs made during and immediately after the war years. My intent is to show that these works of

The real war will never get in the books.

—Walt Whitman

art make manifestly clear that this conflict not only unleashed historical events of great moment, but also wrought great changes in the nation's visual culture and character.

Surprisingly few American painters engaged directly with the war as it was being fought. There was little market for depictions of Americans killing one another, and artists found it difficult to immediately identify heroes and pivotal battles. Without the luxury of time and reflection, these artists approached the Civil War in a more elliptical manner. In some cases the paintings are not specifically about the conflict; nevertheless, the war left an indelible mark on artist and subject alike. To understand the Civil War's effect on American art, we must look beyond the Grand Manner of history painting as it was touted in the European art academies. With little to glorify in this tragic fratricide,

we instead consider landscape and genre painting, while factoring in photography. Photography and telegraphy sped up the transmission of graphic information about the war. Images of dead Americans, although not widely circulated as we think of it today, were on view in New York and Washington throughout the war at Mathew Brady and Alexander Gardner's galleries. Reviews of these photographs indicated that there was little left to romanticize after absorbing firsthand accounts of battle-field carnage.

The lens through which I first approached the Civil War was landscape painting. Its early practitioners believed, as did the Founding Fathers, that the unique features of the American landscape reflected the growth of a specifically American character. More than just our individual lives were shaped by the rocks, soil, waters, and climate of this land. The emerging disciplines of geology, meteorology, and botany were a source of widespread fascination in America and contributed to a rich language vested in scientific metaphors. The idea that environment shaped culture was gaining traction in art and in literature, indeed in the very way we spoke and wrote about our experiences. In 1837 Ralph Waldo Emerson delivered a speech he called "The American Scholar," in which he built on the precepts of his essay *Nature*. He expressed that a truly American culture would emerge through our relationship with nature. Emerson concluded that in America, "The ancient precept, 'Know thyself,' and the modern precept, 'Study nature,' become at last one maxim."[2] During the first half of the nineteenth century, the Hudson River school dominated the New York exhibition halls and presented the American wilderness as a New Eden. The Southern landscape played a less visible role in developing this paradigm, driven largely by the greater influence of Northern collectors and their preferences in the art market. During the war years, Frederic Edwin Church, Sanford Robinson Gifford, and John Frederick Kensett absorbed aspects of the conflict in their landscape paintings; after the war, they would find it impossible to go back to that earlier idiom. The Civil War helped reshape the cultural meaning of landscape painting in America.

The first chapter considers the impact of the war on landscape painting and specifically on the artists whose reputations were vested in the prewar Hudson River school ethos. Church and Gifford channeled the nation's mood as well as their own, layering subtle reverberations of the war in otherwise unrelated subjects. Church had painted the Ecuadoran volcano Cotopaxi several times since his two trips to South America, but in his 1862 painting (see cat. 6) he first portrays this southern paradise in full eruption, on fire and coming apart at the seams. Reviewers at the time noted the violence in Church's painting, and, mindful of the war, they expressed the hope that when the clouds of ash reminiscent of cannon smoke finally cleared, the sun would again shine on a peaceful nation. Painted in 1863, Gifford's *A Coming Storm* (see cat. 11) spanned two of the artist's summers in uniform. He returned to his beloved Catskill Mountains each fall to restore his equilibrium; however, in this stormy scene, he captured the turbulence of the period. That blackness would intensify in 1865, when the painting became associated with Lincoln's assassination, in large part through its ownership by John Wilkes Booth's brother, the Shakespearean actor Edwin Booth. Through circumstance, reviewers claimed this picture symbolized the nation's grief.

Literature of the period in both the North and the South reinforced the use of landscape metaphors to assimilate the war and its impact. Prominent Northern authors and poets Herman Melville, Nathaniel Hawthorne, Emily Dickinson, Ralph Waldo Emerson, Mark Twain, and Walt Whitman, along with writers for the *Atlantic Monthly*, *Harper's Weekly*, and a variety of newspapers, all invoked meteorology and geological processes to convey the sense of life coming loose from its moorings, of a nation morally adrift. For most Americans in both the North and the South, geographical and meteorological metaphors were a common language for comprehending the violence of the war and its uncertainty. Henry Ward Beecher's sermons evoked storms as an image of impending crisis and spiritual tumult. Frederick Douglass spoke for many blacks and white abolitionists when he described slavery as a smoldering volcano ready to erupt. Sunsets, comets, and auroras were malleable portents of disaster or of imminent victory for both sides. With the conflict described everywhere in these terms, why then would landscape painters have remained immune to that

sensibility.[2] A closer look confirms that many of their major works are suffused with the emotional and spiritual significance of the war if not with its daily details.

By the time war broke out, the most vibrant art market was in New York City, centered around the National Academy of Design and clusters of artists' studios nearby. Depictions of the Civil War displayed a decidedly Northern view of the conflict. Not only was the economy more stable in the North, but artists' supplies were more readily available, and the artists' favorite haunts were well out of harm's way. Many Southern patrons, including Confederate sympathizers living in the North or in the border states, left for England to ride out the conflict, further dampening the market for paintings promoting a Southern point of view. In Richmond and Charleston, two of the major Southern markets, patronage dried up as the war dragged on, and even in New Orleans there was little traffic in war-related paintings. Few works by Southern artists were seen publicly outside the city in which they were made; even fewer were made by artists who witnessed the conflict firsthand. As such, the artists who addressed the Civil War and received recognition for their efforts tended to be Northern artists, many of whom enlisted or accompanied the Union army at some point. Their interpretation of the war provides the backbone for this book, as their works shaped the prevailing point of view both during and after the Civil War.

The market for American art simultaneously expressed a craving for war-related subjects and a rejection of them when they did appear. One of the driving forces behind this ambivalence was the new medium of photography. The second chapter considers how photography placed a new and powerful variable on the table, permitting what appeared to be direct documentation of the aftermath of war. The photographers who marched with or followed behind the army took pictures that forever changed the way Americans thought of the conflict. Roger Fenton had photographed the Crimean War in 1855, but his work focused on the landscapes where battles had been fought. Daguerreotypes exist from the Mexican-American War, but they were not widely viewed until this century.[3] Battlefield photography proved an unwelcome reminder of the war's physical and emotional costs. In 1862, Alexander Gardner provided the nation with its first glimpse of bloated corpses strewn across fields, the gruesome aftermath of battle. The visceral impact of those photographs was both fascinating and disturbing. Mathew Brady placed Gardner's images from Antietam on view in his New York gallery, which was adjacent to the Tenth Street Studio Building and the National Academy of Design. Undoubtedly a significant number of New York artists and their patrons saw them, hanging in close proximity to so many artists' paintings. George Barnard chronicled William Tecumseh Sherman's campaigns across the South and, like Gardner, arranged an elaborate album that provided his audience with haunting images of destruction. The advent of photography introduced a level of immediacy even the daily newspapers and illustrated weeklies could not match. Photographs conveyed material facts and gruesome details with dispassionate clarity. They announced a level of verisimilitude impossible to convey in print or on canvas.

That claim to unmediated accuracy initially gave battlefield photography an unmatched reputation for truth.[4] *The New York Herald* expressed frustration with delayed and conflicting information from the front. The editor proclaimed, "The place in town best worth visiting just now is Brady's gallery. There, one has an opportunity of witnessing the most exciting incidents of the campaign without the fear of a stray bullet or the equally uncomfortable sensation of panic. The only reliable records of the war are to be found at Brady's. On no other can dependence be placed. The correspondents of the rebel newspapers lie, the correspondents of the Northern journals lie, the correspondents of the English press lie worse than either; but Brady never lies."[5] Gardner promoted photography as the arbiter of truth, stating, "Verbal representations of such places, or scenes, may or may not have the merit of accuracy; but photographic presentments of them will be accepted by posterity with an undoubting faith."[6] But authenticity would not be the arbiter of success in capturing the Civil War. The most effective works of art, be they paintings or photographs, transcended battlefield realism, and the artists who made them invested their subjects with universal qualities of human suffering or hope.

In considering the changes wrought to landscape painting, I found that, especially in Winslow Homer's war-related works, the landscape played an important role as either subject or protagonist. From there my focus expanded to genre painters and how they addressed the war. Genre painting had long been devoted to scenes of daily life and lowbrow humor focused on American foibles. Homer and Eastman Johnson, however, helped deepen and extend the reach of genre painting. The war gave their work a more serious purpose—probing the lives of common soldiers and enslaved people and dramatizing tensions between the races. These two artists, along with others, rose to the occasion. Whitman's fear that the "real war" would not make it into the books did not anticipate the power behind Homer and Johnson's multilayered vignettes. The universal qualities of the human experience would become focal points of their war-related paintings.

The third chapter addresses artists who experienced the war firsthand, either in uniform or as civilians attached to an army regiment. Gifford's summers in uniform led him to paint scenes of regimental life that, nonetheless, fundamentally remained landscape paintings. The atmosphere in each painting is invested with the emotions uppermost in the artist's mind. His Confederate counterpoint, Conrad Wise Chapman, similarly created paintings of Charleston Harbor that were as much meditations on the quality of light as on the city's fortifications. Homer's studies of camp life, many completed between assignments for *Harper's Weekly*, anchored his art career firmly in current events. Focusing on the common soldier, he brought the war into focus by exploring its human side, forcing viewers to confront aspects of the conflict as matters of conscience. *Home, Sweet Home* (see cat. 52) calls to mind a sentimental song that reminded soldiers of their loved ones, but the song appealed equally to Union and Confederate soldiers, emphasizing their commonalities. As the war dragged on, Homer's imagery deepened in significance, asking tough questions about men's motives for fighting and whether both sides could reconcile at the war's end.

The fourth chapter focuses on the subjects of abolition and emancipation. Prior to the Civil War, the depiction of blacks in American art and popular culture had tended toward caricature, feeding into whites'

negative stereotypes of blacks as an inferior race and quelling the disquieting thought that maybe they were not. Regardless of their political leanings, most white Americans in the North had their first meaningful encounters with black people during the war. This chapter charts the trajectory of growing racial awareness in the works of Eastman Johnson and Winslow Homer, who focused on blacks as individuals determined to move beyond slavery. Johnson's *A Ride for Liberty* (see cat. 67) presents a black family racing for the safety of Union lines. With no assurances of what the future may hold, they are willing to risk their lives for a chance at freedom. In Johnson's hands, enslaved blacks became fully human, their fears and desires as deserving of respect as those of any other American. In the postwar years Winslow Homer painted monumental scenes that equated blacks' struggles with America's struggles—be they political, economic, or moral. He invested *A Visit from the Old Mistress* (see cat. 73) with such tension and antipathy between the black and white figures that, on the eve of the nation's Centennial in 1876, he reveals that there remained much to resolve in race relations.

Throughout the book, but notably in this chapter, newspaper coverage of events and each paper's art reviews play an important role in understanding how the war and art were perceived. Then, as now, every newspaper had an editorial point of view. In New York, for example, three of the major papers vied for readerships across the political spectrum. *The New York Herald* was the favorite of the Northern Democrat. Its editor James Gordon Bennett championed a conservative point of view and was content to leave slavery in place in order to maintain the Union. Bennett's deep-seated racial prejudice against the negro led him to write an 1857 editorial in which he opined that the premise of the Declaration of Independence, that all men were created equal, was but a "figure of speech."[7] He went on to assert, "It is clear that slavery is not the cause of the trouble, but the fanatical disposition at the North to meddle with it."[8] The *Herald*'s daily circulation outstripped its chief rival, Horace Greeley's *New-York Daily Tribune*, a solidly pro-Republican paper with a circulation of well over 100,000 readers. Greeley was an early supporter of Lincoln and a staunch abolitionist. He

called for the end to chattel slavery even if it meant going to war. In 1851 Henry Jarvis Raymond had founded the *New York Times* to tread the middle ground between these two papers, although its sentiments most often leaned toward support of Lincoln and in favor of abolition. The editors of each did not stint their opinions on the pages of their papers. This is an important factor to bear in mind even when reading each newspaper's art criticism, which must be seen through the filter of each paper's editorial point of view. These divergent opinions were expressed by the reviewers of Johnson's *Negro Life at the South* (see cat. 64). The *Herald*'s review praised the painting as presenting a benign view of slavery, where everyone is happy, whereas the *Tribune*'s reviewer decried the dilapidated state of the slave quarters as emblematic of the very institution it represents. Their markedly different interpretations of this painting mirrored the attitudes of their editors and their readers. The illustrated weeklies played a similarly partisan and influential role in constructing narratives of the war. *Harper's Weekly*, founded in 1857, supported Lincoln early on and remained a solidly pro-Republican journal. Its chief rival, *Frank Leslie's Illustrated Weekly*, started as a pro-Democrat, anti-Lincoln paper in 1856, but when war broke out, it threw its support behind the Union.

The final chapter considers the ramifications of the war on American landscape and genre painting. Here I consider briefly how these artists approached the cost of the war, measured in the damage done to the survivors. Fear was palpable in both the North and the South for what a newly freed population of former slaves would portend. No one survived the war unscathed, and both social and artistic conventions changed as a result of the war. Ultimately the shockingly high death rate and four years of unrelenting battles, followed by a presidential assassination and bungled efforts at Reconstruction, reshaped expectations for and the content of American landscape and genre painting. Westward expansion offered the hope of a new landscape in which to envision Eden and escape memories of the war, while eastern landscapes began to dissolve in a tonalist haze. Genre painting, once the purview of lowbrow political comedy and affectionate views of democracy, had tackled serious issues during and after the war. Both genres sustained permanent changes that altered their roles in American art and life.

THE PROBLEMS OF HISTORY PAINTING

History painting, in the traditional, academic sense of monumental canvases depicting elaborate battle scenes and heroes, had gained at best a tenuous foothold on American shores. Even in the hands of the country's finest history painters—Benjamin West, John Trumbull, and John Singleton Copley—Grand Manner history painting never garnered the same support in America as landscape or genre painting. Americans intentionally sloughed off European judgments about the merits of history painting, at least in part, because they had little history to depict. Instead, they developed an American wilderness aesthetic, in which the landscape itself carried morally instructive overtones. In that sense, landscape became the nation's self-defining genre. However, even with the outbreak of the Civil War, history painting gained little traction. The reasons are myriad. First, the American context was different from European battles waged between empires. Combatants and citizens realized early on that there could be no "winners"—and no glory—in this bloody internecine feud. American leaders hoped that the conflict would ultimately be resolved through reunification, a goal that stymied the impulse to demonize opponents. The fighting was different as well. There were few grand charges and decisive campaigns that made for tidy narratives. News of trench warfare, long sieges, and forced marches was circulated in the press and proved ultimately unglamorous. Despite these challenges, some artists aspired to paint in this genre. Exploring a few examples helps us understand why their success was, for the most part, elusive.

From the outset the Civil War was beset by misperceptions. Both sides wanted to believe the war would end quickly, in an afternoon or within three months. Artists were hardly immune to such overly optimistic thinking. *The New-York Daily Tribune* noted that one unnamed artist had left for Manassas expecting to paint the first great Union victory. But the First Battle of Manassas (known as the Battle of Bull Run to the Union) culminated in the Confederacy's rout of Union troops.

The defeat of our army at Bull Run cost us, among many other things, a very fine picture representing the victory which we ought to have gained there. One of our most promising young artists…determined to do his share toward perpetuating the nation's glory by painting a picture of our first great victory over the rebels. So, when the Grand Army of the Potomac set out on its gallant career toward Richmond by way of Manassas Junction, our artist put his canvas upon his easel and sketched in his principal groups of his picture, working upon the sky the smoke and other generalities, and waiting impatiently for the official report of the victory, when he could add the romantic episodes and details of the fight which would give it a local significance. But…the defeat of our Grand Army at Bull Run spoiled the design of our artist. He could not finish his picture, but he keeps it all ready to be filled up whenever we do achieve a victory worthy of being commemorated on canvas.[9]

The laudable goal of providing on-the-spot accounts of the war's first battle presumed that a victory would provide a suitable emblem for the righteousness of the Northern cause. Rather than depicting the battle as it happened, this artist preferred to wait. History as it was unfolding would prove unwieldy, thwarting most efforts to valorize the outcome of any battle on such terms. The reality of war would be an ongoing lesson in recalibrating expectations, whether on the battlefield, in the newspapers, or on canvas.

DOCUMENTING COMBAT

Even victory did not often provide ready imagery for a painter's canvas. Expectations of documentary-like accuracy, as seen in photographs, may have dampened interest in trying to paint a stirring image of a particular charge or skirmish. However, it is also likely that collectors had little interest in owning such scenes. Battles involving sometimes more than one hundred thousand men and waged over miles of varied terrain proved nearly impossible to encapsulate in aesthetically pleasing tableaux. In addition, Union successes at Antietam and Gettysburg came with such steep casualties that they did not lend themselves to romanticized pictorial commemoration. William Tecumseh Sherman's tactics were widely credited with accelerating the surrender of the Confederacy, but his brutal campaigns in Atlanta and Columbia, South Carolina, did not inspire many paintings glorifying his achievements.

The paintings of Antietam by the Vermont artist James Hope (1818–1892) provide an example of the difficulties artists experienced trying to paint the literal reality of combat. Hope made a dogged attempt to sustain his postwar artistic career by creating paintings based on his firsthand experiences in the army. Forty-two years old when he enlisted, Hope helped recruit and organize the B Company of the Vermont Second Infantry, which was mustered into service June 1, 1861.[10] He served primarily as a topographical engineer making field maps. He witnessed no fewer than eleven battles beginning with First Manassas, often sketching in the field with the engineers in advance of the troops. Hope had trained as a landscape painter, seeking advice from Frederic Church. Following the war, he aspired to translate his skills into making what he called "huge historical panoramas to preserve for posterity" based on his experiences.[11] However, ambition outstripped interest, and the market for his work was lukewarm at best. For his massive *The Army of the Potomac (Encamped at Cumberland Landing on the Pamunky River)* (MFA, Boston), Hope took as much care in making sure each general appeared on his favorite horse as he did positioning the troops accurately.[12] Despite the broad sweep of the panorama and his clever inclusion of what was reputed to be eighty thousand soldiers, the painting turned out to be more impressive for those statistics than for its overall aesthetic effect.

At Antietam in September 1862, Hope's brigade withstood withering fire the entire day, although it is not clear if the artist was with his troops or sidelined by illness.[13] In either event, his sketches served as the basis for his later paintings, as did photographs taken by Alexander Gardner after the battle. When Mathew Brady placed these photographs on view in New York, they drew crowds that were as much repulsed as intrigued. Beginning in 1865 as the war ended, Hope created a suite of paintings documenting the course of the battle. His choice of Antietam was unusual. It was the bloodiest day in U.S. history, and a battle that ended in a strategic draw, with the Union claiming victory as Confederate General Robert E. Lee withdrew his troops from the field. As a result, few artists chose this battle for their

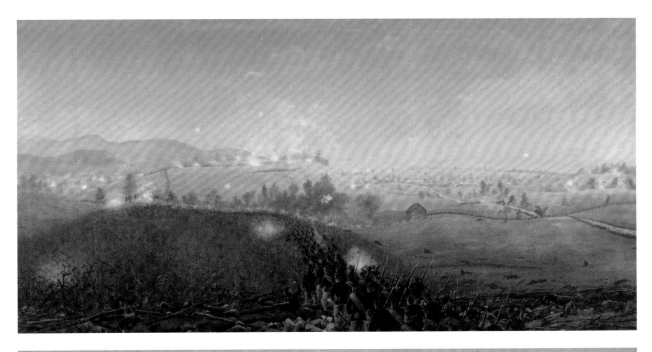

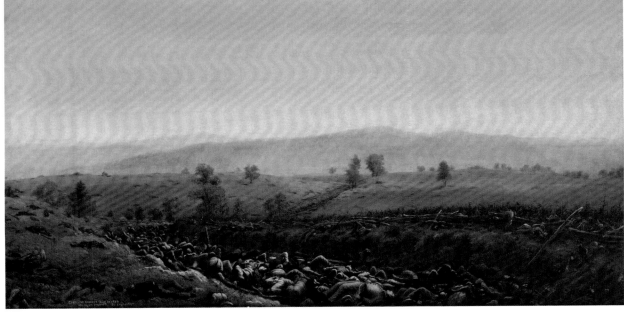

FIG. 1

James Hope
Battle of Antietam, September 17, 1862, 7th Maine Attacking over the Sunken Road through the Piper Cornfield, about 1862, oil on canvas, 18 ⅞ × 35 ⅞ in. Farnsworth Art Museum, Gift of Alice Bingham Gorman

FIG. 2

James Hope
Bloody Lane, about 1862, oil on canvas, 19 × 26 in. Army Art Collection, U.S. Army Center of Military History

subject. Unlike traditional history painters, Hope's approach to the carnage at Antietam resembled a morality play. His intent was not to valorize, but instead to paint a mournful meditation on the true toll of battle. Enamored by statistics, the artist wrote his own texts to accompany each painting, including sobering casualty counts to drive home the futility of war.

In this series of four paintings, Hope chronicled the day of the battle, September 17, from dawn to dusk. His sequence began with the morning's sunny optimism as the troops entered the Piper cornfield (fig. 1) and culminated in the twilit horror of Bloody Lane (fig. 2). As was true of many landscape painters who enlisted, Hope saw the battlefield as a classic landscape rather than a

topographic chessboard. His diminutive soldiers invade the cornfield, swallowed up in the late summer harvest still to be reaped. White clouds of smoke betoken the unseen cannonade and the exchange of fire. On closer inspection, fallen soldiers crush the mature stalks as they fall to earth. In the final painting at day's end, the body count overwhelms the landscape, and the Sunken Road is a trench filled with a mass of bodies. Hope's daring and unpleasant composition draws heavily from Gardner's photographs of the scene (see cats. 15 and 16). In doing so, Hope asserts an air of authenticity but presents an unwelcome scene of the carnage. What had worked in the photographs ultimately did not translate well into paintings of jumbled limbs and dead soldiers.

NARRATIVE PORTRAITS AND THE PROBLEMS OF SCALE

More successful was the poet-turned-painter Thomas Buchanan Read's commemoration of Union General Philip Sheridan's dramatic charge to rally his troops at Cedar Creek, Virginia, on October 19, 1864. This battle represented the last in the Shenandoah Valley Campaigns of 1864, when Union forces destroyed Confederate supply lines. Read (1822–1872) created both a poem and a painting titled *Sheridan's Ride* (fig. 3), depicting the general galloping hard his favorite mount, Rienzi, with his sword raised. One cannot see what is happening through the cloud of dust, but Read's poem fills in the narrative gaps. In both works, Read focused on the dramatic moment when Sheridan, miles from the front of his lines, learned his troops were beginning to yield to Confederate pressure. He charged to the front, rallying his dispirited men, and the battle turned in the Union's favor. The artist made a cottage industry painting copies of his work; seventeen survive.[14] His success at placing so many replicas may be attributed to both the popularity of the poem and the artist's focus on an isolated heroic figure who serves as a synecdoche of the story as a whole. Although Read's talents as a poet surpassed his abilities as a painter, here painting and poem work together to permit the artist to let go of narrative specifics and attempt an action portrait that embodied the determination of the Union cause.

Everett B. D. Fabrino Julio (1843–1879) extracted a similarly emblematic turning point in the war when, in

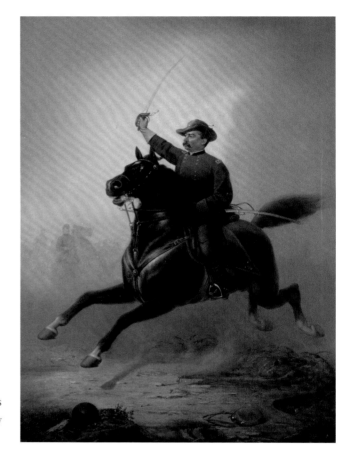

FIG. 3

Thomas Buchanan Read
Philip Henry Sheridan (Sheridan's Ride), 1871, oil on canvas, 54 × 38⅞ in. National Portrait Gallery, Smithsonian Institution; Gift of Ulysses S. Grant III, 1939

FIG. 4

Everett B. D. Fabrino Julio
The Last Meeting of Lee and Jackson, 1869, oil on canvas, 102 × 74 in. The Museum of the Confederacy, Richmond, Virginia

1869, he embarked on his monumental painting titled *The Last Meeting of Lee and Jackson* (fig. 4). Like Read, Julio was reliant on his audience's knowledge of and emotional investment in the scene, but here he invoked the devastating loss to the Confederacy that was about to occur with General Thomas J. "Stonewall" Jackson's death. He sets his scene on the morning of May 2, 1863, near Chancellorsville, Virginia. Later the same day Jackson outflanked Union General Joseph Hooker and secured yet another victory for the Confederate Army. But that evening, one of Jackson's own soldiers mistook him for the enemy and fired the shot that killed Lee's most valuable commander. Julio chose not to depict Jackson's death, preferring to focus on a poignant moment presaging that tragedy.[15] The scale of *The Last Meeting*, which measures over twelve feet high in its frame, matched the artist's ambitions, and Julio was confident that his efforts would be well received. He first presented the painting as a gift to Confederate General Robert E. Lee, who politely

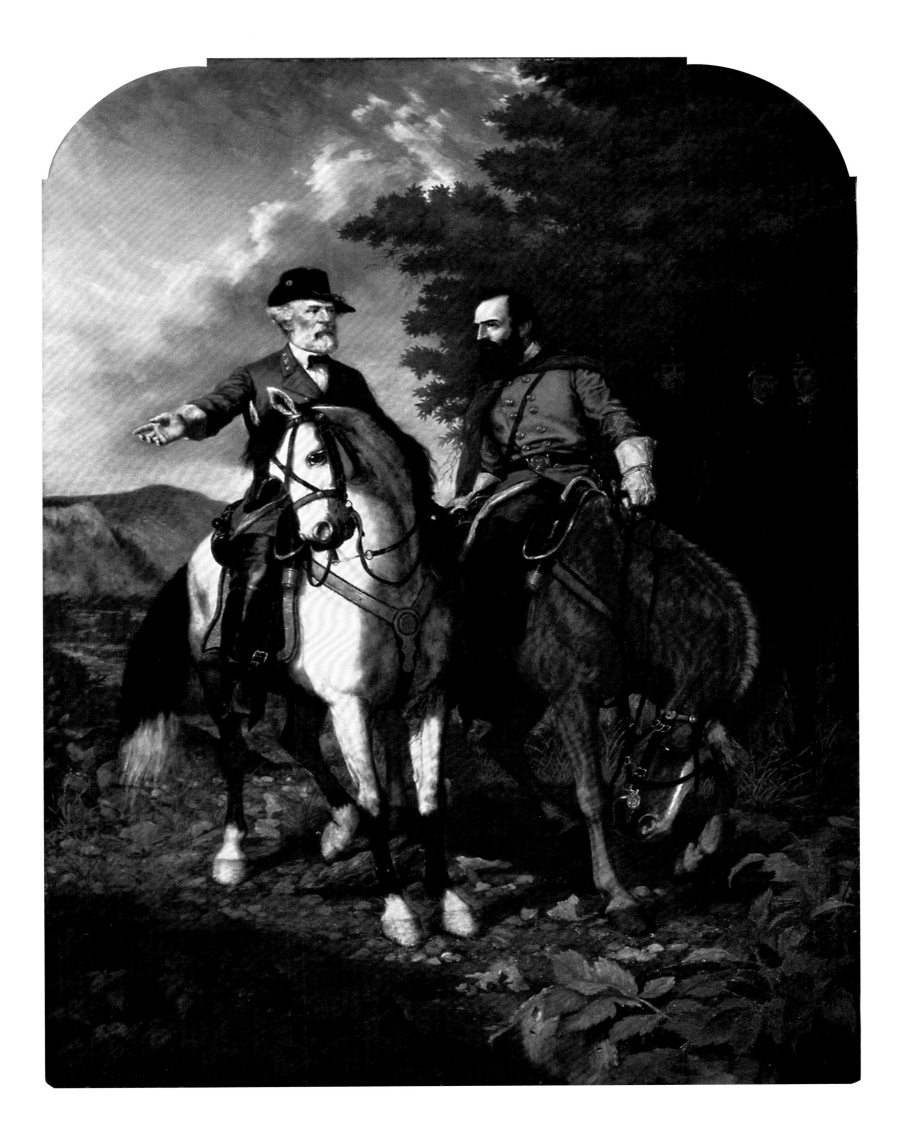

declined the offer.[16] Undaunted, Julio searched for an appropriate home for his masterwork. As popular and revered as Lee and Jackson remained across the South, the painting was unexpectedly difficult to place. The painting's scale and elaborate frame made the work all but impossible to accommodate in even the most gracious Southern dwelling. Its cost in the Southern postwar economy was equally out of scale. Julio placed the work on public display in New Orleans, hoping to attract a buyer in this still-affluent town, to no avail.[17]

Among those who saw the painting was Mark Twain (1835–1910, fig. 5), himself briefly a Confederate soldier, if only for two weeks.[18] Twain earned the undying enmity of Confederate loyalists with his insouciant but perceptive critique of the work:

> [I]n the Washington Artillery building...we saw...a fine oil-painting representing Stonewall Jackson's last interview with General Lee. Both men are on horseback. Jackson has just ridden up, and is accosting Lee. The picture is very valuable, on account of the portraits, which are authentic. But like many another historical picture, it means nothing without its label. And one label will fit it as well as another:
>
> First Interview between Lee and Jackson.
> Last Interview between Lee and Jackson.
> Jackson Introducing himself to Lee.
> Jackson Accepting Lee's Invitation to Dinner.
> Jackson Declining Lee's Invitation to Dinner— with Thanks.
> Jackson Apologizing for a Heavy Defeat.
> Jackson Reporting a Great Victory.
> Jackson Asking Lee for a Match.
>
> It tells one story, and a sufficient one; for it says quite plainly and satisfactorily, "Here are Lee and Jackson together." The artist would have made it tell that this is Lee and Jackson's last interview if he could have done it. But he couldn't, for there wasn't any way to do it. A good legible label is usually worth, for information, a ton of significant attitude and expression in a historical picture.[19]

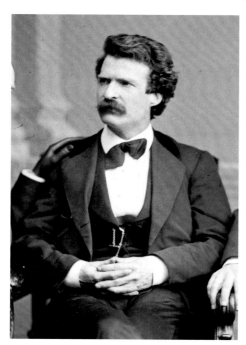

FIG. 5

Unidentified photographer
Mark Twain (Samuel L. Clemens)
(detail), 1871, Library of Congress

Twain's barbed review skewered both the painting and its advocates. His comments also reflected the difficulties portrait painters would encounter with regard to the Civil War. As a genre, portraiture's conventions did not change as a result of the conflict, varying little in substance or symbolism from the works of earlier generations of artists. Read had managed to avoid this problem of interpretation by supplying his own poem in place of an explanatory label with *Sheridan's Ride.* Although Julio was unable to sell his outsized canvas, *The Last Meeting of Lee and Jackson,* he found greater success with a widely distributed and much smaller, more affordable lithographic reproduction, suggesting the popularity of its subject. For the long term, however, the Northern victory all but assured that the original would become a relic of the Confederacy.

Constant Mayer (1832–1911) attempted to capture the universal quality of the Civil War in his own monumental scale painting of 1865, *Recognition: North and South* (fig. 6). Intended for a Northern audience, it portrays the moment when a Confederate soldier recognizes that the Union soldier he has just killed is his brother.[20] Mayer may have meant the painting as a morality play for eventual Confederate remorse for having begun the fight, or he might have intended it simply as a poignant rendering of the consequences of the fratricidal conflict. Either way, his dramatic moment rang curiously hollow. Stories of families split by the war were frequent, especially in the border states; however, what might have been a tender and moving image on an intimate scale reads here as an operatic shout. The oversized canvas with overwrought figures garnered glowing reviews for its emotional power, but it remained without a buyer until Mayer sent it to a benefit auction for the Crosby Opera House in Chicago. A reviewer later noted, "Mr. Mayer's last great picture, *Recognition,* by the way, which was one of the large prizes of the Crosby Opera House lottery in your city, is now stored in the cellar of one of the art stores here, rather hopelessly awaiting sale, being quite too big for the house of the fortunate drawer, and not to the taste of the majority of the picture buying public."[21] That issue of taste would emerge again and again, as art patrons by and large avoided large-scale paintings of the war regardless of the subject.

FIG. 6

Constant Mayer
Recognition: North and South,
1865, oil on canvas, 68 ⅛ × 93 ½ in.
The Museum of Fine Arts, Houston,
Museum purchase with funds provided
by "One Great Night in November,
2011," and gift of Nancy and Richard D.
Kinder in honor of Emily Ballew Neff

PAINTING PERSONAL OUTRAGE

In many people's minds, the Civil War had started years before in the West, after the Missouri Compromise of 1820 had mandated bringing in new states in pairs, one slave, one free. The Kansas-Nebraska Act of 1854 undid this legislation, allowing popular sovereignty to determine how each state entered the Union. That prompted abolitionists from the North, including John Brown (1800–1859, fig. 7), and Southern slaveholders alike to head for Kansas, all hoping to influence the vote there on statehood. The ensuing conflicts led to more than fifty deaths and widespread property damage in "Bleeding Kansas," as the two sides vied to control the territory. George Caleb Bingham (1811–1879) hailed from the slaveholding state of Missouri but missed its involvement in Kansas's

border violence in 1856. That year the self-taught painter and local politician moved to Europe to spend three years studying the Old Masters and absorbing the lessons of history painting. Returning before the outbreak of the Civil War, this Virginia-born son of slaveholders remained a Unionist but felt conflicting allegiances.[22] Steeped in the emotions that surrounded Missouri's troubled western border, he was resentful when Kansas entered the Union as a free state in early 1861. After the Civil War began, violence on the Missouri-Kansas border escalated, and in 1863 Confederate raiders attacked Lawrence, Kansas, executing more than 180 men of fighting age and destroying the town. The guerrilla attack by William Quantrill and his Confederate bushwhackers drew a swift response from Union Brigadier General Thomas Ewing Jr., who sought to quell the violence.

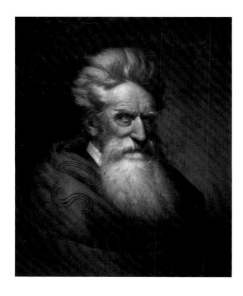

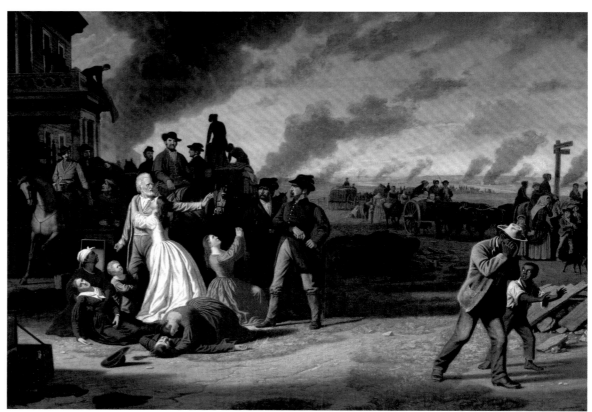

FIG. 7

Ole Peter Hansen Balling
John Brown, 1872, oil on canvas,
30 ⅛ × 25 ⅜ in. National Portrait Gallery,
Smithsonian Institution

FIG. 8

George Caleb Bingham
Order No. 11, 1865–1870, oil on canvas,
56 ³⁄₁₆ × 79 ⁷⁄₁₆ in. Cincinnati Art Museum,
The Edwin and Virginia Irwin Memorial

Bingham's painting *Order No. 11* (fig. 8) highlights
Ewing's controversial decision to force evacuation of four
Missouri counties along its western border. The measure
was intended to deprive Confederate raiders in that area
of supplies, making it harder for them to mount attacks
in Kansas. But the order backfired. Union troops col-
loquially known as Jayhawkers were accused of pillaging
vacated homesteads, creating waves of resentment in
the local populace. Bingham was outraged at the army's
infringement of their civil liberties.[23] The artist wrote to
Ewing's commanding officer, asking him to rescind the
order. Rebuffed, the artist declared in a letter, "If God
spares my life, with pen and pencil I will make this order
infamous in history."[24] As Bingham presents the encoun-
ter, Ewing confronts a family whose patriarch resembles
John Brown. Viewed by Confederates as an abolitionist
willing to resort to murder and arson, Brown was seen as
an Old Testament prophet by sympathetic Northerners.
As out-of-control Union troops burn buildings and

residents flee in terror, a black man and his son lament their fate. Bingham drew on his European training, borrowing liberally from Renaissance paintings, invoking parallels between his subject and those of his source paintings. This was a practice common among artists of Benjamin West's generation of history painters, but it proved of limited interest to later American audiences. In his densely layered diatribe, Bingham equates the horrors of Order Number 11 with the biblical stories of the expulsion from the Garden of Eden (fig 9) and the death of Christ (fig. 10).[25] By invoking the two well-known religious scenes, Bingham equated the local residents' suffering with that of Christ and his followers, and the oppression of the local black population with the expulsion of Adam and Eve. But Bingham's morality play about the abuse of civil liberties and the Constitution became entangled in local politics. He complicated his narrative—perhaps revealing his own ambivalence—by depicting a pro-Union family as slaveholders, and vilifying the behavior of the Union army. In so doing he lost the battle for public opinion. From the moment this work was displayed, reviewers forced Bingham to explain that this painting was not an indictment of the Union and not a veiled apology for the Confederacy.

By pouring outrage into his painting, Bingham's composition collapsed under the weight of his agenda.[26] As an artist accustomed to poking gentle but pointed fun at the foibles of politicians, Bingham here lost his temper along with his usual sense of perspective. He was denounced by politicians and clergy as "prostituting an art which should be dedicated to the noblest purposes."[27] The artist countered with a lengthy pamphlet explaining his motives. Therein he defined art as "the most efficient handmaiden of history, in its power to perpetuate a record of events with a clearness second only to that which springs from actual observation.... By such and similar means only can our bitter and tragical experience give due warning to posterity."[28] But in the end, Bingham could not free his painting to stand for the larger issue of civil liberties as guaranteed by the Constitution. Even the references to Renaissance artworks typical of history painting could not untangle the artist's many messages. Unable to see past his own anger, Bingham created a garbled work that could not rise to the level of universal significance, a goal that is crucial to the success of history painting.

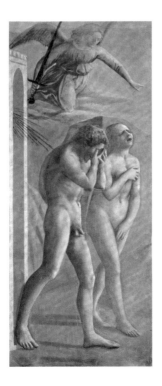

FIG. 9

Masaccio
Expulsion from Paradise,
1425–1428. fresco, Brancacci
Chapel, Santa Maria del Carmine,
Florence, Italy

FIG. 10

Petrus Christus
The Lamentation, about 1450, oil on
wood, 10 × 13 ¾ in. The Metropolitan
Museum of Art, Marquand Collection,
Gift of Henry G. Marquand, 1890

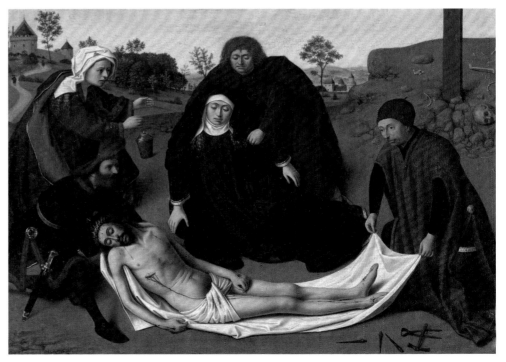

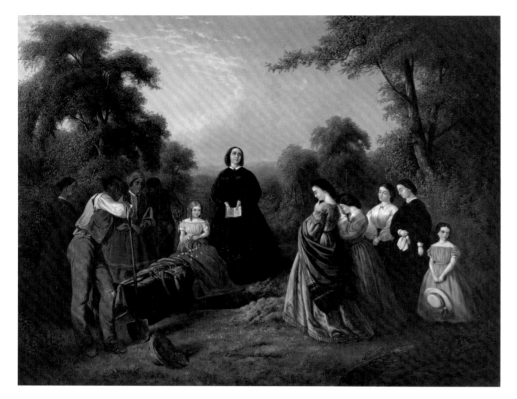

FIG. 11

William D. Washington
The Burial of Latané, 1864,
oil on canvas, 38 × 48 in.
The Johnson Collection

GENRE AND THE LOST CAUSE

The type of history paintings that came closest to capturing the essence of the conflict was a hybrid form of genre painting focused on specific events that carried a clear message. In 1864, Virginia artist William D. Washington (1833–1870) painted perhaps the single most famous image associated with the Lost Cause.[29] White Southerners developed this ideology as the war was ending. With it they rationalized that they had fought for the concepts of honor, loyalty, and faith, thereby giving a noble cast to the Confederate defeat.[30] *The Burial of Latané* (fig. 11) commemorated the death of a cavalryman, Captain William Latané, part of Confederate General J. E. B. Stuart's army during the Peninsular Campaign of June 1862. The painting concerns the story that arose surrounding the retrieval of Latané's body by his brother, and it illustrates the burial by women and enslaved blacks of a nearby plantation. Judith Brockenbrough McGuire's family owned two manor houses, Westwood and Summer Hill, in Virginia. It was to her estate that

the body of Latané was taken after he fell in battle, and it was the McGuires who vowed to give him a proper burial in June 1862.[31] Poet John Thompson quickly set the incident to verse, and his lines were published in the *Southern Literary Messenger* that same summer.[32] At a time when many corpses were left to decompose where they fell, these Southern women came to epitomize loyalty and honor as core Southern traits.

The image carried another layer of Southern mythology: that of the loyal black slave, devoted to the family he served, here mourning the fallen Confederate soldier. Many planters clung to the reassuring notion that their enslaved servants, particularly the household slaves, were almost like family. However, as the war progressed, evidence revealed that this idea was largely fiction. Washington's inclusion of a devoted black man played into this Southern stereotype. *The Burial of Latané* supported the long-embedded idea of willing black subservience to white rule and of white Southern women's devotion to the precepts of the Old South. Neither concept would survive the war.

So many people came to see the painting in the artist's Richmond studio that Washington arranged to have it installed in the State Capitol, where a bucket was placed next to it for donations to the war effort. Without the formal apparatus of a Sanitary Commission or a Patriotic Fund, Washington's painting served as a magnet for Southern pride. There was little market for any ambitious works of art in the South during the war. The strain on the economy rendered all such luxuries beyond most Southerners' reach. The artist arranged to have the painting engraved, and after 1868, prints of this painting became a fixture in countless Southern homes.

Latané's fate became a symbol for the Confederacy of Southern virtue under duress. *The Burial of Latané* specifically, and the Lost Cause in general, epitomized those ideals that would become deeply woven into the fabric of the postwar South. The need to believe that the soldiers of the Confederacy had fought and died honorably, and for a worthwhile cause, lay at the heart of these expressions of grief. As one well-to-do Southern woman wrote in her diary, "We could bear the loss of my brave little brothers when we thought they had fallen at the post of duty defending their Country, but now to know that those glad, bright spirits suffered and toiled in vain, that the end is overwhelming defeat, the thought is unendurable."[33] *The Burial of Latané* created an ennobled Confederate martyr narrative that reinforced the stereotypes of loyalty to the cause and loyalty of slave to master; however, it still required familiarity with the specific episode to plumb its emotional depths. Without that knowledge, the painting remains a generalized and sentimental evocation of death and loss. Not surprisingly it quickly disappeared from public awareness in the North. In the decade following the war, such images were more common across the South, as the region's deposed leadership grieved for their losses—human and political—and struggled to reinvent themselves and reassert power. The same specificity that linked works like *The Last Meeting of Lee and Jackson* and *The Burial of Latané* to cherished ideals of the Lost Cause prevented them from transcending the moment depicted and from achieving the timelessness prized of great works of art.

PAINTING HISTORY AND THE WAR

History painting often stumbles when asked to perform in the moment. Whether for reasons of outsized scale, locally relevant topics, clouded judgment, or even the realities of a wartime economy, painting history without the benefit of hindsight turned out to be far more difficult than it appeared to the artists who embarked down that path. In retrospect, the failure of traditional Grand Manner history painting during the Civil War should come as no surprise. Valorizing a conflict in which Americans killed Americans held no appeal. The casualties and suffering had been too

great, and the economic, political, and moral issues it raised would take decades to resolve. As author Herman Melville ruefully noted, "None can narrate that strife."[34] Artists' attempt to narrate the war met with little success. Far more evocative were the genre paintings that wove more universal messages into images of topical interest and landscapes that caught the prevailing mood and mirrored the meteorological and geological language used to describe the country's dilemmas. Artist and critic Eugene Benson (1839–1908) was rare among contemporary reviewers in arguing that landscape and genre were the means by which current events could be understood in the American fine arts. He wrote in 1869, "No, we cannot ask for historical art in America as it is commonly understood. Give us art that shall become historical; not art that is intended to be so.... The finest pictures are those which represent Nature, or the personal sentiment of the painter uncorrupted by the bad taste of his time. Historical art is the best *contemporary* art; it is portrait-painting at its highest level; it is *genre* painting; it is landscape-painting."[35]

As history painters often struggled to capture the immediacy of war, it would fall to the photographers to provide that instantaneity. Their work added a new interpretive layer to the conflict, blurring the boundary between art and reportage. For Brady, Gardner, and George Barnard, photography was an art form, and the war pushed each man to make and market his photographs within the world of fine art. Some of America's genre painters would be the ones to ask questions central to the Civil War: what kind of nation would emerge from the ashes? What would be the consequences of emancipation? Landscape painters would confront familiar places that had accrued new and often unwelcome meaning due to the war. Many proponents of the genre found in nature's forms and moods a means of expressing higher emotions and ideas. Indeed, genre and landscape painting provides keys to understanding both how artists made sense of the war and how they portrayed what was in many ways an unpaintable conflict. For Church and Gifford, Homer and Johnson, and many of their colleagues, landscape and genre painting would incorporate a powerful layer of meaning inflected by the Civil War.

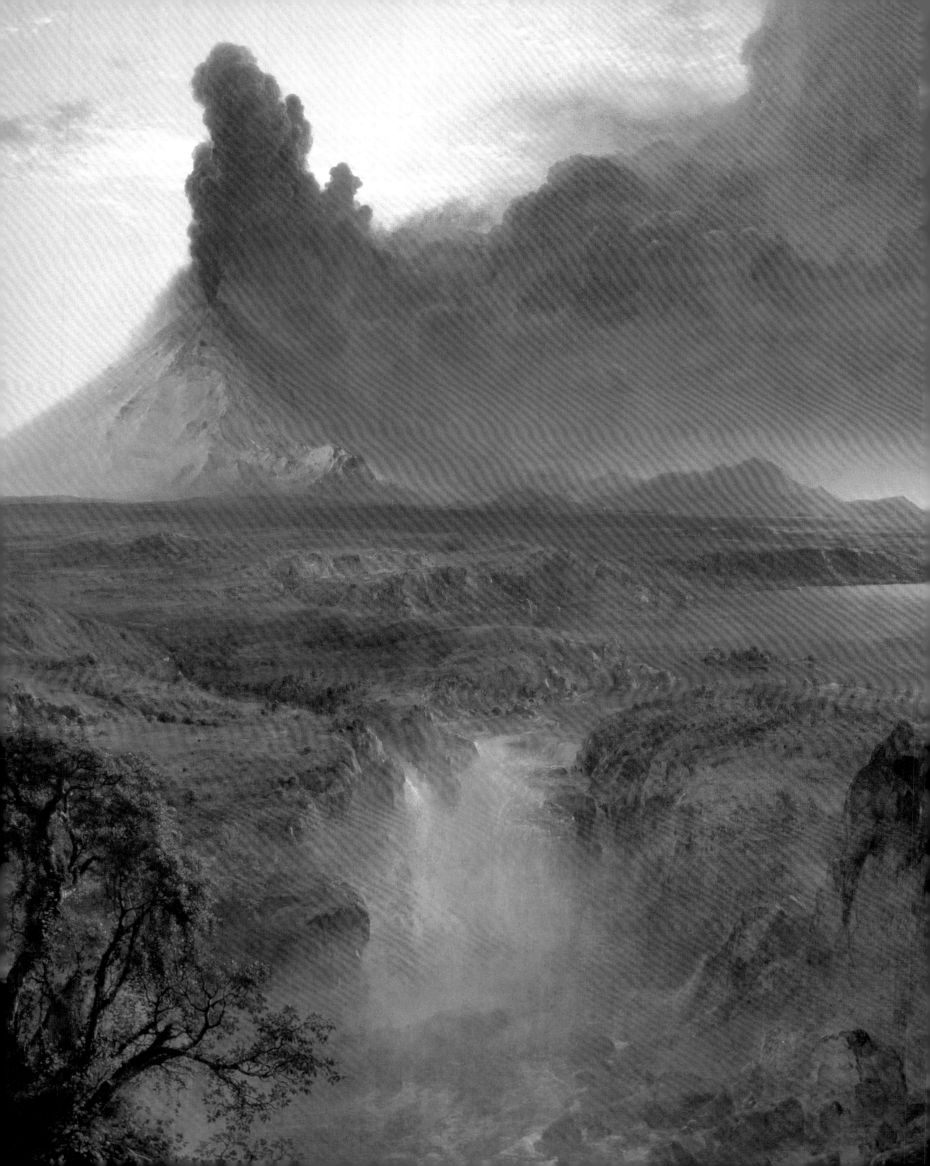

LANDSCAPES AND THE METAPHORICAL WAR

American landscape painting developed in tandem with an appreciation for the physical and metaphorical qualities of the American wilderness. Beginning in the 1820s, American writers began extolling the spiritual qualities of wild nature, bringing positive associations to features that in Europe were more often associated with the devil. European folk tales abounded with stories of the heathen wilderness, dark forests in which people lost themselves and often their souls. As Americans began to see positive resonances in their own natural landscapes, they developed a wilderness aesthetic that linked America's prospects for her future with two things: the potential for progress through cultivating the raw landscape and the virtues found in the pristine aspects of those wild spaces. In 1835 the country's leading landscape painter, Thomas Cole, delivered a lecture titled "Essay on American Scenery" in which he sketched his view of this country's unbounded opportunity based in large part on the existence of the equally vast expanse of land.[1] The country's future prospects, Cole argued, were lodged as much in the inspirational qualities of its wilderness as its potential for cultivation.

Cole and his close friend William Cullen Bryant, the leading landscape poet of his generation, painted and wrote compelling pictures of America as a place, a concept, and a spiritual state of mind. The powerful appeal of this mindset launched a generation of literary essays and poems that glorified the virtues of American nature and inspired a generation of artists whose paintings became known as the Hudson River school. Following Cole's untimely death in 1848, his friend and student Asher B. Durand commemorated this partnership between art and poetry in his 1849 painting *Kindred Spirits* (fig. 12). Cole and Bryant stand together admiring a quintessential vista in the Catskills. Durand's painting

War feels to me an oblique place.

—Emily Dickinson

perfectly summed up the synergy between these two men and their favorite subject, the American wilderness. Ralph Waldo Emerson and Henry David Thoreau elided this concept with American transcendentalism, using their writings and lectures to advocate the spiritual values of experiencing nature firsthand.

That primal experience in nature carried over into the layers of meaning ascribed to landscape paintings. In 1852 a writer for the *American Whig Review* described the power of landscape painting to express human emotions metaphorically: "When landscape enters the mysterious confines of allegory, combining animate with inanimate nature, it rises to a higher sphere of power; . . . A storm may be represented; trees uprent, and driven clouds, and water tortured and foamy, may shadow forth the terrific power of the elements. In such a case we see the mind working in and upon these natural objects, like hate,

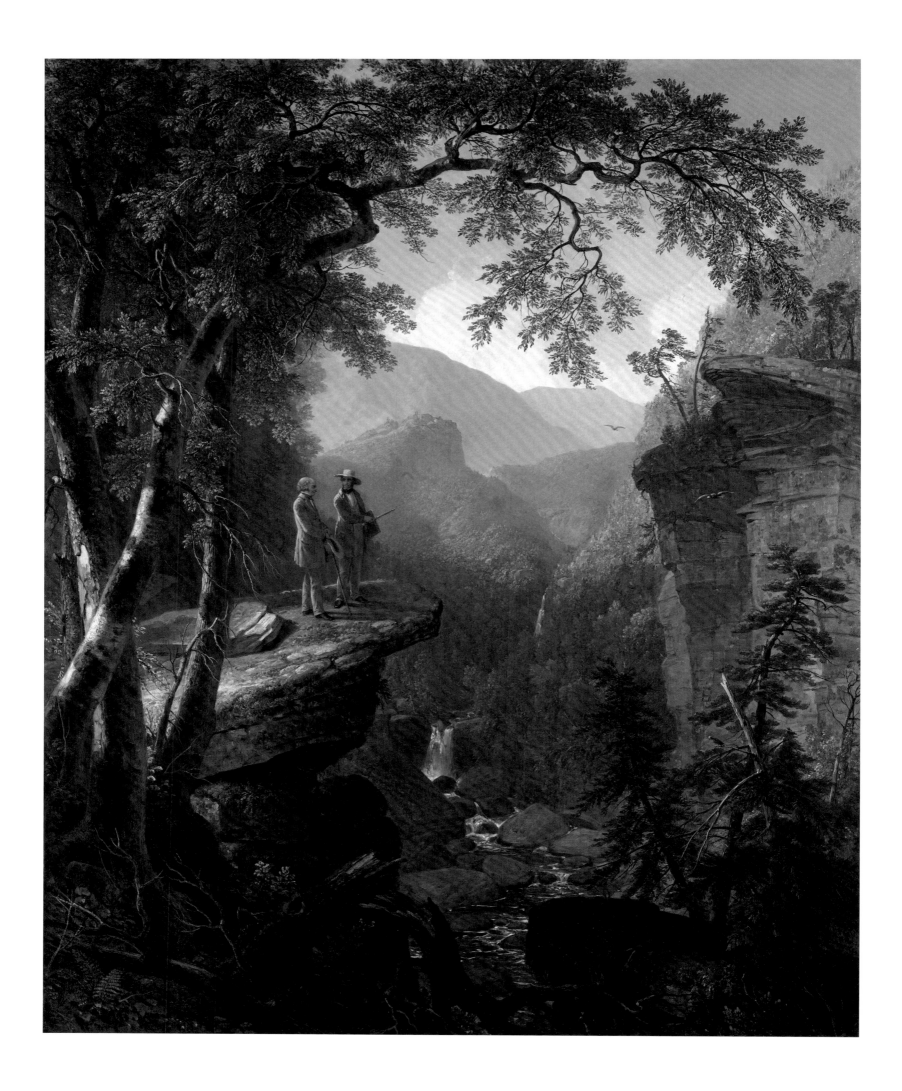

fear, love, friendship, and the multiplex emotions of the soul upon the physical man."[2] In other words, landscape paintings could convey the intensity of emotion usually reserved for the human narrative.

Art—whether poetry or painting—often carries multivalent meaning, even if the audience is not always aware of it. When author James Russell Lowell composed his poem "Washers of the Shroud" in 1861, he wrote to his friend Charles Eliot Norton that the work was "about present matters—but abstract enough to be above the newspapers."[3] He acknowledged that his works reflected current events and that he did not expect his allegory to be equally perceptible to all readers. Without consciously intending to make each utterance or artwork about the war, writers and artists created their works surrounded by, and sometimes suffocated by, the impact of the war on every facet of their daily lives. By reading emotional, religious, and political significance into landscapes, sensitive critics and viewers saw the Civil War manifested in these paintings. The most powerful of these works of art became charged with metaphor and layered complexity that elevated them to the American equivalent of Grand Manner history paintings. Such works made the case for the relevance of landscape painting in a time of national crisis.

During the first half of the nineteenth century, landscape painting was a simulacrum of American life and values. Landscape metaphors and imagery permeated the American consciousness. Whether one lived in a city or a rural setting, life was governed by the terrain and the weather. In landscape paintings during the Civil War years, the skies and geography told a version of the story, bringing together literary metaphor and visual imagery to create a war-inflected layer of meaning.[4] When we consider the writings, speeches, sermons, and letters that invoked stormy weather, volcanic eruptions, and celestial portents to understand the war and all its profound consequences, that imagery gains depth and the paintings' meaning becomes clearer. Landscape painting thus became the emotional barometer of the mood of the nation.

As war approached, imagery manifesting God's beneficence turned toward a more apocalyptic dread that, over the issue of human bondage, the country had lost its way. In sermons preached in both the North and the South, the prevailing message expressed concern that the continuation of slavery presaged a new expulsion from Eden. Among abolitionists and proslavery advocates alike, the fear was essentially the same: that God would judge both sides as morally bereft; that inaction in the North to abolish slavery and action in the South to perpetuate it marked them equally culpable. The Civil War would be described as that "second expulsion," which would in turn require the need to find a path back to redemption. Landscape imagery described the growing destabilization of the country. Balancing the awe-inspiring power of nature was a renewed awareness of nature's amoral state—its indifference to human suffering as a signal of God's displeasure—which insinuated itself into the vocabulary of landscape.

By the late 1850s a decade of idyllic paintings that had defined the Hudson River school obscured the increasingly unsettled political situation further west. By the time Church's *Niagara* of 1857 (see fig. 44) was leaving crowds in awe along the East Coast, the western border regions of Kansas, Nebraska, and Missouri were reeling from bitter division and guerrilla warfare. As remote territories pressed to join the Union, opposing forces battled for what many saw as America's great contradiction left unresolved since Revolutionary times—the sanctioning of slavery. The alliance between the fate of man and the state of nature was never more tightly interwoven than in the years surrounding the Civil War. In 1854 Missouri artist George Caleb Bingham had predicted anxiously that the political tension was "a storm…now brewing in the north, which will sweep onward with a fury, which no human force can withstand."[5]

"THE OMINOUS HUSH"

Meteorology provided a powerful system of metaphors for describing the increased tension as war loomed on the horizon. American landscape painters, in tandem with writers, preachers, and politicians, invoked storms as the single most prevalent image for these unstable times long before the opening shots at Fort Sumter declared that war had begun. By late 1859 most Americans believed war was imminent, but no one yet knew when or where it would begin. Literary editor George

William Curtis likened the tension to a "war-cloud" that "rolled up thicker and blacker" as everyone waited for the moment the storm would finally break.[6] The atmosphere crackled and the nation held its collective breath, wondering what event would finally unleash the deluge. People had no way of knowing whether war would start with John Brown's raid on Harper's Ferry in October 1859, the election of Abraham Lincoln in November 1860, or Lincoln's attempts to resupply Fort Sumter, a Federal fort under threat of Confederate attack, in April 1861. In the anxious months between December 1860 and the following April, one Southern state after another seceded from the Union—first South Carolina, then Mississippi, Florida, Alabama, Georgia, Louisiana, and Texas. As each day passed, Americans could only watch and wait, while the storm clouds gathered, black on the horizon.

Martin Johnson Heade (1819–1904, fig. 13) responded to this overwhelming tension. In the spring of 1860 he displayed his newest painting of a darkening sky over an inlet near Point Judith, Rhode Island. He titled the work *Approaching Thunder Storm* (cat. 1). Its stark contrasts and queasy weather attracted attention, as viewers and reviewers struggled to make sense of the disquieting picture. On a strip of sand running across the foreground, a man and his dog sit quietly as

a storm blackens the entire sky. A thin coral streak of lightning, barely visible, splits the darkness, prefiguring the thunder and rain to come. Two boats on the water make haste for the safety of the shore, but overall the scene conveys an otherworldly calm in the face of an imminent disaster, as though the observers on shore are mesmerized by the approaching storm, unable to respond. Heade's seated figure contributes to the perplexing nature of this painting. He occupies a prominent place in the composition, but he is remarkably passive in demeanor, as though he is a powerless spectator to the impending drama.

As a presidential candidate in 1860, Lincoln had spoken of a "coming storm," when God would run out of patience on the issue of slavery.[7] The metaphor was popular with many abolitionist preachers, but at least two of them went a step further, purchasing Heade's thunderstorm paintings from this moment. Charismatic abolitionist preacher Henry Ward Beecher (1813–1887, fig. 14) already owned one of Heade's 1859 thunderstorm paintings when his colleague Noah Schenck acquired *Approaching Thunder Storm* shortly after it first went on public view.[8] Their fondness for Heade's thunderstorms confirms that perceptive viewers often saw parallels among these paintings, current events, and their religious beliefs. Heade was among Beecher's occasional parishioners at his Plymouth Church in Brooklyn, along with fellow artists Frederic Church and Eastman Johnson. Schenck may have had his newly acquired painting in mind when he delivered a sermon in May 1861, in which he exhorted his flock to see in the storms both political upheaval and each man's spiritual duty. He said, "From the storms which sweep the political horizon, it is held, Christ's officers should . . . go forth to the fulfillment of their plainly revealed duty, and breast the storms which sweep across the spiritual horizon." Schenck, Beecher, and a host of like-minded preachers across the North spoke of the rising need to confront slavery as a Christian moral battle, to stand up and take action in "these o'er darkened days."[9] Heade's seated figure, watching as the dramatic events unfold around him, seems emblematic of the majority in the North who viewed abolitionists as troublemakers and preferred to wait rather than take action.

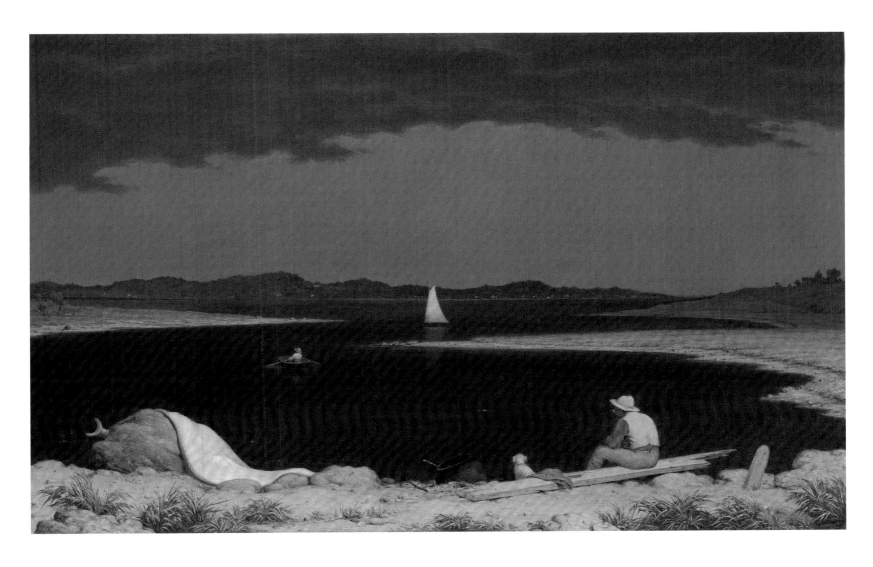

CAT. 1

Martin Johnson Heade
Approaching Thunder Storm, 1859, oil on
canvas, 28 × 44 in. The Metropolitan Museum of
Art, Gift of Erving Wolf Foundation and Mr. and Mrs.
Erving Wolf, in memory of Diane R. Wolf, 1975

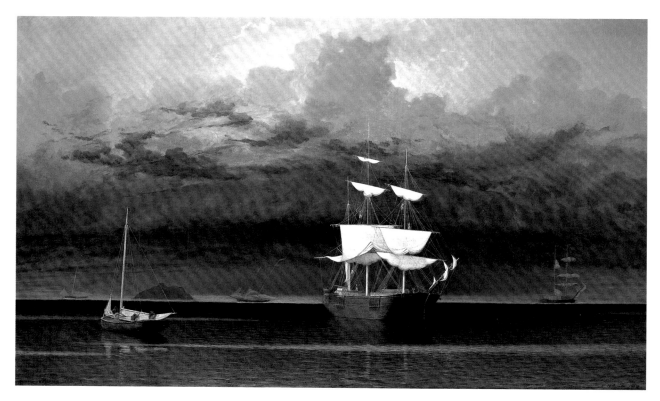

FIG. 15

Fitz Henry Lane
Approaching Storm, Owl's Head,
1860, oil on canvas, 24 × 39 ⅝ in.
Private Collection

Summertime is often a season of extremes. Hot, sultry days give way to brief and sometimes violent storms in the afternoons, the cycle repeating itself over the course of days or even weeks. The summer of 1860 embodied that instability, save that these storms were political in nature. The unsettled weather seemed fraught with portent for unsettling events. Fear served as a touchstone for all manner of responses to the impending war: fear of economic peril, cultural dissolution, and even failure of the republic, echoing the uncertainty underlying Ben Franklin's observation in 1787 that the Constitution had created "a Republic, if you can keep it." But running as a strong undercurrent throughout the arguments for and against disunion was the emotional issue of slavery and abolition. James Gordon Bennett, editor of the *New York Herald*, espoused making peace with slavery in order to preserve the Union and keep Northern merchants in business. He viewed the abolition of slavery as the path to disunion and was not above fear-mongering to sway his readers. In response to the nomination of Abraham Lincoln as the Republican

candidate for president, Bennett quoted an anti-Lincoln orator who questioned the future role of free blacks in American society: "What will you do with these people? Will you allow them to sit at your own table, marry your daughters, govern your states, sit in your halls of Congress and perhaps be President of the United States?"[10] Caught between foreboding and outright alarm, Bennett's fulminations reflected one aspect of the tension found in Heade's approaching storm.

Heade was often overlooked in the group reviews of Academy exhibitions, but not this time. The unsettling qualities of *Approaching Thunder Storm* caught the attention of several perceptive reviewers. One sensed a probing aspect in Heade's painting, pointing out, "The ominous hush—'the light that (seldom) is on sea or land'—the pale foreground, the black water, the dread feeling in the coming storm, and the homely and careless fisherman—are all simply rendered, and present an effect that is rare and true."[11] The reviewer is sucked into Heade's compelling, if unsettling, presentation of nature. His quotation paraphrases a verse

from English poet William Wordsworth's "Nature and the Poet, Suggested by a Picture of Peele Castle in a Storm, painted by Sir George Beaumont," published in 1807. Pairing phrases from well-known literature with works of art was by then a staple of art criticism; during the Civil War many of those quotations would carry specific resonance linking landscape painting to the war. In this poem, Wordsworth laments the loss of calm he once associated with the scene, and he counsels himself to remain stoic in the face of uncertainty and to find solace in the promise of a calmer future. Such moments where paintings and poems are explicitly linked are common during the war years, the synergy between art and literature blending effortlessly together. This critic assumed a level of cultural literacy that made such quotes instantly recognizable and topically relevant to his American audience. Arm in arm, artists and writers during the Civil War invoked each other's work to inform their own as they navigated this turbulent era.

A similar unsettled mood permeates Fitz Henry Lane's *Approaching Storm, Owl's Head* of 1860 (fig. 15). A three-masted schooner in the foreground floats on eerily calm waters, while in the distance another vessel is slammed nearly sideways by the sudden onset of an advancing gale. Tiny figures move with alacrity across the deck and up the masts, furling the sails to protect their own ship from a storm that has been brewing for quite some time. What little we know of Lane's life renders the Civil War a distant event, but Lane was not a recluse, and he had ample opportunity to stay current with the moral and political events that clouded the horizon during the 1850s. His close friend Joseph Stevens served on the Lyceum board and arranged for no fewer than six lectures by Ralph Waldo Emerson (1803–1882, fig. 16). During the 1850s Emerson gave numerous addresses in support of John Brown and abolition that contained warnings about the dire consequences of inaction in the North.[12] The metaphor of the nation as a ship about to founder in the brewing sectional crisis was a staple during the 1850s—but not solely in the North. A Fourth of July speaker at the Mount Vernon Ladies' Association in 1855 observed, "We live in troublous times. Our lot

is cast in a crisis of our country's destiny. The Ship of State is plunged headlong upon an angry sea, amid tempest tost waves and threatening clouds."[13] On the eve of war, Lane's stately vessel, with its majestic presence and powerful lines, might well be read as the ship of state, its occupants aware of trouble brewing, unable to avoid the storm about to erupt upon it.

Amid the drama of these two paintings by Heade and Lane, the viewer occupies a neutral vantage point, caught between two extremes—violent action and complete calm. This eerie sense of being frozen in the moment marks the ramp-up to the Civil War. The Rev. Alonzo Quint, chaplain of Second Massachusetts Infantry, deployed this apocalyptic metaphor, remarking: "There brooded over our country clouds of divine wrath. The air grew heavy. It seemed hard to breathe. The blackness grew fearfully. Then the heavy roll of thunder crashed. Then the forked lightning played. Tempests howled, and fire struck, and the track of the fierce storm ploughed furrows of wrath."[14] The atmosphere in Heade's painting is so oppressive as to have palpable weight, the opaque black mass signaling a drop in barometric pressure that squeezes the air from the artist's usually limpid skies. Heade's thunderstorms, unusual in his oeuvre, give a hint of the change being wrought in landscape painting as artists infused their images with a sense of the nation's growing turmoil. Lane's seascape takes that still moment and reanimates it, as the fury of the storm threatens to topple each vessel. These paintings, like Quint's words, conjure a nation also caught in the stasis between action and inaction on the issue of slavery. God's wrath seemed imminent, and preachers like Beecher, Schenck, and Quint strove to raise the consciences of their flocks and to address the moral quandary of race slavery in America.

"THE METEOR OF WAR"

The summer and early fall of 1860 was an unusually active time for atmospheric phenomena. Comets, meteors, and even the Aurora Borealis were visible up and down the Atlantic seaboard.[15] Newspaper articles and letters to the editor spoke to the broad ripple of unease and fear associated with these events. Anyone seeking portents

to those at that point to be within a few feet of them, and appeared to strike the valley."[17] Church witnessed the strange display and captured the beginning of the meteor's breakup in a small, unearthly painting he titled *Meteor of 1860* (cat. 2).[18] He painted this unusual phenomenon with its double fireball streaking across the center of the small canvas like a rocket illuminating the night sky.

The cover page of *Harper's Weekly* on Saturday, August 4, ran three wood-engraved images of the meteor as its lead story (fig. 18).[19] The *Chicago Press and Tribune* compiled reports from cities across upstate New York, New England, and as far south as Delaware, reporting, "It was at first taken for a rocket; many, in fact, would not believe it was anything else." Other reports described it looking like a balloon on fire, and renowned astronomy professor W. H. C. Bartlett at West Point observed that it resembled "a fire balloon propelled by the burning of a feeble rocket composition," its remarkably low altitude prompting him to think "that it was some new and marvelously successful pyrotechnic device, fired from the western hills."[20] The metaphors consistently invoked artillery, as though the very sky were already at war.

Accounts of the meteor's transit across the sky filled the newspapers up and down the Atlantic seaboard, and as far west as Cincinnati and St. Louis. In both the North and the South, commentators linked the eerie atmospheric phenomenon to the lurking fear of war. In August, the appearance of yet another meteor prompted the Louisville *Journal* to note, "We deem it a duty to science to state our grave suspicion that we had a Southern meteor last night to countervail the prophetic effects of the one recently seen in the North."[21] Observers in both parts of the country watched nervously as the dueling

of war in celestial activity felt vindicated by the meteors that held much of eastern America spellbound from July through August. Frederic Edwin Church (1826–1900, fig. 17) was mesmerized. On July 20, a meteor streaked across the eastern sky. This was no ordinary meteor, and its appearance was met with no ordinary interest among scientists and amateur enthusiasts alike. What Church and so many others saw and remarked upon was a large, earth-grazing meteor, so called when the meteor's trajectory is within earth's atmosphere, but the meteor itself never hits the ground.[16] *The New York Times* wrote that high on the Hudson River, "The meteor was seen, under very favorable circumstances, from the Catskill Mountain House plateau. It seemed

CAT. 2

Frederic Edwin Church
Meteor of 1860, 1860, oil on canvas, 10 × 17 ½ in.
Collection of Ms. Judith Filenbaum Hernstadt

FIG. 19

Rodney Dewey
Herman Melville, about 1860,
Berkshire Athenaeum

FIG. 20

Mathew B. Brady
Walt Whitman, about 1867,
National Portrait Gallery,
Smithsonian Institution

portents lit up the night skies. Meteors, comets, and other unusual atmospheric phenomena were alternately hailed or feared as omens of victory or defeat by both sides. The prospect of war was on everyone's mind. Another Southern writer went on to observe, "It may be interesting to mention, in this connection, that at 3 ½ o'clock yesterday morning, there was a distinct Aurora Borealis. There were lofty ray-like shafts of light that, like the spears of a celestial army, glittered in the north—a moment as pale as silver, and then flashing with the luster of gold."[22] Latent in the writer's metaphor was the growing dread in the South that a vengeful God would favor the North in an apocalyptic condemnation of slavery. Though a nation enamored of the burgeoning sciences, Americans still looked to religion to help explain the unexplainable. The Bible served up parables of divine retribution in the antics of the sky. In the North, abolitionists feared God was angry that they had not done enough to abolish slavery; in the South, the sky became a specter for the fear of Northern retribution; and among millions of African Americans both enslaved and free, word of the meteor provided an emblem of possible liberation and justice. Most Americans, whatever their race or faith, would invoke religion throughout the war to justify their position and to give form to their hopes and fears.

Earlier, in 1859, an unusual daytime sighting of a fireball meteor had sent shudders through eastern newspapers, whose writers wondered if these were omens or warnings.[23] Meteors had already come to be associated with the abolitionist John Brown (1800–1859), the man whom many consider to have triggered the Civil War. In May 1856 Brown substituted action for rhetoric as a participant in "Bleeding Kansas," when settlers battled over whether it would be admitted as a free or slaveholding state. That month, proslavery vigilantes crossed from the slave state of Missouri into Kansas territory and sacked the Free Soil town of Lawrence. Days later, Brown led a band that exacted revenge, killing five settlers at Pottawatomie. In August, he broadened his reputation as a militant abolitionist by leading a spirited defense of nearby Osawatomie, though the invading "Border Ruffians" eventually destroyed the town, leaving Brown's son, Frederick, among the dead. Thereafter Brown vowed to take his antislavery struggle back East. In 1859 he fixed upon the Federal arsenal at Harper's Ferry, Virginia, a strategically important site at the confluence of the Potomac and Shenandoah rivers. When Brown and his followers stormed the arsenal in an unsuccessful attempt to spark a general slave insurrection across the South, they pushed national politics to the breaking point, moving the debate about race slavery onto the front page of every American newspaper.[24]

Contemporary poets likened John Brown to a meteor, his fiery trajectory across the political landscape compared to that of celestial bodies. His raid on Harper's Ferry and subsequent execution became a flare in the night, an omen of strife yet to come. A customs clerk who fancied himself a writer, Herman Melville (1819–1891, fig. 19) penned a poem linking the meteors of 1859 with Brown, portraying him as an equally disturbing force of nature. He closed "The Portent" with the lines comparing Brown's beard with the tail of a meteor: "But the streaming beard is shown / (Weird John Brown), / The meteor of the war." Melville's cryptic phrases recognized that the strange celestial sighting, like Brown's raid, had upended nocturnal stargazing and suffused even that pastime with unease.

Walt Whitman (1819–1892, fig. 20) also witnessed the earth-grazing meteor that inspired Church's painting.

His poem of 1860 is titled "Year of Meteors (1859–60)." In it he reflects on Brown's hanging, proclaiming,

> YEAR of meteors! brooding year!
> I would bind in words retrospective, some of your deeds and signs;
> I would sing your contest for the 19th Presidentiad;
> I would sing how an old man, tall, with white hair, mounted the scaffold in Virginia; . . .

Whitman reiterated the connection between the effect of Brown's actions and the appearance of this particular meteor, comparing Brown to

> . . . the comet that came unannounced, out of the north, flaring in heaven,
> . . . the strange huge meteor-procession, dazzling and clear, shooting over our heads,
> (A moment, a moment long, it sail'd its balls of unearthly light over our heads,
> Then departed, dropt in the night, and was gone;)

For Whitman, John Brown was the meteor in the night sky, the portent of unavoidable sectional strife centered on the issue of slavery.

Between Brown's October raid and his December execution, another meteor shower of extraordinary scale visible across the Northeast rattled nerves and reinforced apocalyptic beliefs.[25] On December 2, Brown was reputed to have handed his jailer a scrap of paper on which he had written, "I, John Brown, am now quite certain that the crimes of this guilty land can never be purged away but with blood. I had, as I now think vainly, flattered myself that without very much bloodshed it might be done." His execution galvanized a seismic shift in his reputation, from an abolitionist who Emerson described as having "lost his head," to "The Saint, . . . whose martyrdom, if it shall be perfected, will make the gallows as glorious as the Cross."[26] Echoing Melville and Whitman's meteor metaphor in more direct prose,

FIG. 21

Benjamin Maxham
Henry David Thoreau, 1856,
The Thoreau Society Collections

Henry David Thoreau (1817–1862, fig. 21) eulogized Brown's life in remarks written for a memorial service for Brown, held at his gravesite on July 4, 1860. The choice of date boldly linked Brown's belief in the abolition of slavery to the nation's celebration of its independence.

> John Brown's career for the last six weeks of his life was meteor-like, flashing through the darkness in which we live. I know of nothing so miraculous in our history. . . . What a transit was that of his horizontal body alone, but just cut down from the gallows-tree! We read that at such a time it passed through Philadelphia, and by Saturday night had reached New York. Thus like a meteor it shot through the Union from the Southern regions toward the North! No such freight had the cars borne since they carried him Southward alive. . . . He is more alive than he ever was. He has earned immortality. He is not confined to North Elba nor to Kansas. He is no longer working in secret. He works in public, and in the clearest light that shines on this land.[27]

Thoreau's declaration made incontrovertible the link between abolition and war. Many Northerners considered abolitionists to be just such radicals as Brown, working in secret on plots to destabilize American society in the name of ending slavery. For Whitman, Emerson, Thoreau, and growing numbers of Americans, Brown's death elevated him to the status of a martyr. Their writings and lectures helped move the discussion of abolition from the fringes of society to the center of the sectional debate.

"DARKNESS VISIBLE"

By 1860 Heade was not the only artist to sense the change in the nation's barometric pressure. As he readied his *Approaching Thunder Storm* for public display, his close friend and fellow landscape painter Frederic Church put the finishing touches on his painting *Twilight in the Wilderness* (fig. 22). Paired with Heade's brooding sky, Church's sunset resonates with a similar tension and anticipation. It captures a breathtaking moment in the Catskills at the artist's favorite hour. The intensity of its tones borders on lurid, yet the majestic wilderness seems alternately familiar and strident, comforting and

FIG. 22

Frederic Edwin Church
Twilight in the Wilderness, 1860,
oil on canvas, 40 × 64 in.
The Cleveland Museum of Art,
Mr. and Mrs. William H. Marlatt Fund

FIG. 23

Brady's National Portrait Gallery
Sanford Robinson Gifford, about
1860s, The Metropolitan Museum of Art

commanding. Its hues vibrate palpably. Church's vibrant sunset struck viewers as a last brilliant moment before the darkness of war overshadowed the landscape. The dead tree in the foreground, aside from being a suitable perch for a lone eagle, implies that all is not healthy and verdant in this wilderness. Reviewers picked up on the ambiguity as well, remarking on the play between hope and melancholy. Church's painting was a visual fulcrum for the tensions that dominated current events.[28]

Amid the period's tumult, artists often depicted their favorite haunts in new ways. Sanford Robinson Gifford (1823–1880, fig. 23) had already made a name for himself as a painter of sun-drenched vistas, his saturated light glowing over the familiar Catskill scenery. But in March of 1861 he displayed a singular landscape unlike any other in his oeuvre. *Twilight in the Catskills* (cat. 3) bears a title reminiscent of Church's *Twilight in the Wilderness* and contains a similar allusion to change in the air. Gifford's twilight carries the somber purple-gray tones of impending darkness, relieved only by flashes of pale

lemony light from the sun setting beyond the distant mountains. This brooding landscape did not speak to the glories of God in the wilderness, nor did it rejoice in the spiritual regeneration these artists typically felt in their beloved Catskills. Instead Gifford vested in his twilight a sense of destruction and loss underscored by the stand of trees framing the view. These are not simply dead trees but the victims of fire. Their scarred remains speak of violence to the landscape unusual in American art. Their jarring presence forces the viewer to look beyond the sweeping view for meaning. Gifford is alone in depicting this kind of destruction to the land at this time, deliberately introducing a disquieting note associated with death to an otherwise luminous sunset. A stream painted to look more like molten rock than water bisects the foreground, the cascade descending in silence to the valley floor below. A black bear in the lower left approaches the trees and the view. It moves slowly toward the sunlit stream, the lone sign of life in this foreboding landscape. Its presence may be a surrogate for the artist himself, a subtle reference to the artist's familiar bearskin hat.[29] Emerging from the damaged landscape, the bear, and by extension the artist, stands on the brink of a precipice as the light disappears.

The writer for the *New-York Daily Tribune* returned to this picture repeatedly and over the course of three months wrote about it no fewer than three times. In each review he probed more deeply into the mood of the painting. Visiting the artist's studio in January 1861, the author observed, "The intervening valleys are sinking into the deep shadow of the coming darkness, though lit up nevertheless to a sort of 'darkness visible' by an atmosphere so full of warmth and brilliancy."[30] The reference to "darkness visible" comes from the first book of John Milton's *Paradise Lost* in which man's disobedience resulted in his expulsion from Eden. In describing Lucifer's fall, Milton wrote,

> The dismal situation waste and wild.
> A dungeon horrible, on all sides round,
> As one great furnace flamed; yet from those flames
> No light; but rather darkness visible
> Served only to discover sights of woe,
> Regions of sorrow, doleful shades, where peace
> And rest can never dwell, hope never comes [31]

Milton's words provide an apt metaphor for the dark tone of Gifford's painting. Latent in the beauty of this Catskill evening is the sobering sense of loss suggested by the burnt, dead trees anchoring the composition on both sides. Dark sentinels, they are harbingers of the destruction to come.

Gifford's painting transfixed many who viewed it that spring. Critic George Sheldon recalled, "It is a twilight scene, dark-purple tones, lowering, strange, almost awful, altogether striking and effective. The persons who thought they had his measure did not know what to say. The work had taken right hold of them, and they could not get away from it."[32] Expecting another of the artist's glowing sunsets, viewers instead encountered a work that reinforced the country's sense of foreboding. Gifford's "strange, almost awful" evocation of "darkness visible" constitutes an elegy for the passing of an era, the passage from peace to war, from unencumbered appreciation of the mountains Gifford loved to a growing sense of melancholy that the New Eden was on the brink of destruction—without the promise of renewal.

"THERE IS A NORTH"

The concept of "The North" as more than a geographic term took hold in the years leading up to the war. In reaction to passage of the Kansas-Nebraska Act in 1854, the *Albany Evening Journal*'s editor Thurlow Weed proclaimed, "There will be a North," implying that it was time for the free states to coalesce their political power and stand up for their beliefs.[33] Metaphors identifying the Arctic with the North and the tropics with the American South permeated political rhetoric. In Congress, iceberg imagery was an emotionally charged symbol for the North's need to assert itself on matters of slavery and federal sovereignty. On the floor of the House of Representatives in 1860, Republican Congressman Owen Lovejoy of Illinois rose to deliver a well-received speech on the evils of slavery, stating, "You who advocate the perpetuity of slavery are like a set of madcaps, who should place themselves on the top of an iceberg which had disengaged itself from the frozen regions of the north, and begun to float

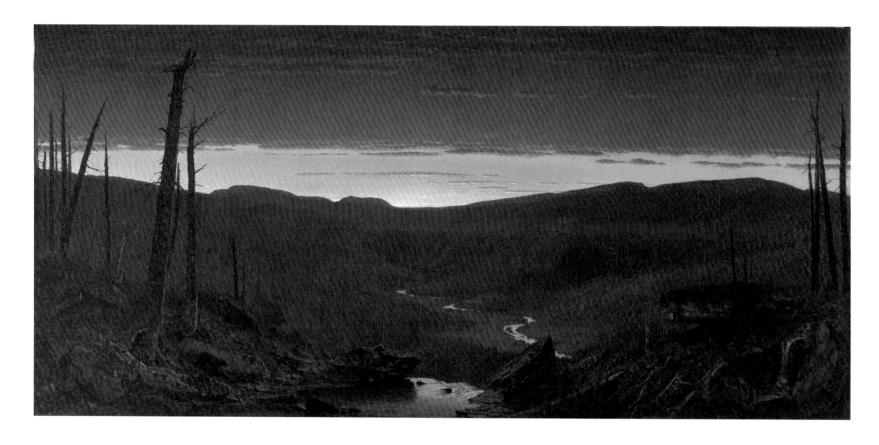

CAT. 3

Sanford Robinson Gifford
Twilight in the Catskills, 1861, oil on canvas,
27 × 54 in. Yale University Art Gallery, Gift of
Joanne and John Payson in memory of Joan
Whitney and Charles Shipman Payson (class of
1921) and in honor of Joan Whitney Payson
(class of 2009)

downward, and downward, through the warm climates. The sun shines, and melts it; the soft winds blow on and melt it; the rains descend and melt it; the water ripples round it and melts it;…It is as preposterous to think of taking slavery down through the civilization of the ages as it is to think of floating an iceberg through the tropics. It is the order of things."[34] The idea that the end of slavery was as inevitable as the melting of polar ice in tropical seas gained a foothold in official Washington, but it extended well beyond the speeches of politicians into the vocabulary of artists, poets, and writers.

A cartoon published March 9, 1861, in *Vanity Fair* titled "Our Great Iceberg Melting Away" (fig. 24) depicted President Buchanan as the hapless berg liquefying under the stern gaze of Lincoln as the sun. Church was at the same time putting the finishing touches on a major painting derived from his trip to Newfoundland and Labrador in the summer of 1859. *The Iceberg*s (cat. 4) was first and foremost a picture about the Arctic and the excitement attendant upon exploration beyond the familiar limits of the world. Church, like so many of his contemporaries, was caught up in the romance of exploration and the potential for scientific discovery in the far north. In preparation for painting this immense canvas, the artist had studied the properties of ice and optics and had made extensive sketches firsthand. When originally painted, the canvas had no broken mast littering the foreground, no reference to human incursion into the Arctic realm; it was that absence that caught so many off guard. Yet Church's daring composition opened avenues of more abstract interpretation. The artist's printed broadside helped the viewer navigate the icescape visually, but as to its meaning, the opinions varied as wildly as the colors streaking the ancient ice. This had not been an easy work to paint; Church had been laboring on it for the better part of a year.[35] As far back as January 1860, even then fully aware of the possibility

FIG. 24

Bobbett & Hooper, sc
Our Great Iceberg Melting Away,
from *Vanity Fair*, March 9, 1861, wood
engraving, The New York Public Library

OUR GREAT ICEBERG MELTING AWAY.

of political upheaval, Church's agent John McClure had written nervously, "I long to hear how the icebergs get on—I hope you still think you will finish them by the time you expected. From present indications there is every appearance of lively spring trade in New York, whether the Cotton States stay out in the cold or not."[36]

Between 1857 and 1860, Church was riding a richly deserved wave of popularity. His travels and his paintings established him as the country's leading landscape painter. He had made his professional debut with his first "Great Picture," *Niagara*, in 1857. He followed that with paintings based on two well-publicized trips to South America in 1853 and 1857, culminating with the public exhibition of *The Heart of the Andes* in 1859, which debuted to wide acclaim just before the artist set sail for Labrador. For *The Heart of the Andes*, Church had enlisted another rising star, author and adventurer Theodore Winthrop, to write a broadside promoting the painting. In preparation for his trip to Labrador, Church went a step further, engaging his good friend (and the late Thomas Cole's pastor) Louis LeGrand Noble to write up their adventures in a book titled *After Icebergs with a Painter*, which was published several weeks before *The Icebergs'* planned debut.

The eruption of the Civil War threatened to topple Church's nascent reputation. On April 12, 1861, Confederate forces in Charleston, South Carolina, opened artillery fire on federally controlled Fort Sumter in Charleston Harbor. After a day and a half of bombardment, Union forces surrendered the fort. At that point, no other news mattered. Church's *Icebergs* was scheduled to debut eleven days later, on April 24. Suddenly all of the publicity and anticipation for the unveiling of this painting seemed like an afterthought compared to news of the Confederate victory and Lincoln's call for troops to defend Washington. Church faced a difficult choice—he could delay his unveiling, hoping for a calmer moment, or stay on schedule. He opted for the latter, forging ahead with the debut of his latest "Great Picture." However, in deference to the war's onset and to the patriotic sentiments sweeping New York City, he changed the title from *The Icebergs* to "*The North.*" *Church's Picture of Icebergs.*[37] Church deliberately made a connection between his painting and the new state

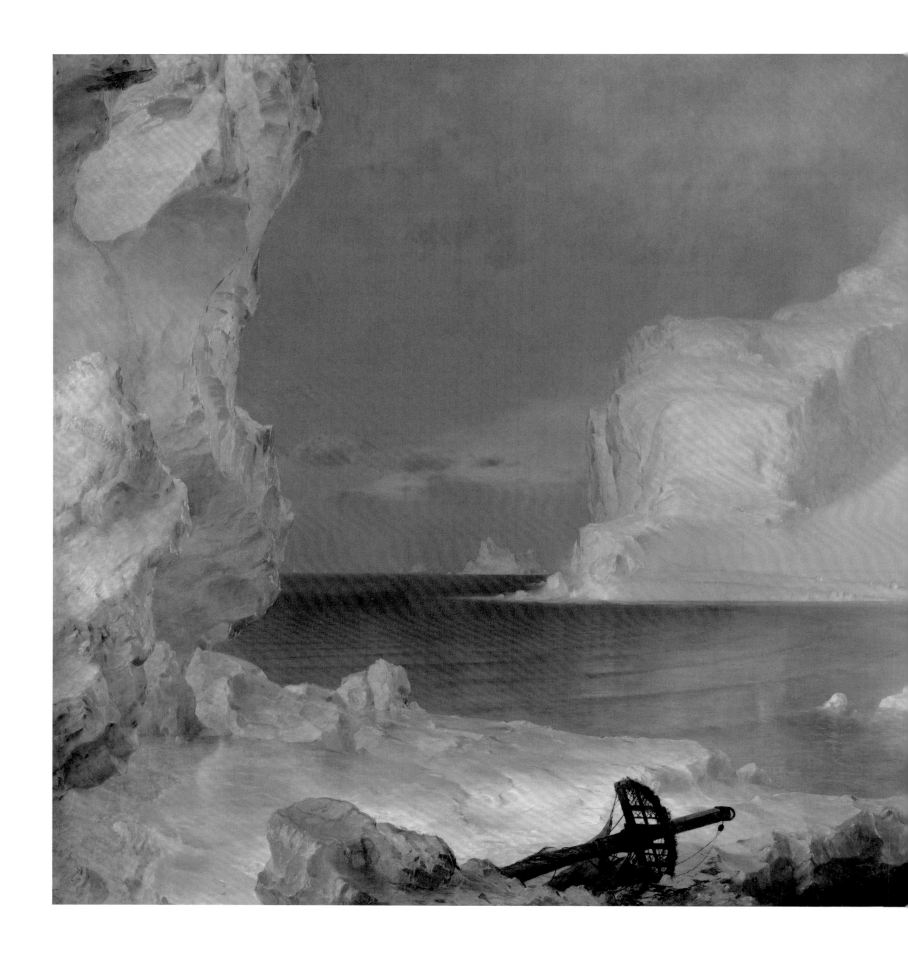

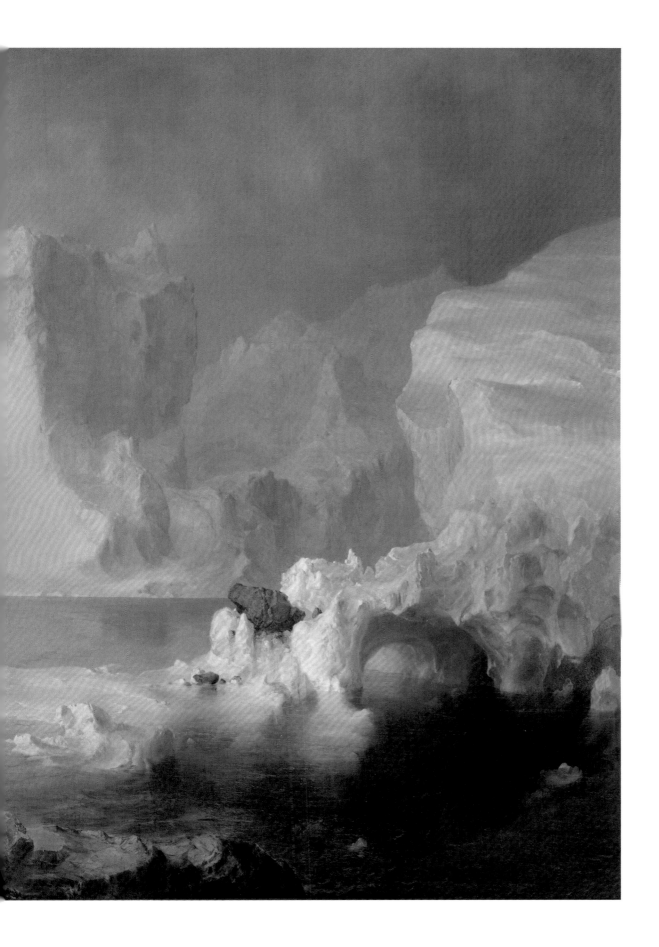

CAT. 4

Frederic Edwin Church
The Icebergs, 1861, oil on canvas,
64 ½ × 112 ½ in. Dallas Museum of Art,
Gift of Norma and Lamar Hurt

of the nation. Altering the title was not the artist's only accommodation to the moment. In a calculated public gesture, he announced that the painting was exhibited to raise money for the newly established Union Patriotic Fund, created to benefit the families of Union soldiers. The *New York Herald* noted this decision with approval, calling it "a munificent contribution" made "in the same spirit of loyalty and devotion to the Union which animates the members of all the other liberal professions."[38]

Fellow artist Eugene Benson, writing as Proteus, affirmed Thurlow Weed's earlier pronouncement on geopolitics, titling his review "There is a North—Church's Last Work."[39] "The North" as a concept and as a painting became linked to the Union cause. By the end of 1861, Cincinnati poet and newspaperman Nathan D. Urner had published a poem titled "The Coming of the North," in which his central metaphor envisioned the meteorological and geological supremacy of the North rolling over the sinful, tropical South like a glacier on the move.[40] Considered in this broader context, Church's change in title had the potential to play on the imaginations of his viewers. No less a literary figure than Emerson wrote passionately about the need to fight to abolish slavery using Arctic and tropical imagery to embody the polarities of the conflict. In his poem "Voluntaries," published in 1863, he described enslaved blacks as the "offspring of the Sun," yearning for Freedom's flag on which "The snow-flake is her banner's star, / Her stripes the boreal streamers are." In Emerson's poem, the stars and stripes of the American flag are writ large in the Northern sky's snowflakes and auroras. Icebergs and the Arctic became powerful metaphors for the righteousness of the Union cause—and for the inevitable end of slavery.

Despite the artist's best efforts to market this painting in association with the war, *The North* failed to find a buyer in the jittery economic and political climate of 1861. The enormous canvas continued to take up space in the artist's Tenth Street studio, and so Church turned to McClure, and the two men made plans to send the painting to England. There the economy was in better shape, and critics had already expressed favorable views of Church's paintings. But Church's decision to send the painting to England also marked the next phase of the

painting's war-related career. By 1862 most Americans suspected that if the British were to get involved in America's Civil War it would be on behalf of the South with whom it enjoyed strong mercantile ties. It would be impossible to get any traction in London with a painting inauspiciously titled *The North*; and although Church could have settled simply for changing the title of the painting, he chose to emphasize this change by altering the painting itself to better invoke that shift in its meaning. With this in mind, Church added the spar and crow's nest of a sailing ship to the foreground and rechristened it *The Icebergs*, thereby emphasizing the tragic human narrative of Arctic exploration.

In doing so, Church attempted to disassociate the painting from the war by reconnecting it to his original focus on Arctic exploration. It was an astute marketing move. Britain's long and storied history of polar exploration revolved around Sir John Franklin's ill-fated voyage of 1845 and the numerous British and American rescue missions beginning in 1848 that attempted to find the lost crew, or at least contribute new scientific discoveries as they sailed deep into the polar ice pack. Evidence of a human tragedy added pathos to Church's unfeelingly beautiful scene. The London premiere for the painting was attended by every living polar explorer of note, along with Lady Jane Franklin.[41] *The Icebergs* was on view from June 22 until September 19, 1863, at the German Gallery on New Bond Street, and it found a buyer in Lord William Watkin, a member of Parliament.[42] Caught in the cross-hairs of history, Church's painting evolved from a conceptual meditation on the alien properties of ice to an emblem of Northern fortitude, and finally to an image honoring the human cost of Arctic exploration.

Church successfully recalibrated the message of his painting in London. Yet even there the image remained inflected by the American war. In his accompanying book, Noble had cast Church's epic adventure with an eye to global politics. In a passage that caught the attention of a British reviewer for the *Atheneum*, Noble had played off the political cartoon characters of John Bull (England) and Brother Jonathan (America) by predicting the ascension of the United States and the decline of the British Empire. Noble wrote, "In fact

Jonathan is a youth only, and John an old man. When the lad gets his growth he will be everywhere, and the old fogy by that time comparatively nowhere." Noble's confident prediction of American growth and expansion, posited on the eve of war, prompted the British reviewer to quote the offending passage and counter, "But what if Jonathan splits asunder like a shattered iceberg!—what if the Northern and Southern sides rend asunder with a fearful crash, while the 'old fogy' continues unmoved like a mountain!"[43] By the time this review was published, North and South had indeed split asunder and what remained unknowable was the duration and permanence of the split. England remained perched on the sidelines, teetering toward support of the Confederacy, with American ambassador Charles Francis Adams stationed in London to keep watch on Parliament and British Prime Minister Lord Palmerston, doing his best to keep Britain officially neutral on the American conflict. Church's painting became conscripted by the war in ways the artist could ultimately not control. Politics had claimed his most abstract landscape, an augur of the significant role that

the landscape painting genre would play in interpreting responses to the conflict.

"THE BANNER OF DAWN . . . MEANS LIBERTY"

American audiences seemed eager to ascribe patriotic sentiments to the landscape as a means of channeling wartime emotions. While *The Icebergs* remained enmeshed in current events, Church turned to a much smaller painting of a more overtly patriotic bent. *Our Banner in the Sky* (cat. 5) may have been conceived as a kind of war-doodle, as Church responded to the plethora of flag-related imagery inspired by Major Robert Anderson's valiant defense of the American flag during the shelling of Fort Sumter, and by the subsequent rally at Union Square in New York, an event that featured both the officer and the flag as rallying points for the new Union cause (fig. 25). On May 19, the *New-York Daily Tribune* noted, "Mr. Church has been painting a symbolical landscape embodying the stars and stripes. It is an evening scene, with long lines of red and gold typifying the stripes, and a patch of blue sky with the dimly-twinkling stars in a corner for the Union."[44] By all accounts Church was responding initially to the desecration of the American flag at Fort Sumter and Henry Ward Beecher's fiery sermon denouncing this insult. On April 28, Beecher had thundered from his pulpit, "A thoughtful mind, when it sees the nation's flag, sees not the flag, but the nation itself." Beecher went on to connect the flag with the view of dawn, saying, "The bright morning stars of God, and the stripes upon it were beams of morning light. . . . As the sun advances that light breaks into bands and streaming lines of color, the glowing red and intense white striving together, and ribbing

FIG. 25

Unidentified photographer
The equestrian statue of Washington, bearing aloft the Flag of Fort Sumter, a great historical picture, April 20, 1861
stereograph, The New-York Historical Society

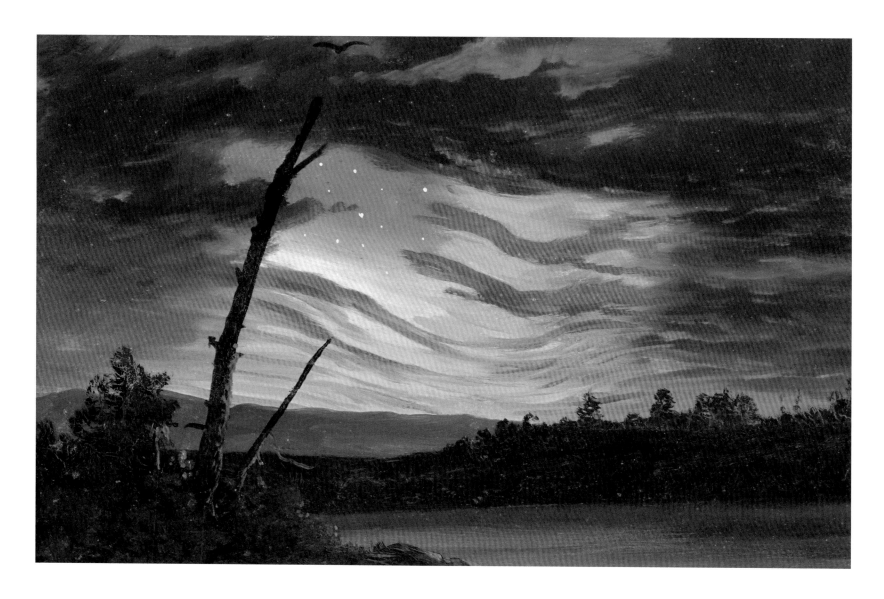

CAT. 5

Frederic Edwin Church
Our Banner in the Sky, 1861,
oil on paper, 7 ½ × 11 ¼ in.
Collection of Fred Keeler

the horizon with bars effulgent, so, on the American flag, stars and beams of many-colored light shine out together.... It is the banner of Dawn. It means *Liberty*; and the galley-slave, the poor oppressed conscript, the trodden-down creature of foreign despotism, sees in the American flag that very promise."[45]

These accounts galvanized a plethora of flag images, sales of American flags, and publication of innumerable flag-related poems that appeared in assorted newspapers.[46] In the *Chicago Tribune* an article on the meaning of the American flag proclaimed, "The whole Northern heavens seem a perfect aurora borealis of stripes and stars."[47] *The New York Times* on May 6 pronounced, "If anyone goes around among our soldiers now, and asks many the reason of their enlistment, they will probably say, 'it was the insult to the old flag at Sumter,' or 'it is for the stars and stripes.' Many unreflecting people laugh at this as an ignorant enthusiasm. But it is not. Who knows human history or human nature, can doubt in regards to the power of an emblem."[48] Church's emblematic painting acquired more personal overtones the following month when the war claimed its first art-world casualty, Theodore Winthrop.

As Lincoln put out the first call for 75,000 troops to "maintain the honor, the integrity, and the existence of our National Union," Church's close friend Theodore Winthrop (1828–1861, fig. 26) eagerly enlisted in the New York Seventh Regiment National Guard, affectionately known as the "Silk Stocking" regiment for its high proportion of scions of wealth and privilege from the city. The young author had endeared himself to many of the city's artists and had secured rooms in the Tenth Street Studio Building alongside them. He was particularly close to Church and *Harper's Weekly* editor George Curtis. In the weeks and months leading up to the war, as Curtis recalled, "We all talked of it constantly,— watching the news."[49]

Winthrop left New York in the middle of April, marching out of the Armory to war. "After long waiting and watching," wrote prominent New York lawyer

FIG. 26

Unidentified photographer
Frederic Edwin Church and Theodore Winthrop (standing), about 1860, Archives of American Art, Smithsonian Institution

George Templeton Strong in his diary, "the Seventh Regiment appeared. far up Broadway—a bluish steel-gray light on the blackness of the dense mob that filled the street, like the livid ashiness of the clouds near the horizon just before the thundershower breaks."[50] Strong's ominous storm metaphor seemed apt. Winthrop epitomized the ready optimism with which these new recruits embraced going to war. Part of Winthrop's charm was his eagerness to prove himself, regardless of the venue. He seized his chance and managed to have himself reassigned as General Benjamin F. Butler's aide-de-camp and set forth from Washington for Fortress Monroe near Norfolk, Virginia. On June 10, barely two weeks after his arrival, Winthrop helped orchestrate and lead Federal troops against the enemy. Both Union and Confederate accounts of the battle described Winthrop dismounting his horse and standing, sword drawn, atop a fallen log to rally his men. A North Carolina sharpshooter brought him down with a single shot to the chest.[51] Back in New York, Church read with increasing dread the reports that at first listed his gallant young friend among the missing and, after three agonizing days, confirmed among the dead, earning him the distinction of the first Union officer to die in battle.[52]

Winthrop's death stunned the cultural world of New York. Eulogies mourned a brilliant career cut short. Frederic Church reeled from the loss, unable any longer to keep the deadly reality of the war at an intellectual arm's length. With Winthrop's death, *Our Banner in the Sky* accrued a more mournful layer of meaning, soberly encompassing loss as well as triumph. For this small work Church clearly borrowed the palette and composition from his *Twilight in the Wilderness*. Quoting from the intense reds and oranges in its sky, Church took an evocative sunset and adapted it to become nature's memorial, the very landscape mourning the dissolution of the Union, the state of the nation, like the edges of the flag, in tatters. Church invested this small oil sketch with all of the emotion he could bring to bear, turning a patriotic gesture into a personal ensign to commemorate the death of his friend. *Our Banner in the Sky*, with its lurid, high-keyed color, battered flag, and overt patriotic symbolism, is a memento of loss, conflating the national calamity with his own personal grief.

FIG. 27

Frederic Edwin Church
Our Banner in the Sky, 1861,
lithographic print on paper with oil
over paint, 7 9/16 × 11 3/8 in. Olana
State Historic Site, Hudson, NY

FIG. 28

Sanford Robinson Gifford
*A Gorge in the Mountains
(Kauterskill Clove)*, 1862, oil on
canvas, 48 × 39 7/8 in. The Metropolitan
Museum of Art, Bequest of Maria
DeWitt Jesup, from the collection of her
husband, Morris K. Jesup, 1914

Late that summer as the work was being copied as a chromolithograph (fig. 27), the *New-York Daily Tribune* called *Our Banner in the Sky* "true enough to touch the patriotic instincts of the popular heart," and "the most successful undertaking among our art-producers since the outbreak of the great rebellion."[53] In September the *Tribune* noted, "With the exception of Mr. Church's *Banner in the Sky*, we have no war pictures."[54] Church sold his "war picture" to a fellow member of the Travellers Club, J. Lorimer Graham Jr.[55] Goupil's published a small broadside to accompany the chromolithograph, detailing the flag's history and symbolism and proudly asserting, "When the Flag of the country was insulted and the Government defied and betrayed, [it] found no more hearty or instant response among any class of citizens than the Artists.... One of the most characteristic and novel results of this patriotic enthusiasm which inspired the artists was a felicitous 'study' of morning clouds, by Frederick [sic] E. Church, wherein by a perfectly natural but ingenious stroke of skill and fancy he made the sun-lit vapors of the dawn and the lingering stars in the firmament wear the aspect of *Our Banner in the Sky*."[56] The patriotic chromolithograph struck a nerve and spawned a small cottage industry of related poems and short essays published in New York and Boston.[57] For an allegorical landscape to step up

and be so recognized signaled a public acceptance that landscape painting did in fact have a central role to play in the understanding of the war.

"TORCHES OF YELLOW FIRE"

The therapeutic qualities of the American landscape still functioned as a panacea in both the real world and its painted counterpart. Art reviewers during the Civil War often yearned for works, and especially landscapes, to provide sanctuary from current events. Artist Sanford Gifford approached painting as an escape as well. Like Winthrop, he enlisted in the Seventh Regiment in 1861, spending three summers in uniform. Between each tour Gifford reveled in his trips through the Catskills, absorbing material for what he called his "unwarlike" paintings.[58] These works embody the idea of nature as sanctuary, an antidote to civilization and to war. Over the course of his enlistment, Gifford painted three works that bracketed the emotional resonance of the landscape during the Civil War. One reviewer who made note of this quality termed them "the magnificent, the opulent, and the intense in nature.... Mr. Gifford's *Twilight in the Catskills*, exhibited at the National Academy of Design four years past, was a remarkable and most exceptional example of what we call intense and imaginative; his *Sunset—Mansfield Mountain*, of the magnificent; and his *Gorge in the Mountains*, of the opulent in nature. They possess in common the emotional element; they are pervaded with fervid feeling, and seem more like the production of an impassioned nature than the work of any man in American art or literature."[59]

The darkening mood of Gifford's *Twilight in the Catskills* (see cat. 3) had captured the air of foreboding on the eve of war; in contrast, *A Gorge in the Mountains (Kauterskill Clove)* (fig. 28), completed in 1862, was suffused with the relief and joy the artist felt upon his release from his first two years of service. Gifford began work on *A Gorge in the Mountains* following his trip through the Catskills at the end of his first tour of duty in 1861. It remained on his easel, unfinished, during his second tour.[60] The second tour, longer than his first, consumed the summer of 1862, but he was home in early September before the Battle of Antietam

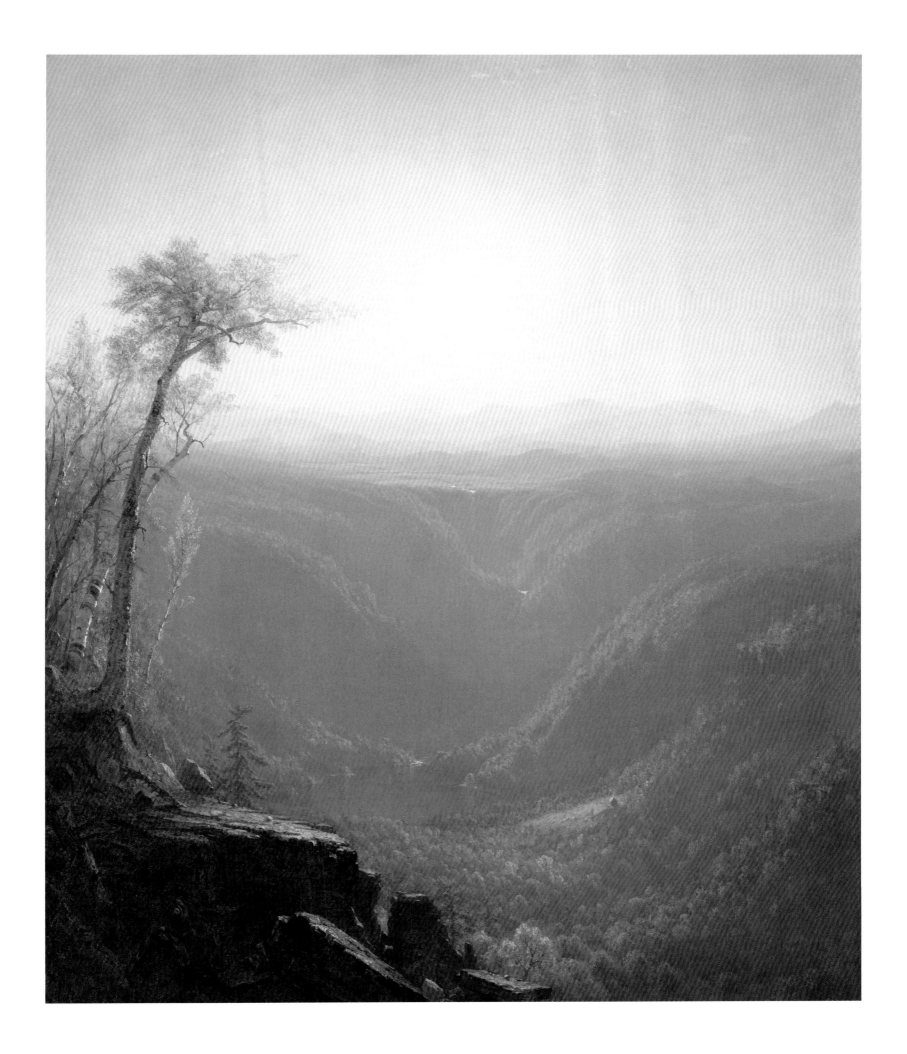

bloodied the landscape. It was then that Gifford wrote to his close friend, fellow landscape painter Jervis McEntee, hoping to entice him to go sketching with him, "You and I can take a day or two in the Catskills to see the color—I don't think I can feel quite easy in my conscience to go to town without paying my respects to the mountains."[61] *A Gorge in the Mountains* made clear the artist's urgent need to experience the restorative powers of nature in order to put back in balance the destabilized world of war. The feelings with which Gifford returned to the mountains late that summer might best be summed up in words written by charismatic Boston preacher and nature lover Thomas Starr King, who in 1860 described being in nature as a benediction, where the glow of the sun "kindled into torches of yellow fire" the autumn-tinged birch trees. Gifford's painting captures that transcendent light, the flame of spiritual purity burning away memories of war, and replacing them with epiphanies of light.[62] His wartime experience reaffirmed the inchoate need for images suffused with the promise of spiritual redemption in the wilderness, affirming the desire to believe that even during civil war, nature could still function as a form of Eden.

A Gorge in the Mountains is a visual sanctuary untouched by the war. The vertical composition and steep point of entry bring the viewer to the edge of the light-filled space in the center. Gifford's traveler climbs up toward this unearthly light, out of the cool, damp shade and up the steep face of the mountain. A few more carefully chosen handholds, a few more climbing steps, and he will boost himself over the lip of the rocks into what one reviewer described as "a flood of golden beams poured upon a mountain glen, with rifted sides, autumn foliage, and a tiny stream; a coming storm obscures but does not hide the distant hills. [This scene is] suggestive of—not paint—but real, palpitating atmosphere."[63] Eugene Benson rapturously described the effect as "like amber,—they hold imprisoned in everlasting glory pure sunlight and immortal beauty."[64] His tone is reverent, the language like that of a sermon, all intensifying the aura of spiritual regeneration and hope associated with the light in this picture. Gifford's figure, a surrogate for the artist himself, strains to reach

upward from the darkness to be bathed in the light of redemption and renewal, powerful concepts, especially at a time of war.

"BATTLE AUTUMN"

From Amherst, Massachusetts, Emily Dickinson's (1830–1886, fig. 29) poetry alluded to the Civil War and to death without confronting it head-on, an elliptical strategy consonant with what Church and Gifford accomplished in their landscape paintings during this turbulent period. Scholars now estimate that more than half of her nearly 1,700 poems were penned during the Civil War.[65] Dickinson, like Church, looked to the landscape for the means to deal with grief and loss, anxiety and hope. Her poetic sensibilities were steeped in landscape and weather imagery, her distinctive phrasing deployed in a periphrastic manner designed to draw parallels between nature and human emotion similar to those found in works by America's landscape painters.

Recent scholarship has clarified that Dickinson's self-imposed isolation was not tantamount to a complete withdrawal from the world. The world, in fact, came to her. Among those who did so during the 1850s were Harriet Beecher Stowe and her equally famous brother, Henry Ward Beecher; Thomas Wentworth Higginson, an ardent abolitionist and member of the "Secret Six" who had supported John Brown; and Samuel Bowles, editor of the *Springfield Daily Republican*, the Dickinsons' newspaper of choice.[66] These influential people visited the Dickinson home and exchanged letters with the family. Emily described herself as an "avid reader" of the *Atlantic Monthly*, and she most likely read Higginson's occasional essays on the war published therein, along with Theodore Winthrop's lively accounts and George Curtis's eulogy following Winthrop's death. Bowles's newspaper kept her abreast of current events and carried extensive reviews of the New York cultural world. Her brother, Austin, who lived next door, put together a collection of Hudson River school paintings, including a work each by Kensett and Gifford, and delighted in unveiling his latest purchase in front of his sister and his wife.[67] Emily Dickinson's father was a staunch abolitionist, active in state politics as

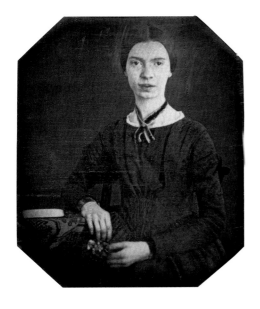

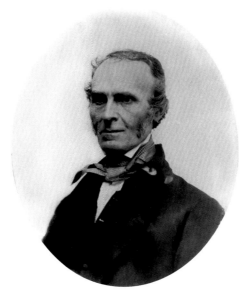

FIG. 29

Unidentified daguerreotypist
Emily Dickinson, about 1847,
Amherst College Archives

FIG. 30

Unidentified photographer
John Greenleaf Whittier, about
1840–1860, Boston Public Library

well as local governance. He also served as Amherst College's treasurer, and the intellectual life of the community flowed freely across the street into the Dickinson home.

In March 1862, Frazer Stearns, son of Amherst College's president, was killed in the Battle of New Bern, North Carolina. In a letter to Bowles, Dickinson appealed for his help in coming to terms with the loss, writing, "Austin is chilled—by Frazer's murder—He says—his Brain keeps saying over 'Frazer is killed'—'Frazer is killed,' just as Father told it—to Him. Two or three words of lead—that dropped so deep, they keep weighing—Tell Austin—how to get over them!"[68] But there would be no getting over Stearns's death, nor over the sobering death toll accrued that year. In May 1862, Henry Ward Beecher gave the commencement address at Amherst, calling on yet another landscape metaphor when he declared that secession was "an Earthquake in the South" that had destabilized American society and triggered war, just as Frazer Stearns's death had shattered the peace and security of the village of Amherst. Emily would borrow Beecher's phrase for one of her own poems, a measure of how deeply it rang in her conscience.[69]

Frazer Stearns's death and the horrors of Antietam framed Dickinson's year. Antietam prompted fellow poet John Greenleaf Whittier (1807–1892, fig. 30) to write "Battle Autumn 1862," a poem first published in the *Springfield Daily Republican* alongside news of the carnage.[70] Dickinson could hardly have missed this item; and at some point she wrote her own powerful poem that encapsulated the pervasive inflection the war had so far from those bloody fields:

> The name — of it — is "Autumn" —
> The hue — of it — is Blood —
> An Artery— upon the Hill —
> A Vein — along the Road —
>
> Great Globules — in the Alleys —
> And Oh, the Shower of Stain —
> When Winds — upset the Basin —
> And spill the Scarlet Rain —
>
> It sprinkles Bonnets — far below —
> It gathers ruddy Pools —
> Then — eddies like a Rose — away —
> Upon Vermilion Wheels —

Dickinson's deliberate use of "Autumn" in quotation marks calls to mind its homonym, Antietam; her relentless emphasis on circulation and blood is superimposed on the landscape, draining its life as autumn's ruddy foliage gives way to the dead of winter. Autumn as a time of transition, of the ebbing of life, took on deeper resonance as Dickinson saw in every aspect of the gorgeous fall foliage the signs of war. Falling leaves

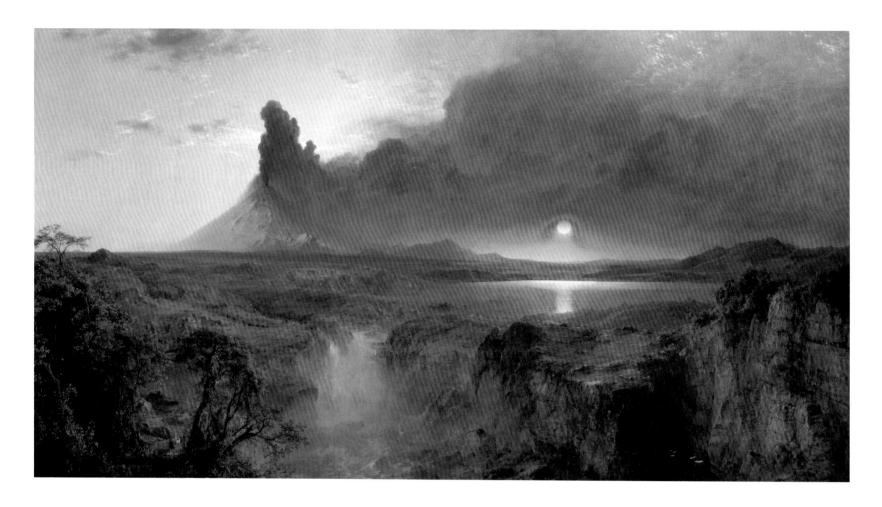

CAT. 6

Frederic Edwin Church
Cotopaxi, 1862, oil on canvas,
48 × 85 in. Detroit Institute of Arts

swirled in the Basin, an emerald-green pool visited by travelers to Franconia Notch, now turned blood red.[71] Dickinson's reaction to Stearns's death mirrored the anguish expressed by Frederic Church upon hearing of Theodore Winthrop's demise; his *Our Banner in the Sky* and her poem plumb a deep well of emotion, trying to make some sense of the loss.[72] Poet and painter shared a rich vocabulary of natural phenomena, focusing on destabilized weather and portents in the skies, exploring the psychological dimension of the actual and literary landscape.

AMERICA'S "MORAL VOLCANO"

The relentless red tonalities of Dickinson's poem find visual resonance in Church's "Great Picture" of 1862, a monumental image of *Cotopaxi* in which his South American paradise is on fire and coming apart at the seams (cat. 6). Volcanoes were widely invoked as harbingers of the war's societal upheavals, and specifically to describe slavery as America's "moral volcano." On the eve of war Frederick Douglass (1818–1895, fig. 31) delivered an address in June 1861 titled "The American Apocalypse" in which he affirmed, "Slavery is felt to be a moral volcano, a burning lake, a hell on the earth, the smoke and stench of whose torments ascend upward forever. Every breeze that sweeps over it comes to us tainted with its foul miasma, and weighted down with the sighs and groans of its victims."[73] A little over a year later, as Church completed *Cotopaxi*, the "moral volcano" of slavery became the central, burning issue of the war itself with Lincoln's announcement of the provisional Emancipation Proclamation on September 22, 1862. Accordingly, all slaves in the Confederacy were legally free as of January 1, 1863. By that time the American Eden had already been destroyed by Civil War, setting the stage for a political and spiritual transformation that could reshape the nation, much as Church's volcano would reshape the landscape. *Cotopaxi*, infused with natural history and steeped with the imagery of cataclysmic moral and social upheaval, was a mirror of its time, a multivalent emblem of America's internal war.

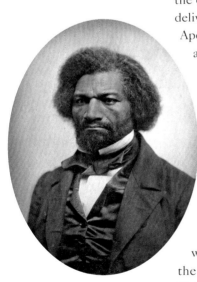

FIG. 31

Unidentified photographer
Frederick Douglass, 1856,
National Portrait Gallery,
Smithsonian Institution

Under Church's brush, *Cotopaxi* erupted as the nation moved into the bloodiest year of the war. This painting presents a panoramic sweep of the Andean plateau, dominated by the cinder cone of the powerful volcano. The smoke and ash rolling from the caldera drift down the side of the mountain, nearly obliterating the surrounding landscape in a superheated wave. The landscape is literally fracturing, flowing underfoot, reflecting the tumult of an unstable nation in a war with no end in sight. Although *Cotopaxi* is not a painting specifically about the Civil War, it is a landscape suffused with it. Louis LeGrand Noble, once again pressed into service to write about Church's accomplishments, described the sulfurous Andean plateau as "this great battlefield of nature's forces."[74] The critics of the day, who often struggled mightily to divest the works of art from their larger historical context, recognized the signs. A reviewer writing for the *Albion* described the ash-laden sky as "the war-clouds, roiling dun" that eclipsed the light.[75] The line comes from a poem written in 1803 by Scottish poet Thomas Campbell called "Hohenlinden," about a bloody battle fought near Munich in 1800 during the French Revolutionary wars. Its use underscores the allusion to war in Church's painting. The surrounding lines reinforce the visual parallels between painting and poem:

> But redder yet that light shall glow
> On Linden's hills of stainèd snow,
> And bloodier yet the torrent flow
> Of Iser, rolling rapidly.
>
> 'Tis morn, but scarce yon level sun
> Can pierce the war-clouds, rolling dun
> Where furious Frank and fiery Hun
> Shout in their sulphurous canopy.

The volcanic imagery deployed in Campbell's poem mirrors that of Church's canvas, the super-heated palette of reds and oranges conflating sunlit water with molten lava, and rivers running red with blood. Like the impenetrable, sulfurous smoke from the cannons that often rendered opponents unable to see each other through the acrid haze, Church's ash cloud descending the Andean slopes threatens to blot out the sun.

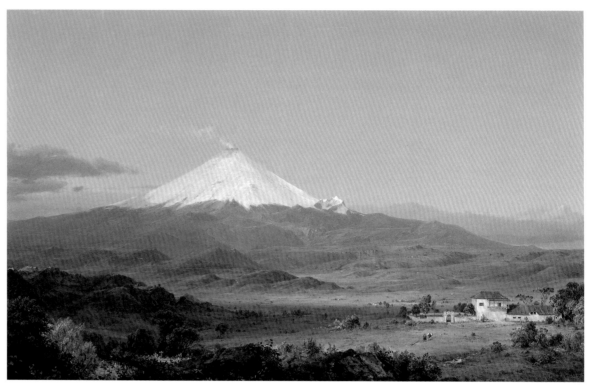

FIG. 32

Julius Schrader
Baron Alexander von Humboldt,
1859, oil on canvas, 62 ½ × 54 ⅜ in.
The Metropolitan Museum of Art,
Gift of H. O. Havemeyer, 1889

FIG. 33

Frederic Edwin Church
Cotopaxi, 1855, oil on canvas,
28 × 42 in. Smithsonian American Art
Museum, Gift of Mrs. Frank R. McCoy

In the American press, volcanoes were variously described in terms of bombs or heavy artillery, the ash clouds reminiscent of cannon smoke drifting across the battlefield. In a review of Church's painting the *New-York Daily Tribune* reviewer described volcanoes as "pillars of warning rather than of guidance."[76] *Cotopaxi* was viewed as envisioning what many newspapers had called the "great national crisis," embodying the "warring elements" in the battle between light and dark. The cross of light formed by the haze over the setting sun was deemed to be an omen of redemption, leaving hope—albeit dimmed by brimstone—that when the smoke cleared, the lurid cross of light shimmering in the rear distance would in fact confirm that God had not abandoned America. In the most favorable such reviews *Cotopaxi* was described as a beacon of hope despite its invoking the dramatic horrors of the war.

Church's interest in this South American volcano was inspired by the writings of the influential German naturalist Alexander von Humboldt (1769–1859, fig. 32). At the time the great traveler was arguably the single most influential voice in natural history in both Europe and America.[77] Humboldt's writings, especially his multivolume opus *Cosmos*, profoundly affected Church's understanding of the natural world. Tracing Humboldt's steps, Church had made two trips to South America, traveling through Colombia and Ecuador in 1853 and 1857. As such, the young artist's earlier images of Cotopaxi had been inspired by Humboldt's vision of a universe in harmony. In an 1855 view of Cotopaxi (fig. 33), the snow-capped peak framed against a clear blue sky puffs peacefully, reinforcing the Edenic associations many in North America ascribed to the southern continent. But now Church painted a more monumental and apocalyptic vision of this American Eden. Building his composition from a series of plein-air and studio sketches, Church embarked on a journey that stretched his technical skills and enhanced his capacity for incorporating multiple layers of meaning in a seemingly straightforward landscape painting. He worked on *Cotopaxi* most of the year, arranging for its debut in March 1863. At four feet by seven feet, it was the

largest of the ten canvases he had already completed of this subject.

The allusions to the Civil War in Church's erupting volcano reveal the artist's absorption of one of Humboldt's central tenets. In *Cosmos*, Humboldt described the relationship between nature and the human mind as one that carries us "beyond the mysterious boundary which connects the metaphysical with the physical, and leads us into another and higher sphere of ideas." He went on to affirm that in art, one needs to paint not only what he calls "the pure objectiveness of external phenomena," but also a "reflection of the image impressed by the sense upon the inner man, that is, upon his ideas and feelings."[78] Thomas Cole had expressed similar sentiments when he called for a "higher style of landscape," urging artists and patrons alike to embrace the idea that landscape painting should be more than topography.[79] Cole's was an influential voice asserting that landscape painting carried moral and cultural significance for Americans. Humboldt's philosophical approach reinforced the power of the fine arts to engage in the sphere of profound ideas, encompassing spiritual and metaphorical levels of meaning in what can be simply understood as geologically inspired landscape painting.

However, the eminent naturalist was also horrified by slavery and continually blended local politics with his scientific observations. In *Cosmos* he asserted that all members of the human species "are in like degree designed for freedom," and throughout his adult life he rejected race as a scientific category, arguing that "race" did not determine or inhibit ability.[80] Observing South American civilization, Humboldt had decried slavery and, although he was fundamentally a pacifist, advocated revolution over oppression. He lamented that revolution required so much bloodshed to accomplish its goals, preferring a more peaceful and gradual emancipation. However, he noted that in the absence of peaceful emancipation, violence of an apocalyptic nature was sure to follow.[81] Humboldt's views inspired his friend, the South American revolutionary leader Simón Bolívar, to proclaim, "A great volcano lies at our feet.... Who shall restrain the oppressed classes? The yoke of slavery will break, each shade of complexion

will seek mastery."[82] Humboldt hoped his views on American slavery would inspire similar action there. Beginning with his first meeting with Thomas Jefferson in 1804, Humboldt shared his strong feelings that America should abolish slavery in order to live up to its democratic ideals. Boston abolitionist Theodore Parker and North Carolina antislavery advocate Hinton Rowan Helper made Humboldt's antislavery views as well known in America as his scientific work. In 1857 Helper published a lengthy excoriation of slavery titled *The Impending Crisis of the South*. The 1860 edition carried a quotation from Humboldt affirming, "Without doubt, slavery is the greatest of all the evils which have afflicted mankind." In 1858 Parker made this quote a centerpiece of his resolution applauding Humboldt's antislavery views, a resolution published in William Lloyd Garrison's abolitionist newspaper, *The Liberator*, and in William Cullen Bryant's mainstream *New York Evening Post*.[83]

Humboldt's pleas for emancipation may have fallen on deaf ears in the White House, but volcanic imagery played a central role in public rhetoric on the moral quandary of American slavery. In a sermon delivered in 1859 at an African Methodist Episcopal church in Pittsburgh, the Rev. J. S. Martin preached about the death of John Brown, proclaiming, "It is thought by the slaves...that the meteors from the heavens are sparks that...strike upon the craters of volcanoes, and that is the cause of their eruption. From the firmament of Providence today, a meteor has fallen. It has fallen upon the volcano of American sympathies, and though, for awhile, it may seem to sleep, yet its igneous power shall communicate...to the slumbering might of the volcano, and it shall burst forth in one general conflagration of revolution that shall bring about universal freedom."[84] Race slavery was North America's volcano, a simmering force, hidden and suppressed, but waiting to erupt explosively. It was a potent image that caught fire across the North. Volcanoes, fireballs, and meteors alike became associated with the burning issue of slavery in America.

A LANDSCAPE OF "DEEP GRIEF OR DESPAIR"

The ability to read the effects of war into a desolate landscape, and the commensurate willingness to do so, marks a turning point in reviewers' expectations for landscape painting. Although Church's friend Jervis McEntee (1828–1891, fig. 34) had spent only three months in uniform in 1861, he returned from the front able to translate his experience into pictures, conveying empathetically the emotional toll wrought on the nation in his landscape paintings.[85] In 1862 McEntee painted a landscape simply titled *Virginia, 1862*. Its current whereabouts are unknown, but the extensive descriptions of the composition attest to its power among fellow artists and critics, one of whom called it "one of the most impressive landscapes of American art" in which "the far flowing lines of the landscape give that monotonous character which we generally associate with the expression of deep grief or despair."[86] *Virginia, 1862* went on view at the Century Club in January 1863 and then at the National Academy of Design later that spring. The reviews were thoughtful, lengthy, and positive, with several writers opining that the work was the artist's best and most eloquent to date. Art critic Barry Gray reviewed the painting for no fewer than three different publications, in each finding ways to note that there was "an exquisite pathos, a tender mournfulness, about his works, wonderfully in keeping with the character of the man."

Gray's haunting description of this missing work, worth quoting at length, said *Virginia, 1862* presents

a story of the devastation and desolation which the war has wrought upon a hitherto fair and productive region. A wan, pale sky bending over a wide waste of country—a portion of the frame of a burned and destroyed homestead, standing spectral-like against the blank heavens—another house smouldering in ruins in the distance—trees torn, bowed and twisted by iron shot and shell—a stream winding through the landscape, its gray waters blocked by the debris of a fallen bridge, the near abutments of which, crumbling and shattered, still remain to denote its site, and a white frost

creeping over the earth, marking the season of the year, are the materials which make up a striking and remarkable picture. There is little in it to show it is a battle-field; the carnage of warfare is nowhere visible; nothing revolting meets the eye; the carcases [sic] of no dead horses cover the plain; no dismantled cannon attract the sight; no broken weapons or other munitions of war are scattered about, and yet the instant one looks upon the picture he realizes that it depicts a scene invaded by contending armies, and ravaged by a victorious foe. . . . It impresses him with a feeling of grief and bitterness. He almost expects to have the oppressive silence, which broods like an incubus over the plain, broken by low wails of agony and grief.[87]

McEntee's devastated landscape was a powerful commentary on the toll of war and on the sorry state of Virginia, which had not eagerly embraced secession. The reviewer covering the Academy exhibition in 1863 for the *Continental Monthly* wrote, "Alas for *Virginia* (No. 218), mother of presidents, and nurse of the Union! can it indeed be her sky that shines down so weird and strange over desolate plains, through broken walls and shattered beams, and darkens as it shrinks in horror from the broken bridge once spanning the blood-stained waters of the fatal run?"[88] In the spring of 1864, the painting's owner, Cyrus Butler, sent this painting to the Maryland State Fair, where it attracted similar notices. In the words of one reviewer, the painting was an object lesson for the prosecessionist citizens of Baltimore, "There were more natural reasons than one why McEntee's *Virginia* should be appreciated to the full in Maryland. Maryland might have been what Virginia is—wasted, depopulated; sunk from the mother of presidents into the daughter of desolation."[89] In McEntee's scene, a viewer might readily conclude that, as goes the landscape, so goes the region, and possibly the nation—here facing a mournful future. The funereal atmosphere explicit in McEntee's somber landscape extends beyond the literal devastation wrought by the war, exemplifying fears for the collateral destruction of the country's moral and cultural landscape. McEntee stated his belief that "in landscape you can tell a certain kind of story. The days and seasons in their gay or solemn beauty, influence you, impress you, awaken emotions, convey teachings."[90] Perhaps more

profoundly than any of his colleagues, McEntee painted works that gave voice to the devastation wrought by the war and used the landscape as a metaphor for human suffering. His own dark moods informed his ability to render the nation's despair.

No longer expecting sanctuary, viewers now sought and found melancholy aspects of the war in works like McEntee's mournful views. Ironically, in spite of, or perhaps in recognition of, the Civil War's destructive legacy on the land, landscape painting continued to reflect the nation's mood.[91] Around 1862, Homer Dodge Martin (1836–1897, fig. 35) painted a haunting landscape titled *The Iron Mine, Port Henry, New York* (cat. 7). The iron ore extracted from several of the Adirondack hills along Lake George was used to forge the deadly Parrott guns used by the Union artillery. In Martin's painting the mines have been abandoned, their rusted tailings staining the slopes from the adits down to the water's surface, resembling streaks of dried blood. The cavernous openings to the mine shafts suggest entry wounds. Here the landscape takes on the sobering quality of a bullet-ridden corpse, yet another casualty of war. In a further irony, the army often tested its heavy artillery by firing ordinance into the cliffs at Storm King and other Hudson River outcroppings, their cannon balls leaving additional scars in the hillsides.

The shift from celebrating the wilderness to sobering overtones of violence and destruction suggests that landscape painters understood that finding the path back to Eden would not be easy. *The Iron Mine, Port Henry* calls to mind the bloated corpses strewn across the battle-scarred landscapes in Alexander Gardner's photographs from Antietam (see cat. 18). The shock most viewers felt upon seeing dead soldiers carried over to the war damage done to the landscape. Martin's landscape shares with these images of unburied soldiers the haunting quality of abandonment. The rusted tailings are not fresh cuts; the empty dock below has no boat waiting to load new ore. The brutalized landscape is reverting back to an untouched state, much as a corpse decomposes and becomes part of nature. The exposed bones visible in photographs of Cold Harbor (see cat. 24) and the Wilderness (see fig. 87), like the streaks of rust and gaping adits in Martin's painting,

FIG. 35

Unidentified photographer
Homer Dodge Martin, about
1850–1860, Martin Family Archives

bear witness to the ravages that only time can efface. The images blur and become one. For Americans unused to considering the landscape as a source of pain and devastation, wartime landscapes evoked a different range of emotions, complicating the messages layered therein.

"NOT THAT RICHMOND"

Experiencing the war at a distant remove could be nearly as unsettling as experiencing it firsthand. American landscape painter Jasper Francis Cropsey (1823–1900, fig. 36) and his wife had lived in England for several years before war broke out. Their Northern sympathies left them in a precarious position as England flirted with support of the Confederacy during the summer of 1862. The pro-Southern *Illustrated London News* dominated the war coverage for its British audience, and there was plenty for the London newspaper to report on during the spring and summer of 1862. Union General George B. McClellan stalled outside Richmond, unable or unwilling to commit his troops to capture the Confederate capital, while to the west Confederate General Thomas "Stonewall" Jackson executed his successful Shenandoah Campaign. The Confederate victories prompted England and France to begin clandestine discussions about whether it was time to step in and barter a mediated separation of the American North and South into distinct countries. That alarming prospect galvanized Ambassador Charles Francis Adams and other U.S. diplomats, prompting numerous meetings with members of Parliament and the prime minister, Lord Palmerston.

Cropsey was aware of some of these negotiations, and his letters to friends and family along with his diary entries alternately express his hope and dismay as war-related events see-sawed back and forth that year. In early September Cropsey encountered fellow artist Louis Rémy Mignot, a Southern sympathizer whose political views had prompted him to move to London. Cropsey observed, "A few days ago Mr. & Mrs. Mignot came out both of whom are 'secessionist' and desire to see their country destroyed.... I am happy however to know that only a few of my profession have turned rebels while some are behaving so nobly as to enter the service

CAT. 7

Homer Dodge Martin
The Iron Mine, Port Henry, New York,
about 1862, oil on canvas mounted on fiberboard,
30 ⅛ × 50 in. Smithsonian American Art Museum,
Gift of William T. Evans

for the Union."⁹² The same week, Cropsey began work on an ambitious painting that on its surface appeared to have little if anything to do with the American Civil War. Titled *Richmond Hill in the Summer of 1862* (cat. 8), Cropsey chose a vantage point beloved of devotees of Arcadian vistas. Situated fifteen miles southwest of central London, Richmond Hill was a favorite spot for long walks, picnics, and people watching. In his painting the viewer looks from the promenade across the Thames River to Marble Hill Park and Twickenham, with Windsor Castle atmospherically framed in the distance against the soft hills. The Star and Garter Inn, a familiar historic landmark, is nestled into the lower left foreground, and the center foreground of the painting is given over to an assortment of characters enjoying an English midsummer's day.

To understand how the artist deftly wove references to the American Civil War in a painting of a beloved English view, we need look only at the resemblances drawn by British commentators between Richmond Hill and Richmond, Virginia. Richmond, Virginia, had long held a particular attraction for the English, having been so named in 1737 by William Byrd II, a homesick British surveyor struck by the resemblance to the landscape of his boyhood home, Richmond Hill.⁹³ In 1796 architect Benjamin Latrobe had made note of this, remarking, "There are I believe few towns, places, or counties in old England that have not a namesake in North America. In few cases has the similarity of situation

had the smallest influence upon the sameness of name. Richmond however, is an exception to this remark. The general landscapes from the two Richmond Hills are so similar in their great features, that at first sight the likeness is most striking.... The windings of the James River have so much the same cast with those of the Thames... that if a man could be imperceptibly and in an instant conveyed from the one side of the Atlantic to the other he might hesitate for some minutes before he could discover the difference."⁹⁴ That similarity took on added significance during the Civil War, when Richmond became the capital of the Confederacy, making it the most important city in the South The London papers were full of articles admiring the Confederacy's viability, and during the summer of 1862 they demonstrated a particular interest in the role of Richmond, Virginia, in battle and politics. In November the *Illustrated London News* called attention to that similarity by printing an illustration by "Our Special Artist" showing the prospect of Richmond, Virginia, from Drury Hill, a vantage point visually similar to the one chosen by Cropsey (fig. 37). The similarities were not lost on the London critics. A reviewer for the *London Observer* described Cropsey's setting as "not that Richmond, in Virginia, which for some time past has been the object of so much bitter hostility and such anxious expectancy, but Richmond on the Thames, known to every lover of English scenery."⁹⁵

The artist himself is among those voyeurs, seated in the left center foreground where he is painting a small-scale version of the scene, his canvas attached to

THE CIVIL WAR IN AMERICA: VIEW, FROM THE WEST, OF RICHMOND, VIRGINIA, CAPITAL OF THE CONFEDERATE STATES.—FROM A SKETCH BY OUR SPECIAL ARTIST.—SEE PAGE 531

FIG. 37

Unidentified artist
The Civil War in America, View from the West of Richmond, Virginia, Capital of the Confederate States, from *Illustrated London News,* November 15, 1862, wood engraving, Beck Center, Emory University

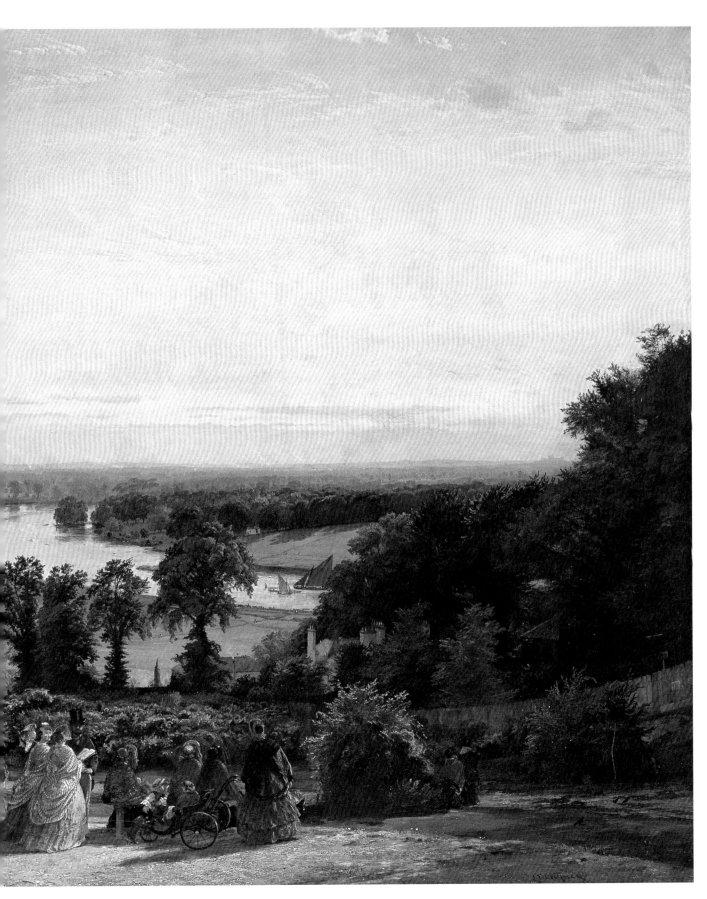

CAT. 8

Jasper Francis Cropsey
Richmond Hill in the Summer of 1862,
1862–1863, oil on canvas, 54 × 96 in.
Private Collection

his portable easel. It is easy to be distracted by the range of anecdotal activity, much as people visiting might do. But following Cropsey's gaze we see a pair of figures walking together along the lower path. They are soldiers, one dressed in blue, the other in gray, weapons couched, chatting amiably (fig. 38, detail of cat. 8). Cropsey's point in conflating the two Richmonds centers on these two soldiers. The style of their uniforms appears to be those of the London Rifle Brigade; however, armed soldiers did not typically patrol the promenade. These men, like those fighting in the American Civil War, were citizen volunteers rather than career military men.[96] By dressing them in blue and gray, Cropsey gave his viewers license to draw parallels between the two Richmonds, London and Virginia, mentally contrasting the war-torn American scene with its Arcadian British counterpart. That these two soldiers are companions, at the very moment the Union and Confederacy were enmeshed in a bloody campaign, speaks to a kind of wish-fulfillment, a homesick longing for peace in his distant homeland. Their

reconciliation would obviate the need for England's intervention in the war and would affirm the United States' future as a single, indivisible country. In light of the political machinations in London and Mignot's discomfiting visit, *Richmond Hill in the Summer of 1862* becomes a meditation on reconciliation and a personal plea for unity. By including a subtle reference to the American war in the title and staffage of a quintessentially Arcadian English landscape, Cropsey linked his painting to current events, but not to any specific one. More important for his British viewers, he did not paint a work that took sides. His admirers appreciated his tact, and on April 29, 1863, *Richmond Hill* sold for a record price.

Painting Richmond Hill may have also solidified the artist's determination to come home. Using the proceeds from the painting's sale, the Cropseys sailed for New York and arrived there on July 3, 1863, the final day of the pivotal Battle of Gettysburg. After stopping at the Tenth Street Studio Building, the artist traded his suitcase for his sketching outfit and headed to the battlefield. There he made pencil sketches for his next large-scale war-related painting, which he titled *Gettysburg, 1863*.[97] For the second and last time the artist would include a year in the title of his painting, suggesting that *Richmond Hill* and *Gettysburg* form unusual pendants. In each case, the setting refers to events specific to the Civil War. In each painting, the fate of the country hangs in the balance. Cropsey has counted on the viewer's recognition of the symbolic weight of each place. In *Richmond Hill*, allusions to the South exude wish-fulfillment for an amicable resolution to the war; in *Gettysburg*, the American flag dominating the sky over the open field carries memorial overtones of loss and a hint of patriotic defiance. Cropsey deliberately interwove layers of metaphorical resonance in each work's title and composition.

THE WAR COMES TO NEW YORK

The war came to New York in the summer of 1863. Ten days after the end of the Battle of Gettysburg, the city descended into its own internecine battle, the draft riots. For five days between July 12 and 17, it was unsafe to walk the streets. What began as a protest against another call for troops, and the infamous "$300 clause"

FIG. 38

Jasper Francis Cropsey
Richmond Hill in the Summer of 1862 (detail), 1862–1863, oil on canvas, 54 × 96 in.
Private Collection

FIG. 39

Brady's National Portrait Gallery
Picture gallery, Metropolitan Fair, N.Y.C., 1864, National Archives

that permitted wealthier residents to pay a fee and avoid being drafted at all, turned ugly. Armed mobs looted and burned residences of Republican supporters and, more chillingly, targeted the city's free black population. Innocent black people were beaten, maimed, or killed, as were whites who tried to protect them.[98] For New Yorkers who had found it all too easy to see the Civil War as a distant conflict measured in news reports, the shock was galvanizing. Two events already underway channeled some of that horror and dismay. One was the long-awaited opening of the new building housing the National Academy of Design, the city's centerpiece for the display of American art. The other was the Metropolitan Fair.

The annual exhibitions at the National Academy of Design and other venues continued throughout the war years, and no fewer than thirty expositions were held in Boston, Brooklyn, Chicago, New York, Philadelphia, and other cities. Overshadowing all of the war-relief efforts was the Metropolitan Fair of New York, organized by the U.S. Sanitary Commission and held in May 1864. The Metropolitan Fair was intended to demonstrate Northern superiority in the arts, cultural achievements, and war spirit. In addition to its laudable goals of providing money and *matériel* to support the Union troops,

it was a gauntlet thrown down to proclaim New York's cultural hegemony over the South—and the rest of the country. Landscape architect Frederick Law Olmsted agreed to serve as the general secretary of the Sanitary Commission. He enlisted Unitarian Minister Henry Whitney Bellows to serve as its president, and lawyer and diarist George Templeton Strong as its treasurer.[99] For artists who did not fight in the war, the Fair represented the premiere opportunity for expressing patriotic sentiments.[100] Landscape painter John Frederick Kensett was appointed head of the Art Committee. Assisting him were many artists and members of the Union League Club who subsequently turned their organizational skills to founding the Metropolitan Museum of Art as a permanent display of the nation's cultural achievements. The selection and display of massive paintings by Church and Albert Bierstadt, who up until then had deftly avoided having their major paintings proximate to each other, sent a stir through the crowds. Church's *Heart of the Andes* and *Niagara* and Bierstadt's *The Rocky Mountains, Lander's Peak* were joined by Emanuel Leutze's *Washington Crossing the Delaware* to send a bold message of national unity and patriotism (fig. 39).[101]

"THE END OF ALL THINGS"

The war years had already proved to be a bounty for celestial portents. The preponderance of meteors, comets, and auroras made it seem as though the American skies, North and South, were witness to an apocalyptic battle overhead that rivaled the rolling war-dun on the ground. Chief among the phenomena invoking apocalypse and days of judgment was the Aurora Borealis, eerie, silent flickerings of lurid light that rippled across the sky like a nocturnal, unhinged rainbow. They conjured images of nature out of control, appearing and disappearing with no warning. From the 1850s the appearance of the auroras spurred lengthy accounts in local newspapers that combined scientific data with astrological interpretations.

That message was delivered in terms both scientific and apocalyptic by one of the most prominent Arctic explorers of his generation. Dr. Isaac Israel Hayes (1832–1881, fig. 40) had been the medical officer aboard Elisha Kent Kane's celebrated exploration of 1854 in search of Sir John Franklin. Both Hayes and Church were members of the American Geographical and Statistical Society in New York, a group of scientists, artists, and literary men who shared a fascination with the natural world, inspired in large part by the popularity of the writings of Humboldt. Church was well versed in Arctic exploration and owned a copy of Kane's memoirs recounting his voyage. Church and Hayes had become friends, each man developing an interest in the other's profession.[102] Prior to Hayes's departure for the far north, Church provided sketching lessons to the explorer, hoping he might return with drawings the artist could use for a painting based on his voyage. In fact, Hayes's sketches would play a significant role four years later, when Church painted his *Aurora Borealis.*

In 1860 Hayes outfitted his own expedition on a vessel he had recently rechristened the SS *United States.* He sailed from Boston in July and wintered over trapped in the Arctic ice pack. His safe return in October 1861 was cause for celebration—a rare bright spot in a winter dark with war. The SS *United States* had survived an Arctic winter and returned intact, which was more than could be said for its namesake, the ship of state. At a lecture on his experiences, Hayes ruefully noted, "Since we last met in this hall great changes have taken place. When I left the regions of eternal ice, I little dreamed that a powerful rebellion was desolating my country, and that civil war was raging among a people which I left prosperous and happy. This great national calamity alters the relations under which we now meet. Had there been peace, I should have come before you to solicit a continuance of your countenance and influence in aiding the further prosecution of Arctic discovery, but for the present I cannot think of it....God willing, I trust yet to carry the flag of our great Republic, with not a single star erased from its glorious Union, to the extreme northern limits of the earth."[103] Hayes cast polar exploration as a form of patriotism, endurance as a Northern value.

Framed against this backdrop, Church's painting, *Aurora Borealis* (cat. 9), took shape on his easel during the winter and early spring of 1864 to 1865. Under a dark Arctic sky, an explorer's ship lies frozen in the pack ice at the base of a looming cliff. Lights inside the diminutive vessel signal a human presence, and the tiny dogsled making its way toward the ship encourages thoughts of rescue from an icy tomb (fig. 41, detail of cat. 9). Overhead the heavens erupt in a cascade of eerie lights ranging from red to greenish-yellow. Church captured the implied motion of the electric luminescence arcing across the sky. As the ice grips the SS *United States*, and by proxy the nation, the auroras snake across the Arctic winter sky like a grim warning from God, a bleak foreshadowing of doom.

Hayes spoke eloquently and extensively about the brilliant auroras he witnessed on his trip. He published a somewhat florid account that emphasized the biblical and apocalyptic overtones of this phenomenon, noting that the strange light "glowed again, as if the air were filled with charnel meteors, pulsating with wild inconstancy over some vast illimitable city of the dead."[104] Church's *Aurora Borealis* is suffused with this vision of the Arctic night, rendering this "illimitable" place with a powerful sense of melancholy and discord. In hue and weirdly undulating motion, Church's painting gives form to Hayes's poetic and yet scientific description of

FIG. 40

Mathew B. Brady
Isaac Israel Hayes, about
1860–1875, Library of Congress

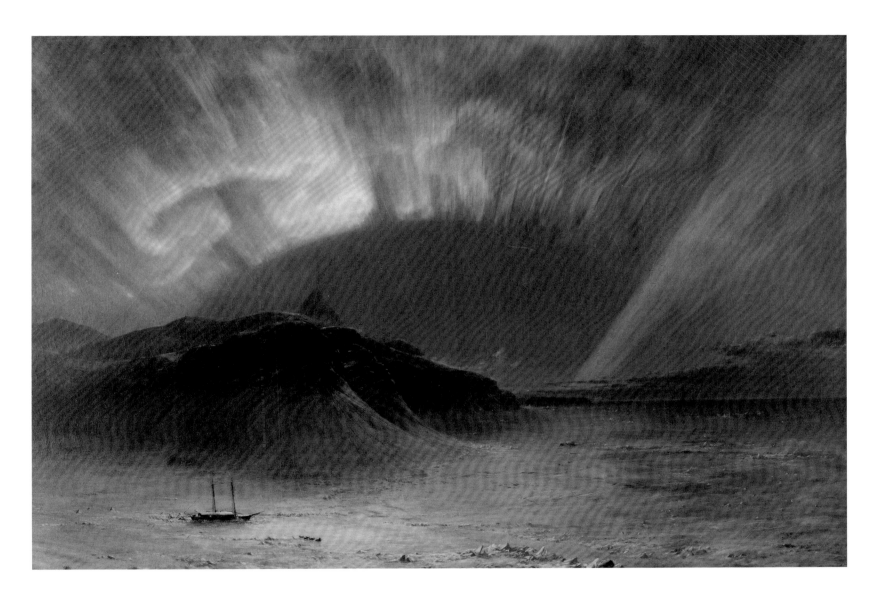

CAT. 9

Frederic Edwin Church
Aurora Borealis, 1865, oil on canvas,
56 × 83 ½ in. Smithsonian American Art
Museum, Gift of Eleanor Blodgett

FIG. 41

Frederic Edwin Church
Aurora Borealis (detail), 1865,
oil on canvas, 56 × 83 ½ in.
Smithsonian American Art Museum,
Gift of Eleanor Blodgett

FIG. 42

Frederic Edwin Church
Aurora Borealis, Mt. Desert Island,
from Bar Harbor, Maine, September
1860, brush and oil paint on cardboard,
10 ⅜ × 13 ⅞ in. Cooper-Hewitt
National Design Museum, Smithsonian
Institution, Gift of Louis P. Church

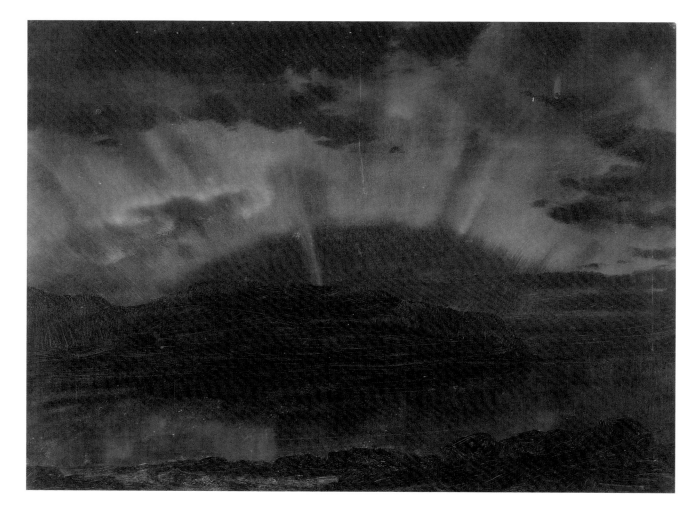

FIG. 43

Thomas Nast
*A Rebel General Startled in His Camp
by the Beautiful and Unexpected
Display of Northern Light*, from
Harper's Weekly, May 25, 1861,
wood engraving, Library of Congress

intensity. For artists, it afforded an opportunity to see firsthand what were usually the province of Canadian and Arctic denizens. And to those fearful of portents on the eve of war, this auroral display must have seemed to augur if not the end of the world, at least the end of its stability and predictability.[106]

In 1863 a massive and colorful aurora again rippled over New York City. Its appearance fed the apocalyptic mood during the war and prompted the *New York Illustrated News* to publish a poem titled "Aurora Borealis" in which the imagery invokes the war, volcanic eruptions, and the auroras with biblical overtones. An excerpt from the lengthy poem reads,

> 'Tis midnight, and the world is hushed in sleep;
> Distant and dim the Southern mountains lie;
> The stars are sparkling in the cloudless sky;
> And hollow murmurs issue from the deep,
> Which, like a mother, sings unto the isles.
> Sure, spirits are abroad! Behold! the North
> Like a volcano glares; and starting forth,
> Red streaks, like Egypt's pyramids in fires—
> Lo! Superstition, palid and aghast,
> Starts to his lattice, and beholds in fear,
> Noiseless, the fiery legions, thronging fast,
> Portending rapine and rebellion near.
> For well he knows, that dark futurity
> Throws forward fiery shadows on the sky.[107]

the scene. Artist and explorer present the Arctic as the antipode of Eden, the inverse of paradise, an unearthly landscape that functions as an inversion of the landscapes that made Church's reputation.

By the time Church painted *Aurora Borealis*, the nation had witnessed several unusual displays of this phenomenon. In 1859 and 1860, Church had seen the auroras himself on several occasions, capturing their eerie pulsations in his sketches (fig. 42).[105] But the spectacle that captured the American imagination occurred after his return to New York, between August 24 and September 4, 1859, when auroras were visible from Cuba to Canada. It was highly unusual to see the auroras so far south, reinforcing many Americans' belief that God had cast these unearthly lights over every part of the United States to make a point. To scientists, this display was unmatched in extent, duration, and

In contrast to more optimistic views that the auroras were augurs of victory, this poem contains nothing positive or reassuring about what the auroras portend. It is laced with dread of a battle yet to come. Using imagery from the book of Revelation—the plague of fire, God's avenging Angel with a flaming sword barring entry to Paradise—the poet foreshadows the fall of the mortal world; and this world is no place of grace. By this time it was difficult to find a description of an aurora that did not link it in some way with the war. In the North a cartoon printed in *Harper's Weekly* showed a Confederate general cowering at the advancing northern lights, appearing like an oncoming army (fig. 43). As Church turned to paint his own vision of the auroras, he seemed to have a similarly apocalyptic framework in mind.

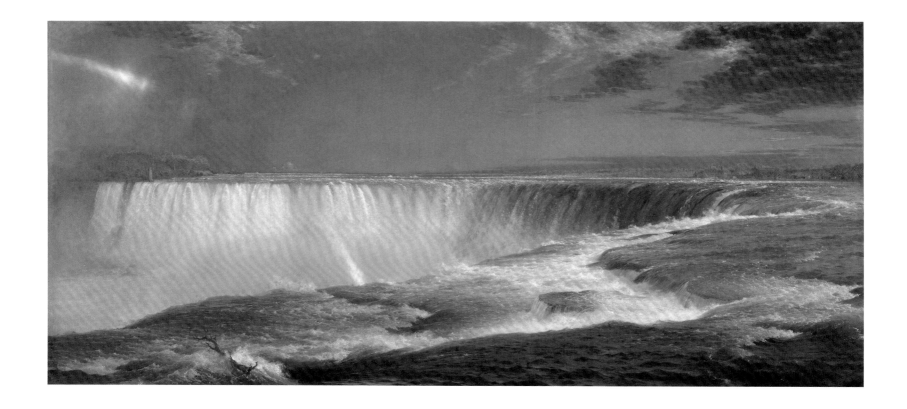

FIG. 44

Frederic Edwin Church
Niagara, 1857, oil on canvas,
40 × 90 ½ in. Corcoran Gallery of Art,
Washington, D.C., Museum Purchase,
Gallery Fund

The compelling focus of *Aurora Borealis* is a rainbow unhinged from its cosmic moorings, weaving irregularly, hypnotically, and silently across the sky. In this painting Church portrays nature in its amoral state, the pulsating auroras a dark inverse of the magisterial rainbow over *Niagara* (fig. 44) that trumpeted the confident promise of America's future. *Niagara* had been the exemplar of the prewar landscape, the falls interpreted as a natural wonder rivaling any in the world. The rainbow married science with religion, a sign of God's blessing. Chosen as a centerpiece of the Metropolitan Fair, this painting affirmed that the country's positive qualities were symbolically evident in the American landscape. By contrast, *Aurora Borealis* summed up the war years with an apocalyptic twist. Everything about this painting stands in opposition to its diurnal counterpart. In *Aurora Borealis*, the sea is solid, the ship trapped and unable to move. The winter sky is dark half the year. This entire landscape seems fraught with deadly beauty. Reviewers claimed to see faces in the looming cliffs: Eskimo features in the basalt highlands and a skull shrouded with icy scree alongside it. Unlike the familiar roar of Niagara Falls, here the silence of the auroras emphasized the Northern landscape's alien qualities. The rays of light comprising the auroras rise in perpendicular waves, another contrast to the long, parabolic, well-ordered prism of the rainbow. Order and discord—the rainbow and the auroras, like heaven and hell, peace and war—appear as inversions of each other.

The auroras lent themselves to yet another layer of foreboding, a metaphorical meaning drawn from the Bible evoking the handwriting on the wall from the story of Belshazzar's Feast. A cartoon published by Currier & Ives showed Jefferson Davis identified as the "Modern Belshazzar" (fig. 45) recoiling from just such a message intended to presage his downfall. In this idiom the South is cast as a modern Babylon ripe for destruction for its continued advocacy of slavery and its disloyalty to the Union. However, the idea of God sending a warning was not confined to mocking the Confederacy. Northern abolitionists fretted that they too would suffer God's wrath for having allowed the perpetuation of slavery. In

Church's *Aurora Borealis* the eerie and silent nocturnal illumination that sways and ripples across the sky might also be taken for the illuminated words that spelled out Belshazzar's doom (fig. 46). Church's auroras, like the handwriting on the wall, spelled out the nation's apocalyptic fear that the skies warned of imminent judgment. Slavery represented the moral abyss facing all Americans. Fear of a final retribution lay behind much public nervousness expressed over the continued appearance of the auroras during the war years.

On December 21, 1864, Church hosted a gathering of the Travellers Club in his studio to see his unfinished painting. Writing to Hayes, Church expressed his hope that the explorer would attend to see the painting he had based largely on Hayes's sketches and stories.[108] Church next made his painting available to visitors to his studio in March 1865. A reviewer stopped by several of the studios to take in the new offerings on March 18, noting "Church's large sketch of the Arctic Aurora Borealis," which he described as "a frozen ocean and a wild bit of frozen coast, a distant ship with a faint light burning in it, while the whole scene is spanned by the weird lurid glare of the Aurora, and you have a specimen of an iced *Inferno*, terribly likely to be true."[109] The reference to Dante, a vision of hell as a frozen landscape, amplified the apocalyptic meaning in Church's painting.

The same day the reviewer admired Church's *Aurora Borealis*, the Church family endured the first of two tragic losses. That day their two-year-old son, Herbert, died of diphtheria, followed eight days later by the death of their five-month-old daughter, Emma.[110] The auroras, portents of dire warnings, set against a bleak, dark landscape, now doubled as a keening of grief of a personal nature for the artist and his wife. Frozen in mourning, Frederic and Isabel made plans to spend the late spring and summer in the warmth of Jamaica. Meanwhile, the painting's public debut underscored its relevance to the war. Instead of leaving *Aurora Borealis* locked in his studio, Church arranged to have the painting shipped to London (or more likely, Church's agent took it upon himself to do so) where it joined *Cotopaxi* and *Chimborazo* on display at McLean's Gallery, along with a suite of Civil War sculptures by John Rogers

"WE ARE NOW HERE IN THE GARDEN OF EDEN"

In March 1865, as Church put the finishing touches on *Aurora Borealis*, in Albert Bierstadt's nearby studio Yosemite glowed from the easel like Eden reborn. In April, Bierstadt (1830–1902, fig. 47) displayed *Looking Down Yosemite Valley, California* (cat. 10) at the National Academy of Design. It was his first large-scale painting of the site. Here a majestic sunset floods the valley floor with intense yellow light. This sun-drenched California landscape teems with the elements of life: water, air, trees, and glowing sunlight. But unique to Bierstadt's many paintings of Yosemite, it is unpopulated. *Looking Down Yosemite Valley, California* is devoid of animals, birds, or humans. It seems to signal a New Eden after the biblical flood, awaiting the arrival of the ark to usher in a new future for mankind. As such, Bierstadt's painting is the antithesis of Church's keening Arctic wasteland. Bierstadt's *Yosemite* represented a return to the transcendental vision that had anchored American landscape painting from its roots and nourished it to full flowering in the years leading up to the war. Whether the West could assume the mantle and the burden of the nation's character, whether the landscape could still function as a place of spiritual renewal and endless possibility was yet to be known. Bierstadt's paintings of Yosemite held out the promise of a New Eden, a place in which all Americans could slough off the trauma of war and sectarian strife, a place of renewal and healing.

From its discovery by white settlers in the early 1850s, descriptions of Yosemite's geological features and verdant valley floor focused on the beneficent hand of God in the wilderness. The earliest tourists drawn to Yosemite invoked biblical exhortations and visions from Revelation to describe it.[111] Its heralded geological formations had been extolled in print by two of America's most influential intellectuals, Horace Greeley

(1811–1872, fig. 48) and Thomas Starr King (1824–1864, fig. 49). Greeley, editor of the *New-York Daily Tribune*, had visited Yosemite in August 1859 and published his account of his trip, first on the pages of his newspaper, and the following year in book form under the title *An Overland Journey*.[112] He summed up his thoughts about Yosemite in a single effusive sentence: "I know of no single wonder of nature on earth which can claim a superiority over the Yosemite."[113] His words affirmed what was already abundantly clear—that by the outbreak of the war, Yosemite held a place of awe and wonder for those few writers who had visited. Their writings laid the groundwork for the special attention it would receive in both California and across the nation as the war raged on.

Inspired by Greeley's travelogue, the eloquent Boston preacher Thomas Starr King relocated to San Francisco in 1860 and made his first visit to Yosemite on July 11 of that year. Afterward he published his account in the form of eight letters that appeared in the *Boston Evening Transcript* between December 1, 1860 and February 9, 1861.[114] Starr King proclaimed of El Capitan, "A more majestic object than this rock I never expect to see on this planet. Great is granite, and the Yo-Semite is its prophet!"[115] He went on to play an active role in politics, with a particular interest in keeping California in the Union. He raised funds for the California Sanitary Commission and helped develop the Republican Party in the state.[116] This activism was a natural extension of his

FIG. 47

Bierstadt Brothers
Double-exposure portrait of Albert Bierstadt, about 1860s, The Metropolitan Museum of Art

FIG. 48

J. E. Baker [for Armstrong and Company], *Horace Greeley*, about 1872, Library of Congress

FIG. 49

James Wallace Black
Thomas Starr King, about 1860, National Portrait Gallery, Smithsonian Institution

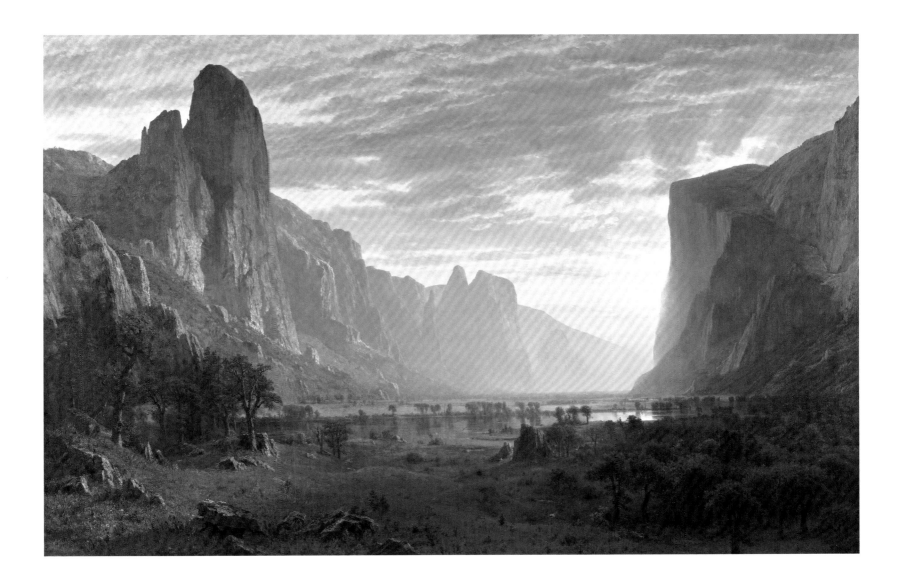

CAT. 10

Albert Bierstadt
Looking Down Yosemite Valley, California,
1865, oil on canvas, 64 ½ × 96 ½ in.
Birmingham Museum of Art; Gift of the
Birmingham Public Library

sermons, the content of which stemmed from his long-standing friendships with Henry Ward Beecher and fellow abolitionist Wendell Phillips.[117] Starr King returned from Yosemite to deliver a sermon to his congregation in San Francisco in which he proclaimed the holy qualities of Yosemite, whose mountains "were created as an overflow of God's goodness," feelings that "lead me to the rock that is higher than I."[118] His biblical play on words equated the rocks of Yosemite with the rock upon which Peter built his church, eloquently sanctifying this landscape as a source of spiritual sustenance.

New Yorkers had seen a glimpse of Yosemite in 1862, when Carleton Watkins showed his mammoth-plate photographs at Goupil's New York gallery. Few easterners had ventured to this remote location, but Greeley's editorials and Starr King's letters had piqued readers' curiosity. It was hardly surprising then that Watkins's views of the valley's unique geological features and dramatic vistas met with admiring reviews. Bierstadt had hoped to travel west in 1862, but the onset of the war delayed his plans. He finally made his way to Yosemite in the summer of 1863 after receiving permission from the War Department for a military escort for his second trip west. His companion was his friend Fitz Hugh Ludlow, a travel writer who would do for Bierstadt what Louis LeGrand Noble had done for Frederic Church: accompany the artist, keep a journal of their travel exploits, and write notices for the press that whet the public's appetite for scenic paintings. It was a tall order to keep attention focused on their travels as the pair embarked during the middle of the Civil War. Ludlow's reports first appeared in serialized form in the *Atlantic Monthly*, forming a lively travelogue that lent the reader a voyeuristic sense of being right there for every bumpy stage coach ride and campfire sketching session.

Ludlow carefully scripted the account of Bierstadt's trip, including references to earlier descriptions of Yosemite. Upon their arrival, both men waxed eloquent on the scenery. Bierstadt's reaction to his first view of the Yosemite Valley is recorded in a letter of August 3, 1863, to his friend John Hay, President Lincoln's personal secretary, "We are now here in the garden of Eden I call it. The most magnificent place I was

ever in, and I employ every moment painting from nature."[119] Ludlow made it official, pronouncing in one of his articles, "If the report was true, we were going to the original site of the Garden of Eden." It was a prophetic and calculated statement of hope and redemption for war-torn America.[120]

Bierstadt's painting captures that idea, presenting Yosemite as a valley baptized with light. In 1865 the reviewer for the new periodical *The Nation* commented, "It occupies precisely the best place in the galleries, the middle of the side of the largest and best lighted room of all; evidently ranking as the most important picture of the exhibition in the estimation of the hanging committee."[121] Nevertheless, *Looking Down Yosemite Valley* garnered mixed reviews. One perceptive commentator expressed pleasure in the "flood of light, the fiery particles of the departing sun," but noticed the disturbing effect of the complete absence of human activity, reminding readers that landscapes benefited from a relationship to the human condition. He further expressed his unease at feeling "cut off from human sympathy."[122] Similar criticism had been leveled at Church's *The Icebergs* prior to his inclusion of the broken mast. The truth was, most viewers felt more comfortable with a landscape invested with a human presence and an implied narrative. *Looking Down Yosemite Valley* places the viewer outside of the scene, looking on at a slight remove. In doing so Bierstadt provides the allure of a new start in a New Eden, but its pristine, unpopulated state leaves the viewer to wonder if he or she has a right to enter. Bierstadt's painting represented a wartime yearning for sanctuary. But what appears to be the promise of redemption is in fact mostly an escape—not a solution to the nation's problems.

"THE COMING STORM"

The Civil War ended on April 9, 1865, as General Robert E. Lee surrendered to General Ulysses S. Grant at Appomattox, Virginia. Less than a week later, John Wilkes Booth, unable to accept the defeat of the Confederacy, shot and killed the president. Lincoln's assassination rocked what little stability remained. In Henry Ward Beecher's words, the assassination "was so

FIG. 50

Unidentified photographer
Edwin Booth as Hamlet,
1863, Alexander Gallery, New York

known and well liked among the artists and writers who rallied around him in support. Gifford's painting became a touchstone for grieving New Yorkers who flocked to see it on display. The poignant connection between Gifford's storm, Edwin Booth's personal anguish, and the nation's grief lent deeper meaning to this painting. Had it not been for the circumstances surrounding its exhibition in April 1865 in the wake of Lincoln's assassination, *A Coming Storm* would have been simply another picture of turbulent weather, open to interpretation as indicative of the emotional turmoil at the midpoint of the war.

That pathos prompted Herman Melville, by then a friend of Gifford's, to write a poem specifically about the triangulation of painting, owner, and fallen president. Melville's "Battle Piece" cemented the connection between Gifford's painting and the tragedy of the war. Titled "The Coming Storm. A Picture by S. R. Gifford, and owned by E. B. Included in the N. A. Exhibition, Apr. 1865," the full poem reads,

> All feeling hearts must feel for him
> Who felt this picture. Presage dim—
> Dim inklings from the shadowy sphere
> Fixed him and fascinated here.
>
> A demon-cloud like the mountain one
> Burst on a spirit as mild
> As this urned lake, the home of shades.
> But Shakspeare's [sic] pensive child
>
> Never the lines had lightly scanned,
> Steeped in fable, steeped in fate;
> The Hamlet in his heart was 'ware
> Such hearts can antedate.
>
> No utter surprise can come to him
> Who reaches Shakspeare's core;
> That which we seek and shun is there—
> Man's final lore.

Melville's turn of phrase interpreted Gifford's storm as emblematic of Edwin's emotional state as well as that of the nation. He was not alone in doing so. A

terrible that at first it stunned sensibility. Citizens were like men awakened at midnight by an earthquake, and bewildered to find everything that they were accustomed to trust wavering and falling. The very earth was no longer solid."[123] Amidst the aftershocks, the National Academy of Design opened its spring exhibition, having been delayed in deference to Lincoln's death.[124] On the walls was a painting Sanford Gifford had completed in 1863 titled *A Coming Storm* (cat. 11). Clouds heavy with rain sweep across the scene, darkening the surface of the water below. Framed against the autumnal foliage, tiny figures animate the left shore, their forms dwarfed by the large, angular boulders along the lake's edge. The weather is in motion, a swirling vortex of dark clouds blotting out the light that suffuses the middle distance. What made this painting stand out were the circumstances surrounding its display. Gifford's painting bore the notation that it was owned by the Shakespearean actor Edwin Booth (fig. 50), brother to the president's assassin. Edwin was well

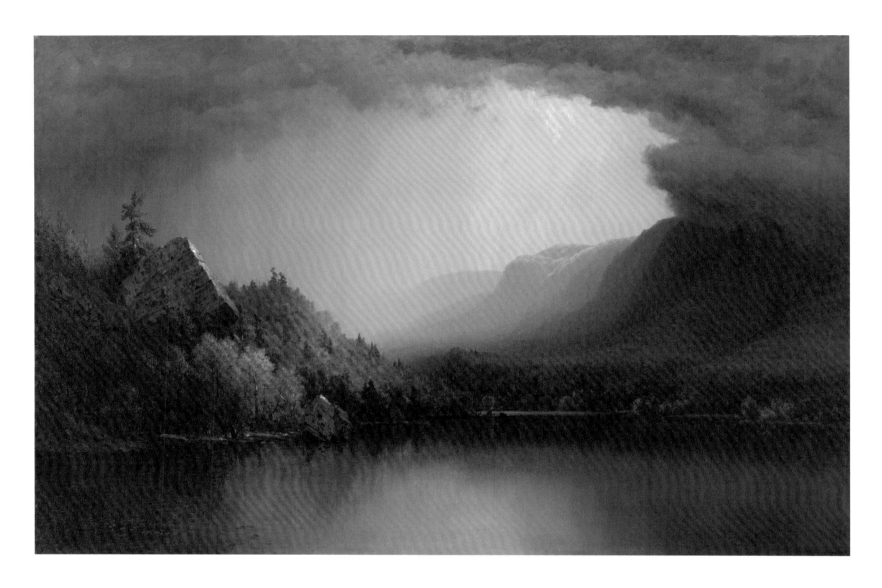

CAT. 11

Sanford Robinson Gifford
A Coming Storm, 1863, retouched and
redated in 1880, oil on canvas, 28 × 42 in.
Philadelphia Museum of Art: Gift of the McNeil
Americana Collection, 2004

reviewer in the *New York Leader* also could not envision this painting outside of its newly assigned elegiac context, writing, "The gem of the whole collection, *The Coming Storm*, No. 85, by S. R. Gifford, is the property of Edwin Booth, who little thought when he became its possessor of the coming storm, under which he, together with our whole country, is bent in mourning.... The awful silence of the picture can be *felt*—ay, *felt*—in all its mingled grandeur and wild, unearthly mournfulness."[125]

Gifford had painted *A Coming Storm* during the winter of 1863 after finishing his third and final tour with the Seventh Regiment. Art critic Barry Gray had hailed it as "probably the most powerfully painted picture Gifford has yet produced."[126] Gifford's temperament favored such melancholy, emotionally resonant works, and the strain of the war years was intensely personal.[127] Prone to dark moods, Gifford was usually able to paint his way out of them. After Lincoln's assassination, *A Coming Storm* came to epitomize grief itself and, later, the power of nature's moods to convey the depth of human emotion. For Gifford, it may have meant something more personal. At some point he bought back the painting from Booth, and it remained in his possession the rest of his life. In his 1881 eulogy for the artist, Gifford's friend and colleague John Ferguson Weir appeared to describe this painting as a metaphor for Gifford's own temperament: "That placidity of the surface was an indication of the depth of the stream that flowed within [Gifford], whose floods, and swirls, and eddies often caught him from the light and carried him into cavernous depths of shade; but there was a stoicism in Gifford's character that never forsook him." It was a painting with which the artist continued to wrestle.[128] Laden with layers of personal and national meaning, *A Coming Storm* served both of its owners and many of its viewers as a paradigm for the nation in crisis.

"LET US CROSS OVER THE RIVER"

For the Churches, the spring of 1865 had blurred the distinction between the national tragedy of Lincoln's untimely death and their personal tragedy in losing their first two children. Summer in Jamaica served as a welcome respite from both. It gave them an opportunity to mourn their loss and rebuild their marriage. Frederic Church had ushered in 1865 with his eloquent testimony to nature out of control in *Aurora Borealis*. Jamaica represented personal and professional release, a lush, fertile environment in which to envision the world anew. Isabel collected ferns; Frederic painted succulent sketches of warm tropical storms and wet, sunlit vistas. It was a time of renewal on all levels, coming when the need for a redemptive landscape rippled throughout the fine arts.

When he returned to New York in the fall, Church turned in earnest to completing the painting he had left unfinished on his easel when he departed for Jamaica. *Rainy Season in the Tropics* (cat. 12) is saturated with moisture and warmth. The chasm dividing the near and far sides of the landscape is bridged by a double rainbow, reinforcing the beneficence of this meteorological phenomenon. The rainbow bridge suggests that the diminutive man and donkey making their way along the path in the lower right will find safe passage to the other side, where a small white city glistens along the distant bank. Church's need to heal suffuses the composition, the tropical setting a lush paradise not unlike the artist's prewar visions of South America and his friend Martin Johnson Heade's Brazilian views. *Rainy Season in the Tropics* reached out to a country facing its own need for healing but lacking a clear path for achieving that goal.

Church's entire composition speaks to a spiritual transition toward healing and finding peace. The depiction of the man and donkey "crossing over" toward the gleaming city imbues nature with the capacity to heal and provide solace and safe transport. In nineteenth-century religious and secular usage, "crossing over" was an eloquent euphemism for death. Implying that the soul of the departed left earth and crossed over into heaven, the concept provided succor to those left behind even as it helped the dying accept their fate. In a lyrical coincidence of word and image, the setting of *Rainy Season in the Tropics* recalls Stonewall Jackson's last words, "Let us cross over the river, and rest under the shade of the trees."[129] A peaceful resting place from which to say good-bye formed the notion of a "good death," wherein the dying person is surrounded by loved ones and is able to make peace with this life and

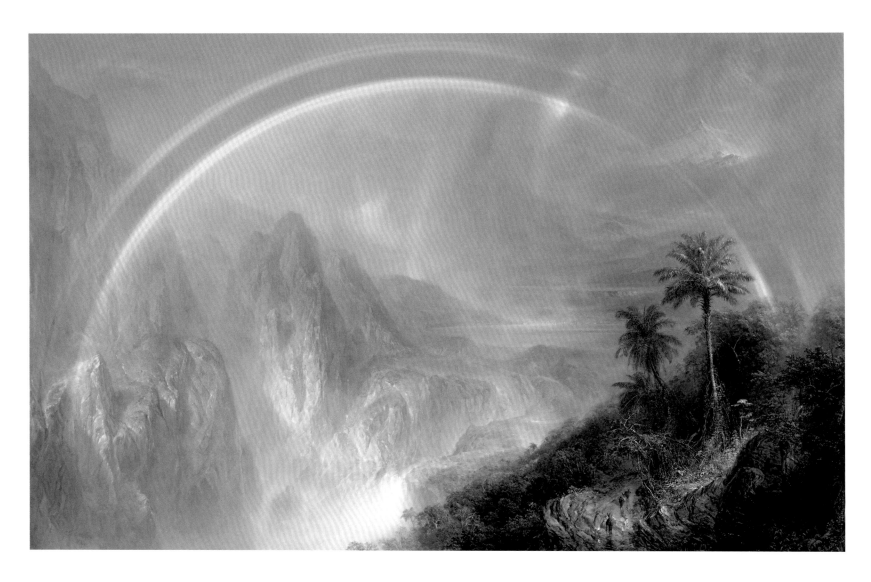

CAT. 12

Frederic Edwin Church
Rainy Season in the Tropics, 1866,
oil on canvas, 56 ¼ × 84 ¼ in. Fine Arts
Museums of San Francisco, Museum
purchase, Mildred Anna Williams Collection

welcome the hereafter. That cherished ideal was an-
other casualty of the Civil War. Death, and particularly
death on a grand and terrible scale, defined the lasting
trauma of the Civil War.[130]

Jackson's words, endlessly repeated as a fitting epi-
taph for this deeply spiritual warrior, defined his state of
grace for those who mourned him. Church's double rain-
bow, perhaps one for each child, denotes a similar state
of grace for the artist, the one left behind. Church and
Jackson's yearning for peace, that desire for redemption
of a more spiritual sort, is in both cases couched in an
encounter with nature. Everyone touched by the Civil
War came away from it changed, often damaged, either
through personal tragedy or by association. In Genesis
the rainbow was the symbol of God's covenant after
the flood. Two days after the war ended at Appomattox
Courthouse, the *New York Times* pronounced, "No more
deluge of blood...no more brooding darkness....The
whole heavens were spanned with the rainbow of
promise."[131] *Rainy Season*'s dual rainbows were an extra-
normal meteorological phenomenon,
emphasizing the spiritual overtones of
healing and the biblical promise of salva-
tion in crossing over from war to peace,
and from this world to the next.

FIG. 51
Unidentified photographer
John Frederick Kensett in his studio,
about 1866, Archives of American Art,
Smithsonian Institution

"A STRAIN OF REMEMBERED MUSIC"

John Frederick Kensett (1816–1872,
fig. 51) found a lyrical way to use his
landscape paintings to express the sense
of loss that accompanied the conflict.
Kensett had not donned a uniform,
although he had served tirelessly on
the art committee of the U.S. Sanitary
Commission's Metropolitan Fair of 1864.
Like McEntee, his reflective personality
gave rise to a more understated approach
to painting the landscape, worlds apart
from the ambitious visions painted by
Church and Bierstadt. Kensett never
painted any works that might readily be classified as
war pictures, and a reviewer in 1864 expressed his relief
when he wrote of Kensett's *Lake George.* "It is certainly

pleasant to contemplate in these lulls of the dread-
ful tumult of war, soothing to the sense of a people
racked by the shattering agitations of battles won and
lost; of sons and brothers and husbands, wounded and
killed;...[Kensett's painting] shows that he has a facility
without feebleness, and is a most consummate and unri-
valed master in the treatment of subjects characterized
by beauty, repose, and tenderness."[132] However, in a pair
of paintings that bracket the war years, Kensett captured
the underlying change in the way landscape was able to
express the mood and the soul of the nation.

In 1859, Kensett first painted the appropriately
named *Sunrise among the Rocks of Paradise, Newport*
(cat. 13). He depicted the sheltered valley in morning
tones of pink and pale gold, the rising sun's glow begin-
ning to warm the surface of the rocks. The ducks rise
from the pond's surface to greet the day. The bright
green grasses suggest it is spring, a season of hope and
renewal. The peaceful setting appears to be a kind of
understated paradise, a place for calm reflection. As in
virtually all of Kensett's works, the scenery is tranquil,
the presumed silence here broken only by the ducks as
they depart the pond. It is a serene picture, an oasis far
from the bustle of the world, a sanctuary for the mind
as well as the heart.

Six years later Kensett returned to this haunt and
painted a nearly identical composition. Yet the season
and mood have changed. In *Paradise Rocks: Newport*
(cat. 14), a cold front moving in from the west sug-
gests the chill of fall or early winter. Kensett's palette
is muted. The ducks seem to contemplate their own
departure; the distant birds, like the somber mood,
muted palette, and overcast sky, all speak to the loss of
paradise. Eugene Benson caught that shift in mood and
commented on Kensett's propensity for gloomy, tonal
scenes, grumbling "He is fascinated with gray tones,
and all nature seems but a gamut of gray tints varied
with Verona brown."[133] Those brown-gray tones bring
down the temperature of the sky and adjust the mood
from anticipation and optimism to somber reflection.
"Kensett is essentially the Beethoven of the American
landscape school," wrote reviewer Cara Montane in
1865. "Some of his later pictures are as a strain of
remembered music, soft and low as from the spirit land,

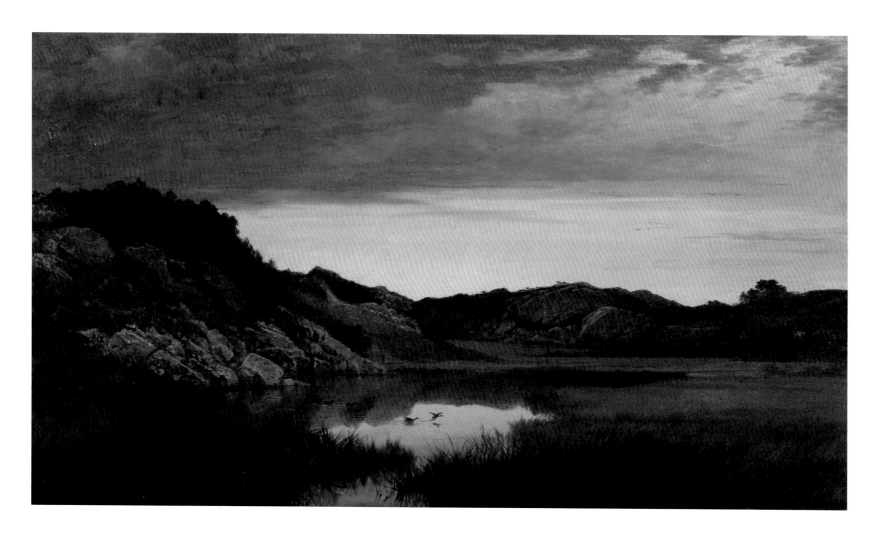

CAT. 13

John Frederick Kensett
Sunrise among the Rocks of Paradise,
Newport, 1859, oil on canvas, 18 × 30 in.
Fine Arts Museums of San Francisco, Gift of
Mr. and Mrs. John D. Rockefeller 3rd

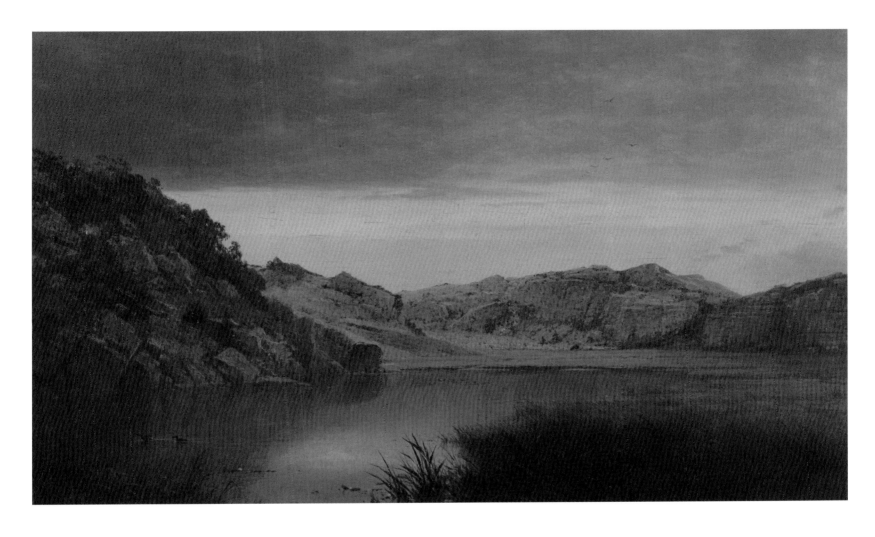

CAT. 14

John Frederick Kensett
Paradise Rocks: Newport, about 1865,
oil on canvas, 18 ⅛ × 29 ⅞ in.
Newark Museum, Gift of Dr. J. Ackerman Coles

speaking of the mourner who faints and hopes."[134] Such might be said of Kensett's *Paradise Rocks* of 1865, the title carrying a bittersweet memory of happier times, warmer weather, benison of a country at peace. Now paradise is a sober place of memory and mourning.

Emily Dickinson found words to express the sense of loss implicit in such a scene. Her poem about death, "There's something quieter than sleep," ends with the stanza

> While simple-hearted neighbors
> Chat of the "Early Dead"—
> We—prone to periphrasis,
> Remark that Birds have fled!

Dickinson's use of birds in flight as a metaphor for an untimely death carries pregnant meaning for a war-torn country, as so many Americans grappled with the loss of friends and family members. In a similar vein, Kensett's moody palette and the birds aloft resonate with Emily Dickinson's meditation on the quality of death.

The weather is the salient difference between Kensett's pictures of Paradise Rocks. When placing these two paintings from 1859 and 1865 side by side, it is not the landscape that has changed, but the artist's and the viewer's experience of it that has been forever altered over the course of the war. Kensett has painted the loss of innocence manifest in our experience of the landscape, a measure of the depth of the change that cannot be undone. In these two quiet paintings, Kensett has created a eulogy for the demise of the Hudson River school. Unlike the "Great Pictures" of Church and Bierstadt, or the glowing universalist light of Gifford, Kensett's melancholy interpretation of his local paradise is intensely personal and yet effectively universal. They are a threnody for the shift from the literal landscape to the metaphorical, and ultimately to the psychological landscape, reflecting the mood and inner state of the artist. The landscape has not been defiled, or become ugly; but its artificial luster has been replaced with the cold, hard light of reality. We can still come to this landscape, but our expectations for it are altered.

This, then, is the realization dawning in Kensett's pair of paintings. Paradise Rocks—the very name seems to mock the viewer, holding out the promise of Eden and withdrawing it in the same moment. The landscape will never be the same because the viewer is no longer the same. Shaped by war, the returned soldier casts new eyes on the familiar scene, returning a stranger to once-familiar groves. Kensett's paintings bracket the war and in that sense lament the loss of innocence.

Kensett's choice of Newport carries significance beyond the felicitous or ironic name of the actual site. The archive for the Newport Synagogue contains a letter from George Washington in which he welcomed the House of God by asserting, "The Government of the United States gives to bigotry no sanction, to persecution no assistance."[135] Geologist Clarence King's grandmother, who was an abolitionist before the term came into prominence, had lived there, inculcating in her grandson an appreciation of pacifism and strong moral beliefs.[136] Henry James spent time there as well, after his father moved the family from New York. Despite its historical involvement with the slave trade, Newport retained that remove from the bustle of modern life. In 1862 Robert Gould Shaw, who also had strong ties to Newport, took note. The man who would command the 54th Massachusetts Infantry, a regiment of colored troops later commemorated in Augustus Saint-Gaudens's powerful *Shaw Memorial*, wrote to his sister of his impressions of various cities and their citizens' reactions to the war. He observed that in Boston, residents in his abolitionist circle were active in various "workings" for the Union; in New York, residents were far more agitated, in his words, "blue, cursing the government"; and in Baltimore, "there is a perfect panic" thanks to Southern sympathies. And yet Shaw noted that in Newport, far from anything resembling a battlefront, residents didn't seem to know that "*any war was going on*."[137] It is against this backdrop of peaceful Quakers, observant Jews, and an outcropping of granite aptly titled "Paradise Rocks" that Kensett placed his pair of his landscapes. He was in good company; Fitz Henry Lane and Martin Johnson Heade had also found themselves drawn to the area. All three turned their back on the town, preferring to spend time along the coast and the marshes.

Kensett's postwar paintings embody a shift away from vernacular landscape to landscape as a vehicle for

changes of mood, changes of mind, changes of heart—
paintings about loss and recovery. Yet implicit in the
timelessness of the rocks is the recognition that life
goes on, regardless of change. In his role as president of
the Artists' Fund Society, Kensett delivered remarks at
the annual meeting in February 1866. He expressed his
sorrow and relief that "four years of civil conflict which
has covered God's green fields with fraternal blood—
carrying ruin and desolation into countless homes—has
ended, victory has crowned our arms, and smiling peace
has once more come. The storm long threatened, which
burst with such terrific and long-continued fury over the
land, has given place to skies purified, to a nation re-
deemed and re-united."[138] Yearning for the truth behind
his words, Kensett expressed the hopes of his genera-
tion: that war could be truly over and that peace would
usher in a reunited landscape, devoid of the trauma that
had afflicted it.

That desire for calmer days resonated through-
out the fine arts and literature, in fact, through all of
society following the Civil War. For some, the fine arts
would be a refuge from the storm, a sanctuary from
current events and a comforting hope that the New
Eden of America would survive the national crisis.
That would prove to be an unsustainable fantasy, but
few perched on the precipice of war could fathom how
brutal and how profound its effects would be—not just
on American politics, but on American culture. By the
end of the war, the emphasis within landscape painting
had begun to change from a confident association of the
nation's geographic features, destiny, and promise to a
psychological reflection of the nation's conscience. Eden
would be found in the establishment of parks as sanctu-
ary, whether in Yosemite or in the middle of New York
City. Americans began to see the land itself in need of
protection. The postwar impulse to set aside emblemat-
ic landscapes would draw protective boundaries around
what seemed most vulnerable—the American sense of
identification with nature, a place in which God's grace
might still operate while America recovered from the
effects of the Civil War.

THE ART OF
WARTIME PHOTOGRAPHY

Photographers were quick to recognize the pictorial opportunities offered by the war, and over the next four years they honed their skills working with a demanding medium and bulky equipment. They went into the field to provide documentary tools for the Union army, recording encampments and troop movements and copying maps for distribution. What pictorial work they did there was more often at the behest of a commercial gallery that contributed funds and equipment to facilitate their enterprise. The vast majority of these photographs were *cartes-de-visites* depicting individual soldiers. However, some of the images make it clear that the individual photographers knew they were interpreting history with their cameras. Of the more than three hundred men who took pictures for the Union army, three stand out as having changed the way war was understood and the way it was depicted. Mathew Brady, Alexander Gardner, and George Barnard each used the Civil War as a turning point in his professional career. As a result of these men's efforts during the war, photography became widely recognized as both historic documentation and an artistic medium. Their work, and that of the talented photographers who worked with them—notably, Timothy H. O'Sullivan, Andrew J. Russell, and John Reekie—provided a new approach to making pictures that were every bit as calculated and composed—and laden with meaning—as paintings.

Photography of the Civil War was by and large a Northern production. Southern photographers had few if any financial backers and limited access to supplies once the war started.[1] George S. Cook is a tantalizing example of how difficult it is to establish authenticity of work he may have done for the Confederate army, as images ascribed to him are sometimes blurry or appear to have been doctored, and it is difficult to assess the exposure his work had during the Civil War.[2] The most enterprising and successful photographers working during the period spent most of their time either following the Union army or trying to anticipate where the next battle or high-level meeting among generals might occur. Even then, the emphasis would be on the eastern theater of war, closer to Washington and New York where the major firms were located. In addition to making *cartes-de-visites* of individual soldiers, they sought compelling narrative images of life in camp, the troops in the field, or the aftermath of a battle. Unable to capture armies in motion or ordnance whistling through the air, these men had to look for meaning in the still shots available to them. Their successes

> *The world is indebted to the photographic art and . . . the willing and indefatigable artist at his post of danger and adventure.*
>
> —Andrew J. Russell

FIG. 52

Charles Loring Elliott
Mathew B. Brady, 1857, oil on
canvas, 24 × 20 in. The Metropolitan
Museum of Art, Gift of the Friends of
Mathew Brady, 1896

FIG. 53

A. Berghaus, del.
*M. B. Brady's New Photographic
Gallery, Corner of Broadway and
Tenth Street, New York*, from
Frank Leslie's Illustrated Newspaper,
January 5, 1861, wood engraving print,
Library of Congress

would redefine photography as a news medium and as an art form.

MATHEW BRADY'S NATIONAL GALLERY

The most prominent Union photographers who took pictures during the Civil War worked at some point for one of the major photography firms of the day: Brady Studios of New York, owned by Mathew B. Brady; Gardner Studios of Washington, D.C., owned by Alexander Gardner; and E. & H. T. Anthony & Company of New York, a distribution and supply firm owned by Edward and Henry T. Anthony. Mathew B. Brady (1822–1896, fig. 52), perhaps more than anyone else, championed the idea that photography required not only technical skill but also artistic sensibility. During the 1850s Brady was the preeminent photographer in New York City. His gallery, which he called the National Gallery (fig. 53), opened in 1844, and when the Civil War broke out, it was located at 785 Broadway, near the National Academy of Design and the Tenth Street Studio Building, placing his work in close proximity to many of the city's artists and their patrons.[3] Brady also cultivated the press, in part to convince them that photography was an art form. He blurred the lines between technical and aesthetic production, using oil paints and India ink to enhance the visual appeal of his portraits of eminent statesmen and prominent ladies. Oliver Wendell Holmes Sr., himself a talented amateur photographer, made a point of connecting Brady's and his own photography with the fine arts. Brady's efforts paid off: during the Civil War, reviewers described the pictures on view as rivaling production in the fine arts.[4]

Like many prewar photographers, Brady specialized in daguerreotypes. In 1857 he hired Alexander Gardner (1821–1882, fig. 54), who had recently immigrated from Glasgow, Scotland. There Gardner had been the editor of a politically active newspaper championing the working class; ever interested in new technologies, he became a photographer—and quite a good one. Gardner's arrival added his skills in paper prints made from wet-plate collodion negatives to the gallery, allowing Brady to introduce "Imperial" photographs to his repertoire.[5] These were contact prints made from glass-plate negatives that measured 17 by 21 inches. Gardner brought more than his talents as a photographer; he also became Brady's business manager, and his acumen

helped to stabilize the financially strapped gallery.[6] After Gardner's arrival, some of Brady's images were distributed by E. & H. T. Anthony & Company, a deal Gardner may have negotiated.[7] By then, the Anthony brothers had expanded their business beyond making photographs to providing supplies to photographers and selling their images mounted on card stock bearing the Anthony brothers' imprimatur. Gardner's business acumen served Brady well, and just as important, by 1858 he opened and managed Brady's Washington, D.C., gallery. Gardner also brought a journalist's eye to the business. An avowed socialist, Gardner had championed the downtrodden, writing editorials that gave a human face to class suffering.[8] That mindset became an important aspect of Gardner's wartime photography and augured an ideological split between the two photographers that would become evident during the war.

PHOTOGRAPHY AT THE FRONT

FIG. 54

Alexander Gardner
Self-Portrait, about 1864,
National Portrait Gallery,
Smithsonian Institution

At the outbreak of the war, as the first wave of volunteers headed for Washington, articles in newspapers and art journals expressed eagerness to see what stirring scenes artists would bring back from the front.[9] The photographers saw an opportunity here, too. No American war had been documented photographically in the press; newspapers and journals would vie for the right to reproduce images from the front, and we can only assume that photographers, like painters, thought at the beginning the war presented opportunities for their careers.[10] However they justified the steep outlay in cameras, portable darkrooms, and supplies, several photographic firms and hundreds of photographers would end up making images of the conflict. Many field photographers took with them two types of cameras. One was a stereo camera, which took a pair of 3-by-3-inch, side-by-side, albumen images on a single glass-plate negative. When prints from these negatives were viewed through a stereo viewer, they resolved into a single, three-dimensional image. These were highly marketable prints, particularly as portable stereo viewers began populating parlors across the county.[11] The other was a medium-format camera that used single-image glass-plate negatives, the size ranging from 7 by 9 inches to 12 by 15 inches or larger. Depending on conditions in the field—including weather and the amount of time the photographer had to set up his equipment—photographers opted to take stereo views first, as these often required shorter exposures that could freeze slight movements. In some cases they reserved their large-format cameras for scenes of particular narrative interest.

At the start of the war, Brady outfitted wagons as field darkrooms, hired photographers, and secured supplies to send his employees to the front lines, likely at Gardner's urging.[12] For the first few months, several of the gallery's best photographers—Gardner, Timothy H. O'Sullivan, James F. Gibson, and George Barnard—took pictures of the troops bivouacked in and around Washington, D.C. Gardner and Brady understood that the images these photographers brought back were eyewitness accounts that had never before been available, in a medium praised for its immediacy and accuracy. Brady himself made it as far as Blackburn's Ford near Manassas on July 21 in time to witness part of the First Battle of Manassas in 1861, although in the chaos of the day he was not able to photograph anything.[13] As one newspaper apologetically noted, "On the disastrous day of Bull Run he stood upon the field with camera and chemicals, and would have photographed the retreat, had it not been conducted with too much rapidity."[14] Instead, he returned to his New York gallery.

Brady's abortive attempt to photograph the battle at Manassas seemed to quell his desire to be in the thick of the action, and he rarely took to the field after that experience. From then on, his routine would be to send out teams of photographers, only occasionally joining them, and most often directing the field activity rather than being the principal photographer himself. His poor eyesight played a role in that decision as well.[15] Gardner, on the other hand, became a civilian photographer attached to the Topographical Engineers for Union General George B. McClellan. Gardner and fellow Brady photographer James Gibson were close behind McClellan's troops at Antietam Creek when that

battle was fought on September 17, 1862. Beginning on September 19, when Union forces controlled the battlefield, Gardner and Gibson set to work, and for the next four days they roamed the rolling terrain, setting up their stereo cameras and taking the first photographs of dead American soldiers.[16]

Gardner's and Gibson's photographs from Antietam are the first unflinching images of dead soldiers and horses, overturned artillery, damaged buildings, and toppled trees. Accounts of the battle, which lasted from dawn until dusk, made the colossal loss of life on both sides a national tragedy. It was then, and remains, the single bloodiest day in the Civil War. Modern historians estimate the Union losses at 12,401 casualties with 2,108 dead. Confederate casualties are estimated at 10,318 wounded with 1,546 dead. The statistics are all the more appalling when we consider that together they represented 25 percent of the Federal force and 31 percent of the Confederate army that took the field that day.[17] Gardner made good use of his time at Antietam, telegraphing to a colleague at the gallery that he was coming back with forty-five negatives from the battlefield.[18] The photographs of the Sunken Road, rechristened Bloody Lane, looked like a mass grave site even before the arrival of a burial detail. Gardner's photographs titled *Bloody Lane, Confederate Dead, Antietam* (cat. 15) and *Confederate Dead in a Ditch on the Right Wing Used as a Rifle Pit, Antietam* (cat. 16) do not spare the grim details. He aimed his lens at the jumble of twisted limbs and contorted faces, creating horrific images that drove home the brutality of the conflict. Gardner's background in journalism and his personal aesthetic sensibility shaped his eye for battlefield photography. His photographs of fallen soldiers carried morality messages, framing the cost of the war concretely, in human lives.

PHOTOGRAPHS OF THE DEAD

A month later Brady put Gardner's and Gibson's photographs on display, giving the public its first exposure to images of dead soldiers. By the time the photographers arrived at Antietam, the Union troops had finished burying their own dead, leaving the Confederate casualties for last. *Confederate Dead at Antietam* (cat. 17) and *Day After the Battle, Antietam* (cat. 18) each capture with gruesome clarity the damage done by bullet and shell to the human body, along with the effects of exposure to the September sun. The distended bodies, stiff limbs, and open mouths sent the signal that war was unrelenting in its capacity for destruction. The Battle of Antietam left scars on both sides of the conflict. Of the fighting at Dunker Church, a member of Confederate General Thomas "Stonewall" Jackson's staff wrote, "On my way to [General] Early, I went off the [Hagerstown] Pike and was compelled to go through a field in the rear of Dunker Church, over which, to and fro, the pendulum of battle had swung several times that day. It was a dreadful scene, a veritable field of blood. The dead and dying lay as thick over it as harvest sheaves."[19] Gardner's post-battle image of *Confederate Dead, Antietam (Dunker Church in background)* (cat. 19) confirms the extent of the damage to the church itself and to the wagons, horses, and soldiers strewn across the field nearby.

Oliver Wendell Holmes Sr. (1809–1894, fig. 55) gave passionate voice to the chilling effects of these postmortem battlefield images. In September, Holmes had raced to Antietam in a panic to search for his son, who was wounded in the battle.[20] The shock he felt in confronting the unburied dead strewn across fields and woods lent poignancy to his observations about the veracity of Brady's exhibition:

Let him who wishes to know what war is look at this series of illustrations. Those wrecks of manhood thrown together in careless heaps or ranged in ghastly rows for burial were alive but yesterday. Many, having seen it and dreamed of its horrors, would lock it up in some secret drawer, that it might not thrill or revolt those whose soul sickens at such sights. It was so nearly like visiting the battlefield to look over these views, that all the emotions excited by the <u>actual sight</u> of the stained and sordid scene, strewed with rags and wrecks, came back to us, and we buried them in the recesses of our cabinet as we would have buried the mutilated remains of the <u>dead</u> they <u>too vividly</u> represented.[21]

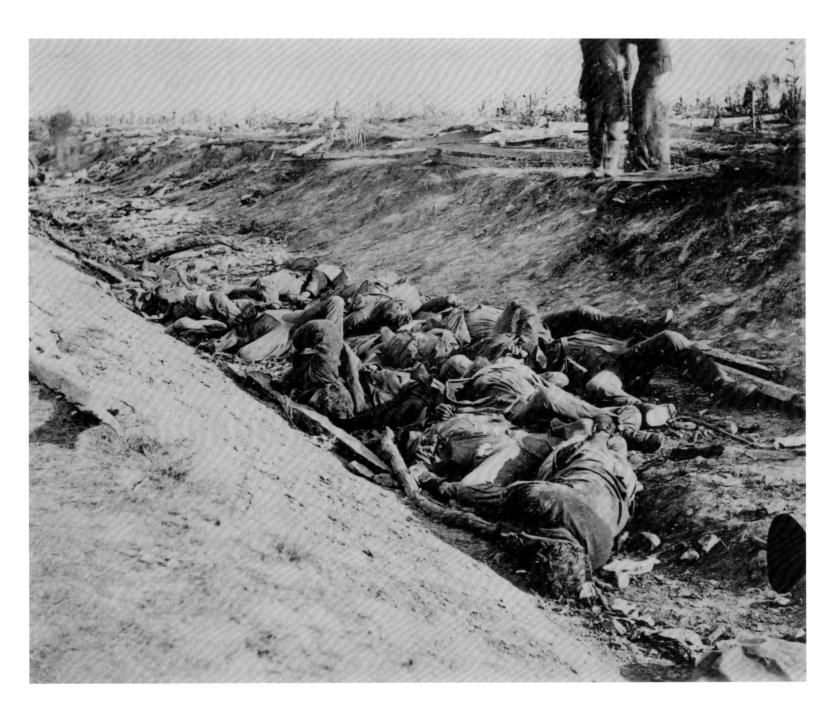

CAT. 15

Alexander Gardner
Bloody Lane, Confederate Dead, Antietam,
September 19, 1862, albumen print, 3 ⅛ × 3 ¾ in.
Chrysler Museum of Art, Norfolk, Va., Gift of David L.
Hack and by exchange Walter P. Chrysler, Jr.

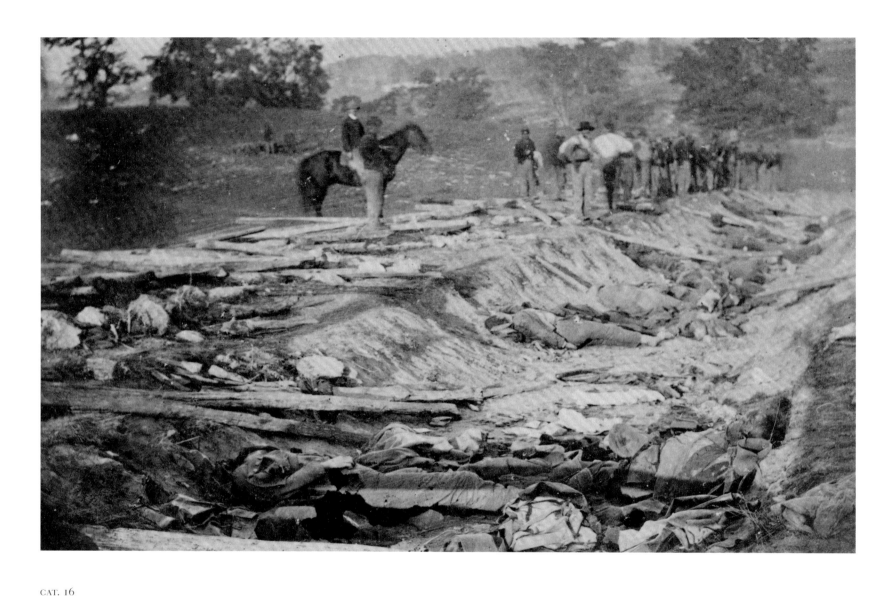

CAT. 16

Alexander Gardner
*Confederate Dead in a Ditch on the Right
Wing Used as a Rifle Pit, Antietam*, 1862,
albumen print, 8 × 7 in. Chrysler Museum of
Art, Norfolk, Va., Gift of David L. Hack and by
exchange Walter P. Chrysler, Jr.

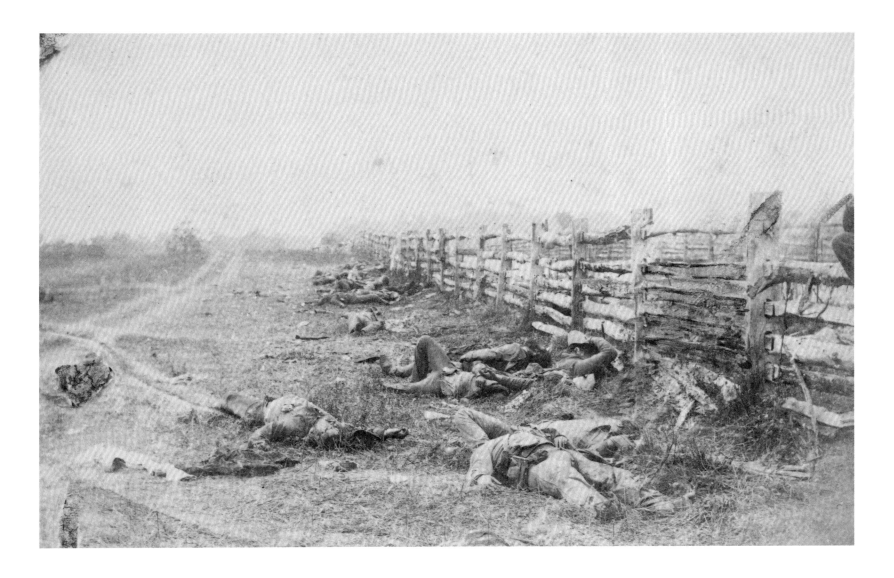

CAT. 17

Alexander Gardner
Confederate Dead at Antietam,
September 19, 1862, albumen print,
3 ½ × 4 ½ in. Chrysler Museum of Art,
Norfolk, Va., Gift of David L. Hack and by
exchange Walter P. Chrysler, Jr.

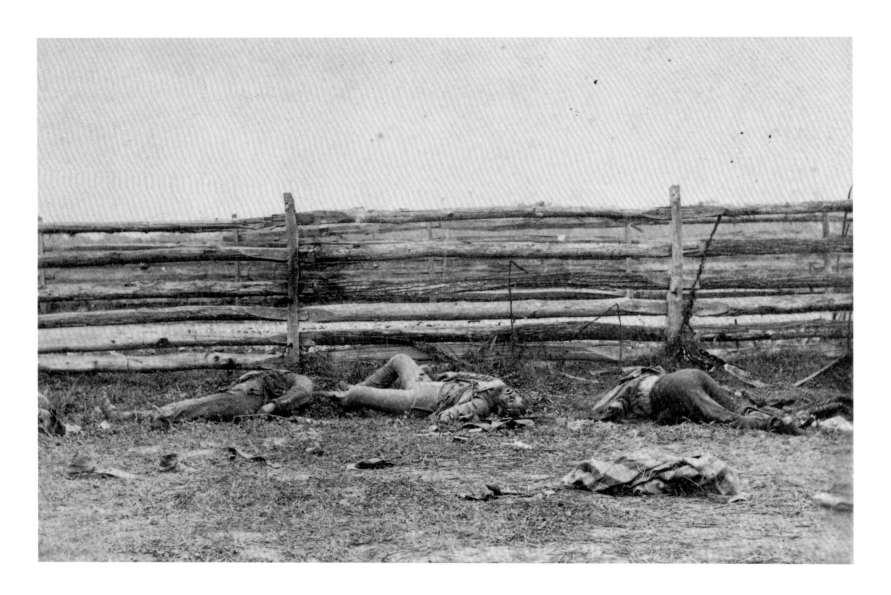

CAT. 18

Alexander Gardner
Day After the Battle, Antietam, 1862,
albumen print, 8 × 7 in. Chrysler Museum of Art,
Norfolk, Va., Gift of David L. Hack and by exchange
Walter P. Chrysler, Jr.

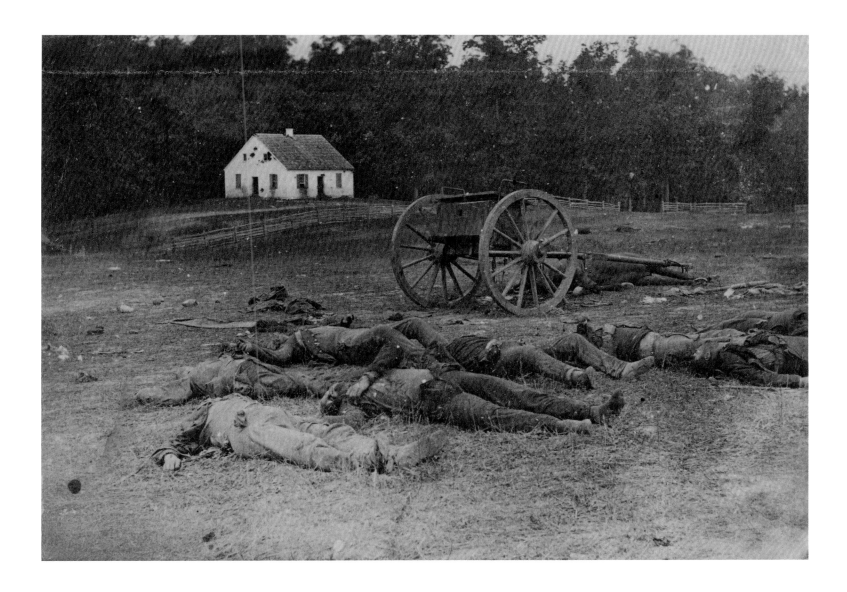

CAT. 19

Alexander Gardner
*Confederate Dead, Antietam (Dunker Church in
background),* September 19, 1862, albumen print,
3 ¼ × 4 ½ in. Chrysler Museum of Art, Norfolk, Va.,
Gift of David L. Hack and by exchange Walter P.
Chrysler, Jr.

For Holmes these photographs captured the real war, presenting a gripping if gruesome corrective to the patriotic press accounts. In an instance of post-traumatic stress, they triggered his memories of horror and dread and confirmed the impossibility of his ever forgetting them. His own response conveys how well he understood the voyeuristic fascination these images held for visitors to Brady's gallery. Holmes's regard for the photographers' accomplishments, tempered by his desire to put the events surrounding Antietam behind him, contributed to the impassioned tone of his review.

Reviews of Brady's exhibition made mention of the crowds of people who came to see them, each bent over the cases or viewers in which the small stereo views were displayed. Many of these images were stereographs, presumably displayed so that viewers would see the dual images magnified, in three dimensions. We have no detailed descriptions or illustrations of Brady's installation, but from one review we know that the room was equipped with magnifiers and possibly stereo viewers to allow visitors to see each image up close. A *New York Times* reviewer penned some of the most memorable words conveying the impact of these photographs:

> Mr. Brady has done something to bring home to us the terrible reality and earnestness of war. If he has not brought bodies and laid them in our dooryards and along the streets, he has done something very like it. At the door of his gallery hangs a little placard, "The Dead of Antietam." Crowds of people are constantly going up the stairs; follow them, and you find them bending over photographic views of that fearful battle-field, taken immediately after the action. Of all objects of horror one would think the battle-field should stand preeminent, that it should bear away the palm of repulsiveness. But, on the contrary, there is a terrible fascination about it that draws one near these pictures, and makes him loth to leave them. You will see hushed, reverend groups standing around these weird copies of carnage, bending down to look in the pale faces of the dead, chained by the strange spell that dwells in dead men's eyes.[22]

Brady's exhibition was a visual memorial service for the fallen soldiers. Like mourners at a viewing, New York's civilians made their way past each image, paying their respects as they undoubtedly felt a measure of relief to be among the living. Gardner's sharp focus on the soldiers' faces stripped away the premise of anonymity, prompting the disquieting thought that it might be possible to identify the dead.[23] Noting this possibility, the *Times* reviewer concluded dramatically, "These pictures have a terrible distinctness. By the aid of the magnifying glass, the very features of the slain may be distinguished. We would scarce choose to be in the gallery, when one of the women bending over them should recognize a husband, a son, or a brother in the still, lifeless lines of bodies, that lie ready for the gaping trenches."[24] That melodramatic pronouncement added an ugly layer of voyeurism to an already grim spectacle. Until that moment, portrait photography had been primarily a means of capturing flattering likenesses of the living, or mortuary photography, often described as providing "lifelike" mementos for the families of recently deceased relatives. Gardner's corpses now offered up a new and harsh commentary on death.

It is not clear how many exhibitions were mounted of Civil War photographs between 1861 and 1865. Following the showing of photographs from Antietam, it appears Brady did not put more war-related images on display in his gallery until July 1864.[25] The New York newspapers are mostly silent on the subject, although the continued production of photographs of dead soldiers—at Fredericksburg and Gettysburg in 1863, and at Petersburg in 1865—attests to some level of sustained interest in, and market for, such images.[26] Brady, and separately Gardner, continued to send photographers into the field for the duration of the war, and Anthony continued to license and distribute photographs made by numerous photographers.

Audiences were not the only ones disturbed by these images—the photographers, whether they served in uniform or trailed the armies, were not unaffected by their tasks. Brady, Gardner, Gibson, Andrew J. Russell, Timothy H. O'Sullivan, John Reekie, George Barnard, and their colleagues saw themselves as battlefield artists, their images composed for maximum visual impact. They did not often comment on the lingering effect such work must have had on them. But what does it do to a person to document fallen soldiers, and to be at times pressed into service as a burial detail? On the scene after the battles

of Manassas, Antietam, Fredericksburg, Gettysburg, The Wilderness, and Cold Harbor, photographers witnessed the aftermath of those events heroically described in newspapers and journals. It was Russell who summed up the gritty character of wartime photographers as men "who were not...afraid of exposure and who could laugh at fatigue and starvation, could face danger in all shapes, and were at all times ready to march, often between the two armies, in the trenches, on the ramparts, through the swamps and forests."[27] His heroic words might seem to make light of his experiences, yet they allude to the inevitable impact of war on those who chronicled it.

Andrew Joseph Russell (1830–1902) remained independent of Brady and Gardner, and he was in uniform during much of the war. He enlisted with the 141st New York Volunteers and spent most of his time photographing newly constructed railroad lines and battlements for the Federal army.[28] However, as the Battle of Chancellorsville raged from April 30 through May 6, 1863, Russell set up his camera and photographed a fleeting moment during which the Union army gained the upper hand. Skirmishes extended to the city of Fredericksburg, which had been the site of a demoralizing Union defeat just five months earlier, in December

1862. The road along Marye's Heights that overlooked the city was a strategic thoroughfare between Washington and Richmond. In Union hands, it would permit General "Fighting Joe" Hooker's army to reach the Confederate forces already engaged at Chancellorsville. Both armies fought for control of the road, with the Confederates holding the position until Maj. General John Sedgwick's Union troops briefly overwhelmed them. Russell's photograph was taken during the single day the Union controlled the Heights before losing possession of it again to the Confederate army. Far from a triumphant view, Russell's photograph presents Marye's Heights as a makeshift grave (cat. 20). Limbs askew, the dead Confederates lie splayed in the trench along the road. Their weapons scattered, the scene appears to have been but recently vacated and in some haste. The dead lay unburied, by then an all too common sight. Russell's image, like Gardner's pictures from Antietam, presents a far more brutal lens through which to understand the conflict, emphasizing its less savory realities. For many civilians at a safe distance from the front, these photographs provided an opportunity to become virtual witnesses to the war.

GETTYSBURG AND THE AESTHETICS OF WAR PHOTOGRAPHY

By the end of 1862, Gardner ended his partnership with Brady, opening his own competing gallery in Washington in May 1863 (fig. 56) within sight of Brady's gallery.[29] Gardner took with him a number of his negatives and many of Brady's talented photographers, among them Gibson, O'Sullivan, and Reekie. Gardner's superior business skills and professional ambitions likely prompted the split, but there is also evidence of a growing divide between his and Brady's pictorial approaches to the war. Beginning with his pastoral and meditative photographs of the landscape at Bull Run taken in 1862, Brady had favored a metaphorical approach to the ravages of war, in keeping with the prevailing aesthetics of landscape painting. Gardner, on the other hand, had long seen the world as a human struggle for dignity and opportunity. A committed abolitionist, he understood from the outset that the war was to be about eliminating slavery and supporting democracy for all Americans. His decision to

FIG. 56

Unidentified photographer
Alexander Gardner's Photographic Gallery, 7th & D Street, NW, Washington, D.C., about 1863, wet collodion glass negative, Library of Congress

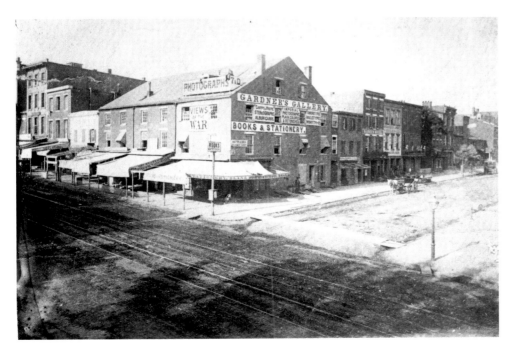

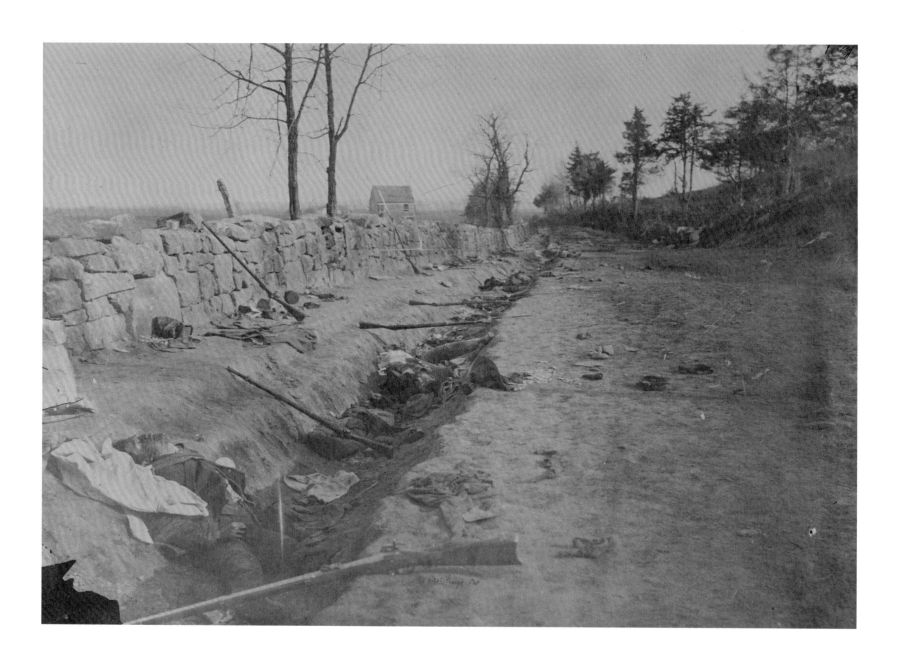

CAT. 20

Andrew Joseph Russell
Confederate Dead, Marye's Heights, Fredericksburg,
May 4, 1863, albumen print, 9 ¼ × 12 ½ in. Chrysler
Museum of Art, Norfolk, Va., Gift of David L. Hack
and by exchange Walter P. Chrysler, Jr.

FIG. 57

Philp and Solomons
Timothy O'Sullivan, about 1870,
National Portrait Gallery, Smithsonian
Institution

photograph dead soldiers reflected his own regard for the price these men paid to achieve the war's goals.

The Battle of Gettysburg began on July 1, 1863, and lasted three days. By July 3, Gardner, O'Sullivan, and Gibson headed north. Gardner had a personal reason for his haste; his son Lawrence was enrolled in a boarding school in nearby Emmitsburg, Maryland, and he understandably wanted to make sure his son was out of harm's way. As a result, he and his colleagues were the first photographers to reach the field, on the morning of July 5, two days after the end of the battle. The three men began taking photographs that afternoon and continued making pictures for the next two days. Between them they brought back more than sixty negatives, roughly 75 percent of them depicting corpses awaiting burial. The images they made have become among the most widely reproduced in American art and history. Gardner credited Timothy H. O'Sullivan (about 1840–1882, fig. 57) with having taken some of the signature images during those three days. He titled O'Sullivan's most riveting image *A Harvest of Death, Gettysburg* (cat. 21), deploying the idiom of soldiers mown down like the harvest from the wheat fields in which they had stood but a moment before—and alluding to the nation's reaping a grim harvest from the war. The shallow depth of field focuses on the contorted bodies in the middle of the image, the foreground in soft focus and the figures in the distance like ghosts on the battlefield. It is a haunting and evocative image that once seen is impossible to dislodge.

With *Home of a Rebel Sharpshooter, Gettysburg* (cat. 22), Gardner and his colleagues went to the unusual length of moving a body to arrange a tableau for maximum visual and narrative impact. Here in the Devil's Den, a natural chimney well suited for a sniper, lies the body of a Confederate soldier. He appears to have fallen backwards after being hit; a rifle lies at close hand. As a single image, Gardner's photograph adopts a genre painter's eye for telling the story of a young man's death. But when paired with another of his photographs from the same day, a different story emerges. *A Sharpshooter's*

Last Sleep (fig. 58) shows the same corpse, and the same rifle, in a slightly different location on the battlefield.[30] A third image originally titled "*Rocks could not save him at the Battle of Gettysburg*" (fig. 59), this one credited to O'Sullivan, reveals a plaid blanket placed under the corpse that the two men used to move the body from one location to the other. Close inspection of *Home of a Rebel Sharpshooter* also shows the edges of the blanket, tucked discreetly under the dead man's legs and head, deliberately obscured from view. Beginning with *A Sharpshooter's Last Sleep* and culminating with *Home of a Rebel Sharpshooter*, these three images capture the body as the photographers found it, with the tools they used to move it, and the final result of their manipulations.[31]

In addition to moving the body, the photographers likely supplied the rifle; most dead bodies were stripped of essential items—weapons and shoes foremost among them—long before the burial detail reached them. The rifle in these photographs is a standard issue Springfield, hardly the weapon of choice for a true sharpshooter, although perfectly serviceable for the close-range sniping that took place at this location. Moving the body and adding a weapon was not the extent of Gardner's manipulations. He also went to considerable effort to turn the dead man's head to the left, so that it would face the camera. The weather at Gettysburg was hot and humid; the advanced decay of most bodies made such adjustments impossible and grossly unpleasant to contemplate. However, here Gardner and O'Sullivan found a soldier who probably died after the end of the battle, and shortly before their arrival. But why go to such great lengths to move his head? For Gardner it was imperative that the young man's face be visible in the photograph; by dramatizing the young Confederate as having died, in his words, "unrecognized and alone," he crafted a framework for his harsh narrative of a rebel soldier left to die unremarked and unacknowledged. Viewers were not meant to understand that this man's body had been moved, only that his death symbolized the larger defeat of the Confederacy and its cause.

By this time, Gardner and O'Sullivan—as well as Brady—had come to see themselves as artists. They took advantage of the opportunity to do more than photograph the dead, using them to tell a story and put forth

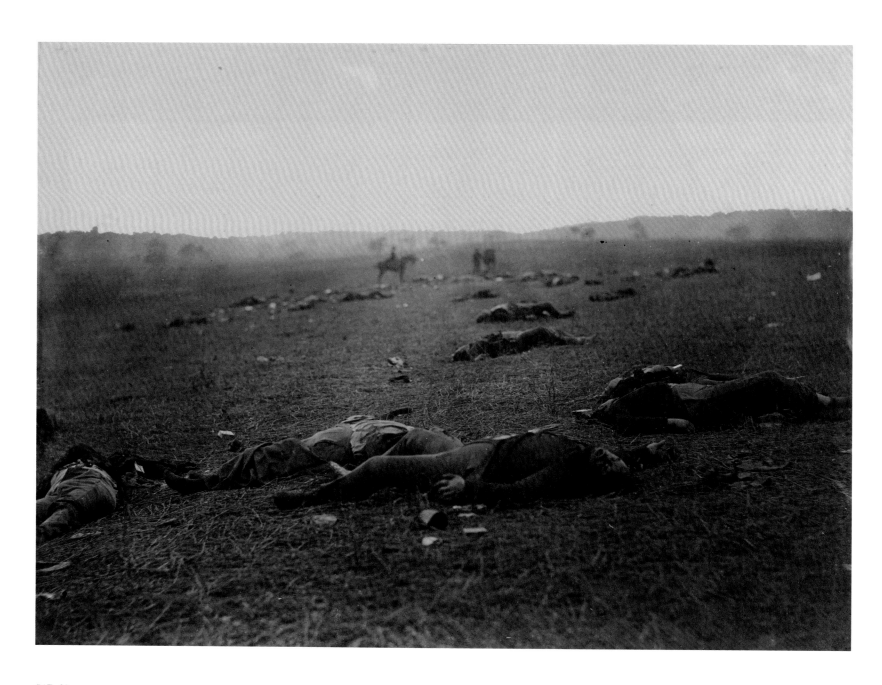

CAT. 21

Timothy H. O'Sullivan
A Harvest of Death, Gettysburg, July 1863,
albumen print, 6 ¾ × 8 ⅞ in. Chrysler Museum of
Art, Norfolk, Va., Museum purchase and partial
gift of Carol L. Kaufman and Stephen C. Lampl in
memory of their parents Helen and Carl Lampl

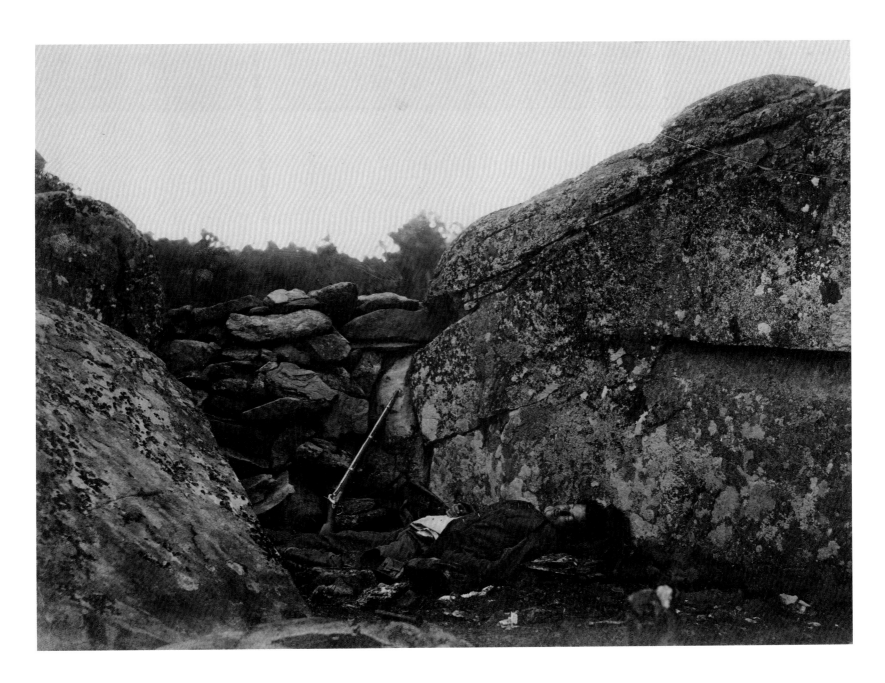

CAT. 22

Alexander Gardner
Home of a Rebel Sharpshooter, Gettysburg,
July 1863, albumen print, 6 ¾ × 8 ⅞ in. Chrysler
Museum of Art, Norfolk, Va., Museum purchase and
partial gift of Carol L. Kaufman and Stephen C. Lampl
in memory of their parents Helen and Carl Lampl

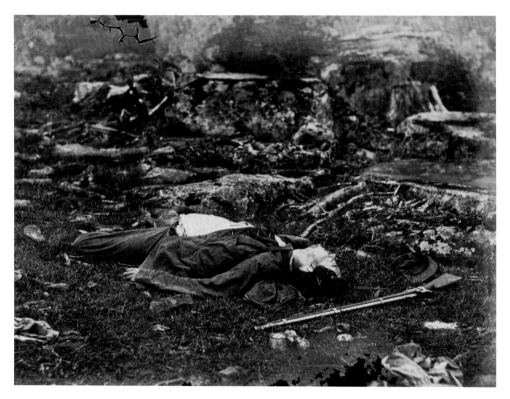

FIG. 58

Alexander Gardner
*A Sharpshooter's Last Sleep,
Gettysburg, Pennsylvania*, July 1863,
albumen print, Library of Congress

FIG. 59

Timothy H. O'Sullivan
*"Rocks could not save him at the
Battle of Gettysburg,"* July 1863,
wet collodion glass negative,
stereograph, Library of Congress

a point of view. Gardner's caption for *Home of a Rebel
Sharpshooter* expressly states, "The artist, in passing over
the scene of the previous days' engagements, found in a
lonely place the covert of a rebel sharpshooter, and pho-
tographed the scene presented here."[32] Gardner identifies
himself as the artist, who through the careful scripting of
both words and image, elevates a photograph to a form
of genre painting. As the war progressed, images these
photographers made became more intense, calculated to
draw out viewers' emotion—even as their work among
corpses must have drained their own.

Their Gettysburg images also demonstrate the grow-
ing divide between Gardner and Brady's photographic
aesthetics. Gardner was willing to manipulate the scene
to achieve a narrative familiar to genre painters: his are
stories of noble goals and failed ambitions. Brady and
his photographers (likely David Woodbury and Anthony
Berger) arrived at Gettysburg a week later, by which
time all of the corpses had been buried.[33] Brady's camera
focused on the landscape, using natural features to stand
in for the missing soldiers. The intense cannonade and

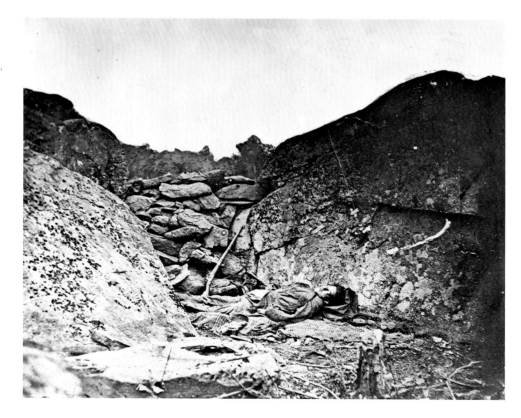

FIG. 60

Mathew B. Brady
Wounded Trees at Gettysburg,
1863, photographic print on stereo
card, Library of Congress

rifle volleys had scarred numerous trees, as both sides used them for cover. Brady's *Wounded Trees at Gettysburg* (fig. 60) focuses on the shattered trunks of stately oaks, riddled with bullets and cannonballs. The trees stand in for the soldiers who so recently had lain in a twisted jumble at their roots. Brady posed a colleague, very much alive, on his back under the trees—either pretending to be dead or encouraging the viewer to imagine a wounded soldier's experience. Brady's choice of title deliberately anthropomorphized the disfigured landscape, creating an evocative reminder of the frightening experience of soldiers being caught in such a crossfire. He developed a strain of Civil War photography that used the landscape to express emotion in a manner consistent with the American landscape painting tradition, looking to nature to provide a surrogate for human suffering.

Both Brady and Gardner published photographs focused on the death of General John F. Reynolds, the highest ranking Union officer to fall at Gettysburg. The differences between them underscore the growing gulf between the way each man articulated his photographic vision. Brady's image (fig. 61), titled *Woods in which Gen. J. F. Reynolds Was Killed, Gettysburg, Pennsylvania,* is a meditation on loss. Brady's camera panned across the sweep of open field adjacent to McPherson's Woods, where Reynolds's death occurred. Standing in a field of wildflowers, Brady and an associate stare intently at the distant woods, lost in a moment of reflection. He deliberately chose a more distant, picturesque vista, placing himself in the foreground as a reminder that the human presence gave meaning to the landscape, while asserting his own significance in the creation of

FIG. 61

Mathew B. Brady
*Woods in which Gen. J. F. Reynolds
Was Killed, Gettysburg, Pennsylvania,*
1863, National Archives

this work.[34] His battlefield is a memorial to those who
had died there. In the idiom of landscape painting, it
associates a place with a momentous event, imparting
great significance to an otherwise innocuous scene.
Timothy H. O'Sullivan's image, titled *The Field Where
General Reynolds Fell, Gettysburg* (fig. 62), focuses closely
on the bodies of unburied soldiers, prompting sobering
thoughts of the staggering losses incurred during the
battle. However, O'Sullivan's image shows the same

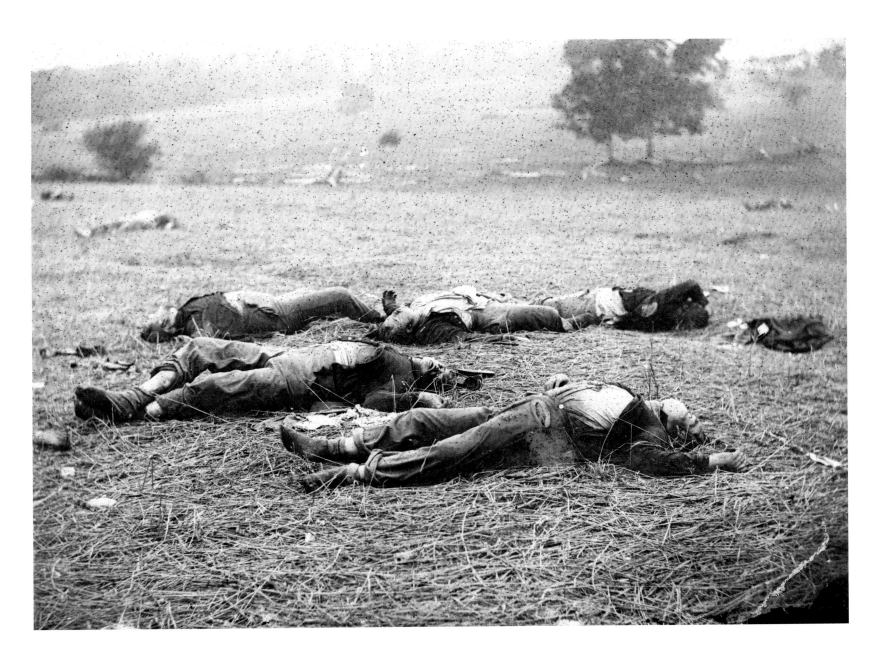

FIG. 62

Timothy H. O'Sullivan
*The Field Where General Reynolds
Fell, Gettysburg,* July 1863, wet
collodion glass negative, stereograph,
Library of Congress

bodies he had photographed in *A Harvest of Death*. Here
he moved his camera to the other side of those fallen
soldiers, most likely members of Union General Dan
Sickles's Third Corps, caught in a lethal crossfire on
Rose's farm on the second day of the battle, far from
McPherson's Woods, where Reynolds had been shot
on July 1. Gardner and O'Sullivan were not primarily
interested in documentary accuracy or poetic reflection.
O'Sullivan's image, *The Field Where General Reynolds*

Fell, represented Reynolds's death by deliberately
underscoring the war's brutality. By contrast, Brady's
photograph is eloquent, understated, and focuses on
the landscape as the evocative subject, blending the
aesthetics of landscape painting and photography.

PRESIDENT LINCOLN AND ALEXANDER GARDNER

Throughout the war President Lincoln took a keen interest in visiting the battlefields around Washington. Two weeks after the Battle of Antietam, on October 2, 1862, he made his way there to meet with General George B. McClellan. Accompanying the president was Gardner, hired to photograph the event (cat. 23). By then Lincoln's frustration with his lead general was well known. McClellan had accrued a deserved reputation for being overly cautious in deploying his troops, habitually overestimating the size and strength of Confederate forces to justify his inaction. At Antietam, McClellan had been in possession of dispatches from Confederate General Robert E. Lee to his generals; despite that presumed tactical advantage and his much larger army, the Union general held back many of his men during the battle and failed to pursue Lee's retreating forces when they left the field. Lincoln's meeting with his general was likely a tense encounter. In a telegram to his wife, Lincoln alluded to his annoyance with his general's handling of Antietam by quipping, "General McClellan and myself are to be photographed tomorrow A.M. by Mr. Gardner if we can be still long enough. I feel Gen. M. should have no problem on his end but I may sway in the breeze a bit."[35] Gardner's photograph captures that tension, artfully emphasizing the commander-in-chief's towering height over his field general. Far from making a neutral, documentary image, Gardner's perspective subtly but effectively reinforces Lincoln's stature, as he deliberately oriented his camera angle to emphasize Lincoln's capacity for leadership through his physical presence.

Gardner took numerous photographs of the president, and there is reason to believe his photographs influenced Lincoln's thoughts about the war. On November 8, 1863, ten days before he boarded a train to Gettysburg to consecrate the new graveyard there, Lincoln entered Gardner's studio for another photography session, resulting in an image that is both stern

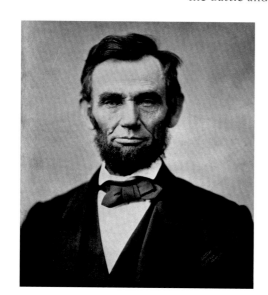

and resolute (fig. 63). By then the two men had formed a friendship. Lincoln understood the power of the new medium of photography to make and shape public opinions of individuals and events. He had taken an early interest in photography, arranging to have his photograph taken at key moments in his rise to the national stage and as president.[36] During his presidency he was a frequent visitor to Gardner's Washington studio. Gardner knew, as did everyone, of Lincoln's upcoming trip. As the banners festooning Gardner's gallery building attest, he continued to display his photographs from the war (see fig. 56). Lincoln's timing makes it highly likely that the president saw some of those works on this visit.[37] Gardner was also working to arrange a catalogue listing his photographs that he titled *Incidents from the War.* Although this was simply a list of images and prices, Gardner's evocative titles provide a terse narrative of his record of the war. Lincoln was a careful wordsmith, laboring over each speech, taking care with his thoughts. It is plausible that Gardner's images inspired the passage in the Gettysburg Address where Lincoln meditates on the sacrifices made by the soldiers who lay dead in the photographs taken by Gardner, Gibson, and O'Sullivan: "But, in a larger sense, we can not dedicate—we can not consecrate—we can not hallow—this ground. The brave men, living and dead, who struggled here, have consecrated it, far above our poor power to add or detract." Set against the backdrop of *A Harvest of Death,* Lincoln's words take on visual form. The close correlation between word and image, and the equally close proximity of Gardner's studio and the White House, make it difficult to imagine one without the other.

"INCIDENTS OF THE WAR" AND *GARDNER'S PHOTOGRAPHIC SKETCH BOOK*

The Civil War inspired Gardner to make innovative use of his wartime photography. During the last week of June and into the first week of July 1864, Gardner teamed up with Massachusetts chemist John Fallon to create a gigantic photographic lantern-slide show titled "Incidents of the War." Fallon had patented his enormous stereopticon, which could magnify 3-by-3-inch

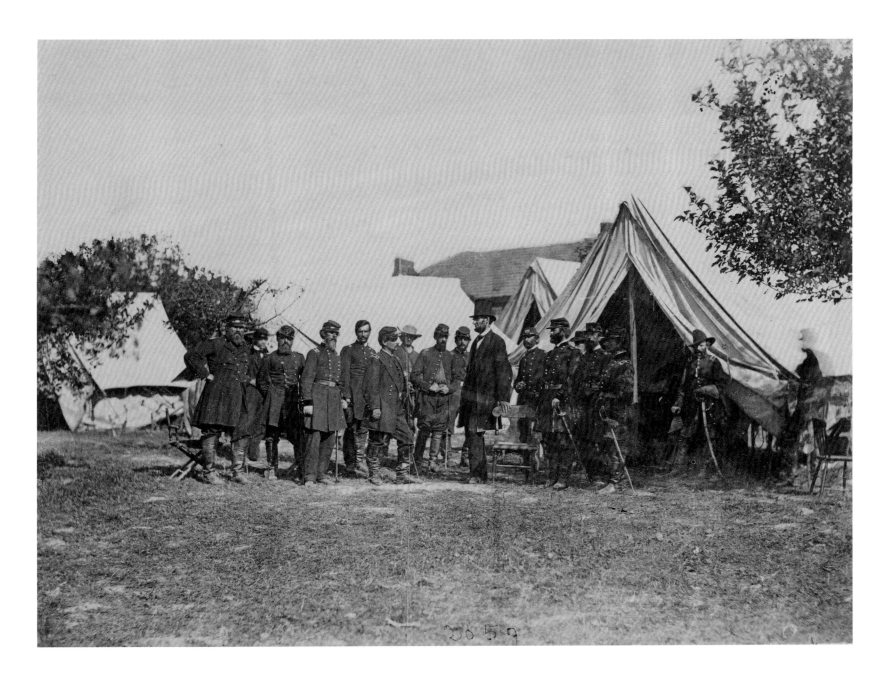

Alexander Gardner
President Lincoln on Battlefield, Antietam,
October 1862, albumen print, 6 ¾ × 8 ⅞ in.
Chrysler Museum of Art, Norfolk, Va., Museum
purchase and partial gift of Carol L. Kaufman and
Stephen C. Lampl in memory of their parents
Helen and Carl Lampl

stereoscopic views and project them on a wall up to a diameter of 24 feet with astonishing clarity and detail.[38] He had arranged to use Irving Hall in New York for seven weeks to show lantern slides of landscapes, European artworks, and, during the final week of the run, Gardner's Civil War photographs. Gardner provided photographs "from the first battle of Bull Run up to the present position…in the most faithful and vivid manner, each view being reproduced on a canvas covering a surface of over 600 square feet." Gardner did not spare his audience the grisly details, as the *New-York Daily Tribune* writer went on to observe, "The dead appear almost to speak; the distant to overcome space and time and be close and palpable."[39] For a week Gardner and Fallon advertised nightly performances and twice-weekly matinees of "Incidents of the War," for which they charged twenty-five cents per ticket. The cinematic spectacle made for a dramatic departure from the more understated fine art

displays in Brady's gallery and proved an innovative way of deploying photographs in a synthesis of art, theater, and reportage.

After the end of the war, in 1866, Gardner developed another landmark project, compiling one hundred of his medium-format Civil War photographs in chronological order in a two-volume project he titled *Gardner's Photographic Sketch Book of the War* (fig. 64). His album is a singular achievement in American photography. In scale, scope, and associated cost, it was unmatched by any photographic effort to date. Bound in gilded leather, the two elegantly designed volumes presented extended narrative captions associated with the images. In a departure from his competitors, Gardner gave his individual photographers credit for their work.[40] It was a stance he had held since his days working for Brady, a decision in keeping with his character, and perhaps also an acknowledgment of the distinct aesthetic merits of

FIG. 64

Alfred R. Waud, del.
Frontispiece from *Gardner's Photographic Sketch Book of the War*, 1866, lithograph, Library of Congress

each man's contributions to the enterprise. His choice of title, calling his album a "Sketch Book," carried meaning as well. It alluded to the high ambitions he had for the aesthetic and literary significance of his project. The term originated with Washington Irving's 1820 publication of the *Sketch Book of Geoffrey Crayon*, a compilation of essays and engravings that cemented Irving's reputation and sparked strong accolades in England for the merits of American literature.[41] Irving's work inspired a genre of similar efforts, in which the author arranges an episodic narrative of events of which he had been a part or had witnessed.[42] Gardner's experience as a newspaper editor in Glasgow reminds us he, like Lincoln, was a wordsmith at heart. He designed the album so that viewers encountered his words before they turned the page to see the associated image, thereby constructing a literary narrative that shaped visual perception of the photographs.

Gardner put considerable effort into his texts, not content to describe the image but intent upon constructing a framework from which the viewer drew meaning. For O'Sullivan's *A Harvest of Death*, he wrote, "Slowly, over the misty fields of Gettysburg—as all reluctant to expose their ghastly horrors to the light—came the sunless morn, after the retreat by Lee's broken army. Through the shadowy vapors, it was, indeed, a 'harvest of death' that was presented; hundreds and thousands of torn Union and rebel soldiers—although many of the former were already interred—strewed the now quiet fighting ground, soaked by the rain, which for two days had drenched the country with its fitful showers." The harvest metaphor applied to this image, and by extension to the many photographs of the war dead, by then was often invoked by soldiers and commentators alike to draw a deliberate and poignant contrast between the bounty usually reaped from the same fields on which the dead now lay. Although the bodies were those of Union soldiers, Gardner reinterpreted them as dead Confederates. Doing so allowed him to end the caption with his unvarnished opinion of the war: "Killed in the frantic efforts to break the steady lines of an army of patriots, whose heroism only excelled theirs in motive, they paid with life the price of their treason, and when the wicked strife was finished, found nameless graves,

far from home and kindred. Such a picture conveys a useful moral: It shows the blank horror and reality of war, in opposition to its pageantry. Here are the dreadful details! Let them aid in preventing such another calamity falling upon the nation." On the next page Gardner printed the related image, which he published with the full title *Field Where General Reynolds Fell, Battle-Field of Gettysburg* (see fig. 62), in which he identifies the same bodies as Union casualties. In his caption he described their angelic features and "calm and resigned expression, as though they had passed away in the act of prayer." The gulf between the sentiments used to describe the same group of bodies made clear Gardner's political and moral objectives for this project.

Gardner wanted the sketchbook to encapsulate the noble sacrifice of the North and the unconscionable folly of the South. Throughout the volumes his language is loaded, leaving little ambiguity as to his support for the Union cause. The stereopticon presentation of "Incidents of the War" and *Gardner's Photographic Sketch Book of the War* together stand as one of the most significant compilations of postmortem battlefield photography, his endeavors serving as a visual and literary reliquary for memories of the dead and the causes for which they died. Ironically, Gardner's *Sketch Book* very likely contributed to collectors' waning interest in paintings that documented battle scenes. Between the raw brutality of the images and the appalling casualties of the war itself, such a project seemed designed to keep alive the memories that Oliver Wendell Holmes had sought to lock away. Gardner advertised the two-volume set for $150, a sum unheard of for a photographic album. We have no reliable record of how many sets Gardner sold, although probably nowhere close to the number he proposed printing. The price and the limited production both suggest that Gardner's underlying ambition was to have the art of photography contribute a lasting and compelling testament to the war's impact on American ideals.

In 1864 the New-York Historical Society's Fine Arts Committee noted the paucity of works made by the fine artists on the war compared to the plethora of literary and journalistic accounts. The committee concluded,

The photographers have made by far the most important additions to the pictorial history of the war. They have prosecuted their undertakings under circumstances of great difficulty and even danger, running the risk of having their dark chambers converted into ambulances, or destroyed by hostile shells. But the caution and deliberation required for successful views of this sort are obviously impracticable in the confusion of a battle, and therefore it is not surprising that what we have hitherto obtained in this way has been little besides a representation of that awful "still life" which the plain shows after the conflict is over.[43]

The committee report expressed the hope that the fine artists would begin to make more significant contributions to war-related art. But it is significant to note that the report invoked the artistic genre of still life, or *nature mort*, to describe the photographers' primary subjects, giving the nod both to the artful qualities of the images—and to the ghastly subjects represented. By the end of the war, Gardner's album stood as an exercise in still life as practiced by the photographer.

Gardner's album spanned the duration of the war, opening with a photograph of the Marshall House in Alexandria, in which Elmer Ellsworth died in May 1861 while removing an oversized Confederate flag, and closing with an image of the dedication ceremony of a monument to the Union dead at Manassas on June 10, 1865. Although he featured his work from Gettysburg, he included very few photographs from Antietam, none of which featured dead soldiers. He may have reduced their number due to their being stereo photographs, too small to be included and their enlargement too cumbersome to be feasible.[44] Gardner did include the work of other photographers, among them John Reekie. Little is known about this photographer, but he captured one of the most disturbing and riveting images of the war. Titled *A Burial Party, Cold Harbor* and taken in April 1865 (cat. 24), the image shows the burial detail that had arrived nearly a year after the battle to complete the unfinished business of burying the dead who had been left on the battlefield or buried in shallow graves that had, by that time, become exposed.

Gardner's decision to include this image in his album reveals a sore point about the abandonment of the usual courtesies of honoring and mourning the dead. At the Battle of Cold Harbor, which had taken place from May 31 to June 12, 1864, Union General Ulysses S. Grant faced Lee for the first time. This battle and the Battle of the Wilderness came to epitomize Grant's tenaciousness and his willingness to incur horrific losses rather than retreat. At Cold Harbor, Grant's forces were badly outnumbered. The night before the battle, even the soldiers seemed to know this might be their last night alive. Union General Horace Porter noted, "In passing along on foot among the troops the previous evening (June 2), I noticed that many of the soldiers had taken off their coats and seemed to be engaged in sewing up rents in them. On closer examination it was found that the men were calmly writing their names and home addresses on slips of paper and pinning them on the backs of their coats, so that their dead bodies might be recognized and their fate made known to their families at home."[45] Their pessimism was warranted. Grant threw his troops against Lee's heavily fortified position and incurred overwhelming losses in the defeat.

In Reekie's photograph a burial detail sent to the battlefield nearly a year later focuses on black grave diggers gathering the remains for reburial. One man squats next to his stretcher, carrying skeletal fragments barely held together. Reekie has captured his frank, appraising gaze with a directness that connects with the viewer, its raw impact undiminished by time. In a rare instance of a photograph focusing on blacks' involvement in the war, Gardner identifies these men as U.S. soldiers, colored troops who were finally allowed to join the Union ranks in 1863. The men in the rear of the photograph wear army pants and kepi hats; however, the man closest to us wears civilian clothes. Together this group of men—soldiers and contraband—cast this image as a pointed reminder of the sacrifices made by and on behalf of black Americans.[46]

Gardner's album was a culminating statement about the role of Civil War photography in remembering the war, appropriating the traditional role of the fine arts to comment on the human drama of the conflict. His was the first, but not the only project with such high ambitions. While Gardner and Brady focused on the eastern theater of the war, at the end of 1863, George Barnard took his cameras further south.

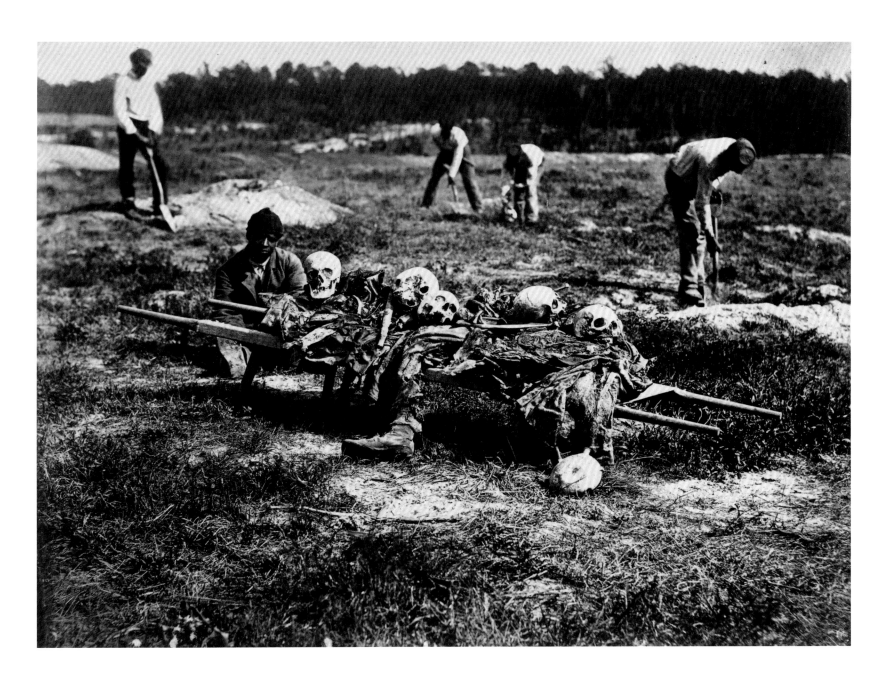

CAT. 24

John Reekie
A Burial Party, Cold Harbor,
April 1865, albumen print, 6 ¾ × 8 ⅞ in. Chrysler
Museum of Art, Norfolk, Va., Museum purchase and
partial gift of Carol L. Kaufman and Stephen C. Lampl
in memory of their parents Helen and Carl Lampl

GEORGE BARNARD AND GENERAL SHERMAN

George N. Barnard (1819–1902, fig. 65) was raised in upstate New York, and he opened his first photographic gallery in Syracuse in 1854. He was principally a daguerreotypist, as were most of his colleagues, and his earliest photography business included posing models to resemble figures from Old Master paintings. Like Brady, he embellished some of his images with paint or ink to enhance the resemblance to works of art. In 1859 Barnard moved to New York City, where he made stereo photographs and *cartes-de-visites* for Brady, a number of which were distributed by Anthony & Company. His work for Brady would have further encouraged Barnard to see his own photographs as part of the larger art world. Barnard continued to supply both firms with images after his arrival in Washington shortly after Lincoln's inauguration in March 1861, and he was at Manassas in July during the first battle there.[47] During 1862 and 1863, he continued to provide war-related images for Brady, Anthony, and Gardner. His career took a momentous turn in December 1863, when he was hired by the Topographical Branch of the Department of Engineers, Army of the Cumberland, under Orlando M. Poe, captain of engineers. Upon his arrival in Nashville in February 1864, Barnard was made head of photographic operations. The next month, General William Tecumseh Sherman (fig. 66) took command of the western theater.[48] Poe led the First Michigan Regiment of Engineers and Mechanics, part of the Union Division of the Mississippi. They were in charge of situating and building Sherman's fortifications, keeping him supplied with maps and dismantling railroad tracks, ordnance, or buildings as ordered.

Barnard began his photographic enterprise for Sherman while the army was in Chattanooga. His primary duty was to document the regiments' engineering feats, but Poe gave Barnard discretion over choosing the subjects of some of his photographs, allowing him to exercise his aesthetic judgment. Shortly after Barnard's arrival, Poe instructed him to make "a series of panoramic views taken from Orchard Knob (Indian Hill). A view of the nose of Lookout Mountain and if possible a view from the top of the mountain of the lines immediately around Chattanooga." Poe went on to qualify his orders, noting, "It is not to be understood that your labors are limited to these points enumerated.... Should the time at your disposal admit of it you can take views of celebrated houses, scenery, &c.—but this must not interfere with the more important object of the expedition."[49] As Sherman planned his march on Atlanta, the photographer documented the army's works in Tennessee and found time to join soldiers and civilians alike on Lookout Mountain. That month he composed several images of the landscape outside Chattanooga, among them *Chattanooga Valley from Lookout Mountain No. 2* (fig. 67), which explicitly evokes Thomas Cole's painting *View from Mount Holyoke, Northampton, Massachusetts, after a Thunderstorm—The Oxbow* (fig. 68). Barnard took multiple photos from the summit down to the river, some with spectators strategically placed to enhance aesthetics; all of them, including

FIG. 65

Mathew B. Brady
George N. Barnard, about 1865,
National Portrait Gallery, Smithsonian
Institution

FIG. 66

George N. Barnard
William Tecumseh Sherman, 1864,
stereograph, Library of Congress

FIG. 67

George N. Barnard
Chattanooga Valley from Lookout Mountain No. 2, 1864, albumen print from *Barnard's Photographic Views of the Sherman Campaign*, about 1866, Hargrett Rare Book and Manuscript Library/University of Georgia Libraries

FIG. 68

Thomas Cole
View from Mount Holyoke, Northampton, Massachusetts, after a Thunderstorm—The Oxbow, 1836, oil on canvas, 51 ½ × 76 in. The Metropolitan Museum of Art, Gift of Mrs. Russell Sage, 1908

his multi-plate panoramas, referring to Cole's painting. Barnard's landscapes demonstrate his strong affinity for Hudson River school-inspired compositions and his ability to compose the actual landscape in a manner consonant with fine art precepts, a talent he would also apply to his war-related photographs.

In May 1864, when Sherman set out to capture Atlanta, Barnard remained behind. On the march through Georgia, Sherman's troops skirmished often with those of Confederate General Joseph E. Johnston. Sherman favored flanking maneuvers to keep the Confederates off balance; Johnston retaliated by burning bridges and destroying track, but his efforts did not stop Sherman from settling in outside Atlanta's defensive perimeter. For forty days Sherman's troops barraged the city. The mayor of Atlanta finally ordered his city evacuated on September 1, as Confederate troops destroyed stockpiled supplies and munitions. Sherman entered Atlanta the next day. Several weeks later, Barnard left Chattanooga and took a train to catch up with the army. In Atlanta he focused on the activities of war, photographing buildings that had been reduced to rubble. He used two different camera formats for his work: a stereo camera for many of his urban views, and his 12-by-15-inch medium-format camera when he had more time to compose his images.[50] In November 1864, as his troops prepared to leave Atlanta, the general gave orders for

the further destruction of buildings and telegraph lines. Barnard's stereo photographs froze the action as Poe's men tore up railroad tracks, making what they called "Sherman's neckties" of the twisted rails (fig. 69).

Barnard accompanied Sherman's march to the sea. Sherman's rationale was chillingly simple: a war of attrition between two fighting forces could go on indefinitely. Only when the people of the South tired of the war would it end. The army arrived in Savannah on December 21, 1864. Curiously Barnard did not make photographs on this leg of the campaign, whether from disgust with the army's destructive actions or due to the pace of travel, we do not know. In January 1865 Sherman's troops left for Charleston and then made their way to Columbia, South Carolina. Barnard remained behind. His medium-format photographs of Savannah convey a sense of tranquility and elegance worlds apart from the devastation he documented in Atlanta, in part because they might have been made after Sherman's departure from the city. Shortly thereafter, Barnard received a month's leave and sailed from Savannah to New York in January 1865. During this furlough, he apparently began developing the concept for his album of photographs narrating Sherman's campaigns.

From then on, Barnard followed in the wake of Sherman's troops. His photographs convey his growing

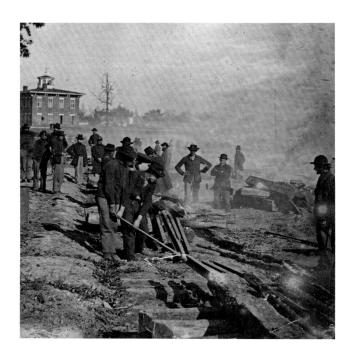

FIG. 69

George N. Barnard
*Destroying the Railroad just before
the "March to the Sea," Atlanta,*
1864, wet collodion glass negative,
stereograph, Library of Congress

understanding of Sherman's deliberate destruction of
Southern cities and the demoralization of its residents
to bring the war to a close. In early March, Barnard
returned to the South, sailing to Charleston, South
Carolina. There he began a series of photographs of the
damage from the Union shelling of the harbor in 1863
and from the February 1865 Confederate evacuation
and Sherman's brief occupation of the city. It was here
Barnard made one of his most poignant photographs
of the rubble-strewn wreckage of this proud Southern
city, which he titled *Ruins in Charleston, South Carolina*
(cat. 25). Barnard's image of two men seated amidst the
shattered buildings resembles European neoclassical
paintings of grand tourists musing on the downward
course of empire, providing a visual corollary between
the Confederacy's demise and the remains of the once-
proud Greek and Roman empires. A significant compo-
nent of the grand tour was wandering amidst the ruins of
earlier civilizations, lamenting their passing and meditat-
ing on the mutability of fortune as empires rose and fell.
The Civil War provided America with modern ruins that
were the product of violent political upheaval. Survivors
were left to wander the devastated urban landscape,
contemplating their fate. Commentators were fond
of comparing the Confederacy to earlier empires,

attributing its defeat to shared attributes of moral decay,
pride, and injustice.[51]

From Charleston, Barnard continued to Columbia.
When Sherman arrived in February he found the city
in a panic. The Union army wreaked destruction on
the city; a fire that burned the city's center created a
major controversy for Sherman, as stories of his "bum-
mers," a pejorative nickname applied to Sherman's
troops, acting with or without orders, outraged many
on both sides of the war. By the time Barnard arrived,
the Union army was gone, marching toward Richmond.
Sherman's brutal tactics and Grant's relentless siege
had worn down Confederate resources and resolve.
Barnard's *Ruins in Columbia, South Carolina No. 2* (cat.
26) captures the effects of Sherman's occupation, taking
as its subject the remnant of a once stately building, its
brick columns stripped of their plaster, standing like
sentinels in front of the blasted remains. Barnard set up
his camera for *Columbia, from the Capitol* (cat. 27) on the
elevated grounds of the capitol building, the displaced
slabs of white marble calling to mind the ruins of the
Parthenon, a monument to the pinnacle of Greek civi-
lization that was badly damaged during a war with the
Ottoman Empire. A horse and buggy, possibly Barnard's
transport, waits patiently in the noonday sun while the
photographer works. Beyond the stockade fence, what's
left of the city stands on either side of a broad avenue.
The burnt shells of buildings, scorched trees, and vacant
lots point up the extent of the damage; the entire scene
is of a city poorly used and abandoned.

Barnard's photographs of the destruction of
Charleston and Columbia reflect the shock he likely
experienced, having just returned from the virtually
untouched city of New York. In the North, the war
appeared to be at a distant remove; in Charleston and
Columbia, with venerable buildings in ruins, there was
no such luxury. The war was very real, ever present.
Barnard's images convey that devastation. However,
in placing his human subjects in contemplative poses
among the rubble, Barnard also conveyed stoic resolve,
a state of meditative reflection that linked the American
South to the classical world of antiquity, where colossal
fragments could inspire a modern man to melancholy
reflection on what had been lost. Clearly moved by both

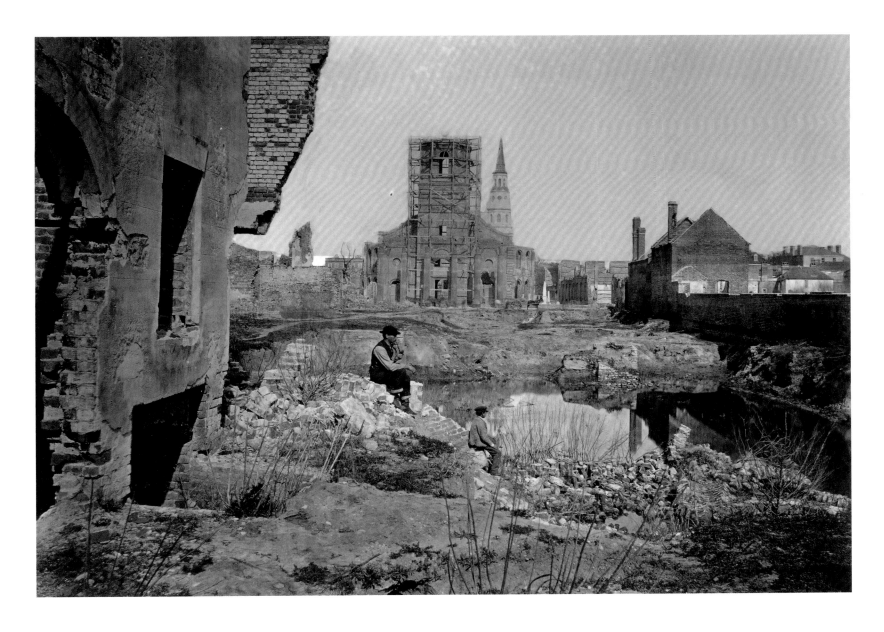

CAT. 25

George N. Barnard
Ruins in Charleston, South Carolina, 1865, vintage
albumen print, 10 × 14 ⅛ in. The Nelson-Atkins
Museum of Art, Kansas City, Missouri.
Gift of Hallmark Cards, Inc.

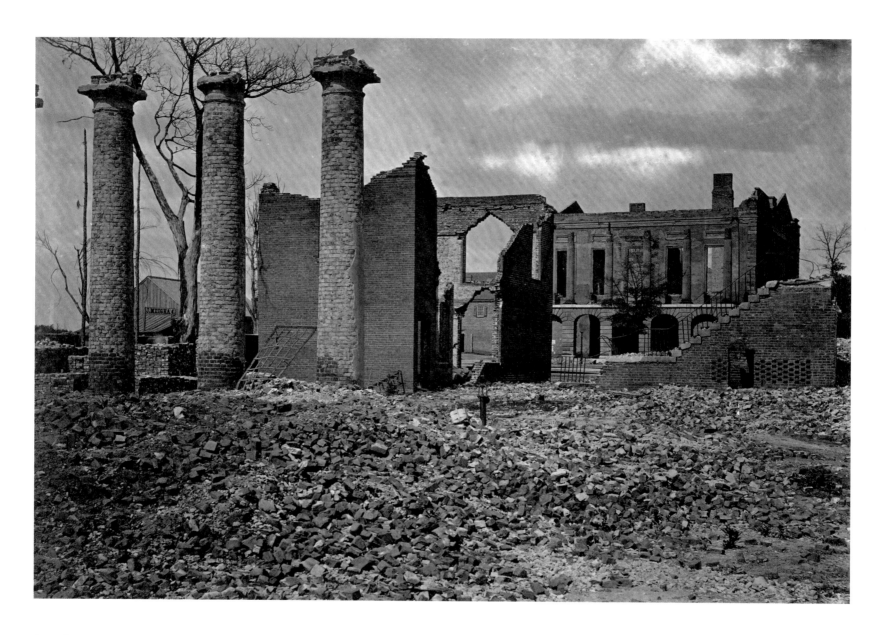

CAT. 26

George N. Barnard
Ruins in Columbia, South Carolina No. 2,
1865, vintage albumen print, 10 × 14 ⅛ in.
The Nelson-Atkins Museum of Art, Kansas City,
Missouri. Gift of Hallmark Cards, Inc.

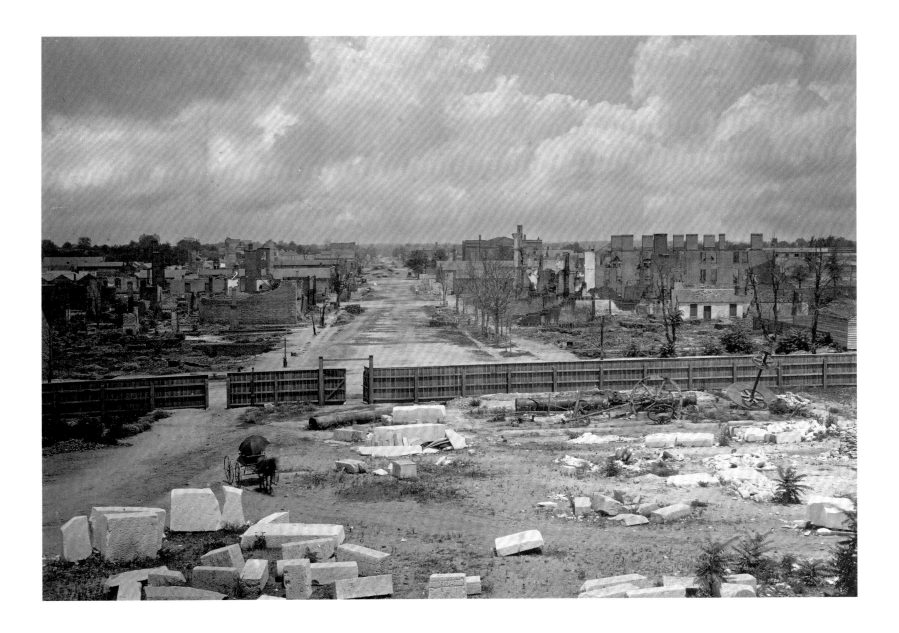

CAT. 27

George N. Barnard
Columbia, from the Capitol, 1865, vintage
albumen print, 10 × 14 ⅛ in. The Nelson-Atkins
Museum of Art, Kansas City, Missouri. Gift of
Hallmark Cards, Inc.

of these displays, Barnard masterfully blended his chronicle of Sherman's effective if destructive campaigns across the South with images reaffirming the dignity of its vanquished survivors. After he completed his photographs, Barnard went home again to New York. However, he was not done with his project, or with the South.

BARNARD'S ALBUM: *PHOTOGRAPHIC VIEWS OF SHERMAN'S CAMPAIGN*

At the end of the war, Barnard mustered out and began compiling an album he anticipated would encompass 150 of his photographs.[52] He envisioned a pictorial narrative following Sherman's campaigns patterned after Alexander Gardner's two-volume *Photographic Sketch Book of the War*. Unlike Gardner, he did not provide captions for each image. Instead he engaged Theodore Davis, a sketch-artist and correspondent for *Harper's Weekly* who had also traveled with Sherman, to write the accompanying text, which appeared as a somewhat dry introductory essay recounting the path of Sherman's forces. The army allowed Barnard to retain some of his negatives, but he was eager to return to the South to supplement his earlier work and retrace his steps to

fill the gaps in the story taking shape in his mind. He sought and received Sherman's endorsement of his project and appealed to Poe for maps and financial support.[53] Both were forthcoming, so Barnard spent the late spring of 1866 in the South taking more pictures.

The photographs Barnard took in 1866 reinforced the extent of the unrepaired damage done to the landscape and infrastructure in the South and form a telling counterpoint to the more dispassionate views he shot during the war. Sherman's tactics had been harsh, designed to bring a swift end to the war by destroying civilian homes and property, rather than engaging in debilitating battles against the Confederate army. In one of his reports as he crossed through Georgia, Sherman noted, "The scene was enchanting; too beautiful to be disturbed by the harsh clamor of war. But the Chattahoochee lay beyond, and I must reach it."[54] Barnard ably captured the devastation wrought by that decision in his photograph *South Bank of the Chattahoochie, GA* (fig. 70). The denuded stretch of shoreline, its trees put to use in making Sherman's bridge, is a wasteland, a far cry from its prewar condition. The brutalized landscape in this view stands in sharp contrast to the photographer's pastoral images of the Tennessee River from atop Lookout Mountain, which he had taken in 1864.

The physical destruction of the landscape was a deep wound, slow to heal. As Barnard retraced the route of Sherman's march on Atlanta, he photographed the effects of that campaign that remained visible two years later. Barnard had not witnessed the battles Sherman and Johnston had fought between Chattanooga and Atlanta; now he photographed the trenches dug by the troops in 1864 in a work he titled *Battle Field of New Hope Church, Georgia No. 2* (cat. 28). The scars in the earth look fresh, as though the battle had just taken place. His image carries a stark, unrelenting quality of destruction and death, the human casualties evoked by the remnants of cloth flung over the embankment. In another photograph from this site, which he titled *The "Hell Hole," New Hope Church, Georgia* (cat. 29), the snapped trees are reminders of the destruction wrought to both soldiers and the landscape in which they fought. The damage created by both armies was widely evident and resulted in a landscape that looked as though a tornado had ripped through it.

FIG. 70

George N. Barnard
South Bank of the Chattahoochie, GA, 1864, albumen print from *Barnard's Photographic Views of the Sherman Campaign*, about 1866, Hargrett Rare Book and Manuscript Library/University of Georgia Libraries

CAT. 28

George N. Barnard
Battle Field of New Hope Church, Georgia No. 2,
1866, vintage albumen print, 10 × 14 in.
The Nelson-Atkins Museum of Art, Kansas City,
Missouri. Gift of Hallmark Cards, Inc.

CAT. 29

George N. Barnard
The "Hell Hole," New Hope Church, Georgia,
1866, vintage albumen print, 10 × 14 in.
The Nelson-Atkins Museum of Art, Kansas City,
Missouri. Gift of Hallmark Cards, Inc.

FIG. 71

George N. Barnard
The Potter House, Atlanta, 1864,
albumen print from *Barnard's
Photographic Views of the Sherman
Campaign*, about 1866, Hargrett
Rare Book and Manuscript Library/
University of Georgia Libraries

Barnard's 1864 photograph of the *Rebel works in Front of Atlanta, Georgia No. 1* (cat. 30) displays his ability to provide both the documentary evidence of war and the sweeping panorama of a landscape painter. In the distance is the Potter House, its white walls shattered by artillery shells. Leading up to it are the bristling *chevaux-de-frises*, ugly but effective deterrents to charging cavalry. Their skeletal spikes snake across the landscape, a nightmarish reenvisioning of the picket fences that once divided property lines. Barnard's close-up image of *The Potter House, Atlanta* (fig. 71) accentuates the damage done to the once-elegant building. His *Rebel works in Front of Atlanta, Georgia No. 4* (cat. 31) made clear that both sides would carve into the landscape in order to hold or capture it. Together these photographs take in the broad panorama and reflect a detailed examination of a landscape disfigured by war.

Barnard incorporated his aesthetic sensibilities into a number of these images, including *Rebel works in Front of Atlanta, Georgia No. 1*, enhancing the skies by taking a second negative specifically of cloud formations and printing the clouds separately on each individual photograph. Theodore Davis noted admiringly that "Barnard has by a new process (double printing) got the

most beautiful clouds in his prints, which excel any thing that I have ever seen in the way of photograph[y]."[55] The critical response to this technique was positive and perceptive. The January 1867 *Harper's New Monthly Magazine* reviewed Barnard's album, noting, "The subjects are admirably chosen, both in respect to the picturesqueness of the scenes and their historical importance, and the execution of the photographs has reached the highest capacity of the art."[56] This technique also resulted in variations between copies of Barnard's albums, in which the same scene could feature a different sky, and multiple images could be printed with the same sky. In an article on landscape photography published in *Photographic News* in 1863, the writer noted with approval Barnard's enhanced skies, rationalizing that most landscape paintings, like these photographs, were the product of separate studies brought together.[57] These and other contemporary reviews of landscape photography borrowed syntax and aesthetic judgments from landscape painting, making it evident that the two media were now subject to the same critical standards. Barnard himself subtly suggested the comparison, captioning all of his album photographs as views taken "from nature," a phrase borrowed from John Ruskin's maxim of "truth to nature" as a guiding principle in making works of art. By the mid-nineteenth century, making sketches and studies "from nature" was identified as an essential feature of American landscape painting, a genre that defined American art and cultural values.[58] Labeling his photographs "from nature," Barnard confirmed that direct observation governed his choice of view, along with a judicious use of artistic license.

Barnard's album also conveys the elegiac quality of his journeys. In both 1864 and 1866, Barnard traveled southeast of Atlanta to record the spot where General James McPherson had fallen. McPherson had been a popular leader and one of Sherman's most effective generals. Shot by a Confederate sniper on July 22, 1864, he fell from the saddle beneath a stand of trees. His riderless horse returned to camp, setting off a search for his body. Upon finding him, fellow soldiers tacked a sign to the closest tree marking his death. Barnard visited the site in 1864 and took pictures with his stereo camera.[59] On one of his visits to the site, Barnard brought

CAT. 30

George N. Barnard
Rebel works in Front of Atlanta, Georgia No. 1,
1864, vintage albumen print, 10 × 14 in. The
Nelson-Atkins Museum of Art, Kansas City,
Missouri. Gift of Hallmark Cards, Inc.

CAT. 31

George N. Barnard
Rebel works in Front of Atlanta, Georgia No. 4,
1864, vintage albumen print, 10 × 14 ⅛ in.
The Nelson-Atkins Museum of Art, Kansas City,
Missouri. Gift of Hallmark Cards, Inc.

his medium-format camera, intending to make a more ambitious image.[60] When he printed the photograph, he made the decision to efface the sign, focusing instead on artfully arranging the partial skeletons of two horses and fragments of a wagon to allude to McPherson's death. The title, *Scene of General McPherson's Death* (cat. 32), sounds like a dramatic setting from a tragic play. Visually it evokes hallowed ground, recalling Brady's landscape photograph *Woods in which Gen. J. F. Reynolds Was Killed* and Lincoln's words from the Gettysburg Address. Barnard's image presents an opportunity for the viewer to reflect on the transience of life and the mutability of death.

Barnard's album was well received, both for its visual power in portraying the destruction of the South and for the aesthetic quality of the individual images. It presents two aspects of Sherman's campaigns: the horrific damage done to homes and cities and the equally distressing damage to the landscape. Its full title— *Photographic Views of Sherman's Campaign, embracing scenes of the occupation of Nashville, the great battles around Chattanooga and Lookout Mountain, the campaign of Atlanta, March to the Sea, and the Great Raid through the Carolinas*—conveys Barnard's sweeping ambition. The sixty-one photographs that comprised the finished work are arranged chronologically, seamlessly weaving together images taken in 1864 and 1866 to tell the larger story of the war and its aftermath. Barnard's storytelling ability was matched by his capacity to compose breathtaking views both of the undisturbed landscape and the army's destructive impact on it. These skills won him the respect of one army captain, who wrote admiringly of Barnard's work as "elegant and artistic, but vastly important to Military engineers," a duality that sets apart his production among a host of wartime photographers.[61] Despite their aesthetic qualities, Barnard's photographs also seemed calculated to shock complacent Northerners into recognition of the actual devastation wrought to the landscape and major cities across the South. Experienced as a visual progression, his photographs capture the determined, inexorable swath cut by Sherman and his troops. Barnard's album chronicles the dismantling of Southern society and Southern identity.

PHOTOGRAPHY AS ART

Pairing Barnard's album with Gardner's two-volume *Sketch Book* reveals the parallels between photographs and paintings of the war. Gardner's focus on the brutal qualities of postmortem battlefields would spur genre painters like Winslow Homer to focus on images of individual soldiers rather than romanticized battle scenes. In contrast to the visceral reaction to these photographs, Homer's paintings would restore a measure of empathy for citizen-soldiers, if not for the tactics of war. Barnard's focus on the landscape reinforced the prevailing ethos of American landscape painting: wilderness served as a culturally significant emblem of the state of American culture—now torn up or in ruins, a ghost of its former beauty. Gardner focused on the cost in human lives of this terrible war; Barnard assembled a visual elegy to the end of the South's antebellum way of life. Both men made individual photographs and then assembled them into narrative sequences conveying far more than the literal words and images. Separately, and in competition with each other, they made an eloquent case for photography as an art form.

Brady, Gardner, and Barnard all created or supervised the taking of photographs during the Civil War that proved that this medium was as well suited to journalistic documentation as it was to artistic and metaphorical expression. Collectively and individually, their photographic presentation of the damage caused by attacking and retreating armies reiterates the causal connections between damage to the landscape and damage done to human bodies and souls. All three men created bodies of work that are meditations on the destructive potential for war, directed at a Northern audience that had experienced little or none of the conflict's physical devastation to land or homes. Whether in pictures of dead soldiers, blasted buildings, or mournful landscapes, photography confirmed the sense that the New Eden had been violated, its surviving human inhabitants expelled from paradise into a damaged world. Barnard, Brady, and Gardner's wartime images signaled their belief in the power of photography as genre painting's equal and history painting's surrogate—art made in the moment rather than at a distant remove.

CAT. 32

George N. Barnard
Scene of General McPherson's Death, 1864 or 1866,
vintage albumen print, 10 × 14 ⅛ in. The Nelson-Atkins
Museum of Art, Kansas City, Missouri. Gift of Hallmark
Cards, Inc.

THE HUMAN FACE OF WAR

T he Civil War provided American artists with an opportunity to witness the combat firsthand, either in uniform or as civilian observers. But what must have seemed a chance to make or enhance a reputation painting history as it unfolded turned out to be very difficult to achieve. Expectations for a swift and bloodless victory made for colossal overconfidence for a country that had no standing army. Citizen soldiers discovered the gulf between patriotic rhetoric and the grim reality of armed combat. The internecine war meant your enemy had been your fellow American a short time before; in the heat of battle, all thoughts of brotherhood and reconciliation were replaced by the fervent desire to kill your opponent. The wounds left by the war—visible and physiological—were very real. Moreover, the stark images of bloated corpses from Antietam, on display in New York during October 1862, indelibly changed the way artists and their audience responded to images of war. Instead of valorizing combat, many painters used their works to reassert the empathy that battlefront experiences and postmortem photographs stripped away. Foremost among them Winslow Homer restored compassion for combatants in paintings that captured Walt Whitman's "real war." Drawing on their own wartime experiences, Homer and several of his colleagues passed over the battlefield narratives and individual heroics of history painting to focus on the common soldier. They strove for the metaphorical high ground by addressing the grief and ambiguity of his fratricidal war, seeking redemption and grasping at hope that this shattered country could be put back together.

In the first few months of the conflict, newspapers in both the North and South predicted a short, decisive

Our painters have worked in the midst of great events, and therefore subjected to the most tumultuous, shattering and ennobling experiences.

—Sordello [Eugene Benson]

war, and the initial enlistment commitments lasted thirty to ninety days. Some eager recruits signed up, convinced if they waited, the war would be over before they had a chance to fight. "Soldiering" sounded at the outset full of gallantry and patriotism; the reality as it set in proved to be far more grim. In the North, several of America's artists volunteered in the first wave of 75,000 recruits Lincoln called to defend Washington and the Union. Others went to the front as observers, eager to sketch what they saw and return with material for larger paintings. It was a struggle for all of them to find the right way to synthesize the war and find the universal chords of meaning in the conflict. The most successful of them were swift to recognize that the human face

FIG. 72
Edward Lamson Henry
*Departing for the Seat of War
from New Jersey,* 1869, oil on panel,
10 ¼ × 15 ¾ in. New York State Military
Museum, New York State Division of
Military and Naval Affairs

of war—the fate of the everyday soldier, the boredom of life in camp, and the trauma of surviving a battle—would make the most captivating images. Genre painters raised probing questions about the tenor, duration, and impact of the Civil War. Landscape painters faced a different challenge. For Union artist Sanford Robinson Gifford and Confederate artist Conrad Wise Chapman, service in the war led to a blend of landscape and narrative genre. Regardless of his preference for the figure or the landscape, each artist found ways to have individual soldiers stand in for larger principles. Moreover, embedded in these wartime paintings are echoes of each artist's personal experiences, evidence of psychological battle scars they carried for the rest of their lives.

THE SOLDIER IN THE LANDSCAPE

Sanford Gifford was among that first wave of volunteers. He enlisted along with writer Theodore Winthrop in the New York Seventh Regiment National Guard. This venerable regiment was among the first to affirm New York's allegiance to the federal government at the onset of the crisis.[1] On April 19, 1861, Winthrop marched down Broadway with the first wave of troops (fig. 72). The so-called "Silk Stocking" Regiment wore its traditional gray uniforms; there would not be standardized colors or regimental markings for either army for some time to come.[2] Gifford departed with the second wave of troops on April 24, sailing on the *Daylight* and landing at the Washington Navy Yard on April 30, when he was mustered into service.[3] The Seventh was initially bivouacked on the floor of the House of Representatives Chamber in the U.S. Capitol. Despite the shock of the bombardment of Fort Sumter that began on April 12, and the fear of imminent attack on the city of Washington, the anticipatory mood in the city quickly devolved into boredom as days stretched into weeks with no action. Winthrop lost no time in penning jaunty

essays to send back to the *Atlantic Monthly*, and Gifford was among those who wrote the occasional letter to the *Crayon* providing news as well. *Harper's Weekly* and the other illustrated newspapers and journals all had artists in town recording the bustling scene, and George Barnard was among Mathew Brady's photographers taking pictures of the regiments stationed in the city.[4]

Gifford was principally a landscape painter, and he used his three summers in uniform as he did his summer sketching trips in the Catskills, relying on pencil sketches of his comrades and surroundings made in bound paper sketchbooks. For this first tour Gifford did not bring a portable painting outfit, not knowing what action he might be seeing, and conscious as ever of the weight of his gear. As it turned out, the Seventh saw little action, due in part to the color of its uniforms and a general reluctance to put the scions of some of New York's wealthier families in harm's way. By June, Gifford realized he could have spared room for his paints, as an unnamed correspondent (possibly Gifford) wrote in the *Crayon*, "Our Seventh Regiment is still at Washington, and was at one time quartered in the midst of those panels in the House of Representatives, which you know were designed for national paintings. Why could not the artists of the 'Seventh' have had a premonition of this—it would have been so easy to have packed colors and brushes in their knapsacks, and have forced some good art on the government at the point of the bayonet.... sketched by artists on duty in defence [sic] of the Capitol, would not, dear *Crayon*, be insignificant or valueless to the country."[5] Despite this perceived liability, Gifford made good use of what free time he had to sketch the anecdotal aspects of camp life: tents, rifles, portraits of comrades and clusters of men, vignettes that would appear in each of his paintings relating directly to his wartime service.[6] In a chatty letter to the *Crayon*, he detailed the routines of daily camp life, most of which revolved around drills, formations, inspections, practice shooting, and free time.[7] In a letter to his Baltimore patron George Buchanan Coale, the artist distinguished between his "unwarlike" paintings and his "historico-military" pictures; in the latter, Gifford used the landscape to convey the setting and mood for his genre scenes of army life.[8]

In part thanks to the Seventh's relative inactivity, and in keeping with the spiritual side of his temperament, Gifford chose as his first subject *Preaching to the Troops, or Sunday Morning at Camp Cameron near Washington, May 1861* (cat. 33). However, even here his composition remains true to his calling as a landscape painter. The artist has softened the contours of the broad meadow to emphasize the bowl-like open space at the center, the ring of soldiers connected by something other than straight lines of military formation. The chaplain stands at a podium that has been draped with a large American flag. The symbolism is not subtle; the men fight for God and country, united under the same banner and by the same words. The members of the various regiments—Colonel Elmer E. Ellsworth's Fire Zouaves in their brightly dyed uniforms, the men of the Seventh in their traditional grays, and others—stand or lounge, clustered along the grassy perimeter or in the open field that slopes down from the artist's elevated vantage point to the wooded copse below. As Winthrop cheerily remarked for his friends back home, "As soon as the Seventh halt anywhere, or move anywhere, or camp anywhere, they resolve themselves into a grand tableau. Their own ranks should supply their own Horace Vernet."[9] Winthrop's readers would have recognized this reference to the prominent French artist, best known for his battle scenes. Beyond the camp, the land slopes down to the Potomac River from above Georgetown, near present-day Meridian Hill. As the chaplain speaks, his words are picked up on the clear morning air and carried across the distance. The sunlight underscores the benison offered by the sermon and affirms the righteousness of the Union cause.

Gifford took this opportunity to turn a military camp painting into a meditation on landscape as an arena of peace, a safe and restful place far from the battlefront. Many of the soldiers sit or lie on the grass, nestled into it, absorbed by it, as though the open meadow contained restorative powers like those of the chaplain's message of God's love. The composition echoes a sentiment espoused by Gifford and formulated by his close friend Candace Wheeler, "I have found that if we come close to the ground, real worries disappear."[10] The atmosphere in Gifford's painting is relaxed,

CAT. 33

Sanford Robinson Gifford
*Preaching to the Troops, or Sunday Morning at
Camp Cameron near Washington, May 1861,*
1862, oil on canvas, 16 × 30 in. The Union League
Club of New York

CAMP CAMERON, GEORGETOWN, D. C., THE ENCAMPMENT OF THE SEVENTH REGIMENT NEW YORK STATE MILITIA.—[See Page 331.]

SERVICE BY REV. DR. WESTON, CHAPLAIN OF THE SEVENTH REGIMENT, AT CAMP CAMERON, ON SUNDAY, MAY 5, 1861.—Sketched by our Special Artist.—[See Page 331.]

FIG. 73

Unidentified artist(s)
*Camp Cameron, Georgetown, D.C.,
The Encampment of the Seventh
Regiment New York State Militia*,
from *Harper's Weekly*, May 25, 1861,
wood engraving, Library of Congress

Unidentified artist(s)
*Service by Rev. Dr. Weston,
Chaplain of the Seventh Regiment,
at Camp Cameron, on Sunday May
5, 1861—Sketched by Our Special
Artist*, from *Harper's Weekly*,
May 25, 1861, wood engraving,
Library of Congress

the sense of calm and peace almost as palpable as the sunlight. *The Albion* reviewer seemed to understand this when he wrote of "the Chaplain officiating as the central figure, and his simply-uniformed audience scattered about at 'magnificent distances,'... more for the artist's happy grouping than for the reverend expounder's attractive eloquence."[11] In *Sunday Morning*, Gifford has painted a subtle yet visible sermon of his own.

Gifford's audience was already familiar with this part of the soldiers' routine. Descriptions and depictions of Sunday services in camp became a staple of the Civil War news media.[12] In the May 25, 1861 issue, *Harper's Weekly* ran a pair of wood engravings depicting Camp Cameron, with a crowd gathered for its Sunday services (fig. 73). The view of the encampment features rows of tents, Springfield rifles stacked in "teepee" formations, and soldiers at leisure. The engraving of Sunday services shows both military and visiting civilian attendees with the regimental band at left. Most such engravings focused on the participants, noting which generals were in attendance. The oil sketch Gifford

painted in his studio, titled *Sunday Prayers* (cat. 34), deviates from this convention, as he already envisioned his first war-picture as a landscape, the figures essential but so diminutive as to be an accent to the larger concerns of light and spirit. Gifford's interpretation of the Seventh Regiment's Sabbath underscores the artist's belief in the power of landscape to convey an essential experience of the war.

Gifford painted a second "historico-military" picture from this first tour, choosing a moment of calm following the one event that prompted the Seventh, and several other regiments, to break camp against the threat of attack. The night of May 24, 1861, the Seventh and Ellsworth's Fire Zouaves received orders to march by moonlight across the Long Bridge from Washington into Arlington, Virginia (fig. 74). While Ellsworth and his Zouaves diverted to capture Alexandria, Virginia, the Seventh's goal was to seize and fortify Arlington Heights—surmounted by the Custis-Lee Mansion, the home of Confederate General Robert E. Lee—across the Potomac River from Washington. There the Seventh

CAT. 34

Sanford Robinson Gifford
*Sunday Prayers (Study For Sunday
Morning in the Seventh Regiment Camp)*,
1862, oil on canvas, 7 × 12 ¼ in.
Private Collection

THE ADVANCE GUARD OF THE GRAND ARMY OF THE UNITED STATES CROSSING THE LONG BRIDGE OVER THE POTOMAC, AT 2 A.M. ON MAY 24, 1861.—[See Page 358.]

FIG. 74

Winslow Homer
The Advance Guard of the Grand Army of the United States Crossing the Long Bridge over the Potomac, at 2 a.m. on May 24, 1861, from *Harper's Weekly*, June 8, 1861, wood engraving, 9 ¼ × 13 ¼ in. Smithsonian American Art Museum, The Ray Austrian Collection, Gift of Beatrice L. Austrian, Caryl A. Austrian and James A. Austrian

spent the next few days digging trenches and building the fortifications of Fort Runyon, which became part of the perimeter defenses for the city of Washington.[13] Bone-tired from the work, the soldiers gratefully made camp. Gifford's finished painting of that scene, *Bivouac of the Seventh Regiment, Arlington Heights, Virginia* (cat. 35), places the artist and viewer at a remove from the camp. The soldiers gather around crackling camp-fires, clustered under the protective canopy of the trees. Dimly discerned figures move about the copse. On his list of "Chief Pictures," Gifford subtitled this painting "Moon and Firelight," bringing the war-related content into equilibrium with the atmospheric effects.[14] That bifurcation reflected the state of mind revealed in Gifford's letters and in so many soldiers' diaries, wherein men recorded the details of the day's marches and drills and waxed eloquent about the fields of wildflowers, or the breeze through the trees, or the quality of moonlight.

Arlington Heights and *Sunday Morning* present times of reflection in the company of strangers drawn together by the same cause. As pendants they extend beyond the

antipodes of time of day; they serve as the ends of the scales tipping from bright light, optimism of the sermon, and clear horizons to the dark, intimate space occupied by one's inner thoughts. The moonlit bivouac, after long days spent digging fortifications against an enemy who is not so different from yourself, inspires introspection rather than secure belief in the righteousness of a cause. Night is a time for second guessing, for living with a decision that can look very different in the clear light of day. These two paintings capture the swings in the artist's mood as well. Gifford's approach to life and to his art tended toward moody and atmospheric scenes, alternately buoyed by hope and tempered by doubt.

Gifford's inaugural tour with the Seventh lasted little more than a month. After its tasks of securing the city and strengthening the perimeter fortifications were complete, the Seventh was released from duty, and in June 1861 Gifford returned to New York and mustered out. His relief at coming home was manifest from the outset. It was not long before he was back in the Catskills, hiking and sketching with fellow landscape painters Jervis McEntee and Worthington Whittredge.

CAT. 35

Sanford Robinson Gifford
*Bivouac of the Seventh Regiment, Arlington
Heights, Virginia*, 1861, oil on canvas, 18 × 30 in.
New York State Military Museum, New York State
Division of Military and Naval Affairs

CAT. 36

Sanford Robinson Gifford
Basin of the Patapsco from Federal Hill,
Baltimore, 1862, 1862, oil on paper,
8 ³/₁₆ × 13 ½ in. Frank M. Gren,
"Annapolis Collection"

And yet as he prepared to display his first two war pictures, Gifford reenlisted with the Seventh for a second year's tour, and in early June 1862 he and his comrades were standing guard over the city of Baltimore. Although Maryland did not secede, it harbored deeply divided loyalties. The earliest credible assassination plot against Abraham Lincoln was to have taken place in Baltimore, and the city was rife with Confederate sympathizers known colloquially as "Sesech." Several of these men were also prominent art collectors, who deemed it more prudent to leave town. William T. Walters was among those who rode out the war years from the safety of England, his absence contributing to a depressive effect on the art market back home. For the Union army, Baltimore was an important strategic port and railroad city, and protecting it from falling into Confederate hands was a priority.

This time Gifford brought his paints along with him. In Baltimore the Seventh settled once again into a mind-numbing routine of drills and pickets. Writing to the Wheelers, Gifford mused, "I think often of my friends at home, of their quiet, peaceful lives, of my studio—of the green fields, and the grand mountains, where, but for these unhappy times, I would now be sitting on a camp stool under a peaceful umbrella."[15] Still, Gifford managed to visit with several of Baltimore's art collectors who extended invitations for dinners and excursions around the city when the artist could obtain a pass.[16] Art collector George Buchanan Coale was already well known to Gifford, McEntee, and other artists by 1860.[17] During Gifford's summer in Baltimore he spent time with the Coales and another local collector, David Bartlett, whose collection included works by fellow landscape painters Asher B. Durand and John F. Kensett.[18] Gifford managed to secure several commissions that year from Baltimore collectors.

From Fort Federal Hill, Gifford stood watch over Baltimore's inner harbor. At some point he translated

that quiet time into a small oil study, *Basin of the Patapsco from Federal Hill, Baltimore, 1862* (cat. 36). Not all of Gifford's oil sketches were painted on site or out of doors; however, *Basin of the Patapsco* captures the specificity characteristic of the artist's field work. His point of view takes in the swelling of the Patapsco River as it empties into the inner harbor, looking south-southeast toward Fells Point. The rising sun and low morning mist silhouette the spars of countless boats, and the sentry's bayoneted rifle echoes that staccato array. The light is muted and carries the early morning chill, the brushwork is vibrant and animated, as the artist's strokes dance across the wet-on-wet surface. The sketch captures a glorious moment of private pleasure at the near silence of a dawning day. That quality of intimacy, along with the artist's vibrant brushwork and light touch, contributes to its powerful appeal.

Gifford's temperament embraced the quality of solitude associated with guard duty. A fellow soldier from the Seventh, Frank Duryée, would go on to wax eloquent over such opportunities: "It was the time for the sentry pacing his lonely beat, to commune with his own soul, to think of home and friends, and all that were dear to him, or perhaps longing that some favorite and loved one could be by his side.... Such a night—to many a true and reverent hero was the time when he could look up to the placid moon and the radiant stars, and have his soul filled with glorious and holy thoughts of the world beyond, where the conflict of earth would at length be ended."[19] Gifford, or his surrogate, stands on the parapet, alone with his thoughts on a quiet night, watching the predawn glow over the city.

Loosely based on his oil sketch, Gifford's finished painting titled *Baltimore—Twilight. 1862,* now known by the title *Fort Federal Hill at Sunset, Baltimore* (cat. 37), abstracts the specifics of atmosphere and artillery and shifts the time to sunset, facing northwest, presenting a flaming sky descending rapidly into twilight. The sentry who stands atop the parapet, fully above the horizon, is most likely the artist himself.[20] While stationed in Washington and Baltimore, Gifford had several *cartes-de-visites* made. In one he posed next to a cannon, and in another (fig. 75) he stands ramrod straight, his posture and build bearing a strong resemblance to his painted

CAT. 37

Sanford Robinson Gifford
Fort Federal Hill at Sunset, Baltimore,
1862, oil on canvas, 18 × 32 in. New York State
Military Museum, New York State Division of
Military and Naval Affairs

soldier standing on guard. The foreground of the finished painting details the apparatus of war: stacked cannonballs, couched cannons, and wooden fortifications to support the parapet walls. Only the Columbiad, the giant cannon, shares the soldier's vantage point. Rigid and architectonic in form, sentry and cannon dwarf the steeples and the skyline. The sentry's bayonet plays off against the church steeples that break the horizon, a more subtle interplay of military prowess and spiritual certainty. Gifford's melancholic sunset manages to capture that sense of time frozen, with no evidence of the pulsing life of a port city. The finished painting likewise seems devoid of sound, as day retreats to the quiet of night. From field sketch to finished painting, Gifford moved from the more direct impression of the harbor at dawn to a more monumental and universal statement about vigilance.

When he placed *Fort Federal Hill at Sunset, Baltimore* on view in New York in the spring of 1863, one reviewer called it "the most pleasing of his works in the Exhibition. The solemn figure of the sentry against the bright evening red—the spires and domes of the distant city—the guns and piles of balls—and the long line of the parapet, are simply and exquisitely done. The picture is a poem."[21] Not all critics were so enchanted, though. The "effect" of the intense bands of color disturbed some viewers. Gifford lived with this picture longer than with the other three Civil War scenes, quite possibly due to its somewhat queasy palette and more abstract composition. The lurid sunset casts an eerie glow over the scene, adding to its disquieting qualities. Gifford's viewers remarked on its unsettling aspects, a reminder that this is not one of the artist's glorious Catskill sunsets.

Gifford's second tour, longer than his first, consumed the summer of 1862. He mustered out and was home by September 2, not long before his younger brother Edward mustered into Company A, 128th Regiment, New York State Volunteers, and headed out to Washington.[22] The artist spent the fall in the Berkshires and was at home in Hudson until mid-October. Gifford returned with the Seventh for a third and final year in June 1863, initially stationed once again outside Baltimore. At the end of the month, Robert E. Lee moved his Army of Northern Virginia into Pennsylvania, bringing the war to the North. It was a bold invasion, designed to tip the balance dramatically in favor of the Confederacy. Lee hoped to reverse what had become a costly war of attrition that the South seemed doomed to lose. On July 1, Confederate troops engaged in what would become the three-day Battle of Gettysburg, a turning point in the war. As that battle ended, the Seventh received orders to head for Monocacy, at the base of South Mountain in Maryland, in an attempt to cut off Lee's retreating army. The regiment arrived and began to make camp on July 7.[23]

The trip from Baltimore to South Mountain had been made through driving rain that turned the roads and fields to mud.[24] Gifford commemorated the storm's passing in an oil sketch painted on site, in which the weather also augurs a change in the fortunes of the war. *The Camp of the Seventh Regiment near Frederick, Maryland* (cat. 38) displays the artist's exuberant touch as he stippled in a cavalcade of tiny figures all orchestrated in the activity of camp life. The seated figure at far left appears to be the artist at work sketching. Here he has turned his back on the camp. Like the sentry in the oil sketch for Baltimore, he is absorbed in his own thoughts, reflected in the landscape and weather. At South Mountain, the sun finally breaks through the clouds. Shafts of light spread across the spongy turf and makeshift shelters, lighting the sodden clothing spread out to dry on every available surface. The mood conveyed by the change in the weather matches the mood of the soldiers in camp, who know that Lee's troops are now in full retreat, that General George G. Meade's Federal army has prevailed. Accompanying one of the divisions in hot pursuit was Gifford's friend and colleague Eastman Johnson, who had hitched a ride with a supply train commanded by Johnson's family friend, Colonel Hiram Hayes.[25] Johnson and Gifford were together in camp when Gifford painted this sketch. The date seemed worth remembering: Gifford used the butt of his brush to inscribe this oil sketch "July 9, 1863." His plein-air oil sketch captures a shift in mood on several fronts: from the drudgery of camp life to the pleasure of Johnson's company, from unrelenting rain to the promise of clear skies, and from a tense three-day battle to the news of a Union victory.

CAT. 38

Sanford Robinson Gifford
The Camp of the Seventh Regiment near
Frederick, Maryland, 1863, oil on canvas,
9 ½ × 15 ½ in. Private Collection

Within days of painting this oil sketch, Gifford and his comrades were recalled from the field to quell the draft riots that had erupted across New York City.[26] On the morning of Monday, July 13, the second day in the latest round of the draft lottery was scheduled to take place. Hundreds of railroad, shipyard, foundry, and construction workers failed to show up for work, instead beginning a campaign of violence and destruction. Rioters burned the building housing the draft lottery, threw bricks and stones through windows, burned private homes and government buildings, and terrorized the free black population.[27] Beyond the fear and resentment of yet another call for volunteers, rioters protested the "$300 clause," permitting draftees to pay to have someone take their place. Substitution of soldiers was legal and had been throughout the war, but now it took on the trappings of class warfare, as the rich could avoid serving while the poorer laborers and their families bore the brunt of wartime sacrifices and casualties. As the riots unfolded, blame fell in large part upon the Tammany Hall Democratic machine, prosecessionists, and the Irish immigrant community, many of whom were angry and fearful that newly freed Southern blacks would flood the city and take their jobs. By late Wednesday night, July 15, the first regiments recalled from the field arrived in the city; on Thursday morning, the city's police and militia, backed by the troops recalled from Gettysburg and its environs, quelled the riots and restored a semblance of order. As Gifford and the Seventh fought against fellow New Yorkers in the streets of Manhattan, it was, ironically, the only action they saw during the Civil War.[28] The draft riots gave an inkling of how deeply social and racial politics would continue to plague the Union even after the war.

Stunned by his riot experience, Gifford mustered out and decamped for the Adirondacks and the Catskills, spending the late summer and fall far from the war. When he returned to his studio, he painted his final composition drawn from his military experience, *Camp of the Seventh Regiment, near Frederick, Maryland,* *July, 1863* (cat. 39), drawn in large part from the vibrant oil sketch he had made in the field. Here the focus shifts to the frieze of army-related activity and away from the emotional and transformative power of the sunlight. Yet in its more polished state the scene still conveys a sense of relief that is palpable in the preliminary version. Gifford's larger-scale figures resemble his sentry from *Fort Federal Hill*, still somewhat stiff, frozen in their repetitive motions. The artist himself appears in the lower left, as in the oil sketch with his back turned to the camp, absorbed in making a sketch. In the center of the painting, Gifford included the sobering detail of a man pulling a tarp over a corpse, a grim reminder of the reality of war. In the wake of the riots, that body may have taken on greater meaning for the artist, evidence of the sacrifices required to restore order to the Union.

Gifford's "historico-military" pictures capture the human side of the war. They carry a gravitas unlike anything else in Gifford's oeuvre. These four large-scale paintings read as a suite—a formal, cadenced meditation on the artist's life in uniform. Unconcerned with troop maneuvers or battle strategy, unwilling to engage in retellings of exploits that changed the shape of the war, Gifford instead chose to focus on the small but profound moments that shaped his personal military experience. Sunday morning services conducted under a glowing spring sky, afternoon in camp as wet gear dries and the sun breaks through the clouds, the evening watch as a city goes to sleep, and the quiet conversations and crackling fires in camp as the troops bed down for the night: these are the moments of quiet camaraderie Gifford cherished. In both technique and composition these paintings are distinctive. The figures are the largest he would ever paint, and yet they remain secondary in importance to the landscape. Gifford's "historico-military" works create a hybrid form of history painting that blends the emotional resonance of his traditional landscapes with genre scenes drawn from his wartime service.

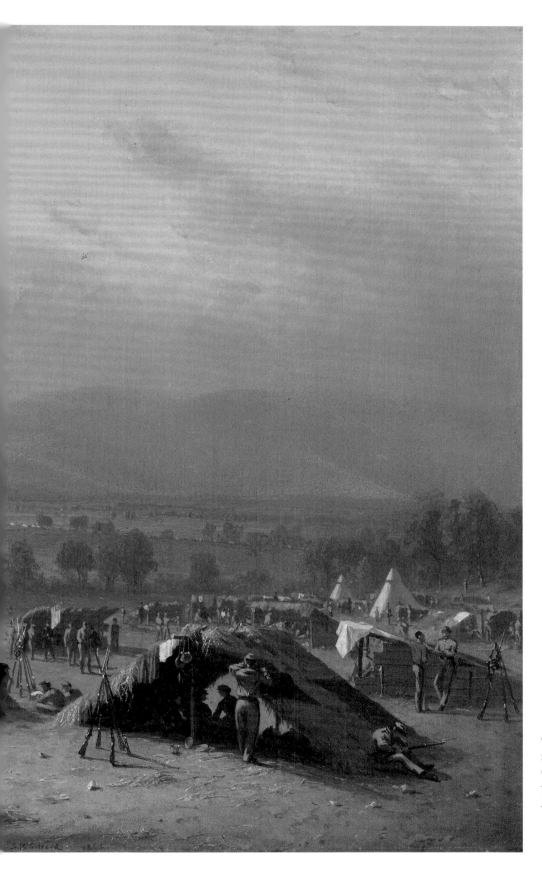

CAT. 39

Sanford Robinson Gifford
Camp of the Seventh Regiment, near Frederick,
Maryland, July, 1863, 1864, oil on canvas,
18 × 30 in. New York State Military Museum, New
York State Division of Military and Naval Affairs

THE CONFEDERATE POINT OF VIEW

Artists enlisted in the Confederate army as well, but painting the Southern perspective on the war proved more difficult. This problem stemmed from two inter-related developments. One was the war's rapid impact on the Southern economy. The other was the effectiveness of Northern blockades, which cut off supplies for artists and photographers. Without a robust economy, many Southern patrons cut back drastically on art purchases. A number of collectors in the border state of Maryland who were sympathetic to the Confederacy left for England or Europe, further diminishing the market for works of art. Illustrators like Adalbert Volck made a living selling drawings to the newspapers and journals; but the market for major paintings, regardless of subject, would have to wait long after the war to recover anything resembling its prewar vibrancy and strength.

Painters who enlisted fared slightly better, finding work as topographical engineers much as James Hope did for the Union army. Foremost among them was Confederate artist and soldier Conrad Wise Chapman (1842–1910, fig. 76). Chapman's career is not as well known as it should be, a legacy of the Union victory and the general disinterest in the art world for Confederate scenes in the decades following the war. Born in Washington, D.C., the youngest son of artist John Gadsby Chapman was raised in Rome as part of an ex-patriate family. Conrad, affectionately known to his family as "Coony," was a landscape painter at heart, although he frequently enliv-ened his paintings with vignettes drawn from his travels. Although he has occasionally been called the Winslow Homer of the South—mostly for having launched his career painting war-related subjects during the 1860s—in temperament and sensibility Chapman most closely resembled Sanford Gifford. Both had introspective personalities and during the war sketched their fellow soldiers in preparation for making larger paintings. Those paintings carry the anecdotal qualities of daily life in their regiments yet also transcend the conflict, revealing each artist's thoughts about the war.

FIG. 76

Unidentified photographer
Conrad Wise Chapman, about 1865,
Library of Virginia

Like Gifford, Chapman was also eager to enlist when war broke out. Conrad was a quintessential Confederate: his first loyalty was to his father's home state of Virginia. As he wrote in his memoir, he "always hailed from Virginia—which would have been the case had I been born in Italy." Of the forces that shaped his life, he continued, "my char-acter was formed in the armies of the South…for better or for worse I must abide by it." He was in Italy when war broke out; over his family's objections, he booked passage for his native land and was mustered into Company D, the Third Kentucky Infantry, at Bowling Green under General Albert Sidney Johnston on September 30, 1861, "for three years or the war."[29] Chapman proved adept at producing vignettes of camp life similar to those drawn by Gifford. However, unlike Gifford's experiences with the Seventh Regiment, Chapman saw action at the front. He suffered a serious head wound during his first major battle, the first day of the Battle of Shiloh on April 6, 1862. The self-inflicted wound was described as accidental, but it resem-bles many accounts of soldiers' reactions to the stress and trauma of actual combat situations.[30] Whether Chapman's injury contributed to or simply hastened his mental instabil-ity, it served as a turning point in this artist-soldier's career. When Chapman recovered consciousness, he recalled, "someone had propped him against a tree and the first thing his eyes met with was a beautiful little field of flowers grow-ing near by and welcoming him back to life."[31] The vision of a tranquil landscape may have temporarily soothed his soul, but his lengthy convalescence kept him in and out of vari-ous hospitals during the first year of his enlistment.[32] Finally his father prevailed upon their old family friend Henry S. Wise, former governor of Virginia and now a general in the Confederate army, to make sure Conrad was reassigned far from the seat of war for the remainder of his tour.[33]

Wise placed Chapman in a division of his own bri-gade, and in August 1862, the young artist found himself in Virginia as part of Company A, 46th Virginia Infantry. That fall and winter gave him plenty of time to sketch at the Chaffin's Farm and Diascund Bridge encampments, strate-gically placed to discourage further attacks on Richmond in the wake of McClellan's Peninsular Campaign. In July 1863, Wise transferred Chapman to Company B, 59th Virginia Infantry, as an ordnance sergeant. Chapman's painting *The Fifty-ninth Virginia Infantry—Wise's Brigade* (cat. 40),

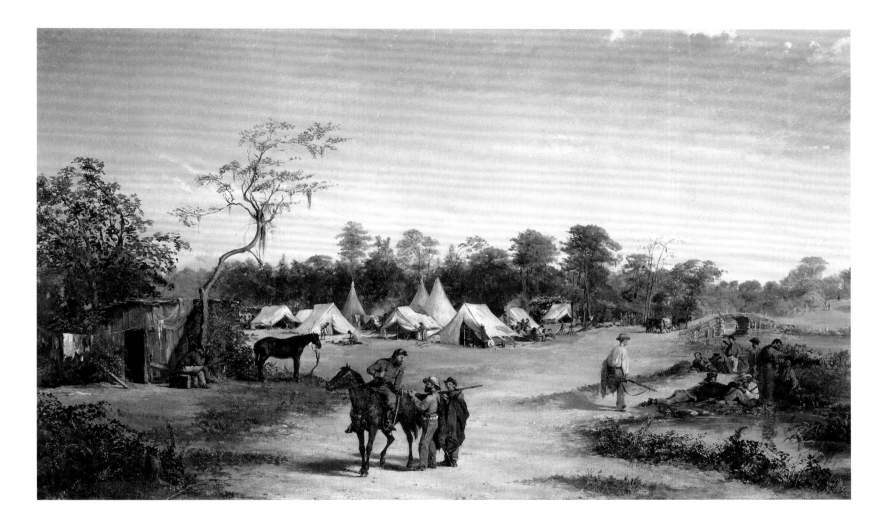

CAT. 40

Conrad Wise Chapman
The Fifty-ninth Virginia Infantry—Wise's
Brigade, about 1867, oil on canvas, 20 ⅛ × 33 ⅞ in.
Amon Carter Museum of American Art, Fort Worth,
Texas

probably painted several years after the end of the war, recalls Gifford's scenes of camp life in which bored inactivity prevails. The mounted officer arriving in the camp is the regiment commander, Colonel William B. Tabb; one of the soldiers chatting with him resembles the artist.[34] Other soldiers play cards, lounge in the heat, or take care of mundane tasks. Their informal dress and incomplete uniforms remind viewers that Confederate forces, like their Union counterparts, were not always provided with full or matching uniforms.

FIG. 77

Unidentified photographer
General Pierre G. T. Beauregard,
about 1860–1870, Library of Congress

During the week of July 11 to 17, 1863, the Union army made several advances on Charleston. The ill-fated charge against Fort Wagner by Robert Gould Shaw's Massachusetts 54th Regiment of colored troops showed the vulnerability of Charleston's Confederate defenses. As a consequence, the following week, the Virginia 59th was reassigned to Charleston to help defend the city against renewed Federal attacks. There, Chapman's fortunes changed again. General Pierre Gustave Toutant Beauregard (fig. 77) was in charge of the fortifications surrounding Charleston. Wise extolled Chapman's drafting skills to the general, and by mid-September Beauregard directed the artist to begin sketching the city's battlements and forts to accompany a "Journal of the Siege of Charleston" he had ordered written.[35] Beauregard had been busy making improvements to the city's defenses, and it is possible he gave Chapman specific instructions for what he wanted him to sketch. He must have liked what he saw; he appeared to take personal interest in Chapman's work and eventually owned several of the artist's images.[36] Beauregard was essentially the sole arts patron in the city, able to offer meaningful work to his artists in uniform. Chapman eagerly set to work, sketching in pencil as a preliminary to making a suite of small paintings.

Chapman was not the only artist working in Charleston, nor the only one sketching for the Confederate army. Maryland-born John Ross Key, grandson of national anthem lyricist Francis Scott Key, was a second lieutenant in the Engineer Corps.

Beauregard called John Ross Key "a young artist of great promise" and set him to work depicting the harbor.[37] His sketches culminated in a large 1865 painting titled *Bombardment of Fort Sumter, Siege of Charleston Harbor, 1863* (fig. 78).[38] Charleston-born artist William Aiken Walker, by then a veteran of the Battle of Seven Pines in Virginia, was also in town. Wounded in action, Walker had spent the rest of 1862 into 1863 in the Confederate Engineer Corps as a cartographer and draftsman. He, like Key, was detailed to draw maps and sketch the defenses of Charleston.[39] All three artists would contribute drawings for Beauregard's publication on the fortifications of the city. Key's would end up being used as illustrations, possibly due to his ability to focus on the military architecture rather than Chapman's preference for capturing the atmospheric landscape setting. Chapman, Key, and Walker formed the artistic milieu of wartime Charleston, where there was now virtually no private market for their paintings.

Chapman's most significant wartime works were a suite of thirty-one small paintings intended to document the fortifications surrounding Charleston's harbor. Although they were assigned by Beauregard as a military exercise, it is not clear if Beauregard had specified a particular number of views or subjects, and it is likely the artist chose scenes of personal interest as well. In addition to sketching fortifications, Chapman appeared fascinated by the Confederacy's attempts to repel the Federal navy, which was resting at anchor in Charleston Harbor. He prowled the docks and made sketches for a painting of the *Submarine Torpedo Boat H. L. Hunley Dec 6 1863* (cat. 41), a small, primitive submersible that the Confederacy hoped would counter the threat of Union ironclads. Chapman's painting of the *Hunley* is exquisitely detailed, the product of time apparently spent with Horace Lawson Hunley, its inventor, and the vessel itself.[40] Hunley stands casually with a seated sentinel, who is most likely the artist himself. Unstable and prone to sinking, the *Hunley* carried a torpedo attached to a pole extending in front of the nose. This required its crew to sail up close to the target before unleashing the charge, with the hope of being able to retreat far enough away to avoid being blown up as well. It was a dangerous concept and proved disastrous to its crews.

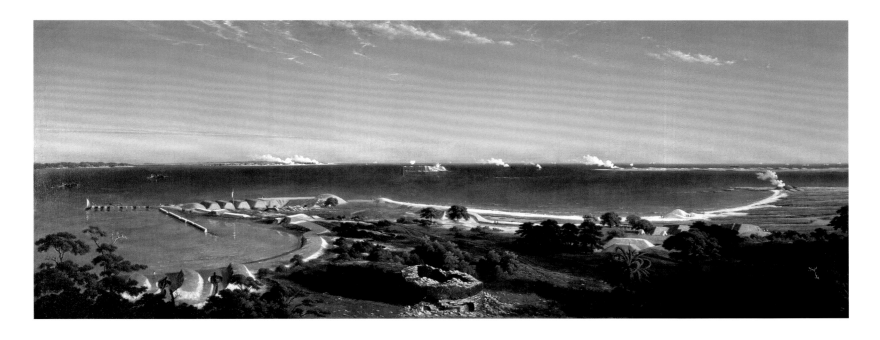

FIG. 78

John Ross Key
Bombardment of Fort Sumter, Siege of Charleston Harbor, 1863, 1865, oil on canvas, 29 × 69 in.
Greenville County Museum of Art

In August and October of 1863, the *Hunley* attempted to sink Union ships blockading the harbor; both times the vessel sank, killing its crew. According to the artist, "After this had happened the second time, some one painted on it the word 'Coffin.' ... The third time it started out, it never came back, nor was anything ever heard from it, but as soon as one of the United States men-of-war in the harbor (USS *Housatonic*) was sunk at about the same time, the supposition was that they both went to the bottom together."[41] Chapman painted the *Hunley* before it went down with that third and final crew on February 17, 1864. In this painting and in another of the submersible *David* in dry dock, Chapman was fascinated by the Confederate forces' creative if ultimately doomed attempts to counter the Union navy's threats.

Viewed together, the majority of Chapman's paintings convey the artist's pride in the Confederacy, tempered with growing concern as the war dragged on, filtered through the sensibility of a landscape painter. Like Gifford, Chapman's approach to his assignment often focused on the changeable skies over the forts and batteries ringing Charleston harbor. Between September 1863 and late February 1864, he made a circuit of the harbor, beginning with Fort Moultrie. Before long his attention turned to Fort Sumter, a locus of pride for the

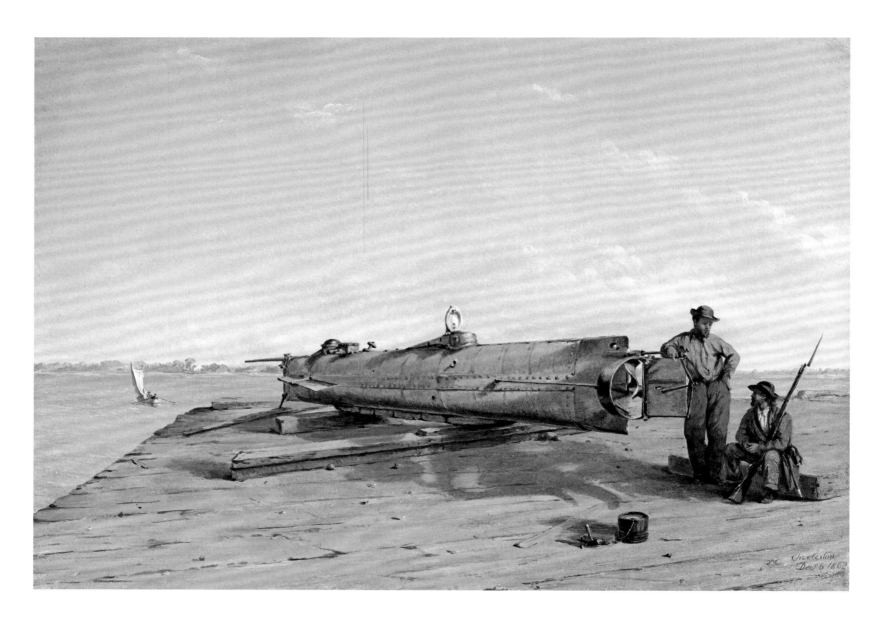

CAT. 41

Conrad Wise Chapman
Submarine Torpedo Boat H. L. Hunley
Dec 6 1863, 1863–1864, oil on board,
11 ½ × 15 ½ in. The Museum of the
Confederacy, Richmond, Virginia

Confederacy. It was here that the nascent Confederacy had shelled the Federal fort in April 1861, forcing Major Robert Anderson to evacuate, thereby starting the war. Now this same fort was being bombarded relentlessly by the Federal navy, which was anchored in the harbor. In defiance of common sense but as a point of pride, an enormous Confederate flag was raised each morning and retired each evening, accompanied by the salute of a thirty-two-pounder cannonade. The flag became an obvious target, and the flagpole was repeatedly shattered and replaced.

Chapman painted two works featuring the Confederate flag flying over the fort. *The Flag of Sumter, Oct 20 1863* (cat. 42) presents the flag waving from the fort at sundown, having survived another day's shelling.[42] A sentry stands atop the gorge wall, gazing out toward Cummings Point, where the Union blockade sat at anchor. *Evening Gun, Fort Sumter* (cat. 43) exists as a copy made by the artist's father.[43] The twisted artillery strewn on the slope below the fort bore witness to the effectiveness of the Federal volleys, their shattered forms a sober reminder of the human casualties resulting from the bombardment. In both paintings, the note of defiance conveyed by the waving flag, set against an evocative sky, underscores the patriotic significance accrued to this site. As Chapman painted the fort that October, Beauregard termed Sumter "the post of honor... on which the eye of the whole country is now fixed."[44] In both paintings Chapman presents the beleaguered structure as a grand ruin, damaged but still capable of providing an effective defense against the Union barrage. His paintings, far from the straightforward documentation of Beauregard's enhanced fortifications, incorporated the artist's emotional investment in the Confederacy and its ideals. Under dramatic skies, the flag snaps defiantly in a strong breeze. Sumter is an embattled landscape, its survival emblematic of the artist's faith in the Confederacy.

On the evening of December 7, 1863, Chapman and Key rowed out to Sumter with "orders to execute sketches and take views of the historic ruin" after the most recent shelling had ceased.[45] Sketching side by side, the two artists spent three days at the fort. The damage was extensive, prompting Chapman to paint his most poignant and effective wartime painting of the fort's bombed interior. The early morning light reflected in the puddles in *Fort Sumter, Interior, Sunrise, Dec. 9 1863* (cat. 44) illuminates the devastated ruin, which looks as much like a crater as a fortification. Sober and yet serene, the view brings into focus the desperation as well as the hope associated with the defense of Charleston— and, by extension, the Confederate cause. A Southern engineer writing home summed it up effectively: "The ruin was beautiful. But it is more than this, it is emblematic also.... Is it not in some respects an image of the human soul, once ruined by the fall, yet with gleams of beauty and energetic striving after strength, surrounded by dangers, and watching, against its foes?"[46] Chapman's painting captures that blend of emotions, blurring pride with futility and hope with despair. His composition brings to mind pictures of the Roman Coliseum, a site undoubtedly familiar from Chapman's youth. The glories of the Greek and Roman empires formed a cherished point of comparison for the prewar South. In 1864 Professor Tayler Lewis wrote a book titled *State Rights: A Photograph from the Ruins of Ancient Greece*, in which he opined that what had toppled the Greek empire was a desire for "petty sovereignty" of each state over the divinely ordained nation. Drawing a deliberate parallel, he wrote, "God has given us a mirror in the past," predicting the fall of the Confederacy on corrupt moral grounds.[47] Chapman might have disagreed with Lewis's conclusions, but he could not help invoking the might of earlier empires in his paintings of Fort Sumter.

Chapman balanced his emotional investment in Sumter with several paintings in which he focused on the architectural geometries of the fortifications. *Fort Sumter [Gun Gallery] Dec 8th 1863* (cat. 45) documents one of Beauregard's most effective improvements to the harbor defenses. The general had ordered three large cannons installed facing northeast, which in Chapman's words "commanded the only point in the harbor that was out of reach from Fort Moultrie on one side, and Fort Johnson on the other. The Yankees were entirely unaware of the existence of these three guns, and when the United States ship *Keokuk* attempted to pass through that part of the channel which could not be reached by the guns from the forts above mentioned,

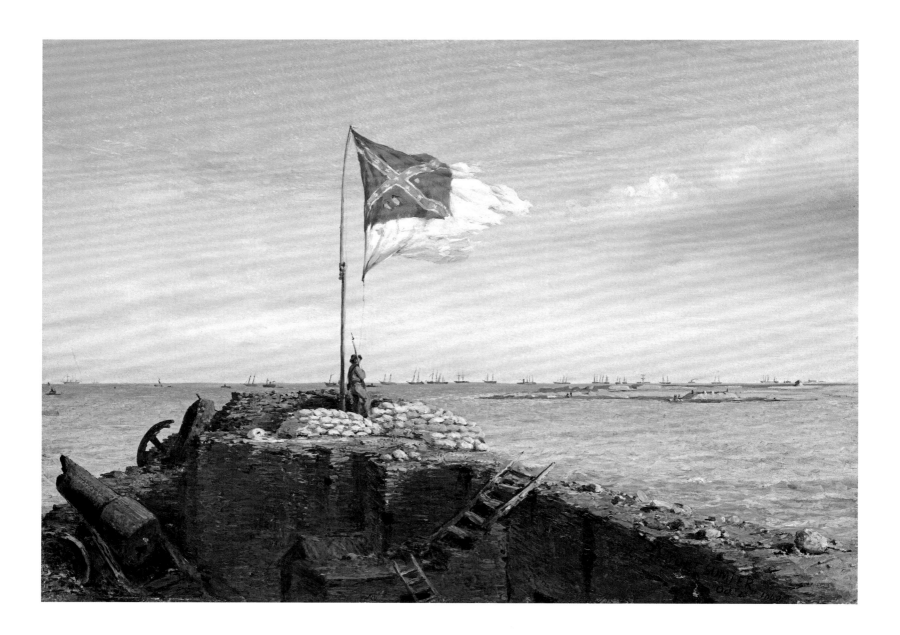

CAT. 42

Conrad Wise Chapman
The Flag of Sumter, Oct 20 1863,
1863–1864, oil on board, 11 ½ × 15 ½ in.
The Museum of the Confederacy, Richmond,
Virginia

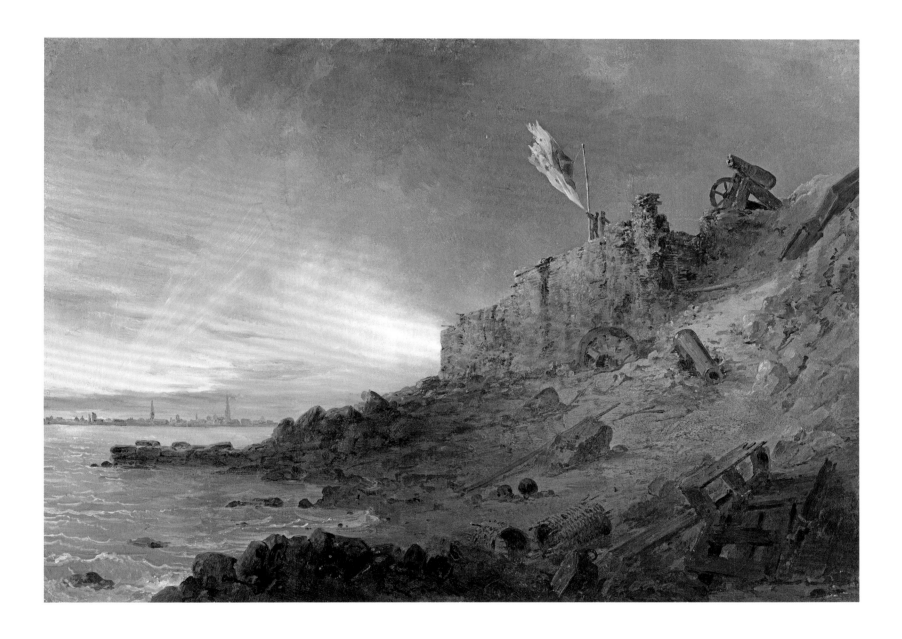

CAT. 43

John Gadsby Chapman
Evening Gun, Fort Sumter, 1863–1864,
oil on board, 11 ½ × 15 ½ in. The Museum of
the Confederacy, Richmond, Virginia

CAT. 44

Conrad Wise Chapman
Fort Sumter, Interior, Sunrise, Dec. 9 1863,
1863–1864, oil on board, 11 ½ × 15 ½ in.
The Museum of the Confederacy,
Richmond, Virginia

CAT. 45

Conrad Wise Chapman
Fort Sumter [Gun Gallery] Dec 8th 1863,
1863–1864, oil on board, 11 ½ × 15 ½ in.
The Museum of the Confederacy,
Richmond, Virginia

she was sunk by the shots from these three guns."[48] Chapman focused on the claustrophobic view of the gallery, where the casemates for the guns doubled as sleeping cots for the attending soldiers. Steeped in Roman architecture from his youth spent in Italy, Chapman was fascinated by the architectonic gravitas of these subterranean arches. These sturdy vaulted spaces, resembling medieval undercrofts, became a focal point equally as compelling as the guns within them.

The bulk of Chapman's remaining paintings are of the batteries lining the perimeter of the harbor, Beauregard's signature accomplishment in strengthening the Confederate defenses. Two of them carry over the artist's fascination with the geometries of military architecture. In *White Point Battery Charleston Dec. 24th 1863* (cat. 46), Chapman paints the sculpted dunes of the fort encircling activities ranging from military preparations to families picnicking on the grass. On the left, Beauregard and his engineers work on what the artist called "the big gun," apparently more impressive in girth than in effectiveness.[49] Chapman juxtaposed the seriousness of their work with the more lighthearted vignette of visitors to the fort, women and children coming to watch the preparations and pay a call on the soldiers. He invests this small work with a surreal quality, pointing out the disconnect inherent in daily life in the midst of war. He himself appears in the foreground, walking eagerly toward the visiting families, dressed in his familiar coonskin hat.[50] That desire for normalcy in the midst of the conflict recalls Gifford's yearning for the company of his friends back home.

Chapman spent the Christmas holiday with friends in Greenville, South Carolina, injecting a note of personal pleasure in his own daily routine. He resumed his sketching duties at Battery Laurens, on the Cooper River, painting *Battery Laurens Street Charleston Feb 7th 1864* (cat. 47). Here his sentry on picket maintains the same stiff posture as Gifford's sentry overlooking Baltimore (see cats. 36 and 37). The similarities between Gifford's service in Baltimore and Chapman's in Charleston are never more evident than in this work. Both artists create landscapes defined by the conflict. The rigid geometry of Chapman's pyramid of stacked cannonballs, flight of steps, and elements of the square

courtyard is balanced by the curve of the earthen fortifications that sculpt the coastal dunes into a military landscape. Chapman's harbor is much more active than Gifford's, in keeping with his purpose in calling attention to the strength of the Confederate forces. He included a "school ship," used to train recruits, steaming by as a Confederate gunboat enters the harbor under the watchful eyes of the men stationed on the nearby batteries. As with Gifford, the sky conveys the emotional pitch of each painting, and in these two works the serene skies match the tenor of the activity.

The sense of watchful calm evident in Chapman's architecturally inspired compositions gives way to a more animated perspective in his oil sketch of *Battery Bee, Dec. 3, 1863*, in which the artist focused on the soldiers at a change of duty (cat. 48). Here the relaxed pose of the assembled soldiers mirrors the slumped dunes of the fortifications, suggesting the effort required to keep both men and dunes in fighting trim. That these men could rise to action becomes clear in the painting *Battery Simkins Feb 25 1864* (cat. 49). A Union shell explodes overhead, while Confederate soldiers bring up ammunition to return fire. A soldier running toward the battery ducks his head, covering his ears against the concussion. Chapman's subject is the tense drama of the exploding shells rather than the battery itself. The artist apparently thrived under the duress of the constant bombardment and made his sketches during some of the fiercest fire, between October 20 and 25, 1863. Chapman recorded that in the ensuing weeks he "never looked in the direction of Fort Sumter that he did not see a shell bursting over it."[51] John S. Wise, the general's son, recalled the artist working "under the severe bombardment of the Federal forts and fleets. Often he sat on the ramparts of Sumter [and] other forts under a heavy cannonade, while painting these pictures, and those who saw him, said he minded it no more than if he had been listening to the post band. Chapman held cannon-balls and shells in great contempt."[52] Chapman's response to the shelling was echoed by numerous soldiers who seemed to relish being in danger, a situation that allowed adrenalin to temporarily cancel out fear.[53] Here again the dunes are pocked with the damage caused by Federal shells, and Chapman's darkening

CAT. 46

Conrad Wise Chapman
White Point Battery Charleston Dec. 24th 1863,
1863–1864, oil on board, 11 ½ × 15 ½ in.
The Museum of the Confederacy,
Richmond, Virginia

CAT. 47

Conrad Wise Chapman
Battery Laurens Street Charleston Feb 7th 1864,
1863–1864, oil on board, 11 ½ × 15 ½ in.
The Museum of the Confederacy, Richmond, Virginia

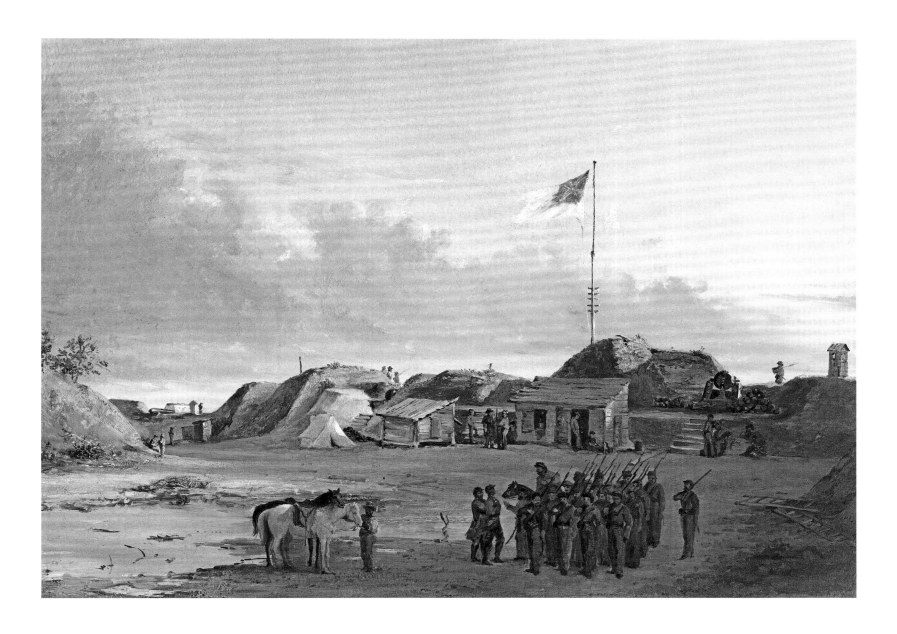

CAT. 48

Conrad Wise Chapman
Battery Bee, Dec. 3, 1863,
1863–1864, oil on board, 11 ½ × 15 ½ in.
The Museum of the Confederacy, Richmond, Virginia

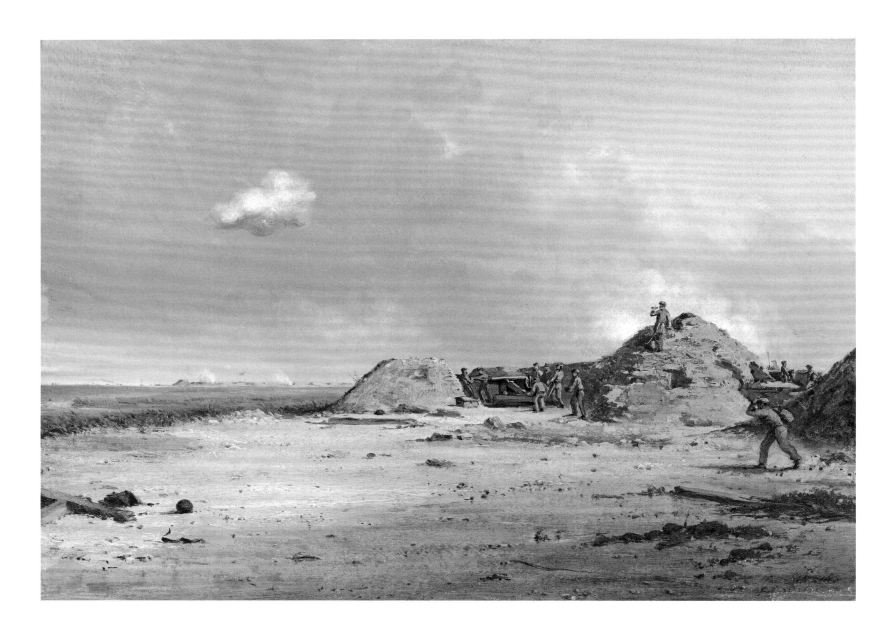

CAT. 49

Conrad Wise Chapman
Battery Simkins Feb 25 1864, 1864,
oil on board, 11 ½ × 15 ½ in.
The Museum of the Confederacy,
Richmond, Virginia

sky suggests thunderstorms as much as the concussive blasts of each volley. In *Battery Simkins* and in *Fort Sumter, Interior, Sunrise*, Chapman is less concerned with the specifics of the fortifications, instead deploying the landscape to allow his viewers to experience the emotional heart of the war.

The date on *Battery Simkins* does not correlate with a recorded bombardment; in fact the dates on most of Conrad's paintings present a much-discussed conundrum. According to his older brother, John Linton Chapman, Conrad "painted some of the pictures while the engagements with the enemy were in action and completed them in Rome before the end of the War."[54] John Wise recalled that "the dates on the pictures themselves show exactly when he painted them, as well as the names of the pictures."[55] In some cases the date on the painting or its frame matches the date Chapman made his preliminary on-site pencil sketches; in other cases those dates appear to correspond to the date the artist painted the work. It remains unclear whether or why Chapman would have back-dated a painting to match the sketch, unless there was to be some correlation between the two for Beauregard's military purposes.[56] Chapman intended to paint the entire series in Charleston, but when he received word of his mother's illness, he requested a furlough to visit his family in Rome. After lengthy delays Chapman finally left Charleston in April 1864.[57] He took his sketches with him. For the rest of the year and with the help of his father, they painted the thirty-one extant works. They may be the only set of battle subjects painted by a Confederate army artist during the war. Chapman hoped to create a niche market for copies of his paintings, and etchings that his father made after several of them, but these hopes were never realized.[58] The family's pronounced Confederate leanings made them unpopular in Rome, where few American expatriates were Southern sympathizers.

By the time Conrad returned from his furlough, Robert E. Lee was on the verge of surrender, and the end of the Civil War was close at hand. As an unreconstructed Confederate, unwilling to accept the Union victory, Chapman's only safe port of entry was in Texas or Mexico. On April 3, 1865, he arrived in the Confederate port of Bagdad, Mexico; from there the disillusioned artist and soldier eventually joined a band of equally embittered veterans under Confederate generals Jubal Early and John B. Magruder, who offered their services to Emperor Maximilian I in Vera Cruz. Described as having "an undying hatred to the Yankees," Chapman renounced "the idea that he could or would live in the United States."[59] Instead the young artist tried to restart his artistic career painting the local landscape, and by 1866 he had made enough money to pay for his return passage to Rome. He was twenty-six years old.

In Rome, Chapman resumed painting Civil War subjects. It was at this time he probably painted his larger, more complete camp scenes, including his *The Fifty-ninth Virginia Infantry—Wise's Brigade*. His largest and most ambitious canvases, among them *Bombardment of Fort Moultrie, Charleston Harbor, South Carolina* (Gibbes Museum of Art, Charleston, SC) and *Interior of Fort Sumter* (The Valentine Richmond History Center, Richmond, VA), adopted the same long, attenuated, and arched-top compositions favored by his father and brother. Like Gifford's larger-scale war pictures, his panoramas lacked the brilliant spark and lively brushwork of the smaller oil sketches. Chapman clearly responded to nature in a manner consonant with Gifford. His weather seems real and captures the shifts of the coastal fronts; his soldiers are equally bored. Their small-scale paintings are vibrant, the lively brushwork conveying each artist's enthusiasm for his task. The landscape often supersedes the nominal military subject in keeping with their personal interests. Their large-scale war paintings also share a similar stiffness, as both artists were more comfortable situating tiny figures and anecdotal activity in a landscape than in showing larger-scale participants in a panoramic genre scene.

Chapman's postwar career highlights the extreme difficulty of sustaining an artistic career in the South. There was no major patronage during the war and little ability to support artistic activity afterward. The artist's Confederate leanings made his work unpopular with the Northern collecting mainstream, and Chapman appears not to have been operating in the circles that would have introduced him to Southern sympathizers like William T. Walters of Baltimore or William W. Corcoran of Washington. Chapman's works were evidence of a

gamble that, should the South prevail, victory might have positioned him to be an artist of some repute. Instead he struggled to obtain the commissions necessary to sustain his career and his family. Because the war had ended by the time Chapman returned, his paintings were never handed over either to the Confederate army or to Beauregard. According to Conrad's brother, John Linton Chapman, the Charleston paintings remained together in Italy, where their father could conveniently make copies

for any interested buyers.[60] As his son descended into mental instability, John Gadsby Chapman recognized the potential value in maintaining Conrad's set of paintings together, and it was with that hope that the family agreed to exhibit the set of works at the Union League Club in New York in 1898. Although they were favorably reviewed, the paintings did not sell.[61] John Wise bitterly—and quite possibly correctly—assumed this was due to "the secret, though not expressed, feeling that they all displayed the Confederate flag."[62] The following year John Linton Chapman finally found a sympathetic buyer and sold the set to Richmond native Granville Valentine. Tucked away in a private collection, and eventually in a museum devoted to the Confederacy, Chapman's paintings remained mostly unknown. His small, lyrical views of Charleston provide an important insight into the power of art both to document and to transcend the conflict.

THE ARTIST AS OBSERVER

For the artists who traveled to observe the war, the experience of being in camp could be quite different from that of their soldier-artist colleagues. In October 1861, at a time of relative calm, Albert Bierstadt and Emanuel Leutze obtained a five-day pass from General Winfield Scott to visit the Federal troops encamped on both sides of the Potomac River north of Washington. Over the summer Leutze had arrived in Washington to begin painting a mural ostensibly on westward expansion in the stair hall of the U.S. Capitol building. There he encountered the soldiers of the Seventh bivouacked on the floor of the Capitol building.[63] He sketched them there and, after the Seventh moved to Camp Cameron, made the two-mile trek north from Willard's Hotel to reach the camp and made further sketches.[64] Leutze was back on the palisades, where he and Bierstadt visited with their artist friends in the various regiments and made sketches of the camp. The result was a work by Bierstadt titled *Guerrilla Warfare, Civil War* (cat. 50), which maintains a curiously emotionally neutral position. This would be Bierstadt's only exposure to the war; when drafted in August 1863, he paid for a substitute to take his place.[65]

Photography played an important role in composing scenes, particularly for those artists like Bierstadt whose firsthand experience was confined to the sidelines. Bierstadt's brother, Edward, had set up a temporary photography studio along with several rival firms at Langley's Tavern, seven miles above Georgetown on the Virginia side of the Potomac River. Positioned next to the camp of the 43rd New York Infantry, Edward did a brisk business in *cartes-de-visites* and camp photos. Albert Bierstadt composed *Guerrilla Warfare* based largely on a stereo photograph he picked up from Edward (fig. 79) and another issued by the rival firm of Dodge, Collier and Perkins of Boston (fig. 80). The Bierstadt Brothers photograph shows a group of Confederate prisoners

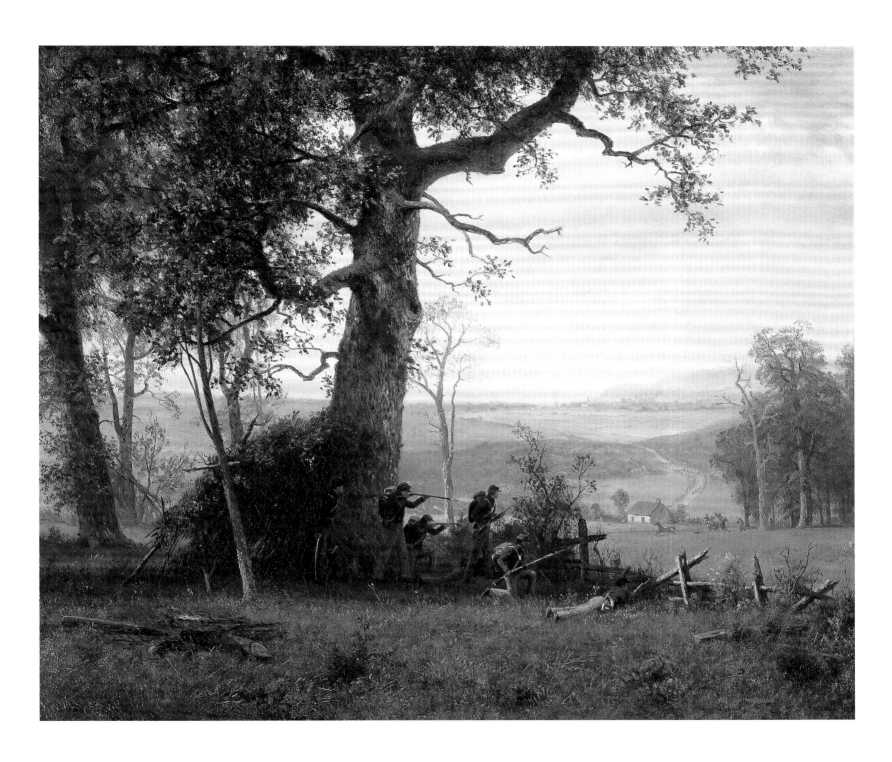

CAT. 50

Albert Bierstadt
Guerrilla Warfare, Civil War, 1862, oil on panel,
15 ½ × 18 ⅜ in. The Century Association, New York

captured near Lewinsville; the stately oak tree behind them anchors both the photograph and Albert's painting. But Albert Bierstadt adapted the Dodge image in arraying the group of Union sharpshooters behind that tree. Forming the focal point of the painting, the sharpshooters' target horsemen gallop across the field at a distance; yet the sunny day and pleasant environs fail to create any sense of tension or animosity. Bierstadt and Leutze may have witnessed such skirmishes between the armies. The following year author Charles Dickens traveled with Union General George B. McClellan from Washington to Manassas in early March of 1862. There he found a Confederate soldier's diary that included mention of harassing the Union army sharpshooters at Lewinsville in the days leading up to October 17, when the soldier's voice fell silent.[66] Bierstadt returned to his studio and quickly completed this painting. On December 26, 1861, he exhibited *Guerrilla Warfare* at the Brooklyn Art Association, at the Academy of Music.[67] The review stated, "Bierstadt gives a good war piece—an effective representation of Picket Duty by the 7th Regiment in Virginia. It is much admired."[68] His painting is quintessentially that of a voyeur, privy to the stories and unblemished by the violence and brutality of first-hand combat experience. There are no scars here; the encounter taking place carries none of the personal investment central to Gifford's and Chapman's works.

WINSLOW HOMER'S CIVIL WAR

The same day that Bierstadt and Leutze received their pass to visit the troops outside Washington, a young artist named Winslow Homer (1836–1910, fig. 81) received his own permission from McClellan's staff to pass "within the line of the main guards for a week."[69] He was working for *Harper's Weekly* and making his first trip to the seat of war, his intent being to "go with the skirmishers in the next battle."[70] As Bierstadt had discovered, there were no battles around the city of Washington.[71] On his next visit, some six months later, Homer encountered the "real

war," attached to his family friend Lieutenant Colonel Francis Channing Barlow's regiment at Yorktown, Virginia.[72] Homer's wartime experiences were intertwined with those of Barlow and fellow officer Nelson Miles, beginning with the Peninsular Campaign in April 1862 and culminating at Appomattox three years later.[73] Although he never donned a uniform, Homer's experience of the Civil War was markedly different from that of every other artist, North or South. He never fired a shot, but he captured the essence of warfare in his paintings.

Winslow Homer came of age as a painter with the Civil War. His paintings and several of his wood engravings from the war years offer a window into his own maturation as an artist. In his two months at Yorktown with Barlow in 1862 he experienced the boredom of camp life, but also the cold, calculating brutality of the month-long siege. Accompanying Barlow's division were Colonel Hiram Berdan's Sharpshooters, a highly regarded corps of riflemen noted for their marksmanship. Beginning with his image titled *The Army of the Potomac—A Sharp-shooter on Picket Duty* (fig. 82), published in the November 15, 1862 issue of *Harper's Weekly*, Homer's wood engravings began to reach beyond anecdotal reportage. In this engraving, Homer has positioned his sharpshooter perched in a pine tree. Camouflaged from the enemy's sight, Homer's Union soldier coldly takes aim. His weapon securely couched against one shoulder, with his other arm he braces himself against the recoil of his rifle, calmly and deliberately waiting for a clean shot. His canteen hangs from a nearby limb, alluding to the length of time he expected to remain aloft. Man, rifle, and canteen together suggest a set of scales depending from the rifle barrel. Homer's allusion is to scales of justice, or the weighing of souls, but here there is no fair trial. Instead the cold steel of a rifle barrel substitutes for humane judgment, making plain the life-or-death seriousness of the shooter's task.

Scholars have long noted the inscription on this print that refers to Homer having already completed the corresponding painting, which would make Homer's *Sharpshooter* (cat. 51) his earliest finished painting from the war, although not the first he would display publicly. Homer's painting hews closely to the composition of the print, save for the omission of the canteen. All we see are

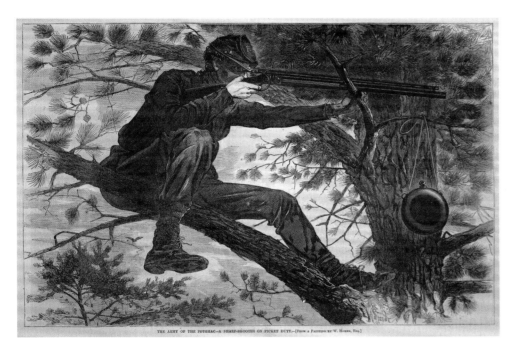

THE ARMY OF THE POTOMAC—A SHARP-SHOOTER ON PICKET DUTY.—[From a Painting by W. Homer, Esq.]

FIG. 82

Winslow Homer
The Army of the Potomac—A Sharp-shooter on Picket Duty, from *Harper's Weekly*, November 15, 1862, wood engraving, 9 ⅛ × 13 ¾ in. Smithsonian American Art Museum, The Ray Austrian Collection, Gift of Beatrice L. Austrian, Caryl A. Austrian and James A. Austrian

FIG. 83

Winslow Homer
Page four of a Winslow Homer letter to George G. Briggs (detail), February 19, 1896, Winslow Homer Collection, Archives of American Art, Smithsonian Institution

the camouflaging pine boughs and Homer's intently focused soldier, taking aim at an unseen and unsuspecting adversary. The clinical chill of the exercise and Homer's own perspective as a close-in observer or fellow shooter makes it impossible for the viewer to recoil from the cold-blooded act. Sharpshooters were often stationed high up in trees, using the foliage for cover. They also employed hollowed out, dead trees as camouflage.[74] Whether prone, standing, or hidden in a tree, sharpshooters were the most revered and feared members of the military. Homer captures both the dread and awe in his painting, refusing to romanticize either his prowess or his function. His experience sketching for *Harper's Weekly* gave him a sharp eye for detail, but his keen artistic sense informed his choice of subject and composition.

Homer picked a compelling subject for his first war painting. Articles on the telescopic sights on newer rifles—including their increased accuracy and range—boosted readers' confidence that this would be a short and decisive war.[75] *Harper's Weekly* had published an article on Berdan's Sharpshooters nine months earlier, touting their accuracy at long-distance shooting. The article described the unit's requirements: each man had to be able to shoot at "600 feet distance, 10 consecutive shots at an average of five inches from the bull's eye."[76] The

ability to pick off an unsuspecting enemy provided a tactical advantage, but simultaneously added a chilling and fatalistic note to service in uniform. As one Confederate recalled, "Some of those Yankee sharpshooters...had little telescopes on their rifles that would fetch a man up close until he seemed to be only about 100 yards away from the muzzle.... I've seen them pick a man off who was a mile away. They could hit so far you couldn't hear the report of the gun."[77] That idea of a silent killer able to drop a man in his tracks a mile away intensified the fear and anxiety of being pinned down under enemy fire. Homer's *Sharpshooter* provides a useful counterpoint to Bierstadt's *Guerrilla Warfare*. Although both artists chose to paint sharpshooters at work, their compositions are radically different—the emotional intensity worlds apart. These two paintings underscore the difference between a voyeur's perspective and that of someone who has been deeply affected by the chaotic reality of combat.

Like the sharpshooter himself, Homer focused intently on his one target, arranging the pine branches and tree trunk to frame his single soldier in a moment forever frozen in Homer's mind. The disembodied feel of the upper branches, disconnected from the ground, from context, from any outside distractions, only concentrated Homer's horror and fascination at watching the sharpshooter at work. Homer's experience with the Berdan Sharpshooters stayed with him the rest of his life. In 1896 he wrote to his friend George Briggs, in which he recalled his reaction to watching one of them coolly picking off unsuspecting Confederates, "I looked through one of their rifles once when they were in a

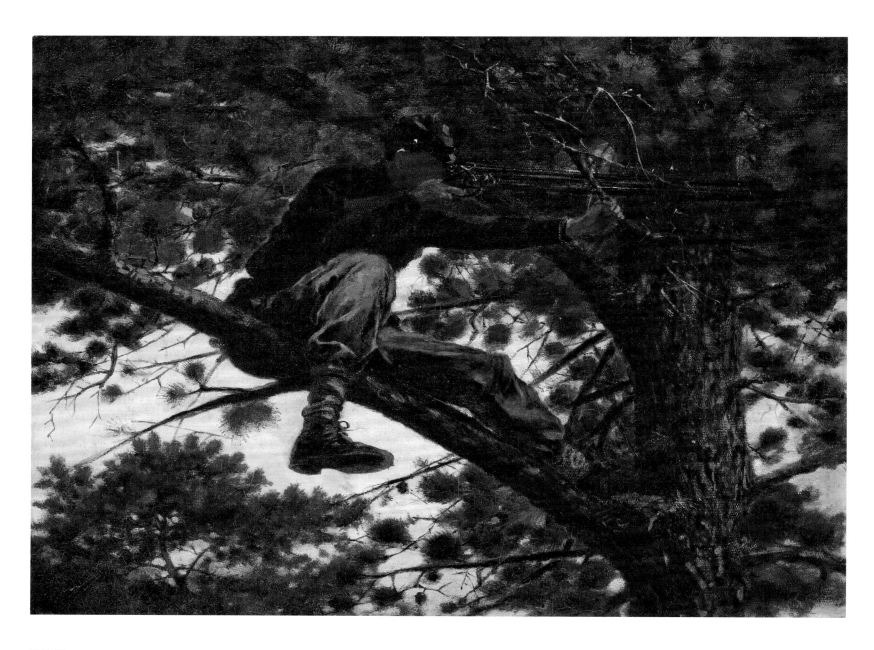

CAT. 51

Winslow Homer
Sharpshooter, 1863, oil on canvas,
12 ¼ × 16 ½ in. Portland Museum of Art, Maine.
Gift of Barbro and Bernard Osher

peach orchard in front of Yorktown in April 1862." To underscore his point, Homer rapidly sketched a soldier standing unawares viewed from behind, his back centered in the crosshairs of an enemy rifle (fig. 83). His point was unmistakable. He continued, "The above impression struck me as being as near to murder as anything I could think of in connection with the army & I always had a horror of that branch of the service."[78] *Sharpshooter* encapsulates Homer's experience watching people die. It is also the earliest indication that Homer's experiences at the front would mark him in indelible ways. As his drawing from three decades later attests, it would not be a memory easily set aside.

Homer's two months at Yorktown were a study in contrasts. His revulsion over the anonymity of long-distance shooting and the impersonal qualities of modern warfare changed the way he depicted the conflict. His experiences in camp gave him insight into the quotidian war, the human drama behind the lines that would mark each of his subsequent war-related paintings. Homer understood the dilemma of painting Whitman's "real war," that of the common soldier rather than the heroics of generals on horseback or the impersonality of panoramic sweeps of troops on the chessboard of battle. Instead Homer would go deep, look inward, and portray individual soldiers with a keen insight often lacking in depictions of men in uniform.

That insight intensified the poignancy of the first painting Homer did place on public view, a small vertical canvas titled *Home, Sweet Home* (cat. 52), also painted after Homer's return from the Peninsular Campaign in 1862. Homer's wartime artworks often alluded to well-known phrases, poems, and songs, imbuing prosaic subjects with a poetic air of melancholy. The song "Home Sweet Home" had quickly become a staple for every regimental band in both armies, blurring the lines between the battlefront and the home front. In Homer's painting, two Union soldiers, shirts untucked, gaze vacantly into space as they hear the band pick up the wistful tune. The seated soldier holds a forgotten piece of paper, most likely a letter just received or one in the process of being written. A third soldier lies prone in a very small tent; unlike Gifford's dead soldier under a tarp in the middle of camp, we assume this soldier

is sleeping, but all through this composition there are hints of death. A small pot boils over an open flame; a shiny metal plate holds hardtack like a communion plate holds wafers. Holly ripe with berries—often a symbol of sacrifice—intrude from the lower right corner, quietly suggesting these infantrymen's fate. The suggestion of death surfaces even in the painting's shape: the upper corners of the canvas were originally painted with spandrel arches, similar to the profile of a tombstone.

Homer's setting is the Federal encampment along the Rappahannock River near Fredericksburg, Virginia. The gentle slope of mountains off to the left shelters the Confederate army, camped on the opposite bank. The Battle of Fredericksburg, fought here in December 1862, was a sobering defeat for the Union army. Casualties were high on both sides; morale was low. A war that many believed should have been concluded swiftly was finishing its second year, with no real hope of resolution by either side at hand. Accounts of the battle and its aftermath were plentiful. Walt Whitman came to Fredericksburg to search for his brother George, and, horrified by the conditions of the sick and wounded, followed the Federal troops back to Washington, where he would stay for the duration of the war, in large part serving as a nurse tending the wounded or dying soldiers. There he wrote some of his most memorable war-related verses.[79]

A few weeks after the battle, with the armies still camped along the river. two men on opposite sides of the conflict recorded what transpired one late afternoon. Frank Mixson, a private in the First South Carolina Volunteers, wrote in his diary,

> [D]uring the afternoon we and the enemy were very near together, with the Rappahannock River only between us, but no fighting going on. Just before sundown the Yankee band came down to the river bank and commenced to play. Very soon our bands were on the bank on our side. The Yankee band would play the popular airs of theirs amid much yelling and cheering; our bands would do the same with the same result. Towards the wind-up the Yankee band struck up "Yankee Doodle." Cheers were immense. When they stopped our band struck up "Dixie," and everything went wild. When they finished this, both bands, with one accord and simultaneously, struck up 'Home, Sweet Home.' There

was not a sound from anywhere until the tune was finished and it then seemed as if everybody had gone crazy. I never saw anything to compare with it. Both sides were cheering, jumping up and throwing up hats and doing everything which tended to show enthusiasm. This lasted for at least a half hour. I do believe that had we not had the river between us that the two armies would have gone together and settled the war right there and then.[80]

Nelson A. Miles (fig. 84), wounded in the Union assault on Marye's Heights, where Confederates were arrayed for miles just west of the town of Fredericksburg, recorded his recollections of that same evening. He wrote, "Late in the afternoons our bands were accustomed to play the most spirited martial and national airs, . . . to be answered along the Confederate lines by the bands playing, with equal enthusiasm. . . . These demonstrations frequently aroused the hostile sentiment of the two armies, yet the animosity disappeared when at the close some band would strike up that melody which comes nearest the hearts of all true men, 'Home, Sweet Home,' and every band within hearing, in both armies, would join in that sacred anthem with unbroken accord and enthusiasm."[81] It was a tune that had a unifying effect, making its listeners long for the simplicity of prewar days.

The popularity of "Home, Sweet Home" long predated the war. Jenny Lind, the "Swedish Nightingale," had made it a staple of her concerts during her tour of the United States in the 1850s. Audiences were often moved to sing along, making it an unofficial anthem for her tour and for the country. Repurposed for war, it instilled pride in fighting for hearth and home and spurred homesickness and thoughts of desertion. These rumblings were loud enough and pervasive enough to worry regimental commanders, some of whom advocated banning the song. During General William Tecumseh Sherman's march to the sea, a reporter accompanying the regiments noted, "The band plays 'Home, Sweet Home;' I have heard it when it sounded sweetly, but here it is sad enough. I think a band should be suppressed for playing such airs on such an evening. Why, when the men *read* the word 'home' it seems to *stick*

FIG. 84

Mathew B. Brady
Major General Nelson A. Miles, about 1860–1865, Library of Congress

CAT. 52

Winslow Homer
Home, Sweet Home, about 1863, oil on canvas, 21 ½ × 16 ½ in. National Gallery of Art, Washington, Patrons' Permanent Fund

out beyond all other words, and sparkle with a diamond brilliancy. The distant peaks of the horizon hills are hid in night, and we lie down to dream of home and the friends we have left behind."[82] During prisoner exchanges, the regimental bands would strike up "Home, Sweet Home," and it was a staple tune for returning soldiers during homecoming parades in Boston, New York, and many other cities and towns.[83]

Homer's title invoked "Home Sweet Home" as a sentimental paean of yearning for peace; but by this time, the song had taken on political overtones within both armies as an anthem for questioning the continuation of the war and, more specifically, each man's participation in it. Letters from home and songs such as this one contributed to a pervasive problem for both armies. Homesickness or "nostalgia" was then an accepted category of disease afflicting men in uniform and a leading cause of discharge from the army.[84] Here Homer layered in the tensions and anxieties felt by the soldier in the field and quite possibly by the artist himself. Reviewers responded favorably to the quiet charm and understated authenticity of Homer's *Home, Sweet Home* when it went on view in May 1863. Homer clearly struck a chord with his painting; in the words of one reviewer, "The artist has left nothing out but the music."[85] Another reviewer, Lionel, concluded, "He will never paint more real soldiers than these."[86] Homer's soldiers embody the complex and irreducible dilemmas posed by the war. Why do they fight and for what? What would happen if, in fact, they did simply go home? Home, however, was also undergoing changes during the war. It would never be the same for any of these soldiers, nor for those left behind. *Home, Sweet Home* avoids the sentimentality of the song by leaving these men's faces inscrutable; vaguely brushed, they allow the viewer to project his or her emotions onto them, rather than narrowing the possibilities with specific details. The painting oscillates between signs of hope and hints of death, that ambiguity lending it a pictorial depth belied by its subject and its scale.

Homer continued to paint "real soldiers," infusing his scenes of camp life with empathy for his subjects and employing titles with layers of meaning. *The Brierwood Pipe* (cat. 53) refers to the common camp pastime of carving pipes from brierwood, an effective and productive

JULY 6, 1861.] VANITY FAIR. 5

THE BRIER-WOOD PIPE.

I.

Ha! bully for me, again, when my turn for picket is over,
And now for a smoke, as I lie, with the moonlight, out in the clover.

II.

My pipe, it's only a knot from the root of the brier-wood tree,
But it turns my heart to the Northward—HARRY gave it to me.

III.

And I'm but a rough, at best, bred up to the row and the riot;
But a softness comes over my heart, when all are asleep and quiet.

IV.

For, many a time, in the night, strange things appear to my eye
As the breath from my brier-wood pipe sails up between me and
the sky.

V.

Last night, a beautiful spirit arose with the wisping smoke;
O! I shook, but my heart felt good, as it spread out its hands and
spoke.

VI.

Saying: "I am the soul of the brier; we grew at the root of a tree
Where lovers would come in the twilight, two ever, for company.

VII.

Where lovers would come in the morning—ever but two, together;
When the flowers were full in their blow, the birds in their song
and feather.

VIII.

Where lovers would come in the noon time, loitering—never but
two,
Looking in each others eyes, like the pigeons that kiss and coo.

IX.

And O! the honeyed words that came when the lips were parted,
And the passion that glowed in eyes, and the lightning looks that
darted!

X.

Enough: Love dwells in the pipe—so ever it glows with fire!
I am the soul of the bush, and spirits call me "SWEET-BRIER."

XI.

That's what the brier-wood said, as nigh as my tongue can tell,
And the words went straight to my heart, like the stroke of the
fire-bell!

XII.

To-night I lie in the clover, watching the blossomy smoke;
I'm glad the boys are asleep, for I ain't in the humor to joke.

XIII.

I lie in the hefty clover: between me and the moon
The smoke from my pipe arises; my heart will be quiet, soon.

XIV.

My thoughts are back in the city, I'm everything I've been;
I hear the bell from the tower, I run with the swift machine.

XV.

I see the red shirts crowding around the engine-house door,
The foreman's hail through the trumpet comes with a hollow roar.

XVI.

The reel in the Bowery dance-house, the row in the beer saloon,
Where I put in my licks at Big PAUL, come between me and the
moon.

XVII.

I hear the drum and the bugle, the tramp of the cow-skin boots,
We are marching on our muscle, the Fire Zouave recruits!

XVIII.

White handkerchiefs wave before me—O! but the sight is pretty
On the white marble steps, as we march through the heart of the
city.

XIX.

Bright eyes and clasping arms, and lips that bid us good hap;
And the splendid lady who gave me the Havelock for my cap.

XX.

O! up from my pipe-cloud rises, between me and the moon,
A beautiful white-robed lady; my heart will be quiet, soon.

XXI.

The lovely golden-haired lady ever in dreams I see,
Who gave me the snow-white Havelock—but what does she care
for me?

XXII.

Look at my grimy features; mountains between us stand:
I with my sledge-hammer knuckles, she with her jewelled hand!

XIII.

What care I?—the day that's dawning may see me, when all is
over,
With the red stream of my life-blood staining the hefty clover.

XXIV.

Hark! the reveillé sounding out on the morning air;
Devils are we for the battle—will there be angels there?

XXV.

Kiss me, again, SWEET BRIER, the touch of your lip to mine
Brings back the white-robed lady with hair like the golden wine!

CHARLES DAWSON SHANLY.

The Reason Why.

Southerners will not come North this year, as usual, to disport
themselves at our charming summer retreats, Saratoga, Newport,
etc. This, we think, must result from a conviction on their part
that Gen. SCOTT will provide them with a great many nice Retreats
at home.

Epi-thalami-gram.

On Tuesday, June 11th, 1861, in Pottstown, Pa., by the Rev. Edmund Leaf, at
the residence of the bride's father, Mr. George H. Potts to Miss Rose Leaf.

Hymen has kindly cherished this fair Rose;
Not, like rash Cupid, with fierce love besotted;
As, from the altar, a veiled bride, she goes,
The Leaf has vanished, but the Rose is Potted!

What Bridesmaids always Stand Up for.

A Wedding.

CAT. 53

Winslow Homer
The Brierwood Pipe, 1864,
oil on canvas, 16 13/16 × 14 3/4 in.
The Cleveland Museum of Art,
Mr. and Mrs. William H. Marlatt Fund

FIG. 85

Unidentified artist
The Brier-Wood Pipe, from *Vanity Fair*,
July 6, 1861, wood engraving,
Smithsonian Institution Libraries

loved ones back home in the smoke rising from their pipes. The accompanying illustration (fig. 85) shows a young woman in profile, her form created by the curling smoke from the abandoned pipe resting beneath. The focal point of both painting and poem is the haunting loneliness of the camp, of separation from friends and family. Soldiers wrote often of melancholy in diaries and letters as they described their loneliness, and Homer stood apart from many of his colleagues in his ability to invest this wartime painting with these complex emotions. His soldiers were everyman; viewers far from the front could relate to their experiences and emotions.

The theme of missing home, and facing the sobering reality that one might not survive to return, runs like a thread through Homer's Civil War paintings. At the Second Battle of Manassas, fought in late August 1862, Duryée's Zouaves lost three-fifths of its men, culminating in a sobering and stunning loss for the Federals.[89] The fields of Manassas, strewn with dead bodies, made a gripping if stomach-churning image. Their bright red and blue uniforms had made them prominent targets. In Confederate General John Hood's regiments, two soldiers from Texas each wrote of that day, trying in some measure to assimilate the horrors of the slaughter. J. P. Polley recalled, "As we looked up the hill, a ghastly spectacle met our eyes. An acre of ground was literally covered with dead, dying and wounded of the 5th NY Zouaves, the variegated colors of whose peculiar uniforms gave the scene the appearance of a Texas hillside in spring, painted with wild flowers of every hue and color."[90] Invoking bluebonnets and Indian paintbrush created a vivid word-picture for

way to pass the time.[87] Homer's soldiers are members of the Fifth New York Infantry, also known as "Duryée's Zouaves." Frank Duryée had been a member of the Seventh Regiment prior to his leadership of this Zouave regiment. Labeled "the best disciplined and soldierly regiment in the Army" by General McClellan, they wore distinctive uniforms adapted from the French Algerian troops they emulated. Homer's title also refers to a poem by Charles Shanly published in *Vanity Fair* in July 1861 titled *The Brier-Wood Pipe*, which spoke of a longing for home.[88] In it the soldiers, described as Ellsworth's Fire Zouaves, fancy they can see the ethereal form of their

the soldiers' families, without resorting to more grue-some descriptions of the carnage. Edward A. Moore, a Confederate artillerist under General Stonewall Jackson, wrote, "The area presented the appearance of an immense flower garden, the prevailing blue thickly dotted with red, the color of the Federal Zouave uniform. In front of the railroad cut...at least three-fourths of the men who made the charge had been killed and lay in line as they had fallen. I could have walked a quarter of a mile in almost a straight line on their dead bodies without putting a foot on the ground."[91]

Knowing the fate of these New York soldiers made viewing Homer's painting an act of paying respects. The descriptions of the battle bring to mind Gardner's photographs from Antietam, fought barely a month later (fig. 86). The exhibition of those photographs forever altered viewers' idealized perceptions of the war

as a gallant fight for moral causes. By the time Homer exhibited *The Brierwood Pipe* in 1864, his allusions to both homesickness and the Zouaves' heavy casualties at Second Manassas would still have been poignant.[92] Drawing on melancholy and temporality, Homer presents a pair of unwitting soldiers, probably longing for home, and quite possibly facing their final battle unawares. That sense of tragic loss permeates much of Homer's wartime oeuvre, lending pathos and power to otherwise quotidian scenes.

DESTRUCTION AND THE LANDSCAPE

The tactics used by the Union to fight the Civil War changed after General Ulysses S. Grant took command of the Army of the Potomac. Grant favored direct assaults and had proved willing at Vicksburg to lay siege to a city to force its surrender. The Battle of the Wilderness was part of a campaign around Fredericksburg and Spotsylvania that took place in the spring and early summer of 1864. General Robert E. Lee's troops held Fredericksburg and Chancellorsville and with them access to Richmond; Grant was determined to force Lee to concede that ground. The Wilderness had earned its sobriquet. It was a nearly impenetrable stretch of woodland punctuated by sluggish streams and dense underbrush. In a bold but costly maneuver, from May 5 through May 6, Grant threw his troops at an entrenched enemy, incurring significant losses in his victory. Midway through the battle, the heat from the artillery set the woods to smoldering. Fire and acrid smoke literally consumed men and trees. It was a horrific contest in which nature favored neither side, but became a third protagonist.

Francis Channing Barlow commanded the First Division of Major General Winfield S. Hancock's Second Army Corps at the Battle of the Wilderness. By this time Homer had accompanied Barlow off and on in 1862 and 1864. Recent scholarship makes a strong case for Homer's having been at the site or nearby when the battle broke out. His cursory pencil sketches of cavalry and infantry engaged in combat have a more frantic, adrenalin-induced quality distinct from the more precise drawings the artist typically

FIG. 86

Alexander Gardner
Gathered together for burial after the Battle of Antietam, about 1862, stereo card, Library of Congress

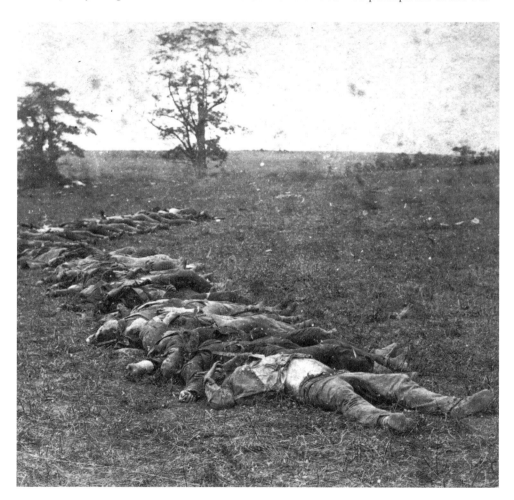

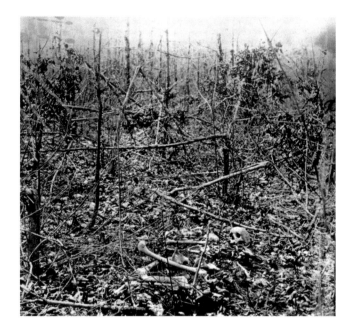

FIG. 87

Unidentified photographer
*Battlefield of the "Wilderness"
—Views in the woods in the Federal
lines on north side of Orange Plank
Road*, about 1864–1865, Library of
Congress

made at calmer moments. They support the anecdotal accounts of Homer's presence there and account for the dark setting and mood of his painting *Skirmish in the Wilderness* (cat. 54).[93]

Skirmish in the Wilderness functions more as a landscape than as a battle scene. It takes effort to discern the figures who themselves are struggling against the dense undergrowth and dark canopy of trees. Homer captured the chaos of that unforgiving setting, in which one dimly sees Union troops amid the overgrown landscape, made visible by their red cap badges and the smoke from their rifles. Every account of the battle stressed the impenetrable jungle of bushes, vines, and tree litter. Homer's painting reinforces the feeling of entering a dark and baleful place, and the impossibility of knowing exactly at what or whom you were shooting. The troops in Homer's wilderness wear the distinctive red badges of Barlow's regiment; the leading officer holds a sabre much like the one Barlow carried. It is hard to imagine Homer being able to create this painting with no firsthand experience of the terrain and the tumult. Certainly the resultant painting echoes the chaotic nature of the actual battle scene. Unlike his composed, thoughtful presentations of individual soldiers, where the focus is on their inner thoughts, here Homer exposes the raw edge of hand-to-hand combat. There

is no room for reflection in this scene. Survival against an unseen enemy and an unfeeling landscape send an unambiguous message about the brutality of war.

Grant pursued Lee out of the woods. Neither army remained behind to bury its dead. Shortly after the end of the war, a writer for the *Boston Herald* visited the site and informed his readers, "The marks of the contest are everywhere to be seen and are horrible.... Ghastliest of all ghastly sights upon this bloody field are the skeletons of dead men broadcast over the land—the nation's seed planted willingly for a glorious harvest of Union and peace—but never covered from sight. Within a circle of one hundred and fifty yards, where an unsuccessful assault was made upon the enemy's works, I counted fifty skulls polished by time, reflecting grimly the rays of the sun."[94] Photographs taken in the years following the battle featured skeletons peeking through the leaf litter (fig. 87). At the Wilderness, bones still protrude through the earth a century and a half after the battle. Unlike Gettysburg, where the stately bullet-ridden trees became pilgrimage sites for visitors, here the landscape retained its dark, untamed character.

Homer's brooding landscape could not have been more different from the qualities of Gifford's paintings, yet these two artists' use of the landscape derives from the same impulse, to allow the land and the sky—or lack thereof—to set the tone and carry the painting's message. The chilling, haunting effect of *Skirmish in the Wilderness* presented the landscape as an amoral protagonist, not favoring one side over the other. Homer's approach is an early signal that the belief in landscape as a beneficent emblem of American cultural values was taking a dark turn. It is an attitude that Homer would invest in several of his Civil War paintings.

Following the Wilderness Campaign, Grant and Lee fought for control of Petersburg, Virginia. By July 1864, Lee's troops were well fortified in a trench-and-fort line of defense. Petersburg was considered the "back door" to Richmond, and overtaking the Confederate capital was Grant's ultimate goal. General Meade was persuaded by his engineers to try a daring offensive: digging a mine shaft under a Confederate fort, packing it with explosives, and literally blowing a hole in Lee's perimeter. If all went well, Meade's troops would rush

CAT. 54

Winslow Homer
Skirmish in the Wilderness, 1864, oil on canvas,
18 × 26 ¼ in. New Britain Museum of American Art,
Harriet Russell Stanley Fund

the breach before the Confederates recovered from the blast. The construction of the tunnel by a cadre of former coal miners from Pennsylvania was an impressive and successful feat, and at 4:44 A.M. on July 30, Union soldiers lit the fuse. The blast ripped a hole in Lee's defenses; the resulting crater measured more than one-hundred feet in diameter and some thirty feet deep. Stunned by the concussion, both Union and Confederate troops seemed unable to take immediate advantage of the situation. Union troops rushed into the bowl-like depression, where they became easy targets for Confederate riflemen who soon surrounded the perimeter. The Union sustained terrible losses, many of whom were U.S. Colored Troops. The Confederate marksmen deliberately killed as many black soldiers as

FIG. 88

Unidentified photographer
Edward Lamson Henry dressed as a coachman, about 1873, New York State Museum, Albany

they could. What began as a daring and unorthodox Union attack turned into a rout. The Battle of the Crater was the prelude to another eight months of siege warfare.

Winslow Homer was most likely near Petersburg at this time, and in 1864 he composed a small painting titled *Defiance: Inviting a Shot Before Petersburg* (cat. 55). Although Homer was not specific beyond the identification of Petersburg, recent scholarship has suggested the scene may allude to the Battle of the Crater.[95] Surrounding Petersburg, the opposing forces' trenches eventually consumed close to thirty-five miles of once-verdant terrain. The denuded landscape had once been a thick forest; now it was littered with splintered tree stumps, the ground churned to mud. A gangly, brash young Confederate stands on top of a breastwork, daring the distant Union troops to take a shot at him. Behind him, other soldiers more prudently take cover as two puffs of white smoke from the Union lines suggest their sharpshooters have risen to this challenge.

A black man with a banjo crouches in relative safety behind the pile of earth. He is a more caricatured figure than some of Homer's other, later paintings of blacks during the war. He looks up at the defiant young man with what appears to be trepidation, his own wary

caution the better part of valor. His presence is deliberate and therefore curious. The black figure bears no arms, and Homer may have included him as a pointed contrast between the Union army's endorsement of colored troops and the Confederates' continued resistance to arming blacks.[96] Subordinate, hidden, he is the antithesis of the eager black troops who fought and died at the Crater. Homer's emerging value judgments about slavery and the South's reasons for fighting come close to the surface here, as he adds a different human face to his images of the war. In *Skirmish in the Wilderness* and *Defiance*, Homer presents direct engagements between the opposing forces of North and South. His protagonists now include the landscape, and his paintings address the issue of destruction—of individuals, of armies, of the land, and ultimately of the Southern way of life.

THE DESTRUCTION OF THE SOUTH

For the Confederacy, the battlefront and the home front were nearly indistinguishable. Grant and Sherman developed tactics for bringing the war to a close based around the destruction of the South's infrastructure. The final year of the war coalesced around their campaigns. Grant's attacks on Petersburg, Virginia, lasted from June 1864 through the war's end in April 1865, an exercise in stubborn siege warfare. Further south, Sherman's series of advances made it all too clear that the Union sought a rapid and conclusive end to the war. Sherman's ruthless progression from Nashville to Atlanta between May and September 1864, followed by his march to the sea early that winter, and the subsequent occupations of Charleston and Columbia, South Carolina, in February 1865 made him the most feared Union general. Each campaign was marked by extensive destruction of ordnance, homes, cities, and the land. The artists, including photographers, who accompanied various regiments created images both poignant and shocking that hinted at the extent of the damage, and they used them to create moving narratives about the larger destruction of the South's culture and identity.

Artist Edward Lamson Henry (1841–1919, fig. 88) conveyed his dismay over the occupation of one of these

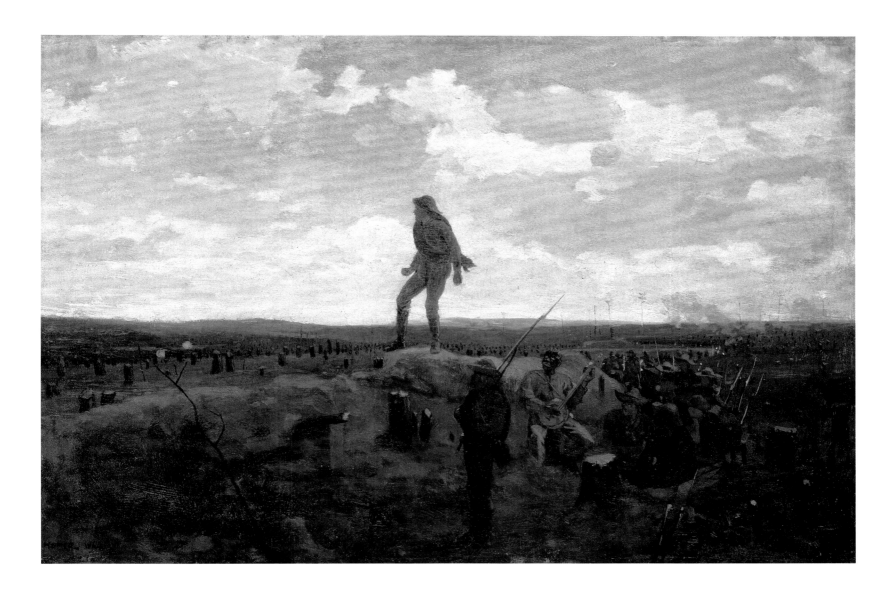

CAT. 55

Winslow Homer
Defiance: Inviting a Shot Before Petersburg,
1864, oil on panel, 12 × 18 in.
Detroit Institute of Arts, Founders Society
purchase and Dexter M. Ferry Jr. Fund

stately residences in his painting *The Old Westover House* (cat. 56). At the time, Westover was perhaps the most famous Southern estate, a Georgian-style colonial-era plantation house on the north bank of the James River. It had been home to generations of the Byrd family, a family of equal prominence. In 1737 William Byrd II had christened Richmond, Virginia, after his home near Richmond Hill in London. He served as a surveyor for the Dismal Swamp Land Company, which included George Washington among its investors, and he built Westover as his family seat in America. Whether one sided with the North or the South, Westover, like Mount Vernon, commanded respect for anyone who appreciated American history. By 1864 Westover was already feeling the brunt of the war. The core of the house had served first as McClellan's headquarters and subsequently General Fitz John Porter's during July 1862, and it was once again the Union field headquarters, this time for Grant.[97] By then the left outbuilding had been burnt, its roof caved in, exposing the blackened timbers. Laundry waved from open windows, Union soldiers conferred in the wings and across the front lawn, which now doubled as a campsite. The fence defining the front yard had been pulled down as the artillery wagons rolled over the white pickets. A signal corps station mounted on the roof provided a vantage point for relaying messages inland to nearby regiments.

E. L. Henry invested the damaged property with larger resonances of Southern dignity and resolve in the face of unrelenting attack.[98] Henry had been born in Charleston but raised in New York and developed a lifelong love of historical architecture in both parts of the country. He was in Europe when war broke out and returned to New York in July 1863. Soon thereafter he volunteered to accompany a Union transport ship and became a captain's clerk for the quartermaster. During October and November of 1864 the ship was anchored near City Point, Grant's headquarters during his James River Campaign. Henry spent most of his time on board ship, and in October 1864 he sketched the occupation of Westover by Grant's troops.

The artist's dismay over the damage done to a piece of American history came through in a letter he wrote to Virginia sculptor and virulent Confederate Edward V.

Valentine, in which he lamented, "I have painted and sold some of those gorgeous old Manors on the James River.... Old Westover is one, that place set me nearly crazy."[99] Although it is unclear if Henry's comments signal his own conflicted loyalties, brought to the surface by his shock over Westover's condition, or his sympathy for a friend's fierce loyalty to the Confederate cause, Henry was deeply moved by what he witnessed at Westover. In Henry's painting, this stately, war-ravaged plantation home suggests the core dignity of the South and forms a solid foundation from which to rebuild and restore its former glory. But the plethora of Union troops equally signals the inexorable changes as Grant prosecuted the final stages of the war. An early description of the painting in progress described the home as Porter's headquarters, suggesting that Henry had chosen initially to paint its first occupation from 1862, but in fact he painted a portrait of the cumulative damage to the august property. In doing so he also summed up the damage done to Southern infrastructure by the Northern army, which, under Grant, was rolling across Southern cities and homes with unrelenting force.

LOSS AND SURRENDER

For many Confederates, the idea of surrender cut to the quick, toppling the personal sense of honor that had animated their fervor to fight. How a man surrendered, and to whom, became an important part of the war, as did his treatment by the Federals. If the goal was reconciliation and the restoration of the Union, the victors' conduct was equally important. The many images of Confederate surrender painted in the North after the war ended tended to treat the subject with dignity. A small but compelling image titled *Surrender of a Confederate Soldier* (cat. 57) painted by Julian Scott epitomizes the genre. Scott (1846–1901) had lied about his age to enlist in 1861, when he was fifteen. Even then, due to his small size, he served first as a fifer.[100] He rose through the ranks, earning the Union's Medal of Honor for his conduct.[101] Scott's poignant study shows a Confederate soldier raising a makeshift white flag as he prepares to surrender to his unseen Union counterpart. Behind him sits a woman cradling an infant, presumably his wife and

CAT. 56

Edward Lamson Henry
The Old Westover House, 1869, oil on paperboard,
11 5/16 × 14 3/8 in. Corcoran Gallery of Art, Washington, D.C.,
Gift of the American Art Association

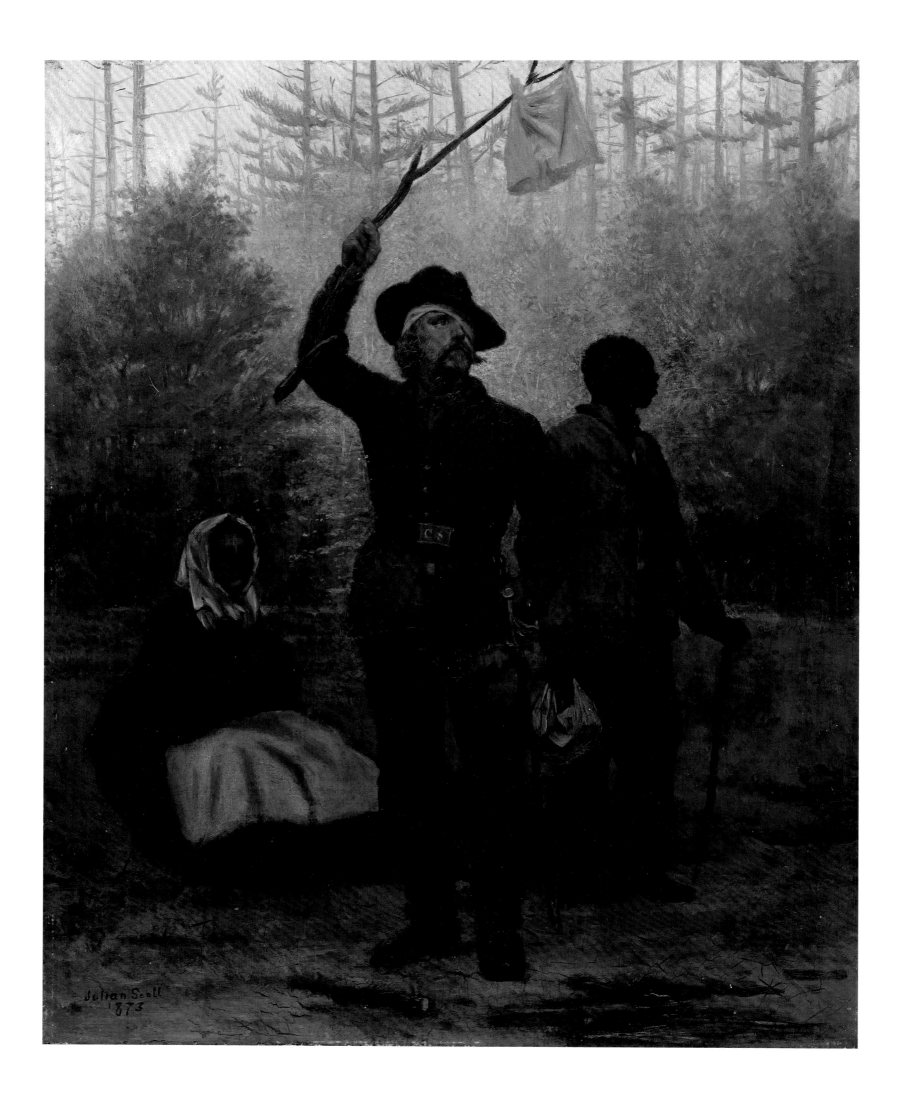

child. Standing next to them, looking off in the distance, is a black man whom we take to be the family's slave. His passive stance implies that his own fate is unclear. The soldier's surrender does not suggest a future for any of them beyond the tone of present hopelessness.

Scott's painting is symbolic of a larger surrender of a way of life. The concept of the South as something distinct and separate animated many Confederate soldiers to take up arms in the first place. They fought, in many cases, for a sense of honor tied to individual and state sovereignty, feeling stronger ties to their homes and immediate surroundings than to the country as a whole. In this regard, Scott's Confederate soldier is a synecdoche for the South as a concept steeped in individual honor. He surrenders with stoic calm, his stiff posture radiating his dignified, if disconsolate state of mind. Union Major General Joshua L. Chamberlain, recalling a moment at Appomattox Courthouse April 9, 1865, might have been describing this scene when he wrote, "Suddenly rose to sight another form—a soldierly young figure, a Confederate staff officer undoubtedly, to whom someone in my advanced line seemed to be pointing out my position. Now I saw the white flag, and its possible purport swept before my inner vision. I could even smile at the material of the flag, wondering where in either army had been found a towel, and one so white. But that simple emblem of homely service bore a mighty message."[102] Scott's respect for his Confederate counterpart elevates this small painting from anecdote to symbol, sounding a hopeful note for national reconciliation with the same honor and dignity embodied in his soldier.

That mighty message was one of reconciliation—of the desire to find an honorable end to a long and bloody war and to begin the process of crafting the future for each individual and the nation. Scott continued to paint war-related works infused with that message. In 1884 he based a larger and more elaborate work on this study, *Death of General Kearny* (location unknown). In the larger painting the same Confederate soldier raises a white flag of truce, but now it is to permit Federal soldiers to retrieve safely Kearny's body. Out of respect for Kearny's military leadership, the Confederate soldiers did not desecrate his body or strip him of his gear. Instead someone found a white towel and signaled a truce to allow his

comrades to cross enemy lines and retrieve his body for a proper burial. The mutual respect among officers who had been colleagues at West Point before the outbreak of war remained intact during and after the conflict. Moments like these, with their focus on humanitarian gestures, helped support a belief that in the wake of the war, reconciliation was in fact possible, that animosities could be repaired. If we could in fact call upon what Lincoln described as "the better angels of our nature" in the heat of battle, perhaps there was hope for a reunited white America with honor for both sides.

The idea of reconciliation found similar expression in one of Jervis McEntee's tender yet somber landscape paintings. *The Fire of Leaves* (cat. 58) of 1862 takes its title from the two small boys huddled over a tiny flame they have kindled from the dry leaves at the edge of a wood. One is dressed in blue, his a kepi hat beside him, the other in butternut with a red scarf and slouch hat. Their clothes evoke the uniforms of the Union and the Confederacy. Like Cropsey's painting of *Richmond Hill* (see cat. 8), the message is understated, representing a yearning for peace based on mutual regard. In the fading light, McEntee's two children have shed their differences, drawing close, knowing that in the shared warmth of the fire and their bodies lies their survival, here and now, and for the future. Children—so often read as portents of the future—here, whether playing at soldiers or as literal adversaries, have abandoned their quarrels, finding common cause.

The underlying message of McEntee's *The Fire of Leaves* is subtle, yet pointed. The future will quite literally be in the hands of children raised on war. Their ability to step beyond their differences and find strength in their commonalities will determine the country's future. This landscape offers choices: different paths to take, different directions. The artist himself recognized the potential for a landscape to express that kind of emotion: "I look upon a landscape as I look upon a human being— its thoughts, its feelings, its moods, are what interest me; and to these I try to give expression. What it says, and thinks, and experiences, this is the matter that concerns the landscape painter."[103]

Both art and literature often couched Civil War losses and reconciliation in landscape imagery. Walt Whitman found in the Virginia landscape fertile ground

CAT. 58

Jervis McEntee
The Fire of Leaves, 1862, oil on canvas,
20 × 36 in. Private Collection

for his wartime work. In the poem "As Toilsome I Wander'd Virginia's Woods," he wrote,

As toilsome I wander'd Virginia's woods,
To the music of rustling leaves kick'd by my feet,
 (for 'twas autumn,)
I mark'd at the foot of a tree the grave of a soldier;
Mortally wounded he and buried on the retreat,
 (easily all could understand,)
The halt of a mid-day hour, when up! no time to lose—
 yet his sign left,
On a tablet scrawl'd and nail'd on the tree by the grave,
Bold, cautious, true, and my loving comrade.
Long, long I muse, then on my way go wandering,
Many a changeful season to follow, and many a scene
 of life,
Yet at times through changeful season and scene,
 abrupt, alone, or in the crowded street,
Comes before me the unknown soldier's grave, comes
 the inscription rude in Virginia's woods,
Bold, cautious, true, and my loving comrade.[104]

Homer's *Trooper Meditating Beside a Grave* (cat. 59) stands before one such memorial, marked with a crude plank of wood. Additional markers dot the background, alluding to more extensive losses. The impromptu approach to honoring the dead, born of necessity, hit Americans hard, used as they were to more formal observances of a loved one's passing. Whitman's eloquent lines convey the compelling need to honor the dead, even with a hastily crafted, makeshift marker. Yet they also honor the living soldier whose gesture the poet continues to recall over the years. The act of remembering, during and after a war in which the sheer number of the dead defied comprehension, is cherished by a poet who feared the numbing effects of the seemingly endless conflict. Here Homer stops to remember the small, empathetic gestures that reminded everyone of their frailty and spiritual kinship. The artist's small and intimate glimpse of a soldier stopping a moment to honor a fallen comrade remains a touchstone for the humanity that he firmly believed beat in every American soldier's breast. To relinquish this small act would itself be a form of slow death.

Homer resisted the general tendency among soldiers to become immune to the horror of killing.[105] Suffering was the measure of a man's soul, and a benumbed soul turned a man into a killing machine. Homer needed to remain attuned to the horrors of war—he could not afford to let himself become inured. His very ability to capture the tragic essence of the conflict depended on exposing himself constantly to war's brutality and reacting with anguish and sympathy. Eventually Sanford Gifford acquired *Trooper Meditating Beside a Grave* from Homer.[106] We know little of their friendship, but mutual respect is evident. In 1865 Gifford nominated Homer for membership in the National Academy of Design, and it appears the two artists may have been more than passing acquaintances. Homer's pensive trooper has Gifford's lean build and contemplative air. There is an empathetic understanding in both men's work that seems to suggest a quiet respect based on similarly sensitive personalities shaped by the war.

When he first returned from Yorktown in 1862, Homer seemed shell-shocked by his experiences. His mother wrote to his younger brother, Arthur, of the privation Winslow had endured at the front. She expressed her concern for her son's mental state of mind, fretting, "He came home so changed that his best friends did not know him."[107] We have but fragments of this letter; later in it Henrietta Homer writes to console herself that her middle son is "much better now." Her words are those of a worried mother's fervent wish-fulfillment. How can anyone, particularly an emotionally fine-tuned soul such as Homer, ever completely recover? Overwhelming evidence supports the pervasive emotional trauma experienced by all participants in the war, culled from firsthand accounts from fellow soldiers, medical officers, and families struggling to go back to normal when their loved ones came home. The war changed Homer, and he poured his emotions, the scarring, and the memories into each painting. In them he makes an eloquent case for the war's damage to individuals and to the nation. Those scars were what made it possible for Homer to paint the signature work that defined his postwar career, a painting that showed that the end of the war was only the beginning of an equally difficult struggle to heal the wounds—literal, societal, and psychological—inflicted by the conflict.

THE WAR THAT DOES NOT END

In 1866, a full year after the war ended, Homer painted *Prisoners from the Front* (cat. 60), the Civil War painting that would define his career for years. It received stirring accolades when it was first displayed and was widely reviewed as a painting about Northern triumph over a South in disarray. A young Union general, easily recognized at the time as a portrait of Francis Barlow (fig. 89), inspects the three Confederate prisoners that his troops bring to him. For many viewers, this composition portrayed the crowning achievement in Barlow's illustrious military career, when he and his troops captured an entire brigade of Confederates during the Battle of Spotsylvania in 1864.[108] Barlow stares at the three men as members of his regiment look on. The youngest of these prisoners resembles the daring soldier in *Defiance*, his slouch hat riddled with four bullet holes, evidence of more than one close call. In both paintings he represents a hothead, willing to take unwise risks, a youth not yet in full possession of his mature faculties.[109] He is an object lesson for North and South—that reconciliation will require spiritual growth and maturity during the postwar years.

Homer's bleak landscape carries as much significance as the figural group on which most viewers focused. Across the South, the devastation to the actual landscape mirrored the physical and psychological damage done to the men who fought. That damage stretched well beyond the destruction of crops and homes to the infrastructure of the Southern economy and no fewer than four of its major cities. Homer's painting, like George Barnard's album of photographs from Sherman's campaigns, presents the landscape as a casualty of the war—as significant a loss as that of trust and regard between North and South. Homer's underlying message seems all too clear: This is the price we pay, not just in principle, but in fact. Until this mess is fixed—until nature can regenerate what has been damaged, and mankind can do the same—we are not done with this conflict, and we cannot simply walk away.

John Esten Cook, a Confederate soldier turned author, vented his bitterness in 1863, writing of the transformation of the once-verdant Virginia landscape as a metaphor for the larger destruction wrought by the war: "When I saw it in the early months of the war the whole region was beautiful—a virgin land untouched by the foot of war.... A land which the hot breath of war had never scorched—where the tramp of cavalry had never resounded—the wheels of artillery had never rumbled;—where the roar of cannon and the rattle of musketry, had never yet come to startle the echoes, or awake the old 'sleepy Hollow' from its reveries and dreams. What dreamer ever fancied its future—ever thought it possible that this summer land, all flowers and sunshine and peace, would become as Golgotha, 'the place of skulls'—a Jehoshaphat full of dead men's bones?" He soberly concluded, "The old era of tranquility was to pass away, and a hideous spirit of destruction to rush in."[110] Cook, like Homer, equates human casualties with the denuded landscape. The lasting damage of the war was the literal and psychological destruction of the landscape, especially and principally in the South. The real war—the blunt reality of armed conflict—resulted in churned-up fields of wheat and corn, forests chopped down for battlements and firewood, ransacked homesteads, fouled creeks, and everywhere unburied corpses left by the retreating army. It would be a sight no one got used to, but it was ubiquitous wherever the armies clashed.

The critic for the *Round Table* extolled *Prisoners from the Front* as "*the* figure picture of the exhibition. It expresses, in a graphic and vital manner, the conditions of character North and South during the war." And yet this reviewer, captivated by the "types" Homer had limned, concluded, "It is unnecessary to define and characterize at greater length what almost every visitor of the Academy must readily understand and admire, for there is nothing occult in Mr. Winslow Homer's work; his methods are direct and plain."[111] The reviewer reads in the frank gaze of Union general and Confederate prisoner an air of mutual respect, and the meeting of equals, which is quintessentially the view of the victors. But the writer appears oblivious to the underlying hostility seething in this picture. One wonders how many of Homer's viewers also read this picture as a chivalric meeting of vanquisher and vanquished coming to an honorable truce, rather than focusing on

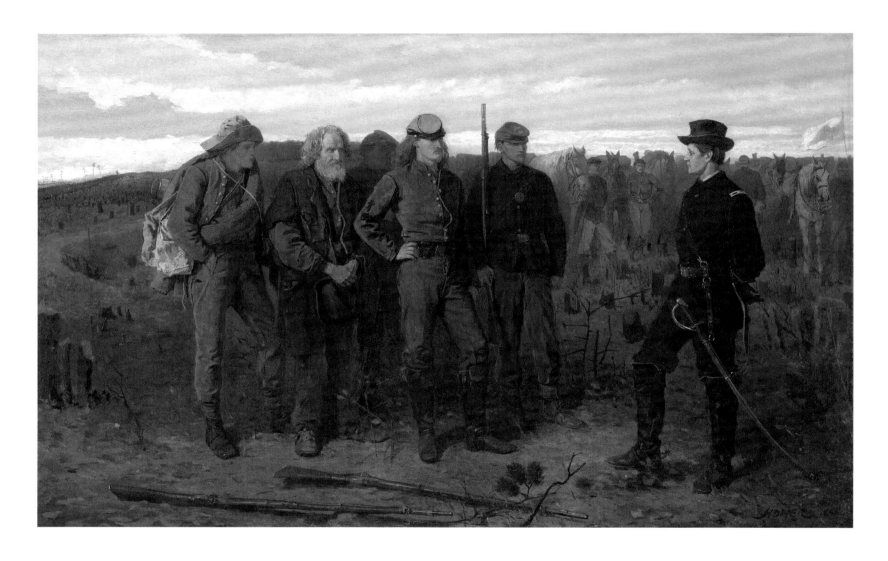

CAT. 60

Winslow Homer
Prisoners from the Front, 1866,
oil on canvas, 24 × 38 in. The Metropolitan
Museum of Art, Gift of Mrs. Frank B. Porter, 1922

the tension inherent in the totality of the painting. In his complacent unwillingness to probe the painting beyond its surface, Homer's reviewer misses the point. Homer has painted more than history or anecdote. *Prisoners from the Front* presents a standoff that epitomizes the lingering hostility and bitterness felt on the part of the Confederates, and by extension the Northerners' cluelessness as to the depths of that animosity.

Left to pick up the pieces and start anew, many in the South descended into bitter recriminations against the "rude barbarians," and they conjured gallant fantasies of the Lost Cause. The Southern writer T. C. DeLeon captured in words the animosity underlying Homer's *Prisoners from the Front*. "But, deeper than any bitterness could have sunk, was that ingrained feeling that there were two peoples that these could never again mingle in former amity, till oil and water might mix."[112] Oil and water is an apt metaphor to describe the profound disconnect between North and South at the end of the war. In the North it was relatively easy to go back to business as usual; no battles had destroyed the land as had happened across the South, and notably in Virginia. No cities had been damaged, no railroad lines torn up. However, Homer had witnessed the war firsthand, and such complacency was out of the question. Through the resentment on the other prisoners' faces, the blasted Virginia landscape—which was so often described as Edenic in its prewar beauty—Homer emphasizes that the damage wrought by the war was not solely of the intellectual kind, but cut to the heart of landscape as home—as a reflection of self. The damage done there stands in for the damage done to the South as a place, as a political body, and as a group of Americans whose physical wounds would heal faster than those inflicted upon their psyches.

Sanford Gifford and Conrad Chapman each painted the war through the lens of landscape painting. They understood the synergy between nature and culture, as articulated by Cole and Bryant and Emerson. The vocabulary of landscape provided the structure for comprehending the emotional toll of their participation in the war, more so than the military subjects they chose to paint. Like Mathew Brady's elegiac photographs at Gettysburg, their works embody the powerful pull of landscape associated with human events. However, their blending of landscape and genre lent their work an anecdotal quality, focusing on moments that stressed the war's human scale. Winslow Homer's ability to synthesize the Civil War and use his paintings to focus on the larger issues confronting the country sets him apart from his colleagues. Although he never served in uniform, he experienced the war in a visceral way, the raw edges of emotion evident in the equally raw execution of figure and landscape.

Prisoners from the Front transcends the usual parameters of genre painting. Homer's friend, artist and critic Eugene Benson, extolled the painting in the *New York Evening Post*, in which he opined, "It is a genuine example of true historical art—the only kind of historical art which is trustworthy in its facts, free from flimsy rhetoric and barbaric splendor; sensible, vigorous, honest."[113] What Homer accomplished combines the lessons of history painting, landscape painting, and the gimlet-eyed perspective of Civil War photography. In this canvas he has summed up the war in a single image and made plain the difficulties of reconciliation. The scars left by the war would complicate the healing process and serve as painful reminders of what was yet left undone. Homer seemed to understand that his Northern audience did not yet grasp the enormity of the task ahead, nor the depths of the animosity felt across the South. The denuded landscape, like Barnard's shattered trees and rubble-strewn cities, spoke volumes about the extent and the depth of the damage to the Southern landscape, its infrastructure, and its very identity. With *Prisoners from the Front*, Homer made a powerful statement about the long-term consequences of the war. The expressions on the faces of Homer's unrepentant Confederates tell the hard truth. Overcoming the divide between Northern and Southern attitudes at the close of the war would prove far harder than the conflict itself.

FIG. 89

Unidentified photographer
General Francis Barlow,
about 1855–1865, Library of Congress

ABOLITION AND EMANCIPATION

In the decades leading up to the Civil War, American genre painters often took a humorous approach to their subjects. Artists like George Caleb Bingham, Francis Edmonds, and William Sidney Mount used their paintings to celebrate the quirks of democracy and expose the foibles of human nature. They poked gentle fun at politicians soliciting votes and speculators conning rural folk, often composing scenes to elicit a chuckle from their viewers. Genre painters who depicted blacks in America had long tended to invoke ethnic caricatures to set apart these subjects, their depictions consistent with the embedded racial prejudices of the day, North and South.[1] The widespread belief, even among abolitionists, that blacks were less intelligent than whites left them prone to gross caricature. Whether these kinds of images were made out of ignorance or unease, they formed the basis of many white Americans' perceptions of blacks as an inferior race. That would change dramatically during the Civil War, principally in the paintings of Eastman Johnson and Winslow Homer. The war spurred a trajectory of racial awareness in both men, and in contemporaries such as Thomas Waterman Wood, that became visible in their paintings. Their depictions of black Americans moved from caricature to empathy during the war years, likely in response to their own interracial experiences. Consequently, their paintings plumbed some of the issues African Americans faced during and after the Civil War with increased sensitivity.

Out of the morass of intertwined causes of the Civil War, two emerged as central governing ideas: the preservation of the Union and the abolition of slavery. Bringing the Confederate states back into the Union, rather than letting them secede to form a separate country, was the original reason given for fighting the war. But at the heart of the division between North and South was the unavoidable issue of slavery. One has only to read the Articles of Secession written and approved by each of the Confederate states to understand the pervasive hold of the "peculiar institution" over the South's governing principles.[2] No matter that the vast majority of Southern families did not own slaves; power resided with those who did. Most Southerners joined the Confederate army or supported the Confederacy out of a deep-seated and heartfelt sense of local and regional loyalty and not specifically to advance the institution of slavery. It was a stance grounded in the founding of the nation on the eve of Revolution. Slavery had nearly blocked the vote for

> *The truth is, dear madame, we are here, and here we are likely to remain.*
>
> — Frederick Douglass

independence in 1776, and in 1860 it again threatened the viability of the nation.

Race relations across America came into sharp focus during the 1850s. The divisive issue of slavery led to violence with alarming regularity, and war seemed increasingly unavoidable. The Christiana Riot in southern Pennsylvania in 1851, though poorly remembered in the national narrative, provided an immediate and shocking challenge to the Fugitive Slave Act.[3] In the next year, Harriet Beecher Stowe published her first novel, *Uncle Tom's Cabin*, sparking furious debate, North and South, over the accuracy of its racial portrayals and its political goals in support of abolition. Agitation over the Kansas-Nebraska Act and expansion of slavery in the western territories was followed by the Dred Scott Decision, handed down by the Supreme Court in 1857. This corrosive decision, asserting that Americans of African descent could not be citizens, sparked violent protests and paved the way for John Brown's raid on Harper's Ferry in October 1859. The term "Slave Power" took on two distinct meanings.[4] Abolitionists used it to describe what they viewed as the increasingly unholy alliance between the slaveholding states and the federal government. In the South, "Slave Power" was an incendiary term designed to foment rebellion. But beyond political rhetoric, for many in the South the nomination and election of Abraham Lincoln to the presidency in 1860 was confirmation that the institution of slavery was under attack. With secession came renewed debate about the intent of the Founding Fathers. Their inability to solve the issue of slavery had a cancerous effect on succeeding generations in the East and implications for the opening and settlement of the West.

THE FOUNDERS AND AMERICAN SLAVERY

In 1850s press and politics, discussion over the future of slavery necessarily included debate about its past, specifically Thomas Jefferson's and George Washington's stances on the issue. Gaining the commitment of Southern states to the new nation had meant omitting any direct mention of slavery from the Declaration of Independence and the U. S. Constitution. The framers, many of them slave-owning planters, left that

contentious issue for a later generation. The Founding Fathers, what they were thinking, and the ramifications of their unwillingness to settle the issue formed a backdrop to discussion of impending civil war.[5] As sectional and racial divisions intensified, so too did the emphasis on the Founders as heroes of an earlier generation. Washington and Jefferson were singled out for particular acclaim. Washington's home, Mount Vernon, became a shrine; Jefferson's ideas served as guideposts for a generation seeking to recapture the perceived stability of their era. Few who idolized these men wished to accept their inconsistent views on freedom and slavery, preferring to focus on their better qualities of statesmanship. The fascination with Washington and Jefferson bordered on veneration; travelers to sites associated with them took on the aura of pilgrimages.

In June 1851, Frederic Church accompanied his friend and patron Cyrus Field to visit two important landmarks in Virginia, Mount Vernon and Natural Bridge. Their trip sheds some light on the hold these sites had on many Americans. Mount Vernon had become a national pilgrimage site in the 1830s and 1840s, as the Revolutionary era receded. Though the estate itself was in increasing disarray, aging enslaved and free blacks worked there to interpret the site and answer questions about what it was like when the great man was alive. Church and Field may well have encountered old West Ford, a free black carpenter in his seventies who had been one of Washington's slaves. Following his manumission, he remained employed at Mount Vernon and through the 1850s occasionally escorted sightseers through the grounds to Washington's tomb, regaling them with stories about life with George Washington.[6]

After visiting Mount Vernon, the pair journeyed west to another shrine. From the colonial period, the Natural Bridge had been an important natural landmark mentioned in the same breath with Niagara Falls. It was commonly referred to by awed Americans as one of the seven natural wonders of the world, and countless artists journeyed there to sketch and paint. During the nineteenth century it was widely reported that in 1750 the aptly named Lord Rockbridge had hired young George Washington, trained as a surveyor, to survey the landmark and the surrounding acreage. Proof of this

UNDER THE NATURAL BRIDGE.

FIG. 90

Harry Fenn, illustrator
J. A. Bogert, engraver
Under the Natural Bridge, from
Picturesque America, wood engraving,
Smithsonian Institution Libraries

was found in the initials "G. W." inscribed about 23 feet up the southeast wall, off the floor of Cedar Creek, the stream running through the arch.[7] Vignettes of attentive visitors populated most prints and drawings made of the Natural Bridge to provide scale for the impressive rock formation. Most of the time they sat or stood on the large rocks next to Cedar Creek; others fished from the banks or walked the stream bed. Gesturing up at Washington's initials was also a popular motif. William Cullen Bryant's *Picturesque America* included an image of Natural Bridge epitomizing the way the arch was depicted, including diminutive figures pointing up to the location of Washington's initials (fig. 90). Looking up

at the bridge, like looking down over the lip of Niagara Falls, conveyed the enormous scale and commensurate drama associated with viewing the natural wonder.

At Field's request, Church painted *The Natural Bridge, Virginia* (cat. 61). Both men were devotees of Alexander von Humboldt and thus were as interested in the geological history of the Natural Bridge formation as its colonial-era history. However, it is likely that Cyrus Field's interest in George Washington influenced Church's unusually specific narrative element in the picture. Seated in the foreground, a young white woman listens as a black man standing next to her points to the spot where Washington carved his initials. For a modern viewer, it is important to understand how unusual it would have been in 1851 to present a black man towering over an unescorted white woman, were it not for the history behind the site. As Washington's stature grew, first during his presidency and beyond his death in 1799, the owner of the Natural Bridge arranged to have an enslaved black man named Patrick Henry stationed there as a cicerone, offering tours to the base of the arch where he would point out Washington's initials. Patrick Henry eventually purchased his freedom, and in 1817 after Thomas Jefferson acquired the property, he requested that Henry stay on to instruct visitors and keep an eye on the site for its absent owner, the same role West Ford played for decades at Mount Vernon.[8]

Past and present reverberate subtly in Church's picture. He has in effect made his landscape painting of Natural Bridge into a history painting, knowing that Field would appreciate both the geology and the history as he admired it hanging in his home.[9] But if *The Natural Bridge* invokes the era of Virginia's patriotic white founders—Washington, Jefferson, and the

original Patrick Henry—it does not ignore the Virginia present of black Patrick Henry. The state's "Reform Constitution" of 1851 had just mandated that newly freed black Virginians who did not leave the Commonwealth within the next year would be reenslaved, just as states in the North were passing controversial new anti-immigration laws to keep free blacks like Henry and Ford from taking up residence.[10] Even wandering along bucolic Cedar Creek, a minor tributary of the James River, the two white travelers could hardly avoid the contemporary political issues that swirled around them. Church's painting, therefore, becomes a masterful blending of past and present, conveying the timeless appeal of the Founding Fathers and the link between American destiny and the landscape, in this case, literally carved into its features. For Field and Church, *The Natural Bridge* brought together the magnificence of the geological feature with the monumental achievements of the Founders, while also hinting at the tectonic shifts taking place in their own time.

Humboldt inflected this painting of Natural Bridge in more ways than one. As a natural scientist, his insatiable curiosity about geological processes delighted in the apparent conundrum that an arch that rose above the surrounding landscape was in fact the lone remnant of a collapsed cavern. But Humboldt was also a dedicated abolitionist. In his meeting with President Thomas Jefferson in 1804, Humboldt entreated the sage of Monticello to abolish slavery, much as the Marquis de Lafayette, another product of the European Enlightenment, had implored his friend President Washington to do in 1783.[11] Like Lafayette and many other foreign supporters of postrevolutionary America, Humboldt felt that to ignore this vital issue was to doom the country with which he had been smitten. His writings on South America were laced with commentaries on land use and human rights, demonstrating the breadth of his mind and his belief in the interlocking destinies of science and politics. He followed up on his impassioned conversation with letters to American scientists, politicians, and abolitionists, arguing that America was a country too good to be a slaveholding nation.[12] His views on abolition were published in American newspapers; they were as well known as

his theories linking climate change to deforestation. Church and Field were steeped in Humboldt's writings. In 1853 the pair retraced the great man's journey across Colombia and Ecuador, hiring his guides and staying in the same lodgings in an effort to channel Humboldt's way of thinking about geology, botany, and man's impact on his environment. On this 1851 trip through Virginia, Humboldt's concern for black emancipation became a more concrete and visible part of Church's and Field's world. At both Mount Vernon and Natural Bridge, they encountered formerly enslaved people who were now charged with explaining the virtuous qualities of the Founders associated with them. However, it was also an opportunity for these former slaves to serve as interpreters of their own history, relating their personal experiences as part of the narrative. Their voices alternately affirmed and undermined the vision of slavery as a benign institution. More significantly, their presence and their stories set the stage for black perspectives to become an integral part of the American experience during the war years.

UNCLE TOM'S CABIN AND THE STIRRINGS OF SELF-EMANCIPATION

The push for abolition hinged in large part on public acceptance of blacks as people—and not as property. Some black individuals and families who escaped slavery, like Frederick Douglass and Harriet Jacobs, told their stories publicly. The Underground Railroad encouraged networks of blacks and whites to bring these fugitives to freedom and give them a voice in the escalating debate. As Church and Field made their way to Natural Bridge, Harriet Beecher Stowe (fig. 91) began publication of a book that reshaped the country's views of slavery as well as regional and national politics. *Uncle Tom's Cabin* (fig. 92) painted blacks as people deserving of freedom, and slavery as a wicked institution needing to be abolished. Her narrative first appeared as a forty-one-part serial publication in the *National Era*, a Washington, D.C., abolitionist newspaper.[13] Before she had finished writing the conclusion to her novel, Stowe's story had caught fire across the country, as readers eagerly awaited each installment. By March 20, 1852,

FIG. 91

Unidentified photographer
Harriet Beecher Stowe, about 1865,
National Portrait Gallery, Smithsonian
Institution

FIG. 92

Harriet Beecher Stowe
Frontispiece from *Uncle Tom's Cabin;
or, Life among the Lowly*, 1852, steel
engraving, The Lilly Library, Indiana
University

the author had produced *Uncle Tom's Cabin* in book
form. The statistics are well known: 10,000 copies
sold within the first few days, and 300,000 copies sold
during the first calendar year. Thanks to lax copyright
laws, playwrights could adapt her work without need-
ing her permission. As a result, the first dramatizations
of her novel reached the stage with imagined endings,
months in advance of Stowe's own published conclu-
sion. Although Stowe herself disapproved of the theater,
there were many adaptations developed by dramatic
troupes and minstrel shows. The mania for Uncle Tom
plays and memorabilia had begun.

Stowe's fictional polemic about the evils of slavery
captured the American imagination, but reaction to the
play was deeply mixed. It was pilloried among well-
to-do Southerners as a slanted and pejorative view of
the institution of slavery, which many now defended
not as a necessary evil but as a positive good. Southern
critics feared *Uncle Tom's Cabin* would inspire a new

generation of abolitionists and give rise to further
slave insurrections.[14] There was even a subgenre of
"anti-Uncle Tom" plays popular in the South deemed
corrective to the perceived inaccuracies in Stowe's
book.[15] The region's initial wave of virulent criticism
gave way to sullen silence, as though by ignoring her
work, Stowe's diatribe about the evils of slavery might
be less influential. Rufus Choate, a proslavery lawyer in
Massachusetts, voiced that fear when he remarked that
Uncle Tom's Cabin would create "two million abolition-
ists."[16] Southern slaveholders viewed abolitionists as dan-
gerous meddlers who threatened the delicate balance
that allowed white planters to maintain firm control over
their more numerous enslaved workers, avoiding open
revolt. Among the various factions of Northern abolition-
ists, some admired Stowe's work and exhorted others to
champion its point of view, while other, more strident
voices felt it did not go far enough in painting the evils
of the South's "peculiar institution."

Literary, theatrical, and artistic illustrations of Stowe's
characters contributed significantly to Americans' views of
race. Artists were quick to pick up on the visual qualities
of Stowe's narrative, and images derived from key scenes
in the book soon appeared in popular prints, on sheet
music, and in paintings. The scene of Eliza racing to cross
the frozen Ohio River, her baby in her arms, became an
oft-illustrated symbol of the risks blacks were willing to
take in a desperate bid for freedom. Stowe herself un-
derstood the power of images to convey the emotional
depth of the racial injustice presented in *Uncle Tom's
Cabin*. In a letter she wrote, "My vocation is simply that
of a painter, and my object will be to hold up in the most
lifelike and graphic manner possible Slavery.... There is
no arguing with pictures, and everybody is impressed by
them, whether they mean to be or not."[17]

Many artists composed recognizable scenes from
Uncle Tom's Cabin. Among the earliest of these paint-
ings drawn from the novel is Robert S. Duncanson's
Uncle Tom and Little Eva (cat. 62), painted in 1853,
where the saintly Eva is teaching Tom to read the
Bible and describing to him the eternal grace of heaven.
Duncanson conflates two moments from Stowe's book
in order to place his figures outdoors during this pivotal
scene in the narrative. The landscape is an Arcadian

CAT. 62

Robert S. Duncanson
Uncle Tom and Little Eva, 1853,
oil on canvas, 27 ¼ × 38 ¼ in.
Detroit Institute of Arts, Gift of Mrs. Jefferson
Butler and Miss Grace R. Conover

vision of the South based on Stowe's description of the view from the villa, "surrounded by light verandas of bamboo-work" on Lake Pontchartrain, near New Orleans. "The common sitting room opened on to a large garden, fragrant with every picturesque plant and flower of the tropics, where winding paths ran down to the very shores of the lake, whose silvery sheet of water lay there, rising and falling in the sunbeams. . . .It is now one of those intensely golden sunsets which kindles the whole sky into one blaze of glory, and makes the water another sky."[18] Eva stands next to Tom and declares, "I'm going there . . . to the spirits bright, Tom. I'm going before long." In Stowe's narrative, salvation is achieved through love and personal sacrifice. "The child rose, and pointed her little hand to the sky; the glow of evening lit her golden hair and flushed cheek with a kind of unearthly radiance, and her eyes were bent earnestly on the skies."[19] Duncanson's painting is of a vision beheld in an Arcadian landscape, placing Eva poised between Eden on this earth and heaven in the next. In Duncanson's painting, heaven is a tropical landscape, a reward for a life well lived.

Uncle Tom and Little Eva was commissioned by the Reverend Francis Conover, an Episcopalian minister and newspaper editor who was himself a staunch abolitionist. Conover's support extended beyond simply wanting a painting from Stowe's novel; his goal was to support the artist as well. Robert Seldon Duncanson (1821–1872, fig. 93) was a man of mixed race. His parents, both free mulattoes, moved the family from Virginia to Fayette, New York, near Seneca Falls.[20] In 1840 the artist moved to Cincinnati, then the largest and most prosperous city on the western frontier. By the 1850s the Queen City had developed a reputation for its proabolitionist leanings. But even here Duncanson walked a fine line, acknowledging his heritage without flaunting it. With his light skin and fine features, Duncanson easily crossed the color barrier, but he worked hard to make a decent living and raise a family working as an artist of color during the antebellum and Civil War years.

FIG. 93

William Notman
Robert S. Duncanson, artist, Montreal, QC, 1864, McCord Museum, McGill University, Purchase from Associated Screen News Ltd.

Notwithstanding his desire for race-neutral acceptance, as sectional and racial tensions intensified during the 1850s, Duncanson's race became a more central and public part of his career. Cincinnati was home to a substantial group of prominent abolitionists, among them Conover, James Birney, Nicholas Longworth, Rev. Charles Avery, Freeman Cary, and Rev. Richard Rust, all of whom were among the artist's patrons.[21] During the 1840s Lyman Beecher and his family—including daughter Harriet and son Henry Ward Beecher—were friends and fellow residents. Stowe and her brother left for Boston shortly before she wrote *Uncle Tom's Cabin*; however, their ties to Cincinnati meant it was highly likely Duncanson, and many of his patrons, read the book in serial form and saw one of the early plays.[22] In fact, Duncanson's composition is based on an engraving that was published in the first edition of Stowe's novel, that adaptation possibly made at Conover's request.[23]

Duncanson's career prospects in Cincinnati seemed bright, and commissions for landscapes and portraits did not push the artist toward painting scenes that were overtly politically charged. Although it is possible to read into some of his landscapes the desire for peace and racial harmony, Duncanson did not make racial politics a prominent part of his public persona or his artwork. He did find ways to participate in antislavery activities in Cincinnati, collaborating with another mulatto artist and photographer, James P. Ball, on his ambitious and monumental panorama addressing the evils of slavery. In 1855 he donated a painting described as "the most creditable work which has emanated from his pencil" to the Anti-Slavery Bazaar to be sold to raise funds for the cause.[24] Local abolitionist journals took pride in pointing out Duncanson's accomplishments as evidence of the capabilities of African Americans.

The issue of "passing for white" was a fraught one for mulattoes capable of doing so. For some it meant easier passage in a majority white culture; for others it represented an abrogation of race. Duncanson's son Reuben had harsh words for his father and was disappointed that he was not more of an activist. The artist responded vehemently, writing to his son,

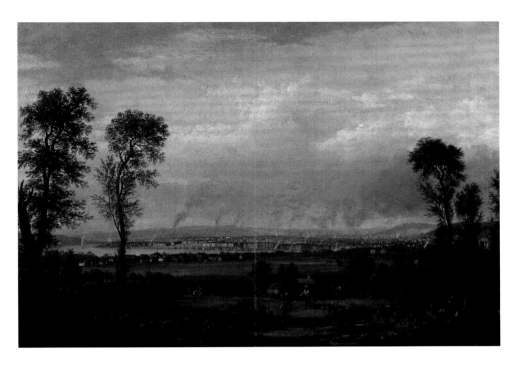

FIG. 94

Robert S. Duncanson
View of Cincinnati from Covington, KY,
about 1851, oil on canvas, 25 × 36 in.
Cincinnati Museum Center, Cincinnati
Historical Society Library

FIG. 95

J. W. Steel, engraver
View of Cincinnati, Ohio, from
Graham's Magazine, June 1848,
steel engraving, Smithsonian
Institution Libraries

I heard today, not for the first time, of your abusive language toward me. . . . Shame on you! Shame!! Shame!! Reuben. My heart has always been with the down-trodden race. There are colored persons in this city that I love and respect, true and dear to me. It does not follow that because I am colored that I am bound to kiss every colored or white man I meet. Hog's [sic] pick their company, and I have the same right. . . . I have no color on the brain all I have on the brain is paint. . . . What have the colored people done for me? or what are they going to do to me? please answer? I care not for color: "Love is my principle, order is the basis, progress is the end." Reuben one step more in the course you have pursued and you fall. How often we see the total destruction of disobedient and God forsaken children. You have gone for [sic] enough in your abuse.[25]

Reuben's accusation, that his father had turned his back on his race in an effort to thrive in a white economy, clearly stung the artist. Duncanson had likely found it difficult enough to sustain a career as an artist of color, even in Cincinnati. Having artfully navigated the turbulent waters between the shoals of race baiting and race blindness, Duncanson foundered on the rocks of his son's judgment.

The Civil War made it increasingly difficult for Duncanson to feel comfortable even in Cincinnati, and by 1863 the artist had moved with his family to Montreal. There he was in good company; Canada was a terminus of the Underground Railroad. Even Frederick Douglass had headed north of the border after John Brown's raid on Harper's Ferry in 1859, when his arrest seemed imminent. Cincinnati had long been an important stop on the Underground Railroad. Across the river was Covington, Kentucky, and between them flowed the Ohio River. For many who escaped, the Ohio River represented the last obstacle to freedom. It was across that river that Stowe's character Eliza escaped with her infant daughter, crossing the ice floes that choked the river at the height of winter.[26] Early in Duncanson's career, he had composed a view of Cincinnati from Covington, Kentucky (fig. 94), based on an engraving that had appeared as the frontispiece in the June 1848 issue of *Graham's Magazine* and was titled *View of Cincinnati, Ohio* (fig. 95).[27] In adapting the print, Duncanson took care to distinguish between the prosperous industrial waterfront of Cincinnati and the bucolic landscape of Covington; and in doing so he paid particular attention to the figures in the foreground. Whereas all of the figures in the print are white, the central grouping in Duncanson's painting is black, and one man carries a scythe instead of a rifle. The artist has moved the scene from one of white recreation to black field labor. Kentucky was a slave state, and the view across the river to the free state of Ohio must have been an

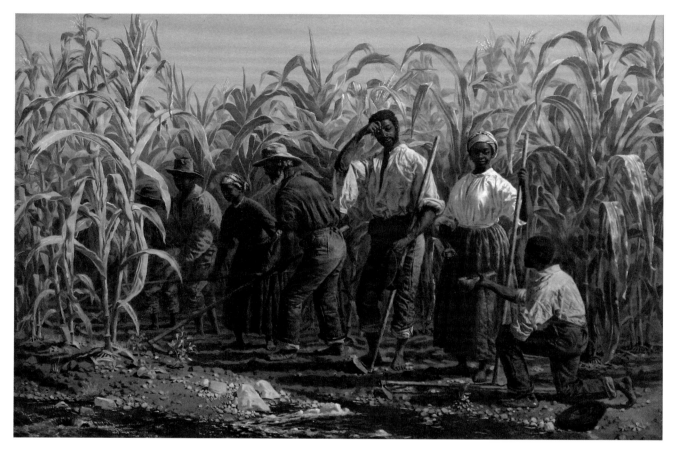

FIG. 96

Thomas Waterman Wood
Southern Cornfields, 1861,
oil on canvas, 27 × 40 in.
T. W. Wood Gallery,
Montpelier, Vermont

appealing reminder of the hope and determination felt by black people willing to risk their lives to be free. A later version of the same print carried the subtitle "from Covington, Kentucky," strengthening the implication that it was a view toward sanctuary and a symbol of the free states in America.

Most of the routes used for the Underground Railroad followed waterways, as water blurred footprints and frustrated tracking dogs. Many of the escaping blacks who made their way north to Cincinnati passed through Tennessee and Kentucky en route to Ohio. In 1861, the Vermont artist Thomas Waterman Wood (1823–1903) was working in Nashville, Tennessee, and from his studio there sent a large painting entitled *Southern Cornfields* to the National Academy of Design (fig. 96). Wood already boasted a deserved reputation as

a keen observer of character, but here he also made clear his views on slavery. Black men and women appear to be working in the cornfield, through which a small irrigation stream flows. In the right foreground a young black man holds up a dipper gourd full of water, presenting it to the man and woman closest to him. As they consider his offer, the other figures behind them turn and disappear into the depths of the cornfield, vanishing into the protective cover of the landscape. In the parlance of the Underground Railroad, to "follow the drinking gourd" meant heading due north at night, toward the North Star, since African Americans referred to the Big Dipper (the constellation that points to the North Star) as the Drinking Gourd. Wood's young man offers more than a drink of water; he offers a taste of freedom.

EASTMAN JOHNSON AND THE POLITICS OF GENRE PAINTING

The power of genre painting to express significant political and moral issues took root in the work of Eastman Johnson (1824–1906, fig. 97). Trained as a portraitist, he developed a strong interest in creating works of art that embraced a more serious and complicated view of race relations in the United States. During the Civil War, he made a name for himself for his willingness to paint subjects that delved deeply and intentionally in the issues surrounding slavery and emancipation. Several of these paintings challenged the prevailing ideas about race in America. Johnson's developing racial awareness probably owed a great deal to Stowe's novel, which inspired many casual readers to become more emotionally vested in the idea of ending slavery. Its popularity overseas rivaled that in America, boosted in part by the author's tour of Europe in 1853. By 1860 *Uncle Tom's Cabin* had been published in twenty-two foreign languages and enjoyed wide circulation across

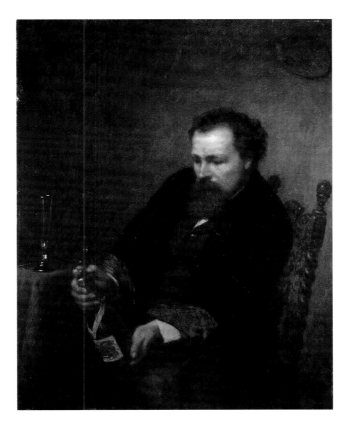

FIG. 97

Eastman Johnson
Self Portrait, 1863,
oil on millboard, 15 ½ × 12 in.
The Art Institute of Chicago,
Gift of Mrs. Arthur Meeker

the continent. Johnson was living in Belgium when he exhibited a painting at The Hague Living Artists annual exhibition titled *Uncle Tom and Evangeline* (location unknown). The catalogue mentioned the subject in connection with Stowe's novel, confirming the international popularity of the book and its growing influence on the question of abolition in America.

Johnson's early interest in a subject based on Stowe's work suggests signs of his own abolitionist sentiments. However, he had grown up in rural Maine in a Democratic family. His father brought the family to Washington, D.C., after he secured a political appointment to the U.S. Navy Yard under the patronage of Maine's former governor and newly elected Democratic senator, John Fairfield. Although the artist found ready sittings for his portraits thanks to his father's connections on Capitol Hill, Johnson sailed for Europe in 1849 and spent the next six years abroad. He was in Paris in early September 1855 when he received word of his mother's death. He cut short his studies to return home to Washington the following month.[28] By then his father and siblings were living in a house at 266 F Street, between 13th and 14th streets, not far from the White House or the Navy Yard.[29] Johnson came home in time to witness James Buchanan's inauguration at a moment when congressional politics were heating to the boiling point. The family home was near a spot that was later aptly nicknamed "Secessionist Hill," since Jefferson Davis of Mississippi and Georgia's Robert Toombs both lived there, along with other Southern members of Congress.[30]

Sometime after Eastman arrived home in early November 1855, his father began courting the woman who would become his second wife, Mary Washington James, a descendant of the first president. Their wedding date was set for August 1857. Her marriage would bring three enslaved blacks into the Johnson household. Prior to the wedding, during the summer of 1857, Eastman made a foray across the Potomac to investigate and paint Mount Vernon. He was accompanied on his trip by another artist, Charleston-born Louis Rémy Mignot.[31] The two men were the guests of John Augustine Washington, who had inherited much of the lands comprising Mount Vernon from his uncle, Bushrod Washington, who had been George

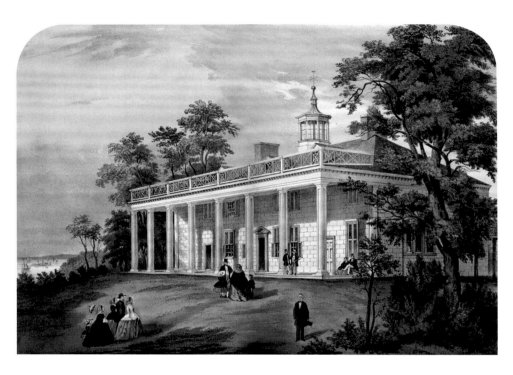

FIG. 98

Currier & Ives
The Home of Washington, Mount Vernon, Va., about 1856–1872, hand-colored lithograph print, Library of Congress

shrine for admirers of the country's first president. Visitors who wandered the grounds as the house was being restored absorbed the aura of America's most beloved founding father, unaware that Augustine Washington, himself a planter, was using the money from the Ladies' Association's purchase of the mansion and tomb to buy additional slaves to work his lands.[33]

Most artists and visitors focused on the main house and paid specific attention to the portico facing the Potomac River, with its stately columns and magisterial vantage point (fig. 98). Johnson's largest known canvas of Mount Vernon, painted in 1857 after his visit and titled *The Old Mount Vernon* (cat. 63), eschews the traditional focus on the front portico. Instead Johnson adopted a vantage point looking south, at an angle that catches the edge of that famous columned expanse, but which encompasses the northernmost outbuilding and the covered walkway connecting this domain of household servants to the main house. At the time of Johnson's visit, the property housed seventeen families of enslaved blacks to keep the house and grounds.[34] In the doorway of this smaller structure sits a black man; other small figures appear to be traversing the space between the main house and this outbuilding. His perspective encourages the viewer to address the entirety of Mount Vernon: its classically inspired, lofty façade, emblematic of the high ideals of the nation and its first president—and the practical acknowledgement that without the outbuildings, support staff, and enslaved people, this façade cannot be sustained. For Johnson it was a paradox with which he could not make peace. Newly arrived in a town consumed by political controversy, living in a neighborhood populated with future secessionists, and his own family soon to be linked by marriage to the Washington clan, Johnson could not ultimately square his own abolitionist beliefs. *The Old Mount Vernon* carries a subtle indictment both of Washington's acceptance of slavery and his own father's acceptance of enslaved people in his household.

Henry Adams (fig. 99) was twelve when his father Charles Francis Adams brought him to Mount Vernon in May 1850. The younger Adams—and likely the older one as well—was struck by the terrible condition of the roads leading to the property and equated bad roads

Washington's nephew and heir. Augustine's family now served as primary caretakers for the estate. Perhaps drawn to the spot by the associations with his soon-to-be stepmother, Johnson prowled the derelict grounds, which had only recently come into the care of a small cadre of Northern women who fashioned themselves as the Mount Vernon Ladies' Association.[32] This group would oversee the rehabilitation of the Founding Father's tomb, main house, and surrounding outbuildings, all while welcoming guests and voyeurs.

In 1832 the nation had celebrated the centennial of George Washington's birth, and artists rallied to the occasion, painting numerous scenes drawn from his life as a soldier, civilian, and patriarch. The following year his old Virginia friend, John Marshall, launched the Washington National Monument Society, promising a column in the capital that would take decades to complete. Mount Vernon also came in for enhanced scrutiny, and the first president's tomb attracted a steady stream of visitors, but the main house and grounds had fallen into disrepair. Initial restoration efforts in the 1850s by the Mount Vernon Ladies' Association gradually improved the situation, and George Washington's home went from being a dilapidated ruin to a nascent

CAT. 63

Eastman Johnson
The Old Mount Vernon, 1857, oil on board,
23 ¼ × 34 ½ in. Mount Vernon Ladies' Association,
Purchased with funds courtesy of an anonymous donor
and the Mount Vernon Licensing Fund, 2009

with bad morals. Henry Adams later wrote, "The moral of this Virginia road was clear, and the boy fully learned it. Slavery was wicked, and slavery was the cause of this road's badness which amounted to social crime—and yet, at the end of the road and product of the crime stood Mount Vernon and George Washington."[35] Acknowledging the same fundamental paradox as that which confounded the Founding Fathers, Adams somehow managed to reconcile his abhorrence of slavery with his admiration for Washington. His words epitomized the internal struggle with which so many Americans wrestled when they attempted to reconcile their respect for the great deeds of the founders in establishing this country with the contradictions lodged in their personal behaviors. Set against the contemporary notions of the evils of slavery, such hero-worship of the founders threatened to ring hollow. Johnson's painting captures something of that predicament, and perhaps some of the strain his father's engagement must have placed on their relationship.

FIG. 99

John Adams Whipple
Henry Brooks Adams, Quincy, 1858,
Harvard Art Museums/Fogg Museum

NEGRO LIFE AT THE SOUTH

Soon after painting *The Old Mount Vernon,* Eastman Johnson departed the capital city and his father's home for the Upper Peninsula of Michigan and Wisconsin to visit with siblings. He remained there through August 1857 and did not return to Washington for his father's wedding. Nor did he return afterward, instead traveling first to Cincinnati, and thence to New York, where he opened a studio.[36] There Johnson embarked on the large-scale painting that would establish his artistic career and place the issue of slavery front and center in the New York art world as war loomed.

Negro Life at the South (cat. 64) debuted in April 1859 at the National Academy of Design, where it attracted immediate and sustained praise for its frank yet engaging portrayal of the lives of enslaved black people in Washington, D.C., on the eve of war. Critics focused most of their attention on the human activity staged across the painting's foreground, parsing each character and seeing in each an illustration of a negro type

drawn from literature, notably from *Uncle Tom's Cabin.*[37] Johnson's painting depicts a young mulatto couple courting in the lower left corner, while a darker-skinned woman holds a small child in the open window above their heads. They listen to the notes of a somber banjo player, as does a small boy holding a broken pull-toy. An older, dark-skinned woman guides a young boy in a dance. Two young girls, one perched on a short ladder, the other beckoning toward the open gate joining the two properties, gaze on a white woman who is entering the yard. Behind her is a black woman in a turban. Reviewers commented on the power of music to bring people together, including the curious young mistress drawn from what they described as the master's house.

Many noted with approval the implicit criticism of the decaying slave quarters, reading into it the decay of the institution itself, drawing moral distinctions between the slaveholding South and the free North. The day is ending, but no fire for dinner blazes in the hearth. Vegetables rest in baskets at the far left, but the young woman charged with peeling them has her mind on other things. The leeks at her feet allude to her servitude, as described in a line from the biblical book of Numbers.[38] An axe lies casually on the ground, perhaps dropped there by the young man or simply overlooked, but there is no stack of wood to feed a fire. A scythe, hanging properly in the tree, speaks of rural labor, unlikely in downtown Washington. The appearance of an axe and a scythe in the living quarters of an enslaved family is puzzling but would appear to underscore the feeling that these people are no threat to their masters, nor capable of insurrection. Johnson's figures, at leisure and enjoying the music and the children's antics, encouraged Democratic-leaning papers to consider this painting as a benign referendum on the effects of slavery, noting the denizens of the yard appeared happy and healthy.

The earliest review, from the *New York Times,* noted with pleasure the anecdotal visual details but failed to connect the individual vignettes into a coherent narrative. This reviewer, like so many others, delighted in pointing out "the slovenly courtyard, the tatterdemalion walls of the negro house, the rich damp moss upon the roofs, and the diverse groups that make up the humanity of the picture.... The cock, high perched in

CAT. 64

Eastman Johnson
Negro Life at the South, 1859,
oil on linen, 37 × 46 in.
The New-York Historical Society,
The Robert L. Stuart Collection

the branches, the cat slinking in the open window, the loose swinging clapboards and dislodged bricks of the building." He singled out the courting couple on the far left, referring to the young mulatto girl as "so perfect a type of her strange, hybrid race." He concluded by calling the painting "a true Southern idyl, and offers the best promises in its kind that have ever been given to the public on the walls of this Association."[39] By terming it an "idyl," the reviewer banished any deeper consideration of the content and disregarded any seriousness of purpose. However, Johnson's myriad details are fraught with significance. The artist has woven together his vignettes to form a narrative that challenges the very idea of race as a means of determining a person's status.

The largest of those vignettes encompasses the people in the foreground. However, the number of enslaved blacks portrayed was a significant anomaly. In Washington, D.C., the average number for a single urban household was three—the same number Eastman's new stepmother had brought into the Johnson household with her marriage to the artist's father.[40] The eleven enslaved blacks included in this painting far exceed most urban households, and since none are dressed as field hands, they suggest the range of the urban black community instead. The conviviality and gathering of so many people spanning three generations speaks to the strength of community within the enslaved world, but also to the attempt to create and maintain family structures and pass on traditions and possibly information. The slave grapevine was a powerful tool across cities and even through plantations for news of the war and emancipation. Many of Johnson's New York viewers would not necessarily have picked up on this curiosity, but the artist knew how Washington society operated.

Critics tended to see the activity as a stage set, complete with musician and the kind of dancing and merriment associated with traveling minstrel shows, which were quite popular in the North. The frieze of figures in the foreground contributed to the sense that this was a tableau with musical entertainment and characters that seemed familiar from songs and plays. The activity in that rear yard nominally centers on the banjo player. His music accompanies the child dancing with the oldest woman there. She appears much older

than the others, her stern, dignified features and very dark skin alluding to her African origins. In Johnson's day, she was seen as the matriarch of the family, teaching the younger children African folkways in an effort to keep those traditions alive in the new world. The rest of the figures, some dark-skinned, others much lighter, referred both to the variety of skin tones inherent in the black population and to the practice that would soon be called miscegenation, or the mixing of the races.[41] Several of the reviewers paid some attention to the activity in the upper half of the painting, noting with pleasure the vignettes of the cat entering into the upstairs window, the dark-skinned woman holding a lighter-skinned child from the other upstairs window, and the rooster calling to the hen, denoting the close of the day. Critics praised all of these separate pieces as evidence of the artist's close observation of nature and his surroundings and lauded the entire painting as a significant accomplishment in the field of genre painting.

Critics, however, neglected to read the upper and lower halves of the painting together and failed to integrate the narrative threads. Johnson's masterful portrayal places the slave quarters next to the master's house, an unorthodox architectural relationship that sets the tone for reading the entire painting as a series of connections between the two dwellings and their residents. Ordinarily urban slave quarters faced the back yard of the owner's house, joined by an alley running between the back of each domicile.[42] Adjacency here speaks to a closer relationship between the two structures. The advanced state of decay exhibited by the exposed and rotting rafter beams of the back porch (which shows signs of once having been an enclosed kitchen area) raises questions about the kind of oversight provided by the master. The neatly kept brick home stands in stark, deliberate contrast to the deteriorating wood and chipped plaster next door. Henry Tuckerman made much of this in his review, linking the dilapidation of the slave quarters to the pernicious effects of slavery on America: "The very details of the subject are prophetical. How fitly the dilapidated and decaying negro quarters typify the approaching destruction of the 'system' that they serve to illustrate! And, in the picture before us, we have an illustration also of the

FIG. 100

Eastman Johnson
Negro Life at the South (detail),
1859, oil on linen, 37 × 46 in.
The New-York Historical Society,
The Robert L. Stuart Collection

'rose-water' side of the institution. Here all is fun and freedom. We behold the very reality that the enthusiastic devotees of slavery have often painted with high-sounding words. And yet this dilapidation, unheeded and unchecked, tells us that the end is near."[43]

If that were all Johnson had intended, *Negro Life at the South* would still be a fine rendering of urban enslaved society, but Johnson took the trouble to include far more in this painting. The fence that both divides and connects the two houses is breached in two places: by the open gate, through which the two women arrive, and above, by a wooden ladder perched on the mossy roof of the slave quarters and resting against the brick wall of the master's house, near one of the upstairs bedroom windows (fig. 100). Out of the adjacent window on the same corner, a bolt of light blue fabric descends, as though suggesting there is a way into and out of the master's house without using the front door.

The cock that crows in the tree, level with those two bedroom windows, calls to his mate to join him for the night—a habit of chickens noted by a reviewer, who commented, "not the least poetical incident on the canvas is that by which we recognize the time of day to be the evening hour, namely, the attitude of a hen at the top of the old shed, who is in the act of springing into a tree where her lord and master has preceded her to select a roosting-place."[44] Indeed, it would seem that the lord and master had called to one of his female slaves to join him in a tryst. Johnson artfully places the white cat slinking through the open window into the bedrooms of the slave quarters. Leaning out of the corresponding window on the other side of the chimney is the darker-skinned woman holding a much lighter-skinned baby. Johnson's upper half of the painting carries a subtle narrative of blood connections between slave and master, resulting in at least one of the light-skinned offspring.[45]

But it is in the appearance of the young white girl, furtively stepping through the doorway into the slave yard, that Johnson has actually focused his painting. She comes, perhaps to hear the music, but is drawn by something more elemental. No one in the yard is surprised to see her; no one stops what he or she is doing to acknowledge her arrival. She is a familiar presence there; the dog greets her joyfully, the young black girl in the blue dress beckons to her, as if to encourage her to enter fully. The white girl's gaze goes not to the children who welcome her, or to the musician; instead she is focused on the young woman, close to her own age, flirting with her suitor on the far side of the yard. She comes because Johnson strongly implies that part of her belongs here, too, that like the young mulatto girl and baby, she, too, is a product of miscegenation. Able to pass for white, she lives as a free woman in the master's house. Should her secret be discovered, her status would change dramatically, closing permanently that passage between these two worlds. Perhaps that accounts for the older black woman following the young white girl. She appears to be a house servant and quite possibly is the young girl's mother. She checks to make sure her young mistress is not observed as she ducks into the yard next door to engage with the other side of her family, the unspoken aspect of slaveholding society.[46]

Stories out of the South of enslaved women bearing their master's children fascinated and horrified both Northerners and Southerners. Southern diarist Mary Chesnut (fig. 101) cast a disapproving eye on such dual families, writing in her diary, "A magnate who runs a hideous black harem with its consequences under the same roof with his lovely white wife, and his beautiful and accomplished daughters. Is there such a being? . . . He holds his head as high and poses as the model of all human virtues to those poor women whom God and the laws have given him. From the height of his awful majesty, he scolds and thunders at them, as if he never did wrong in his life."[47] Former enslaved woman Harriet Jacobs (fig. 102) noted with disgust, "The secrets of slavery are concealed like those of the Inquisition. My master was, to my knowledge, the father of eleven slaves. But did the mothers dare tell who was the father of their children? Did other slaves dare allude to it, except in whispers among themselves? No indeed!"[48] That a man could enslave his own children struck many as one of the gross moral failings of a slave society, and one that took place with far greater frequency than anyone was comfortable believing.

Putting all of the compositional elements of *Negro Life at the South* together, it seems clear that this white girl is in fact passing for white, that she looks to her sister—possibly a full sister—whose features do not accommodate the same possibilities. The only way the young girl from the "Big House" can connect with the rest of her heritage is on the sly, when the coast is clear, lest she be found out. Passing for white was a narrative thread in the nineteenth century, one that Duncanson wrestled with as he lived on the border between slave and free states. If you could pass, your way was clear in free society, but your contact with the black part of your heritage was forfeit.[49] Only the dog in Johnson's painting seems to call her out—he of the mixed brown and white spots, here seeming to sniff out a fellow mixed traveler. Dogs were often used by slave hunters to find their fugitive quarry. The dog here resembles a water spaniel, a breed brought over from England and used along the rivers and coastal marshes to retrieve game shot down by hunters. Here the dog conjures slave-hunting posses along American waterways and

FIG. 103

Dion Boucicault
Frontispiece from *The Octoroon; or,
Life in Louisiana*, 1859, steel
engraving, Colby College Special
Collections

signals the arrival of yet another consequence of the slaveholding South.

In December 1859, Dion Boucicault's play *The Octoroon; or, Life in Louisiana* (fig. 103) premiered and captivated New York theatergoers with its sensational plot. Set on a plantation, the play follows the tragic life of Zöe, an octoroon, the legal term for a person who was one-eighth black. She is the daughter of an enslaved woman and her master, raised under her father's roof in the "Big House" as the master's daughter. Her ancestry kept secret, she passed for white and was romanced by a young white suitor. Upon her father's untimely death, she is revealed to be black and is to be sold at auction along with the rest of the enslaved people. Distraught at her fate, Zöe drinks poison and dies in her lover's arms. The play ran in New York and was reviewed in the newspapers and the art press, providing ample opportunity for viewers and readers to sympathize with the young girl and her precarious position.[50] Understood against this backdrop, Johnson's panoply of skin tones makes visible the conundrum of race and color as arbiters of a person's legal status.

With *Negro Life at the South*, Johnson has painted a referendum on the definition of race on the eve of Civil War. Enfolded within his frieze of varied skin tones he has posed a question central to the debate around slavery: how color determines whether someone is a person or property. Johnson's paintings often presented a benign, simple surface layer of meaning, which on closer evaluation reveals deeper thinking and more complicated issues. In this complex and meticulously rendered scene, each element alludes to connections between white and black spaces and white and black people. When we rejoin the two halves of the painting, we appreciate how deftly Johnson has woven into this image open-ended yet pointed questions about what constitutes the definition of race. It is an unexpectedly dense commentary on the country. What at first appears harmonious eventually sounds enough jarring notes to render the artist's verdict on slavery and its impact on American society as unstable and as decayed as the mossy ceiling that appears one stiff breeze away from crashing down on everyone beneath. The young white girl's tentative behavior as she enters the yard reflects

her own uncertainty. But on a larger scale, her temerity reflects Southern fears that their happy slaves were on the brink of insurrection, particularly on plantations where they outnumbered their white masters. The issues developed a personal cast. Johnson was by then bound by his father's marriage to the Washington family and to its legacy of slaveholding. The artist was no longer simply a bystander, but a part of this narrative.

By 1859 when Johnson painted *Negro Life at the South*, the Southern way of life was on the verge of imploding. The previous year Lincoln had declared, "A house divided against itself cannot stand. I believe this government cannot endure, permanently, half slave and half free. I do not expect the Union to be dissolved—I do not expect the house to fall—but I do expect it will cease to be divided. It will become all one thing or all the other. Either the opponents of slavery will arrest the

further spread of it, and place it where the public mind shall rest in the belief that it is in the course of ultimate extinction; or its advocates will push it forward, till it shall become alike lawful in all the States, old as well as new—North as well as South."[51] Lincoln's architectural metaphor resonates in Johnson's composition. The house divided—in this painting, between the solid brick house of the master and the decaying frame of the slave quarters—is itself a world that is half-slave, half free. Similarly, Johnson focuses on the subtle unraveling of white control, the subtle intermingling of black and white, the stark divisions between two halves of society eroding and decaying like the vestigial rafters over the enslaved people's heads.

The potential for a more complicated reading of *Negro Life at the South* dissipated quickly. By August 1859, when the painting was on view at the Boston Athenaeum, its title had been changed to *Old Kentucky Home*, presumably by its first owner, William P. Wright.[52] The change is significant. Wright was a cotton magnate, a New York Democrat with deep financial ties to the Southern economy. Without plantation-based slave labor, the cotton industry would falter badly.[53] The new title evoked Stephen Foster's popular song of the same name written in the 1840s, but it also alluded to the reworked final scene from *Uncle Tom's Cabin* found in some stage productions, wherein Tom returns to his old Kentucky home to be reunited with his family and live out his days in relative harmony with his former owner.[54] This altered message advocated reconciliation between former owners and freed blacks as a way to rebuild Southern society without slavery. Wright's new title for *Negro Life at the South* started the process of seeing this painting through the veil of nostalgia for a time when living was easy, life was good, and even enslaved people seemed to make the best of it when not at work. One reviewer in Brooklyn reminded his readers that this was no plantation in Kentucky, but a "purlieu of Washington DC," but for all intents and purposes the painting had been rechristened, and reinvented, as a soul-soothing image of slavery.

The new name stuck. Eastman Johnson's use of genre painting to build narratives and metaphors for the injustices of slavery influenced reviewers for many years, however. In 1867, when the work was chosen

for the Paris Exposition, a reviewer for *Harper's* noted, "The *Kentucky Home* was as unique among our pictures as *Uncle Tom's Cabin* among our stories. Here was the great tragedy of our national life, with countless passionate and poetic aspects, teeming with every kind of inspiring subject, and our moral pusillanimity was such that Literature and Art avoided it, and 'society' made it impolite to allude to it." The reviewer then stated, "Mrs. Stowe broke the spell in literature. Eastman Johnson broke it in art."[55] That spell Stowe broke was the unspoken rule that fiction was to remain clear of national politics. Her fictional account of slavery deliberately addressed burning moral and political issues dividing the country. Johnson followed suit, taking the benign expectations of genre painting and investing *Negro Life at the South* with an equally pointed, yet subtle commentary. Both Stowe and Johnson forced their audiences to confront slavery as a moral issue involving people—whether black, white, or some fraction of each—with their subjects' racial distinctions secondary to the larger question of their innate humanity. Johnson portrayed black people as individuals rather than caricatures. Humanizing his black subjects, Johnson raised questions about the morality of slavery. It is Eastman Johnson's particular gift to elevate a quotidian scene, investing in it historical and topical relevance of such acute sensibility that a simple genre painting becomes a national referendum on humanitarian and political issues.

THE RACIAL POLITICS OF SUGAR

Far more subtle, but equally pointed, were Johnson's well-known series of paintings focused on the production of New England maple sugar. Maple sugar had long been called "free sugar," a term that stemmed from resistance to British taxation. But the politics of maple sugar also related to slavery, beginning in that same era. Benjamin Rush wryly noted in 1792, "I cannot help contemplating a maple sugar tree without a species of veneration, for I behold in it a happy means of rendering commerce and slavery of African brethren in sugar islands as unnecessary."[56] By contrast, white cane sugar was produced in the Caribbean and along the Gulf Coast by black slave labor on vast sugar plantations. Louisiana led American

sugar production, but it was dwarfed by Barbados and Brazil. Overall, antebellum writers estimated that fully two-thirds of all the Africans brought to the Americas were enslaved workers in the sugar industry.[57] Hence, white sugar, so refined in flavor, texture, and appearance, actually bore the stigma of slavery in every teaspoon.

"Sugaring off" had been a community ritual across New England since colonial times, and though learned from the American Indians, this process had come to epitomize the Puritan-inspired values of hard work and exceptionalism that Alexis de Tocqueville had identified as central to American identity.[58] Before the Revolution, homemade maple sugar became a symbol of American ingenuity and self-sufficiency at a time when the British were taxing sugar and molasses from the Caribbean.[59] In *Card Players, Fryeburg, Maine* (cat. 65), Johnson, who was raised in Fryeburg, trains his eye on the men who make their camps deep in the sugar maple forests around his hometown, spending their days and nights hauling in the raw sap and boiling it down in huge cauldrons resting atop a roaring fire. It is the archetypal communal endeavor balancing hard work and camaraderie.

The activity in this painting moves from right to left, and focuses on production. Early every spring, local men across New England came together as the weather began to warm and the sap began to run. On the far right, one man hauls a sledge bringing in the raw sap from the trees. Under the shelter of the sugaring hut, two men play cards while another monitors the cauldron centered in the foreground. Here the alchemy of turning sap into sugar takes place. As the sap evaporates at the boil, the sugars concentrate, first into a thin, golden syrup, and further along into a thicker, more opaque mass. The syrup is decanted into kegs, which are stacked at the far left, and the thicker sugar is cooled into bricks on the snow. Johnson made this painting about the work rather than the play, but his men are not without their entertainments. The two kettle-watchers play cards, and banked in the snow behind them is an earthenware jug faintly labeled "RUM." Johnson casts sugaring as a timeless activity, and he underscores that sense of nostalgia by deliberately rusticating the equipment central to the enterprise. Most notably the giant kettle occupying the center of the composition had been replaced in large part by shallow metal troughs, hardly as picturesque as the steaming cauldron.

Johnson was not interested in featuring progress, at least not in the sugaring business, and yet these paintings do carry a message linked to current events. Just as there were abolitionists who wore no cotton garments in protest of the slave trade, there were those who made sugar an item fraught with political resonance. Choosing to use "free sugar" over white table sugar meant politics entered the parlor. Decades before the outbreak of war, abolitionists and Quakers, among others, rejected the use of white sugar for this very reason. A Vermont history published in 1840 asserted that maple sugar "is a product of our state, and it is never tinctured with the sweat, and the groans, and the tears, and the blood of the poor slaves."[60] Geologist Clarence King, who became close friends with Henry Adams, famously declared that he would have only "free sugar" on his table. King's politics were shaped by his grandmother, Sophia Little, who, he recalled, "ate no sugar but free-soil maple and refused Southern oranges, as they were to her mind 'full of the blood of slaves.'"[61] Sophia Little had been a confirmed abolitionist for decades prior to the Civil War, finding fault with the South for its promotion of slavery and with the North for its willing compliance in supporting it.[62] In 1863 Johnson arranged to have a large keg of the syrup sent via express mail to his friend and fellow abolitionist, Henry Wadsworth Longfellow, whose portrait he had sketched years before during an extended stay at the poet's home in Cambridge.[63] The gesture was friendly but freighted with political and moral weight. Johnson's audience of the 1860s would have immediately understood this frame of reference with regard to his "sugaring off" paintings and likely appreciated the layering of meaning. Johnson vested in these paintings the virtues of New England society as a model for a post-slavery American society.

SLAVERY AND THE SOUTHERN LANDSCAPE

The Southern landscape played into the national dialogue on slavery. Frederick Douglass's metaphorical definition of slavery as America's "moral volcano" carried

CAT. 65

Eastman Johnson
Card Players, Fryeburg, Maine,
about 1865, oil on canvas, 18 ⅞ × 29 in.
Private Collection

the rhetoric to ever higher levels, but the distinctive Southern landscape became emblematic of the cultural dissolution associated with slavery. If the New England landscape, with its community-based work ethic, served as an emblem of America's moral rectitude, the Southern landscape was often cast as its topographical and ideological opposite. Cotton fields and sugar plantations carried connotations of slave labor. But the exhaustion of the soil itself from continual planting of cotton each year fed the urge to acquire new land and, by extension, to expand the use of slave labor in America.

Apart from agricultural landscapes, the South was identified with another feature, the Great Dismal Swamp, which straddled the border between Virginia and North Carolina. George Washington had been part-owner of the Dismal Swamp Land Company that claimed ownership of the tract, and William Byrd II of Westover had been among his surveyors. Even in the late 1700s it had become home to an extensive fugitive community. Accounts of the swamp often dwelled on its inhabitants, one noting, "It is within the deep recesses of this gloomy Swamp, 'dismal' indeed, beyond the power of human conception, that the runaway Slaves of the South have been known to secret themselves for weeks, months and years, subsisting on frogs, terrapins, and even snakes! and when these have failed them, would prefer becoming the victims of starvation to returning again to bondage!"[64] Harriet Beecher Stowe's second book, *Dred, A Tale of the Dismal Swamp*, was published in 1856. Its title character alluded to the miscarriage of justice associated with the Dred Scott case, which was at that time still winding its way through the courts. Stowe set her tale in the Great Dismal Swamp and drew heavily on stories of Nat Turner's rebellion in 1831, one of the key slave revolts that raised black hopes in the South and fueled white fears of abolitionist-instigated uprisings.

Stowe, who had not actually visited the Dismal Swamp nor traveled further South than the border state of Kentucky, linked the wetland to the moral evils of slavery.[65] In her premise, the swamp symbolized the isolated slave labor camps in which millions of black Southerners were confined. "The wild, dreary belt of swamp-land which girds in those states scathed by the fires of despotism is an apt emblem, in its rampant and we might say delirious exuberance of vegetation, of that darkly struggling, wildly vegetating swamp of human souls, cut off, like it, from the usages and improvements of cultivated life."[66] In Stowe's literary turn of phrase, even the landscape is warped.

The Northern view of Southern wetlands was deeply inflected with the belief that the South was a landscape in moral and actual decline. Henry Adams's observations as he rattled down the derelict road to Mount Vernon—that the dilapidation was emblematic of slavery—finds a corollary in the swamp as a landscape redolent of languid sloth and torpid decay. The high ground is here both a literal and metaphorical construct, positioning the slough, the low ground, as its ethical and horticultural inferior. A rotting landscape, the swamp reflected the decay at the core of Southern society. For Northern readers, a useful and productive landscape served as evidence of an industrious, virtuous society. Northerners who saw themselves in the landscape, their virtues reflected in its features, easily associated negative Southern traits with a landscape described in terms of loss, disease, and decay. Only by draining the swamp and restoring order to its chaotic heart could the actual land be redeemed; only by abolishing slavery and bringing the South back into the Union could the metaphorical wasteland be reclaimed.

Thomas Moran (1837–1926, fig. 104) set his one finished painting concerning slavery in just such a decaying setting. Born in England and raised in Philadelphia, Moran was visiting England in 1862 when he painted one of his most unusual and most compelling landscapes, titled *Slave Hunt, Dismal Swamp, Virginia* (cat. 66), for an abolitionist patron who commissioned the work.[67] England's population was divided on the American Civil War, but not on American slavery. Even at the height of Southern sympathy expressed by the British government, there was little tolerance for the American South's "peculiar institution." Although we do not know Moran's opinions on slavery, his subject hints strongly at his sympathy for the fugitives.[68] In addition to Stowe's novel, Moran's source of inspiration appears to have been Longfellow's poem of 1855, an antislavery moral allegory titled "The Slave in the Dismal Swamp." It included lines closely allied to Moran's composition:

In dark fens of the Dismal Swamp
The hunted Negro lay;
He saw the fire of the midnight camp,
And heard at times a horse's tramp
And a bloodhound's distant bay.
…
Where hardly a human foot could pass,
Or a human heart would dare,
On the quaking turf of the green morass
He crouched in the rank and tangled grass,
Like a wild beast in his lair.

In Moran's painting, a fugitive family—a man and a woman carrying a small child—make their way through the fens. The man has just dispatched a hunting dog, the bloody knife in his hand as the hound sinks into the swamp. Two more bloodhounds leap down the embankment toward them, followed by a slave hunter. He gestures back to two more armed pursuers standing on the rise, framed by the tiny glimpse of open sky behind them. The verdant landscape seems oppressive rather than comforting. The water that might have thrown the dogs off their scent now slows the fugitives' progress. The giant tree leaning over the escaping black family and the smaller dead trees near the path enclose the primary action within a tight triangle in the center foreground. The Spanish moss and vines festooning the trees add to the claustrophobic feel of the scene. This is the antithesis of the classic American landscape. The vegetative decay mirrors the chaos and moral tangle of the South's dominant ideology. It is also a dangerous place, where blacks escaping from slave labor camps must kill in order to survive.

For these fugitives the swamp offered a kind of unholy sanctuary, a dangerous landscape for both the hunter and the hunted. After escaping from his master's cotton plantation in Alabama in 1864, Wallace Turnage spent much of his time in Southern swamps evading recapture, trying to make a break for freedom and dry land. In his words, "It was death to go forward and it was death to go back and it was death to stay there and freedom was before me; it could only be death to go forward if I was caught

FIG. 104

Unidentified photographer
*Thomas Moran at age 18, 1855,
Philadelphia PA*, East Hampton
Library, Long Island Collection

and freedom if I escaped."[69] Moran's painting portrays a place that is simultaneously a sanctuary and a trap for these fugitives. It is not a landscape of hope but of chance, arbitrary and amoral. There you live by your wits. You learn the terrain and elude the enemy, or die.

Frederick Law Olmsted, a Yale-educated landscape architect who would make his name designing Central Park in New York City, traveled to the Dismal Swamp the same year Stowe's *Dred* was published. His goal was to observe the Southern landscape and way of life, and he remarked, "These negroes 'in the swamp' were often hunted after, but it was very difficult to find them, and, if caught, they would run again, and the other negroes would hide and assist them."[70] The network of communications through the swamps was well understood. Confederate General Joseph Finegan wrote in the spring of 1863 that messages were "conducted through swamps and under cover of the night, and could not be prevented."[71] That loosely knit community of fugitives living in the swamp was not completely lost to this alien and condemned world. Stories circulated of Union soldiers who stumbled into the region and were assisted by its black denizens.

The swamp was a place in need of remediation, both temporal and spiritual. For close to two centuries, John Bunyan's *Pilgrim's Progress* had described the toils of this life that hold us back from salvation as the Slough of Despond, a metaphorical swamp that "cannot be mended; it is the descent whither the scum and filth that attends conviction for sin doth continually run, and therefore it is called the Slough of Despond: for still as the sinner is awakened about his lost condition, there ariseth in his soul many fears, and doubts, and discouraging apprehensions, which all of them get together, and settle in this place. And this is the reason for the badness of this ground."[72] For Northerners familiar with Bunyan's rhetoric, the Dismal Swamp was concrete manifestation of Bunyan's Slough, the visual proof of the spiritual and moral decay fostered under slavery.

In *Harper's Weekly* David Hunter Strother described the Dismal Swamp with its "gigantic skeletons of cypress that rose so grandly in the foreground, their wild contorted limbs waving with weepers of funereal moss, that hung down even to the water. It was at all points

CAT. 66

Thomas Moran
Slave Hunt, Dismal Swamp, Virginia,
1862, oil on canvas, 34 × 44 in.
Philbrook Museum of Art, Tulsa, Oklahoma,
Gift of Laura A. Clubb

FIG. 105

Thomas Cole
The Course of Empire: Desolation,
1836, oil on canvas, 39 ¼ × 63 ¼ in.
The New-York Historical Society

a picture of desolation—Desolation."⁷³ The capitaliza-tion, and the added emphasis in the repetition of that word—*desolation*—links the word-picture created by Strother to Cole's series of paintings titled *The Course of Empire*, where the cycle of mankind collapsed into the miasmic swamp, bereft of the ennobling sentiments that had marked its ascendance. Cole's *Desolation* of 1836 (fig. 105) from that series represented the final stage of empire, in which man has exhausted nature's resources and watched his civilization implode. Cole's message is clear: if the Hudson River school extolled the cultural virtues of Americans living in spiritual harmony with nature, then a society descending into moral decay would lead instead to its own destruction. Like the Southern swamp in Moran's painting and Strother's description, Cole's desolate wetlands mark the nadir of human civilization. In Moran's swamp, humankind's violence plays out in racial terms, paral-leling Cole's larger warning about society as a whole.

In 1864 the pioneering naturalist, lawyer, scholar, and diplomat George Perkins Marsh (fig. 106) pub-lished *Man and Nature*, a book that quickly became the leading tome on land management. In his intro-duction, Marsh decried man's overuse of lands and the exhaustion of resources, advocating smart, long-term land use planning.⁷⁴ The South's dependence on slave labor and its planting system (which usually relied on one crop and did not allow for crop rotation and soil re-covery) argued for the expansion of territory and thus of slavery. Marsh's support of intelligent husbandry sounds the same alarm as Cole's dire warning. Slavery was an aspect of that downward spiral of the course of empire. Moran's painting takes that abstract warning and applies it to a nightmarish landscape on the verge. The fetid swamp, like the exhausted field, bespoke a civilization on the brink of collapse.

CONTRABAND AND THE FUGITIVE SLAVE ACT

After the outbreak of the Civil War, enslaved people took greater risks and endured even more hardships to achieve freedom. In May 1861, barely a month after the war started, Union General Benjamin Butler, with his Aide-de-Camp Theodore Winthrop in tow, took in three black men who had escaped from their master, a Confederate colonel stationed near Fortress Monroe. Butler (fig. 107), a lawyer before the outbreak of war, announced that all enslaved people who arrived safely across Union lines were to be considered "contraband of war." Therefore, he and his troops would no longer enforce the Fugitive Slave Act. His legal reasoning was simple and strategically incisive: if the Confederacy was not part of the United States, then the Fugitive Slave Act was no longer binding, and confiscated property, including enslaved African Americans—whom Southern laws defined as property—did not have to be returned.[75] Butler's clever interpretation of the term "contraband" defied more than the Fugitive Slave Act. It made slavery the central issue of the war. Butler was far ahead of Lincoln's own actions regarding emancipation; however, the president allowed Butler's declaration to stand, tacitly encouraging enslaved blacks to take initiative in seeking their own freedom.

Butler set his new recruits to work for the Union army.[76] He and other commanders quickly found themselves overwhelmed by the number of escapees in their camps, many of whom would work willingly building forts, digging trenches, and providing intelligence on the position of Confederate forces in exchange for sustenance, protection, and the hope of a Union victory. The immediate effectiveness of Butler's declaration presaged its long-term consequences. "Contraband" entered the vocabulary of Americans everywhere. As one Union officer noted, "Never was a word so speedily adopted by so many people in so short a time...[it] leaped instantaneously to its new place, jostling aside the circumlocution 'colored people,' the extrajudicial 'persons of African descent,' the scientific 'negro,' the slang 'nigger,' and the debasing 'slave.'"[77] Butler's "contraband of war" effectively opened a breach in the levee. What started as a trickle of fugitives grew to a steady flow as word spread and Union forces advanced. With each act of personal resistance against chattel slavery, black people contributed to their own emancipation and to the eventual uprooting of slavery in the United States. Butler's actions prompted Winthrop to note with satisfaction in his diary, "An epigram abolished slavery in the United States."[78] Winthrop's confidence was premature but reflected the depth of determination developing among abolitionists to see this war end race slavery in America.

Not every black person who crossed Union lines was met with such welcome. Many who sought out Union troops were turned away or handed back to their owners by officers either opposed to abolition or unwilling to challenge the Fugitive Slave Act. Eastman Johnson's *A Ride for Liberty—The Fugitive Slaves, March 2, 1862* (cat. 67) presents a tense moment as a black family makes a break for the Union lines, hoping to achieve freedom in just such a manner. Johnson set his narrative in the chilly predawn glow, the eerie bluish tints tinged with pink as the sun begins to rise. In the murky light, a black family aboard a dark bay horse makes its break for freedom. As the horse trots quickly across the rolling terrain, the father leans forward over the horse's withers, urging him on. His hunched shoulders seem braced against the expected and dreaded bullet. He is

FIG. 106

Mathew B. Brady
George Perkins Marsh, about 1850,
Library of Congress

FIG. 107

Brady National Photographic Art
Gallery, *General Benjamin Butler*,
about 1855–1865, Library of Congress

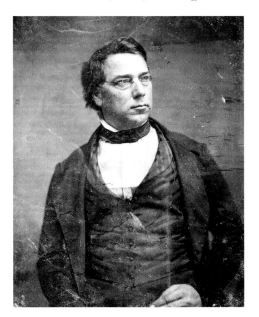

focused on the future and on the struggle to achieve freedom for himself and his family. Sitting in front of him, his young son echoes the father's resolve. The man's wife sits behind him, one arm around his waist to hold herself in place against the bone-jarring gait of the horse, the other clasping an infant to her chest. She looks back, half in fear and watchfulness, half in sorrow for what she might have left behind, acknowledging the element of loss in their bold move. For as they move forward to a new life, they cast off the familiar—friends, possibly family, even routines—in short, the only lives they have known. Johnson's composition emphasizes the familial bonds that hold these people together and yet the two adults' gazes seem to divide them into past and future.

An inscription on the verso of this painting reads, "A veritable incident in the civil war seen by myself at Centerville on the morning of McClellan's advance towards Manassas. March 2nd 1862 Eastman Johnson."[79] However, the date indicated on the inscription is problematic. McClellan did not leave Washington until late Friday, March 7, following a hearing in front of the Council of War to explain his continued inaction. More significant is Lincoln's order of March 13 barring all Union commanders from returning any black people, thereby nullifying the fugitive slave laws. Up until that time, McClellan was one of many Union commanders who returned fugitives to their owners. He was locked in controversy with his commander-in-chief over how to prosecute the war in Virginia, and he and Lincoln would continue to differ sharply over the war's relationship to slavery. *A Ride for Liberty* has everything to do with capturing the gripping saga of a black family escaping from enslavement, but it contains the added dimension of uncertainty, of not knowing what reception these fugitives would receive. Better than any other painting, it captures the moment when the full scope of the slavery question begins to loom in the foreground.

A Ride for Liberty valorizes the risks blacks were willing to take to reach freedom and raises sympathy for their plight once they did reach Union lines and the "free states." The painting also offers up a more subtle lesson in the politics of skin tone. The artist quite consciously places both adult figures in profile,

facing different directions. In doing so he bifurcates the canvas, twinning the composition over a central dividing line between them. The dark-skinned, ethnically pronounced features of the man mark his African descent. His body is tense. Johnson emphasizes his determination to reach the relative safety of Union lines. The woman's features are more delicate, her skin color lighter even in the ghost light of dawn. Her complexion also speaks to the notion—broadly accepted at the time, even by many otherwise enlightened people—that lighter skin, resulting from mixed blood, denoted a brighter intellect and better prospects for independent thinking. It was a stance couched in the pervasive underlying assumptions about race in America. But Johnson appears to have had one other reason for this woman's appearance: her profile resembles the figure of Liberty on many U.S. coins (fig. 108), and it is liberty that hangs in the balance of this painting—and, explicitly, in its title.[80] Through this prism, Johnson's family blends determination and courage with careful planning.[81] *A Ride for Liberty* centers on a dramatic moment wherein a family faces the uncertainty of its fate—and by extension the fate of all enslaved Americans. Its predawn ride also evokes two biblical stories often associated with escaped slaves: the Flight into Egypt from the Gospel of Matthew, and Moses freeing the Israelites from the book of Exodus.[82] Johnson has interwoven so many layers of meaning in this painting, which is at its core a testament to determination, longing, and hope.

Against this backdrop, Johnson's *A Ride for Liberty* embraces the worthiness of African Americans to take charge of their own destiny. The painting also focuses on the poignancy of these people's plight. They are not ciphers or caricatures; in Johnson's hands, they are real people whose anguish and determination are universal qualities of mankind. Johnson's family is not bound by race but speaks to all who are displaced in an effort to make a better life. At the same time, the artist has not turned away from the issues specific to black Americans. Johnson placed them squarely in the foreground and, in doing so, elevated them in the national debate.

Johnson painted two nearly identical versions of the composition for *A Ride for Liberty*.[83] The inscribed version remained in his possession until his death. Johnson

FIG. 108

U.S. Mint, James B. Longacre "Liberty" twenty-dollar coin, 1860, National Museum of American History, Smithsonian Institution

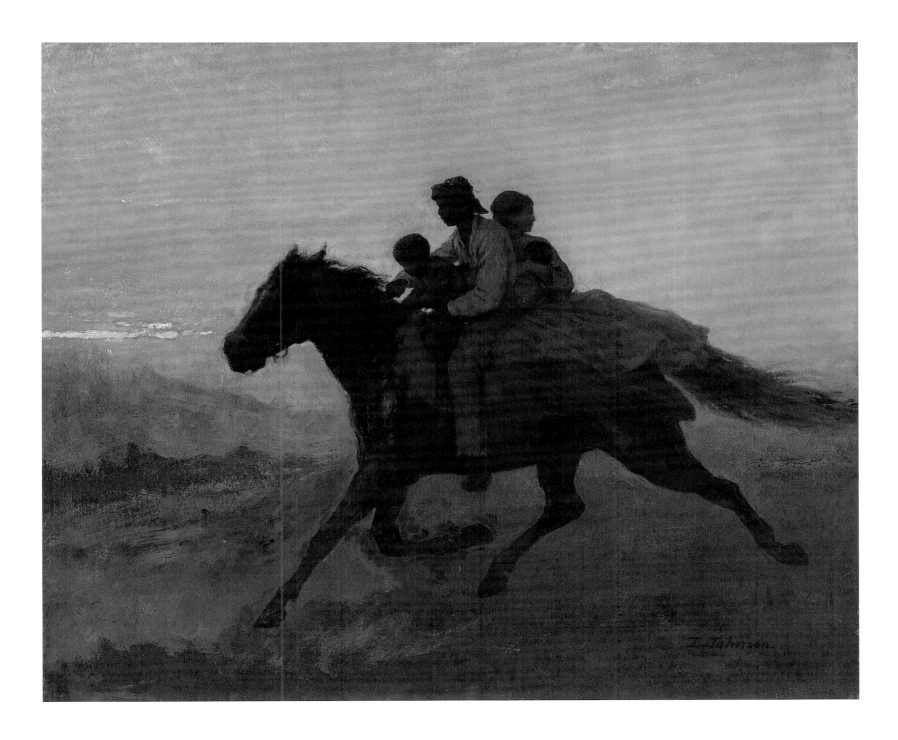

CAT. 67

Eastman Johnson
A Ride for Liberty—The Fugitive Slaves,
March 2, 1862, 1862, oil on board, 21 ½ × 26 in.
Virginia Museum of Fine Arts, Richmond,
The Paul Mellon Collection

never publicly displayed either version of this painting, and it is likely that politics played a role in that decision. Even in the North, slavery and adherence to the Fugitive Slave Act remained a divisive issue. New York was home to a large population of Northern Democrats, few of whom were interested in seeing provocative reminders of the evils of slavery. Cotton and sugar investments were behind the fortunes of two of Johnson's patrons. By 1862, a subject like *A Ride for Liberty* might have been admired by abolitionists, who constituted a minority, but it remained controversial for a deeply divided public.[84]

THE UNITED STATES COLORED TROOPS

As the issues surrounding whether or not to accept contrabands intensified, so too did the related question of allowing them to enlist in the Union army and fight alongside white soldiers. From the beginning of the war Frederick Douglass agitated for colored troops, declaring, "Colored men were good enough to fight under Washington. They are not good enough to fight under McClellan. They were good enough to fight under Andrew Jackson. They are not good enough to fight under Gen. Halleck. They were good enough to help win American independence, but they are not good enough to help preserve that independence against treason and rebellion."[85] On May 9, 1862, David Hunter, a white Union general, had on his own initiative emancipated all enslaved people in Florida, Georgia, and South Carolina and authorized the arming of all able-bodied black men. He further organized the first all-black army unit, which he called the First South Carolina Volunteer Regiment. His actions soon became generally known throughout the North. However, Lincoln was not ready for wholesale emancipation, and the army command was not yet ready to authorize colored troops. Hunter's emancipation order was rescinded and his regiment was ordered to disband.[86]

But everything changed on August 22, 1862, when Benjamin Butler, then in Louisiana and again acting on his own authority, issued a general order authorizing the enlistment of free African Americans.[87] He raised the First, Second, and Third Louisiana Native Guards,

called the Corps d'Afrique. Once again Lincoln allowed his general's independent actions to stand. Three days later Secretary of War Edwin Stanton authorized the enlistment of black troops in the Federal army. Butler's unwavering commitment to emancipation may have put him a step ahead of his commander-in-chief, but he was able to trigger changes in policy on contrabands and black enlistment. David Hunter was right behind him, and the First South Carolina Volunteers was mustered in on November 7, 1862, led by Thomas Wentworth Higginson. Eight days later in coastal Georgia, the black garrison of Sergeant Trowbridge, stationed on St. Simon's Island, was mustered in as Company A, completing the first official regiment made up entirely of formerly enslaved men.[88] The rapid addition of what were called U.S. Colored Troops acknowledged blacks' willingness to fight for their own freedom and the Union army's recognition that they could—and would—fight.

The dire circumstances and future situation of enslaved black Americans was a topic of heated debate in the summer of 1862. At that time, the Union army stumbled badly against the Confederacy. Stonewall Jackson's Shenandoah Campaign bolstered the confidence of the Confederacy, as did McClellan's stalled attempts to capture Richmond. On September 22, 1862, less than a week after the Battle of Antietam, Lincoln announced his intention to put his Emancipation Proclamation in effect as of January 1, 1863. The sequence of events beginning with Butler's initiative and coupled with Lincoln's Emancipation Proclamation changed the nature of the war, acknowledging that a fight to preserve the Union would have to encompass the abolition of slavery.

After the Emancipation Proclamation took effect in January, Douglass proselytized all the harder for colored troops. In a sermon he thundered, "Do you ask me whether black men will freely enlist in the service of the country? I tell you that that depends upon the white men of the country. The Government must assure them of protection as soldiers, and give them a fair chance of winning distinction and glory in common with other soldiers.... I know the colored men of the North; I know the colored men of the South. They are ready to rally

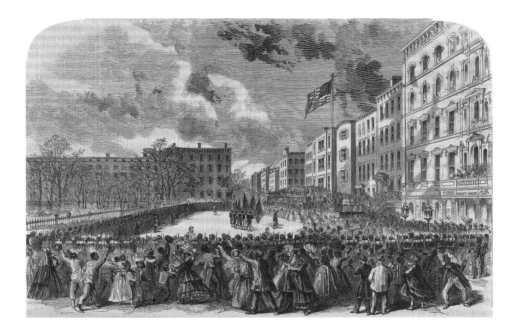

FIG. 109

Unidentified artist
*Presentation of Colors to the
20th U.S. Colored Infantry, Col.
Bartram, at the Union League Club
House, N.Y., March 5*, from *Frank
Leslie's Illustrated Newspaper*,
March 26. 1864, engraving,
Smithsonian Institution Libraries

under the stars and stripes at the first tap of the drum.
Give them a chance, stop calling them 'niggers,' and call
them soldiers.... Stop telling them they can't fight, and
tell them they can fight and shall fight, and they will
fight, and fight with vengeance. Give them a chance."[89]
In Massachusetts, an idealistic and well-connected young
officer named Robert Gould Shaw agreed to command
the Massachusetts 54th Infantry. Two of Douglass's sons
were among the first recruits from New York to join that
regiment. The proud father stated publicly, "To allow us
in the army at all, is a great concession. Let us take this
little the better to get more. By showing that we deserve
the little is the best way to gain much."[90] Douglass railed
against white ambivalence toward arming blacks as part
of the larger uncertainty over the role blacks should play
in American society. He understood that to be taken
seriously, blacks had to be more than strong, courageous,
and patriotic. They not only had to swim rivers and hide
in swamps—they had to be willing to stare down death
on the battlefield to be free.

In March 1864 the New York Union League
Club raised the first regiment of colored troops in New
York, the 20th U.S. Colored Infantry. E. L. Henry was
commissioned to portray that momentous event in his
painting titled *A Presentation of Colors to the First Colored
Regiment of New York by the Ladies of the City in Front of*
*the Old Union League Club, Union Square, New York City in
1864* (cat. 68).[91] Henry had returned from Europe in time
to witness this gathering. and he may have based his
composition in part on the engraving published in *Frank
Leslie's Illustrated Newspaper* later that month (fig. 109),
showing the same event seen from the opposite side of
Union Square. Both address the same exuberant scene:
the array of uniformed black troops around three sides of
the plaza in front of the club's headquarters, the raised
platform filled with the ladies who sponsored the troops,
with American flags waving in the brisk March wind.
The joyous black men, women, and children celebrating
around one side of Union Square in the foreground of
the engraving provide a counterpoint to the painting's
large crowd of white spectators who stand quietly in a
deep throng around the square's opposite edge. Sunlight
cuts through the ominous, early spring clouds, the light
strong and clear on the club building, the assembled
ladies, and the open square where the troops present
the colors. In front of the flag-bearers, a lower platform
carries dignitaries who spoke at the event. Both Henry
and the engraver play down the other participants in
the drama, the uniformed militia and police, who were
brought in to discourage a repeat of the violence of the
previous summer. Instead, the focus is on the triumph of
well-drilled black troops, eager to fight for the Union.

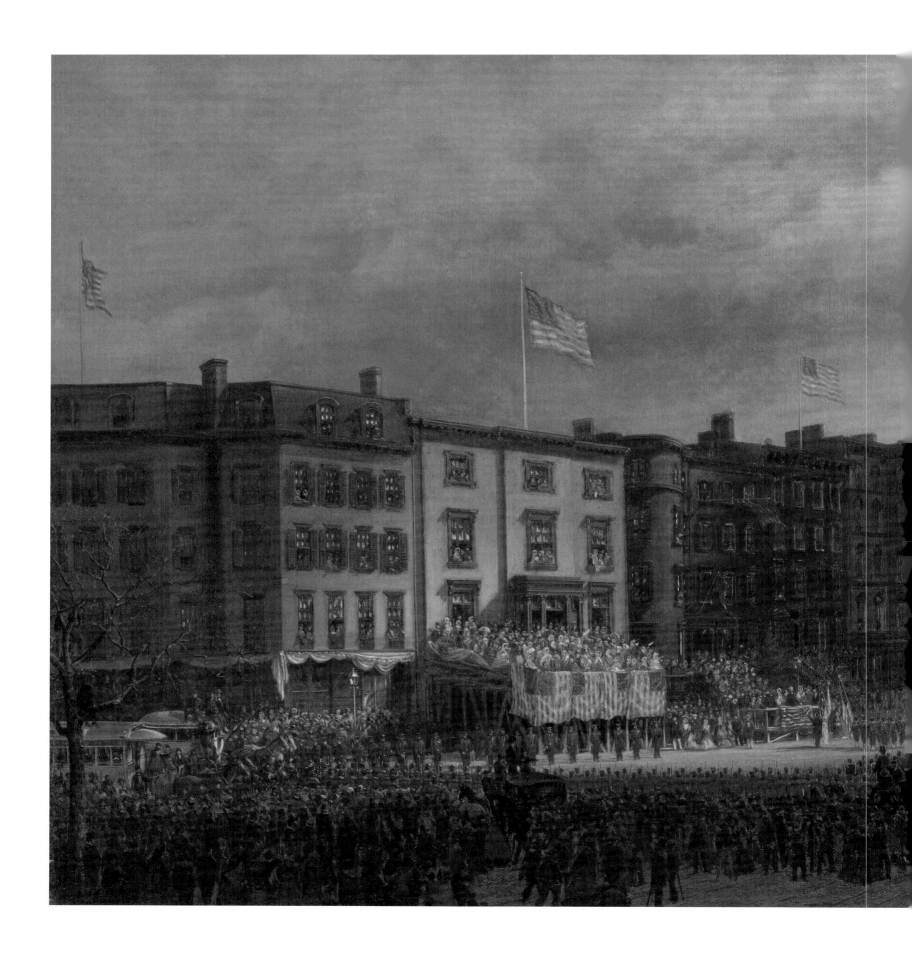

CAT. 68

Edward Lamson Henry
Presentation of the Colors 1864 1869,
oil on board, 25 × 34 in. The Union League
Club of New York

Any viewer of Henry's painting would have known the turbulent history behind the Club's decision to raise colored troops, involving a three-day battle for the soul of New York City. The Draft Riots of 1863 were an incendiary moment in Civil War history and in the annals of New York. Prompted by the call for another draft to fill the ranks of Union troops, disgruntled Irish laborers and New York Democrats took to the streets ten days after the costly Union victory at Gettysburg. What began as civil disobedience turned ugly almost immediately. On Monday, July 13, hundreds of railroad, shipyard, foundry, and construction workers failed to show up for work, instead beginning a campaign of violence and destruction. Rioters burned the building housing the draft lottery, threw bricks and stones through windows, burned private homes and government buildings, and terrorized the free black population.[92] By Monday evening, rioters had sacked and burned the Orphan Asylum for Colored Children, home to as many as eight hundred black children. The structure was burned to the ground despite repeated efforts by outraged onlookers to extinguish the flames. Farther downtown, black men and boys were chased in the streets and, if caught, were beaten and lynched to the cheers of the crowd. Anyone daring to come to their assistance became targets of the mob violence as well. The vicious cruelty that characterized the worst actions of the mobs was the fate of William Jones—who was beaten, lynched, and then his body burned as it hung from a lamp post. Both *Frank Leslie's Illustrated Newspaper* and *Harper's Weekly* ran wood engraved depictions of this shocking event, along with a series of panels documenting the mob violence, decrying the savage cruelty. The wanton destruction of public and private property shocked most residents, but as the *New York Times* pointed out, "The worst feature of the riotous demonstrations which have made the fair name of our City a by-word and a hissing during the past four days is the dastardly and wanton outrages committed upon the persons of our colored people—men, women and children. The columns of the *Times* and of its contemporaries have been filled with verified reports of unprovoked attacks upon the persons of the negroes, of brutalities absolutely sickening in detail, of burnings, beatings, and drowning."[93]

The draft riots exposed the fractured lines of New York politics, so carefully subsumed during the early days of the conflict. The riots were explained as a backlash against the fear of an influx of free blacks and formerly enslaved people into the New York economy, taking jobs and starting businesses that would negatively impact the existing, largely immigrant, working class. Blacks and whites alike chronicled the fear attendant on roving bands of marauders who beat or killed black passersby, set fire to their homes, and threatened white citizens who sheltered black families.[94] Smoldering racial tensions flared, and the idea that emancipation solved all problems was replaced with a growing awareness that Northern white society had few viable notions about how to accommodate newly freed black people.

The Union League Club had been founded in early February 1863 with the goals of cultivating a "profound national devotion" and "strengthen[ing] a love and respect for the Union." Among its founders were many members of the Century Club and the U.S. Sanitary Commission. The membership roster was full of cultural leaders and pro-Union voices in the city. Member Henry Marquand's property at Union Square became the club's first headquarters. The Square carried significant historic assocations as the site of the city's first patriotic rally in April 1861 after the shots were fired on Fort Sumter (see fig. 25). Major Robert Anderson had been the guest of honor at that rally, complete with the American flag that had once flown over the fort he had commanded. The Union League Club's cultural ranks were swelled by a significant number of artists and patrons among its members along with Union generals and future presidents.[95]

The Draft Riots prompted the Union League Club to stand against Northern Democrats, believing they had overstepped in their tacit or clandestine support of the rioters. By the fall, when the secretary of war renewed the call for volunteers to avert the need for another draft, the Union League Club voted to raise black troops under the leadership of decorated Union Colonel Nelson B. Bartram.[96] This gesture, referred to internally as "The Club's First Work," was a deliberate rejoinder to those who supported or participated in the riots. The local black population responded with

enthusiasm to the call for volunteers, and within two weeks the regiment was full.[97] Unlike any other colored regiment, the 20th Colored Infantry had one black officer, its chaplain, the Rev. Le Van, who enlisted along with members of his congregation.[98] They recruited, trained, and outfitted a thousand black men, many of whom were residents of the city. On March 5, 1864, the troops of the 20th U.S. Colored Infantry marched from Riker's Island to the Club's headquarters at Union Square. *The New York Times* reported that their appearance was "noble vengeance—a vengeance taught by Him who commanded, 'Love them that hate you; do good to them that persecute you.'...They are a fine, strong and hearty set of men, and their splendid appearance, combined with the apparent readiness and determination with which they enter their new profession, created a very favorable impression in the minds of those who saw them."[99] Despite the mob violence of the draft riots, this was the new face of the Union, black and white fighting side by side for shared goals.

Eastman Johnson enfolded the mixed reaction to black troops in another painting, this one ostensibly about a family celebration. Among the members of the Union League Club was art collector William Tilden Blodgett. Later in 1864 he commissioned Johnson to paint his family at home. In *Christmas-Time, The Blodgett Family* (cat. 69), five members of the family gather in the parlor. What appears to be a celebratory painting carries deeper layers of meaning, complicating the opulent setting with its festive seasonal decorations. Mr. Blodgett stands with his back to the fireplace, watching along with his wife and two daughters as their son demonstrates a new toy. The doll occupies center stage, with all eyes on its diminutive figure. It represents a black man, a variation on the minstrel and jig-dolls popular during this period, with limbs manipulated by strings or, in this case, a lever attached to the back that governs the doll's marching steps.[100] Its clothes are painted to resemble a soldier's uniform. Although the toy soldier appears to be the focus of the painting, it is the Blodgetts' youngest child who holds the key to the composition's more subtle layer of meaning. She stands dressed in white, her own toy forgotten as she watches the jig-doll with an expression of concern and sadness.

Her hands are tightly clasped in front of her, the tension in her body a contrast to the more languid and passive expressions of her parents and older siblings. In her white dress and pink sash, she is dressed identically to so many portrayals of Little Eva from *Uncle Tom's Cabin*. Young children were often portrayed in prints and paintings as bellwethers of the future, small reminders of lives and attitudes yet to be shaped. It is her gaze that keeps us from joining in the merriment. The white boy manipulating the toy soldier under the watchful eye of his parents, the sad and anxious expression of his younger sister, and the curious gaze of his older sister—these people encapsulate the murky and conflicting attitudes toward African Americans, including free blacks and soldiers, that prevailed even among the more genteel and liberal supporters of the Union cause.

As the confidently marching black soldier struts off the edge of the table, two generations of Blodgetts consider the free man's service in the Union army with differing emotions, a situation that plays into the current events of 1864. Johnson's edgy composition appears to raise, if not answer, questions posed by the youngest child's body language: at what point is it no longer okay to play with such a doll, and when is this no longer a game? When does the black man embodied in the doll cease to be a plaything, a lesser being, fit to be controlled by a white master? At what point is he able to march under his own power to his own destiny? William Blodgett played an important role in affirming the value of the free black man as a viable soldier and defender of his country—for all citizens, black and white.[101] However, as this doll attests, even free blacks are not yet equals in white society. This scene takes place on the cusp of that revolution. Johnson subtly suggests that it will be the children—and especially the very young children—who will be the agents of that profound societal shift.

THE RIGHT TO CITIZENSHIP

A central goal of black freedom and independence was citizenship. Seizing the moment with the establishment of colored troops, Douglass argued in 1863, "Once let the black man get upon his person the brass letters, *U.S.*, let him get an eagle on his button, and a musket on his shoulder and bullets in his pocket, and there is no power on earth which can deny that he has earned the right to citizenship in the United States."[102] That goal opened up the rights to education, to own property, and for men to vote—in short, to equal rights and protection under the U.S. Constitution. From 1865 to 1866, Thomas Waterman Wood explored Douglass's progression of racial respect with a trio of paintings titled *A Bit of War History: The Contraband, The Recruit,* and *The Veteran* (fig. 110). Wood's central point is unavoidable: sacrifice and resolve must be honored, irrespective of skin color. By pointedly focusing on one individual's personal sacrifice, Wood presents the contraband, who risks his life to achieve freedom, then willingly risks it again in its defense, paying a high price to ensure lasting freedom for himself and so many other black people. Wood argues in support of increased trust and respect due to freed blacks willing to fight for the Union.

Fighting to abolish slavery did not mean accepting blacks as equals in American society. As public attitudes in the North shifted to embrace abolition and emancipation as goals for the country, there remained deep disagreement over the role of a newly freed black population. The lack of a coherent plan, or even a broad understanding, fostered competing and contradictory ideas ranging from full assimilation to complete repatriation to Africa, with little regard for the fates of the individuals involved. Americans simply had not grasped what it would mean to free more than three million black people and accept them into mainstream society. As early as August 1862 Lincoln tentatively floated the idea of repatriating black Americans to colonies in Central America. In a clandestine meeting with free black leaders, Douglass among them, Lincoln failed to persuade any of them of the merits of his plan. Harriet Beecher Stowe advocated a similar idea in *Uncle Tom's Cabin*. She argued that an exodus to the African country of Liberia carried more promise than an oppressed life in America, but few blacks given that choice agreed.

Painters occasionally took up that subject, as in Edwin White's *Thoughts of Liberia, Emancipation*, where a black man contemplates the idea of such a relocation (fig. 111). White has dressed his subject in winter clothing, seated near a fireplace, as if to suggest that moving to a warmer country would be incentive enough for blacks to repatriate voluntarily. A handbill advertising

CAT. 69

Eastman Johnson
Christmas-Time, The Blodgett Family, 1864, oil on canvas, 30 × 25 in. The Metropolitan Museum of Art, Gift of Mr. and Mrs. Stephen Whitney Blodgett, 1983

FIG. 110

Thomas Waterman Wood
A Bit of War History: The Contraband, The Recruit, and *The Veteran*, 1866, oil on canvas, 28 ¼ × 20 ¼ in. each. The Metropolitan Museum of Art, Gift of Charles Stewart Smith, 1884

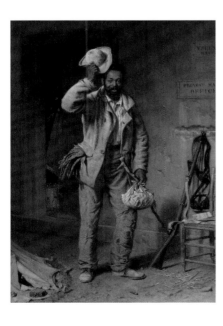
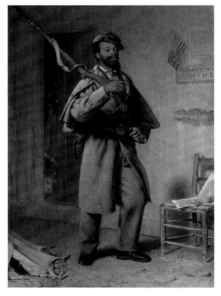
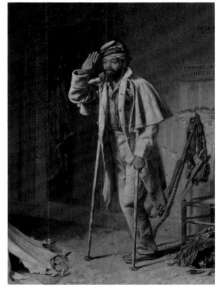

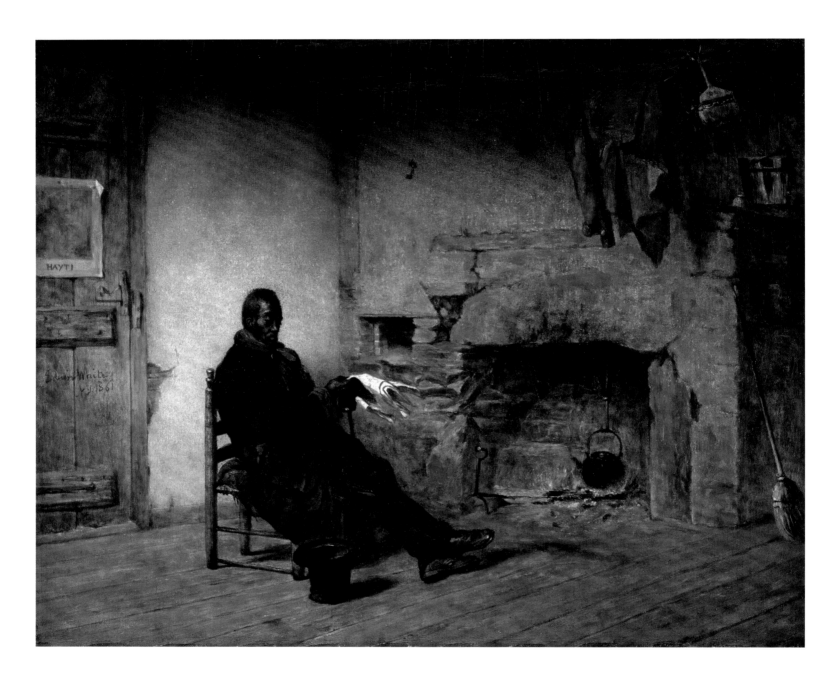

FIG. 111

Edwin White
Thoughts of Liberia, Emancipation,
1861, oil on canvas, 18 × 21 in.
The New-York Historical Society

the sunny clime of Haiti, another proposed site for mass relocation of former slaves, is tacked to the wall behind him. In Haiti, enslaved blacks had mounted a successful revolt, winning their freedom but living in privation. For proponents of a colony in Liberia, both black and white, their dream was for black Americans to return to Africa and use their experiences to bring that continent out of darkness—to live out a romantic ideal of returning as missionaries and cultural liberators. None of these options gained much traction among the majority of American blacks, for whom Douglass spoke when he memorably responded to Stowe's suggestion, "The truth is, dear madame, we are *here*, and here we are likely to remain."[103] For Douglass, the issue was about staying in America, becoming citizens, becoming part of its cultural mainstream, and changing that culture from the inside.

"THE ALPHABET IS AN ABOLITIONIST"

In the absence of citizenship, literacy was considered the single most important first step toward empowerment for both black men and women. Teaching enslaved people to read had long been illegal in the South, though such laws were not enforced uniformly. White fears that teaching blacks to read might spark rebellion were enflamed by alarmist stories of Nat Turner's Rebellion in Virginia. Turner, the enslaved man of a Methodist minister in Southampton County, had been taught to read and write. In the wake of his unsuccessful revolt, many feared he had used these abilities to plan and execute the uprising. Hysterical and deeply skewed accounts of his actions were deliberately intended to discourage whites from permitting blacks to read.[104]

Shortly after Lincoln's Emancipation Proclamation went into effect in 1863, Eastman Johnson composed a small work titled *The Lord Is My Shepherd* (cat. 70).[105] This affirming image would seem to posit the gentle nature of a formerly enslaved man reading the Psalms as a model of emerging humanity and citizenship. Johnson's warm, sepia-toned brushwork provides little detail in the architecture of the setting. The young black man sits on a folding stool with a canvas seat, absorbed in the book he holds in his powerful hands. He is seated next to an open-air fireplace, his chair resting on the hearth stones. A large wooden cabinet closes off the left side of the composition, and a metal-tipped cane rests against the wall. A dark blue coat lined in scarlet is draped over the back of the chair, possibly hinting that this man has seen service in the Union army. Embers glow near the man's feet, providing more warmth than light. Wide wooden planks mark the transition from hearth to floorboards, sketching out a crude dwelling.[106]

A black person reading the Bible affirmed blacks' capacity for understanding Christian scripture, of finding in them messages of hope and faith. For whites, many of whom had limited direct contact with blacks, it reassured them that in freeing enslaved people they were encouraging an influx of Christian believers who would become part of American society with minimal disruption to those norms. It was comforting to whites to think of formerly enslaved people not as angry and vengeful, but as forgiving New Testament believers. The painting's title conjures the beneficent words of the Psalms. But the Bible on this strapping young man's lap is not open to the Psalms, which are in the middle of the book. Rather, Johnson painted the Bible open to the front—to Exodus—with its much more compelling message, "Let my people go." Exodus runs like a river through stories of escape from slavery. The parallels were easy to draw between plantation overseers and Pharaoh; and between their strongest advocates, regardless of gender—Sojourner Truth, Harriet Tubman, and, of course, Frederick Douglass—and Moses. Themes of justice, judgment, and redemption found in Exodus made that book popular with new readers.

The story of Moses bringing the Israelites out of bondage held particular resonance among enslaved people. "Go Down Moses" was a familiar negro spiritual in Virginia.[107] The Reverend Lewis C. Lockwood, a Northern chaplain sent South by the American Missionary Association to aid black refugees, heard it sung as a rallying anthem by Butler's contrabands at Fortress Monroe. Impressed by the timely and heartfelt song, he copied it down in late 1861 and submitted twenty verses to Horace Greeley's *New-York Daily Tribune*. The song immediately became popular among Northern readers, and in December, a New York printer and a Boston music company collaborated to publish a sheet music arrangement under the title "The Song of the Contrabands: 'O Let My People Go'"[108] (fig. 112). The opening and closing verse of the song lyrics read

> Oh! go down, Moses
> Away, down to Egypt's land,
> And tell King Pharaoh
> To let my people go.

For many Americans, enslaved or free, this story from Exodus described the conditions of slavery in the

FIG. 112

Thomas Baker, arranger
Sheet music cover for *The Song of the Contrabands: "O Let My People Go,"* 1861, Library of Congress

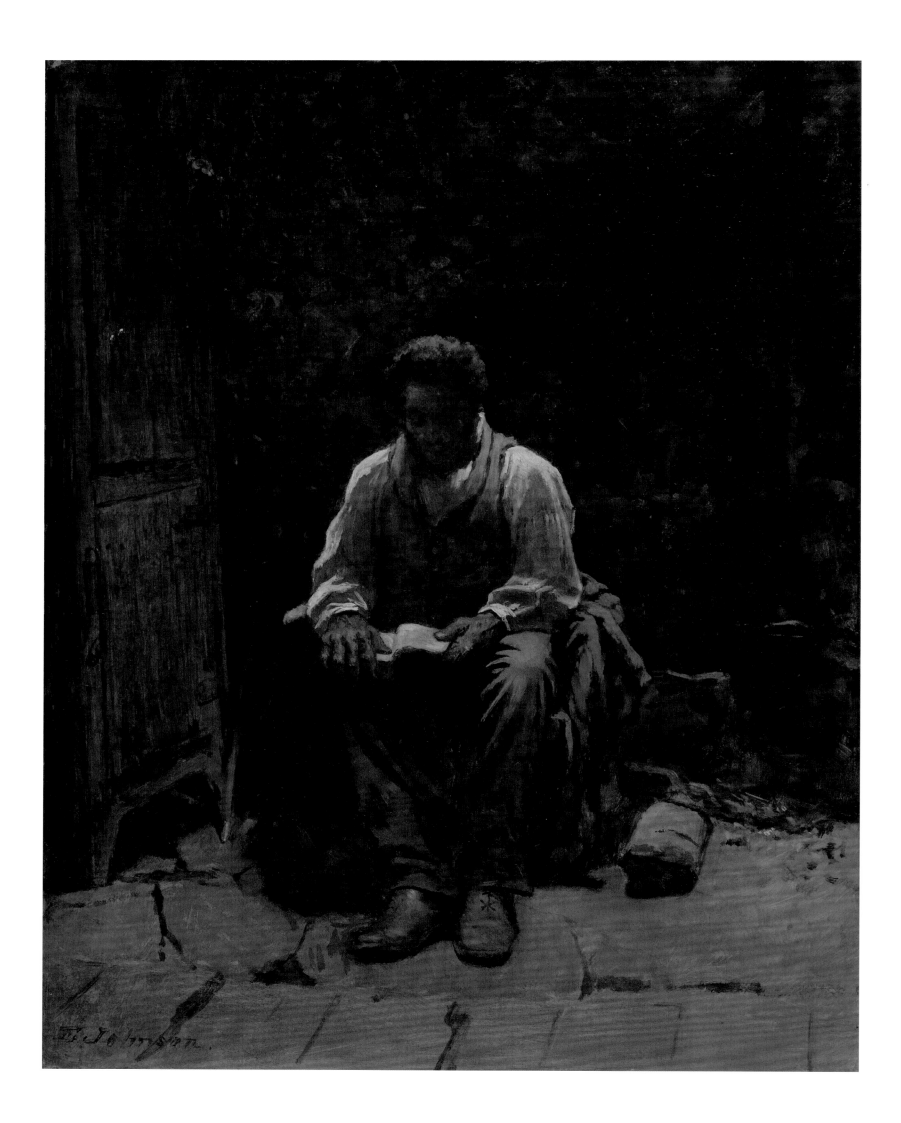

CAT. 70

Eastman Johnson
The Lord Is My Shepherd,
1863, oil on wood,
16 ⅝ × 13 ⅛ in. Smithsonian
American Art Museum, Gift of
Mrs. Francis P. Garvan

FIG. 113

Winslow Homer
A Bivouac Fire on the Potomac,
from *Harper's Weekly*, December 21,
1861, wood engraving, 13 ¾ × 20 ¼ in.
Smithsonian American Art Museum,
The Ray Austrian Collection, Gift of
Beatrice L. Austrian, Caryl A. Austrian
and James A. Austrian

South and the moral imperative for the North to free all
enslaved blacks. The leading abolitionist preacher Henry
Ward Beecher delivered a sermon on January 4, 1863, in
celebration of the Emancipation Proclamation in which
he warned his congregation that just as the Egyptian op-
pressors faced death and destruction with the departure
of the Hebrews, so, too, North and South awaited God's
judgment for their selfish behavior regarding chattel
slavery.[109] It is possible that Johnson heard this stirring
sermon, as he occasionally attended Beecher's Church of
All Souls, formerly his First Unitarian Church.[110] Johnson
painted this composition as Americans began to consider
the actual impact of emancipation, not simply its theo-
retical and moral aspects.

Both Winslow Homer and Thomas Waterman
Wood painted similar subjects, but Johnson is alone
among American artists in portraying a black person
reading from the front of the Bible.[111] Wood's *Sunday
Morning* (Smithsonian American Art Museum and
Detroit Institute of Arts) of 1877 and Homer's *Sunday
Morning in Virginia* (Cincinnati Art Museum) of 1877
each depict a child reading the Bible to an adult or a
group of family members, presumably illiterates. In
Wood's and Homer's paintings, the thick book is open
at its center and is often interpreted as indicating the

book of Psalms. The Bible—all of it—represented a
path to betterment through literacy that merged reli-
gious and political thought. Lawyer and author Albion
Tourgée noted of newly freed blacks, "Their religion
is tinged with political thought, and their political
thought shaped by religious conviction."[112] As Johnson
subtly points out, literate blacks will read more than the
peaceful and comforting parts of the Bible. Eventually
they will find Exodus. Eventually they will find their
voices, and when they do, America will need to listen.

The Lord Is My Shepherd does not distinguish be-
tween literacy in the service of faith or of political aware-
ness. Literacy was in its own way a declaration of inde-
pendence and humanity for a people long denied both.
The idea of wanting to learn—through reading, writing,
talking, and being heard—was a powerful force in black
communities. It embodied the concepts of determination
and self-advocacy, of independent thinking and initia-
tive.[113] As a writer for *Harper's Weekly* bluntly put it, "The
alphabet is an abolitionist. If you would keep a people
enslaved, refuse to teach them to read."[114] Literacy was
also a means of understanding the past and of using that
knowledge to create a future. Invoking Psalm 63:34,
Beecher thundered from his pulpit, "Princes shall come
out of Egypt; Ethiopia shall soon stretch out her hands
to God."[115] Faith and literacy were intertwined—the
faith that God would look out for all His children, that
the moral component of the war would win out, that
enslaved people were destined to achieve freedom.

WINSLOW HOMER AND POSTWAR RACIAL ISSUES

For many white Northerners, Union army service pro-
vided their first encounters with slavery and with black
people. Wartime experiences made many men adjust
their views to accept blacks as individuals and encour-
aged armchair abolitionists to commit to more active roles
in supporting emancipation. From the time he turned
twenty-one in 1857, Winslow Homer had been composing
wood engravings for *Harper's Weekly*, the new illustrated
magazine based in New York. Over the course of his first
decade with the journal, his approach to depicting blacks
changed steadily. He moved from generalized ethnic
caricature (fig. 113) to more nuanced people, individuals

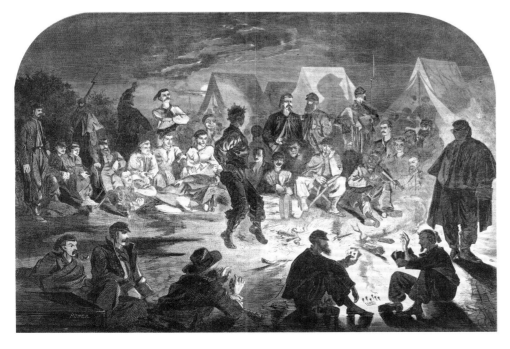

as authentic and complex as the rest of his painted characters. Although Homer concentrated on genre paintings of white soldiers for most of the war years, his most significant production of paintings dealing with blacks began in 1865, as the war ended.

The first of these paintings to attract attention was titled *The Bright Side* (cat. 71). From its debut at the National Academy of Design, the painting was singled out as a significant achievement. Clarence Cook termed it "altogether the best thing he has painted."[116] Homer's painting focuses on five black teamsters in camp. Four of the men lie on the ground outside their Sibley tent, resting against its canvas sides.[117] Their hats shade their eyes from the sun as they bask in its warmth. Their jackets and long-sleeved shirts suggest cooler weather, making the appearance of the sun all the more welcome. The fifth man sticks his head outside the tent, a field-carved pipe clenched in his teeth. He is the only man to make eye contact with the viewer, his gaze calm and stern. The tent is strong, but a stick appears to be poking through a tear in the canvas. Close by, someone has scrawled a symbol on the tent fabric resembling the Confederate battle flag, with its distinctive square format and St. Andrew's cross. Its presence may be incidental, or it may allude to these men as having escaped through Confederate lines to join the Union army as contraband.

They have been put to work with thousands of other black teamsters, guiding clumsy supply wagons over rutted roads. Their tent appears to be at a remove from the main camp, pitched among the mules and wagons they tend. Still, they are dressed in variants on the Union army uniform, although none of their clothing is matched. The teamster at far right plays with the ends of a braided quirt, his army-issue pants tucked into his boots. His attire suggests he spends much of his time riding—possibly a lead mule on a team pulling supply wagons or a caisson. The few scrub plants are typical of an army camp site, denuded by hungry animals and hard packed by the wheels of rolling stock and the constant tramp of hooves and booted feet.

Homer's title represents a multivalent play on words. To find the "bright side" is to focus on the consoling aspect of a difficult situation, to seek comfort in times of disappointment. Literally, it describes this painting's scene, as the men are arrayed on the bright, unshaded side of the tent. However, Homer did not title his works lightly, and "the bright side" may also refer to these teamsters' prospects. On the one hand, if they are contraband, they have escaped from slavery and are contributing to the Union cause. If they are Northern recruits, they are fighting to free their fellow men. On the other hand, their life in the army is hard and uncertain. They face dangers at the front and, if they are captured, death at the hands of the Confederate army. "The bright side" carries irony in its optimism, for their lot is hardly easy or without hazard.

Reviewers of the period mulled the implications of the title, too. Many inferred that these men at rest were lazy, enjoying the sunshine and relaxation and oblivious to all else. T. B. Aldrich reproduced an engraving of the painting, and in his commentary he described Homer's "picturesque-looking Contrabands, loving the sunshine as bees love honey, [who] have stretched themselves out on the warm side of a tent, and, with their ragged hats slouched over their brows, are taking 'solid comfort.' Something to eat, nothing to do, and plenty of sunshine constitute a Contraband's Paradise. The scene is one that was common enough in our camps down South during the war; but the art with which it is painted is not so common."[118] Another reviewer connected the lazy donkeys with the lazy teamsters: "The lazy sunlight, the lazy, nodding donkeys, the lazy, lolling negroes, make a humorously conceived and truthfully executed picture."[119] Homer's reviewers seemed content to declare his intentions obvious and satirical, but they failed—or shrank from—addressing *The Bright Side*'s weightier aspects. As had been the case with Johnson's *Negro Life at the South*, the tendency to remain engaged with the surface was more attractive to viewers than looking hard for more substantial layers of meaning.

The standing man emerging from the tent has a sense of initiative and determination that distinguishes him from the group of men at his feet. The gravitas with which Homer imbued him seemed lost on the critics, who were far more comfortable with the potential for humor than for depth of character. As

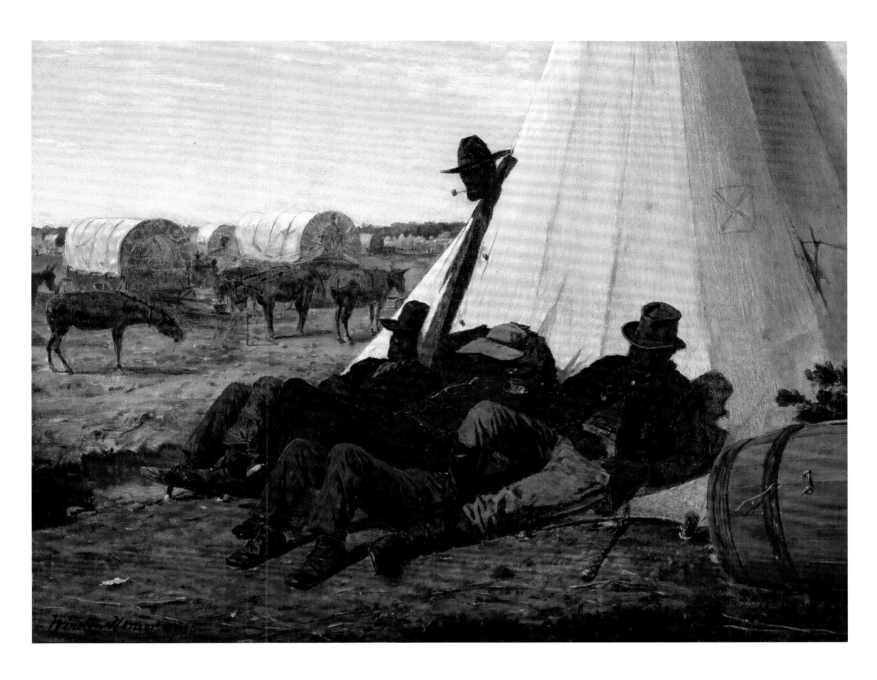

CAT. 71

Winslow Homer
The Bright Side, 1865, oil on canvas,
12 ¾ × 17 in. Fine Arts Museums of San Francisco,
Gift of Mr. and Mrs. John D. Rockefeller 3rd

the writer for the *New York Leader* noted, "The present work, however, has no political significance. It is simply a strikingly truthful delineation of Ethiopian [sic] comfort of the most characteristic, and therefore the most purely physical sort."[120] He appears to be willfully oblivious to the political and racial nuances of Homer's painting, or the wry irony of its title. Homer, on the other hand, paid close attention to portraying this standing man's intellect, the very thing that distinguishes him from the majority of his comrades and makes him most like the soldiers he serves.[121] Eyes wide open and alert, face outlined sharply against the sky, he is, in a phrase, "all head," and he confronts the viewer as an equal. The teamster's stern, level gaze locks eyes with ours, his pipe clenched in his teeth reinforcing his determination to be taken seriously. He is painted to command respect, with or without regard for his race.

Homer's experiences accompanying the army gave him firsthand access to all parts of camp life. His pencil sketches of black teamsters show the same degree of acute observation characteristic of his best work. In *The Bright Side*, he has translated those observations with humor and respect as he takes the measure of the variety of people who will first support, and then ultimately become, the Northern cause. These men are neither valorized nor mocked; Homer presents them in a manner seemingly straightforward but potentially quite complex, leaving open the possibility that for each of them "the bright side" means something different.

In the decade following the end of the Civil War, Homer painted several works in which his rendering of free blacks achieved dignified monumentality. Homer's enigmatic painting titled *Near Andersonville* (cat. 72) shows a young black woman standing at the threshold of an open doorway. Drawn there by the tramp of booted feet and the sound of soldiers' voices, she listens intently as armed Confederates beyond the low fence move their Union prisoners toward Andersonville, the infamous prison camp erected in southwest Georgia early in 1864. Her expression is sober as she stands stock-still and listens. As with the teamster in *The Bright Side*, her head is the focal point of the picture, and her mind is full of thoughts. The emblematic dipper gourds growing around her imply that her mind is set on freedom, which for now

remains out of reach, as her would-be liberators have been captured. The tension in her rigid body carries through to her hands, both of which are tightly clenched in the folds of her apron. Her rude dwelling and plain clothes mark her as an enslaved woman. Her red, white, and blue kerchief turbaned around her head echoes the colors and pattern of the Confederate battle flag held aloft by the soldiers marching by.

The painting's title suggests the horrors awaiting the prisoners being taken there. By 1865 Andersonville had become synonymous with the worst abuses and failings of the prisoner-of-war camps. Designed to house ten thousand Union prisoners, the camp swelled to as many as thirty-two thousand inmates at a time. Food, medicine, tents, and clean water were in short supply. Of the forty-five thousand prisoners sent there over the camp's fourteen months of operation, more than thirteen thousand died from malnutrition, disease, poor sanitation, overcrowding, or exposure to the elements. The Northern press carried stories detailing the gruesome conditions, and photographs of the emaciated survivors shocked the public.[122] Homer's composition, which includes Union soldiers being marched off to the camp, may allude to a failed but daring attempt by one of Sherman's regiments to free Union prisoners from Andersonville and Macon, another notorious prison camp. Rather than becoming their comrades' liberators, they joined them as prisoners.[123]

Homer took great care with this composition, lining up the woman's eyes with those of the soldiers, carrying the trajectory of her gaze toward their destination. She contemplates their fate and also her own, for both are intertwined. Standing on the raised board extending behind her into the gloom of her cabin, this woman considers whether to retreat once again into its recesses or step forward into the light. She stands at a literal crossroads; the broad planks at her feet run in two directions. One parallels the path of the soldiers; the other marks a deliberate turning away, out toward the viewer's space. Her body is turned slightly toward that most daring option, away from the safety of her cabin, away from the marching feet, and away from all that is familiar. The foremost board directs her away from the enclosed spaces to which she is confined:

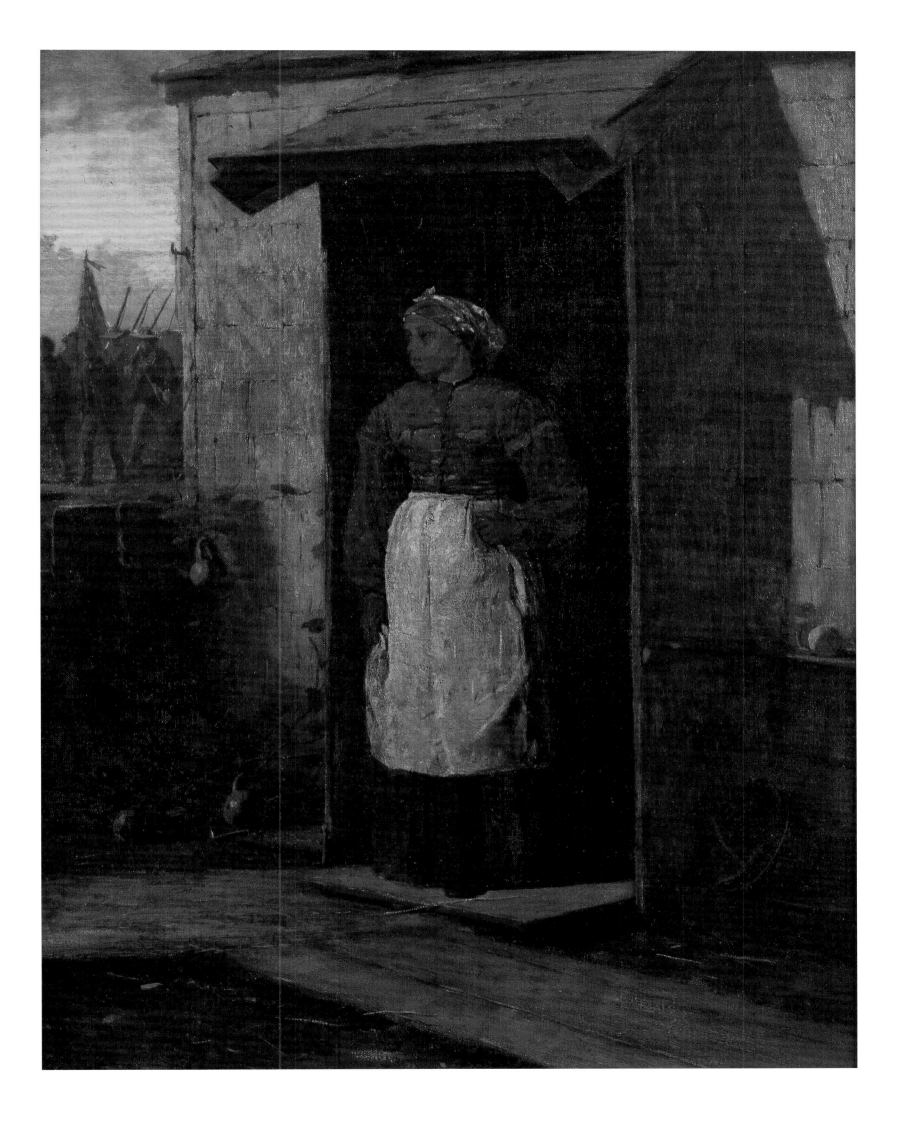

cabin and fenced yard. Homer introduces options into this young woman's carefully circumscribed world.

At the war's end, the imprisonment of slavery gave way to the need to make choices, to explore risky options as millions of black people emerged from forced darkness into the light of day. That process of discovery associated with freedoms unimaginable just four years earlier would not be easy or obvious. Homer's painting raises more questions than it can answer—about this woman's resolve, about her ability to step forward and choose between safe retreats and daring prospects. Homer has made her a symbol for all of her race. The Union soldiers behind her are in no position to help her. She must contemplate the options before her and look to her own abilities to take the next steps.

HOMER AND RECONSTRUCTION

Lincoln's assassination in April 1865 at the war's end shocked everyone and exposed deep divisions over how Reconstruction should be pursued. In the North, the end of the war brought a resumption of business-as-usual in many sectors. Northerners were by and large eager to put the war behind them and celebrate a reunited country. In the South, newly freed blacks found promise in the passage of three key constitutional amendments ending slavery, granting citizenship, and assuring the right for men to vote. But the national economy was a shambles. Southern cities and homes remained in ruins, and many newly free blacks ended up indentured back to their former owners as sharecroppers, seeing little of the promised change for the better.

Given this context, an understandable tension and frustration lurks close to the dark surface of Homer's 1876 painting *A Visit from the Old Mistress* (cat. 73). Whereas *Near Andersonville* placed a young enslaved woman on her threshold, contemplating the possibilities for her future, *A Visit from the Old Mistress* moves the action inside a claustrophobic cabin. Three black women, one holding a small child, form a frieze arrayed in opposition to the rigid figure of an older white woman. That they share the space is awkward enough; that the door through which they entered is shut, and

blocked by one of the black women, adds to the sense of unresolved tension between these protagonists. The former mistress, apparently now a widow, is dressed prophetically in black and white; no shades of gray leaven the stern polarities of her garb.[124] Her stare is equally cold and direct, matched by the returned gaze of the black woman closest to her. This freedwoman now stands with her back to the door, her demeanor one of relaxed defiance. These two figures, equal in height and matched in perceived dominance, convey a tone of wary adversarial uncertainty.

The end of the war unraveled the power white slaveholding women held over their black, predominantly female, house slaves. Homer's mistress may be experiencing one of the most common postwar adjustments: confronting her formerly enslaved women with whom she must now negotiate for their labor. What was once considered insubordination now carries a menacing overtone. The artist leaves the reason for this visit deliberately ambiguous, as murky as the sepia tones of the interior and the impassive expressions on both black and white faces. The tensions attendant on that change alone surfaced in countless diaries kept by Southern women having to rethink their everyday lives. In Homer's painting, the three black women are not happy to see their former mistress. Here the artist echoes the moment of disconnect described by one former slaveholding woman who wrote, "It seemed humiliating to be compelled to bargain and haggle with our own former servants about wages."[125] That irritation makes profoundly clear how deeply some of these white women misunderstood and underestimated the effects of slavery and how little they had comprehended the minds of those who had been enslaved.[126]

A Visit from the Old Mistress projects the dismay felt by an overwhelming majority of former slaveholders who discovered that their slaves did not in fact love them or wish to be enslaved, no matter how benign the owner might have been. In numerous Southern diaries kept during the war years, writers commented on how much they thought their enslaved people were loyal to them, how much they thought their favorites loved them, and how tight the emotional bonds were between master and slave. Ella Clanton Thomas of

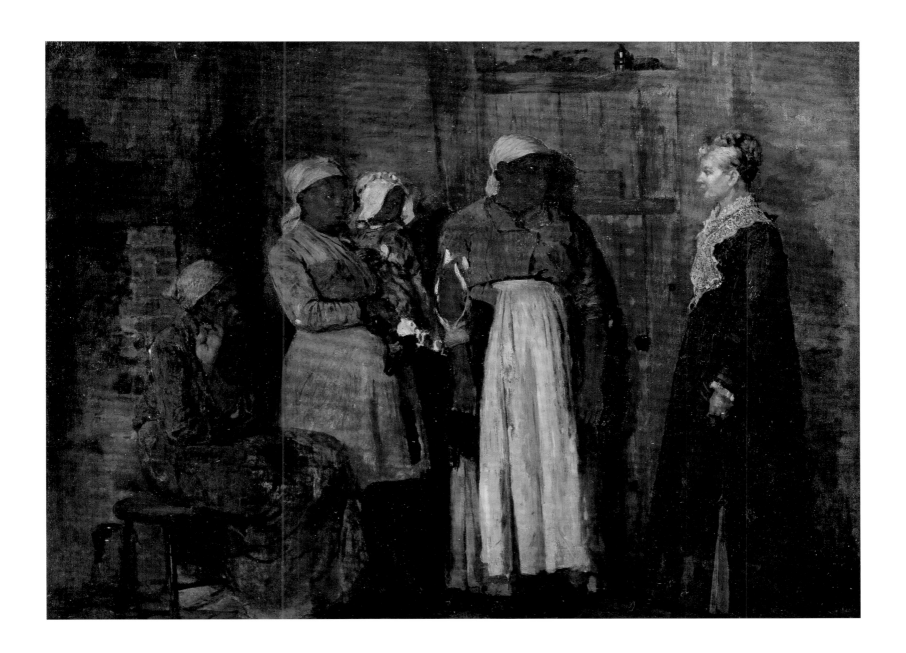

CAT. 73

Winslow Homer
A Visit from the Old Mistress, 1876,
oil on canvas, 18 × 24 in.
Smithsonian American Art Museum,
Gift of William T. Evans

Georgia wrote in her diary, "Those we loved best, and who loved us best—as we thought, were the first to leave us."[127] One woman wrote to her sister that her former slaves had left "to assume freedom without bidding any of us an affectionate adieu."[128] They wrote with apparently genuine shock and a sense of betrayal when inevitably their newly freed slaves left for the promise of emancipation or remained to assert their freedom where they already lived. The animosity evident between this white woman and her former slaves in *A Visit from the Old Mistress* shows that Homer understands this disconnect and has found a powerful way to make it visible. The mistress has returned, expecting to be greeted by the formerly enslaved people who loved her, only to find herself mistaken. They are not happy to see her, and the painting seethes with hostility, anger, and bitterness. The angular, rigid stance of the white woman echoes the rigidity of her mindset. This is her moment of cognitive dissonance. Homer's composition highlights an issue that had not yet been resolved: the understanding that both black and white carried baggage from slavery and the war years. Only when that pain was acknowledged could the nation move toward integration.

In composition, this painting bears a strong affinity to Homer's *Prisoners from the Front* (see cat. 60), painted ten years earlier.[129] In 1866 the issue needing to be resolved was the larger one between North and South, his composition a metaphor for the rift in the nation. Ten years later, when the nation was celebrating its Centennial, Homer's message shifted but was equally stark: the fighting may be long over on the battlefield, but there is still much work to be done. In both paintings a figure of authority stares down a group, and the intransigence and tension send a powerful signal that this is an unhappy meeting, holding little promise of resolution. This confrontational standoff between former slaves and former mistress stands in for the larger issues between the black and white races. Homer seems to assert that

until blacks and whites learn to live together in harmony, we are still a country at war. Together, Homer's two paintings frame the key issues of sectional hatred and racial inequality that continued long after April 1865. Homer's unflinching rendering of the aftermath of the Civil War reminds us that despite desperate and well-intentioned efforts to present postwar America as unified and happy, the damage lingered, simmering close to the surface. No one was off the hook; there was no moral high ground in the antipathy expressed between Northern and Southern soldiers and between a mistress and her former property. Homer's genius lies in understanding, capturing, and conveying profound emotions and quintessential American dilemmas that divided the nation.

"A FUTURE WITH HOPE IN IT"

Soldier-turned-lawyer Albion W. Tourgée wrote two novels, *A Fool's Errand, Told by One of the Fools*, published in 1879, and *Bricks without Straw*, published in 1880. In both of them his subject is the failure of Reconstruction. Central to his narratives was the observation that Reconstruction had been predicated on the Northern fallacy that if left alone, Southern blacks and whites could solve their own problems, as the characters did at the end of some of the theatrical versions of *Uncle Tom's Cabin*. That unrealistic assumption underpinned the central tenets of Reconstruction under presidents Andrew Johnson and Ulysses S. Grant. As Tourgée eloquently articulated, these policies are shot through with an unrealistic assessment of the situation, seen and developed at a safe distance—the same safe distance Stowe had adopted when writing her book two decades earlier.[130]

Albion Tourgée (1838–1905, fig. 114) is an interesting figure in his own right, and his background is useful for understanding Winslow Homer's evolving attitudes toward and depictions of blacks. Tourgée grew up in Ohio, a self-described casual abolitionist whose Union army service fostered his growing racial awareness. Captured by the Confederates, he spent four months in Richmond's notorious Libby Prison. He wrote that being held a prisoner of war, however temporary, made

FIG. 114

Emily Sartain
Albion Tourgée, 1870,
Tourgée Papers at the Chautauqua
County Historical Society,
Westfield, N.Y.

him experience a kind of enslavement.[131] Calling him-self an "egregious ass" for his earlier, relaxed views on emancipation, he vowed to become more actively in-volved in ending slavery.[132] At the war's end, he moved to Greensboro, North Carolina, and established schools for freedmen. He purchased orchards, hired black laborers, paid them the same wages paid to whites, and encouraged them to become more involved in main-stream society. Joining up with the Quakers, Tourgée provided opportunities for free blacks to learn to read, to acquire land, and to attain full citizenship and equal justice under the law. He became a circuit lawyer and eventually a superior court judge in North Carolina, his unstinting support for equal rights making him a target of the newly established Ku Klux Klan. He persevered in his quest for racial equality, coining the term "color-blind" in a legal brief.[133]

Tourgée's trajectory of emerging racial aware-ness was shared by other whites, including some of America's greatest genre painters, who in essence became the history painters of the Civil War. Homer and Johnson changed the way blacks were represented in American art between 1857 and 1877. Their per-spectives on the process of emancipation and life after the abolition of slavery demonstrate an acuteness of vision rare in American art. Johnson painted his most thoughtful and riveting images of black Americans in the years prior to and during the Civil War. Although he never served in uniform and did not live in the South outside his years in Washington, D.C., Johnson developed a heightened level of racial sensitivity and awareness. Each of Johnson's racially charged paintings presents black people taking their present and future into their own hands. They are active participants in their emancipation, rather than passive recipients of God's, or Lincoln's, or the Union army's action. Homer's epiphany occurred with direct contact with black contraband and enslaved people while he was traveling with the Union army. His evolution as a man and as an artist parallels that of Tourgée and countless other white Americans who rapidly became aware that blacks, fully human and deserving of freedom, faced unimaginable choices and hardships. In the years following the Civil War, Homer executed masterful

paintings of newly freed black people. In these works he focused on the steps they took beyond slavery, as soldiers in uniform or women reenvisioning their lives. For Johnson and Homer, their black protagonists are people, as complex as any white person, willing to take risks to achieve freedom. Whether quietly read-ing the Bible, absorbing the Psalms or Exodus, actively fleeing in the predawn hours, enlisting in the army, or standing at a crossroads, there is active mental con-templation of the consequences of action and inaction. The narratives underlying these paintings reinforce the way these artists used genre painting to reshape American culture.

From this same body of work, Homer produced another deeply thoughtful painting about the postwar South. Painted in 1876, *The Cotton Pickers* (cat. 74) attracted immediate and positive attention when it debuted at the Century Association in March 1877.[134] Homer's figures fill the foreground of the painting, the cotton extending to mid-thigh. The artist has drawn clear distinctions between the two women and en-capsulated in them a question about the future each woman faces. The young woman on the left looks down at her work, her fingers gently trailing against the soft bolls. Cotton surrounds her, flowing from her basket, encircling her skirts. Her facial features are fleshy and rounded but not caricatured. Absorbed in her thoughts, she is far distant from the here and now, as though her world is circumscribed by the work she has done in the fields. Her companion radiates a far different demeanor. Head up, eyes alert, she gazes with determination at what lies beyond the cotton fields. Her features are finer than those of her com-panion, a trait often associated with expectations of higher intelligence.[135] Her sack holds the cotton she has harvested but might as easily double for a sack for her belongings should she dare to step forward and out of the field. She appears to be contemplating just such action, taking advantage of opportunity and initiative to chart a new path, a new future.

Henry Ward Beecher summed up the opportu-nities and challenges facing black Americans newly secure in their freedom, noting, "None can escape that forty years in the wilderness who travel from the

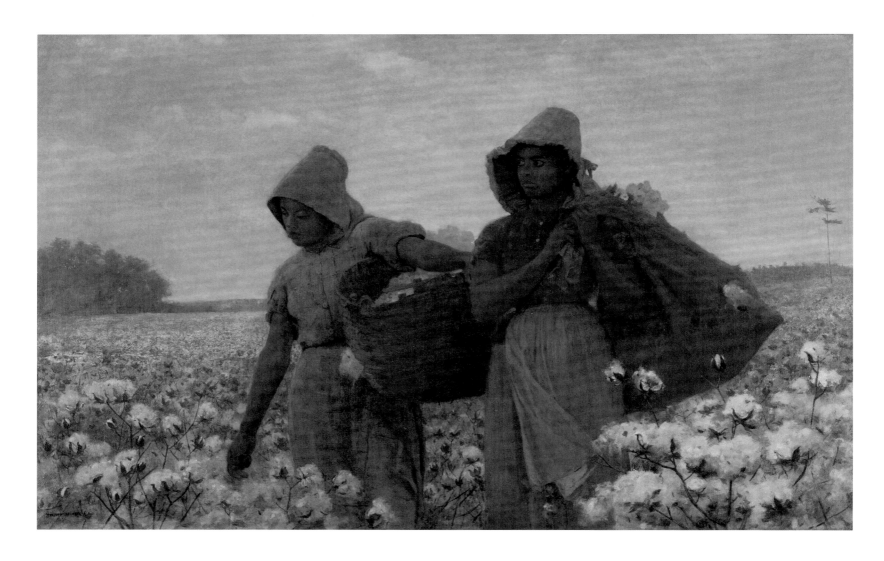

CAT. 74

Winslow Homer
The Cotton Pickers, 1876,
oil on canvas, 24 1/16 × 38 1/8 in.
Los Angeles County Museum of Art

Egypt of ignorance to the promised land of civilization. The freedmen must take their march.... If they have the stamina to undergo the hardships which every uncivilized people has undergone in its upward progress, they will in due time take their place among us."[136] A reviewer commenting on *The Cotton Pickers* seemed to sense that this painting carried this resonance in his conclusion, "The story is one not only worth telling, but one that can be told better by the artist than by the historian. Its deep meaning stares you in the face, as it should do to be worth anything. The composition is simple, unpretentious, natural, and the technical execution is brilliant and complete."[137]

The answer for newly freed African Americans would not be monolithic or successful for every individual. The barriers posed by entrenched racial bias were immense, and much depended on the resolve, character, intelligence, and drive within each person. Homer has made it clear these are real, functioning, complete people—no longer three-fifths a person, no longer a lesser race. Homer frames a question for emancipated blacks: Are you ready for the future? Will you take up the challenges and pursue opportunities that seemed impossible just ten years earlier, and can you take advantage of the changes wrought by the war? And for his predominantly white viewers, he begs the question, are you ready for a future with these people a full part of it? Are you ready for them to step into your space? Are you willing to embrace their struggle for freedom as you cherish your own?

Homer imbues his black protagonists with intelligence, gravity, and character, providing an avenue of sympathy for his predominantly Northern audience. His portrayals made it easier for his viewers to envision themselves in these people's shoes, facing their choices with a similarly analytical mien.

Frederick Douglass described an enslaved person as "a creature of the past and present" who craved "a future with hope in it."[138] Homer's cotton pickers stop in their tracks, each contemplating her past, her present, and her future. One may remain lost in the past and the present, surrounded by a sea of cotton. The other craves what the future holds. Stalks of cotton snag her apron and appear to slow her progress, but providentially Homer has placed her in front of a break in the row of cotton plants. She needs only to take the next step to free herself of her past and engage in the space we occupy. Homer's message is clear—it will be up to each individual to determine what kind of future lies ahead.

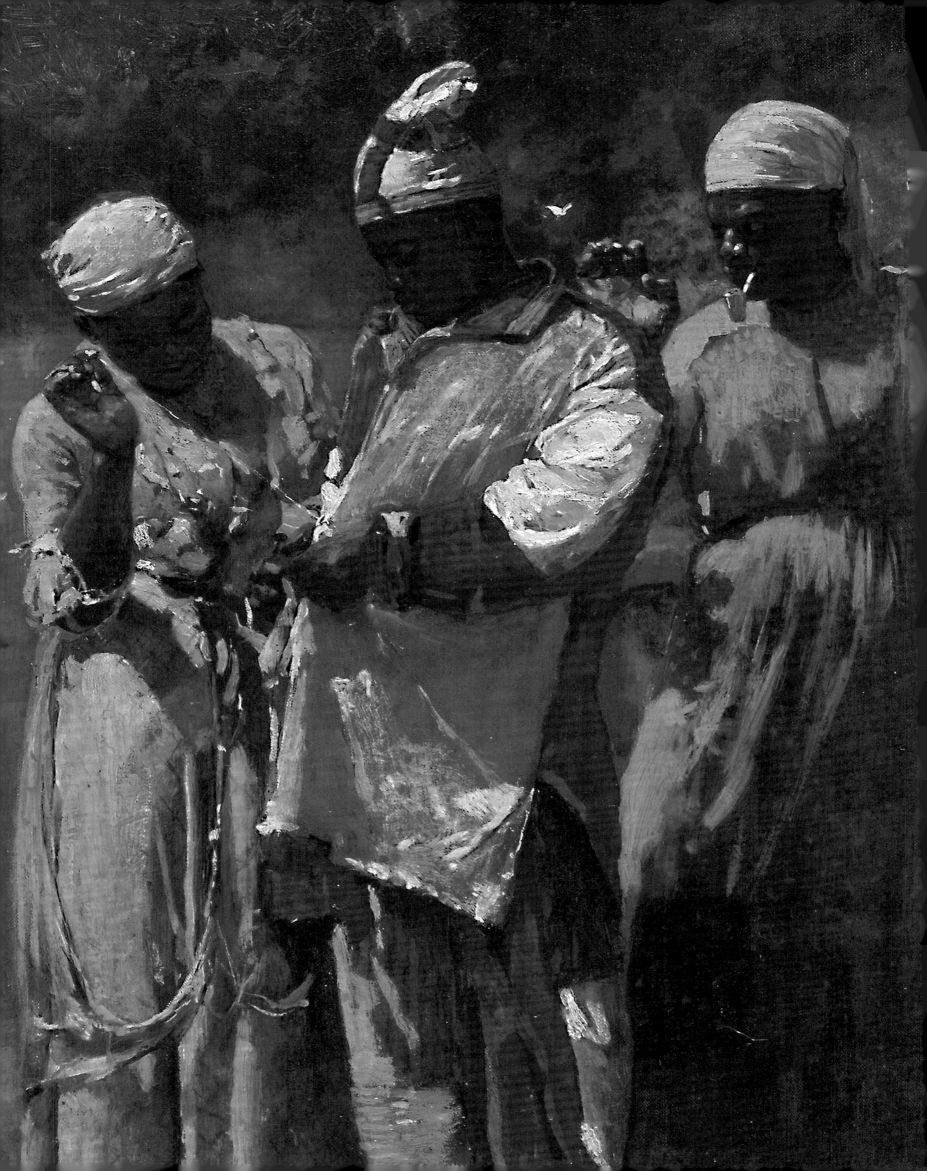

AFTERMATH

nding the war and returning home was harder and more complicated than anyone imagined. The readjustment of veterans, the options faced by millions of newly freed blacks, and the changes that had taken place on the home front all came into sharp relief. As they had during the war, artists looked for ways to make sense of the changes that were taking place around them, as veterans were reunited with loved ones who had weathered the war years at home. Whether it was readily apparent or not, home had changed as a result of the Civil War, too. Those changes had the potential to be as disruptive for returning soldiers as for their homebound families. Eastman Johnson and Winslow Homer used their postwar paintings to address two universal truths: everyone was in some sense a veteran, and no one would emerge from those four years unscathed.

As the war came to an end, Henry James (fig. 115) published his first short story in the *Atlantic Monthly*. Titled "Story of a Year," it followed the turbulent relationship between soldier John Ford and his fiancée, Lizzie Crowe. The growing disconnect between their wartime experiences—his in Virginia and hers at home—threatens to topple their relationship, an all too common scenario. In summing up their situation, James noted of his protagonists, "John Ford became a veteran down by the Potomac. And, to tell the truth,

Lizzie became a veteran at home."[1] His message is clear—the war changed everyone's perspective, affecting hearts and minds, forcing confrontation on values and viewpoints during the conflict and in its aftermath.

Winslow Homer turned his attention to a painting in which landscape and figure merge into a meditation on the difficulties of returning home. *The Veteran in a*

We shall never any of us be the same as we have been.

—Lucy Rebecca Buck

New Field (cat. 75) incorporates several complicated layers of meaning.[2] Painted during the summer of 1865, after the war's end, the picture is foremost about re-engaging with civilian society and providing sustenance for family and community. Homer's veteran is back at work in his fields, scythe in hand, reaping that summer's bountiful harvest. He stands in his shirtsleeves, his army jacket and canteen discarded on the ground behind him. His straw hat shelters his head from the noonday sun, and the uncut wheat, standing nearly as tall as the soldier, gleams in the light.

As critics noted with satisfaction, the harvests of 1865 and 1866 were plentiful—symbolic, some said, of prosperity returning to the victorious North. Wheat was a ripe metaphor for renewal and fulfillment. Viewers of

FIG. 115

John Singer Sargent
Henry James, 1913,
oil on canvas, 33 ½ × 26 ½ in.
National Portrait Gallery, London

foreboding figure whose scythe associates him with the grim reaper. Made metaphorical in its meaning, the old-fashioned scythe reminds all of us that returning from war is not as easy as resuming farm tasks.

For those who remained at home, wheat fields symbolized the North's prosperity. It is a crop harvested by free men for individual and communal sustenance. But in Homer's painting that agrarian landscape harbors a more complicated message. The vast majority of Civil War battles were fought in corn and wheat fields. Soldiers' accounts of battles often make reference to the terrain and to the irony of fighting in such places. During the war, harvest metaphors and images of grim reapers permeated newspapers and journals, making it impossible for anyone paying attention to current events to avoid or deny such imagery. Union General Joe Hooker, describing the carnage at Antietam, recalled, "Every stalk of corn in the northern and greater part of the field was cut as closely as could have been done with a knife, and the slain lay in rows precisely as they stood in their ranks a few minutes before."[4] Homer's veteran moves away from us deeper into the wheat field. As he does so the cut wheat stacks up behind his legs, trapping him between the harvest and the standing stalks. The only way for this veteran to move forward is to scythe the wheat, much as the soldiers mowed down their enemies. He cannot retreat, for the cut stalks behind him block his backward step. What runs through the unnamed veteran's head each time he swings his scythe? Wheat fills his field of vision, just like the memories that fill his head. One soldier spoke of his battlefield experience, confirming that "ghastly pictures of carnage will ever be present before my eyes, and those half-smothered sobs and groans, and those death-appeals will always ring their solemn chorus in my ears."[5] Every time Homer's veteran swings his scythe in this unending field of wheat, memories of soldiers—from both sides—being mowed down in rows haunt him. Timothy H. O'Sullivan's *Harvest of Death* has met its reaper.

Homer's metaphorical and symbolic intentions are profound and deliberate. However, there is an auto-biographical quality to this painting that carries more subtle reverberations of meaning. We do not see this

the era delighted in praising Homer's deft interweaving of the biblical reference to beating swords into plow-shares, and of the great Roman General Cincinnatus, reborn in George Washington, who gladly exchanged his sword for his farming tools and embraced his return to civilian life. The idea of a reaper, in this case return-ing to a harvest of plenty rather than a harvest of death, comforted many contemporary viewers. On the surface of this painting, all seems well; the soldier has returned, his household reunited like the country, his actions nurturing a prosperous future.[3]

But even before Homer displayed *The Veteran in a New Field*, he deliberately altered the man's scythe, and in doing so opened the door to a more profound and symbolic reading. Originally, Homer's veteran held a modern cradled scythe, an implement common to wheat harvesting for over a century. Later he would paint out the trees that once hovered over the edge of the wheat field. Homer's alterations winnowed its meaning. These thoughtful and deliberate adjust-ments render Homer's soldier a more timeless and

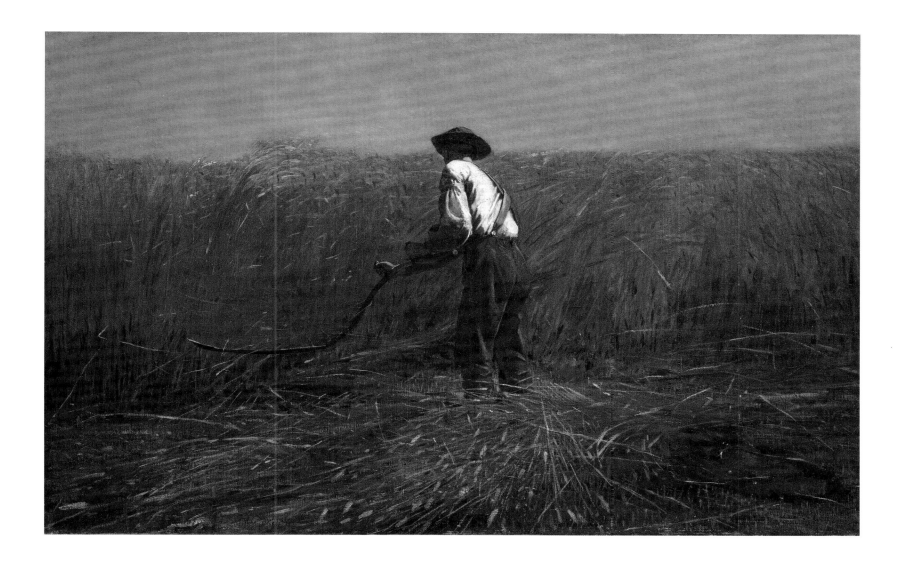

CAT. 75

Winslow Homer
The Veteran in a New Field, 1865,
oil on canvas, 24 ⅛ × 38 ⅛ in.
The Metropolitan Museum of Art,
Bequest of Miss Adelaide Milton de Groot
(1876–1967), 1967

veteran's face, for he is everyman. But we do see his canteen and jacket, so recently sloughed like a molt. The red cloverleaf insignia on the jacket and canteen marks the soldier's garb as from Francis Barlow's regiment, the same division Homer spent time shadowing during the conflict, the same insignia that appears in two of Homer's other war-related paintings, *Skirmish in the Wilderness* and *Prisoners from the Front*. These emblems tie this unnamed veteran to Homer himself. Homer's veteran, like the artist, has shed the outer layer of his wartime experience, but he cannot shed his memories so easily. When he began painting *The Veteran in a New Field*, Homer had also recently returned from war. By 1865 he had experienced no fewer than three tours at the front. He had witnessed battle firsthand, commemorated events of the war in paintings and wood engravings, and may have been present at Appomattox for the close.[6] He had known his friend Francis Barlow grievously injured twice, finally forced to resign in order to heal. A veteran of the field if not of the front lines, Homer returned, in his mother's words, "so changed that his best friends did not know him." The artist's propensity for situating himself in his images strongly suggests that this veteran reflects Homer's state of mind upon returning home. His veteran encapsulates the experience of every soldier who survived the conflict. Beneath the surface, Homer, like his soldier, relives his wartime experiences, working through them as surely as the harvester works his way through the wheat field.

The Veteran in a New Field functions as a kind of therapy for the artist. In it Homer paints his veteran's homecoming as an attempt to leave the war behind and resume his prewar routines. He stands in an endless field, his own vision stretching beyond the here and now, beyond the task at hand. By removing the trees that once loomed over the right horizon, the artist has created a limitless sweep of sky to match the expanse of wheat. Lost in his thoughts, the veteran reaps his memories along with the harvest. His back turned to the viewer, we cannot see his eyes nor read his thoughts. This returned soldier, like so many others, carries the burden of vision and memory in silence. Glimpses into the lives of the survivors of the Civil War battlefront reveal that no one escaped the conflict unscathed. Nineteenth-century doctors' accounts of treating veterans focused on former soldiers' inability to withstand the stresses of the front lines and their difficulties in segueing back into civilian life. This veteran presents the appearance of a return to normalcy, yet Homer paints him as a man disengaged from society, alone with his thoughts. His gradual immersion in the landscape suggests his increased emotional isolation. A writer for the *New-York Daily Tribune* echoed this aspect of Homer's painting, noting that the returned veterans "have grown very old in the brief while; old in experience, not in years.... Their vision stretches further than the scene before them, beyond the Present and the Peace, into the Past and the Struggle and reveals the horrors of the battle-field; and . . . the anxiety and suffering, and agony worse than death that have consecrated our cause forever."[7] This writer recognized that the emotional toll of the war was as real as its physical scars.

All Civil War veterans came home profoundly altered by their experiences. Homer's figure, facing his meditative yet haunted landscape, poses the powerful question: can you ever recover from the war? Homer's mother expressed those fears in her letter to her youngest son, Arthur, "He will never be the same." She saw the external changes in Winslow and most likely perceived the changes that were more deeply buried. She tried to reassure herself that as her son's physical appearance improved, so, too, did his mind. Under her roof that fall in 1862, Winslow found the room to regain his stability. We have but a fragment of the entire letter. Henrietta's tantalizing words speak to that process of recovery, which makes discovering that letter in its entirety so important for better understanding the impact of Homer's war experiences. Many veterans undoubtedly struck their families in a similar manner: internally changed forever, even as their friends and relatives reassured themselves that with their external recovery, all would be fine.

For Homer, the postwar landscape signaled a profound shift in the way land expressed American culture and its ideals. The ground, churned to mud in *Prisoners from the Front*, gave notice that the landscape would amplify the intensity of the figural narrative. *The Veteran*

in a New Field transformed a bucolic vista of a bountiful harvest into a metaphor for endless replaying of the war on the American conscience long after it had ended. The field to which Homer's veteran returns was often interpreted as a field of new possibilities represented by the harvest. However, the way the artist places him in that field, his back turned away from his army jacket and canteen, his entire field of vision dominated by the stalks of wheat awaiting his scythe, augur a less sanguine layer of meaning. Psychologically this field is new territory as the veteran grapples with memories and emotions unfamiliar to his prewar consciousness. Homer deftly intertwines the possibilities for relief and torment in a single image, the landscape posing an obstacle to his desire for peace and harmony. In Homer's postwar world, Sanford Gifford's Hudson River school ideal of returning to a familiar landscape for psychological recovery is no longer possible.

Wheat was not the only agricultural field for postwar commentary on the struggles that lay ahead. Homer's *The Cotton Pickers* (see cat. 74) presents a Southern iteration on agricultural bounty as a barrier to recovery. Cotton was not only a staple crop on Southern plantations, it also represented slavery, a blight on the nation's conscience. As a metaphor for the institution that held them in bondage, cotton is more than a physical obstacle blocking these two women from leaving the field. It symbolizes the cultural obstacles they face after the war as well. Here the endless rows of cotton block one woman's path, while an individual stalk subtly tugs at the other woman's skirts. Homer's landscape actively impedes these women from taking the next step into their future. In *The Cotton Pickers* and *The Veteran in a New Field*, Homer affirms that the postwar landscape is no longer a sanctuary, but evidence of a problem yet to be solved, a challenge that may or may not be overcome.

AMERICA AT A CROSSROADS

For those who had remained at home, the end of the war represented a different kind of battleground. Women assumed different roles as they became the heads of households, some temporarily, others permanently. The ambiguities associated with the end of war carried over to all aspects of the home front; nothing had remained in stasis during the preceding four years. That message about unavoidable change and pervasive uncertainty surfaces in a haunting painting by Eastman Johnson titled *The Girl I Left Behind Me* (cat. 76), painted around 1872. In Johnson's painting a girl stands on a promontory, her hair streaming into the wind. Fog obscures the horizon, making it difficult to determine whether she stands near the coast or further inland. Her head is framed by the light behind the clouds, but there is no sense of time of day or even which direction she faces. Her fingers hold her place in a small stack of books, and on her left hand she wears a wedding ring, glinting dully in the overcast light. Below her the landscape is divided by a split-rail fence. Johnson himself did not quite seem to know how to position this work in the public eye. In 1872 he displayed it under the title *The Foggy Day*, subsequently opting for *Young Maidenhood* before settling on *The Girl I Left Behind Me*, the title of a song popular during the Civil War with both Union and Confederate soldiers.[8]

Reviewers, too, seemed confounded by this enigmatic painting. Their unease at being unable to determine where this girl is, why she is there, and what she is doing reinforces one consistent feature: uncertainty. Her age is unclear, her face seemingly too young for the wedding ring she wears. One reviewer, focusing on her delicate features, referred to her as a school girl, heading home with her books. This same reviewer wrote,

> The air is full of the flying scud, and some effect of sea or storm, some tumult of sea and sky, has touched a chord in the maiden bosom. She has turned sharply round and faces the wind that drives out her wrappings, and seizes with fierce caressing her fair hair. The pose is peculiar but full of force; the chief attraction, however, is the head, which is grandly beautiful in its lines, and very suggestive. It is not alone admiration for the sublimity of the scene, but she is dimly conscious of a sympathy with the hitherto disregarded senseless things of nature. There is a trembling of the soul, a movement of the wings before they expand.[9]

That sense of latent anticipation, of a premonition that something is about to change, permeates the atmosphere of this painting.

Johnson's girl stands rocked back on one heel as if buffeted by the wind, but determined to stand firm. The path before her trails off, making it unclear if she must retrace her steps or can find a way to move forward. Her wedding ring speaks to a commitment to her union, but is Johnson referring to her personal life or to the Union as the nation? The dense fog, unusual in the annals of American landscape painting, alludes to an equally undecided and impenetrable consciousness. Henry David Thoreau wrote of the weather as emblematic of the American state of mind in his 1862 essay *Walking*, in which he equated an American's "clearer, fresher" thinking to living in a country with clear skies and grand weather. Of overcast days and muddled thinking, Thoreau mused, "Or is it unimportant how many foggy days there are in his life?"[10] The fence below this young girl and the fog surrounding her speak to a world fraught with division and ambivalence. Johnson's figure appears to be waiting for a break in the clouds, for her thinking to clear, for some sign of what to expect next. She is resolute and determined, but her future path is as occluded as the atmosphere surrounding her, suggesting that one aspect of this painting is a compelling, if complicated, commentary on Reconstruction-era America.

Johnson's *The Girl I Left Behind Me* and Homer's *Near Andersonville* (see cat. 72) present two variations on the postwar uncertainty about what kind of country would emerge from the Civil War, and how Americans—black and white—would make their way forward from this moment. If Johnson's figure is determined to wait for a sign, Homer's young woman considers the ramifications of her options from a less exposed vantage point, equally unsure where they might lead. Her quiet strength is central to this painting's power. Homer gives his black woman at the cabin door equality—both in dignity and introspection. He gives her the strength to stand in the raw sunlight and contemplate her options, but she is no more in control of her destiny than Eastman Johnson's girl. The path to take is not clear to either of them, but in each painting the artist has suggested that such choices are inevitable as the country faces a postwar future full of uncertainty. Each of these women must call upon her inner strength and fortitude to choose her path into the future.

THE UNRAVELING OF RECONSTRUCTION

Reconstruction began as a well-intended effort to repair the obvious damage across the South as each state reentered the Union. It was an overwhelming task under ideal circumstances. Following Lincoln's assassination, that effort soon faltered, beset by corrupt politicians, well-meaning but inept administrators, speculators, and very little centralized management for programs. President Andrew Johnson, a slaveholder from Tennessee, reversed many of the provisions enacted by Congress to protect newly freed blacks. Many former slaves found themselves bound over as sharecroppers working for their former masters. "Black codes" set restrictive and punitive guidelines for how blacks who remained in the South were treated. Johnson's administration encouraged the rapid reentry of the former Confederate states but at the expense of protecting black civil rights.

As conditions for black Southerners worsened in the mid-1870s, Homer was reputed to have revisited Petersburg, Virginia. At this time he completed a group of oil and watercolor paintings, demonstrating the artist's acute perceptiveness to this ongoing dilemma.[11] Among these works, *Dressing for the Carnival* (cat. 77) stands out, containing complex layers of meaning in what at first seems a straightforward picture. At the center of the painting, a young black man stands patiently while two people sew him into his brightly colored costume. The woman on the left plies her needle, her thread rendered visible. The young man pays close attention, as he holds the stiff cloth of his coat away from his body as she works. His multicolored outfit, seemingly still under construction, anchors the composition and alludes to generations of street pageants behind the present day's activities. Recent scholarship has linked Homer's *Carnival* to the West Indian Jonkonnu festival, itself derived from medieval European Mummers Plays. That lineage of door-to-door street pageants provides the backdrop for Homer's depiction of this group of Southern blacks.

Mummers Plays were seasonal parades in which a costumed and masked troupe of performers went from house to house reciting songs, teasing the passers-by, and demanding small cakes or coins if the individuals

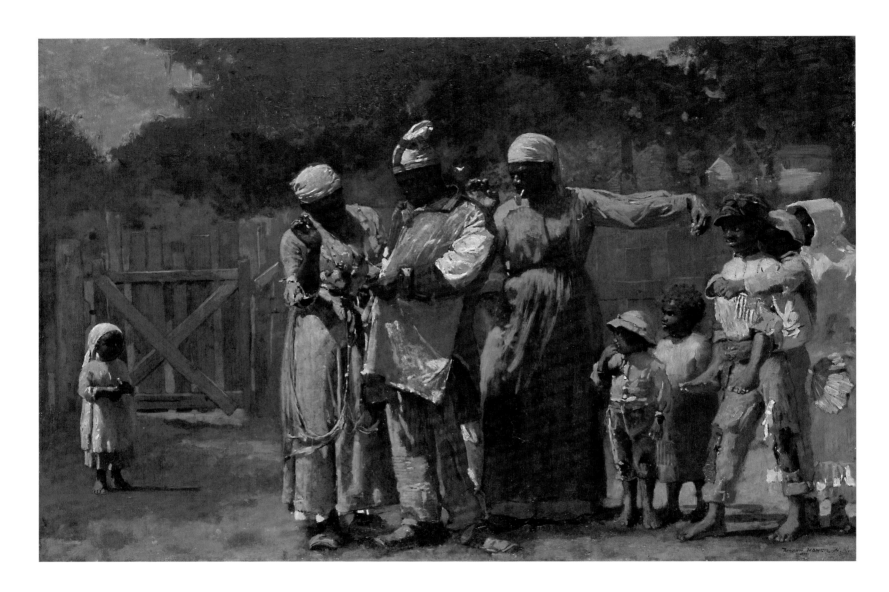

CAT. 77

Winslow Homer
Dressing for the Carnival, 1877,
oil on canvas, 20 × 30 in.
The Metropolitan Museum of Art,
Amelia B. Lazarus Fund, 1922

were not recognized. Often these plays carried religious overtones, the story focusing on the death and resurrection of a key character, usually St. George.[12] During the eighteenth century, this custom formed the basis of the West Indian festival of Jonkonnu, as enacted by slave laborers of the British colony of Jamaica. There, on the day after Christmas, enslaved people, mostly men, were permitted to dress in costume and masks and to parade through the community. On that one day each year, they could pass through the gates, dance on their masters' porches, and demand small gifts of money or trinkets. This form of Carnival was a sanctioned occasion to mock the upper classes. This custom continued its migration with the slave trade to Virginia and North Carolina. Known colloquially in the American South as "John Canoe" or "John Cooner" celebrations, they came to represent the single day of the year when blacks and whites could approach each other with a semblance of equality.

In the Caribbean, Jonkonnu celebrations included parades of gaily costumed men, often wearing masks, blending European, African, and Caribbean folkways. Kings and queens, both often portrayed by men, "ruled" the parades in an idiom that evolved into Mardi Gras in the American cities of Mobile and New Orleans. In Homer's canvas, the figure standing behind the costumed man wears a dress and head scarf, but in keeping with the tradition of Jonkonnu celebrants as mostly male, he is likely a man who has borrowed a woman's dress.[13] The pipe clenched between his teeth leads us to notice this figure's masculine features and powerful hands. His attention has been diverted by the appearance of a small white butterfly hovering behind the younger man's neck. He appears to stop himself from batting at it, his large hand frozen in mid-gesture. The butterfly, so casually yet intentionally placed, suggests transformation and change. The metamorphosis from caterpillar to butterfly, associated with spiritual transformation, may allude to the hope—widespread in the North—that a similarly transformative process could take place for newly freed blacks in American society.

However, white butterflies have for centuries been a personification of the human soul, and many cultures view them as harbingers of death. Placed near the very center of the painting, Homer's butterfly stops this older man in his tracks as he contemplates its meaning. His arrested gesture lends weight to the butterfly's appearance at this moment. The sobriety of the seamstress and celebrants casts a pall over what should be a moment of gaiety and celebration. The red carnation the costumed man holds gently between his lips speaks of a heart that aches. The somber seamstress stitches the young man into his costume as though it were a shroud. It is as though this gaily dressed man, like St. George of the traditional Mummers Play, is being prepared for his own death. Homer's complex tableau raises the question: does he represent a sacrifice on the path to African American independence? As the group of children gather to take part in the incipient celebration, American flags at the ready, they seem transfixed as much by the butterfly as the preparations for the parade. The butterfly hovers, like a held breath, a hint of the fragility of the cultural and political transformations taking place in the lives of these black men, women, and children.

Apart from the group is the youngest and smallest of the assembled children, standing by herself off to the far left. She is dressed in white, her face uplifted, looking with eager attention at the proceedings. She is young enough to have been born after emancipation, even after the end of the war. Unlike the others who stand against the backdrop of their former lives, she stands nearest the gate, and above her is open sky. The choices Homer made in placing her there and in dressing her differently call attention to her perspective on the scene. She is not linked to the plantation house or the old slave quarters behind the other children. She smiles, diminishing the sober intensity of the three adults and the watchful anticipation of the older children. Her white dress and head scarf link her presence to that of the butterfly, perhaps a suggestion that her fate is not tied to this place and this event, but rather it carries the possibility of her own metamorphosis. Her presence gives meaning to the implied sacrifice of the young man in his costume.

It is possible that this painting was first displayed under the title *Sketch–Fourth of July in Virginia* at the Century Association in 1877.[14] Small American flags join

colorful African-inspired cloth costumes as Homer's free blacks prepare for an event that blends African folkways with the celebration of American independence. Homer focuses on the efforts undertaken by the local black population to retain their cultural identity, fragmented under race slavery, and integrate it into celebration of their freedom as Americans. Connecting Carnival with American independence conveys another layer of this painting's meaning. After the war ended, such rituals held over from slavery took on a new significance. During Reconstruction that symbolism shifted to a more open defiance of oppression.[15] The group of figures has gathered alongside the fence separating them from the plantation house, its twin brick chimneys rising above the outstretched arm of the figure with the pipe. As though staging their own Mummers Play, they appear almost ready to breach the gate and demand their place alongside the white residents of the property, daring their former masters to recognize them—permanently—as free people. But the implied equality between blacks and whites represented by this man's costume may have struck Homer as ironic, given the failures of Reconstruction and the South's regression into more virulent forms of racism.

Homer's message here is not as clear as in *A Visit from the Old Mistress* (see cat. 73), painted the preceding year, in which the acute tensions between black and white protagonists left little doubt as to the artist's assessment of race relations in the postwar South. *A Visit from the Old Mistress* took up the subject of renegotiating the power between white and black women during Reconstruction. Homer's black women look with open defiance on their former mistress, understanding the implications of the change in their relationship. *Dressing for the Carnival* addresses the more limited power of black men to navigate this same terrain, their aspirations for freedom presented in more oblique terms, cloaked in costumes and framed in a centuries-old pageant about hope, sacrifice, and resurrection. And it is in the hopeful eyes of the youngest child in which we see the future. In *Dressing for the Carnival*, Homer has painted a far more complicated and nuanced view of black life in which the potential for the merging of cultural traditions, literally stitched together, takes center stage.

Winslow Homer created genre paintings during Reconstruction that reflected the sober realities of postwar America. His works spoke forcefully to the social and moral issues bedeviling the period. But neither Homer nor Eastman Johnson could sustain that level of direct engagement with American politics beyond the Centennial. By that time, Homer had shifted his focus first to Europe, and to the women of Cullercoats, and then to the Adirondacks and Prout's Neck. He continued to make paintings invested with a strong and often sardonic point of view, but Homer did not, in fact, recover completely from the Civil War, and he assiduously rededicated himself to painting the elemental contest between man and nature. Johnson continued to paint works that carried multiple layers of meaning, but his subjects shifted to embrace the colonial revival as a means of exploring core American values. His early idealism and his sympathetic portrayal of blacks during the Civil War gave way to a postwar cynicism that dismayed his friend Jervis McEntee.[16] But Johnson, like Homer, may have found it impossible to maintain that acute level of political and moral focus beyond the decade encompassing Reconstruction. Both men had painted works that addressed questions of conscience, faith, and character—for individuals and for the nation. They had plumbed the depths of the war by finding humanity in every individual's struggle. Like the country, each man had to move on, countering the war's damage with his need to recover.

LANDSCAPE AFTER THE WAR

By the war's end, in landscape painting the concept of America as the New Eden had yielded to a more sober vision of a nation trying to find its way back to the Garden. The confident promise of Frederic Church's *Niagara* (see fig. 44), painted in 1857, its rainbow over a waterfall symbolizing unlimited power and ambition for a resourceful and gifted nation, was supplanted by the more thoughtful vision of *Rainy Season in the Tropics* (see cat. 12) of 1866, with its double rainbow arcing over a chasm that appears to separate this world from the next. In 1867 both of these paintings were sent to the Paris Exposition, along with Johnson's

FIG. 116

Timothy H. O'Sullivan
*Battlefield of Cedar Mountain House
riddled with cannon balls in which
Gen. Winder was killed*, August 1862,
Library of Congress

Old Kentucky Home (Negro Life at the South), McEntee's *Virginia*, and Homer's *Prisoners from the Front* and *The Bright Side*.[17] The Paris Exposition heralded American artists' return to Europe in the years following the war. It also signaled a swerve in patronage by American collectors who increasingly opened their eyes and homes to European works of art. The narrow provincialism so often ascribed to American art patronage was beginning to broaden, a trend that would only increase as the century drew to a close.[18] Church's pair of landscapes was well received. But what is intriguing, and appeared to go unnoticed, was that Church was represented by two monumental landscapes in which rainbows rise over a cataract. *Niagara* was a prewar exemplar of America's power and majesty, while *Rainy Season in the Tropics* was a postwar vision affirming the blessing of spiritual redemption following personal and national tragedy. In concert, the two scenes framed the impact of the war on American landscape painting, spanning an earlier idea of America as Eden to a postwar yearning for a return to peace and prosperity. Confident promise gave way to a more psychologically

fraught path, concerned with making peace with this world as a bridge to the next.

The change in perception of the war-torn landscape marked a seismic shift in the postwar understanding of the genre. In 1877 the editor of the *North American Review* noted, "The entire school of landscape-painters [was] the product of the public taste as it existed before the war."[19] Two years later, Henry James observed that America certainly had been evicted from Eden but approached the postwar world as a willing and knowing participant in building what would come next. He described the nation's transition as moving away from the "broad morning sunshine" of life shot through with a "simple and uncritical faith" in the country's grandeur, a belief "that a special Providence watched over it, that it would go on joyously for ever." The war, James continued, "introduced into the American consciousness a certain sense of proportion and relation, of the world being a more complicated place than it had hitherto seemed, the future more treacherous, success more difficult.... He has eaten of the tree of knowledge. He will not, I think, be a sceptic, and still less, a cynic; but

he will be, without discredit to his well-known capacity for action, an observer."[20] During the war, the very earth had seemed to be coming apart. The world as Americans knew it had become unstable, unpredictable. James's metaphors, invoking the loss of Eden and affirming nature's destructive powers to describe the war and its impact, acknowledge the growing interest in the emerging sciences of meteorology and geology.

Changes in the Northern landscape were often those of association rather than destruction. Shortly after the Battle of Antietam, a reviewer describing wartime photography regretfully concluded that the war had changed even the most innocuous of vistas. Writing of one of Timothy H. O'Sullivan's photographs (fig. 116), he commented:

> There is nothing in the scene to suggest the throes of war—nothing to arrest the fancy or the eye. Turn to the title and what do you read: "Battle-field of Cedar Mountain. House in which Gen. Charles Winder was killed."...Cedar Mountain is no more the Cedar Mountain that yesterday it was. How strange, how impalpable, and yet how real is this signet which history sets upon nature! the place where a great event has come to pass—the scene of a martyrdom—the birth-place of genius—the battle-fields of nations—are looked upon by us all with another than an outward eye.[21]

That inner eye—the ability to see and appreciate the metaphorical richness of landscapes during the war—would fundamentally alter the mission of postwar landscape painting. For American artists, landscape would continue to operate as a cultural metaphor, but on a different, more complicated footing. Landscape painting as the national genre began a steep, swift decline as the optimism of the Hudson River school necessarily gave way to the more ethereal tonalist works. Smaller-scale paintings took on a somber mood or a distant, luminous air as though they were not really of this world but spoke of hazy recollection, nostalgia, or longing for a time and state of mind now lost.

THE PHOTOGRAPHER AS VETERAN

Among the artists who served in uniform or accompanied the troops, the photographers also returned with vivid memories of the war's devastation. Many of them were observers, rather than soldiers, not obligated to endure the same privations as enlisted men and officers, and yet they understood that they were witnessing and interpreting history as it unfolded. Alexander Gardner and Timothy H. O'Sullivan stripped any veneer of romanticism from the accounts of Antietam and Gettysburg. Mathew Brady and George Barnard had used their photographs of the war-torn landscape as surrogates for the damage wrought on the war's human survivors. The war changed the photography profession as well, expanding the prewar emphasis on providing portraits and *cartes-de-visites* to capturing the essence of current events in a more immediate and visceral way. Within five years of the war's end, many of the prominent photographers for the Union army had left their galleries on the East Coast. The East would still need photographers, but A. J. Russell, John Reekie, Gardner, and O'Sullivan headed west working for various railroad companies or the U.S. Geological Survey expeditions to document a different kind of progress. Of the best-remembered Union photographers, only George Barnard eventually settled in the South, returning to Charleston in 1869 to establish his own business. Their decisions epitomize the more general desire for a fresh start, new perspectives, and perhaps above all the need for distance from the battlefields to cope with their memories.

O'Sullivan's postwar career provides a case in point. In 1867 he signed on with geologist Clarence King's Fortieth Parallel Survey as the expedition's artist. King's official task was to document evidence of the geological processes that supported his theory of catastrophism, the then-controversial belief that the earth's features were as much the result of brief periods of upheaval as of long-running processes of weathering and erosion. King (1842–1901, fig. 117) was a strong proponent of catastrophism, which he developed from reading Alexander von Humboldt, who continually emphasized the instability of the

FIG. 117

Silas Selleck
Clarence King (standing, right)
and the Field Party of 1864, 1864,
National Portrait Gallery, Smithsonian
Institution

FIG. 118

Timothy H. O'Sullivan
Limestone Cañon, Humboldt
Mountains, Nevada, 1868,
Library of Congress

earth's crust, noting that it underwent "great changes in the course of centuries . . . large plains are raised and sunk . . . the boundaries of sea and land, of fluids and solids, are . . . variously and frequently changed."[22] King's firm belief in change as the governing agent in geology built on the work of Humboldt, geologist Charles Lyell, and even Charles Darwin. Each man's theories, whether on the evolution of the earth or its inhabitants, were disconcerting ideas when introduced. In the wake of the Civil War and Lincoln's assassination, destabilization had become a national metaphor. Catastrophism was its geological corollary.

O'Sullivan's body of work as a wartime photographer served as an apt background for rendering this idea of instability made visible. O'Sullivan understood King's geological theories and intentionally skewed the horizon in numerous survey photographs, including one titled *Limestone Cañon, Humboldt Mountains, Nevada* (fig. 118).[23] The Fortieth Parallel Survey would be a simulacrum of the war King never fought, a personal and metaphorical war, and for veterans like O'Sullivan, a challenge to the mind and body embracing the promise of cathartic exorcism of the demons of the battlefield.[24] Throughout King's field notes and published reports, he used militaristic language in describing the difficulties they encountered in reaching certain spots. He characterized steep outcroppings as "battlemented rocks," his descriptors deliberately invoking the language of war. King's and O'Sullivan's understanding of the western landscape corroborated the widespread recognition of the deeper rupture in the fabric of American society.

O'Sullivan's photographs with the King survey manifest the nation's sense that the world itself had come off its axis, that locked in the ancient rocks was evidence of the cycles of catastrophe that marked creation. In one of his earliest photographs for the King survey, O'Sullivan

THE POSTWAR YEARNING FOR EDEN

The postwar western landscape incorporated the same duality of cataclysm and sanctuary evident in the wartime paintings of Church and Albert Bierstadt. In both paintings and photographs, the rock strata are a reminder that the past is always present. Balanced with the sublime views of tortured rock strata and antipicturesque open spaces prevalent in O'Sullivan's western photographs was the expression of the West as an Edenic paradise awaiting a population of war-weary aesthetes in search of solace. Yosemite became the first of many western landscapes identified during the war years as a rugged sanctuary. A group of Californians advocated that the site be designated a park and sought federal acknowledgment of the area's unique landforms and recreational potential.[25] Among the group was Frederick Law Olmsted (fig. 120), who had been hired in 1851 to begin work on creating New York's Central Park. In March 1864, Olmsted teamed up with his boyhood friend, geologist Clarence King, to survey the perimeter of the future park.[26] The experience would shape both their lives and postwar careers. Fascinated by Yosemite, Olmsted saw consonances between the rugged western valley and the Edenic garden he envisioned for the middle of New York City. Both sites, in Olmsted's mind, were protective sanctuaries for mankind, places in which one could slough off the cares and anxieties of modern life and experience nature in the manner Emerson had advocated in his 1836 essay *Nature*. Olmsted joined the small group of politicians and naturalists crafting the language that would protect the site. Their efforts were rewarded in June 1864, when Abraham Lincoln signed legislation setting aside Yosemite as America's first federally recognized park.[27] In location and topography, this valley was deemed exactly what the nation needed while Civil War raged—hallowed ground—and marked a return to Eden. In setting aside this place, Lincoln declared Yosemite a regenerative sanctuary for the entire country.[28] With his signature the president designated a literal and psychological place of refuge from the war.

By positioning paradise on the western edge of the country, American artists, photographers, and writers promoted the concept that wilderness areas could be set aside as protection against unwelcome change. In doing

photographed a geothermal vent—steam issuing from a crack in the earth's surface that seems to split the landscape in half (fig. 119). Barely discernable in the mist is the figure of a man on the far side of the chasm. As a technical feat, O'Sullivan captured the active geological feature with great clarity. Viewed through an artistic lens, his composition separates past from future. The tear in the earth's crust alludes to that other wrenching event, the Civil War. It suggests the divide between East and West, North and South, past and future. In 1862 Church's *Cotopaxi* (see cat. 6) revealed the emerging fissures in the American social fabric. In O'Sullivan's photographs of the American West, the actual landscape provides a metaphorical commentary on the country's fractured and upended condition. O'Sullivan, like so many war veterans, created in this picture a desire for literal and psychological distance from those traumatic experiences. The mist commingles past and future, the ghostlike figure representing the past, as O'Sullivan moves forward with King into the future.

so, they implied that nature would continue to operate as a spiritual force in America and that its future and its prospects for recovery lay in the West. The transcontinental railroad, completed in 1869, made that arduous passage more accessible, prompting many Americans to consider relocating as part of their postwar recovery. The urge to pick up and leave the devastation behind would prove irresistible for many, as they tried to bury the memories of slaughter and loss. Just as Exodus provided the template for black Americans to understand their passage from bondage to freedom, for many other Americans the journey westward represented a postwar variation on that theme as they uprooted themselves and started over. Olmsted saw in Yosemite the same emblematic potential for the country's future that Emanuel Leutze featured in his panorama *Westward the Course of Empire Takes Its Way* (fig. 121), which was completed during the first year of the war and graced the stair hall of the U.S. Capitol.[29] The postwar impulse to set aside emblematic landscapes fed the development of the nascent state and national park system, instinctively drawing protective boundaries around what seemed most vulnerable—the American sense of identification with nature, a place in which God's grace might still operate on this earth.

Ralph Waldo Emerson noted, "Above his will and out of his sight [the artist] is necessitated by the air he breathes and the idea on which he and his contemporaries live and toil, to share the manner of his times, without knowing what that manner is."[30] Whether or not they were fully aware of it, American landscape painters did capture the manner of their time, which was embedded as deeply in the landscape as in literature. The "Great Pictures" Frederic Church painted during the war years and afterward all seem deliberately allied with the trajectory of the war and the emotional toll it took on the nation as a whole and in his own life. *The Icebergs*, *Cotopaxi*, *Aurora Borealis*, and *Rainy Season in the Tropics* are not "war pictures" in the same sense as Conrad Wise Chapman's paintings of Charleston or Sanford Robinson Gifford's camp scenes. Instead of being an avid student of the movement of troops and the desire to find heroic or poignant tales amidst the carnage, Church lifted his head and sought a more universal note of defiance, fear, despair, and hope.

THE MANNER OF THESE TIMES

In 1868 Scotsman David Macrae toured eastern America in an effort to absorb the impact of the war. The published account of his travels touched on the pressing issues of the day, and his evocative descriptions of the landscape convey something of the pall that had descended upon the South. As he rode the train from Washington to Richmond in the predawn hours of January 11, he observed, "The ghostly houses standing in the cold weird moonlight, the empty streets, the profound stillness over all, made it seem as if we were entering a city of the dead. Great shells of building gutted with fire glided past, looking at us with their eyeless sockets. On one side of the valley, rising alone from what seemed to me a wilderness of gray tombs, a ghastly wall like the gable of a ruined cathedral towered into the frosty sky." Struck by the difference between North and South, Macrae continued, "A few hours had brought me from a land of light into a land of darkness; from gladness into mourning; from the victorious North into the vanquished and stricken South."[31] George Inness may have felt the same ghosts keeping pace with his train that brought him to the same part of the Virginia countryside in 1884. In his painting *Gray Day, Goochland* (fig. 122), he captures the predawn chill, the vacant farmstead relic seemingly poised to crumble and disappear before our eyes. Inness's late style proved well suited to express the psychologically fraught aspects of the postwar landscape. The figures are equally ghostlike, apparitions of the past as haunting as O'Sullivan's surveyor vanishing in a cloud of steam. They complicate the view, blending landscape with genre to address the lingering matters of conscience tugging at the nation.

A similarly haunting chimney, the lone remnant of a once elegant dwelling, anchors one of the photographs Alexander Gardner included in his *Sketch Book* titled *Breaking Camp, Brandy Station, Virginia* of May 1864 (fig. 123). The scene prompted the photographer to write in his caption, "What sad reflections crowd upon the mind

FIG. 120

Unidentified photographer
Frederick Law Olmsted, about 1860, National Park Service, Frederick Law Olmsted National Historic Site

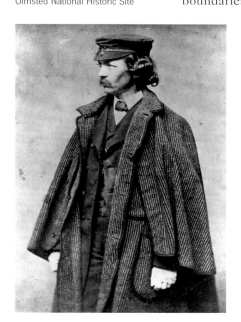

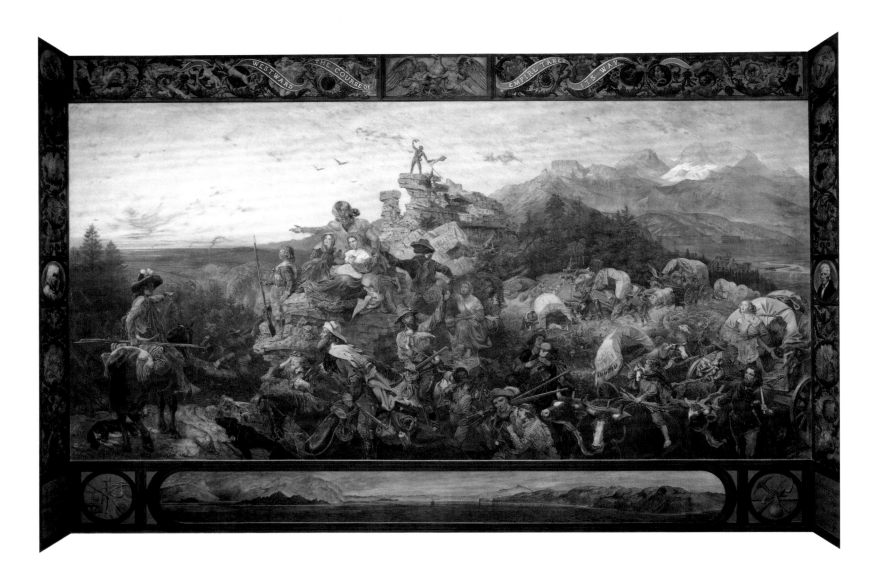

FIG. 121

Emanuel Leutze
*Westward the Course of Empire
Takes Its Way*, 1861, stereochromy,
20 × 30 ft. Architect of the Capitol

in visiting these relics of the past! All through the South in many a lonely waste such columns stand as mournful monuments of forgotten joys and aspirations; sealed volumes, whose unwritten lore none can interpret save those who made the record. Fragments of a sorrowful era, and witnesses of events which the world may pray shall never be re-enacted."[32] Inness and Gardner each felt and conveyed a sense of timeless melancholy, a place transformed by what had occurred there, the ruins serving as a memorial for cultural and material loss. The postwar mapping of the American landscape—North, South, and West—would interweave national and local history

and memory, extending beyond the traditional reach of landscape painting.

In 1873 Mark Twain observed, "The eight years in America from 1860 to 1868 uprooted institutions that were centuries old, changed the politics of a people, transformed the social life of half the country, and wrought so profoundly upon the entire national character that the influence cannot be measured short of two or three generations."[33] Like Walt Whitman, Twain recognized the impossibility of capturing the impact of the "real war" in real time. And yet the real-time clamor for responses to the war, both literary and artistic,

encouraged some of this country's finest writers and artists to do just that: to give meaningful voice to the ongoing or recently concluded upheaval and to provide insight into the cost of the war in human terms. In many cases, these artists chose a metaphorical perch from which to observe and comment on the conflict, their words and images resonating with a public steeped in the events and worried about the nation's future. This "Second American Revolution" forced all Americans of this generation to consider the validity of the founding precepts for the country. But the war also left unanswered many questions central to the country's further development as a democratic republic, about the relationship between state and federal governance and about relations between races and ethnicities.

The Civil War had a profound and lasting impact on American art, as it did on American culture as a whole. Both genre painting and landscape painting were fundamentally altered by the war and its aftermath. For landscape painters, the new challenge would be in finding continued cultural relevance for a genre that had been predicated on this country being a New Eden. Setting aside Yosemite hinted at one solution—using the actual landscape in place of its painted corollary. The postwar profusion of national and state parks and memorials bore witness to this impulse to protect and enshrine places emblematic of an American ethos. Photography had played a more expansive role than simply documenting aspects of the war; it had staked a claim to providing an aesthetically mediated experience, even in images exceedingly brutal in nature. Genre painters had entered territory previously reserved for history painting and in doing so had proved capable of addressing thorny societal issues of the period: racial inequality, political fracturing, westward expansion, and the failure of Reconstruction to put everything back together again. The conflict had left no aspect of American life unscathed, and traces of its presence remained long after the fighting was done. Like part of the geological strata, the Civil War exists as an integral layer of meaning in the arts made in the years surrounding the conflict and must be reckoned with as an essential aspect of our understanding of these works of art—and of the artists who made them.

FIG 122

George Inness
Gray Day, Goochland, 1884,
oil on plywood panel, 18 ⅛ × 24 in.
The Phillips Collection,
Washington, D.C., Acquired 1917

FIG. 123

James Gardner
*Breaking Camp, Brandy Station,
Virginia*, May 1864,
Library of Congress

NOTES

INTRODUCTION

Epigraph: Walt Whitman, "The Real War Will Never Get in the Books," *Specimen Days & Collect* (Philadelphia: David McKay, 1882; Dover reprint, 1995), 80.

1 Bruce W. Chambers admirably outlines the problems encountered by history painters in "Painting the Civil War as History, 1861–1910," in *Picturing History: American Painting, 1770–1930*, ed. William Ayres (New York: Rizzoli, 1993), 117–134. Stephen Conn also insightfully evaluates the failures in painting the Civil War in "Narrative Trauma and Civil War History Painting, or Why Are These Pictures So Terrible?" *History and Theory* 41, no. 4 (Dec. 2002): 17–42.

2 Ralph Waldo Emerson, "The American Scholar," address delivered to the Phi Beta Kappa Society in Cambridge, Massachusetts, 31 August 1837. Oliver Wendell Holmes Sr. declared this speech to be America's "intellectual Declaration of Independence." See Wilson Sullivan, *New England Men of Letters* (New York: Macmillan, 1972), 235–236.

3 For a thorough consideration of Fenton's career, see *All the Mighty World: The Photographs of Roger Fenton, 1852–1860*, by Gordon Baldwin et al. (New York: Metropolitan Museum of Art in association with Yale University Press, 2004). For a thoughtful discussion of photography during the Mexican-American War, see Martha A. Sandweiss, "'The Spirit is Wanting,'" in *Print the Legend: Photography and the American West* (New Haven: Yale University Press, 2002), 15–45.

4 By 1863 it became clear to some observers that Gardner and other photographers had moved bodies. It did not take long for viewers to determine that the same bodies were identified by Gardner as Confederates in one photograph and Union soldiers in another, the only changes being that of camera angle or body placement. Since then it has only become more apparent how artfully these photographers arranged their compositions to maximize the aesthetic impact of each photograph.

5 "Brady's Incidents of the War," Fine Arts, *New York Herald*, 26 Aug. 1861, 5.

6 Quoted in Alan Trachtenberg, "Albums of War: On Reading Civil War Photographs," in *Critical Issues in American Art: A Book of Readings*, ed. Mary Ann Calo (Boulder, CO: Westview Press, 1998), 143.

7 *New York Herald*, 14 April 1857; quoted in Douglas Fermer, *James Gordon Bennett and the New York Herald: A Study of Editorial Opinion in the Civil War Era, 1854–1867* (New York: St. Martin's Press, 1986), 62.

8 *New York Herald*, 4 Dec. 1861; quoted in Fermer, *James Gordon Bennett and the New York Herald*, 65.

9 Art Items, *New-York Daily Tribune*, 1 Sept. 1861, 2.

10 Larry Freeman, *The Hope Paintings* (Watkins Glen, NY: Century House, 1961), 8–9.

11 Ibid., 9n32.

12 "Hope's Great Picture of the Army of the Potomac at Cumberland Landing, on the Pamunky," *Daily National Intelligencer* (Washington, DC), 8 March 1865; quoted in Freeman, *The Hope Paintings*, 24.

13 Freeman states that Hope was with the brigade and under fire in *The Hope Paintings*, 25. The National Park Service Antietam website says Hope was ill and serving as scout and mapmaker. "In the Antietam Campaign: Hope had taken part in a dozen engagements prior to Antietam, but disabled by illness, was assigned to sideline duties as a scout and mapmaker. He recorded in his sketchbook the battle scenes before his eyes, and then after the battle converted his sketches into a series of five large paintings." National Park Service, introduction to an online exhibitition of the Hope paintings, http://www.nps.gov/anti/photosmultimedia/hopepaintings.htm. Both sources indicate Hope made sketches he later used as the basis for paintings.

14 Harold Holzer and Mark E. Neely Jr., *Mine Eyes Have Seen the Glory: The Civil War in Art* (New York: Orion Books, 1993), 155.

15 Julio took as his model the tradition of European royal and military portraiture in which Lee and Jackson confer, and their favorite horses—Traveller and Little Sorrel—are as recognizable as their riders. Viewers familiar with European Grand Manner portraits would easily recognize the inspiration of Anthony Van Dyck's equestrian portrait of Charles I and Sir Joshua Reynolds's portraits of Commodore Keppel, whose outstretched arm was itself borrowed from the *Apollo Belvedere* sculpture. Julio made Robert E. Lee the beneficiary of this regal tradition as he strove to ennoble his sitters and the cause for which they fought.

16 Julio wrote to Lee, offering to present the work to him as a gift. In response, Lee politely declined in August 1869. On November 1, 1869 Julio sent him a photograph of the work. Lee again declined the gift. The story of the painting's history is told in great detail in Estill Curtis Pennington, *The Last Meeting's Lost Cause* (Spartanburg, SC: Robert M. Hicklin Jr., Inc., 1988), 16.

17 The painting remained unsold during Julio's lifetime. Col. John Richardson, of the Washington Artillery of New Orleans, purchased the painting from the artist's estate. See Pennington, *The Last Meeting's Lost Cause*, 42.

18 Mark Twain, "The Private History of a Campaign that Failed," *Century Illustrated Monthly Magazine* 31, no. 2 (Dec. 1885), 193–204. Accessed at: http://books.google.com.

19 Twain concludes his point by stating, "In Rome, people with fine sympathetic natures stand up and weep in front of the celebrated *Beatrice Cenci the Day before her Execution*. It shows what a label can do. If they did not know the picture, they would inspect it unmoved, and say, 'Young girl with hay fever; young girl with her head in a bag.'" His sarcasm did not endear him then, nor does it now to his Confederate loyalist readers. Mark Twain, *Life on the Mississippi* (New York and London: Harper & Brothers, 1902), 313–314.

20 Critics then were, just as scholars now remain, divided as to whether Mayer intended to portray brothers or a father and son. Regardless of the filial relationships, Mayer's message is clear: this war divided families, all too often without the opportunity for reconciliation.

21 Art Matters, *Chicago Tribune*, 15 May 1867, 2.

22 Born in Virginia to a slaveholding family, Bingham nonetheless developed deep political ties to the Whig party in Missouri. The artist began his political career as a candidate for a seat in the Missouri state legislature. After a brief stint in the Union army he returned to Missouri when he was appointed treasurer of the provisional Union government in 1862. See letter of 29 June 1861 in Curtis Burnham Rollins, "Letters of George Caleb Bingham to James S. Rollins," *Missouri Historical Review* 31 (July 1933): 520; cited in Nancy Rash, *The Paintings and Politics of George Caleb Bingham* (New Haven: Yale University Press, 1991), 186. Bingham's earliest political genre paintings skewered the foibles of frontier elections and electioneering. Although he did not vote for Abraham Lincoln in 1860, he could write with cautious optimism, "I look forward to the election of Lincoln with far more hope than apprehension." Rollins, "Letters of George Caleb Bingham to James S. Rollins," 496; quoted in Barbara S. Groseclose, "Painting, Politics, and George Caleb Bingham," *American Art Journal* 10, no. 2 (Nov. 1978): 15.

23 Those views became personal when Ewing imprisoned a group of Confederate women in a building owned by the artist. The building collapsed, killing five of the women. In retaliation Quantrill led his troops on his rampage in Lawrence, which in turn prompted Ewing's Order Number 11 in a desperate attempt to quell the violence.

24 An account of this exchange between Bingham and General John M. Schofield, Union commander of Missouri, was published in "Order No. 11," Kansas City *Daily Tribune*, 27 Feb. 1877, 2; quoted in Rash, *The Paintings and Politics of George Caleb Bingham*, 191; also paraphrased in Curtis Burnham Rollins, "Some Recollections of George Caleb Bingham," *Missouri Historical Review* 20, no 4 (July 1926): 480.

25 Rash, *The Paintings and Politics of George Caleb Bingham*, 206.

26 This is not the first time Bingham considered painting a picture with a political agenda. Not one to mince words or back away from an argument, Bingham vowed to "paint a new series of pictures illustrative of 'Squatter Sovereignty' as practically exhibited under the workings of the Kansas-Nebraska Bill. I shall commence with the March of the Border Ruffians, and will take pains to give those infamous expeditions of organized rowdyism all those features which truth and justice shall warrant." Bingham to James Rollins, 10 Aug. 1856; quoted in Rollins, "Some Recollections of George Caleb Bingham," 476.

27 *Saline County Progress* (KS), 8 Jan. 1869, 1–4; quoted in Maurice Bloch, *The Paintings of George Caleb Bingham: A Catalogue Raisonné* (Columbia, MO: University of Missouri Press, 1986), 23.

28 George Caleb Bingham, *An Address to the Public, Vindicating a Work of Art Illustrative of Federal Military Policy in Missouri During the Late Civil War* (Kansas City, MO, 1871), 1; quoted in Bloch, *The Paintings of George Caleb Bingham*, 23–24.

29 Washington came to the nation's capital in 1834 and was trained as a draftsman with the Patent Office. He studied painting with Emanuel Leutze there from 1851 to 1852. Washington and Eastman Johnson overlapped in Düsseldorf in 1853, and he likely reconnected with Johnson when they both returned to the District of Columbia—Washington in 1854 and Johnson the following year. Washington spent 1865 to 1866 in England. He returned to New York between 1866 and 1868 and began teaching art at the Virginia Military Academy in 1869. He died the following year at age 36.

30 In 1866 historian Edward A. Pollard introduced the term in his book *The Lost Cause: A New Southern History of the War of the Confederates*. The concept gained in popularity with a series of articles written in the 1870s by Confederate General Jubal A. Early, in which he limned the contours of the Lost Cause as a Southern cultural phenomenon. In 1865, General Robert E. Lee's parting words to his defeated troops consoled them for having faced overwhelming odds, a staple element of Lost Cause ideology.

31 Judith Brockenbrough McGuire kept a diary during 1863 and 1864, chronicling the family's hardships as Union General Ambrose Burnside's troops drew near and eventually occupied both Westwood and Summer Hill. In it she described the destruction of the outbuildings, the tents pitched across the lawn, soldiers camped both in the main home and surrounding property, and the destruction of fences, fields, and livestock during the eight days the Union army occupied the house. See her "Diary of a Southern Refugee during the War, June 1863–July 1864," in *Virginia at War, 1864*, ed. William C. Davis and James I. Robertson Jr. (Lexington: The University Press of Kentucky, 2009), 164–165 and 202–203.

32 John Reuben Thompson, *"The Burial of Latané," Southern Literary Messenger* 34, issue 8 (Aug. 1862): 475–476.

33 Quoted in Gaines M. Foster, *Ghosts of the Confederacy: Defeat, the Lost Cause, and the Emergence of the New South, 1865 to 1913* (New York: Oxford University Press, 1987), 37.

34 Melville wrote, "None can narrate that strife in the pines, / A seal is on it—Sabaean lore! / Obscure as the wood, the entangled rhyme / But hints at the maze of war." Herman Melville, "The Armies of the Wilderness" (1863–64), in *Battle-Pieces and Aspects of the War* (New York: Harper & Sons, 1866).

35 Eugene Benson, "Historical Art in the United States," *Appleton's Journal of Popular Literature, Science, and Art*, 10 April 1869, 46.

LANDSCAPES AND THE METAPHORICAL WAR

Epigraph: Emily Dickinson to Colonel Thomas Wentworth Higginson, February 1863 (Letter 280), *The Letters of Emily Dickinson*, ed. Thomas H. Johnson (Cambridge: Belknap-Harvard University Press, 1958).

1 Thomas Cole, "Essay on American Scenery," *The American Monthly Magazine* n.s. 1 (Jan. 1836), 1–12; reprinted in John McCoubrey, *American Art: 1700–1960, Sources and Documents* (Englewood Cliffs, NJ: Prentice-Hall, 1965), 98–110. William Cullen Bryant made the case for America as the New Eden in his *Home Book of the Picturesque; or, American Scenery, Art, and Literature*, published in 1852. The essays featured only Northern scenery, in keeping with Bryant's strong political views, narrowing rather intentionally the author's definition of Eden in America.

2 "The American School of Art," *The American Whig Review* 16, issue 92 (Aug. 1852): 138–148.

3 Lowell to Norton, 12 Oct. 1861. *Letters of James Russell Lowell*, ed. Charles E. Norton (New York: Harper & Brothers, 1894), 1:317.

4 As one writer for the *Atlantic Monthly* noted, weather was a literal influence on the outcome of war, too. "A hard frost, a sudden thaw, a 'hot spell,' a 'cold snap,' a contrary wind, a long drought, a storm of sand,—all these things have had their part in deciding the destinies of dynasties, the fortunes of races, and the fate of nations. Leave the weather out of history, and it is as if night were left out of the day, and winter out of the year." C. C. Hazewell, "Weather in War," *Atlantic Monthly*, May 1862, 593.

5 Letter of 29 May 1854. C. B. Rollins, "Letters of George Caleb Bingham to James S. Rollins," 185; quoted in Rash, *The Paintings and Politics of George Caleb Bingham*, 185.

6 Curtis knew the leading transcendentalist thinkers, including Emerson and Thoreau. Curtis was close friends with numerous artists, especially John Kensett. From 1850 to 1852 he wrote for the *New-York Daily Tribune*, and between 1863 and 1869 he was editor of *Harper's Weekly*. He also contributed articles to *Putnam's Magazine* and the *Atlantic Monthly*, among others. In 1861 he wrote the eulogy "Theodore Winthrop," *Atlantic Monthly*, Aug. 1861, 245.

7 The metaphor was well established by the time Lincoln invoked it. Of slavery, Jesse Torrey wrote, "It is a black, accumulating, threatening-thundercloud, in our moral horizon, the sudden explosion of which, might produce dangerous and fatal consequences." Jesse Torrey, *A Portraiture of Domestic Slavery in the United States* (Philadelphia: Jesse Torrey, 1817), 18; quoted in Terrie Dopp Aamodt, *Righteous Armies, Holy Cause: Apocalyptic Imagery and the Civil War* (Macon, GA: Mercer University Press, 2002), 22.

8 Sarah Cash, *Ominous Hush: The Thunderstorm Paintings of Martin Johnson Heade* (Fort Worth, TX: Amon Carter Museum, 1994), 44.

9 Noah Hunt Schenck, "Christian Moderation: The Word in Season to the Church and the Country, a Sermon Preached in Emmanuel Church, Baltimore, on the Evening of Whitsunday, May 19, 1861." Cornell Digital Archive, the Samuel J. May Anti-Slavery Collection. Relevant passages equating storms with the need for political and spiritual action occur throughout Schenck's sermon. These excerpts appear on pages 16 and 23–24.

10 "The Political Canvass: The Bell-Everett Movement, Speech of General Washington Barrow of Nashville, Tenn.," *New York Herald*, 5 Oct. 1860, 3; quoted in Adam Goodheart, *1861: The Civil War Awakening* (New York: Alfred A. Knopf, 2011), 45.

11 "National Academy of Design: Fourth Room," *Home Journal*, 5 May 1860, 2; quoted in Cash, *Ominous Hush*, 73.

12 Emerson's rhetoric, whether on politics, morality, personal spiritualism, or integrity, sounded a common theme: each man must make his own judgments and be prepared to stand behind them. For an extended discussion of Lane's life, see James A. Craig, *Fitz H. Lane: An Artist's Voyage through Nineteenth-Century America* (Charleston, SC: The History Press, 2006); and John Wilmerding, *Fitz Hugh Lane* (Westport, CT: Praeger, 1971).

13 Beverly R. Wellford Jr., "Address Delivered before the Ladies' Mt. Vernon Association, July 4, 1855," *Southern Literary Messenger*, Sept. 1855, 565; quoted in David C. Miller, "The Iconology of Wrecked or Stranded Boats in Mid- to Late Nineteenth-Century American Culture," in *American Iconology* (New Haven: Yale University Press, 1993), 198.

14 Quint wrote this to describe the onset of the war. Alonzo Hall Quint, *National Sin Must Be Expiated by National Calamity* (New Bedford, MA: Mercury Press, 1865), 10; quoted in Aamodt, *Righteous Armies, Holy Cause*, 78.

15 "'Yale' writes to the *New Haven Palladium* as follows on the morning of the 10th: '*five hundred and sixty five* different shooting stars were seen by a corps of observers stationed on top of a high building in this city. Most of the meteors moved in paths which, if traced back, would intersect in the constellation Perseus.... The Aurora Borealis was visible during the night, and occasionally presented groups of bright streamers, some of them reaching to an altitude of full forty degrees.'" "The Meteoritic Displays. Tarrytown, Friday, Aug. 10, 1860," *New York Times*, 14 Aug. 1860, 6; see also "Still Another Meteor," *New York Times*, 8 Aug. 1860, 1; and "A Magnificent Meteor," *Chicago Press and Tribune*, 7 Aug. 1860, 3.

16 A meteor procession occurs when that meteor breaks into multiple meteors traveling nearly identical paths. According to Ava Pope, it would have been visible upwards of thirty seconds passing horizontally, and thus an earth-grazer. See Donald W. Olson et al., "Walt Whitman's 'Year of Meteors,'" *Sky and Telescope* 120, no. 1 (July 2010): 31–32.

17 "The Great Meteor of Friday," *New York Times*, 24 July 1860, 5.

18 According to Theodore Cole's diary, the Churches were in Catskill and New York City during July 1860. Vedder Library, Catskill New York.

19 "The Meteor," *Harper's Weekly*, 4 Aug. 1860, 1. It is important to know that *Harper's* was on newsstands a week before the published date. I thank Barbaranne Liakos for this observation.

20 "A Remarkable Meteor," *Chicago Press and Tribune*, 26 July 1860, 2. For similarly worded descriptions, see also "The Great Meteor of Friday Night," *New York Times*, 23 July 1860, 5; and "Meteor over Connecticut River," *Vermont Phoenix* (Brattleboro), 28 July 1860, http://brattleborohistory.com/customs-music-misadventure/the-meteor.html.

21 *Louisville Journal*, 3 Aug. 1860; as reported in "Another Great Meteor," *New York Times*, 7 Aug. 1860, 3.

22 "The Meteor at the South. It is observed in South Carolina, Virginia, Kentucky, and Tennessee," *New York Times*, 9 Aug. 1860, 5. For a detailed scientific assessment of the meteor's visibility across the South, see Hon. Thomas L. Clingman of North Carolina, "The Great Meteor of 1860," as recounted in *Appleton's Journal of Popular Culture*, 7 Jan. 1871, 10–13.

23 Olson et al., "Walt Whitman's 'Year of Meteors,'" 31.

24 Tony Horwitz has written a lucid and engaging account of John Brown's life in *Midnight Rising: John Brown and the Raid that Sparked the Civil War* (New York: Henry Holt and Company, 2011).

25 Zoë Trodd and John Stauffer, eds. *Meteor of War: The John Brown Story* (Maplecrest, NY: Brandywine Press, 2004), 224.

26 *New-York Daily Tribune* (8 Nov. 1859) reported on Emerson's lecture; the same quote subsequently appeared in the *Liberator* 29, no. 45 (11 Nov. 1859): 178. For an in-depth assessment of Emerson's views on John Brown, see John J. McDonald, "Emerson and John Brown," *The New England Quarterly* 44, no. 3 (Sept. 1971): 377–396.

27 "The Last Days of John Brown," July 4, 1860 address written for a memorial service for John Brown held at his grave in North Elba, New York. Thoreau did not attend; the address was delivered by proxy. Quoted in Trodd and Stauffer, *Meteor of War*, 232–235.

28 Franklin Kelly makes a convincing case for this painting's relevance to the tensions accruing on the eve of war in his book *Frederic Church and the National Landscape* (Washington, DC: Smithsonian Institution Press, 1988), chapter 6. He also includes an appendix of extensive reviews of *Twilight in the Wilderness* on pp. 130–137. Many cited reviews comment on the dualities of sadness and hope vested in the work.

29 Gifford is described in November 1860 by a friend from Brown as being closely associated with "his top piece of pointed black bear-skin cap." See Bruno, "Correspondence of the Journal. Art and Artists of New York. New York, November 29, 1860," *Providence Daily Journal*, 4 Dec. 1860, 2; quoted in Gerald L. Carr, "Sanford Robinson Gifford's *Gorge in the Mountains* Revived," *Metropolitan Museum Journal* 38 (2003): 216.

30 "National Academy Exhibition," *New-York Daily Tribune*, 27 March 1861, 8.

31 John Milton, *Paradise Lost: A Poem Written in Ten Books* (London: P. Parker, R. Boulter, and M. Walker, 1667), bk. 1, lines 60–66.

32 George W. Sheldon, "How One Landscape Painter Paints," *Art Journal* n.s. 3 (1877): 284–285.

33 Thurlow Weed, "There Will Be a North," *Albany Evening Journal*, 19 May 1854; cited in Susan Mary-Grant, *North over South: Northern Nationalism and American Identity in the Antebellum Era* (Lawrence: University Press of Kansas), 86–91. Weed favored abolition. He was also a friend of several landscape painters, Church among them.

34 "Slavery Question." Speech of Hon. Owen Lovejoy, of Illinois, in the House of Representatives, April 5, 1860. *Congressional Globe*, 36th Congress, First Session, Appendix, 202–207. I am grateful to Gerald L. Carr for bringing this speech to my attention.

35 A year earlier Church had fretted in a letter, "If I am interrupted now—I shall very probably be obliged to give up attempting the Icebergs until next winter which will be a serious damage because I wished to commence it this season and after getting it fairly started lay it by for the summer months in order that I might see it with refreshed eyes next season." Frederic Edwin Church to Theodore Winthrop, New York, 16 March 1860. Manuscripts and Archives Division, New York Public Library, Ford Collection; quoted in Gerald L. Carr, "Early Documentation of *The Icebergs*," in *The Voyage of "The Icebergs": Frederic Church's Arctic Masterpiece*, by Eleanor Jones Harvey (New Haven: Yale University Press and the Dallas Museum of Art, 2002), 87.

36 John McClure to Frederic Edwin Church, Chicago, 19 Jan. 1860. David C. Huntington Archives, Olana State Historic Site, Hudson, NY, New York State Office of Parks, Recreation and Historic Preservation (Olana Archives, OL.1998.1.65.1.A.B).

37 Gerald L. Carr, *Frederic Edwin Church: "The Icebergs"* (Dallas: Dallas Museum of Fine Arts, 1980), 72.

38 "Church's New Picture, *The North*," Fine Arts, *New York Herald*, 7 May 1861, 5.

39 Proteus [Eugene Benson], "There Is a North—Church's Last Work," *New-York Commercial Advertiser*, 29 April 1861, 2; quoted in Gerald L. Carr, "Early Documentation of *The Icebergs*," in Harvey, *Voyage of "The Icebergs*," 91.

40 I am grateful to Gerald L. Carr for bringing this poem to my attention.

41 The complex story of *The Icebergs* is recounted in detail in Carr, *Frederic Edwin Church: "The Icebergs*;" and in Harvey, *The Voyage of "The Icebergs": Frederic Church's Arctic Masterpiece*.

42 *Court Journal* (London), 27 June 1863, 633; cited in Harvey, *The Voyage of "The Icebergs*," 84n24; also noted in Carr, *Frederic Edwin Church: "The Icebergs*," 88.

43 "After Icebergs with a Painter: A Summer Voyage to Labrador and around Newfoundland, by Rev. Louis L. Noble (Low & Co.)," *The Athenaeum*, 21 Sept. 1861, 370; quoted in Harvey, *The Voyage of "The Icebergs*," 83–84n18.

44 Art Items, *New-York Daily Tribune*, 19 May 1861, 3.

45 "Sermons by Henry Ward Beecher: The National Flag," *The Independent*, 2 May 1861, 8; quoted in Doreen Bolger Burke,

"Frederic Edwin Church and *The Banner of Dawn*," *American Art Journal* 14, no. 2, (Spring 1982): 43. On Page 45, Burke notes that on the front page of the same issue there was a review of Church's *Icebergs*, strengthening the assumption that Church would have had easy access to the sermon in print.

46 See Burke, "Frederic Edwin Church and *The Banner of Dawn*," 41, for a lengthy list of citations.

47 "What Do the Stars and Stripes Mean?" *Chicago Tribune*, 27 May 1861, 2.

48 "The Stars and Stripes," *New York Times*, 6 May 1861, 4; also quoted in Burke, "Frederic Edwin Church and *The Banner of Dawn*," 42–43.

49 George Curtis, "Theodore Winthrop," 245.

50 Entry for 19 April 1861, George Templeton Strong, *The Diary of George Templeton Strong: The Civil War, 1860–1865*, ed. Allan Nevins and Milton Halsey Thomas (New York: Macmillan, 1952), 126.

51 A Confederate account of the battle noted, "During one of these assaults a gallant young officer, Major Theodore Winthrop, of New Haven, Conn., who was General Butler's private secretary, and who volunteered as an aid on General Pierce's staff for this expedition, while attempting to rally a wavering column, drew his sword, waved it aloft, leaped on the trunk of a fallen tree, and shouted to his men: 'One more charge, boys, and the day is ours!' Alas, for poor Winthrop! It was his last charge. A North Carolinian sent a bullet crashing through his heart, and he fell dead at the head of the column, which retired in great confusion. This practically ended the battle, after four or five hours of fighting, and the Federals returned to Fortress Monroe." "Battle of Bethel: First Engagement of the War between the States," *Southern Historical Society Papers*, Vol. 29, Richmond, Va., January–December (1901), http://www.civilwarhome.com/bethelbattle.htm.

52 Winthrop is listed as missing in the front-page coverage of the battle in the June 12th and 13th issues of the *New York Times*. He is confirmed dead in "The Latest from Fortress Monroe. Fortress Monroe, Wednesday June 12, via Baltimore, Thursday, June 13," *New York Times*, 14 June 1861, 8.

53 Art Items, *New-York Daily Tribune*, 18 Aug. 1861, 1.

54 Art Items, *New-York Daily Tribune*, 1 Sept. 1861, 2.

55 The Travellers Club was a gentleman's supper club made up of artists, writers, scientists, and entrepreneurs and was an offshoot of the American Geographical and Statistical Society in New York. See Art Items, *New-York Daily Tribune*, 18 Aug. 1861, 1. The story behind the recent rediscovery

of the original painting is related in Alfred C. Harrison Jr., "Frederic Edwin Church's *Our Banner in the Sky*: An Update on an American Icon," *Antiques*, Nov. 2008, 150–151. Goupil's paid Church $200; Lorimer paid the same amount for the original painting.

56 "Our Banner in the Sky," brochure published by Goupil's, 772 Broadway, New York. A copy is at Olana (OL1986.142). The chromolithograph and its accompanying text were reviewed in Fine Arts, *New-York Illustrated News*, 12 Aug. 1861, 238.

57 See Art Items, *New York Times*, 30 June 1861, 2; "O Banner of the morning, / lead our victorious way!" *The Living Age* (Boston) 70, no. 899 (24 Aug. 1861): 512; "Editor's Easy Chair," *Harper's New Monthly Magazine*, Dec. 1861, 121.

58 Sanford Gifford to George B. Coale, 13 Jan. 1863, Boston Public Library.

59 "American Genius Expressed in Art," *Round Table*, 26 Dec. 1863, 22.

60 Gerald L. Carr notes three journalists saw and wrote about it between December 1862 and January 1863; Gifford called it "A Gorge in the Mountains," and in fact it is a composite scene rather than a transcription of Cauterskill Falls. See Carr, "Sanford Robinson Gifford's *Gorge in the Mountains Revived*," 215.

61 Sanford R. Gifford to McEntee, Hudson, NY, 8 Oct. 1862. Jervis McEntee papers (1796), 1848–1905, Archives of American Art, Smithsonian Institution.

62 Thomas Starr King, *The White Hills: Their Legends, Landscape, and Poetry* (Boston: Crosby, Nichols and Co., 1860), 78.

63 "Visit to the National Academy of Design. April 1863," *Continental Monthly*, June 1863, 717.

64 Proteus [Eugene Benson], "Art in New York. National Academy of Design," *New-York Commercial Advertiser*, 4 April 1862, 1; quoted in Carr, "Sanford Robinson Gifford's *Gorge in the Mountains* Revived," 218.

65 Of the 1656 poems dated by Johnson, more than half were written during the Civil War. See Shira Wolosky, *Emily Dickinson: A Voice of War* (New Haven: Yale University Press, 1984), 35. Dickinson's poems now accepted as relating to the Civil War include 409, 426, 444, 502, 582, 596, 615, 622, 639, 658, 759, and 907. The numbering of poems is from *The Poems of Emily Dickinson*, ed. Thomas H. Johnson (Cambridge: Harvard University Press, 1955).

66 See Jack Capps, *Emily Dickinson's Reading: 1836–1886* (Cambridge: Harvard University Press, 1966), esp. 140. Of the Springfield newspaper, Emily Dickinson wrote to friends, "I read in it every night" (Letter 133); quoted in *The Letters of Emily Dickinson*, ed. Thomas H. Johnson (Cambridge: Belknap-Harvard University Press, 1958).

67 Austin Dickinson developed an interest in Hudson River school landscapes during the 1850s and built a small but select paintings collection. On his trips to New York he would buy directly from the artists or at auction and have the paintings sent to Amherst. There he would dramatically unveil each new purchase, placing the work on a carved easel behind a curtain for maximum effect. He invited his sister to join them for each unveiling, and then the family would discuss the merits of each work before it found a place on the walls. Sonia Alicia Ochoa, "'A Passion for Pictures': The Art Collection of Austin and Susan Dickinson" (master's thesis, University of Delaware, 2000). Judith Farr writes that the Dickinsons considered Gifford's works a family favorite, although it does not appear they knew the artist personally. See Judith Farr, "Disclosing Pictures: Emily Dickinson's Quotations from the Paintings of Thomas Cole, Frederic Church, and Holman Hunt," *The Emily Dickinson Journal* 2, no. 2 (Fall 1993): 68.

68 Emily Dickinson to Samuel Bowles, March 1862, (Letter 256); quoted in Leigh-Anne Urbanowicz Marcellin, "Emily Dickinson's Civil War Poetry," *The Emily Dickinson Journal* 5, no. 2 (Fall 1996): 111.

69 Poem 502, *The Poems of Emily Dickinson*.

70 Whittier's poem was first published in the September 20, 1862 issue of the *Springfield Republican* (Springfield, MA) alongside reports including the description of Antietam as "the bloodiest field of this most bloody war." Whittier's poem was reprinted in *Atlantic Monthly*, Oct. 1862, 510–511.

71 David Cody traces the sources Dickinson may have used in framing this poem. See King, *The White Hills*, 120–121; and more specifically Catherine Maria Sedgwick's "The White Hills in October," *Harper's New Monthly Magazine*, Dec. 1856, 44–56. See also David Cody, "Blood in the Basin: The Civil War in Emily Dickinson's 'The name—of it—is "Autumn"—,'" *The Emily Dickinson Journal* 12, no. 1 (Spring 2003): 27–30.

72 Dickinson wrote another poem at the outset of the war eliding images of soldiers dying in battle with the lurid tones of sunrise and sunset (204): "A slash of Blue— / A sweep of Gray— / Some scarlet patches/ on the way, / Compose an Evening Sky— / A little purple—slipped between— / Some Ruby Trousers / hurried on— / A Wave of Gold— / A Bank of Day— / This just makes out the Morning Sky."

73 Frederick Douglass, "'The American Apocalypse,'" An Address Delivered in Rochester, NY, June 16, 1861; quoted in John W. Blassingame, ed., *The Frederick Douglass Papers*, series 1, *Speeches, Debates, and Interviews*, vol. 3, *1855–63* (New Haven: Yale University Press, 1991), 437–439; also quoted in Louis P. Masur, "*…The real war will never get in the books": Selections from Writers during the Civil War* (New York: Oxford University Press, 1993), 103.

74 Louis LeGrand Noble, essay on *Cotopaxi*, 1862. His essay appears not to have been published but exists in manuscript form at Olana. It was reprinted as an appendix in Katherine E. Manthorne's *Creation and Renewal: Views of Cotopaxi by Frederic Edwin Church* (Washington, DC: Smithsonian Institution Press for the National Museum of American Art, 1985), 63.

75 "Mr. Church's Cotopaxi," Fine Arts, *Albion*, 21 March 1863, 141; partially quoted in Rebecca Bedell, *The Anatomy of Nature: Geology & American Landscape Painting, 1825–1875* (Princeton: Princeton University Press, 2001), 81. Kevin J. Avery identifies the source of the quotation in "'Rally 'round the Flag': Frederic Edwin Church and the Civil War," *The Hudson River Valley Review* 27, no. 2 (Spring 2011): 101n35.

76 "Cotopaxi," *New-York Daily Tribune*, 24 March 1863, 2.

77 A thorough and engaging study of the depth of Humboldt's influence in the United States is Aaron Sachs', *The Humboldt Current: Nineteenth-Century Exploration and the Roots of American Environmentalism* (New York: Penguin Books, 2006). Katherine E. Manthorne addresses Church's South American subjects in depth in her book, *Creation and Renewal: Views of Cotopaxi by Frederic Edwin Church*. Joni L. Kinsey is the first scholar to connect the war-related aspects of Church's four major paintings—*The Icebergs*, *Cotopaxi*, *Aurora Borealis*, and *Rainy Season in the Tropics*—in her essay "History in Natural Sequence: The Civil War Polyptych of Frederic Edwin Church," in *Redefining American History Painting*, ed. Patricia M. Burnham and Lucretia Hoover Giese (New York: Cambridge University Press, 1995).

78 Alexander von Humboldt, *Cosmos: A Sketch of a Physical Description of the Universe*, trans. E. C. Otté (London: Henry G. Bohn; New York: Harper & Brothers, 1849–1859), 3:1.

79 Letter from Thomas Cole to Robert Gilmor Jr., 21 May 1828; quoted in "Correspondence between Thomas Cole and Robert Gilmor Jr.," *Studies on Thomas Cole, an American Romanticist* (Baltimore: Baltimore Museum of Art, 1967), 58.

80 For an extensive and thoughtful examination of Humboldt's attitudes toward race and slavery, see Laura Dassow Walls, *The Passage to "Cosmos": Alexander von Humboldt and the Shaping of America* (Chicago: University of Chicago Press, 2009), esp. ch. 3. This quotation comes from Humboldt, *Cosmos*, 1:355; cited in Walls, pp. 174–175. Another good

source is Philip S. Foner, "Alexander von Humboldt on Slavery in America," *Science and Society* 47, no. 3 (Fall 1983): 330–342.

81 Alexander von Humboldt, *Personal Narrative of Travels to the Equinoctial Regions of the New Continent, during the Years 1799–1804*, trans. Helen Maria Williams (London: Longman, Hurst, Rees, Orme, and Brown, 1822), 7:267. Also in Humboldt, *Political Essay on the Kingdom of New Spain*, trans. John Black (London, 1811), 1:262; cited in Walls, *The Passage to "Cosmos,"* 180–181.

82 Quoted in Mary Louise Pratt, *Imperial Eyes: Travel Writing and Transculturation* (London: Routledge, 1992), 141. See also J. Fred Rippy and E. R. Brann, "Alexander von Humboldt and Simón Bolívar," *American Historical Review* 52 (July 1947): 697–703; quoted in Aaron Sachs, *The Humboldt Current* (New York: Penguin Books, 2006), 82.

83 The quotation from Humboldt appears in his *Essai politique sur l'Isle de Cuba* (Paris, 1826) and was printed in Hinton Rowan Helper, *Compendium of the Impeding Crisis of the South* (New York: A. B. Burdick, 1859), 204. A condensed version was distributed by Horace Greeley in 1859 as pro-Republican literature during the presidential campaign. Not surprisingly, Helper's book was banned across parts of the South. Garrison published a letter Humboldt wrote decrying Daniel Webster as architect of the Fugitive Slave Act in the 11 May 1855 issue of the *Liberator*. This same letter had been published the previous day in the *New York Evening Post*, further expanding its readership. Garrison later published Humboldt's 1845 letter to George Sumner, brother of Massachusetts Senator Charles Sumner, in the 20 Nov. 1863 issue of the *Liberator*, 187. On July 4, 1858, Theodore Parker, a Boston Unitarian preacher and one of the most widely read authors of his day, offered a resolution applauding Humboldt's humanitarian efforts at the Independence Day meeting of the Massachusetts American Anti-Slavery Society. His speech was published by both the *New York Evening Post* and the *Liberator* the same week. All *Liberator* citations cited in Walls, *The Passage to "Cosmos,"* 198, 208.

84 Rev. J. S. Martin, sermon delivered on 2 December 1859 at the Pittsburgh Wylie Street AME Church, Friday evening; quoted in Trodd and Stauffer, eds., *Meteor of War*, 217. For the ubiquity of meteor/volcano twinning, see another sermon, "The Conflict in America, a funeral discourse occasioned by the death of John Brown of Ossawattomie, who entered into rest, from the gallows, at Charlestown, Virginia, Dec. 2, 1859, preached at the Warren St. M. E. Church, Roxbury (MA), Dec. 4 by Rev. Fales Henry Newhall" (Boston: J. M. Hewes, 1859); reprinted in James Redpath, *Echoes of Harper's Ferry* (Boston: Thayer and Eldridge, 1860), 195–211. Redpath, p. 195 contains this Newhall quotation, for example: "a volcanic blaze, that rises as if to 'lick the stars.'" All cited in Trodd and Stauffer, *Meteor of War*, 4.

85 Art Items, *New-York Daily Tribune*, 16 June 1861 notes, "Mr. McEntee, our practical landscapist, who marched to the war with the 20th (Ulster) Regiment of New-York State Militia, has been promoted from a Lieutenancy, and is now Captain McEntee. Gifford, who returned with the Seventh from Washington, was promoted, while he was absent, from the ranks to Corporalship. He is now at his studio in Tenth-street, diligently working at his easel." Gifford alerted *Crayon* readers, "I had a letter from McEntee, who is first lieutenant in the 20th Regiment. The regiment is now at the Junction [Manassas]." [Gifford—not credited] "Military Correspondence, Washington, May 17, 1861," *Crayon*, June 1861, 135.

86 Atticus, "Art Feuilleton. Art in New York," *New York Leader*, 3 Jan. 1863, 1.

87 Barry Gray [Robert Barry Coffin], "McEntee, the Artist," *New York Leader*, 24 Jan. 1863, 1.

88 "Visit to the National Academy of Design. April 1863," 717.

89 "Baltimore" in Frank Boott Goodrich, *The Tribute Book, a Record of the Munificence Self-sacrifice and Patriotism of the American People during the War for the Union* (New York: Derby & Miller, 1865), 351. The painting was displayed in New York and Baltimore with a stanza from Byron's *Childe Harold's Pilgrimage* to underscore the desolation and melancholy of the painting.

90 Stated by McEntee in George W. Sheldon, *American Painters* (New York: D. Appleton, 1879), 52; quoted in J. Gray Sweeney, *McEntee & Company* (New York: Beacon Hill Fine Art, 1997) 6.

91 Nicolai Cikovsky Jr. posits that the destruction of land in the Civil War leads to a decline in the perception that landscape painting reflected national beliefs. See David Dearinger, ed., *Rave Reviews: American Art and Its Critics, 1826–1925* (New York: National Academy of Design, 2000), 96n32.

92 Journal entry, 5 September 1862. In the same entry Cropsey wrote that he was beginning work on *Richmond Hill* (p. 122). On November 16, 1862 he wrote, "The political matters on this side in regard to my country, this last disposition of the French Emperor to interfere in our affairs in behalf of the Southern Mobocracy—has so wrought upon my feelings that on Friday last during the darkness of the thick fog that hung over everything I could not refrain from addressing a letter to the President / Lincoln / —encouraging him to stand fast in the cause—Perhaps this was impertinent, but it came by kind of inspiration, and may God bless it for the purpose it had in view" (p. 130). Jasper Francis Cropsey Journals, 1858–1867, Newington-Cropsey Foundation, Hastings-on-Hudson, NY.

93 Byrd also surveyed the Great Dismal Swamp for George Washington's Dismal Swamp Land Company and built his home, Westover, on the James River outside Richmond.

94 Diary entry, 7 April 1796. Benjamin Henry Latrobe, *The Papers of Benjamin Henry Latrobe*, ed. Edward C. Carter, series I, *Journals*, vol. 1, *The Virginia Journals of Benjamin Henry Latrobe, 1795–1797* (New Haven: Yale University Press and Maryland Historical Society, 1977), 89–90.

95 *London Observer*, 19 April 1863. Clipping courtesy of the Newington-Cropsey Foundation, Hastings-on-Hudson, New York. My thanks to Kenneth Maddox for providing me with this and numerous other citations about this painting.

96 Cropsey made his pencil sketches of these two soldiers in a sketchbook dated 1859 (MFA Boston). He apparently did not use them in a painting until embarking on *Richmond Hill in the Summer of 1862*. I am grateful to Bart Hacker and Margaret Vining, curators in the Armed Forces History department of the Smithsonian's National Museum of American History, for their assistance in identifying the style of uniforms.

97 Cropsey's *Gettysburg* was exhibited at the National Academy of Design in 1866 and purchased by the Union League Club by 1868. It was destroyed in a fire at the Club on Sunday, 25 April 1875. An illustration of the blaze and the painting appears in the *Daily Graphic* (New York), 27 April 1875, 428.

98 For a thorough analysis of the riots, the events leading up to them, and their consequences, see Iver Bernstein, *The New York City Draft Riots: Their Significance for American Society and Politics in the Age of the Civil War* (New York: Oxford University Press, 1990).

99 The goal of these fairs was to provide medical and humanitarian supplies to soldiers in the field, recognizing that the casualties had overwhelmed the army and the federal government's ability to respond. Their efforts raised money, purchased supplies, and delivered aid to the front. Medical relief remained a pressing matter throughout the war. It proved impossible to keep up with the volume of casualties or the needs of soldiers' families. These fairs and expositions are a topic unto themselves. The most recent and thorough discussion of the fine arts at the Metropolitan Fair is Charlotte Emans Moore, "Art as Text, War as Context: The Art Gallery of the Metropolitan Fair, New York City's Artistic Community, and the Civil War" (PhD diss., Boston University, 2009).

100 We have an incomplete record of the artists who were drafted. Of the artists discussed in this chapter, we know that both Church and Bierstadt paid for substitutes. Martin, and likely Kensett, received medical deferments. Whittredge wrote of his desire to enlist but remained in New York. Heade was in Brazil from 1862 to 1863.

101 Albert Bierstadt's *The Rocky Mountains, Landers Peak* had only recently been rechristened as a war painting. Following Church's example with *The Icebergs*, Bierstadt added the subtitle to honor the memory of Frederick W. Lander, who had led the expedition Bierstadt accompanied to Wyoming in 1859. When Civil War broke out, Lander volunteered. He was elevated to brigadier-general and served as McClellan's aide-de-camp. Wounded in a skirmish following the Battle of Ball's Bluff, he died in early March 1862 from complications of his injuries. Widely respected, he was eulogized publicly as the ultimate soldier. His death inspired Bierstadt to append the subtitle to his work, allowing it to take on the trappings of a war-related painting, named for the "beau ideal" of American soldiers and showing the peak as the "beau ideal" of American mountains. An obituary for Lander appears in the *New York Times*, 3 March 1862, 1. For a biography of Lander, see Gary L. Ecelbarger, *Frederick W. Lander: The Great Natural American Soldier* (Baton Rouge: Louisiana State University Press, 2000).

102 For accounts of their friendship in relation to this painting, see William H. Truettner, "The Genesis of Frederic Edwin Church's *Aurora Borealis*," *Art Quarterly* 31 (Autumn 1968): 267–283; and Harvey, *The Voyage of "The Icebergs*," 63.

103 "Arctic Explorations. Lecture of Dr. J. S. [sic] Hayes before the New-York Geographical and Statistical Society," *New York Times*, 15 Nov. 1861, 2. In a lecture delivered at the Smithsonian in 1861, Hayes noted he had petitioned Congress successfully to change the ship's name. See I. I. Hayes, "Lecture on Arctic Explorations," *Annual Report of the Board of Regents of the Smithsonian Institution…for the Year 1861* (Washington, DC: Government Printing Office, 1862), 151.

104 Hayes described the otherworldly aspects of the nocturnal Arctic landscape and in doing so set up the polar region as Eden's alter-ego: "filling the mind with the overpowering consciousness of universal death—proclaiming the end of all things, and heralding the everlasting future. Its presence is unendurable.… I have seen no expression on the face of Nature so filled with terror as THE SILENCE OF THE ARCTIC NIGHT." Gen. George W. Cullum, "Biographical Sketch of Doctor Isaac I. Hayes," *Journal of the American Geographical Society of New York* 13 (1881): 114, 116.

105 In 1859 Church saw the auroras with Louis LeGrand Noble in Labrador and in Maine with Isabel. He was back in New York City to witness the auroras of August to September.

106 "The late displays of the Aurora was witnessed from Cuba and Jamaica on the south, to an unknown distance beyond the Canadas on the north, and from Central Europe on the east, to California on the west." Elias Loomis, "The Great Auroral Exhibition of August 28th to September 4th, 1859," *American Journal of Science and Arts* (New Haven, CT) 2nd ser., 27, no. 1 (Nov. 1859): 385.

107 "Aurora Borealis," *New-York Illustrated News*, 9 May 1863, 27. There was a long tradition of such militaristic imagery associated with the auroras. In 1831 John Greenleaf Whittier penned his poem, "The Aerial Omens," which described the play of the auroras as an apocalyptic narrative of armies clashing and contained the following lines: "It is deemed / A revelation of the things to come— / Of war and its / calamities—the storm / Of the pitched battle, and the midnight strife."

108 "My dear Dr. Hayes, The Travellers will meet at my studio on Wednesday evening next (Dec 21st) at eight o'clock. I should not feel that that evening was complete without your presence—I am painting a large picture of The North—Aurora Borealis—with Church's Peak—and your vessel. I should like your opinion of it although it is very far from being finished." Frederic Church to Isaac Hayes, New York, 16 Dec. 1864. Manuscript collection, Gift of James H. Penniman, 1922, Library of Congress.

109 Barbone, "Art in New York. March 18," *Philadelphia Daily Evening Bulletin*, 21 March 1865, 6.

110 Isabel Church noted the children's deaths in an inscription in a book from her personal library, *Heart's Easy for the Weary and Worn* (Philadelphia: American Sunday School Union, 1863), Olana State Historic Site, Hudson, NY, New York State Office of Parks, Recreation and Historic Preservation (OL.1989.5a-b).

111 James Mason Hutchings led the first group of tourists to Yosemite in 1855. He quoted these tourists as saying, "'What!' exclaimed one at length, 'have we come to the end of all things?' 'Can this be the opening of the Seventh Seal?'" *San Francisco Chronicle*, 18 Aug. 1855, reprint of an article in the *Mariposa Gazette*; quoted in David Robertson, *West of Eden: A History of the Art and Literature of Yosemite* (Yosemite CA: Yosemite Natural History Association and Wilderness Press, 1984), 4.

112 Greeley occupied a prominent bully pulpit for his views. In 1860 the *Tribune* boasted a circulation of close to 300,000. Noted in John F. Sears, *Sacred Places: American Tourist Attractions in the Nineteenth century* (Amherst: University of Massachusetts Press, 1998), 127.

113 Quoted in Thomas Starr King, *A Vacation among the Sierras: Yosemite in 1860*, ed. John A. Hussey (San Francisco: Book Club of California, 1962), xxiv.

114 Starr King, *A Vacation among the Sierras*, 70n72. His letters appeared in the *Boston Daily Evening Transcript* on Dec. 1, 15, and 31, 1860; and Jan. 12, 19, and 26, 1861; and Feb. 2 and 9, 1861.

115 Starr King, *A Vacation among the Sierras*, 48; first published by Starr King as "A Vacation among the Sierras—No. 6, San Francisco December 1860," *Boston Daily Evening Transcript*, 26 Jan., 1861.

116 Starr King, *A Vacation among the Sierras*, xxxi. King privately commented on his exasperation with the Union leadership in a letter to Randolph Ryer, San Francisco, 10 Sept. 1862 (Thomas Starr King papers, Bancroft Library, University of California–Berkeley): "What louts & boobies are [sic] leaders are! Pope is a swaggering braggart; McClellan a slowpoke; Lincoln a wretched tavern-joker in the most serious hours of history.' Quoted in Starr King, *A Vacation among the Sierras*, xxviii.

117 Starr King, *A Vacation among the Sierras*, ix. In a footnote King writes of his antislavery sermons, "I have given the people one or two decided intimations in that line wh[ich] frighten the timid parishioners, but still the church is crowded." He also noted with amusement that Southerners refused to attend his sermons. Letter to Randolph Ryer, San Francisco, 20 May 1860, MS in Thomas Starr King papers, Bancroft Library, University of California–Berkeley; quoted in Starr King, *A Vacation among the Sierras*, p. x and n 3.

118 Starr King, *A Vacation among the Sierras*, xix–xx. On the same page Hussey quotes a response to the sermon published in the local newspaper that noted, "A sermon on Yosemite?' asked the *San Francisco Evening Bulletin* in anticipation of the scornful smiles of the orthodox. Yes, the editor answered. 'Did not He preach a sermon on the mount?'" *San Francisco Evening Bulletin*, 30 July 1860; excerpts published in Oscar T. Shuck, comp. *The California Scrap-Book: A Depository of Useful Information and Select Reading* (San Francisco: H. H. Bancroft & Co., 1869), 446–457.

119 Bierstadt to John Hay, 3 Aug. 1863, Brown University; quoted in Nancy Anderson and Linda S. Ferber, *Albert Bierstadt: Art & Enterprise* (Brooklyn, NY: The Brooklyn Museum, 1991), 178.

120 Fitz Hugh Ludlow, "Seven Weeks in the Great Yo-Semite," *Atlantic Monthly*, June 1864, 740. See also Fitz Hugh Ludlow, *The Heart of the Continent: A Record of Travel across the Plains and in Oregon, with an Examination of the Mormon Principle* (New York: Hurd and Houghton, 1870), 412.

121 "Fine Arts. The Fortieth Annual Exhibition of the National Academy of Design. [First Notice]," *The Nation*, 6 July 1865, 26.

122 "National Academy of Design. South Room," *New York Times*, 13 June 1865, 4–5.

123 Henry Ward Beecher, "Abraham Lincoln," in *Lectures and Orations*, ed. Newell Dwight Hills (New York: Fleming H. Revell, 1913), 269; quoted in Aamont, *Righteous Armies, Holy Cause*, 117.

124 The National Academy of Design exhibition opened April 27, 1865. It was originally scheduled to open April 15, the day Lincoln died.

125 Cara Montane, "Another Woman's View of the New Academy of Design," *New York Leader*, 3 June 1865, 2.

126 Barry Gray [Robert Barry Coffin], "1 December 1863, Artists Fund Society of New York," *Boston Daily Evening Transcript*, 5 Dec. 1863, 5; quoted in Carr, "Sanford Robinson Gifford's *Gorge in the Mountains* Revived," 229n46.

127 As Gifford enlisted, his older brother, Charles, (with whom he was very close) succumbed to depression and committed suicide in 1861. Theodore Winthrop had been Gifford's friend and a fellow member of the Seventh Regiment before his death in combat in 1861. Gifford's brother, Edward, enlisted in September 1862, and he died in 1863 following a daring escape from a Confederate POW camp, swimming the Mississippi River as part of his ordeal.

128 *A Coming Storm* was included in Gifford's Memorial Catalogue (Metropolitan Museum of Art, 1881), where it was listed as No. 718: "First painted and sold about 1863, but subsequently bought back, repainted and dated 1880. Size 28 × 42. Owned by Elisha Gunn, Springfield, Mass." Philadelphia Museum of Art Conservator Diane Dwyer noted in 1986 that there were some touches that may have been added in 1880: red strokes on the boulder; red and greenish spots in the water in the left foreground—these areas are somewhat opaque and seem to have darkened in relation to tone of earlier work. Information courtesy of the PMA conservation records. For Weir's quote, see John F. Weir, "Sanford R. Gifford. His Life and Character as Artist and Man," *Catalogue of Valuable Oil Paintings, Works of the Famous Artist, Sanford Robinson Gifford, N.A., Deceased, to be sold, without reserve, by order of the Executor, . . .* (New York: Thomas E. Kirby & Co., 1881), 15.

129 James I. Robertson Jr., *Stonewall Jackson: The Man, The Soldier, The Legend* (New York: MacMillan Publishing, 1997), 753, 921n6.

130 For a thoughtful consideration of the notion of a "good death" and the impact of death on a horrific scale during the Civil War, see Drew Gilpin Faust, *This Republic of Suffering* (New York: Alfred A. Knopf, 2008), 6–11 and 161.

131 "The New Epoch—The Advent of Peace," *New York Times*, 11 April 1865, 4.

132 "Art. Kensett's Lake George," *Round Table*, 19 March 1864, 216.

133 Sordello [Eugene Benson], "National Academy of Design. Fortieth Annual Exhibition, Third Article," *New York Evening Post*, 22 May 1865, 1.

134 Montane, "Another Woman's View of the New Academy of Design," 1.

135 Quoted in Alfred Kazin, *A Writer's America: Landscape in Literature* (New York: Knopf, 1988), 133.

136 Thurman Wilkins with Caroline Lawson Hinkley, *Clarence King: A Biography*. rev. ed. (Albuquerque: University of New Mexico Press, 1988), 218.

137 Robert Gould Shaw to his sister, Susanna Shaw, New York, Sept. 3, 1862. Letter sold at Heritage Auctions, October 2010, Beverly Hills Signature Historical Manuscripts Auction #6049, lot 34079.

138 Comments of J. F. Kensett, president, *VIth Annual Report of Artists' Fund Society of the City of New York, 1865–66* (New York: G. A. Whitehorse, Printer, 1866), 12. Remarks made at the meeting held Tuesday evening, 13 Feb. 1866; quoted in Ellen H. Johnson, "Kensett Revisited," *Art Quarterly* 20, no. 1 (1957): 92n34.

THE ART OF WARTIME PHOTOGRAPHY

Epigraph: Andrew J. Russell, "Photographic Reminiscences of the Late War," *Anthony's Photographic Bulletin* 13 (July 1882): 212.

1 Bob Zeller provides an overview of Civil War photography in the South in his book *The Blue and Gray in Black and White: A History of Civil War Photography* (Westport, CT: Praeger, 2005).

2 One such blurry image, of the *H. L. Hunley* submersible, may be a photograph of Conrad Wise Chapman's painting rather than of the vessel itself; another presuming to show shells exploding over Fort Sumter appears to be a copy of a painting by John Ross Key. Zeller discusses Cook's wartime career in *The Blue and Gray in Black and White*, 122–137, 178–180. For another view of Cook's career, see Jack C. Ramsay Jr., *Photographer . . . Under Fire: The Story of George S. Cook* (Green Bay, WI: Historical Resources Press, 1994).

3 Alan Trachtenberg situates Brady in this artistic milieu in *Reading American Photographs: Images as History, Mathew Brady to Walker Evans* (New York: Hill and Wang, 1989), 38–43.

4 "It is his cultivated taste and skill in arranging the details of his pictures that entitle Mr. Brady's productions to a fine art classification." Fine Arts, *New York Herald*, 3 Sept. 1861, 5.

5 "The Imperial Photograph," *New York Times*, 22 April 1857, 4.

6 Brady's gallery had been in financial difficulty, and shortly after Gardner's arrival the firm's balance sheet began to stabilize. I am grateful to Will Stapp for providing me with his

transcript of the credit reports for Mathew Brady's gallery. Relevant citations are in R. G. Dun & Co. Credit Report for New York vol. 368, Original Dun volume number: New York City, 8, pp. 442, 483, 500. The original registers are part of the Baker Library Historical Collections, Harvard Business School. After Gardner split from Brady, Brady's Washington Gallery went into rapid financial decline, and Brady's relationship with Anthony similarly evaporated, suggesting Gardner's role in handling Brady's finances. Josephine Cobb, "Mathew B. Brady's Photographic Gallery in Washington," *Columbia Historical Society Records* (Washington, DC: Columbia Historical Society, 1955), 29; and Josephine Cobb, "Alexander Gardner," *Image* 7 (1958): 129.

7 Many prints of Brady's images bear Anthony & Co. logos. The negatives are in the Brady Meserve Collection at the National Portrait Gallery, Smithsonian Institution. Frederic Meserve acquired the archive from Anthony & Co. at the turn of the century, supporting the inference that Anthony served as Brady's distributor during the war years. I am grateful to Will Stapp for this information.

8 For a biography and assessment of Gardner's career, see Brooks Johnson et al., *An Enduring Interest: The Photographs of Alexander Gardner* (Norfolk, VA: The Chrysler Museum, 1991).

9 "Any photographer who would follow the Army…and be fortunate enough to obtain views of battles, or even skirmishes, would make a fortune by the sake of copies." "Photographic Views of the Army," *Boston Transcript*, 10 June 1861, 2; quoted in Mary Panzer, *Mathew Brady and the Image of History* (Washington, DC: Smithsonian Institution Press, 1997), 102.

10 There are daguerreotypes taken during the Mexican War, ably described and assessed in Martha A. Sandweiss, *Print the Legend: Photography and the American West* (New Haven: Yale University Press, 2002). Her chapter "Photography and the Mexican-American War" details the known photographs, but she notes that these images were only recently rediscovered and had minimal if any exposure nationally at the time.

11 Oliver Wendell Holmes Sr. invented the portable stereo viewer and used his status as an amateur photographer and prominent essayist to promote photography.

12 Several scholars cite the strong circumstantial evidence that Gardner had become the gallery's entrepreneur as well as its business manager. See Cobb, "Mathew B. Brady's Photographic Gallery in Washington," 3–44; Cobb, "Alexander Gardner," 124–136; William A. Frassanito, *Grant and Lee: The Virginia Campaigns, 1864–65* (New York: Charles Scribner's Sons, 1983), 16–17; and William F. Stapp, "'To…Arouse the Conscience, and Affect the Heart,'" in Johnson, *An Enduring Interest*, 21–37 and 117–119.

13 "Brady's Photographs of the War," *New-York Daily Tribune*, 19 July 1862, 3.

14 "Photographic Phases," *New York Times*, 21 July 1862, 5.

15 There are numerous references to Brady's weak eyes, although one assumes he was capable of correcting his vision to a degree with the glasses he wore. One article noted, "Brady is not an operator himself, a failing eyesight precluding the possibility of his using the camera with any certainty, but he is an excellent artist." The distinction drawn between an operator and an artist may be more important for understanding Brady's approach to claiming photography as an art form than any commentary on his eyesight. "The Daguerreian Art—its Origin and Present State," *Photographic Art-Journal* (March 1851): 138; quoted in Zeller, *The Blue and Gray in Black and White*, 110.

16 William A. Frassanito discusses when Gardner and Gibson arrived at the battlefield, based on Gardner's dates on his negatives in *Antietam: The Photographic Legacy of America's Bloodiest Day* (New York: Charles Scribner's Sons, 1978), 71–72. William F. Stapp thinks Gardner is there with McClellan, based on Gardner's inscription dated the 17th on two of his photographs. See "'To…Arouse the Conscience, and Affect the Heart,'" 23.

17 The statistics regarding Antietam are fairly consistent among the authoritative sources. See James McPherson, *Crossroads of Freedom. Antietam, The Battle That Changed the Course of the Civil War* (New York: Oxford University Press, 2002), 3, 129; Stephen W. Sears, *Landscape Turned Red: The Battle of Antietam* (Boston: Houghton Mifflin, 1983), 173.

18 On 21 September 1862, Gardner sent a telegram to David Knox: "got forty-five negatives of battle." Quoted in Stapp, "'To…Arouse the Conscience, and Affect the Heart,'" 117n9; see also Frassanito, *Antietam*, 53.

19 Henry Kyd Douglas, *I Rode with Stonewall: The War Experiences of the Youngest Member of Jackson's Staff* (Chapel Hill: University of North Carolina Press, 1968), 175. Douglas began writing his memoirs shortly after the end of the war. They were assembled after his death by family members and first published in 1940.

20 Oliver Wendell Holmes, "My Hunt After the Captain," *Atlantic Monthly*, Dec. 1862, 738–764.

21 Oliver Wendell Holmes, "Doings of the Sunbeam," *Atlantic Monthly*, July 1863, 11–12.

22 "Brady's Photographs; Pictures of the Dead at Antietam," *New York Times*, 20 Oct. 1862, 5.

23 The only known instance of names put to the dead in a photograph was at Corinth, Mississippi, October 4, 1862. Photographer Nicholas Brown took two photographs showing two Confederate officers, Col. William P. Rogers of the Second Texas Brigade and Col. W. H. Moore, a brigade commander, lying dead alongside a group of jumbled bodies. Cited and illustrated in Zeller, *The Blue and Gray in Black and White*, 86–87. For a compelling analysis of how death on a grand scale defined America's response to the Civil War, see Faust, *This Republic of Suffering*.

24 "Brady's Photographs; Pictures of the Dead at Antietam," 5.

25 *The New York Times* and *New-York Daily Tribune* covered exhibitions of war photography at Brady's gallery in July, September, and October 1862, then not again until July 1864 and March 1866.

26 Frassanito makes this point in his concluding remarks in *Antietam*, 284–287.

27 Andrew J. Russell, "Photographic Reminiscences of the Late War," *Anthony's Photographic Bulletin* 13 (July 1882): 212.

28 Russell was assigned to document the work of the U.S. Military Railroad Construction Corps under General Haupt. He was at Fredericksburg for the second battle, where he photographed Marye's Heights, and in Alexandria, Virginia, where he photographed the army remount depot at Giesboro Point. He also took photographs at Petersburg and the fall of Richmond. See *Russell's Civil War Photographs: 116 Historic Prints by Andrew J. Russell* (New York: Dover Publications, 1982).

29 Brady's Washington, D.C., gallery was located at 626 Pennsylvania Avenue, NW; Gardner's, at the corner of 7th and D streets, NW.

30 Frassanito tells this story in his book *Antietam*, 187–190. He points out that as far as we know the first person who noted that the body had been moved was Frederic Ray, "The Case of the Rearranged Corpse," *Civil War Times*, Oct. 1961, 19.

31 Will Stapp has recently examined seven images belonging to the Library of Congress collection, all of which show the same body. Each image is different from the others. Together they confirm that the soldier's body and his gear were moved in some way for each of the photographs, far more manipulation than indicated in Frassanito's outstanding book on the Antietam photographs. Stapp confirmed the appearance of the blanket tucked under the body in *Home of a Rebel Sharpshooter*. He also noted that to do so, the body would have had to have been lifted after being dragged to its final location, in order to hide the blanket in the final photograph. Another of his observations, that the rifle is missing its ramrod, supports the supposition that this was picked up on the battlefield by the photographers and used as a prop. He noted that when

soldiers were fighting from a fixed position they would jam their ramrods into the ground in front of them, which saved energy and time reloading. Emails between Will Stapp and the author, Feb. 2 and 5, 2012.

32 Caption to Plate 41, in Alexander Gardner, *Gardner's Photographic Sketchbook of the Civil War* (1866), vol. 1.

33 Brady's assistants are identified by name by Zeller in *The Blue and Gray in Black and White*, 104.

34 I am grateful to Robert Wilson for sharing his insights on Brady's Gettysburg photographs. His forthcoming biography of Brady will be a welcome addition to the literature on nineteenth-century photography.

35 Quoted in Lloyd Ostendorf, "President Lincoln," in Johnson et al., *An Enduring Interest*, 63.

36 David C. Ward, "'Vaulting Ambition': Poetry, Photography and Lincoln's Self-Fashioning," *Poetry Nation Review 188*, vol. 35, no. 6 (July–Aug. 2009): 45–49.

37 I am grateful to Randall Griffin for calling my attention to the timing of this visit by Lincoln to Gardner's studio.

38 Fallon's stereopticon is described in "An Optical Wonder," *Merchants Magazine and Commercial Review*, May 1863, 430. For a detailed history of the stereopticon and how it works, see "The Stereopticon: Projecting Photographic Images," in Charles Musser, *The Emergence of Cinema: The American Screen to 1907* (Berkeley: University of California Press, 1994), 29–38. For more on Fallon's stereopticon, see Kentwood D. Wells, "The Stereopticon Men: On the Road with John Fallon's Stereopticon, 1860–1870," *The Magic Lantern Gazette* 23, no. 3 (Winter 2011): 2–35.

39 *New-York Daily Tribune*, 27 June 1864, 3. *The New York Times* listed advertisements for this spectacle on page 7 of the issues published on June 28 and 29, and July 4, 1864.

40 The photographers identified by name in Gardner's album are Alexander Gardner, his brother James Gardner, Timothy H. O'Sullivan, William R. Pywell, George N. Barnard, James Gibson, John Reekie, John Wood, David. B. Woodbury, David Knox, and W. Morris Smith.

41 *The Sketch Book* introduced Irving's stories of Ichabod Crane and Rip van Winkle. Four stories about Christmas were influential enough to change the way Americans celebrated the holiday. New York publisher C. S. Van Winkle published the stories in a seven-part paperback serial between 1819 and 1820. Copies appeared simultaneously in New York, Boston, Baltimore, and Philadelphia. The hardback artist's edition of *The Sketch Book*, published in 1848 by George Putnam, featured engravings to accompany each story. Washington Irving,

The Sketch Book of Geoffrey Crayon, Gent. (New York: C. S. Van Winkle in serial form, 1819–1820). Elizabeth Young is the first scholar to make this connection in her insightful essay on the literary merits of Gardner's album. See "Verbal Battlefields," in Anthony Lee and Elizabeth Young, *On Alexander Gardner's Photographic Sketch Book of the Civil War* (Berkeley: University of California Press, 2008), 58–59.

42 For a history of this literary device, see Kristie Hamilton, *America's Sketchbook: The Cultural Life of a Nineteenth-Century Literary Genre* (Athens: Ohio University Press, 1998); cited in Young, "Verbal Battlefields," *On Alexander Gardner's Photographic Sketch Book*, n14.

43 "Art and the War: Report of the Fine Arts Committee of the New York Historical Society," *Chicago Tribune*, 12 Jan. 1864, 3.

44 Stereo photographs could be enlarged, using a solar enlarger on the negative. However, exposure times for this process extended to hours instead of minutes. A photographer could also rephotograph a small print using a larger negative. Both techniques resulted in degradation of the quality of the image. I am grateful to Will Stapp for explaining these processes.

45 "Cold Harbor, 3 June 1864" in Horace Porter, *Campaigning with Grant* (New York: The Century Co., 1897); quoted in Otto Eisenschiml and Ralph Newman, *Eyewitness: The Civil War as We Lived It* (New York: Grosset & Dunlap, 1956), 579. Grant's army suffered terrible losses the next day, estimated to be as many as 7,000 killed and wounded in less than one hour. See Eisenschiml and Newman, *Eyewitness*, 581.

46 Gardner's caption for this image reads, "This sad scene represents the soldiers in the act of collecting the remains of their comrades." *Gardner's Photographic Sketchbook of the Civil War* (1866), vol. 2, plate 94.

47 An account of Barnard's unsuccessful attempt to photograph the battle concluded with the note that the photographer "shouldered his heavy equipment, and after weary walking he reached Washington, footsore and tired." Reminiscence published in Barnard's obituary notice in *Anthony's Photographic Bulletin*, April 1902, 127; quoted in Keith F. Davis, *George N. Barnard: Photographer of Sherman's Campaign* (Kansas City, MO: Hallmark Cards, 1990), 57.

48 After Vicksburg fell to Grant's forces on July 4, 1863, Grant moved his headquarters to Nashville. By March 1864, Grant was promoted to lieutenant-general, and he named Sherman his replacement.

49 Orlando Poe's Letterbook, Nov. 25, 1863–Aug. 5, 1864, p. 101; and letter from Poe to Barnard, 8 Feb. 1864. Both in the Poe Collection, Library of Congress manuscript division. Both cited in Davis, *George N. Barnard*, 66.

50 Davis provides an insightful account of Barnard's career and his photographic process in *George N. Barnard: Photographer of Sherman's Campaign*

51 The glories of the Greek and Roman Empires formed a cherished point of comparison for the prewar South. In 1864 Professor Tayler Lewis wrote a book in which he opined that what had toppled the Greek empire was a desire for "petty sovereignty" of each state over the divinely ordained nation. Drawing a deliberate parallel, he wrote, "God has given us a mirror in the past," predicting the fall of the Confederacy on corrupt moral grounds. Prof. Tayler Lewis, *State Rights: A Photograph from the Ruins of Ancient Greece* (Albany: J. Munsell, 1864), 5, 20; cited in Davis, *George N. Barnard*, 175. Lewis taught at Union College in Schenectady, NY. He was a prominent member of the Dutch Church and a highly regarded author of treatises on the Union cause and the evils of slavery. For a general consideration of ruins in Civil War images, see Leo Mazow, *Images of Annihilation: Ruins in Civil War America*, The Huntington Library, Art Collections, and Botanical Gardens, April 16–June 30, 1996 (exhibition brochure) (San Marino, CA: The Huntington Library, Art Collections, and Botanical Gardens, 1996).

52 Barnard's finished album would comprise either 60 or 61 images, and there were small variations in the views included from individual album to album. The number of photographs may have been dictated by the strength of the binding. Gardner had divided his photographs into two fifty-image books, and in many cases the surviving albums have weakened spines from the stresses of use.

53 Barnard wrote to Orlando Poe, concerned that he did not have enough photographs to do justice to the march to the sea. He wanted to travel from Chattanooga to Savannah and make additional images to include in the book. To protect his investment of time and effort, Barnard wanted to secure fifty subscribers at $100 each before he embarked on this trip. Barnard to Poe, 7 March 1866, letter 118, Poe Collection, Library of Congress manuscript division; cited in Davis, *George N. Barnard*, 97.

54 United States War Department, "Reports of Maj. Gen. William T. Sherman, U.S. Army, commanding Military Division of the MS (Hdqrs. Military Division of the MS, in the field, Acworth, GA, 8 June 1864)," *The War of the Rebellion: A Compilation of the Official Records of the Union and Confederate Armies*, series 1, vol. 38, *The Atlanta, GA, Campaign, May 1–September 8, 1864*, part 1, *Reports* (Washington, DC: Government Printing Office, 1891), 67. Quoted in Holzer and Neely Jr., *Mine Eyes Have Seen the Glory*, 34.

55 Theodore Davis to Orlando Poe, 9 Sept. 1866, letter 266, Poe Collection, Library of Congress manuscript division; quoted in Davis, *George N. Barnard*, 103.

56 "Photographic Images of Sherman's Campaigns," *Harper's New Monthly Magazine*, Jan. 1867, 266.

57 V. Blanchard, "On the Production and use of Cloud Negatives," *The Photographic News* (4 Sept. 1863): 424–425. Cited in Davis, *George N. Barnard*, 103.

58 Asher B. Durand titled many of his plein-air paintings "Studies from Nature" when he exhibited them at the National Academy of Design during the 1850s. He advocated working directly from nature in his "Letters on Landscape Painting," published in the art journal the *Crayon*. See Eleanor Jones Harvey, *The Painted Sketch: American Impressions from Nature, 1830–1880* (New York: Abrams in association with the Dallas Museum of Art, 1998), esp. 35–36, 64–65.

59 This image was reproduced in *Harper's Weekly* on February 18, 1865, in which the placard is clearly visible, the only visual clue to the subject of the picture.

60 The horses' bones could not have been picked clean when Barnard was there in 1864, meaning this image has to date from his 1866 trip. In the absence of such clues, dating Barnard's photographs is an ongoing challenge. Keith Davis has astutely assessed each photograph, taking into account Barnard's whereabouts in 1864 to 1865 and 1866. The result is a sequencing of the works that allows the viewer to follow the photographer's path and watch the evolution of his pictorial approach to presenting war and its aftermath. See Davis, *George N. Barnard*.

61 The *Syracuse Standard* (3 Nov. 1864, 3) printed a letter dated 20 Oct. 1864 from Capt. Moses Summers; cited in Davis, *George N. Barnard*, 81.

THE HUMAN FACE OF WAR

Epigraph: Sordello [Eugene Benson], "National Academy of Design. Fortieth Annual Exhibition," *New York Evening Post*, 3 May 1866.

1 Although Gifford never put his thoughts about patriotism on paper, at his funeral address, the Rev. Dr. Bellows noted, "Patriotism…was at one time a greater force in Gifford's life than even love of Art; and his resolve to fight as a private soldier in the late war for the Union was greater in its influence upon the man, and in its possession of him, then even his devotion to his profession." "Sanford R. Gifford," *Art Journal* n.s. 6 (1880): 319.

2 The Seventh still had not received blue uniforms as late as 1863. As Gifford wryly noted, "Our men, as they go by, say it wouldn't be safe for us of the 7ᵗʰ to go into a fight, as we would surely be pitched into by our own men on account

of our uniforms." Sanford R. Gifford to Elihu Gifford, 3 July 1863. Sanford Robinson Gifford papers, 1840s–1900, circa 1960s–1970s, Archives of American Art, Smithsonian Institution. Gifford had mentioned being allowed to wear various colored shirts in 1862 while stationed at Mount Clare Station in Baltimore.

3 Sanford R. Gifford to Elihu Gifford, Thirty-Sixth Congress, House of Representatives, United States of America, 1 May 1861. Sanford Robinson Gifford papers, 1840s–1900, circa 1960s–1970s, Archives of American Art, Smithsonian Institution.

4 Barnard took a number of photographs of the Seventh Regiment, reproduced in Davis, *George N. Barnard*, 55.

5 "Domestic Art Gossip," *Crayon*, June 1861, 133.

6 Six of Gifford's wartime sketchbooks are in the collection of the Albany Institute of History and Art, catalogued as: D. "7ᵗʰ Reg & Catskills, 61" (1861–62); E. "8ᵗʰ Co—7ᵗʰ Reg—N G July 1862" (MD and NY 1862–63); SG 6. "7ᵗʰ Regiment, Washington 1861" (1854–61); SG 8. MD, VA, NY, 1860; SG 9. NY 1860–63; SG 10. NY, Maine, Mass, 1863–65.

7 "Military Correspondence, Washington, May 17, 1861," *Crayon*, June 1861, 134.

8 "I am very glad to hear you like your picture—and I hope Jas. Carey will not be disappointed in his. J.C.'s being a historico-military picture representing the 'Occupation of Maryland by the Seventh Regiment, N.Y.' quorum corporal fui [of which I was a Corporal]. There was a poetical propriety in adding to the signature my full military rank. What is the use of military glory and dignities if they are not aired now and then?
 Although I do not see the propriety of recording these dignities on your unwarlike picture, I will nevertheless do it as you wish whenever my good fortune takes me again to Baltimore." Sanford R. Gifford to George Coale, 13 Jan. 1863, Boston Public Library.

9 Theodore Winthrop, "Washington as a Camp. Our Barracks at the Capitol," *Atlantic Monthly*, July 1861, 115–166.

10 Candace Wheeler's "Earth Cure," her antidote to civilization, as expressed in Jane Curley, "Candace Wheeler, Wise Woman and Muse of American Decorative Arts," *The Hemlock* (Spring 2001); http://www.mths.org/archive/the-hemlock/hemsp01.html. Candace Wheeler was a prominent interior designer who would go on to design the interior of the Women's Building at the 1893 World's Columbian Exposition in Chicago. She also founded and ran an artistic retreat in upstate New York called Onteora. She chronicled her life in her book *Yesterdays in a Busy Life* (New York: Harper & Brothers, 1918).

11 "The NAD. Third and Concluding Notice," Fine Arts, *Albion*, 17 May 1862, 237.

12 "Religious Services at Head Quarters, Harrison's Landing, Virginia. Every Sunday morning an open-air service is held in the camp of head-quarters, at which General M'Clellan is a punctual attendant. Seated around may be seen generals, with members of the staff, and other officers of the army; sometimes a naval officer, and a few outsiders of various denominations.... The groups of officers and soldiers, so lately grimed with dust and battle-sweat, and gaunt with fatigue and hunger, refreshed by rest, show few signs of their recent struggles. The sentries, leaning their heads upon their keep sabre-bayonets, join in the hymns—real Ironsides these. The military band takes the place of the organ, precluding and accompanying the hymns, in which few join, and playing for opening and closing voluntaries, selections from *Traviata*." "The Army of the Potomac," *Harper's Weekly*, 18 Aug. 1862, 523. On p. 517, same issue, a full page wood engraving "Sunday at General M'Clellan's Head-Quarters—Divine Services in Camp.—Sketched by Mr. A. R. Waud.—[see page 523]."

13 That first night, while the Seventh was hard at work, Ellsworth and his Fire Zouaves headed into Alexandria. They were determined to take down an enormous Confederate flag flying from a boarding house, so large that it was visible from the White House. Ellsworth succeeded in removing the flag and paid for it with his life, his death at the hands of the irate proprietor making him an instant martyr. See Adam Goodheart, *1861: The Civil War Awakening* (New York: Alfred A. Knopf, 2011), 270–291 for an engaging description of Ellsworth's brief but electric life.

14 The preliminary sketch for *Bivouac* was owned initially by J. W. Pinchot, head of the Yale School of Forestry; it is currently unlocated. At Gifford's estate sale there was brief mention that this finished work "was damaged in the Madison-Square Garden disaster when on exhibition at the Hahnemann Hospital Fair, but afterward restored by the artist." The painting sold for $630 to dealer William Schaus. Noted in "Sale of the Gifford Pictures. Seventy-five of them bring nearly Twelve Thousand Dollars." Unidentified and undated newspaper clipping, of the first night of the Chickering Hall sale. Gifford papers, Dr. Sanford Gifford, Cambridge, Massachusetts.

15 Sanford R. Gifford to the Wheelers, from Fort Federal Hill, Baltimore, 2 July 1862. Sanford Robinson Gifford papers, 1840s–1900, circa 1960s–1970s, Archives of American Art, Smithsonian Institution.

16 According to Gifford's father, he was able to make these visits thanks to an "indulgent superior officer allowing him to visit close friends often." Elihu Gifford to Mary Child Gifford, 10 Oct. 1862. Sanford Robinson Gifford papers,

1840s–1900, circa 1960s–1970s, Archives of American Art, Smithsonian Institution

17 Sanford R. Gifford to Jervis McEntee, 21 Oct. 1860. Jervis McEntee papers (1796), 1848–1905, Archives of American Art, Smithsonian Institution.

18 Sanford R. Gifford to Jervis McEntee, 7 Aug. 1862 from Fort Federal Hill—Baltimore Jervis McEntee papers (1796), 1848–1905, Archives of American Art, Smithsonian Institution.

19 Entry for Sunday, June 23, in Alfred Davenport, *Camp and Field Life of the Fifth New York Volunteer Infantry (Duryee Zouaves)* (New York: Dick and Fitzgerald, 1879), 82–83.

20 Samuel Benjamin noted the resemblance between the lone sentry and Gifford, proclaiming the figure to be a self-portrait. See Samuel Benjamin, "Our American Artists," *Wide Awake* 2 (May 1876): 307; cited in Ila Weiss, "Sanford Robinson Gifford (1823–1880)" (PhD diss., Columbia University, 1968), 212

21 "The Lounger. The National Academy of Design," *Harper's Weekly*, 2 May 1863, 274.

22 Elihu Gifford to Mary Child Gifford, Hudson, NY, 2 Sept. 1862. Sanford Robinson Gifford papers, 1840s–1900, circa 1960s–1970s, Archives of American Art, Smithsonian Institution.

23 In a letter to his father, the artist noted: "We are in the midst of the Army of the Potomac, which is now passing and has been passing on all sides of us since we have been here, in the direction of Harper's Ferry, South Mountain, and Antietam.... We have a fine opportunity of seeing almost the entire Army of the Potomac. The apparently endless lines of infantry and artillery and supply trains of the different corps are constantly filing past in full sight on the different roads leading to the river." Sanford R. Gifford to Elihu Gifford, "In camp near Frederick, Md., July 9, 1863." Sanford Robinson Gifford papers, 1840s–1900, circa 1960s–1970s, Archives of American Art, Smithsonian Institution.

24 "We came here from Monocacy on the 7th, marching in the rain. We came into this field (where Hooker was relieved by Meade) in the rain and bivouacked in the mud. It did not take long to strip the neighboring fences of their remaining rails, and thatch them with sheaves of wheat from the next field....The next afternoon it cleared and the ground is now fast drying up." Sanford R. Gifford to Elihu Gifford, "In camp near Frederick, Md., July 9, 1863." Sanford Robinson Gifford papers, 1840s–1900, circa 1960s–1970s, Archives of American Art, Smithsonian Institution.

25 Hayes hailed from Superior, WI, and met Johnson and his family when he arrived there in 1854. During the war Hayes was quartermaster of the Eleventh Army Corps and in a eulogy for Johnson recalled, "Just following the battle of Gettysburg our army made a detour through Maryland to intercept General Lee's crossing of the Potomac into Virginia. In this movement, Eastman fell into my line of march, with some army trains which I commanded, and we campaigned together for a week or more." Col. Hiram Hayes, "Memories of the 50's: Recalled by the Yuletide," *Superior Telegram* (WI), 22 Dec. 1906, 3; copy in the Wisconsin Historical Library, http://www.wisconsinhistory.org. Johnson himself was never in uniform. Although he may have intended to make sketches on this trip for use in his own war-related paintings, no evidence survives to suggest he did so.

26 "The Seventh Regiment New-York National Guard, arrived here from the seat of war at a late hour Wednesday night." They, along with other troops recalled from Gettysburg and its environs, were a significant factor in diminishing the rioters' actions. "The Riot Subsiding," *New York Times*, 17 July 1863, 1.

27 "The Mob in New York. Resistance to the Draft—Rioting and Bloodshed," *New York Times*, 14 July 1863, 1.

28 "The Regiment has been constantly on duty since it arrived. . . . Immediately afterwards my company with a police force marched through 26th St to 1st Ave., when a number of files from the right were deployed across the Avenue as Skirmishers, facing up and down. . . . The firing from windows and house-tops was pretty lively for a while. . . . We popped away wherever a head popped out or a man appeared on a roof." Sanford R. Gifford to Phoebe, New York City, 18 July 1863. Gifford papers, Dr. Sanford Gifford, Cambridge, Massachusetts.

29 Conrad Wise Chapman, *Ten Months in the Orphan Brigade: Conrad Wise Chapman's Civil War Memoir*, ed. Ben L. Bassham (Kent, Ohio: Kent State University Press, 1999), 30.

30 For an eye-opening discussion of Civil War soldiers' reactions to the stresses of war, see Eric T. Dean Jr., *Shook over Hell: Post-Traumatic Stress, Vietnam, and the Civil War* (Cambridge: Harvard University Press, 1997). He addresses self-inflicted injuries and other irrational behaviors after battle in chapter four, "'A Gizzard Full of Sand': Reactions to Violence," esp. 76–77.

31 Quoted in Edward D. C. Campbell Jr., "The 'Eccentric Genius' of Conrad Wise Chapman," *Virginia Cavalcade* 37, no. 4 (Spring 1988): 159.

32 Ben L. Bassham, the leading authority on Conrad Chapman, considers the possible causes of the artist's instability in *Conrad Wise Chapman: Artist and Soldier of the Confederacy*

(Kent, OH: Kent State University Press, 1998), 250–253. He further notes that Chapman was in and out of hospitals his first year in uniform. Hospitals would prove anything but soothing to recuperating soldiers. Doctors, nurses, and patients alike described them as the site of gruesome horrors equivalent to battlefields. See also Dean, *Shook over Hell*, 78–80.

33 Conrad's middle name was given in honor of the Chapman family's friend, Henry A. Wise, then a congressman from Virginia; Wise served as Virginia's Governor from 1856–60 and signed the order to hang John Brown in 1859. Wise took up arms for the Confederacy, rising to brigadier general during the war.

34 In a letter to Granville G. Valentine, John S. Wise—Henry Wise's son—mentioned that Conrad and Tabb had become good friends during the war. John S. Wise to Granville G. Valentine, 15 April 1893. Valentine Richmond History Museum, Richmond, Virginia.

35 "Gen. Beauregard had detailed an officer, Major Gilchrist, to write the history of the siege of Charleston. My father, knowing Chapman's talents, . . . suggested to him that it would be an excellent idea to have Chapman illustrate the siege. Gen. Beauregard approved the suggestion, and my father gave Chapman all the leaves of absence requested to make the illustrations." Wise to Valentine, 15 April 1893.

36 Cited in United States War Department, *The War of the Rebellion: A Compilation of Official Records of the Union and Confederate Armies*, series 2, vol. 35 (Washington, DC: Government Printing Office, 1880–1901), 477. Illustrations based on Conrad Wise Chapman, John Ross Key in George B. Davis, et al., *The Official Military Atlas of the Civil War* (New York: Fairfax Press, 1983).

37 United States War Department, *The War of the Rebellion: A Compilation of Official Records of the Union and Confederate Armies*, series 1, vol. 38 (Washington, DC: Government Printing Office, 1880–1901), 11–116.

38 Bassham, *Conrad Wise Chapman*, 126. Page 127 describes site of the John Ross Key bombardment painting. Key's painting used to be attributed to Albert Bierstadt; see Alfred C. Harrison Jr., "Bierstadt's *Bombardment of Fort Sumter* Reattributed," *Antiques*, Feb. 1986, 416–422, for the correction of that attribution.

39 Walker's career blossomed in the postwar years with his genre paintings of blacks pursuing everyday activities. Many of his paintings convey the persistent lifeways of so many former slaves despite Reconstruction. Donald B. Kuspit et al., *Painting in the South: 1564–1980* (Richmond: Virginia Museum of Fine Arts, 1983), 96–97. See also Whitelaw Reid, *After the War: A Tour of the Southern States, 1865–1866*, ed.

C. Vann Woodward (New York: Harper & Row, 1965), for his assessment of the lives of formerly enslaved people who remained in the South.

40 The artist's eye for the details of its construction and repair were confirmed when the *Hunley* was finally raised from the depths of Charleston Harbor on 8 August 2000. The presiding marine archaeologist used a copy of Chapman's painting as a guide. Inside the submarine was a repair bucket filled with tar, matching the one the artist depicted on the dock beside the vessel. Author's correspondence with Cathy Wright, museum registrar, The Museum of the Confederacy, Richmond, Virginia, April 2010.

41 Chapman visited Granville G. Valentine in Richmond at his request to comment on each of his paintings on 25 April 1898. Valentine had Chapman's comments transcribed, which were then attached to the bill of sale dated 29 April 1898. The transcript is in the Eleanor S. Brockenbrough Library, The Museum of the Confederacy, Richmond, Virginia.

42 The flag, formally adopted in November 1863, was the "Stainless White" version, in which the stars and bars battle flag occupies the upper left quadrant of a white field. Bassham, *Conrad Wise Chapman*, 148.

43 This work is an undated panel based on sketch made by Conrad on 25 Oct. 1863, and it is virtually identical to a painting by Conrad that appeared on the market in 1982 and is now in a private collection in Charleston. Chapman file, The Museum of the Confederacy, Richmond, Virginia.

44 U. S. Department of War, *The War of the Rebellion: A Compilation of Official Records of the Union and Confederate Armies*, series 2, vol. 28 (Washington, DC: Government Printing Office, 1880–1901), 446. Cited in Bassham, *Conrad Wise Chapman*, 151.

45 "On the night of the 7th of December, Lieutenant John R. Key of the Engineers, and Mr. Chapman, artist on duty in the chief engineer's office at Richmond, arrived under orders to execute sketches and take views of the historic ruin." John Johnson, *The Defense of Charleston Harbor, Including Fort Sumter and the Adjacent Islands, 1863–1865* (Freeport, NY: Books for Libraries Press, 1889; reprinted 1970), 187.

46 Letter home from an Engineer captain, quoted in Shelby Foote, *The Civil War: A Narrative* (New York: Vintage Books, 1986), 2:824.

47 Prof. Tayler Lewis, *State Rights: A Photograph from the Ruins of Ancient Greece* (Albany, NY: J. Munsell, 1864), 5, 20; quoted in Davis, *George N. Barnard*, 175. Lewis taught at Union College in Schenectady, NY. He was a prominent member of the Dutch Church and a highly regarded author of treatises on the Union cause and the evils of slavery.

48 Transcript of Conrad W. Chapman's comments to Granville G. Valentine, dated 25 April 1898 (see n. 41).

49 Of this painting, Chapman noted that this British-made gun "often ploughed up the water, the damage done by it, if any, was very slight." Transcript of Conrad W. Chapman's comments to Granville G. Valentine, dated 25 April 1898 (see n. 41).

50 Chapman recalled that when he arrived in Liverpool en route to Rome in 1864 he was "a mark, especially my Coon Skin cap and Confederate Uniform taking their attention." Conrad Wise Chapman to John S. Wise, Hampton, VA, 3 March 1910. Chapman papers, Valentine Richmond History Museum, Richmond, Virginia. Also quoted in Bassham, *Conrad Wise Chapman*, 169.

51 Transcript of Conrad W. Chapman's comments to Granville G. Valentine, dated 25 April 1898 (see n. 41).

52 John S. Wise to Mrs. Isobelle Bryan, New York, 7 June 1906. Chapman file, The Museum of the Confederacy, Richmond, Virginia.

53 Dean, *Shook over Hell* 55–56.

54 John Linton Chapman to Granville G. Valentine, New York, 29 April 1898. Chapman file, The Museum of the Confederacy, Richmond, Virginia.

55 Wise to Valentine, 15 April 1893 (see n. 34).

56 According to Ben Bassham, Conrad Chapman "sketched in oil, pencil, and watercolor or in a combination of the three. For some subjects as many as four sketches survive, and in the case of a few paintings no extant preparatory studies exist. All but three of the group of thirty-one small paintings on panel bear a precise date in one corner, on the back, or on the frame, not of the day the picture was painted but of the occasion on which the preparatory sketch or studies were made." Bassham, *Conrad Wise Chapman*, 130.

57 His traveling companion was Bishop Patrick Lynch of Charleston, Confederate commissioner to the Vatican on a mission from Jefferson Davis. Together the two men ran the naval blockade and eventually landed in Liverpool, England, en route to Italy.

58 A 1867–68 prospectus announces fourteen etchings by John Gadsby Chapman ready for sale. But apparently there was not enough interest to continue to complete the set, projected at twenty-three more.

59 Wise to Valentine, 15 April 1893 (see n. 34).

60 According to Bassham, John Linton Chapman "stated that his father, who kept the Charleston set with him long after Conrad departed Rome for good, wanted the series to remain together and to find a home somewhere in the South; John Gadsby continued painting copies of Conrad's originals as patrons expressed interest in them." Bassham, *Conrad Wise Chapman*, 131.

61 "In the World of Art," *New York Times*, 15 Dec. 1895, 20. Of the display, the reviewer noted, "Mr. Chapman fought on the southern side during the Civil War and made these sketches on the spot."

62 Campbell Jr., "The 'Eccentric Genius' of Conrad Wise Chapman," 172.

63 Daniel Clayton Lewis, "Emanuel Leutze's *Westward the Course of Empire Takes its Way*: Imagining Manifest Destiny, the 'Stars and Stripes,' and the Civil War," in Donald Kennon, ed., *The United States Capitol: Designing a National Icon* (Athens, OH: Ohio University Press, 2000), 243.

64 The unnamed correspondent for the *Crayon* (possibly Gifford) wrote, "Leutze has been to see me a number of times and has been a good deal about the camp making memoranda. He will find great use for the material he collects here, in his military subjects. "I was at his studio in Washington the other day...." "Military Correspondence, Washington, May 17, 1861," *Crayon*, June 1861, 134.

65 Bierstadt enrolled for the draft on 1 July 1863 and was drafted on 20 August 1863, when the draft was resumed after the riots. He paid the $300 fee for a substitute. For a partial list of the artists drafted, see Thomas S. Cummings, *Historic Annals of the National Academy of Design. New-York Drawing Association, etc. with Occasional Dottings by the Way-Side from 1825 to the Present Time* (Philadelphia: George W. Childs, 1865), 331. Available online at http://archive.org/stream/historicannalsofoocumm#page/n5/mode/2up. For Bierstadt's draft records, see the Records of the Provost Marshall General's Bureau, 6th Congressional District NY (National Archives and Records Administration, Washington, D.C.). Finding aid at http://www.archives.gov/research/guide-fed-records/groups/110.html.

66 Dickens published the diary he found, which included the following entry: "Oct. 5. Went out on the Lewinsville picket, and had a lively time. Was in sight of five thousand Yankees all day....Saw them advancing on one of the posts, and gave the alarm. Sent for some infantry, and followed the villains back to their encampment, and killed four, and wounded several others." Dickens notes, "A day or two more contain entries of such picket service on the skirts of a strong enemy. The last is on the seventeenth of October, but while he was keeping it with regularity the diary abruptly closed, and we may suppose that on the day following he was himself one of the shot." Charles Dickens, "The Diary of a Confederate Boy," in *All the*

Year Round, A Weekly Journal, 17 May 1862, 230. Compiled in book form (London: Chapman and Hall, 1862).

67 See Nancy K. Anderson and Linda S. Ferber, *Albert Bierstadt: Art & Enterprise* (New York: The Brooklyn Museum in Association with Hudson Hills Press, 1990), 148.

68 *Brooklyn Daily Eagle*, 27 Dec. 1861; see Anderson and Ferber, *Albert Bierstadt* (New York: The Brooklyn Museum in Association with Hudson Hills Press, 1990), 167.

69 Homer's pass reads: "Headquarters Army of the Potomac, Washington, Oct. 15, 1861. Pass Mr. Homer within the line of main guards one week. By command of Major General McClellan: Not transferable. [signed] A. Williams. Assistant Adjutant General." From the collections of the Brian Sutton-Smith Library and Archives of Play™ at The Strong™, Rochester, New York.

70 Quote from a Winslow Homer letter cited in Gordon Hendricks, *The Life and Work of Winslow Homer* (New York: Harry N. Abrams, 1979), 46.

71 Homer crossed the Potomac River and sketched at Mount Vernon while engraving interior genre scenes and portraits for *Harper's Weekly*. It would be interesting to know if Homer had seen Eastman Johnson's painting *The Old Mount Vernon* (cat. 63) by this time, as Homer's sketch adopts the same perspective. Peter H. Wood discusses this juxtaposition in "*Near Andersonville": Winslow Homer's Civil War* (Cambridge: Harvard University Press, 2010), 35–37.

72 Lieutenant Colonel Barlow was in command of the 61st NY Volunteer Infantry, part of the Second Corps of the Army of the Potomac at Yorktown. He and Homer's brother, Charles, graduated in the same class at Harvard. In a letter dated 18 Feb. 1862, Barlow wrote to his mother, Almira Pennington Barlow: "I should be glad to see Homer here & if we are farther out he must come out there—Tell Charles I will write him." Barlow papers, Massachusetts Historical Society, Boston.

73 Three pencil sketches now in the National Gallery of Art, Washington. D.C., bear inscriptions indicating Homer was in Virginia during late March and early April 1865. Accession numbers: 1996.121.3; 1996.121.18; and 1996.121.6.a.

74 In his memoirs, soldier Alfred Bellard sketched a "Sharp shooters Tree at Yorktown" on p. 57; on p. 60 he sketched a more typical scene similar to Homer's painting. See Alfred Bellard, *Gone for a Soldier: The Civil War Memoirs of Private Alfred Bellard, from the Alec Thomas Archive*, ed. David Herbert Donald (Boston: Little, Brown and Company, 1975).

75 "Sharpshooters," *Scientific American* vol. 7 (22 Nov. 1862) included a promotional piece by a Vermont captain that made being a sharpshooter sound like the celebrity duty for aspiring soldiers. Cited in Nicolai Cikovsky Jr. and Franklin

Kelly, *Winslow Homer* (Washington, DC: National Gallery of Art; New Haven: Yale University Press, 1995), 40n4.

76 "Colonel Berdan and His Sharp-Shooters," *Harper's Weekly*, 24 Aug. 1861, 541.

77 Quoted by Christopher Kent Wilson in "Marks of Honor and Death," in Marc Simpson et al., *Winslow Homer: Paintings of the Civil War* (San Francisco: Bedford Arts, Publishers, 1988), 36n51.

78 Winslow Homer to George C. Briggs, 19 Feb. 1896. Winslow Homer collection, Archives of American Art, Smithsonian Institution. Soldier John De Forest described being under constant sniper fire as a "sickening, murderous, unnatural, uncivilized way of being." John W. De Forest, *A Volunteer's Adventures: A Union Captain's Record of the Civil War* (New Haven: Yale University Press, 1946), 144; quoted in Faust, *This Republic of Suffering*, 43.

79 Later the same year, Whitman traveled to Fredericksburg, VA, to search for his brother, who was listed among the injured. After finding his brother alive and virtually unharmed, the grateful poet went to Washington, where he determined to stay and nurse the wounded soldiers there. His efforts—reading letters to the convalescents, writing home for dying soldiers, offering such succor as was within his power—were devoted to providing a "good death." Whitman helped dying soldiers, without friends or family at hand, make peace with this world and embrace the next in the makeshift hospitals of the nation's capital. Whitman wrote of his experiences in *The Wound Dresser: Letters Written to His Mother from the Hospitals in Washington during the Civil War*, ed. Richard M. Bucke (New York: The Bodley Press, 1949). For a thoughtful consideration of a "good death" as an essential part of American society, see Faust, *This Republic of Suffering*, esp. 6–11, and 161.

80 Frank M. Mixson, *Reminiscences of a Private* (Camden, SC: J. J. Fox, 1910), 37–38.

81 Nelson Appleton Miles, *Serving the Republic: Memoirs of the Civil and Military Life of Nelson A. Miles, Lieutenant-General, United States Army* (New York: Harper & Brothers Publishers, 1911), 50.

82 "From Another Correspondent. Camp in the Field, near Dallas, Georgia, May 31, From General Sherman's Army," *The Louisville Daily Journal* (KY), 9 June 1864, 1.

83 "From Brownsville," *Daily Picayune* (New Orleans, LA), 7 April 1865, 5; "The Exchange of Prisoners Yesterday," *Charleston Mercury*, 4 Aug. 1864, 2; "From Fredericksburg: Our Own Reporter," *Daily Dispatch* (Richmond, VA), 8 June 1863, 1. "Returned Prisoners Welcomed Home," *Boston Herald*, 16 June 1862, 2; "Return of the Seventh Regiment to New York," *Daily Dispatch* (Richmond, VA), 7 June 1861, 2.

84 See Dean, *Shook over Hell*, 128–131.

85 Atticus, "Art Feuilleton. Exhibition of the Academy of Design," *New York Leader*, 9 May 1863, 1.

86 Lionel, "The Artists' Fund Society, Fourth Annual Exhibition," *The New Path* 1, no. 8 (Dec. 1863): 95.

87 "A common occupation of a leisure hour…is the carving of pipes from the roots…it is a slow business." George Grenville Benedict, *Army Life in Virginia: Letters from the Twelfth Vermont Regiment and Personal Experiences of Volunteer Service in the War for the Union, 1862–63* (Burlington, VT: Free Press Association, 1895), 67–68; quoted in Holzer and Neely Jr., *Mine Eyes Have Seen the Glory*, 282.

88 "The Brier-wood Pipe," by Charles Dawson Shanly, *Vanity Fair*, July 1861, 5.

89 Davenport, *Camp and Field Life of the Fifth New York Volunteer Infantry*, 286: "From the time the first shot was fired at the regiment to their getting off the field, it was not over fifteen minutes. It stood in line receiving the murderous fire only about seven short minutes, yet in that short space of time *one hundred and thirteen* were killed or mortally wounded; four missing, who were never heard of, and one hundred eighty wounded; a total of two hundred and ninety-seven, out of the four hundred and ninety engaged.…No other regiment suffered an equal loss in so short a space of time, on the Union side during the war.…They lost at the battle of Antietam in twenty minutes, eighty men dead on the field, and two hundred and twenty-four wounded, out of a total of five hundred and fifty-six men engaged."

90 "Hood's brigade, 2nd Bull Run, 4 pm, 30 August 1862," in J. P. Polley, *A Soldier's Letters to Charming Nellie* (New York: Neale Publishing, 1908); quoted in Eisenschiml and Newman, *Eyewitness*, 234.

91 "Recollection of 2nd Battle of Bull Run, 31 August 1862," in Edward A. Moore, *The Story of a Cannoneer under Stonewall Jackson* (Lynchburg, VA: J. P. Bell Co., 1910); quoted in Eisenschiml and Newman, *Eyewitness*, 242.

92 "Fourth Artists Reception" *New-York Daily Tribune*, 26 March 1864, 6. The reception was at Dodworth's Hall.

93 Nicolai Cikovsky Jr. makes a convincing case for accepting Lloyd Goodrich's supposition that Homer was in fact present in the area during the battle. See Cikovsky and Kelly, *Winslow Homer*, 45–45.

94 "The Battlefield of Spotsylvania," *Boston Herald*, 24 May 1865, 2.

95 Peter Wood has made a convincing argument linking this painting to the Battle of the Crater, not only in Homer's composition and characters, but noting that an early owner of the painting was a survivor of this notorious battle. See Peter H. Wood, "*Near Andersonville*," 47–50.

96 In the South, suggestions that the Confederacy should compel blacks to fight were met with strong opposition, summed up by Georgian Howell Cobb: "Use all the Negroes you can get, for all the purposes for which you need them, but don't arm them....The day you make soldiers of them is the beginning of the end of the revolution. If slaves will make good soldiers our whole theory of slavery is wrong." Quoted in Robert Franklin Durden, *The Gray and the Black: The Confederate Debate on Emancipation* (Baton Rouge: Louisiana State University Press, 2000), 184; cited in Forster and Nagler, *On the Road to Total War*, 203. Cobb was speaker of the United States House of Representatives, governor of Georgia, then and secretary of the treasury in the Buchanan administration. He became a founding member of the Confederacy. He became a colonel in the Sixteenth Georgia Infantry when war broke out.

97 A description of Henry's work in progress describes it as "View of Porter's Headquarters near Harrison's Landing, Virginia," indicating the artist was setting his scene two years earlier than his own arrival on the James River. See Art Notes, *Albion*, 26 June 1869, 365. For an account of the condition of Westover during the Civil War, see Private Robert Cox Sneden, *Eye of the Storm: A Civil War Odyssey*, ed. Charles F. Bryan and Nelson D. Lankford (New York: The Free Press, 2000), esp. 101–108, 112–113. My thanks to Abby Davis, curatorial intern, Corcoran Gallery of Art, for assistance in compiling accounts of Westover from the museum's files.

98 The most thoughtful discussion of this painting is Emily D. Shapiro, "Recollection and Reconstruction: Edward Lamson Henry's Depictions of Westover," *American Art* 25, no. 1 (Spring 2011): 74–95.

99 E. L. Henry to Edward V. Valentine, 21 Sept. 1870. Ms. C 57, Valentine Richmond History Museum, Richmond, Virginia. Henry met the Valentines in Italy during the 1850s/early 1860s.

100 Robert J. Titterton, *Julian Scott: Artist of the Civil War and Native America* (Jefferson, NC: McFarland & Co., 1997), 6; cited in Barbaranne Elizabeth Mocella Liakos, "The American Civil War and Collective Memory: Reconstructing the National Conflict in Paintings and Prints, 1869–1894" (PhD diss., University of Iowa, 2009).

101 Titterton, *Julian Scott*, 32–33; cited in Liakos, "The American Civil War and Collective Memory."

102 Joshua L. Chamberlain, "Appomattox, 9 April 1865," in *Personal Recollections of the War of the Rebellion: Addresses Delivered before the Commandery of the State of New York, Military Order of the Loyal Legion of the United States*, third series (New York: J. J. Little & Co., 1907), 260–280; quoted in Eisenschiml and Newman, *Eyewitness*, 682.

103 George W. Sheldon, *American Painters* (New York: D. Appleton, 1879), 52; quoted in J. Gray Sweeney, *McEntee & Company*, 9 (see chap. 1, n. 90).

104 This poem inspired the title of a very thoughtful exhibition and book concerning the links between Whitman's writings and the Civil War. See Kevin Sharp, *Bold, Cautious, True: Walt Whitman and American Art of the Civil War Era* (Memphis, TN: Dixon Gallery and Gardens, 2009).

105 Both Eric Dean and Drew Gilpin Faust examine at length the numbing effects of the Civil War and the struggles soldiers underwent to maintain a sense of compassion without breaking down completely. See Dean, *Shook over Hell*, 70–71; and Faust, *This Republic of Suffering*, 59–60.

106 According to Kevin Avery of the Metropolitan Museum of Art: "1886 codicil to the 1865 will of Elihu Gifford, father of Charles and Sanford (the artist). Section E of the codicil lists pictures in Elihu Gifford's will to be bequeathed to the children of his deceased son Charles, who died in May 1861 (who therefore never owned the picture himself). The pictures [in the 1886 codicil] included 'Soldier' by 'W. Homer.' Elihu died in 1889, at which time presumably the picture passed to Harold Gifford, M.D. (1858–1929), the only surviving son of Charles. From Harold, it passed to his daughter Anna Gifford (Mrs. John Ewing) Forbes (b. 1894) and his son Harold Gifford, M.D. (born 1906)." Information courtesy of the Joslyn Art Museum, Omaha, NE.

107 Henrietta Homer to Arthur Homer, 7 June 1862; quoted in Hendricks, *The Life and Work of Winslow Homer* (New York: Harry N. Abrams, 1979), 50.

108 "General F. C. Barlow," *Harper's Weekly*, 9 July 1864, 444. The writer describes the capture of these divisions and generals as "perhaps the most brilliant single feat of the war." In 1865 Barlow ran for state senate, adding a political dimension to the timing of Homer's painting. See "The Union Candidates. Gen. Barlow's Military Career," *New York Times*, 23 Sept. 1866, p. 4, which calls Barlow "one of the most conspicuous soldiers of the war—one of its most heroic and romantic figures." D. R. Lauter suggested *Prisoners from the Front* shows Confederate Colonel John A. Baker of the Third North Carolina Cavalry, captured 21 June 1864 by Barlow. Part of General Barringer's regiment was captured by Barlow on Tuesday, 21 June 1864; and the other two soldiers may be members of the First and Second NC cavalry. Letter from D. R. Lauter to the Metropolitan Museum of Art's American art curatorial department, 16 April 1979, Metropolitan Museum of Art, American Art Department archives. Barlow's son confirmed his father's presence and offered an unsubstantiated anecdote: "During the war Winslow

Homer had been at the front and had painted pictures of soldiers there.…One of Homer's pictures represented some confederate prisoners being inspected by a Union officer. Miles [Nelson A. Miles] was a very fine figure of a man, and my father was nothing special in this respect. So Homer got Miles to pose for the officer's figure. Then when the figure was finished, Homer put my father's head on top of Miles's body, apparently merely because my father held higher rank than Miles. At any rate Miles was seriously annoyed." Letter from R. S. Barlow to A. Tucker, 21 July 1932, Metropolitan Museum of Art, American Art Department archives.

109　This young man would reappear again the following decade in Homer's paintings of Adirondack guides. He is often seen in the company of an older, wiser man teaching him the ways of the forest, or alone, and when by himself either unable to hunt deer properly or steward the forest's resources.

110　John Esten Cook, "The Sorrows of Fairfax," *Southern Illustrated News*, 7 March 1863; quoted in Masur,"…*The real war will never get in the books*," 64–65.

111　"Art: About 'Figure Pictures' at the Academy," *Round Table*, 12 May 1866, 295.

112　T. C. DeLeon, *Four Years in Rebel Capitals: An Inside View of Life in the Southern Confederacy, from Birth to Death* (Mobile, AL: Gossip Printing Company, 1890), 369.

113　Sordello [Eugene Benson], "National Academy of Design," *New York Evening Post*, 28 April 1866; quoted in John C. Davis and Sarah Burns, *American Art to 1900: A Documentary History* (Berkeley: University of California Press, 2009), 527.

ABOLITION AND EMANCIPATION

Epigraph: Frederick Douglass, *Life and Times of Frederick Douglass: Written by Himself* (Hartford, CT: Park Publishing Co., 1881), 293.

1　Only rarely, as in William Sidney Mount's *The Power of Music* of 1847 (Cleveland Museum of Art), did an American genre painter provide a more nuanced and sensitive depiction of his black subject. For a thoughtful assessment of prewar depictions of blacks in American art, see Elizabeth Johns, *American Genre Painting: The Politics of Everyday Life* (New Haven: Yale University Press, 1991).

2　For the Declaration of Causes of Secession for Georgia, Mississippi, South Carolina, and Texas, see http://sunsite.utk.edu/civil-war/reasons.html.

3　Christiana, PA, was at the confluence of several Underground Railroad routes from across Virginia and from Maryland's Eastern Shore. On September 11, 1851, a gunfight broke out between slavers intent on capturing and remanding fugitive slaves and white abolitionists and local free blacks equally intent on securing the fugitives' freedom. After the arrest of more than fifty people, the subsequent trial and acquittal of most of them was seen as a victory for the abolitionists and a signal that the second fugitive slave law would not be strictly enforced. In 1855 poet John Greenleaf Whittier wrote the poem, "For Righteousness' Sake," which commemorated the events and was dedicated to "friends under arrest for treason against the slave power." For more on the Christiana Riot, see Steven Lubet, *Fugitive Justice: Runaways, Rescuers, and Slavery on Trial* (Cambridge: Belknap Press of Harvard University Press, 2010).

4　For an extensive discussion of Slave Power, see Susan-Mary Grant, *North over South: Northern Nationalism and American Identity in the Antebellum Era* (Lawrence: University Press of Kansas, 2000), 74. For an extended consideration of this concept in relationship to American artist William Rimmer, see Randall R. Griffey, "Herod Lives in This Republic': Slave Power and Rimmer's Massacre of the Innocents," *American Art* 26 no. 1 (Spring 2012): 112–125.

5　Letter from abolitionist author and intellectual Lydia Maria Child to Lucy Searle, Wayland, MA, 5 June 1861: "When our fathers joined hands with slave-holders to form the Constitution, with their feet on the prostrate and helpless slaves, they did sad work for their descendants.…Law is not law, if it violates principles of eternal justice." *Letters of Lydia Maria Child* (Boston and New York: Houghton Mifflin, 1882), 152–53. Also quoted in Masur, "…*The real war will never get in the books*," 43.

6　Scott E. Casper, *Sarah Johnson's Mount Vernon: The Forgotten History of an American Shrine* (New York: Hill and Wang, 2008), 31, 58. I am grateful to Peter H. Wood for bringing this source to my attention.

7　Although twentieth-century scholars have long debated the truth of this assertion, at the time of this painting, the hagiography was widely repeated and cheerfully accepted as fact. For an engaging recitation of this history, see Curtis Carroll Davis, "The First Climber of Natural Bridge: A Minor American Epic," *Journal of Southern History* 16 no. 3 (Aug. 1950): 279–281, esp. n15.

8　Jefferson to William Caruthers, June 11, 1817. "I received yesterday your favor of the 2d. inst. and I readily consent that Patrick Henry, the freeman of colour whom you recommend, should live on my land at the Natural Bridge, and cultivate the cultivable lands on it, on the sole conditions of paying the taxes annually as they arise, and of preventing trespasses." The Thomas Jefferson Papers, series 1, *General Correspondence, 1751–1827*. Also available at http://hdl.loc.gov/loc.mss/mtj.mtjb.b022886. For a discussion of Patrick Henry's role as cicerone, see Davis, "The First Climber of

the Natural Bridge," 280–284. See also Edmund Pendleton Tompkins, M.D., and J. Lee Davis, *The Natural Bridge and Its Historical Surroundings* (Natural Bridge, VA: Published by Natural Bridge of Va., Inc., 1939).

9 At Natural Bridge, Field wanted Church to paint the scene and Church agreed, making pencil sketches as was his usual fashion. Field expressed some concern that Church might need rock samples in order to recall the intense reddish color of the stone, but Church assured his friend that his memory would suffice. Field pocketed a few rocks as souvenirs, and the two men continued on their journey. The pencil sketches, annotated with Church's color notes, are at Church's estate, Olana. The story of this painting has always culminated with the moment when Field sees the finished painting, and pulls the rocks from his pocket, amazed and delighted to find that in fact, Church's visual memory had captured exactly the ruddy tones of the rocks.

10 For a summary of the contents of the Reform Constitution, see Virginia General Assembly, "Virginia Constitution, 1851," in Virginia Civics, Item 519, accessed on 9 Dec. 2011, http://vagovernmentmatters.org/primary-sources/519. For laws intended to discourage or bar free blacks from settling in Northern states, see Leon F. Litwark, *North of Slavery: The Negro in the Free States, 1790–1860* (New York: University of Chicago Press, 1961).

11 Letter from British abolitionist Thomas Clarkson to Mrs. H. G. Chapman, 3 Oct. 1845. Of Lafayette: "He was a real gentleman, and of soft and gentle manners. I have seen him put out of temper, but never at any time except when slavery was the subject. He has said, frequently, 'I would never have drawn my sword in the cause of America, if I could have conceived that thereby I was founding a land of slavery.'" Reprinted in *Liberty Bell* 16, no.1 (1846): 64.

12 For information on Humboldt's views on American slavery, see Philip S. Foner, "Alexander von Humboldt on Slavery in America," 330–342 (see chap 1, n. 80).

13 The series began in the June 5, 1851 issue and ended in the April 1, 1852 issue. See "Uncle Tom's Serialization: The National Era Text," http://utc.iath.virginia.edu/uncletom/erahp.html.

14 Dr. Leonard Bacon, a pro-Beecher minister, probably wrote this review: "Mrs. Stowe has done what multitudes would much rather she had not done....She has made the public realize, to a most alarming extent, the unspeakable wickedness of American slavery. She has told, in general, nothing more than what all intelligent persons knew well enough before....But Mrs. Stowe has brought the dreadful meaning of facts into contact with millions of minds." "Review of *Uncle Tom's Cabin*," *New Englander*, Nov. 1852, 588–89; quoted in Thomas F. Gossett, "*Uncle Tom's Cabin*"

and American Culture (Dallas: Southern Methodist University Press, 1985), 178.

15 Among the earliest proslavery rebuttals was W. L. G. Smith, *Life at the South; or "Uncle Tom's Cabin" as It Is* (1852). The hostility speaks to the effectiveness of Stowe's novel.

16 Quoted in the *Independent*, 26 Aug. 1852, 137.

17 From a letter written by Stowe to Gamaliel Bailey, editor of the weekly antislavery journal *National Era*, Brunswick, ME, 9 March 1851; quoted in E. Bruce Kirkham, *The Building of "Uncle Tom's Cabin*," 3rd ed. (Knoxville: University of Tennessee Press, 1977), 67; and reprinted in Jim O'Loughlin, "Articulating *Uncle Tom's Cabin*," *New Literary History* 31, no. 3 (2000): 592. For a full transcript of the letter, see http://utc.iath.virginia.edu/uncletom/utlthbsht.html, accessed 9 Dec. 2011.

18 Harriet Beecher Stowe, *Uncle Tom's Cabin; or, Life among the Lowly* (Boston: John P. Jewett., 1853; 1981 ed.), 258; quoted in Joseph D. Ketner II, *The Emergence of the African-American Artist: Robert S. Duncanson, 1821–1872* (Columbia: University of Missouri Press, 1993), 48.

19 Stowe, *Uncle Tom's Cabin*, 259–260; Ketner, *The Emergence of the African-American Artist*, 47.

20 Julie Aronson of the Cincinnati Art Museum has uncovered an early biography of Duncanson that corrects the artist's middle name (formerly thought to be Scott), and his parentage, which was mulatto on both sides for several generations. See "Artists and the Fine Arts among Colored People," *Repository of Religion and Literature and of Science and Art* (Indianapolis, IN) 3, no. 1 (Jan. 1860): 3. Joseph Ketner has researched the artist's family through census records, affirming that both of Duncanson's parents were listed as mulattos, as were several prior generations of the extended family. See Joseph D. Ketner II, *Robert S. Duncanson: "The Spiritual Striving of the Freedmen's Sons"* (Catskill, NY: Thomas Cole National Historic Site, 2011), n11, unpaginated.

21 Ibid.

22 Ketner draws these conclusions as well in *The Emergence of the African-American Artist*, 47.

23 Stowe, 1852 ed., ii, 63. Ketner notes the print source in *The Emergence of the African-American Artist*, 48.

24 Ketner, *The Emergence of the African-American Artist*, 104–105n23.

25 Letter from Robert S. Duncanson to his son Reuben; quoted in *Artists in Ohio, 1787–1900: A Biographical Dictionary*, ed. Mary Sayre Haverstock, Jeannette Mahoney, and

Brian L. Meggitt (Kent, OH: Kent State University Press, 2000), 245.

26 Stowe stated that she based her novel on stories told her by escaped slaves who reached the city.

27 In *Graham's Magazine* (Philadelphia), June 1848, the frontispiece was "Engraved by J. W. Steel Expressly for *Graham's Magazine* from an Original Daguerreotype."

28 Teresa A. Carbone and Patricia Hills, *Eastman Johnson: Painting America* (Brooklyn: Brooklyn Museum of Art in association with Rizzoli, 1999), 30, 32.

29 John Davis has written a masterful account of this painting's history, and I am indebted to him for the specificity of information we have regarding the location and milieu of the Johnson home in Washington, the sheer number and content of the period reviews, the curious story of the painting's subsequent ownership, and the changes to its title. John C. Davis, "Eastman Johnson's *Negro Life at the South* and Urban Slavery in Washington, D.C." *Art Bulletin* 80, 1 (March 1998): 68.

30 Ibid., 67–92.

31 It is possible Johnson and Mignot discussed painting a collaborative work of Mount Vernon. Ultimately it would be fellow artist John Rossiter who teamed up with Mignot to paint what is now called *Washington and Lafayette at Mount Vernon*, in 1859 (Metropolitan Museum of Art, New York). Mignot's Southern sympathies would prompt him to move to London permanently in 1861. One has to wonder if he and Johnson discovered their conflicting political views on their visit to Mount Vernon in 1857. See Maurie D. McInnis, "The Most Famous Plantation of All," in *Landscapes of Slavery*, ed. Angela Mack and Stephen G. Hoffius (Columbia: The University of South Carolina Press, 2008), 103.

32 The Mount Vernon Ladies' Association, founded in 1853, ensured the long-term care of the property, and in 1858 the house and grounds were open to the public, inaugurating a restoration campaign.

33 Casper, *Sarah Johnson's Mount Vernon*, 73.

34 Seventeen enslaved families lived there in 1856, totaling 76 people. List of Slaves Belonging to John A. Washington (III) Mount Vernon, January 15, 1856, taken from a diary kept by John A. Washington, Mount Vernon Ladies' Association, Mount Vernon, Virginia. Patricia Hills also cites these statistics in Carbone and Hills, *Eastman Johnson: Painting America*, 160n11.

35 Henry Adams, *The Education of Henry Adams*, ed. Ernest Samuels (Boston: Houghton Mifflin, 1974), 47.

36 In a letter to Henry Wadsworth Longfellow dated 3 June 1857, Johnson is clearly thinking about leaving Washington and settling in New York. [bMs Am 1340.2 (3044)], Houghton Library, Harvard. Cited in Carbone and Hills, *Eastman Johnson: Painting America*, 49.

37 "It is a sort of *Uncle Tom's Cabin* of pictures, and gives rise, therefore, to quite as many painful as pleasant reflections.... In the *Life at the South* there is a story within a story; first, that of slave-life, as telling as a chapter from 'Slavery as It Is,' or a stirring speech from the Anti-Slavery platform." "The National Academy Exhibition," *New-York Daily Tribune*, 21 May 1859, 6. *American Slavery as It Is* was written in 1839 by abolitionist Theodore D. Weld, who based his narrative on firsthand accounts from slaves. His book inspired Stowe and at the time was the most influential piece of abolitionist literature.

38 Frederick Douglass described Northern politicians unwilling to confront slavery as themselves "servile in spirit" and "longing for the leeks and onions of Egypt." The reference is from the book of Numbers (11:5) in the Old Testament, where the Israelites lament their privation in the wilderness, longing for the food they had enjoyed under Pharaoh: "We remember the fish, which we did eat in Egypt freely; the cucumbers, and the melons, and the leeks, and the onions." See Douglass, "The Future of the Abolition Cause," *Douglass' Monthly*, April 1861, 436.

39 "The Academy of Design. The Thirty-fourth Exhibition of the Academy of Design." *New York Times*, 20 April 1859, 10.

40 See Davis, "*Negro Life at the South* and Urban Slavery," esp. 78–79.

41 Lincoln's opponents raised the specter of miscegenation during the 1859–60 election campaign, hence the term "Black Republicans." The term "miscegenation" was coined during the 1863–64 campaign by David Goodman Croly and George Wakeman in a satirical pamphlet avowing to support it. See George Frederickson, *Black Image in the White Mind: The Debate on Afro-American Character and Destiny, 1817–1914* (Middletown, CT: Wesleyan University Press, 1971), 171–173.

42 See Davis, "*Negro Life at the South* and Urban Slavery," 67–92.

43 Henry T. Tuckerman. *Book of the Artists: American Artist Life* (New York: G. P. Putnam & Son, 1867), 468.

44 "National Academy of Design. Second Notice," *Crayon*, June 1859, 191.

45 Nona Martin notes that the white cat "sneaking" into the upper floor of the slave quarters alludes to the behavior of white male slaveholders, the result being miscegenation, and she continues by suggesting that the woman entering the yard has the right to "pass in and out of slavery." Nona R. Martin, "*Negro Life at the South*: Eastman Johnson's Rendition of Slavery and Miscegenation" (master's thesis, University of Pittsburgh, 1994), 23–24.

46 Escaped slave John T. Washington recalled, "I see myself a small light haired boy (very often passing easily for a white boy)." David. W. Blight, *A Slave No More: Two Men Who Escaped to Freedom, Including Their Own Narratives of Emancipation* (New York: Harcourt, 2007), 15–16.

47 Diary entry for 27 August 1861. Mary B. Chesnut, *A Diary From Dixie*, ed. Ben Ames Williams (Cambridge: Harvard University Press, 1980), 122–123.

48 Harriet Jacobs, *Incidents in the Life of a Slave Girl, Written by Herself*, ed. Jean Fagan Yellin (1861, reprint Cambridge: Harvard University Press, 1987), 35; quoted in Blight, *A Slave No More*, 22.

49 Photographer Alexander Ball, a mulatto from Cincinnati, passed for white his entire adult life, although his early partner, Robert Duncanson, perhaps the best known mid-nineteenth-century African American painter, did not.

50 See also Sue Bridwell Beckham, "By 'N By Hard Times…Eastman Johnson's *Life at the South* and American Minstrelsy," *Journal of American Culture* 6, no. 3 (Sept. 1983): 22.

51 Abraham Lincoln, "A house divided" speech, delivered in Springfield, Illinois, June 16, 1858, given upon Lincoln's accepting the Illinois Republican Party's nomination for State Senator.

52 John Davis notes that the *Home Journal* refers to this painting as *Negro Life at the South* in June 1859 and as *Old Kentucky Home* two months later. See "Fine Arts. National Academy of Design," *Home Journal*, 18 June 1859, 3; and 27 Aug. 1859, 6. Cited and discussed in Davis, "*Negro Life at the South* and Urban Slavery," 70.

53 The second owner of *Negro Life at the South* was Johnson's patron, Robert L. Stuart, who was invested heavily in Southern sugar plantations. His collection painted a pleasant picture of rural labor, slave and free—a yearning for a simple time before people questioned the propriety of the work. For a thoughtful discussion of the politics of the ownership of this painting during the 1860s, see Davis, "*Negro Life at the South* and Urban Slavery," 84–87.

54 One version of the stage play at the National Theater ended with Uncle Tom being taken back to Kentucky and freed by George Shelby. That version opened on August 23, 1852 and closed on September 10, 1852. Noted in Thomas F. Gossett, "*Uncle Tom's Cabin*" *and American Culture* (Dallas: Sothern Methodist University Press, 1985), 272.

55 "American Artists," *Harper's Weekly*, 4 May 1867, 274.

56 *1792 Transactions of the American Philosophical Society*, 111–112; quoted in Brian T. Allen, *Sugaring Off: The Maple Sugar Paintings of Eastman Johnson* (New Haven: Yale University Press, 2004), 37, 54n32.

57 George Perkins Marsh calculated production of white sugar and maple sugar from 1850 to 1862. In 1850 New England produced more than 34 million pounds of maple sugar, while the South produced more than 237 million pounds of white sugar. In 1862, Louisiana alone produced more than 528 million pounds of cane sugar. George Perkins Marsh, *Man and Nature; or, Physical Geography as Modified by Human Action* (New York: Charles Scribner, 1864), 149. For the number of slaves working sugar plantations, see W. R. Akroyd, *Sweet Malefactor: Sugar, Slavery, and Human Society* (London: Heinemann Press, 1967), 23–24; cited in Allen, *Sugaring Off*, 54n31.

58 Alexis de Tocqueville, *Democracy in America*, ed. J. P. Mayer and Max Lerner (New York: Harper & Row, 1966), esp. 28–33; cited in Allen, *Sugaring Off*, 41.

59 William Grimshaw, *History of the United States* (Philadelphia: Grigg, 1832), 194; cited in Allen, *Sugaring Off*, 39.

60 Zadock Thompson, *History of Vermont* (Burlington, VT: Goodrich Press, 1842), 210; quoted in Allen, *Sugaring Off*, 54n34.

61 Clarence King to John Hay, (March?) 1888, John Hay Library, Brown University, John Hay papers, A37865[26], microfilm reel 8; quoted in Wilkins with Hinkley, *Clarence King*, 22 (see p. 252, n. 136).

62 Wilkins with Hinkley, *Clarence King*, 13, 21–22.

63 Eastman Johnson to Henry Wadsworth Longfellow, 8 May 1863. Photocopy in Brooklyn Museum Archives.

64 Samuel Warner's overtly racist account borrows heavily from Byrd. Samuel Warner, *Authentic and Impartial Narrative of the Tragical Scene which was Witnessed in Southampton County (Virginia) on Monday the 22nd of August Last, When Fifty-Five of Its Inhabitants (mostly women and children) were inhumanely Massacred by the Blacks!*, pamphlet (New York: printed for Warner & West, 1831), 34.

65 Frances Anne Kemble made similar observations in her *Journal of a Residence on a Georgian Plantation in 1838–1839*, ed. John A. Scott (New York: Knopf, 1961), esp. 18. Stowe had made only one trip South in 1834. Southern writer Louisa S. McCord sensed Stowe's unfamiliarity and stated, "We doubt if Mrs. Stowe has ever crossed the line of a slave state at all.... If she has, it has evidently not been further south than the mere crossing of the Kentucky border." See "Art. III.—Uncle Tom's Cabin," *Southern Quarterly Review* 23 (Jan. 1853): 108.

66 Stowe, *Dred, A Tale of the Dismal Swamp* (Boston: Phillips, Sampson, 1856), 2:274–75. Also available through the University of North Carolina at Chapel Hill's Documenting the American South project at http://docsouth.unc.edu/nc/stowe2/stowe2.html#p273.

67 Thomas Moran's daughter, Ruth B. Moran, wrote that *Slave Hunt* was painted in 1861 in London and sold in 1862 in order to fund the trip back to the United States. Thomas Moran papers, 1870–1940, Archives of American Art, Smithsonian Institution. Originals in East Hampton Free Library.

68 Moran sold this painting for 9 pounds in 1862, enough to bring him home to the United States. Thurman Wilkins with Caroline Lawson Hinkley, *Thomas Moran: Artist of the Mountains*, 2nd ed. (Norman: University of Oklahoma Press, 1998), 35, 47.

69 Blight, *A Slave No More*, 109–110. After finally reaching safety, Turnage concluded his narrative, "I had made my escape with safety after such a long struggle and had obtained that freedom which I desired so long. I now dreaded the gun and handcuffs and pistols no more. Nor the blewing [sic] of horns and the running of hounds; nor the threats of death from the rebels' authority. I could now speak my opinion to men of all grades and colors, and no one to question my right to speak." Quoted in Blight, *A Slave No More*, 120.

70 Frederick Law Olmsted, *A Journey to the Seaboard States in the Years 1853–54, with Remarks on Their Economy* (New York: Dix and Edwards, 1856), 101. Octave Johnson of St. James Parish in Louisiana told of his escape with others through the local swamps, being chased by bloodhounds before finding Union troops who would protect them. Testimony of Corporal Octave Johnson before the American Freedman's Inquiry Commission, February 1864; cited in Ira Berlin et al., ed., *Freedom: A Documentary History of Emancipation, 1861–1867*, volume 1, series 1, *The Destruction of Slavery* (New York: Cambridge University Press, 1985), 217.

71 Quoted in James M. McPherson, *The Negro's Civil War: How American Negroes Felt and Acted during the War for the Union* (New York: Vintage Books, 1965), 61.

72 John Bunyan, "What Makes a Slough of Despond," in *The Pilgrim's Progress from This World to That Which Is to Come*, ed. Roger Sharrock (Hammondsworth: Penguin, 1965), 45; partially quoted in David C. Miller, *Dark Eden: The Swamp in Nineteenth-Century American Culture* (London: Cambridge University Press, 1990), 49.

73 Porte Crayon [David Hunter Strother], "The Great Dismal Swamp," *Harper's New Monthly Magazine*, Sept. 1856, 446.

74 Marsh, *Man and Nature*, 11.

75 Butler's decision opened the floodgates. Within a week he had taken in close to fifty escapees, including women and children. By the end of July, the number had swelled to 900. Edward Lillie Pierce, "The Contrabands at Fortress Monroe," *Atlantic Monthly*, Nov. 1861, 626–632. Pierce was assigned to supervise the work of these black men and wrote glowingly of their service.

76 Butler was the first but by no means the only Union general to protect escaped slaves and put them to work for the Union army. On 20 Sept. 1861, Gen. John E. Wool, Butler's successor at Ft. Monroe, received a telegram from Washington: "Send to Gen. McClellan at this place all Negro men capable of performing labor, accompanied by their families. They can be usefully employed in the military works in this vicinity." p. 95; On 22 Aug. 1862, Butler, acting on his own authority, issued a general order authorizing the enlistment of free African Americans "to defend the Flag of their native country, as their fathers did under Jackson at Chalmette, against Packenham and his myrmidons, carrying the black flag of 'beauty and booty;'" p. 117; and on 17 July 1862, Congress passed the Confiscation Act, which declared free the slaves of all who were in rebellion, p. 75. All citations from Benjamin Quarles, *The Negro in the Civil War* (Boston: Little, Brown, 1969).

77 Charles Cooper Nott, *The Coming Contraband: A Reason against the Emancipation Proclamation, not Given by Mr. Justice Curtis, to Whom It Is Addressed, by an Officer in the Field* (New York: G. P. Putnam, 1862), 2–3; quoted in Kate Masur, "'A Rare Phenomenon of Philological Vegetation': The Word 'Contraband' and the Meanings of Emancipation," *Journal of American History* 93, no 4 (March 2007): 1051. Nott was a New York lawyer and Union army officer.

78 Quoted in *Harper's Weekly*, 6 Feb. 1864, 82.

79 The painting and inscription are described in Johnson's estate sale: "No. 123. A Ride for Liberty—The Fugitive Slaves—1862. A colored man and woman, with two small children, are mounted on a large horse, which is trotting along a road at its utmost speed in the early dawn. The man, holding in front of him a child of three or four years of age, urges the animal to action, and the mother, clasping her husband around the waist, and holding to her bosom an infant, looks behind

her anxiously to see if they are pursued. Through a rift in the clouds on the left of the horse is seen a narrow streak of light. Upon the back of this picture is inscribed the following: 'A veritable incident in the Civil War, seen by myself at Centerville on the morning of McClellan's advance to Manassas. March 2, 1862. Eastman Johnson.'" *The Works of the Late Eastman Johnson, N. A. To be sold at unrestricted public sale at the American Art Galleries on Tuesday and Wednesday Evenings February 26th and 27th* (1907); Archives of American Art, Smithsonian Institution, Roll N51 Frame 1004. McClellan did not leave Washington until March 7. He arrived in Centreville two days later and by the 17th was 160 miles southeast of Manassas, preparing to begin his Peninsular Campaign.

80 Christine Anne Bell, "A Family Conflict: Visual Imagery of the 'Homefront' and the War Between the States, 1860–1866" (PhD diss., Northwestern University, 1996), 232.

81 Blight, *A Slave No More*. Page 19 cites a runaway female slave described as a "bright Mulatto." The author notes that many runaways were described as bright, smart, or tricky. "Ten Dollars Reward," *Political Arena* (Fredericksburg, VA), 19 Feb. 1841, in Central Rappahannock (VA) Public Library. See Blight, 269n8 for source of this newspaper ad.

82 Bell, "A Family Conflict: Visual Imagery of the 'Homefront,'" 239. For the Underground Railroad likened to the Flight into Egypt or Nativity scene, see Silex, "A Story of the Underground Railroad—To the Editor of the *New-York Tribune*," reprinted in *Douglass' Monthly*, Jan. 1859, 12. Guy McElroy has written about the Flight into Egypt aspect of this painting in his book *Facing History: The Black Image in American Art, 1710–1940* (San Francisco: Bedford Arts and Washington DC: Corcoran Gallery of Art, 1990), 55.

83 The other version of this painting is at the Brooklyn Museum. *A Ride for Liberty—The Fugitive Slaves*, ca. 1862. Oil on paper board, 21 15/16 × 26 1/8 in. (55.8 × 66.4 cm). Brooklyn Museum, Gift of Gwendolyn O. L. Conkling, 40.59a-b.

84 Johnson was not the only artist whose market was affected by his pointed subject matter. John Rogers made his own war-related sculptural debut in 1859 with his table-top group titled *The Slave Auction*. He soon discovered to his dismay that no New York merchant would carry it in his shop window, for fear of alienating wealthy customers. Some of them were Southerners, and others were Northerners who invested heavily in cotton and sugar, industries wholly reliant on enslaved labor. Rogers was not deterred and hired a black man to sell his sculpture on a street corner. Abolitionist Louis Tappan purchased a copy from Rogers's street vendor and went as far as to call out Rogers for praise in the New York abolitionist press, but Tappan's advocacy and the risks Rogers endured to promote this sculpture were unusual. Mr. and Mrs. Chetwood Smith, *Rogers Groups: Thought and Wrought by John Rogers* (Boston: Charles E. Goodspeed, 1934) page 28 quotes

an excerpt from a letter from Rogers to his aunt about this subject. See also Bell, "A Family Conflict: Visual Imagery of the 'Homefront,'" 72.

85 McPherson, *The Negro's Civil War*, 163.

86 The National Park Service recently created an online brochure about Hunter, http://www.nps.gov/fopu/historyculture/david-hunter.htm. I thank Peter H. Wood for bringing this to my attention.

87 Quarles, *The Negro in the Civil War*, 117.

88 Ibid., 110–119.

89 Frederick Douglass, "The Proclamation and the Negro Army," An Address Delivered in New York, NY, February 6, 1863; quoted in Masur, "*…The real war will never get in the books*," 116.

90 McPherson, *The Negro's Civil War*, 176.

91 Commissioned for $500, it was the first painting to enter the club's fledgling art collection, commemorating "The Club's First Work." Elizabeth McCausland, *The Life and Work of Edward Lamson Henry N.A., 1841–1919*, New York State Museum Bulletin no. 339 (Albany: University of the State of New York, 1945), 29.

92 "The Mob in New York. Resistance to the Draft—Rioting and Bloodshed," *New York Times*, 14 July 1863, 1.

93 "The Riot Subsiding," *New York Times*, 17 July 1863, 1.

94 The city's newspapers and journals carried extensive coverage of the riots. Among the eyewitness accounts published is William O. Stoddard, *The Volcano under the City. By a Volunteer Special* (New York, 1887). For a thorough analysis of the riots, the events leading up to them, and their consequences, see Iver Bernstein, *The New York City Draft Riots: Their Significance for American Society and Politics in the Age of the Civil War* (New York: Oxford University Press, 1990).

95 Four of the Union League Club's prominent founders were Henry Adams Bellows, Frederick Law Olmsted, George Templeton Strong, and Oliver Walcott Gibbs. Artist members included Albert Bierstadt, Vincent Colyer, John F. Kensett, Jasper F. Cropsey, Samuel Colman, Sanford Gifford, Martin J. Heade, Daniel Huntington, Eastman Johnson, Emanuel Leutze, Thomas Nast, Frederic Remington, and Worthington Whittredge. Arts patrons included John Jacob Astor, R. L. Stuart, Marshall O. Roberts, William E. Dodge, Morris K. Jesup, Hamilton Fish, Cyrus Field, J. P. Morgan, John Jay, John T. Johnston, William Cullen Bryant, and the van Rensselaers. Joining them would be generals Grant and Sherman, John D. Rockefeller, and Theodore Roosevelt.

For a history of the Club, see Will Irwin, Earl Chapin May, and Joseph Hotchkiss, *A History of the Union League Club of New York City* (New York: Dodd, Mead, 1952).

96 Bartram had seen distinguished service in the Peninsular Campaign and at Fredericksburg and Chancellorsville. The previous October he had been made lieutenant-colonel of the Eighth U.S. Colored Troops, which fought in Florida. "Ovation to Black Troops. Reception of the Twentieth U.S. Colored Regiment. Flag Presentation at the Union League Club-House. Addresses from Dr. Charles King, Col. Bartram and the Loyal Ladies. Enthusiastic Demonstrations of the Populace. The Spectators Number More than a Hundred Thousand. The Negro's Vengeance for the July Riots," *New York Times*, 6 March 1864, 8.

97 Quarles, *The Negro in the Civil War*, 190.

98 Irwin, May, and Hotchkiss, *A History of the Union League Club*, 32.

99 "Ovation to Black Troops: Reception of the Twentieth U.S. Colored Regiment, Glad Presentation at the Union League Club-House," *New York Times*, 6 March 1864, 8.

100 Suzaan Boettger has researched jig dolls as part of her article, "Eastman Johnson's *Blodgett Family* and Domestic Values during the Civil War Era," *American Art* 6, no. 4 (Autumn 1992): 61. Susan Powell Witt has explored this painting in depth along with the larger idea of parlors as sites of Civil War meaning in "The Gendered Language of War: Picturing the Parlor in Civil War America" (PhD diss., Stanford University, 2010).

101 Blodgett and his wife actively supported Union causes during the Civil War. Both were deeply involved in organizing the Metropolitan Fair of 1864. Mrs. Blodgett underwrote the creation of a flag designed by artist Emanuel Leutze, which was presented at the Fair to General John A. Dix in recognition of his service to the Union army and as Lincoln's secretary of the treasury. For discussion of the Dix flag, see *Memoirs of John Adams Dix*, comp. Morgan Dix (New York: Harper and Brothers, 1883), 1:362–374; 2:70–108. For a biography of Blodgett, see Robert W. de Forest, "William Tilden Blodgett and the Beginnings of the Metropolitan Museum of Art," *Bulletin of the Metropolitan Museum of Art* 1, no. 3 (Feb. 1906): 37–42.

102 Frederick Douglass, "Should the Negro Enlist in the U.S. Army?" speech delivered at National Hall, Philadelphia, 6 July 1863; published in *Douglass' Monthly*, Aug. 1863.

103 *Life and Times of Frederick Douglass*, 293.

104 One such overtly racist account demonized Nat Turner's actions, claiming, "Nat Turner, (a slave of Mr. Edward Travis) who had been taught to read and write, and who hypocritically and the better to enable him to effect his nefarious designs, assumed the character of a Preacher, and as such was sometimes permitted to visit and associate himself with many of the Plantation Negroes, for the purpose (as was by him artfully represented) of christianizing and to teach them the propriety of their remaining faithful and obedient to their masters: but, in reality, to persuade them and to prepare them in the most sly and artful manner to become the instruments of their slaughter!" Samuel Warner, *Authentic and Impartial Narrative of the Tragical Scene Which Was Witnessed in Southampton County* (Virginia), (New York: Warner & West, 1831), 5–6; Samuel J. May Anti-Slavery Collection, Cornell University Library.

105 In August 1863, the *New York Times* critic noted, "E. Johnson has been in Maine and also on Long Island, where he painted two studies—one a picturesque interior without figures; another with a figure of a black man reading the Bible in a chimney-corner." "Our Artists—Where They Are and What They Are Doing," *New York Times*, 14 Aug. 1863, 8.

106 Olmsted had remarked on this style of architecture on a trip through the South in 1856: "The houses of the slaves are usually log-cabins, of various degrees of comfort and commodiousness. At one end there is a great open fire-place, which is exterior to the wall of the house, being made of clay in an inclosure, about eight feet square and high, of logs. The chimney is sometimes of brick, but more commonly of lath or split sticks, laid up like log-work and plastered with mud. They enjoy great roaring fires, and, as the common fuel is pitch pine, the cabin, at night when the door is open, seen from a distance, appears like a fierce furnace." Olmsted, *A Journey to the Seaboard States*, 111.

107 The lyrics are based on Exodus 8:1, "And the Lord spoke unto Moses, go unto Pharaoh, and say unto him, thus saith the Lord, Let my people go, that they may serve me." Thomas Wentworth Higginson noted of his black troops, that the biblical books of Moses and Revelation "constituted their Bible; all that lay between, even the narratives of the life of Jesus, they hardly cared to read or hear." Thomas Wentworth Higginson, *Slave Life in a Black Regiment* (Boston: Fields, Osgood & Co., 1870), 218; quoted in Aamodt, *Righteous Armies, Holy Cause*, 39.

108 The verses were also published in the *Continental Monthly*, July 1862, 112–113: "We are indebted to Clark's *School-Visitor* for the following song of the Contrabands, which originated among the latter, and was first sung by them in the hearing of white people at Fortress Monroe, where it was noted down by their chaplain, Rev. L. C. Lockwood. It is to a plaintive and peculiar air, and we may add has been published with it in 'sheet-music style,' with piano-forte accompaniment, by Horace Waters, New York."

109 Cited in Bell, "A Family Conflict: Visual Imagery of the 'Homefront,'" 244.

110 Eastman Johnson to Jervis McEntee, 12 June 1866. Reel 4707, frame 134, Jervis McEntee papers (1796), 1848–1905, Archives of American Art, Smithsonian Institution; cited in Carbone and Hills, *Eastman Johnson: Painting America*, 66.

111 Eastman Johnson painted two nearly identical versions of *The Lord is My Shepherd*. The other (Munson-Williams-Proctor) was originally titled *Old Joe* in 1864 then listed as *The Chimney Corner* by 1867. John T. Johnston, a prominent New York art collector, owned the painting initially titled *Old Joe* by 1864. By 1867 Henry Tuckerman refers to Johnston's painting as *The Chimney Corner* (in *Book of the Artists: American Artist Life*, p. 469). The Munson-Williams-Proctor Institute acquired this painting in 1964.

112 Albion Winegar Tourgée, *Bricks without Straw: A Novel*, ed. Carolyn L. Karcher (Durham NC: Duke University Press, 2009), 35, 206.

113 For an insightful and thorough discussion of these issues, see Blight, *A Slave No More*.

114 "Education in the Southern States," *Harper's Weekly*, 9 Nov. 1867, 706; quoted in Peter H. Wood and Karen C. C. Dalton, *Winslow Homer's Images of Blacks: The Civil War and Reconstruction Years* (Houston: The Menil Collection; Austin: University of Texas Press, 1988), 79.

115 "Universal Suffrage: an Argument by Reverend Henry Ward Beecher," a sermon delivered at Plymouth Church, Brooklyn, on Sunday 12 February 1865; cited in Bell, "A Family Conflict: Visual Imagery of the 'Homefront,'" 243.

116 Clarence Cook, "National Academy of Design," *New-York Daily Tribune*, 3 July 1865, 6. For an extended discussion of this painting, see also "Winslow Homer, *The Bright Side*: Truth and Humor" in *Masterworks of American Painting at the De Young* (Fine Arts Museums of San Francisco, 2005), 155–158; and Marc Simpson, *Winslow Homer: Paintings of the Civil War*, 199–207.

117 Sibley tents were tall, conical structures used during the early phase of the war. By 1862 they were in use only at semi-permanent camps due to their cumbersome nature. See Lucretia Giese, "Winslow Homer: 'Best Chronicler of the War,'" in Nicolai Cikovsky Jr., ed., *Winslow Homer: A Symposium* (Washington, DC: National Gallery of Art, 1990), 29n10.

118 T. B. Aldrich, "Among the Studios, III," *Our Young Folks*, July 1866, 396–97.

119 "National Academy of Design. Seventh Article," *Watson's Weekly Art Journal* 3 (1 July 1865): 148–49; quoted in David Dearinger, ed. *Rave Reviews: American Art and Its Critics, 1826–1925* (New York: National Academy of Design, 2000),

209; and in Simpson, *Winslow Homer: Paintings of the Civil War*, 51.

120 Art Matters, *New York Leader*, 11 March 1865, 3.

121 A writer for the *New York Leader* noted, "nearly all [Homer's] works contain a grotesque element; witness particularly the comic old darkey with the pipe, poking his head through the tent opening." George Arnold, Art Matters, *New York Leader*, 3 June 1865; quoted in Dearinger, *Rave Reviews*, 209.

122 See "At Andersonville," *Atlantic Monthly*, March 1865, 285–296; article reprinted in the *New York Leader*, 4 March 1865, 1.

123 Peter Wood makes a strong case that this episode in Sherman's Atlanta Campaign was a motive behind Homer's choice of subject and title for this painting. See Peter H. Wood, *"Near Andersonville,"* 51–57.

124 It would be interesting to know if Homer had seen Whistler's *Arrangement in Grey and Black: The Artist's Mother* (1871) when he composed this painting. The similarities in the portrayal of Homer's mistress and the artist's mother make for tantalizing speculation.

125 Eliza Frances Andrews, *The War-Time Journal of a Georgia Girl, 1864–1865* (New York: D. Appleton, 1908), 319; quoted in Thavolia Glymph, *Out of the House of Bondage: The Transformation of the Plantation Household* (New York: Cambridge University Press, 2008), 155.

126 Glymph explores in depth the reactions of both black and white women to the changes wrought by the end of the war. Albion Tourgée wrote that most people "did not, and do not yet, comprehend" the institution of slavery as a reality. Albion W. Tourgée, "The Literary Quality of *Uncle Tom's Cabin*," *Independent*, 20 Aug. 1896, 3–4.

127 James L. Roark, *Masters without Slaves: Southern Planters in the Civil War and Reconstruction* (New York: Norton, 1977), 89. On page 82 Roark also quotes Catherine Edmonston of North Carolina: "As to the idea of the faithful servant, it is all a fiction. I have seen the favorite and most petted negroes the first to leave in every instance." Both in Blight, *A Slave No More*, 145. One woman who ran her family's plantations as a widow wrote that the slaves she liked best were most likely to be the ones who would harm her, because they understood her contempt for them. On 3rd of February [1861] she wrote, "I am every now & then awakened to the fact that they hate me—My God—My God—what are we to expect from slaves—when mine hate me as they do—it is nothing on earth—but that I am white & own slaves—My Southern Sisters & brothers who think their slaves would be on our side in a civil war, will, I fear, find they have been artfully taken in—" Keziah Goodwyn Hopkins Brevard, *A Plantation Mistress*

on the Eve of the Civil War: The Diary of Keziah Goodwyn Hopkins Brevard, 1860–1861*, ed. John Hammond Moore (Columbia, SC: University of South Carolina Press, 1993), 86–87.

128 Eva Jones to Mary Jones, 14 July 1865, reprinted in *The Children of Pride: The True Story of Georgia and the Civil War*, ed. Robert Manson Myers (New Haven: Yale University Press, 1972), 1280. Quoted in Glymph, *Out of the House of Bondage*, 141.

129 The congruence between these two compositions was first noted by Sidney Kaplan, in "Notes on the Exhibition," in *The Portrayal of the Negro in American Painting* (Brunswick, ME: Bowdoin College Museum of Art, 1964), unpaginated. Credit given in Cikovsky and Kelly, *Winslow Homer*, 149n7.

130 For a thorough and insightful account of Tourgée's life, see *Undaunted Radical: The Selected Writings and Speeches of Albion W. Tourgée*. Albion Winegar Tourgée, Mark Elliott, and John David Smith (Baton Rouge: Louisiana State University Press, 2010).

131 Comparing his imprisonment to the experience of slavery, Tourgée concluded, "It is chagrin, humiliation—insult—fused in fierce flash of misery." Letter to Emma Tourgée, 6 May 1863 (#467), Albion Tourgée papers, Chautauqua County Historical Society, Westfield, NY; quoted in *Bricks without Straw*, 7, 66.

132 Albion W. Tourgée to W. M. Coleman, 4 Feb. 1868 (#765), Albion Tourgée papers, Chautauqua County Historical Society, Westfield, NY; quoted in *Bricks without Straw*, 6.

133 Tourgée achieved national renown in 1896, when he argued *Plessy v. Ferguson* before the U. S. Supreme Court, challenging Louisiana's segregation laws. For an excellent biography, see Mark Elliott, *Color-Blind Justice: Albion Tourgée and the Quest for Racial Equality from the Civil War to* Plessy v. Ferguson (Oxford: Oxford University Press, 2006).

134 A perceptive critic described the differing character of the two slave women, noting, "One of them grasps with her left arm a large bushel basket already almost full of cotton, and stoops slightly to pick some more. She is unhappy and disheartened. The other having filled an immense gunny-bag and slung it across her shoulder, stands erect, defiant and full of hatred for her adversaries." "Winslow Homer's *Cotton Pickers*," *New York Evening Post*, 30 March 1877; quoted in Lloyd Goodrich, *Record of Works by Winslow Homer: Volume II, 1867 through 1876*, ed. Abigail Booth Gerdts (New York: Spanierman Gallery, 2005), 416.

135 "The mulattoes…are the best specimens of manhood found in the South. The African mothers have given them a good physical system, and the Anglo-Saxon fathers a good mental constitution." C. G. Parsons, *Inside View of Slavery: or a Tour among the Planters* (Boston: John P. Jewett, 1855), 65–66;

quoted in Frederickson, *The Black Image in the White Mind*, 121 (see p. 265, n. 41).

136 *Henry Ward Beecher's "Cleveland Letters," The two letters on reconstruction of the Southern States. Written by Henry Ward Beecher, in 1866, upon being invited to act as chaplain of the "Soldier's and Sailor's Convention" held at Cleveland, Ohio, in the summer of that year* (n.p., 1884).

137 "Winslow Homer's *Cotton Pickers*;" quoted in Goodrich, *Record of Works by Winslow Homer*, 2:416.

138 Frederick Douglass, *My Bondage and My Freedom* (1855; reprinted, New York: Collier Books, 1969), 272.

AFTERMATH

Epigraph: Lucy Rebecca Buck, *Sad Earth, Sweet Heaven: The Diary of Lucy Rebecca Buck during the War between the States* (Birmingham, Alabama: Cornerstone, 1973), 50; quoted in Drew Gilpin Faust, *This Republic of Suffering*, (New York: Alfred A. Knopf, 2008) 268.

1 Henry James, "The Story of a Year," *Atlantic Monthly*, March 1865, 266.

2 Several scholars have done an admirable job in teasing out the layers of meaning in this painting. See Nicolai Cikovsky Jr., "Winslow Homer's Harvest of Death: *The Veteran in a New Field*," in Marc Simpson, *Winslow Homer: Paintings of the Civil War*, 83–102; and Christopher Kent Wilson, "Winslow Homer's *The Veteran in a New Field*: A Study of the Harvest Metaphor and Popular Culture," *American Art Journal* 17, no. 4 (Autumn 1985), 3–27. I am especially grateful to Randall Griffin for our many conversations about this painting. See "Negotiating Identity after the Civil War in the Paintings of Winslow Homer," in Griffin's book, *Homer, Eakins, and Anshutz: The Search for American Identity in the Gilded Age* (University Park: Pennsylvania State University, 2004).

3 The ubiquitous Henry Ward Beecher made this a theme in his novel *Norwood, or Village Life in New England* (New York: Charles Scribner & Company, 1867). On pp. 493–494 he wrote, "War ploughed the fields of Gettysburg, and planted the furrows with men. But, though the seed was blood, the harvest shall be peace, concord, liberty, and universal intelligence."

4 Hooker to Brigadier General S. Williams, assistant adjutant-general, Army of the Potomac. Washington, D.C., 8 Nov. 1862. Recorded in United States War Department, *The War of the Rebellion: A Compilation of the Official Records of the Union and Confederate Armies*, series 1, vol. 19, *Antietam, part 1* (Washington, DC: Government Printing Office, 1891), 213–219.

5 "The Minnesota First: From Our Special Correspondent, Washington, July 23, 1861," *New-York Daily Tribune*, 26 July 1861, 7; quoted in Eric T. Dean Jr., "'We Will All Be Lost and Destroyed': Post-Traumatic Stress Disorder and the Civil War," *Civil War History* 37, no. 2 (June 1991): 144–145.

6 Three pencil sketches now in the National Gallery of Art, Washington. D.C., bear inscriptions indicating Homer was in Virginia during late March and early April 1865. Accession numbers 1996.121.3; 1996.121.18; and 1996.121.6.a.

7 "Our Unreturning Heroes," *New-York Daily Tribune*, 21 July 1865, 7; quoted in Wilson, "Winslow Homer's *The Veteran in a New Field*," 19.

8 This painting is called *The Foggy Day* in "Reception at the Union League Club—Greenough's Portia, &c.," Fine Arts, *New York Times*, 17 May 1872, 3. It is displayed as *Young Maidenhood* in "The American Collection in the Somerville Gallery—The Best Works of Our Best Artists," Fine Arts, *New York Times*, 3 May 1873, 4; see also Art Notes, *The Daily Graphic* (New York), 2 May 1873, 6. It is rechristened *The Girl I Left Behind Me* in "The Art Gallery of the Chicago Exposition, from a Special Correspondent, Tuesday, September 21, 1875," Fine Arts in the West, *New York Times*, 26 Sept. 1875, 10.

9 "The American Collection in the Somerville Gallery—The Best Works of Our Best Artists," Fine Arts, *New York Times*, 3 May 1873, 4. The reviewer describes her as "a school-girl about fourteen, who, returning from school, books in hand, has chosen to take the pathway by the sea, that rages and flares under the lashing of the wind."

10 Henry David Thoreau, *Excursions* (Boston: Ticknor and Fields, 1863), 183.

11 Considerable uncertainty remains over whether Homer revisited the South, and if so, when and how many times. The lone published reference in the *New-York Tribune* of 9 June 1877 mentions Homer "has been spending a few weeks in the south, and is just home." Sketches and paintings Homer made prior to that date suggest greater familiarity with Southern subjects possibly stemming from firsthand experiences. Enumerations of what is known and conjectured appear in Mary Ann Calo, "Winslow Homer's Visits to Virginia during Reconstruction," *American Art Journal* 12, no. 1 (Winter 1980): 5–27; and Michael Quick, "Winslow Homer in Virginia," *Los Angeles County Museum Bulletin* 24 (1978): 60–81.

12 The Mummers Play migrated to America during the colonial era, notably in Philadelphia, which still stages a Mummers Play every New Year. For a history of street festivals in America, see Simon P. Newman, *Parades and the Politics of the Street: Festive Culture in the Early American Republic* (Philadelphia: University of Pennsylvania Press, 1997).

13 Stephen Nissenbaum, *The Battle for Christmas* (New York: Vintage Books 1997), 285.

14 "The Century Club," *New York Evening Post*, 2 June 1877; cited in Cikovsky and Kelly, *Winslow Homer*, 96.

15 Thavolia Glymph discusses this shift in tone from pre-war customs to postwar renegotiation of the relationships between blacks and whites in her book, *Out of the House of Bondage*, esp. 217–219.

16 In his diary entry for Thursday, 15 April 1890, McEntee made note of reading "a bitter partisan letter to Pres. Harrison published in the *Post* sent by Eastman Johnson who I am sorry to say now enjoys any abuse of the Republican party of which he was once a loyal and enthusiastic member." Jervis McEntee papers (1796), 1848–1905, Archives of American Art, Smithsonian Institution.

17 "Paris Exposition," *New York Times*, 6 April 1867, 5.

18 For a thorough and engaging account of the American presence at the Paris Exposition, see Carol Troyen, "Innocents Abroad: American Painters at the 1867 Exposition, Paris," *American Art Journal* 16, no. 4 (Autumn 1984): 2–29.

19 The Editor [A. T. Rice], "The Progress of Painting in America," *North American Review*, May–June 1877, 456.

20 Henry James, *Hawthorne* (Ithaca, NY: Cornell University Press, 1966), 112, 114.

21 "Brady's Photographs of the War," *New York Times*, 26 Sept. 1862, 5.

22 Humboldt, *Cosmos*, 1:153 (see p. 248, n. 78).

23 Toby Jurovics discusses the visible aspects of catastrophism in *Framing the West: The Survey Photographs of Timothy H. O'Sullivan* (New Haven: Yale University Press, 2010), 18–19.

24 Clarence King's friend, Henry Adams, also came to see himself as a failure for not having enlisted. In a letter to his brother, who was in uniform at the time, Adams wrote, "I've disappointed myself, and experience the curious sensation of discovering myself to be a humbug. How is this possible? Do you understand how, without a double personality, I can feel that I am a failure now?" Letter from Henry Adams to his brother, Charles Francis Adams Jr., 14 Feb. 1862; quoted in Adams, *The Education of Henry Adams*, 282. King survey botanist William Bailey noted with annoyance that O'Sullivan's "chief fault is his reminiscences of the Potomac Army. One would think he had slept with Grant and Meade and was the direct confidant of Stanton." William Whitman Bailey to his brother, Loring Bailey, 14 Aug. 1867 (HM 27841). The Huntington Library, San Marino, CA.

25 The primary goal in 1864 was to forestall the advent of hydraulic mining in the Yosemite area, but from this pragmatic foundation emerged a far more visionary articulation of Yosemite as a sanctuary for all Americans. See George Dimock, *Exploiting the View: Photographs of Yosemite and Mariposa by Carleton Watkins* (North Bennington, VT: Park-McCullough House, 1984), 17.

26 Clarence King arrived in March 1864 with Olmsted for King's first visit to Yosemite, then spent October 1864 with Olmsted, James T. Gardiner, and Richard Cotter to set the preserve boundaries. Wilkins with Hinkley, *Clarence King*, 59, 75–78 (see p. 252, n. 136).

27 Yosemite was introduced in the U.S. Senate on 28 March 1864 and was approved two days later "for public use, resort, and recreation…inalienable for all time." Noted in John F. Sears, *Sacred Places: American Tourist Attractions in the Nineteenth Century* (Amherst: University of Massachusetts Press, 1998), 130.

28 Kevin Starr notes that in the nineteenth century, Yosemite was a symbol of America as promised land, bestowed by God on chosen people. He calls it a second Eden, a new world utopia, a home of prosperity and justice. It carries forward the idealized view of nature as a place of spiritual and moral benefits. Human history in the park played no role in assigning these values. Kevin Starr, *Americans and the California Dream, 1850–1915* (Oxford: Oxford University Press, 1973), 183. Kate Nearpass Ogden also links the Edenic vision of California as attractive to Lincoln during the Civil War in her essay "California as Kingdom Come," in *Yosemite: Art of an American Icon*, ed. Amy Scott (Los Angeles: Autry National Center in Association with the University of California Press, 2006), 33.

29 Frederick Law Olmsted, "Yosemite and the Mariposa Grove: A Preliminary Report," (Washington, DC: Library of Congress, 1865), unpaginated. Olmsted notes that this place was set aside in part due to Watkins's photographs and Bierstadt's paintings "during one of the darkest hours" of the country's history.

30 Ralph Waldo Emerson, "Art," in *Emerson's Essays: First and Second Series* (New York: Gramercy Books, 1993), 185; quoted in Carbone and Hills, *Eastman Johnson: Painting America*, 43.

31 Chapter XIII, "On to Richmond," in David Macrae, *The Americans at Home: Pen and Ink Sketches of American Men, Manners, and Institutions* (New York: E. P. Dutton, 1952), 129–130, 131.

32 Caption to Plate 63 in Alexander Gardner, *Gardner's Photographic Sketchbook of the Civil War* (1866), vol. 2.

33 Mark Twain and Charles Dudley Warner, *The Gilded Age: A Tale of Today* (New York: Trident Press, 1964), 137–138.

BIBLIOGRAPHY

ART AND ART HISTORY

Aldrich, T. B. [Thomas Bailey]. "Among the Studios, I." *Our Young Folks*, September 1865, 594–598.

———. "Among the Studios, III." *Our Young Folks*, July 1866, 393–98.

———. "Among the Studios, V." *Our Young Folks*, October 1866, 622–25.

Allen, Brian T. *Sugaring Off: The Maple Sugar Paintings of Eastman Johnson*. Williamstown, MA: Sterling and Francine Clark Art Institute, 2004.

"American Genius Expressed in Art." *Round Table* 1, no. 2 (December 26, 1863), 21–22.

Anderson, Nancy K., and Linda S. Ferber. *Albert Bierstadt: Art & Enterprise*. New York: The Brooklyn Museum in association with Hudson Hills Press, 1990.

Anderson, Nancy K. *Thomas Moran*. With contributions by Thomas P. Bruhn, Joni L. Kinsey, and Anne Morand. Washington, DC: National Gallery of Art, 1997.

Art Institute of Chicago. *Terrain of Freedom: American Art and the Civil War*. Museum Studies Series, vol. 27, no. 1. Chicago: Art Institute of Chicago, 2001.

Aschenbrenner, Michael J. "The Hope of a Nation: Frederic Edwin Church's *Our Banner in the Sky* and *Aurora Borealis*." MA thesis, University of Wisconsin–Milwaukee, 2006.

Avery, Kevin J. *Church's Great Picture: "The Heart of the Andes."* New York: Metropolitan Museum of Art, 1993.

———. "'Rally 'round the Flag': Frederic Edwin Church and the Civil War." *Hudson River Valley Review* 27, no. 2 (Spring 2011): 66–103.

Avery, Kevin J., and Franklin Kelly, ed. *Hudson River School Visions: The Landscapes of Sanford R. Gifford*. New Haven, CT: Yale University Press for the Metropolitan Museum of Art, 2003.

Ayres, William, ed. *Picturing History: American Painting 1770–1930*. New York: Rizzoli in association with Fraunces Tavern Museum, 1993.

Balge-Crozier, Marjorie P. "Through the Eyes of the Artist: Another Look at Winslow Homer's *Sharpshooter*." *Imprint* 21, no. 1 (Spring 1996): 2–10.

Bascom, John. *Aesthetics: or, The Science of Beauty*. New York: Woolworth, Ainsworth, 1872.

Bassham, Ben L. *Conrad Wise Chapman: Artist & Soldier of the Confederacy*. Kent, OH: Kent State University Press, 1998.

———. "John Gadsby Chapman and Son: American Etchers in Italy, 1850–1884." *Tamarind Papers* 12 (1989): 28–37.

Baur, John I. H. *An American Genre Painter: Eastman Johnson, 1824–1906*. Brooklyn, NY: Brooklyn Museum, 1940.

Baxter, Jean Taylor. "Burdens and Rewards: Some Issues for American Artists, 1865–1876." PhD diss., University of Maryland, 1988.

Bayley, W. P. "Mr. Church's Picture of *The Icebergs*." *Art Journal* (London) 25 (September 1, 1863): 187–88.

———. "Mr. Church's Pictures: *Cotopaxi, Chimborazo*, and the *Aurora Borealis*." *Art Journal* (London) 27 (September 1, 1865): 265–67.

Beckham, Sue Bridwell. "By 'N By Hard Times…Eastman Johnson's *Life at the South* and American Minstrelsy." *Journal of American Culture* 6, no. 3 (Fall 1983): 19–25.

Bedell, Rebecca Bailey. *The Anatomy of Nature: Geology & American Landscape Painting, 1825–1875*. Princeton, NJ: Princeton University Press, 2001.

Bell, Christine Anne. "A Family Conflict: Visual Imagery of the 'Homefront' and the War Between the States, 1860–1866." PhD diss., Northwestern University, 1996.

Benson, Eugene. "Historical Art in the United States." *Appleton's Journal* 1, no. 2 (April 10, 1869), 45–46.

Bingham, George Caleb. *An Address to the Public, Vindicating a Work of Art Illustrative of Federal Military Policy in Missouri during the Late Civil War*. Kansas City, MO, 1871.

Bloch, E. Maurice. *The Paintings of George Caleb Bingham: A Catalogue Raisonné*. Columbia: University of Missouri Press, 1986.

Boettcher, Graham Corray. "Domestic Violence: The Politics of Family and Nation in Antebellum American Art." PhD diss., Yale University, 2006.

Boettger, Suzaan. "Eastman Johnson's *Blodgett Family* and Domestic Values during the Civil War Era." *American Art* 6, no. 4 (Autumn 1992): 50–67.

Boime, Albert. *The Art of Exclusion: Representing Blacks in the Nineteenth Century*. Washington, DC: Smithsonian Institution Press, 1990.

Bonham's Auction House. *Jasper Francis Cropsey: "Richmond Hill in the Summer of 1862."* London: Bonham's Auction House, catalogue for the sale of 14 December 1999.

Brewster, Anne. "Emmanuel Leutze, the Artist." *Lippincott's Magazine* 2 (November 1868), 533–38.

Bryant, William Cullen, ed. *Picturesque America: or, The Land We Live In*. New York: D. Appleton, 1872.

Bullard, CeCe. "Why Not Goochland? George Inness and Goochland County." *Goochland County Historical Society Magazine* 20 (1988): 24–35.

Burgard, Timothy Anglin, ed. *Masterworks of American Painting at the DeYoung*. San Francisco: Fine Arts Museums of San Francisco, 2005.

Burke, Doreen Bolger. "Frederic Edwin Church and *The Banner of Dawn*." *American Art Journal* 14, no. 2 (Spring 1982): 39–46.

Burnham, Patricia M., and Lucretia Hoover Giese, eds. *Redefining American History Painting*. New York: Cambridge University Press, 1995.

Burns, Sarah. *Painting the Dark Side: Art and the Gothic Imagination in Nineteenth-Century America*. Berkeley: University of California Press, 2004.

Burns, Sarah. *Pastoral Inventions: Rural Life in Nineteenth-Century American Art and Culture*. Philadelphia: Temple University Press, 1989.

Burns, Sarah, and John Davis. *American Art to 1900: A Documentary History*. Berkeley: University of California Press, 2009.

Calo, Mary Ann. "Winslow Homer's Visits to Virginia during Reconstruction." *American Art Journal* 12, no. 1 (Winter 1980): 5–27.

Campbell, Catherine. "Benjamin Bellows Grant Stone: A Forgotten American Artist," *New-York Historical Society Quarterly* 62 (January 1978): 22–42.

Campbell, Edward D. C., Jr. "The 'Eccentric Genius' of Conrad Wise Chapman." *Virginia Cavalcade* 37, no. 4 (Spring 1988): 158–75.

Campbell, William P. *The Civil War: A Centennial Exhibition of Eyewitness Drawings*. Washington, DC: National Gallery of Art, 1961.

Carbone, Teresa A., and Patricia Hills. *Eastman Johnson: Painting America*. Brooklyn, NY: Brooklyn Museum of Art in association with Rizzoli International Publications, 1999.

Carr, Gerald L. *Bierstadt's West*. New York: Gerald Peters Gallery, 1997.

———. "Beyond the Tip: Some Addenda to Frederic Church's *The Icebergs*." *Arts Magazine* 55 (November 1981): 107–11.

———. *Frederic Edwin Church: Catalogue Raisonné of Works of Art at Olana State Historic Site*. 2 vols. New York: Cambridge University Press, 1994.

———. *Frederic Edwin Church: "The Icebergs."* Dallas: Dallas Museum of Fine Arts, 1980.

———. *In Search of the Promised Land: Paintings by Frederic Edwin Church*. New York: Berry-Hill Galleries, 2000.

———. "Sanford Robinson Gifford's *Gorge in the Mountains* Revived." *Metropolitan Museum Journal* 38 (2003): 213–30.

S. N. C. [Carter, Susan N.] "Paintings at the Centennial Exhibition." *Art Journal* (New York) 2 (September 1876): 283–85.

Cash, Sarah. *Ominous Hush: The Thunderstorm Paintings of Martin Johnson Heade*. Fort Worth, TX: Amon Carter Museum, 1994.

Cassedy, David. *A Civil War Album: Works by Twenty Artists Exhibited at the Great Central Fair in Philadelphia, June 1864, and Sold to Benefit the U.S. Sanitary Commission*. Edited by Sherry Babbitt. Philadelphia: Schwarz Gallery, 1999.

Cavallo, A. S. "*Uncle Tom and Little Eva*: A Painting by Robert S. Duncanson." *Bulletin of the Detroit Institute of Arts* 30, no. 1 (1950–1951): 21–25

Chambers, Bruce W. *Art and Artists of the South: The Robert P. Coggins Collection*. Columbia: University of South Carolina Press, 1984.

———. "The Southern Artist and the Civil War." *Southern Quarterly* 24, nos. 1–2 (Fall/Winter 1985): 71–94.

———. *The World of David Gilmour Blythe (1815–1865)*. Washington, DC: Smithsonian Institution Press for the National Collection of Fine Arts, 1980.

Cikovsky, Nicolai, Jr. *George Inness*. New York: Praeger, 1971.

———. "'The Ravages of the Axe': The Meaning of the Tree Stump in Nineteenth-Century American Art." *Art Bulletin* 61, no. 4 (December 1979): 611–26.

———. *Winslow Homer*. New York: Abrams in association with the National Museum of American Art, Smithsonian Institution, 1990.

———. "A Harvest of Death: *The Veteran in a New Field*." In Marc Simpson, *Winslow Homer: Paintings of the Civil War*, 83–102. San Francisco: Bedford Arts, 1988.

————. "Winslow Homer's *Prisoners from the Front*." *Metropolitan Museum Journal* 12 (1977): 155–72.

Cikovsky, Nicolai, Jr., and Franklin Kelly. *Winslow Homer*. Washington, DC: National Gallery of Art; New Haven, CT: Yale University Press, 1995.

Cincinnati Art Museum. *Robert S. Duncanson: A Centennial Exhibition*. Cincinnati: Cincinnati Art Museum, 1972.

Clair, Jean, ed. *Cosmos: From Romanticism to the Avant-garde*. Montreal, Canada: Montreal Museum of Fine Arts, 1999.

Clapper, Michael. "Reconstructing a Family: John Rogers's *Taking the Oath and Drawing Rations*." *Winterthur Portfolio* 39, no. 4 (Winter 2004): 259–78.

Coddington, Edwin B. "Rothermel's Paintings of the Battle of Gettysburg." *Pennsylvania History* 27, no. 1 (January 1960): 1–27.

Colbert, Charles. "Winslow Homer's *Prisoners from the Front*." *American Art* 12, no. 2 (Summer 1998): 66–69.

Conn, Steven. "Narrative Trauma and Civil War History Painting, or Why Are These Pictures so Terrible?" *History and Theory* 41, no. 4 (December 2002): 17–42.

Connor, Holly Pyne. "City-Country Contrasts in American Painting, 1830–1860." PhD diss., Rutgers, The State University of New Jersey, 1996.

Conrads, Margaret C. *Winslow Homer and the Critics: Forging a National Art in the 1870s*. Princeton, NJ: Princeton University Press in association with the Nelson-Atkins Museum of Art, 2001.

[Cook, Clarence]. "Art. Painting and the War." *Round Table* 2, no. 32 (July 23, 1864), 90.

Cowdrey, Mary Bartlett. *National Academy of Design Exhibition Record, 1826–1860*. 2 vols. New York: New-York Historical Society, 1943.

Craig, Barbara L., and James O'Toole. "Looking at Archives in Art." *American Archivist* 63, no. 1 (Spring–Summer 2000): 97–125.

Cummings, Thomas Seir. *Historic Annals of the National Academy of Design, New-York Drawing Association, etc., with Occasional Dottings by the Way-Side, from 1825 to the Present Time*. Philadelphia: G. W. Childs, 1865.

Curry, David Park. "Winslow Homer: *Dressing for the Carnival*." In *Winslow Homer: A Symposium*, edited by Nicolai Cikovsky Jr., 91–113. Studies in the History of Art 26. Center for Advanced Study in the Visual Arts. Symposium Papers XI. Washington, DC: National Gallery of Art, 1990.

Davis, John. "Children in the Parlor: Eastman Johnson's *Brown Family* and the Post–Civil War Luxury Interior." *American Art* 10, no. 2 (Summer 1996): 51–77.

————. "Eastman Johnson's *Negro Life at the South* and Urban Slavery in Washington, D.C." *Art Bulletin* 80, no. 1 (March 1998): 67–92.

Day, Holliday T., and Hollister Sturges, eds. *Joslyn Art Museum: Paintings & Sculpture from the European & American Collections*. Omaha: Joslyn Art Museum, 1987.

Dearinger, David, ed. *Rave Reviews: American Art and Its Critics, 1826–1925*. New York: National Academy of Design, 2000.

Delamaire, Marie-Stéphanie. "William Wetmore Story's Nubian Cleopatra: Egypt and Slavery in 19th-Century America." In *Cleopatra Reassessed*, edited by Susan Walker and Sally-Ann Ashton, 113–17. The British Museum Occasional Paper. London: British Museum, 2003.

Driscoll, John Paul, and John K. Howat. *John Frederick Kensett: An American Master*. New York: Worcester Museum in association with W. W. Norton & Company, 1985.

Eldredge, Charles C. "Tales from the Easel." In *Tales from the Easel: American Narrative Paintings from Southeastern Museums, circa 1800–1950*, 7–70. Athens: University of Georgia Press in cooperation with the Southeastern Art Museum Directors Consortium, 2004.

"The Empty Sleeve at Newport; or, Why Edna Ackland Learned to Drive." *Harper's Weekly*, August 26, 1865, 532–34.

Everett, Patricia R. "John S. Jameson (1842–1864)." *American Art Journal* 15, no. 2 (Spring 1983): 53–59.

Falconer-Salkeld, Bridget. "Louis Moreau Gottschalk: Evidence for the Dedication of *Adieu funebré*." *American Music* 25, no. 3 (Fall 2007): 353–65.

Favis, Roberta Smith. "Worthington Whittredge's Domestic Interiors." *American Art* 9, no. 1 (Spring 1995): 14–35.

Ferber, Linda S. "John Brown's Grave and Other Civil War Themes in William Trost Richards's Adirondack Landscapes." *Antiques* 162, no. 1 (July 2002), 72–81.

Forman, William Henry. "Jasper Francis Cropsey, N. A." *Manhattan* 3, no. 4 (April 1884), 372–82.

Freeman, Larry. *The Hope Paintings*. Watkins Glen, NY: Century House, 1961.

Fryd, Vivien Green. *Art & Empire: The Politics of Ethnicity in the United States Capitol, 1815–1860*. New Haven, CT: Yale University Press, 1992.

Giese, Lucretia H. "Winslow Homer: 'Best Chronicler of the War.'" In *Winslow Homer: A Symposium*, edited by Nicolai Cikovsky Jr., 15–31. Studies in the History of Art 26. Center for Advanced Study in the Visual Arts. Symposium Papers XI. Washington, DC: National Gallery of Art, 1990.

———. "Winslow Homer's Civil War Painting *The Initials*: A Little-Known Drawing and Related Works." *American Art Journal* 18, no. 3 (Summer 1986): 4–19.

Gilbert, Barbara C. *Henry Mosler Rediscovered: A Nineteenth-Century American-Jewish Artist*. Los Angeles: Skirball Museum, 1995.

Gislason, Eric. "Imaging America: *The Red Badge of Courage* and Visual Representations of the Civil War." MA thesis, University of Virginia, 1996.

Goodrich, Lloyd. "The Painting of American History: 1775–1900." *American Quarterly* 3, no. 4 (Winter 1951): 283–94.

———. *Record of Works by Winslow Homer*. Vol. 1, *1846 through 1866*. Edited and expanded by Abigail Booth Gerdts. New York: Spanierman Gallery, 2005.

———. *Record of Works by Winslow Homer*. Vol. 2, *1867 through 1876*. Edited and expanded by Abigail Booth Gerdts. New York: Spanierman Gallery, 2005.

Griffin, Randall C. *Winslow Homer: American Vision*. London: Phaidon, 2006.

———. *Homer, Eakins, and Anshutz: The Search for American Identity in the Gilded Age*. University Park: Pennsylvania State University, 2004.

Greenhalgh, Adam. "'Darkness Visible': *A Twilight in the Catskills* by Sanford Robinson Gifford." *American Art Journal* 32, nos. 1–2 (2001): 45–75.

Groseclose, Barbara S. "Painting, Politics, and George Caleb Bingham." *American Art Journal* 10, no. 2 (November 1978): 4–19.

Grover, Jan Zita. "The First Living-Room War: The Civil War in the Illustrated Press." *Afterimage* 11, (February 1984): 8–11.

Guernsey, Alfred H., and Henry M. Alden. *Harper's Pictorial History of the Great Rebellion*. 2 vols. New York: McDonnell Bros., 1866.

Haltman, Kenneth. "Antipastoralism in Early Winslow Homer." *Art Bulletin* 80, no. 1 (March 1998): 93–112.

Harrison, Alfred C., Jr. "Bierstadt's *Bombardment of Fort Sumter* Reattributed." *Antiques* 129 (February 1986), 416–22.

———. "Frederic Edwin Church's *Our Banner in the Sky*: An Update on an American Icon." *Antiques* 174, no. 5 (November 2008), 150–51.

Hart, Julie Carol. "Frederic Edwin Church's *Aurora Borealis*: A Symbol of Union Nationalism during the Civil War." MA thesis, George Washington University, 1996.

Hartigan, Lynda Roscoe. *Sharing Traditions: Five Black Artists in Nineteenth-Century America*. Washington, DC: Smithsonian Institution Press, 1985.

Harvey, Eleanor Jones. *The Painted Sketch: American Impressions from Nature, 1830–1880*. Dallas: Harry N. Abrams in association with the Dallas Museum of Art, 1998.

———. *Thomas Moran and the Spirit of Place*. Dallas: Dallas Museum of Art, 2001.

———. *The Voyage of "The Icebergs": Frederic Church's Arctic Masterpiece*. New Haven, CT: Yale University Press and the Dallas Museum of Art, 2002.

Hasker, Leslie A., and J. Kevin Graffagnino. "Thomas Waterman Wood and the Image of Nineteenth-Century America." *Antiques* 118, no. 5 (November 1980), 1032–42.

Hendricks, Gordon. *Albert Bierstadt: Painter of the American West*. New York: Abrams in association with the Amon Carter Museum of Western Art, 1974.

———. "Bierstadt and Church at the New York Sanitary Fair." *Antiques* 102, no. 5 (November 1972), 892–98.

———. *The Life and Work of Winslow Homer*. New York: Abrams, 1979.

Hicklin, Robert M., Jr. *Calm in the Shadow of the Palmetto & Magnolia: Southern Art from the Charleston Renaissance Gallery*. Charleston, SC: Charleston Renaissance Gallery, 2003.

Hills, Patricia. "Cultural Racism: Resistance and Accommodation in the Civil War Art of Eastman Johnson and Thomas Nast." In *Seeing High and Low: Representing Social Conflict in American Visual Culture*, edited by Patricia Johnston, 103–23. Berkeley: University of California Press, 2006.

———. "Eastman Johnson's *The Field Hospital*: The U. S. Sanitary Commission and Women in the Civil War." *Minneapolis Institute of Arts Bulletin* 65 (1981–1982): 66–81.

———. *The Painters' America: Rural and Urban Life, 1810–1910*. New York: Whitney Museum of American Art in association with Praeger Publishers, 1974.

———. "Painting Race: Eastman Johnson's Pictures of Slaves, Ex-Slaves, and Freedmen." In *Eastman Johnson: Painting America*, edited by Teresa C. Carbone and Patricia Hills, 120–165. Brooklyn, NY: Brooklyn Museum of Art in association with Rizzoli International Publications, 1999.

———. "Picturing Progress in the Era of Westward Expansion." In *The West as America: Reinterpreting Images of the Frontier, 1820–1920*, edited by William H. Truettner, 97–148. Washington, DC: Smithsonian Institution Press for the National Museum of American Art, 1991.

Holzer, Harold, and Mark E. Neely Jr. *Mine Eyes Have Seen the Glory: The Civil War in Art*. New York: Orion Books, 1993.

Home Book of the Picturesque. New York: G. P. Putnam, 1852.

Honour, Hugh. *The Image of the Black in Western Art*. Vol. 4, *From the American Revolution to World War I, Part 1: Slave and Liberators*. Cambridge, MA: Harvard University Press, 1989.

Howat, John K. "American Paintings and Sculpture: *Christmas-Time*; *The Blodgett Family*." In *Notable Acquisitions, 1983–1984*, 85–86. New York: Metropolitan Museum of Art, 1984.

———. *American Paradise: The World of the Hudson River School*. New York: Metropolitan Museum of Art, 1987.

———. *Frederic Church*. New Haven, CT: Yale University Press, 2005.

Hult, Christine. "*Uncle Tom's Cabin:* Popular Images of Uncle Tom and Little Eva, 1852–1892." *Nineteenth Century* 15, no. 1 (1995): 3–8.

Huntington, David C. "Church and Luminism: Light for America's Elect." In *American Light: The Luminist Movement, 1850–1875*, edited by John Wilmerding, 155–87. Washington, DC: National Gallery of Art, 1980.

———. "Frederic Church's *Niagara*: Nature and the Nation's Type." *Texas Studies in Literature and Language* 25, no. 1 (Spring 1983): 100–138.

———. *Frederic Edwin Church*. Washington, DC: National Collection of Fine Arts, 1966.

———. "Frederic Edwin Church, 1826–1900: Painter of the Adamic New World Myth." PhD diss., Yale University, 1960.

Hynes, Samuel. "The Death of Landscape." *Quarterly Journal of Military History* 3, no. 3 (Spring 1991): 17–27.

Janney, Caroline E. "*The Burial of Latané*." In *Encyclopedia Virginia*, edited by Brendan Wolfe. Virginia Foundation for the Humanities. 2011. http://www.encyclopediavirginia.org/Burial_of_LatanAC._The.

Janson, Anthony F. *Worthington Whittredge*. New York: Cambridge University Press, 1989.

Jarves, James Jackson. *The Art-Idea: Sculpture, Painting, and Architecture in America*. Edited by Benjamin Rowland Jr. Cambridge, MA: Belknap Press of Harvard University Press, 1960. First published 1865 by Hurd & Houghton.

Jensen, Leslie D. "Conrad Wise Chapman: Soldier and Artist." *Connoisseur* 200, no. 805 (March 1979): 195–99.

Johns, Elizabeth. *American Genre Painting: The Politics of Everyday Life*. New Haven, CT: Yale University Press, 1991.

Johnson, Ellen H. "Kensett Revisited." *Art Quarterly* 20, no. 1 (1957): 71–92.

Johnston, Patricia, ed. *Seeing High & Low: Representing Social Conflict in American Visual Culture*. Berkeley: University of California Press, 2006.

Kaplan, Sidney. "Notes on the Exhibition." In *The Portrayal of the Negro in American Painting*. Brunswick, ME: Bowdoin College Museum of Art, 1964.

Kelly, Franklin. *Frederic Edwin Church and the National Landscape*. Washington, DC: Smithsonian Institution Press, 1988.

Kelly, Franklin, Stephen Jay Gould, James Anthony Ryan, and Debora Rindge. *Frederic Edwin Church*. Washington, DC: National Gallery of Art, 1989.

Kensett, J. F. *VIth Annual Report of Artists' Fund Society of the City of New York, 1865–66*. New York: G. A. Whitehorne, 1866.

Ketner, Joseph D. *The Emergence of the African-American Artist: Robert S. Duncanson, 1821–1872*. Columbia: University of Missouri Press, 1993.

Ketner, Joseph D., II. "Robert S. Duncanson: The Late Literary Landscape Paintings." *American Art Journal* 15, no. 1 (Winter 1983): 35–47.

———. *Robert S. Duncanson: "The Spiritual Striving of the Freedmen's Sons."* Catskill, NY: Thomas Cole National Historic Site, 2011.

Keyes, Donald K. "Catalogue no. 97." In *Joslyn Art Museum: Paintings & Sculpture from the European & American Collections*, edited by Holliday T. Day and Hollister Sturges, 147–148. Omaha, NE: Joslyn Art Museum, 1987.

Kinsey, Joni. "History in Natural Sequence: The Civil War Polyptych of Frederic Edwin Church." In *Redefining American History Painting*, edited by Patricia M. Burnham and Lucretia Hoover Giese, 158–73. New York: Cambridge University Press, 1995.

Kleeblatt, Norman L. "Master Narratives/Minority Artists." *Art Journal* 57, no. 3 (Autumn 1998): 29–35.

Knox, Ella-Prince, David S. Bundy, Donald B. Kuspit, et al. *Painting in the South: 1564–1980*. Richmond: Virginia Museum of Fine Arts, 1983.

Lansing, Amy Kurtz. *Historical Fictions: Edward Lamson Henry's Paintings of Past and Present*. New Haven, CT: Yale University Art Gallery, 2005.

Lewis, Daniel Clayton. "Emanuel Leutze's *Westward the Course of Empire Takes Its Way*: Imagining Manifest Destiny, the 'Stars and Stripes,' and the Civil War." In *The United States Capitol: Designing and Decorating a National Icon*, edited by Donald Kennon, 239–55. Athens: Ohio University Press, 2000.

Liakos, Barbaranne Elizabeth Mocella. "The American Civil War and Collective Memory: Reconstructing the National Conflict in Paintings and Prints, 1869–1894." PhD diss., University of Iowa, 2009.

Lionel. "The Artists' Fund Society, Fourth Annual Exhibition." *New Path* 1, no. 8 (December 1863), 92–98.

Lubin, David M. *Picturing a Nation: Art and Social Change in Nineteenth-Century America*. New Haven, CT: Yale University Press, 1994.

Mack, Angela D., and Stephen G. Hoffius, eds. *Landscape of Slavery: The Plantation in American Art*. Columbia: University of South Carolina Press, 2008.

Macrae, David. *The Americans at Home: Pen-and-Ink Sketches of American Men Manners and Institutions*. 2 vols. New York: E.P. Dutton & Co., 1952. First published 1870 by MacMillan and Co.

Maddox, Kenneth W. *An Unprejudiced Eye: The Drawings of Jasper F. Cropsey*. Yonkers, NY: Hudson River Museum, 1979.

Manthorne, Katherine E. *Creation and Renewal: Views of Cotopaxi by Frederic Edwin Church*. Washington, DC: Smithsonian Institution Press, 1985.

———. *Tropical Renaissance: North American Artists Exploring Latin America, 1839–1879*. Washington, DC: Smithsonian Institution Press, 1989.

Manthorne, Katherine E., with John W. Coffey. *The Landscapes of Louis Rémy Mignot, a Southern Painter Abroad*. Raleigh, NC: Published for the North Carolina Museum of Art by Smithsonian Institution Press, 1996.

Martin, Elizabeth Gilbert. *Homer Martin, a Reminiscence*. New York: W. Macbeth, 1904.

Martin, Nona R. "*Negro Life at the South*: Eastman Johnson's Rendition of Slavery and Miscegenation." MA thesis, University of Pittsburgh, 1994.

Matthews, Mildred. "The Painters of the Hudson River School in the Philadelphia Centennial of 1876." *Art in America* 34 (July 1946): 143–60.

McCausland, Elizabeth. *The Life and Work of Edward Lamson Henry, N.A., 1841–1919*. New York State Museum Bulletin no 339. Albany: University of the State of New York, 1945.

McElroy, Guy. "Robert S. Duncanson: A Study of the Artist's Life and Work." In *Robert Duncanson: A Centennial Exhibition*, 1–17. Cincinnati. OH: Cincinnati Art Museum, 1972.

McInnis, Mauric D. "The Most Famous Plantation of All: The Politics of Painting Mount Vernon." In *Landscape of Slavery: The Plantation in American Art*, edited by Angela D. Mack and Stephen G. Hoffius, 86–114. Columbia: University of South Carolina Press, 2008.

———. *Slaves Waiting for Sale. Abolitionist Art and the African Slave Trade*. Chicago: University of Chicago Press, 2011.

A Memorial Catalogue of the Paintings of Sanford Robinson Gifford, N.A., with a Biographical and Critical Essay by Prof. John F. Weir, of the Yale School of Fine Arts. New York: Metropolitan Museum of Art, 1881.

Miller, Angela. "Albert Bierstadt, Landscape Aesthetics, and the Meanings of the West in the Civil War Era." *Art Institute of Chicago Museum Studies* 27, no. 1 (2001): 40–59.

Miller, David C. *Dark Eden: The Swamp in Nineteenth-Century American Culture*. New York: Cambridge University Press, 1989.

———. "The Iconology of Wrecked or Stranded Boats in Mid- to Late Nineteenth-Century American Culture." In *American Iconology: New Approaches to Nineteenth-Century Art and Literature*, edited by David C. Miller, 187–208. New Haven, CT: Yale University Press, 1993.

Mills, Cynthia, and Pamela H. Simpson, eds. *Monuments to the Lost Cause: Women, Art, and the Landscapes of Southern Memory*. Knoxville: University of Tennessee Press, 2003.

Milroy, Elizabeth. "Avenue of Dreams: Patriotism and the Spectator at Philadelphia's Great Central Sanitary Fair." In *Making and Remaking Pennsylvania's Civil War*, edited by William Blair and William Pencak, 23–57. State College: Pennsylvania State University Press, 2001.

Mitchell, W. T. J., ed. *Landscape and Power*. Chicago: University of Chicago Press, 1994.

Moore, Charlotte Emans. "Art as Text, War as Context: The Art Gallery of the Metropolitan Fair, New York City's Artistic Community, and the Civil War." PhD diss., Boston University, 2009.

Moore, James. "The Storm and the Harvest: The Image of Nature in Mid-Nineteenth-Century American Landscape Painting." PhD diss., Indiana University, 1974.

Morgan, Jo-Ann. "Thomas Satterwhite Noble's Mulattos: From Barefoot Madonna to Maggie the Ripper." *Journal of American Studies* 41 (2007): 83–114.

National Gallery of Art. *The Civil War: A Centennial Exhibition of Eyewitness Drawings.* Washington, DC: National Gallery of Art, 1961.

Naylor, Maria K. *The National Academy of Design Exhibition Record, 1861–1900.* New York: Kennedy Galleries, 1973.

Neely, Mark E., Jr., and Harold Holzer. *The Union Image: Popular Prints of the Civil War North.* Chapel Hill: University of North Carolina Press, 2000.

Neely, Mark E., Jr., Harold Holzer, and Gabor S. Boritt, eds. *The Confederate Image: Prints of the Lost Cause.* Chapel Hill: University of North Carolina Press, 1987.

Nicoll, Jessica. "Winslow Homer, *Sharpshooter.*" *American Art Review* 5, no. 3 (Spring 1993): 104, 165–66.

Noble, Louis LeGrand. *After Icebergs with a Painter.* New York: D. Appleton, 1861.

Novak, Barbara. *Nature and Culture: American Landscape and Painting, 1825–1875.* New York: Oxford University Press, 1980.

Ochoa, Sonia Alicia. "'A Passion for Pictures': The Art Collection of Austin and Susan Dickinson." MA thesis, University of Delaware, 2000.

O'Leary, Elizabeth L. *At Beck and Call: The Representation of Domestic Servants in Nineteenth-Century American Painting.* Washington, DC: Smithsonian Institution Press, 1996.

Orcutt, Kimberly, ed. *John Rogers: American Stories.* New York: New-York Historical Society, 2010.

Parks, James Dallas. *Robert S. Duncanson, 19th Century Black Romantic Painter.* Washington, DC: Associated Publishers, 1980.

Parry, Ellwood. *The Image of the Indian and the Black Man in American Art, 1590–1900.* New York: G. Braziller, 1974.

Penn, Dorothy. "George Caleb Bingham's *Order No. 11.*" *Missouri Historical Review* 30 (1946): 349–57.

Pennington, Estill Curtis. *The Last Meeting's Lost Cause.* Spartanburg, SC: Robert M. Hicklin, Jr., Inc., 1988.

———. *Look Away: Reality and Sentiment in Southern Art.* Spartanburg, SC: Saraland Press, 1989.

Peters-Campbell, John. "The Big Picture and the Epic American Landscape." PhD diss., Cornell University, 1989.

Pohl, Frances K. "Black and White in America." In *Nineteenth-Century Art: A Critical History,* edited by Stephen C. Eisenman, 166–67. New York: Thames and Hudson, 1994.

Quick, Michael. "Winslow Homer in Virginia." *Los Angeles County Museum Bulletin* 24 (1978): 60–81.

Rash, Nancy. "A Note on Winslow Homer's *Veteran in a New Field* and Union Victory." *American Art* 9, no. 2 (Summer 1995): 88–93.

———. *The Painting and Politics of George Caleb Bingham.* New Haven, CT: Yale University Press, 1991.

Ray, Frederic E. *Alfred R. Waud, Civil War Artist.* New York: Viking, 1974.

Richards, T. Addison. "The Landscapes of the South." *Harper's New Monthly Magazine* 6, no. 36 (May 1853): 721–33.

Rutledge, Anna Wells. *The Annual Exhibition Records of the Pennsylvania Academy of the Fine Arts, 1807–1870.* Madison, CT: Sound View, 1989.

Savage, Kirk. *Standing Soldiers, Kneeling Slaves: Race, War and Monument in Nineteenth-Century America.* Princeton, NJ: Princeton University Press, 1997.

Scott, Amy, ed. *Yosemite: Art of an American Icon.* Los Angeles: Autry National Center of the American West, 2006.

Seibels, Cynthia. *The Sunny South, the Life and Art of William Aiken Walker.* Spartanburg, SC: Saraland Press, 1995.

Shapiro, Emily D. "Recollection and Reconstruction: Edward Lamson Henry's Depictions of Westover." *American Art* 25, no. 1 (Spring 2011): 74–95.

Sharp, Kevin. *Bold, Cautious, True: Walt Whitman and American Art of the Civil War Era.* Memphis, TN: Dixon Gallery and Gardens, 2009.

Sheldon, George. *American Painters.* New York: D. Appleton, 1879.

———. "How One Landscape Painter Paints." *Art Journal* 3, no. 9 (1877): 284.

Sheley, Nancy Strow. "Taking Up the Gauntlet: George Henry Hall's Raspberries." *American Art* 19, no. 3 (Fall 2005): 82–91.

Sill, Geoffrey M., and Roberta K. Tarbell, eds. *Walt Whitman and the Visual Arts*. New Brunswick, NJ: Rutgers University Press, 1992.

Simms, L. Moody, Jr. "Conrad Wise Chapman: a Virginia Expatriate Painter." *Virginia Cavalcade* 20, no. 4 (Spring 1971): 12–27.

Simpson, Marc, et al. *Winslow Homer: Paintings of the Civil War*. San Francisco: Bedford Arts, 1988.

Simpson, Pamela H. *So Beautiful an Arch: Images of the Natural Bridge, 1787–1890*. Lexington, VA: Washington and Lee University, 1982.

Skalet, Linda Henefield. "The Market for American Painting in New York: 1870–1915." PhD diss., Johns Hopkins University, 1980.

Spassky, Natalie, et al. *American Paintings in the Metropolitan Museum of Art*. Vol. 2, *A Catalogue of Works by Artists Born between 1816 and 1845*. New York: Metropolitan Museum of Art in association with Princeton University Press, 1985.

Spassky, Natalie. "Winslow Homer at the Metropolitan Museum of Art." *Metropolitan Museum of Art Bulletin* 39, no. 4 (Spring 1982): 2–49.

Stebbins, Theodore E., Jr. *The Life and Works of Martin Johnson Heade*. New Haven, CT: Yale University Press, 1975.

———. *The Life and Work of Martin Johnson Heade, a Critical Analysis and Catalogue Raisonné*. New Haven, CT: Yale University Press, 2000.

Stehle, Raymond Louis. "Five Sketchbooks of Emanuel Leutze." *Quarterly Journal of the Library of Congress* 21, no. 2 (April 1964): 81–93.

———. "'Westward Ho!': The history of Leutze's Fresco in the Capitol." *Records of the Columbia Historical Society of Washington, D.C.*, 1960/1962, 306–22.

Stein, Roger B. "After the War: Constructing a Rural Past." In *Picturing Old New England: Image and Memory*, edited by William H. Truettner and Roger B. Stein, 15–42. Washington, DC: Yale University Press for the National Museum of American Art, 1999.

Stern, Philip Van Doren. *They Were There: The Civil War in Action as Seen by Its Combat Artists, with Six Poems by Walt Whitman*. New York: Crown Publishers, 1959.

Sternberger, Paul Spencer. "'Wealth Judiciously Expended': Robert Leighton Stuart as Collector and Patron." *Journal of the History of Collections* 15, no. 2 (2003): 229–40.

Stevenson, Laura Lee Trent. *Confederate Soldier Artists: Painting the South's War*. Shippensburg, PA: White Mane, 1998.

Sturgis, Russell, Jr. "American Painters." *Galaxy* 4, no. 2 (June 1867): 226–36.

Sweeney, J. Gray. "A 'very peculiar' picture: Martin J. Heade's *Thunderstorm over Naragansett Bay*." *Archives of American Art Journal* 28, no.4 (1988): 2–14.

———. *McEntee & Company*. New York: Beacon Hill Fine Art, 1997.

Talbot, William S. *Jasper F. Cropsey, 1823–1900*. Washington, DC: Smithsonian Institution Press for National Collection of Fine Arts, 1970.

Tatham, David. "Winslow Homer at the Front in 1862." *American Art Journal* 11, no. 3 (July 1979): 86–87.

Thistlethwaite, Mark. "Magnificence and Terrible Truthfulness." In *Making and Remaking Pennsylvania's Civil War*, edited by William Blair and William Pencak, 211–44. University Park: Pennsylvania State University Press, 2001.

———. *Painting in the Grand Manner: The Art of Peter Frederick Rothermel (1812–1895)*. Chadds Ford, PA: Brandywine River Museum, 1995.

Thomas Waterman Wood, P.N.A., 1823–1903. Montpelier, VT: Wood Art Gallery, 1972.

Titterton, Robert J. *Julian Scott: Artist of the Civil War and Native America*. Jefferson, NC: McFarland, 1997.

Torchia, Robert Wilson. *Xanthus Smith and the Civil War*. Philadelphia: Schwarz Gallery, 1999.

Trovaioli, August P., and Roulhac B. Toledano. *William Aiken Walker, Southern Genre Painter*. Baton Rouge: Louisiana State University Press, 1972.

Troyen, Carol. "Innocents Abroad: American Painters at the 1867 Exposition Universelle, Paris." *American Art Journal* 16, no. 4 (Autumn 1984): 2–29.

Truettner, William H. "The Genesis of Frederic Edwin Church's *Aurora Borealis*." *Art Quarterly* 31 (Autumn 1968): 267–83.

Tuckerman, Henry T. *Book of the Artists: American Artist Life*. New York: G. P. Putnam, 1867.

Wallace, David H. *John Rogers: The People's Sculptor*. Middletown, CT: Wesleyan University Press, 1967.

Weidner, Ruth Irwin. *George Cochran Lambdin, 1830–1896*. Chadds Ford, PA: Brandywine River Museum, 1986.

Weir, John F. "Sanford R. Gifford. His Life and Character as Artist and Man." In *Catalogue of Valuable Oil Paintings: Works of the Famous Artist, Sanford R. Gifford, N.A., Deceased, to Be Sold.* New York: Thomas E. Kirby, 1881.

Weiss, Ila. *Poetic Landscape: The Art and Experience of Sanford R. Gifford.* Newark, NJ: University of Delaware Press, 1987.

———. "Sanford Robinson Gifford (1823–1880)," PhD diss., Columbia University, 1968.

Whiting, Cécile. "Trompe l'oeil Painting and the Counterfeit Civil War." *Art Bulletin* 79, no. 2 (June 1997): 251–68.

Whittredge, Worthington. "The Autobiography of Worthington Whittredge, 1820–1910." Edited by John I. H. Baur. *Brooklyn Museum Journal* 1 (1942): 4–67.

Wierich, Jochen. "*War Spirit at Home*: Lilly Martin Spencer, Domestic Painting, and Artistic Hierarchy." *Winterthur Portfolio* 37, no. 1 (Spring 2002): 23–42.

Wilkins, Thurman, with Caroline Lawson Hinkley. *Thomas Moran: Artist of the Mountains.* 2nd ed. Norman: University of Oklahoma Press, 1998.

Williams, Hermann Warner. *The Civil War: The Artists' Record.* Washington, DC: Corcoran Gallery of Art, 1961.

Wilmerding, John. "The Allure of Mount Desert." In *American Views: Essays on American Art*, 99–122. Princeton, NJ: Princeton University Press, 1991.

Wilmerding, John, ed. *American Light: The Luminist Movement, 1850–1875.* Washington, DC: National Gallery of Art, 1980.

Wilson, Christopher Kent. "A Contemporary Source for Winslow Homer's *Prisoners from the Front*." *Source* 4, no. 4 (Summer 1985): 37–40.

———. "Marks of Honor and Death: Sharpshooters and the Peninsular Campaign of 1862." In Marc Simpson, *Winslow Homer: Paintings of the Civil War*, 25–46. San Francisco: Bedford Arts, 1988.

———. "Winslow Homer's *Thanksgiving Day—Hanging Up the Musket*." *American Art Journal* 18, no. 4 (Autumn 1986): 76–83.

———. "Winslow Homer's *The Veteran in a New Field*: A Study of the Harvest Metaphor and Popular Culture." *American Art Journal* 17, no. 4 (Autumn 1985): 2–27.

Witt, Susan Powell. "The Gendered Language of War: Picturing the Parlor in Civil War America." PhD diss., Stanford University, 2009.

Wood, Peter H. "*Near Andersonville*": Winslow Homer's Civil War.* Cambridge, MA: Harvard University Press, 2010.

Wood, Peter H., and Karen C. C. Dalton. *Winslow Homer's Images of Blacks: The Civil War and Reconstruction Years.* Austin: University of Texas Press, 1988.

Wright, Lesley Carol. "Men Making Meaning in Nineteenth-Century American Genre Painting, 1860–1900." PhD diss., Stanford University, 1993.

Xanthus Smith: Scenes from the Battle of Mobile Bay. Mobile, AL: Mobile Convention and Visitors Corporation, 1977.

HISTORY: PRIMARY SOURCES

Adams, Henry. *The Education of Henry Adams.* Edited with an introduction and notes by Ernest Samuels. Boston: Houghton Mifflin Company, 1973. First published 1918 by the Massachusetts Historical Society.

Beecher, Henry Ward. *Lectures and Orations.* New York: Fleming H. Revell, 1913.

Bellard, Alfred. *Gone for a Soldier: The Civil War Memoirs of Private Alfred Bellard.* Edited by David Herbert Donald. Boston: Little, Brown, 1975.

Benedict, George Grenville. *Army Life in Virginia: Letters from the Twelfth Vermont Regiment and Personal Experiences of Volunteer Service in the War for the Union, 1862–63.* Burlington, VT: Free Press Association, 1895.

Bibb, Henry. *Narrative of the Life and Adventures of Henry Bibb, an American Slave, Written by Himself.* New York: Negro Universities Press, 1969. First published 1849 by the author.

Blight, David W. *A Slave No More: Two Men Who Escaped to Freedom: Including Their Own Narratives of Emancipation.* Orlando, FL: Harcourt, 2007.

Brevard, Keziah Goodwyn Hopkins. *A Plantation Mistress on the Eve of the Civil War: The Diary of Keziah Goodwyn Hopkins Brevard, 1860–1861.* Edited by John Hammond Moore. Columbia: University of South Carolina Press, 1993.

Butler, Benjamin F. *Butler's Book.* Boston: A. M. Thayer, 1892.

Chapman, Conrad Wise. *Ten Months in the "Orphan Brigade": Conrad Wise Chapman's Civil War Memoir.* Edited by Ben L. Bassham. Kent, OH: Kent State University Press, 1999.

Chesnut, Mary Boykin. *A Diary from Dixie.* New York: D. Appleton, 1905.

———. *The Private Mary Chesnut: The Unpublished Civil War Diaries.* Edited by C. Vann Woodward and Elisabeth Muhlenfeld. New York: Oxford University Press, 1984.

Davenport, Alfred. *Camp and Field Life of the Fifth New York Volunteer Infantry (Duryee Zouaves)*. New York: Dick and Fitzgerald, 1879.

DeLeon, T. C. *Four Years in Rebel Capitals: An Inside View of Life in the Southern Confederacy, from Birth to Death*. Mobile, AL: Gossip Printing Company, 1890.

Douglass, Frederick. *Narrative of the Life of Frederick Douglass, an American Slave, Written by Himself*. Edited with an introduction by David W. Blight. Boston: Bedford Books, 1993. First published 1845 by Anti-Slavery Office.

———. "Why Should a Colored Man Enlist?" *Douglass' Monthly*, April 1863, http://teachingamericanhistory.org/library/index. asp?document=1135.

Eisenschiml, Otto, and Ralph Newman, eds. *Eyewitness: The Civil War as We Lived It*. New York: Grosset & Dunlap, 1956. First published 1947 as *The American Iliad* by Bobbs-Merrill.

Forten, Charlotte. "Life on the Sea Islands, Part I." *Atlantic Monthly* 13, no. 79 (May 1864), 587–96.

———. "Life on the Sea Islands, Part II." *Atlantic Monthly* 13, no. 80 (June 1864), 666–76.

Goodrich, Frank Boott. *The Tribute Book: A Record of the Munificence, Self-sacrifice and Patriotism of the American People during the War for the Union*. New York: Derby & Miller, 1865.

Higginson, Thomas Wentworth. *The Complete Civil War Journal and Selected Letters of Thomas Wentworth Higginson*. Edited by Christopher Looby. Chicago: University of Chicago Press, 2000.

———. "The Ordeal by Battle." *Atlantic Monthly* 8, no. 45 (July 1861), 88–95.

Holmes, Emma. *The Diary of Miss Emma Holmes, 1861–1866*. Edited by John F. Marszalek. Baton Rouge: Louisiana State University Press, 1979.

Holmes, Oliver Wendell. "Bread and the Newspaper." *Atlantic Monthly* 8, no. 47 (September 1861), 346–362.

———. "My Hunt after the Captain." *Atlantic Monthly* 10, no. 62 (December 1862), 738–64.

Holmes, Theodore J. *A Memorial of John S. Jameson, Sergeant in the 1st Conn. Cavalry, Who Died at Andersonville, Ga.* n.p., 1866.

Jacobs, Harriet A. *Incidents in the Life of a Slave Girl, Written by Herself*. Edited by Jean Fagan Yellin. Cambridge, MA: Harvard University Press, 1987. First published 1861.

Johnson, John. *The Defense of Charleston Harbor, Including Fort Sumter and the Adjacent Islands, 1863–1865*. 1889. Reprint, Freeport, NY: Books for Libraries Press, 1970.

Keller, Dean H. "A Civil War Diary of Albion W. Tourgée." *Ohio History* 74 (Spring 1965): 99–131.

———. *An Index to the Albion Winegar Tourgée Papers in the Chautauqua County Historical Society, Westfield, N.Y.* Kent, OH: Kent State University, 1964.

Kennedy, E. "Mount Vernon—A Pilgrimage." *Southern Literary Messenger* 18 (January 1852): 53–57.

Latrobe, Benjamin Henry. *The Papers of Benjamin Henry Latrobe*. Series I, Journal 1, *The Virginia Journals of Benjamin Henry Latrobe, 1795–1798*. Edited by Edward C. Carter. New Haven, CT: Yale University Press for the Maryland Historical Society, 1977.

Mayo, Ellen Wise. "A War-Time Aurora Borealis." *Cosmopolitan* 21, no. 2 (June 1896): 134–41.

McGuire, Judith Brockenbrough. "Diary of a Southern Refugee during the War, June 1863–July 1864." In *Virginia at War, 1864*, edited by William C. Davis and James I. Robertson Jr. for the Virginia Center for Civil War Studies, 159–224. Lexington: University Press of Kentucky, 2009.

Miles, Nelson Appleton. *Serving the Republic: Memoirs of the Civil and Military Life of Nelson A. Miles, Lieutenant-General, United States Army*. New York: Harper & Brothers, 1911.

Mixson, Frank M. *Reminiscences of a Private*. Camden, SC: J. J. Fox, 1910.

Moore, Edward A. *The Story of a Cannoneer under Stonewall Jackson*. Lynchburg, VA: J. P. Bell, 1910.

Murray, Stuart A. P., ed. *Witness to the Civil War: First Hand Accounts from "Frank Leslie's Illustrated Newspaper."* Compiled by J. G. Lewin and P. J. Huff. New York: Collins, 2006.

Olmstead, Charles H. *Reminiscences of Service with the First Volunteer Regiment of Georgia, Charleston Harbor, in 1863; an Address Delivered Before the Georgia Historical Society, March 3, 1879*. Savannah, GA: J. H. Estill, 1879.

Pinkerton, Alan. *The Spy of the Rebellion: Being a True History of the Spy System of the United States Army during the Late Rebellion*. New York: G. W. Carleton, 1883.

Polley, J. P. *A Soldier's Letters to Charming Nellie*. New York: Neale Publishing, 1908.

Porter, Horace. *Campaigning with Grant*. New York: Century, 1897.

Reid, Whitelaw. *After the War: A Tour of the Southern States, 1865–1866*. Edited with an introduction and notes by C. Vann Woodward. New York: Harper & Row, 1965.

Russell, William Howard. *My Diary North and South*. Edited by Eugene H. Berwanger. New York: Knopf, 1988.

Seay, Samuel. "A Private at Stone River." *Southern Bivouac*, August 1885, 156–60.

Shaw, Robert Gould. *Blue-Eyed Child of Fortune: The Civil War Letters of Colonel Robert Gould Shaw*. Edited by Russell Duncan. Athens: University of Georgia Press, 1992.

Sherman, William Tecumseh. *Home Letters of General Sherman*. Edited by M. A. DeWolfe Howe. New York: C. Scribner's Sons, 1909.

Shewchuck, Diane. "'All is excitement and anxiety here': A New York Family's Experience of the Civil War." *The Hudson River Valley Review* 27, no. 2 (Spring 2011): 27–48.

Stoddard, William O. *The Volcano under the City. By a Volunteer Special*. New York: Fords, Howard & Hulbert, 1887.

Swinton, William. *History of the Seventh Regiment National Guard, State of New York, during the War of the Rebellion*. New York: Fields, Osgood, 1870.

Tourgée, Albion Winegar. *Undaunted Radical: The Selected Writings and Speeches of Albion W. Tourgée*. Edited by Mark Elliott and John David Smith. Baton Rouge: Louisiana State University Press, 2010.

U.S. Department of War. *The War of the Rebellion: A Compilation of Official Records of the Union and Confederate Armies*. 128 vols. Washington, DC: Government Printing Office, 1880–1901.

———. *The War of the Rebellion: A Compilation of the Official Records of the Union and Confederate Armies*. Series 1, Vol. 38, *The Atlanta, Ga., Campaign, May 1–September 8, 1864*. Washington, DC: Government Printing Office, 1891.

———. *The War of the Rebellion: A Compilation of the Official Records of the Union and Confederate Armies*. Series 1, Vol. 40, *Correspondence*. Washington, DC: Government Printing Office, 1892.

Watkins, Sam R., *"Co. Aytch," Maury Grays, First Tennessee Regiment; or a Side Show of the Big Show*. Nashville, TN: Cumberland Presbyterian Publishing House, 1882.

Whitman, George. *Civil War Letters of George Washington Whitman*. Edited by Jerome M. Loving. Durham, NC: Duke University Press, 1975.

Williams, George F. *Bullet and Shell. War as the Soldier Saw It: Camp, March, and Picket; Battlefield and Bivouac; Prison and Hospital*. New York: Fords, Howard, & Hulbert, 1883.

Winthrop, Theodore. "New York Seventh Regiment: Our March to Washington." *Atlantic Monthly* 7, no. 44 (June 1861), 744–56.

———. "Washington as a Camp." *Atlantic Monthly* 8, no. 45 (July 1861), 105–18

HISTORY: SECONDARY SOURCES

Aamodt, Terrie Dopp. *Righteous Armies, Holy Cause: Apocalyptic Imagery and the Civil War*. Macon, GA: Mercer University Press, 2002.

Ayers, Edward L. *In the Presence of Mine Enemies: War in the Heart of America, 1859–1863*. New York: W. W. Norton, 2003.

———. *The Promise of the New South: Life after Reconstruction*. New York: Oxford University Press, 1992.

Ayers, Edward L., and Ann S. Rubin. *The Valley of the Shadow: Two Communities in the American Civil War—The Eve of War*. New York: W. W. Norton, 2000.

Bernstein, Iver. *The New York City Draft Riots: Their Significance for American Society and Politics in the Age of the Civil War*. New York: Oxford University Press, 1990.

Blair, William, and William Pencak, eds. *Making and Remaking Pennsylvania's Civil War*. State College: Pennsylvania State University Press, 2001.

Blight, David W. *Race and Reunion: The Civil War in American Memory*. Cambridge, MA: Belknap Press of Harvard University Press, 2001.

Brown, Joshua. *Beyond the Lines: Pictorial Reporting, Everyday Life, and the Crisis of Gilded-Age America*. Berkeley: University of California Press, 2002.

Bruce, Dickson D. *Violence and Culture in the Antebellum South*. Austin: University of Texas Press, 1979.

Bruce, Robert V. *Lincoln and the Tools of War*. Indianapolis: Bobbs-Merrill, 1956.

Campbell, Edward D. C., Jr., and Kym S. Rice, eds. *A Woman's War: Southern Women, Civil War, and the Confederate Legacy*. Richmond, VA: Museum of the Confederacy, 1996.

Cashin, Joan E., ed. *The War Was You and Me: Civilians in the American Civil War*. Princeton, NJ: Princeton University Press, 2002.

Catton, Bruce. *The Centennial History of the Civil War.* 3 vols. Garden City, NY: Doubleday, 1961.

Clark, Emmons. *History of the Seventh Regiment of New York, 1806–1889.* 2 vols. New York: Seventh Regiment, 1890.

Davis, William C. "Confederate Exiles." *American History Illustrated* 5, no. 3 (June 1970): 30–43.

Dean, Eric T., Jr. "'We Will All Be Lost and Destroyed': Post-Traumatic Stress Disorder and the Civil War." *Civil War History* 37, no. 2 (June 1991): 138–153.

———. *Shook over Hell: Post-Traumatic Stress, Vietnam, and the Civil War.* Cambridge, MA: Harvard University Press, 1997.

Eliot, Ellsworth, Jr. *Yale in the Civil War.* New Haven, CT: Yale University Press, 1932.

Faust, Drew Gilpin. *The Creation of Confederate Nationalism: Ideology and Identity in the Civil War South.* Baton Rouge: Louisiana State University Press, 1988.

———. *This Republic of Suffering: Death and the American Civil War.* New York: Knopf, 2008.

Fermer, Douglas. *James Gordon Bennett and the "New York Herald": A Study of Editorial Opinion in the Civil War Era, 1854–1867.* New York: St. Martin's Press, 1986.

Foner, Eric. "The Causes of the American Civil War: Recent Interpretations and New Directions." In *Politics and Ideology in the Age of the Civil War,* 15–33. New York: Oxford University Press, 1980.

———. *Free Soil, Free Labor, Free Men: The Ideology of the Republican Party before the Civil War.* 2nd ed. New York: Oxford University Press, 1995.

Foote, Shelby. *The Civil War: A Narrative.* 3 vols. New York: Vintage Books, 1986. First published 1958 by Random House.

Förster, Stig, and Jörg Nagler, eds. *On the Road to Total War: The American Civil War and the German Wars of Unification, 1861–1871.* Washington, DC: German Historical Institute, 1997.

Foster, Gaines M. *Ghosts of the Confederacy: Defeat, the Lost Cause, and the Emergence of the New South, 1865 to 1913.* New York: Oxford University Press, 1987.

Fredrickson, George M. *The Inner Civil War: Northern Intellectuals and the Crisis of the Union.* New York: Harper & Row, 1965.

Gallagher, Gary W. *The Confederate War: How Popular Will, Nationalism, and Military Strategy Could Not Stave Off Defeat.* Cambridge, MA: Harvard University Press, 1997.

Goodheart, Adam. *1861: The Civil War Awakening.* New York: Knopf, 2011.

Grant, Susan-Mary. *North over South: Northern Nationalism and American Identity in the Antebellum Era.* Lawrence: University Press of Kansas, 2000.

Horstman, N. W. "The Mount Vernon Ladies' Association of the Union." *Antiques* 135 (1989), 452–61.

Horwitz, Tony. *Confederates in the Attic: Dispatches from the Unfinished Civil War.* New York: Pantheon, 1998.

———. *Midnight Rising: John Brown and the Raid that Sparked the Civil War.* New York: Henry Holt, 2011.

Irwin, Will, Earl Chapin May, and Joseph Hotchkiss. *A History of the Union League Club of New York City.* New York: Dodd, Mead, 1952.

Jimerson, Randall C. *The Private Civil War: Popular Thought during the Sectional Conflict.* Baton Rouge: Louisiana State University Press, 1988.

Laderman, Gary. *The Sacred Remains: American Attitudes toward Death, 1799–1883.* New Haven, CT: Yale University Press, 1996.

Leech, Margaret. *Reveille in Washington, 1860–1865.* New York: Harper & Brothers, 1941.

Lord, Francis A., and Arthur Wise. *Bands and Drummer Boys of the Civil War.* New York: T. Yoseloff, 1966.

Manning, Chandra. *What This Cruel War Was Over: Soldiers, Slavery, and the Civil War.* New York: Knopf, 2007.

Marten, James. *Civil War America: Voices from the Home Front.* New York: Fordham University Press, 2007.

McKay, Ernest A. *The Civil War and New York City.* Syracuse, NY: Syracuse University Press, 1990.

McPherson, James M. *Battle Cry of Freedom: The Civil War Era.* New York: Oxford University Press, 1988.

Mitchell, Reid. *The Vacant Chair: The Northern Soldier Leaves Home.* New York: Oxford University Press, 1993.

Neff, John R. *Honoring the Civil War Dead: Commemoration and the Problem of Reconciliation.* Lawrence: University Press of Kansas, 2005.

Nevins, Allan. *War for the Union.* 4 vols. New York: Konecky & Konecky, 1971.

Newman, Simon P. *Parades and the Politics of the Street: Festive Culture in the Early American Republic*. Philadelphia: University of Pennsylvania Press, 1997.

Parrish, T. Michael, and Robert M. Willingham Jr. *Confederate Imprints: A Bibliography of Southern Publications from Secession to Surrender*. Austin, TX: Jenkins Publishing, 1984.

Rhodes, James Ford. "Newspapers as Historical Sources." *Atlantic Monthly* 103 (May 1909), 650–57.

Roberts, Bruce with Elizabeth Kedash. *Plantation Homes of the James River*. Chapel Hill: University of North Carolina Press, 1990.

Rolle, Andrew F. *The Lost Cause: The Confederate Exodus to Mexico*. Norman: University of Oklahoma Press, 1965.

Sears, Stephen W. *Landscape Turned Red: The Battle of Antietam*. New Haven, CT: Ticknor & Fields, 1983.

Silber, Nina. *The Romance of Reunion: Northerners and the South, 1865–1900*. Chapel Hill: University of North Carolina Press, 1993.

Smith, Page. *Trial by Fire: A People's History of the Civil War and Reconstruction*. New York: McGraw-Hill, 1982.

Stampp, Kenneth M. *America in 1857: A Nation on the Brink*. New York: Oxford University Press, 1990.

Stampp, Kenneth M., ed. *The Causes of the Civil War*. 3rd rev. ed. New York: Simon and Schuster, 1991.

Starr, Kevin. *Americans and the California Dream, 1850–1915*. New York: Oxford University Press, 1973.

Temple, Wayne C. "Lincoln's Fence Rails." *Journal of the Illinois State Historical Society* 47, no. 1 (Spring 1954): 20–34.

Varon, Elizabeth R. *Disunion! The Coming of the American Civil War, 1789–1859*. Chapel Hill: University of North Carolina Press, 2008.

Vinovskis, Maris A., ed. *Toward a Social History of the American Civil War: Exploratory Essays*. New York: Cambridge University Press, 1990.

Wecter, Dixon. *When Johnny Comes Marching Home*. Westport, CT: Greenwood Press, 1944.

Werner, Emmy E. *Reluctant Witnesses: Children's Voices from the Civil War*. Boulder, CO: Westview Press, 1998.

LITERATURE AND MUSIC

Aaron, Daniel. *The Unwritten War: American Writers and the Civil War*. New York: Knopf, 1973.

Abel, Ernest L. "'Home, Sweet Home': A Civil War Soldier's Favorite Song." *America's Civil War*, May 1996, http://www.historynet.com/home-sweet-home-a-civil-war-soldiers-favorite-song.htm.

Barrett, Faith. "'Drums off the Phantom Battlements': Dickinson's War Poems in Discursive Context." In *A Companion to Emily Dickinson*, edited by Martha Nell Smith and Mary Loeffelholz, 107–32. Malden, MA: Blackwell Publishing, 2008.

Barrett, Faith, and Cristanne Miller, eds. *"Words for the Hour": A New Anthology of American Civil War Poetry*. Amherst: University of Massachusetts Press, 2005.

"Battle of the Wilderness." *Continental Monthly* 6 (August 1864): 207–9.

Berkove, Lawrence I. "'A Slash of Blue!': An Unrecognized Emily Dickinson War Poem." *Emily Dickinson Journal* 10, no. 1, (2001): 1–8.

Brückner, Martin, and Hsuan L. Hsu, eds. *American Literary Geographies: Spatial Practice and Cultural Production, 1500–1900*. Newark, NJ: University of Delaware Press, 2007.

Bunyan, John. *The Pilgrim's Progress*. Edited with an introduction by Roger Sharrock. Baltimore: Penguin Books, 1965. First published 1678.

Cadava, Eduardo. *Emerson and the Climates of History*. Stanford, CA: Stanford University Press, 1997.

Cody, David. "Blood in the Basin: The Civil War in Emily Dickinson's 'The name—of it—is "Autumn"—.'" *Emily Dickinson Journal* 12, no. 1 (Spring 2003): 25–52.

Conway, Moncure Daniel. *Emerson at Home and Abroad*. Boston: J. R. Osgood, 1882.

Curtis, George. "Theodore Winthrop." *Atlantic Monthly* 8, no. 46 (August 1861), 242–52.

Dickens, Charles. "The Diary of a Confederate Boy." *All the Year Round, A Weekly Journal* 7 (May 17, 1862): 224–30.

Dickinson, Emily. *The Poems of Emily Dickinson*. Edited by Thomas H. Johnson. 3 vols. Cambridge, MA: Belknap Press of Harvard University Press, 1955.

Emerson, Ralph Waldo. "Art." In *Emerson's Essays: First and Second Series*, 192–203. London: M. J. Dent & Sons, 1910.

———. *The Letters of Ralph Waldo Emerson*. Edited by Ralph L. Rusk. 6 vols. New York: Columbia University Press, 1939.

———. *Works: Journals and Miscellaneous Notebooks*. Edited by Ronald A. Bosco and Glen Jackson. Cambridge, MA: Harvard University Press, 1982.

Fahs, Alice. *The Imagined Civil War: Popular Literature of the North & South, 1861–1865*. Chapel Hill: University of North Carolina Press, 2001.

Farr, Judith. "Disclosing Pictures: Emily Dickinson's Quotations from the Paintings of Thomas Cole, Frederic Church, and Holman Hunt." *Emily Dickinson Journal* 2, no. 2 (Fall 1993): 66–77.

Fuller, Randall. "Hawthorne and War." *The New England Quarterly* 80, no. 4 (December 2007): 655–86.

Garner, Stanton. *The Civil War World of Herman Melville*. Lawrence: University Press of Kansas, 1993.

Genoways, Ted. *Walt Whitman and the Civil War: America's Poet during the Lost Years of 1860–1862*. Berkeley: University of California Press, 2009.

Gossett, Thomas F. *"Uncle Tom's Cabin" and American Culture*. Dallas: Southern Methodist University Press, 1985.

Gougeon, Len. *Virtue's Hero: Emerson, Anti-Slavery, and Reform*. Athens: University of Georgia Press, 1990.

Hawthorne, Nathaniel. "Chiefly about War Matters, by a Peaceable Man." *Atlantic Monthly* 10, no. 57 (July 1862), 43–61.

Hensel, Octavia. *Life and Letters of Louis Moreau Gottschalk*. New York: O. Ditson, 1870.

Higginson, Thomas Wentworth. *Cheerful Yesterdays*. Boston: Houghton Mifflin, 1898.

———. "Emily Dickinson's Letters." *Atlantic Monthly* 68, no. 408 (October 1891), 444–56.

Hoffman, Tyler B. "Emily Dickinson and the Art of War." *Emily Dickinson Journal* 3 (1994): 1–18.

James, Henry. *The American Scene*. New York: Harper & Brothers Publishers, 1907.

———. *Hawthorne*. Ithaca, NY: Cornell University Press, 1966. First published 1879.

———. "The Story of a Year." *Atlantic Monthly* 15, no. 89 (March 1865), 257–81.

Kazin, Alfred. *A Writer's America: Landscape in Literature*. New York: Knopf, 1988.

Ljungquist, Kent. "'Meteor of the War': Melville, Thoreau, and Whitman Respond to John Brown." *American Literature* 61, no. 4 (December 1989): 674–80.

Lowell, James Russell. *Letters of James Russell Lowell*. Edited by Charles E. Norton. New York: Harper & Brothers, 1894.

Lowenfels, Walter, ed. *Walt Whitman's Civil War*. New York: Da Capo Press, 1960.

Magoon, Elias L. "Scenery and Mind." In *The Home Book of the Picturesque*, 1–48. New York: G. P. Putnam, 1852.

Marcellin, Leigh-Anne Urbanowicz. "Emily Dickinson's Civil War Poetry." *Emily Dickinson Journal* 5, no. 2 (Fall 1996): 107–12.

Masur, Louis P., ed. *"…The real war will never get in the books": Selections from Writers during the Civil War*. New York: Oxford University Press, 1993.

McCord, Louisa S. "Art. III.—*Uncle Tom's Cabin*." *Southern Quarterly Review* 23 (January 1853): 81–120.

McDonald, John J. "Emerson and John Brown." *New England Quarterly* 44, no. 3 (September 1971): 377–96.

Melville, Herman. *Battle-Pieces and Aspects of the War*. New York: Harper & Brothers, 1866.

Moore, Frank, ed. *Rebel Rhymes and Rhapsodies*. New York: G. P. Putnam, 1864.

Norton, Charles Eliot. *The Complete Writings of James Russell Lowell*. Boston: Houghton Mifflin, 1904.

Scholnick, Robert J. "Politics and Poetics: The Reception of Melville's *Battle-Pieces and Aspects of the War*." *American Literature* 49, no. 3 (November 1977): 422–30.

Sealts, Merton M., Jr. "Melville and Richard Henry Stoddard." *American Literature* 43, no. 3 (November 1971): 359–70.

Shuck, Oscar, ed. *The California Scrap-Book: A Repository of Useful Information and Select Reading*. San Francisco: H. H. Bancroft, 1869.

Silber, Irwin, ed. *Songs of the Civil War*. New York: Columbia University Press, 1960.

Smith, W. L. G. *Life at the South; or Uncle Tom's Cabin as It Is*. Buffalo, NY: Geo. H. Derby, 1852.

Starr, S. Frederick. *Louis Moreau Gottschalk*. Urbana: University of Illinois Press, 2000. Reprint of *BAMBOULA! The Life and Times of Louis Moreau Gottschalk*. New York: Oxford University Press, 1995.

Stowe, Harriet Beecher. *Dred: A Tale of the Dismal Swamp*. 2 vols. Boston: Phillips, Sampson, 1856.

———. *Uncle Tom's Cabin; or, Life among the Lowly*. Boston: J. P. Jewett, 1853.

Strong, George Templeton. *The Diary of George Templeton Strong*. Edited by Allen Nevins and Milton Halsey Thomas. 4 vols. New York: MacMillan, 1952.

Taylor, Bayard. *The Picture of St. John*. Boston: Ticknor and Fields, 1866.

Thomas, M. Wynn. "Weathering the Storm: Whitman and the Civil War." *Walt Whitman Quarterly Review* 15, no. 2 (Fall 1997): 87–109.

Tourgée, Albion Winegar. *Bricks without Straw*. Edited with a new introduction by Carolyn L. Karcher. Durham, NC: Duke University Press, 2009.

———. *A Fool's Errand. By One of the Fools*. New York: Fords, Howard and Hulbert, 1879.

———. "The Literary Quality of *Uncle Tom's Cabin*." *Independent* 48 (August 20, 1896): 3–4.

Twain, Mark, and Charles Dudley Warner. *The Gilded Age: A Tale of Today*. New York: Trident, 1964.

Ward, David C. "The Green Man: Walt Whitman and the Civil War." *Poetry Nation Review* 32, no. 5 (May–June 2006): 38–42.

———. "'Vaulting Ambition': Poetry, Photography and Lincoln's Self-Fashioning." *Poetry Nation Review* 35, no. 6 (July–August 2009): 45–49.

Whitman, Walt. *Leaves of Grass and Selected Prose*. Edited by Lawrence Buell. New York: Modern Library, 1981.

———. *The Wound Dresser: Letters Written to his Mother from the Hospitals in Washington during the Civil War*. Edited by Richard M. Bucke. New York: Bodley, 1949.

Whittier, John Greenleaf. "The Battle Autumn of 1862." *Atlantic Monthly* 10, no. 60 (October 1862), 510–11.

Winthrop, Theodore. *The Life and Poems of Theodore Winthrop*. Edited by his sister. New York: H. Holt, 1884.

Wolosky, Shira. *Emily Dickinson: A Voice of War*. New Haven, CT: Yale University Press, 1984.

PHOTOGRAPHY

Barnard, George N. *Photographic Views of Sherman's Campaign*. New York: Wynkoop & Hallenbeck, 1866. Reprint, New York: Dover, 1977.

Barnard, George N. "Read before the Third Ordinary meeting of the N.Y.S. Daguerreian Association by B. N. Barnard, Esq." *Photographic and Fine Art Journal*, May 1855, 158–59. Reprinted in Keith F. Davis, *George N. Barnard: Photographer of Sherman's Campaign*, 209–11. Kansas City, MO: Hallmark Cards, 1990. "The Battle of Antietam." *Harper's Weekly*, October 18, 1862, 663–65.

Blanchard, V. "On the Production and Use of Cloud Negatives." *Photographic News*, September 4, 1863, 424–25.

"Brady's Photographs. Pictures of the Dead at Antietam." *New York Times*, October 20, 1862, 5.

Cobb, Josephine. "Alexander Gardner." *Image* 7 (1958): 124–36.

———. "Mathew B. Brady's Photographic Gallery in Washington." *Records of the Columbia Historical Society*. Washington, DC: Columbia Historical Society, 1955.

Cooney, Charles F. "Andrew J. Russell: The Union Army's Forgotten Photographer." *Civil War Times Illustrated* 20 (April 1982): 32–36.

Davis, Keith F. *George N. Barnard: Photographer of Sherman's Campaign*. Kansas City, MO: Hallmark Cards, 1990.

———. "'A Terrible Distinctness': Photography of the Civil War Era." In *Photography in Nineteenth-Century America*, edited by Martha A. Sandweiss, 130–79. Fort Worth, TX: Amon Carter Museum, 1991.

Davis, William C., ed. *The Image of War, 1861–1865*. 6 vols. Garden City, NY: Doubleday, 1981–84.

Dimock, George. *Exploiting the View: Photographs of Yosemite & Mariposa by Carleton Watkins*. North Bennington, VT: Park-McCullough House, 1984.

"Fine Arts. Brady's Incidents of the War." *New York Herald*, August 26, 1861, 5.

Frassanito, William A. *Antietam: The Photographic Legacy of America's Bloodiest Day*. New York: Scribner, 1978.

———. *Early Photography at Gettysburg*. Gettysburg, PA: Thomas Publications, 1995.

———. *Gettysburg: A Journey in Time*. New York: Scribner, 1975.

———. *Grant and Lee: The Virginia Campaigns, 1864–1865*. New York: Scribner, 1983.

Gardner, Alexander. *Gardner's Photographic Sketch Book of the Civil War*. New York: Dover, 1959. First published 1866 by Philp & Solomons.

"Historical Photography." *New York Times*, March 29, 1867, 8.

Holmes, Oliver Wendell. "Doings of the Sunbeam." *Atlantic Monthly* 12, no. 69 (July 1863), 1–15.

———. "The Stereoscope and Stereograph." *Atlantic Monthly* 3, no. 20 (June 1859), 738–48.

———. "Sun-Painting and Sun-Sculpture." *Atlantic Monthly* 8, no. 45 (July 1861), 13–30.

Horan, James D. *Timothy O'Sullivan: America's Forgotten Photographer*. Garden City, NY: Doubleday, 1966.

Johnson, Brooks. *An Enduring Interest: The Photographs of Alexander Gardner*. Norfolk, VA: Chrysler Museum, 1991.

Jurovics, Toby, Carol M. Johnson, Glenn Willumson, and William F. Stapp. *Framing the West: The Survey Photographs of Timothy H. O'Sullivan*. New Haven, CT: Yale University Press for the Library of Congress and Smithsonian American Art Museum, Washington, DC, 2010.

Katz, D. Mark. *Witness to an Era: The Life and Photographs of Alexander Gardner*. New York: Viking, 1991.

Kelsey, Robin. *Archive Style: Photographs & Illustrations for U.S. Surveys, 1850–1890*. Berkeley: University of California Press, 2007.

Klingsporn, Geoffrey. "Icon of Real War: *A Harvest of Death* and American War Photography." *Velvet Light Trap* 45 (Spring 2000): 4–19.

Lee, Anthony, and Elizabeth Young. *On Alexander Gardner's Photographic Sketch Book of the Civil War*. Berkeley: University of California Press, 2008.

Mazow, Leo. *Images of Annihilation: Ruins in Civil War America*. San Marino, CA: Huntington Library, Art Collections, and Botanical Gardens, 1996.

Miller, Francis Trevalyan, ed. *Photographic History of the Civil War*. 10 vols. New York: Review of Reviews, 1912.

Naef, Weston J., and James N. Wood. *Era of Exploration: The Rise of Landscape Photography in the American West, 1860–1885*. Buffalo, NY: Albright-Knox Art Gallery, distributed by the New York Graphic Society, 1975.

Panzer, Mary. *Mathew Brady and the Image of History*. Washington, DC: Smithsonian Institution Press, 1997.

"Photographic Phases." *New York Times*, July 21, 1862, 5.

"Photographs of the War." *New York Times*, August 17, 1861, 4.

Pierce, Sally. *Citizens in Conflict: Prints and Photographs of the American Civil War*. Boston: Boston Athenaeum, 1981.

Russell, A. J. "Photographic Reminiscences of the Late War." *Anthony's Photographic Bulletin* 13 (July 1882): 212–13.

Russell, Andrew J. *Russell's Civil War Photographs: 116 Historic Prints*. Preface by Joe Buberger and Matthew Isenberg. New York: Dover Publications, 1982.

Sandweiss, Martha A., ed. *Photography in Nineteenth-Century America*. New York: Abrams, 1991.

Snyder, Joel. *American Frontiers: The Photographs of Timothy O'Sullivan, 1867–1874*. Millerton, NY: Aperture in association with the Philadelphia Museum of Art, 1981.

Stapp, William F. "'Subjects of Strange . . . and of Fearful Interest.'" In *Eyes of Time: Photojournalism in America*, edited by Marianne Fulton, 2–33. Boston: Little, Brown, 1988.

———. "'To . . . Arouse the Conscience, and Affect the Heart.'" In *An Enduring Interest: The Photographs of Alexander Gardner*, edited by Brooks Johnson, 21–37 and 117–19. Norfolk, VA: Chrysler Museum, 1991.

Sweet, Timothy. *Traces of War: Poetry, Photography, and the Crisis of the Union*. Baltimore: Johns Hopkins University Press, 1990.

Townsend, George. "Still Taking Pictures: Brady, the Grand Old Man of American Photography." *World* (New York), April 12, 1891, 26.

Trachtenberg, Alan. "Albums of War: On Reading Civil War Photographs." In *Critical Issues in American Art: A Book of Readings*, edited by Mary Ann Calo, 135–54. Boulder, CO: Westview Press, 1997.

———. *Reading American Photographs: Images as History, Mathew Brady to Walker Evans*. New York: Hill and Wang, 1989.

Wilson, Richard B. "American Vision and Landscape: The Western Images of Clarence King and Timothy O'Sullivan." PhD diss., University of New Mexico, 1979.

Zeller, Bob. *The Blue and Gray in Black and White: A History of Civil War Photography*. Westport, CT: Praeger, 2005.

SCIENCE AND EXPLORATION

Adams, Henry. "Review of *Report of the Geological Exploration of the Fortieth Parallel*, by Clarence King, Geologist in Charge, and *Mining Industry*, by James D. Hague." *North American Review* 113, no. 232 (July 1871): 203–10.

"The Aurora Borealis." *Atlantic Monthly* 4, no. 26 (December 1859), 740–50.

Bowles, Samuel. *Across the Continent: A Summer's Journey to the Rocky Mountains, the Mormons, and the Pacific States, with Speaker Colfax.* Springfield, MA: Bowles, 1865.

———. *Our New West: Records of Travel between the Mississippi River and the Pacific Ocean.* Hartford, CT: Hartford Publishing, 1869.

Bryson, Michael A. *Visions of the Land: Science, Literature, and the American Environment from the Era of Exploration to the Age of Ecology.* Charlottesville: University Press of Virginia, 2002.

Bushnell, Horace. "California, Its Characteristics and Prospects." *The New Englander* 16 (February 1858): 142–82.

Carter, Samuel, III. *Cyrus Field: Man of Two Worlds.* New York: Putnam, 1968.

Cohen, Geoff. "'I hear the musketry of the Falls': *Systematic Geology*, the Civil War, and Nation Building." *American Transcendental Quarterly* 18, no. 4 (December 2004): 247–62.

Cullum, George W. "Biographical Sketch of Doctor Isaac I. Hayes." *Journal of the American Geographical Society of New York* 13 (1881): 110–24.

Deverell, William. "Niagara Magnified: Finding Emerson, Muir, and Adams in Yosemite." In *Yosemite: Art of an American Icon*, edited by Amy Scott, 9–21. Los Angeles: Autry National Center in association with University of California Press, 2006.

Greeley, Horace. *An Overland Journey, from New York to San Francisco in the Summer of 1859.* New York: C. M. Saxton, Barker & Co., 1860.

Hayes, Isaac Israel. *The Open Polar Sea: A Narrative of a Voyage of Discovery towards the North Pole, in the Schooner* United States. New York: Hurd & Houghton, 1867.

Herring, Scott. *Lines on the Land: Writers, Art, and the National Parks.* Charlottesville: University of Virginia Press, 2004.

Humboldt, Alexander von. *Cosmos: A Sketch of a Physical Description of the Universe.* Translated by E. C. Otté. London: Henry G. Bohn, 1849–1858.

Huth, Hans. *Nature and the American: Three Centuries of Changing Attitudes.* Lincoln: University of Nebraska Press, 1972. First published in 1957 by University of California Press.

———. "Yosemite: The Story of an Idea." *Sierra Club Bulletin* 33 (March 1948): 47–78.

Hyde, Anne F. *An American Vision: Far Western Landscape and National Culture, 1820–1920.* New York: New York University Press, 1990.

Judson, Isabella Field. *Cyrus W. Field: His Life and Work.* New York: Harper & Brothers, 1896.

King, Clarence. "Catastrophism and Evolution." *American Naturalist* 9 (1877): 449–70.

———. "The Education of the Future." *Forum* 13 (March 1892): 20–33.

———. "The Falls of the Shoshone." *Overland Monthly* 5 (October 1870), 379–85.

King, Thomas Starr. *A Vacation among the Sierras: Yosemite in 1860.* Edited, with an introduction and notes, by John A. Hussey. San Francisco: Book Club of California, 1962.

———. *The White Hills: Their Legends, Landscape, and Poetry.* Boston: Crosby, Nichols, 1860.

Ludlow, Fitz Hugh. "Among the Mormons." *Atlantic Monthly* 13, no. 78 (April 1864), 479–95.

———. *The Heart of the Continent: A Record of Travel across the Plains and in Oregon, with an Examination of the Mormon Principle.* New York: Hurd & Houghton, 1870.

———. "Letters from Sundown." *New York Evening Post*, May 26, 1863; June 5, 1863; July 24, 1863; July 25, 1863; July 30, 1863; October 24, 1863; October 28, 1863.

———. "On Horseback into Oregon." *Atlantic Monthly* 14, no. 81 (July 1864), 75–86.

———. "On the Columbia River." *Atlantic Monthly* 14, no. 86 (December 1864), 703–15.

———. "Seven Weeks in the Great Yo-Semite." *Atlantic Monthly* 13, no. 80 (June 1864), 739–54.

———. "Through-Tickets to San Francisco: A Prophecy." *Atlantic Monthly* 14, no. 85 (November 1864), 604–17.

Marsh, George Perkins. *Man and Nature; or, Physical Geography as Modified by Human Action.* New York: Charles Scribner, 1864.

Nash, Roderick. *Wilderness and the American Mind.* 3rd ed. New Haven, CT: Yale University Press, 1982.

Olmsted, Frederick Law. *Papers of Frederick Law Olmsted.* Vol. 5, *The California Frontier, 1863–65.* Edited by Victoria Post Ranney, Gerard J. Rauluk, and Carolyn Hoffman. Baltimore: Johns Hopkins University Press, 1990.

———. *Yosemite and the Mariposa Grove: A Preliminary Report, 1865.* Washington, DC: Library of Congress, 1865.

Olson, Donald W., Marilynn S. Olson, Russell L. Doescher, and Ava G. Pope. "Walt Whitman's 'Year of Meteors.'" *Sky and Telescope* 120, no. 1 (July 2010): 28–33.

Porte Crayon [David Hunter Strother]. "The Great Dismal Swamp." *Harper's New Monthly Magazine*, September 1856, 441–55.

Sachs, Aaron. *The Humboldt Current: Nineteenth-Century Exploration and the Roots of American Environmentalism*. New York: Penguin Books, 2006.

Schwarz, Ingo. "'Shelter for a Reasonable Freedom' or Cartesian Vortex: Aspects of Alexander von Humboldt's Relation to the United States of America." *Debate y Perspectivas* 1 (2000): 169–82.

Sears, John F. *Sacred Places: American Tourist Attractions in the Nineteenth Century*. Amherst: University of Massachusetts Press, 1998.

Smith, Henry Nash. *Virgin Land: The American West as Symbol and Myth*. Cambridge, MA: Harvard University Press, 1950.

Walls, Laura Dassow. *The Passage to Cosmos: Alexander von Humboldt and the Shaping of America*. Chicago: University of Chicago Press, 2009.

Wilkins, Thurman, with Caroline Lawson Hinkley. *Clarence King: A Biography*. Albuquerque: University of New Mexico Press, 1988. First published 1958 by MacMillan.

SLAVERY AND ABOLITION

Berlin, Ira, and Leslie Harris, eds. *Slavery in New York*. New York: New Press, 2005.

Berlin, Ira, Joseph P. Reidy, and Leslie S. Rowland, eds. *Freedom: A Documentary History of Emancipation, 1861–1867*. Series II, *The Black Military Experience*. Cambridge: Cambridge University Press, 1982.

Blight, David W. *Frederick Douglass' Civil War: Keeping Faith in Jubilee*. Baton Rouge: Louisiana State University Press, 1989.

Brown, William Wells. *The Negro in the American Rebellion: His Heroism and His Fidelity*. With an introduction and notes by John David Smith. Athens: Ohio University Press, 2003. First published 1867 by Lee & Shepard.

Casper, Scott E. *Sarah Johnson's Mount Vernon: The Forgotten History of an American Shrine*. New York: Hill and Wang, 2008.

Dalton, Karen C. Chambers. "'The Alphabet Is an Abolitionist': Literacy and African Americans in the Emancipation Era." *Massachusetts Review* 32, no. 4 (Winter 1991): 545–80.

Douglass, Frederick. "John Brown: An Address by Frederick Douglass at the Fourteenth Anniversary of Storer College, Harper's Ferry, West Virginia, May 30, 1881." Dover, NH: Morning Star Job Printing House, 1881.

Durham, Walter T. *The State of State History in Tennessee in 2008: The Underground Railroad in Tennessee to 1865*. Nashville: Tennessee State Library and Archives, 2008.

Dusinberre, William. *Them Dark Days: Slavery in the American Rice Swamps*. New York: Oxford University Press, 1996.

"Education in the Southern States." *Harper's Weekly*, November 9, 1867, 706–7.

Elliott, Mark. *Color-Blind Justice: Albion Tourgée and the Quest for Racial Equality from the Civil War to* Plessy v. Ferguson. New York: Oxford University Press. 2006.

Faust, Drew Gilpin. *Mothers of Invention: Women of the Slaveholding South in the American Civil War*. Chapel Hill: University of North Carolina Press, 1996.

———. *Southern Stories: Slaveholders in Peace and War*. Columbia: University of Missouri Press, 1992.

Fields, Barbara Jeanne. *Slavery and Freedom on the Middle Ground: Maryland during the Nineteenth Century*. New Haven, CT: Yale University Press, 1985.

Foner, Philip S. "Alexander von Humboldt on Slavery in America." *Science & Society* 47, no. 3 (Fall 1983): 330–42.

Foner, Philip Sheldon. *Business and Slavery: The New York Merchants & the Irrepressible Conflict*. Chapel Hill: University of North Carolina Press, 1941.

Fredrickson, George M. *The Black Image in the White Mind: The Debate on Afro-American Character and Destiny, 1817–1914*. Middletown, CT: Wesleyan University Press, 1971.

Genovese, Eugene D. *Roll, Jordan, Roll: The World the Slaves Made*. New York: Pantheon Books, 1974.

Gladstone, William A. *United States Colored Troops, 1863–1867*. Gettysburg, PA: Thomas Publications, 1990.

Glymph, Thavolia. *Out of the House of Bondage: The Transformation of the Plantation Household*. New York: Cambridge University Press, 2008.

Higginson, Thomas Wentworth. *Army Life in a Black Regiment*. Boston: Fields, Osgood, 1870.

Horton, James O., and Lois E. Horton. *Hard Road to Freedom: The Story of African America*. New Brunswick, NJ: Rutgers University Press, 2001.

———. *Slavery and the Making of America*. New York: Oxford University Press, 2005.

Litwack, Leon F. *North of Slavery: The Negro in the Free States, 1790–1860*. Chicago: University of Chicago Press, 1961.

Lubet, Steven. *Fugitive Justice: Runaways, Rescuers, and Slavery on Trial*. Cambridge, MA: Belknap Press of Harvard University Press, 2010.

Masur, Kate. "'A Rare Phenomenon of Philological Vegetation': The Word 'Contraband' and the Meanings of Emancipation." *Journal of American History* 93, no. 4 (March 2007): 1050–84.

McPherson, James. "Abolitionist and Negro Opposition to Colonization during the Civil War." *Phylon* 26, no. 4 (Fourth Quarter 1965): 391–99.

McPherson, James M. *The Negro's Civil War: How American Negroes Felt and Acted during the War for the Union*. New York: Vintage Books, 1965.

Nott, Charles C. *The Coming Contraband: A Reason against the Emancipation Proclamation, Not Given by Mr. Justice Curtis, to Whom It Is Addressed, by an Officer in the Field*. New York: G. P. Putnam, 1862.

Olmsted, Frederick Law. *The Cotton Kingdom: A Traveller's Observations on Cotton and Slavery in the American Slave States*. 2 vols. New York: Mason Bros., 1861.

———. *A Journey in the Back Country*. New York: Mason Bros., 1860.

———. *A Journey in the Seaboard Slave States, with Remarks on their Economy*. New York: Dix & Edwards, 1856.

Pierce, Edward Lillie. "The Contrabands at Fortress Monroe." *Atlantic Monthly* 8, no. 49 (November 1861), 626–41.

———. "The Freedmen of Port Royal." *Atlantic Monthly* 12, no. 17 (September 1863), 291–315.

Price, Richard, ed. *Maroon Societies: Rebel Slave Communities in the Americas*. Baltimore: Johns Hopkins University Press, 1979.

Quarles, Benjamin. *The Negro in the Civil War*. Boston: Little, Brown, 1969.

Redpath, James. *Echoes of Harper's Ferry*. Boston: Thayer and Eldridge, 1860.

Story, William Wetmore. *The American Question*. London: G. Manwaring, 1862.

Trodd, Zoë, and John Stauffer, eds. *Meteor of War: The John Brown Story*. Maplecrest, NY: Brandywine Press, 2004.

Warner, Samuel. *Authentic and Impartial Narrative of the Tragical Scene which was Witnessed in Southampton County (Virginia) on Monday the 22nd of August Last, When Fifty-Five of its Inhabitants (mostly women and children) Were Inhumanely Massacred by the Blacks!* New York: Printed for Warner & West, 1831.

Weld, Theodore Dwight. *American Slavery as It Is: Testimony of a Thousand Witnesses*. New York: American Anti-Slavery Society, 1839.

Winthrop, Theodore. "Voices of the Contraband." *Atlantic Monthly* 8, no. 46 (August 1861), 248–51.

ARCHIVAL SOURCES

Albert Bierstadt, Miscellaneous Documents, Archives of American Art, Smithsonian Institution, Washington, DC.

Albert Bierstadt, Miscellaneous Documents, Manuscript Division, The New York Public Library, New York, NY.

Bierstadt Scrapbook, Joyce Randall Edwards Collection, Dobbs Ferry, NY.

Chapman Family Correspondence and Other Documents, MSS 48, Mandeville Special Collections Library, University of California, San Diego.

Conrad Wise Chapman, "Civil War Memoirs: August, 1861 to July, 1862," Unpaginated Manuscript, Mayo Collection, Gloucester, VA.

Frederic E. Church Letters, Archives of American Art, Smithsonian Institution, Washington, DC.

Frederic E. Church Letters, Library, and House, Olana State Historic Site, Taconic Region, Hudson, NY.

Jasper F. Cropsey Library, Letters, Diaries, and Papers, Newington-Cropsey Foundation, Hastings-on-Hudson, NY.

Ford Collection, Manuscripts and Archives Division, New York Public Library, New York, NY.

Sanford R. Gifford Journals, 3 Volumes, Archives of American Art, Smithsonian Institution, Washington, DC.

Sanford R. Gifford Correspondence and Sketchbooks, Collection Sanford Gifford, M.D., Cambridge, MA.

Gordon Hendricks Papers, Archives of American Art, Smithsonian Institution, Washington, DC.

James Hope Letters, MSA 230–231, Leahy Library, Vermont Historical Society, Barre, VT.

Eastman Johnson Papers, Archives of American Art, Smithsonian Institution, Washington, DC.

John F. Kensett Journal, 1840–41, Frick Art Reference Library, New York, NY.

John F. Kensett Miscellaneous Papers, Archives of American Art, Smithsonian Institution, Washington, DC.

John F. Kensett Papers, Edwin Morgan Collection, New York State Library, Albany, NY.

Jervis McEntee Diaries, 1872–1881, Archives of American Art, Smithsonian Institution, Washington, DC.

Jervis McEntee Papers (1796), 1848–1905, Archives of American Art, Smithsonian Institution, Washington, DC.

Rogers Family Papers, New-York Historical Society, New York, NY.

Xanthus Smith, "An Unvarnished Tale," reel 2039, Archives of American Art, Smithsonian Institution, Washington, DC.

Bayard Taylor Papers, Department of Manuscripts and Archives, Olin Library, Cornell University, Ithaca, NY.

DIGITAL RESOURCES

Center for Civil War Photography. http://www.civilwarphotography. org/index.php.

Civil War Photos. http://www.civilwarphotos.net/.

Cornell University. "Cornell University Library on the Past." http://digital.library.cornell.edu.

Cornell University. "Making of America." http://ebooks.library. cornell.edu/m/moa/

Cornell University. "Samuel J. May Anti-Slavery Collection." http://ebooks.library.cornell.edu/m/mayantislavery/.

Eugene Goodwin Civil War Diary. http://www.ioweb.com/ civilwar/goodwin_diary/.

Hathi Trust Digital Library. http://babel.hathitrust.org/.

JSTOR. http://www.jstor.org.

Library of Congress. "Selected Civil War Photographs." http:// memory.loc.gov/ammem/cwphtml/cwphome.html.

Metropolitan Museum of Art. "Photography and the Civil War, 1861–1865." http://www.metmuseum.org/toah/hd/phcw/hd_phcw. htm.

New-York Historical Society. "John Rogers American Stories." http://www.johnrogers-history.org/.

New York Times. "Disunion" series in the *Opinionator* blog. http://opinionator.blogs.nytimes.com/category/disunion/.

University of Detroit Mercy. Black Abolitionist Archive. http://research.udmercy.edu/find/special_collections/digital/ baa/index.php?collectionCode=baa&field=DC_title_ parent&term="Anglo-African

University of Michigan. "Making of America." http://quod.lib. umich.edu/m/moa/.

U.S. National Archives and Records Administration. "Pictures of the Civil War." http://www.archives.gov/research/military/civil-war/photos/index.html.

PERIOD NEWSPAPERS

Anglo-African Weekly (NY)
Boston Daily Evening Transcript
Boston Herald
Brooklyn Daily Eagle
Charleston (SC) *Mercury*
Frank Leslie's Illustrated Newspaper
The Independent (Washington, DC)
New York Commercial Advertiser
New-York Daily Tribune
New York Evening Post
New-York Herald
New York Leader
New York Times
Springfield (MA) *Daily Republican*
Richmond (VA) *Enquirer*
Daily National Intelligencer (Washington, DC)

PERIOD JOURNALS

The Albion
The Aldine
Appleton's Journal of Popular Culture
Atlantic Monthly
Continental Monthly
The Crayon
Douglass' Monthly
Harper's Weekly
Harper's New Monthly Magazine
Home Journal
The Liberator
Littell's Living Age
The Nation
North American Review
Putnam's
Scribner's Monthly
Southern Literary Messenger
Round Table
Vanity Fair

CATALOGUE OF THE EXHIBITION

LANDSCAPES AND THE METAPHORICAL WAR

CAT. 1
Martin Johnson Heade
Approaching Thunder Storm, 1859
oil on canvas, 28 × 44 in.
The Metropolitan Museum of Art, Gift of Erving
Wolf Foundation and Mr. and Mrs. Erving Wolf, in
memory of Diane R. Wolf, 1975 (1975.160)
Image © The Metropolitan Museum of Art

CAT. 2
Frederic Edwin Church
Meteor of 1860, 1860
oil on canvas, 10 × 17 ½ in.
Collection of Ms. Judith Filenbaum Hernstadt

CAT. 3
Sanford Robinson Gifford
Twilight in the Catskills, 1861
oil on canvas, 27 × 54 in.
Yale University Art Gallery, Gift of Joanne and John
Payson in memory of Joan Whitney and Charles
Shipman Payson (class of 1921) and in honor of
Joan Whitney Payson (class of 2009), 2007.178.1

CAT. 4
Frederic Edwin Church
The Icebergs, 1861
oil on canvas, 64 ½ × 112 ½ in.
Dallas Museum of Art, Gift of Norma and
Lamar Hunt, 1979.28

CAT. 5
Frederic Edwin Church
Our Banner in the Sky, 1861
oil on paper, 7 ½ × 11 ¼ in.
Collection of Fred Keeler

CAT. 6
Frederic Edwin Church
Cotopaxi, 1862
oil on canvas, 48 × 85 in.
Detroit Institute of Arts, Founders Society Purchase,
Robert H. Tannahill Foundation Fund, Gibbs-Williams
Fund, Dexter M. Ferry Jr. Fund, Merrill Fund,
Beatrice W. Rogers Fund, and Richard A. Manoogian
Fund, 76.89
Image courtesy the Bridgeman Art Library

CAT. 7
Homer Dodge Martin
The Iron Mine, Port Henry, New York, about 1862
oil on canvas mounted on fiberboard, 30 ⅛ × 50 in.
Smithsonian American Art Museum, Gift of William T.
Evans, 1910.9.11

CAT. 8
Jasper Francis Cropsey
Richmond Hill in the Summer of 1862,
1862–1863
oil on canvas, 54 × 96 in.
Private Collection

CAT. 9
Frederic Edwin Church
Aurora Borealis, 1865
oil on canvas, 56 × 83 ½ in.
Smithsonian American Art Museum,
Gift of Eleanor Blodgett, 1911.4.1

CAT. 10
Albert Bierstadt
Looking Down Yosemite Valley, California, 1865
oil on canvas, 64 ½ × 96 ½ in.
Birmingham Museum of Art; Gift of the Birmingham
Public Library, 1991.879

CAT. 11
Sanford Robinson Gifford
A Coming Storm, 1863, retouched and
redated in 1880
oil on canvas, 28 × 42 in.
Philadelphia Museum of Art: Gift of the McNeil
Americana Collection, 2004. 2004-115-1

CAT. 12
Frederic Edwin Church
Rainy Season in the Tropics, 1866
oil on canvas, 56 ¼ × 84 ¼ in.
Fine Arts Museums of San Francisco, Museum
purchase, Mildred Anna Williams Collection, 1970.9

CAT. 13
John Frederick Kensett
Sunrise among the Rocks of Paradise, Newport,
1859
oil on canvas, 18 × 30 in.
Fine Arts Museums of San Francisco, Gift of Mr. and
Mrs. John D. Rockefeller 3rd, 1979.7.69

CAT. 14
John Frederick Kensett
Paradise Rocks: Newport, about 1865
oil on canvas, 18 ⅛ × 29 ⅞ in.
Newark Museum, Gift of Dr. J. Ackerman Coles,
1920, 20.1210

THE ART OF WARTIME PHOTOGRAPHY

CAT. 15
Alexander Gardner
Bloody Lane, Confederate Dead, Antietam,
September 19, 1862
albumen print, 3 ⅛ × 3 ¾ in.
Chrysler Museum of Art, Norfolk, Va., Gift of David L.
Hack and by exchange Walter P. Chrysler, Jr.,
98.32.137

CAT. 16
Alexander Gardner
*Confederate Dead in a Ditch on the Right Wing
Used as a Rifle Pit, Antietam*, 1862
albumen print, 8 × 7 in.
Chrysler Museum of Art, Norfolk, Va., Gift of
David L. Hack and by exchange Walter P. Chrysler, Jr.,
98.32.333

CAT. 17
Alexander Gardner
Confederate Dead at Antietam, September 19, 1862
albumen print, 3 ½ × 4 ½ in.
Chrysler Museum of Art, Norfolk, Va., Gift of
David L. Hack and by exchange Walter P. Chrysler, Jr.,
98.32.178

CAT. 18
Alexander Gardner
Day After the Battle, Antietam, 1862
albumen print, 8 × 7 in.
Chrysler Museum of Art, Norfolk, Va., Gift of
David L. Hack and by exchange Walter P. Chrysler, Jr.,
98.32.332

CAT. 19
Alexander Gardner
*Confederate Dead, Antietam (Dunker Church in
background)*, September 19, 1862
albumen print, 3 ¼ × 4 ½ in.
Chrysler Museum of Art, Norfolk, Va., Gift of
David L. Hack and by exchange Walter P. Chrysler, Jr.
98.32.228

CAT. 20
Andrew Joseph Russell
Confederate Dead, Marye's Heights, Fredericksburg,
May 4, 1863
albumen print, 9 ¼ × 12 ½ in.
Chrysler Museum of Art, Norfolk, Va., Gift of David L.
Hack and by exchange Walter P. Chrysler, Jr., 98.32.60

CAT. 21
Timothy H. O'Sullivan
A Harvest of Death, Gettysburg, July 1863
albumen print, 6 ¾ × 8 ⅞ in.
Chrysler Museum of Art, Norfolk, Va., Museum
purchase and partial gift of Carol L. Kaufman and
Stephen C. Lampl in memory of their parents Helen
and Carl Lampl, 91.23.36

CAT. 22
Alexander Gardner
Home of a Rebel Sharpshooter, Gettysburg, July 1863
albumen print, 6 ¾ × 8 ⅞ in.
Chrysler Museum of Art, Norfolk, Va., Museum
purchase and partial gift of Carol L. Kaufman and
Stephen C. Lampl in memory of their parents Helen
and Carl Lampl, 91.23.41

CAT. 23
Alexander Gardner
President Lincoln on Battlefield, Antietam,
October 1862
albumen print, 6 ¾ × 8 ⅞ in.
Chrysler Museum of Art, Norfolk, Va., Museum
purchase and partial gift of Carol L. Kaufman and
Stephen C. Lampl in memory of their parents Helen
and Carl Lampl, 91.23.23

CAT. 24
John Reekie
A Burial Party, Cold Harbor, April 1865
albumen print, 6 ¾ × 8 ⅞ in.
Chrysler Museum of Art, Norfolk, Va., Museum
purchase and partial gift of Carol L. Kaufman and
Stephen C. Lampl in memory of their parents Helen
and Carl Lampl, 91.23.94

CAT. 25
George N. Barnard
Ruins in Charleston, South Carolina, 1865
vintage albumen print, 10 × 14 ⅛ in.
The Nelson-Atkins Museum of Art, Kansas City,
Missouri. Gift of Hallmark Cards, Inc. 2005.27.3194
Photo by Michael Lamy

CAT. 26
George N. Barnard
Ruins in Columbia, South Carolina No. 2, 1865
vintage albumen print, 10 × 14 ⅛ in.
The Nelson-Atkins Museum of Art, Kansas City,
Missouri. Gift of Hallmark Cards, Inc. 2005.27.3189

CAT. 27
George N. Barnard
Columbia, from the Capitol, 1865
vintage albumen print, 10 × 14 ⅛ in.
The Nelson-Atkins Museum of Art, Kansas City,
Missouri. Gift of Hallmark Cards, Inc. 2005.27.3187

CAT. 28
George N. Barnard
Battle Field of New Hope Church, Georgia No. 2,
1866
vintage albumen print, 10 × 14 in.
The Nelson-Atkins Museum of Art, Kansas City,
Missouri. Gift of Hallmark Cards, Inc. 2005.27.3158
Photo by Michael Lamy

CAT. 29
George N. Barnard
The "Hell Hole," New Hope Church, Georgia, 1866
vintage albumen print, 10 × 14 in.
The Nelson-Atkins Museum of Art, Kansas City,
Missouri. Gift of Hallmark Cards, Inc. 2005.27.3159
Photo by Michael Lamy

CAT. 30
George N. Barnard
Rebel works in Front of Atlanta, Georgia No. 1,
1864
vintage albumen print, 10 × 14 in.
The Nelson-Atkins Museum of Art, Kansas City,
Missouri. Gift of Hallmark Cards, Inc. 2005.27.3170

CAT. 31
George N. Barnard
Rebel works in Front of Atlanta, Georgia No. 4,
1864
vintage albumen print, 10 × 14 ⅛ in.
The Nelson-Atkins Museum of Art, Kansas City,
Missouri. Gift of Hallmark Cards, Inc. 2005.27.3173
Photo by Michael Lamy

CAT. 32
George N. Barnard
Scene of General McPherson's Death,
1864 or 1866
vintage albumen print, 10 × 14 ⅛ in.
The Nelson-Atkins Museum of Art, Kansas City,
Missouri. Gift of Hallmark Cards, Inc. 2005.27.237

THE HUMAN FACE OF WAR

CAT. 33
Sanford Robinson Gifford
*Preaching to the Troops, or Sunday Morning at
Camp Cameron near Washington, May 1861*,
1862
oil on canvas, 16 × 30 in.
The Union League Club of New York
Image © The Metropolitan Museum of Art

CAT. 34
Sanford Robinson Gifford
*Sunday Prayers (Study For Sunday Morning in
the Seventh Regiment Camp)*, 1862
oil on canvas, 7 × 12 ¼ in.
Private Collection

CAT. 35
Sanford Robinson Gifford
*Bivouac of the Seventh Regiment, Arlington
Heights, Virginia*, 1861
oil on canvas, 18 × 30 in.
New York State Military Museum, New York State
Division of Military and Naval Affairs

CAT. 36
Sanford Robinson Gifford
*Basin of the Patapsco from Federal Hill,
Baltimore, 1862*, 1862
oil on paper, 8 ³⁄₁₆ × 13 ½ in.
Frank M. Gren, "Annapolis Collection"

CAT. 37
Sanford Robinson Gifford
Fort Federal Hill at Sunset, Baltimore, 1862
oil on canvas, 18 × 32 in.
New York State Military Museum, New York State
Division of Military and Naval Affairs

CAT. 38
Sanford Robinson Gifford
*The Camp of the Seventh Regiment near
Frederick, Maryland*, 1863
oil on canvas, 9 ½ × 15 ½ in.
Private Collection

CAT. 39
Sanford Robinson Gifford
*Camp of the Seventh Regiment, near Frederick,
Maryland, July, 1863*, 1864
oil on canvas, 18 × 30 in.
New York State Military Museum, New York State
Division of Military and Naval Affairs

CAT. 40
Conrad Wise Chapman
*The Fifty-ninth Virginia Infantry—Wise's
Brigade* about 1867
oil on canvas, 20 ⅛ × 33 ⅞ in.
Amon Carter Museum of American Art, Fort Worth,
Texas, 2001.7

CAT. 41
Conrad Wise Chapman
Submarine Torpedo Boat H. L. Hunley Dec 6 1863,
1863–1864
oil on board, 11 ½ × 15 ½ in.
The Museum of the Confederacy, Richmond, Virginia
(0985.14.37a)
Photography by Alan Thompson

CAT. 42
Conrad Wise Chapman
The Flag of Sumter, Oct 20 1863, 1863–1864
oil on board, 11 ½ × 15 ½ in.
The Museum of the Confederacy, Richmond, Virginia
(0985.14.37l)
Photography by Alan Thompson

CAT. 43
John Gadsby Chapman
Evening Gun, Fort Sumter, 1863–1864
oil on board, 11 ½ × 15 ½ in.
The Museum of the Confederacy, Richmond, Virginia
(0985.14.37g)
Photography by Alan Thompson

CAT. 44
Conrad Wise Chapman
Fort Sumter, Interior, Sunrise, Dec. 9 1863,
1863–1864
oil on board, 11 ½ × 15 ½ in.
The Museum of the Confederacy, Richmond, Virginia
(0985.14.37j)
Photography by Alan Thompson

CAT. 45
Conrad Wise Chapman
Fort Sumter [Gun Gallery] Dec 8th 1863,
1863–1864
oil on board, 11 ½ × 15 ½ in.
The Museum of the Confederacy, Richmond, Virginia
(0985.14.37aa)
Photography by Alan Thompson

CAT. 46
Conrad Wise Chapman
White Point Battery Charleston Dec. 24th 1863,
1863–1864
oil on board, 11 ½ × 15 ½ in.
The Museum of the Confederacy, Richmond, Virginia
(0985.14.37dd)
Photography by Alan Thompson

CAT. 47
Conrad Wise Chapman
Battery Laurens Street Charleston Feb 7th 1864,
1863–1864
oil on board, 11 ½ × 15 ½ in.
The Museum of the Confederacy, Richmond, Virginia
(0985.14.37i)
Photography by Alan Thompson

CAT. 48
Conrad Wise Chapman
Battery Bee, Dec. 3, 1863, 1863–1864
oil on board, 11 ½ × 15 ½ in.
The Museum of the Confederacy, Richmond, Virginia
(0985.14.37b)
Photography by Alan Thompson

CAT. 49
Conrad Wise Chapman
Battery Simkins Feb 25 1864, 1864
oil on board, 11 ½ × 15 ½ in.
The Museum of the Confederacy, Richmond, Virginia
(0985.14.37e)
Photography by Alan Thompson

CAT. 50
Albert Bierstadt
Guerrilla Warfare, Civil War, 1862
oil on panel, 15 ½ × 18 ⅝ in.
The Century Association, New York

CAT. 51
Winslow Homer
Sharpshooter, 1863
oil on canvas, 12 ¼ × 16 ½ in.
Portland Museum of Art, Maine. Gift of Barbro and
Bernard Osher, 1992.41

CAT. 52
Winslow Homer
Home, Sweet Home, about 1863
oil on canvas, 21 ½ × 16 ½ in.
National Gallery of Art, Washington, Patrons'
Permanent Fund, 1997.72.1
Image courtesy National Gallery of Art, Washington

CAT. 53
Winslow Homer
The Brierwood Pipe, 1864
oil on canvas, 16 ¹³/₁₆ × 14 ¾ in.
The Cleveland Museum of Art, Mr. and Mrs.
William H. Marlatt Fund, 1944.524
Image © The Cleveland Museum of Art

CAT. 54
Winslow Homer
Skirmish in the Wilderness, 1864
oil on canvas, 18 × 26 ¼ in.
New Britain Museum of American Art, Harriet
Russell Stanley Fund, 1944.05

CAT. 55
Winslow Homer
Defiance: Inviting a Shot Before Petersburg, 1864
oil on panel, 12 × 18 in.
Detroit Institute of Arts, Founders Society purchase
and Dexter M. Ferry Jr. Fund, 51.66
Image courtesy the Bridgeman Art Library

CAT. 56
Edward Lamson Henry
The Old Westover House, 1869
oil on paperboard, 11 ⁵/₁₆ × 14 ⅜ in.
Corcoran Gallery of Art, Washington, D.C., Gift of
the American Art Association, 00.11

CAT. 57
Julian Scott
Surrender of a Confederate Soldier, 1873
oil on canvas, 19 ½ × 15 ½ in.
Smithsonian American Art Museum, Gift of
Mrs. Nan Altmayer, 2012.23

CAT. 58
Jervis McEntee
The Fire of Leaves, 1862
oil on canvas, 20 × 36 in.
Private Collection

CAT. 59
Winslow Homer
Trooper Meditating Beside a Grave, about 1865
oil on canvas, 16 ⅛ × 8 in.
Joslyn Art Museum, Omaha, Nebraska, Gift of
Dr. Harold Gifford and Ann Gifford Forbes, 1960

CAT. 60
Winslow Homer
Prisoners from the Front, 1866
oil on canvas, 24 × 38 in.
The Metropolitan Museum of Art, Gift of
Mrs. Frank B. Porter, 1922 (22.207)
Image © The Metropolitan Museum of Art

ABOLITION AND EMANCIPATION

CAT. 61
Frederic Edwin Church
The Natural Bridge, Virginia, 1852
oil on canvas, 28 × 23 in.
The Fralin Museum of Art at the University of Virginia

CAT. 62
Robert S. Duncanson
Uncle Tom and Little Eva, 1853
oil on canvas, 27 ¼ × 38 ¼ in.
Detroit Institute of Arts, Gift of Mrs. Jefferson Butler
and Miss Grace R. Conover, 49.498
Image courtesy the Bridgeman Art Library

CAT. 63
Eastman Johnson
The Old Mount Vernon, 1857
oil on board, 23 ¼ × 34 ½ in.
Mount Vernon Ladies' Association, Purchased with
funds courtesy of an anonymous donor and the
Mount Vernon Licensing Fund, 2009

CAT. 64
Eastman Johnson
Negro Life at the South, 1859
oil on linen, 37 × 46 in.
The New-York Historical Society, The Robert L.
Stuart Collection, S-225

CAT. 65
Eastman Johnson
Card Players, Fryeburg, Maine, about 1865
oil on canvas, 18 ⅞ × 29 in.
Private Collection

CAT. 66
Thomas Moran
Slave Hunt, Dismal Swamp, Virginia, 1862
oil on canvas, 34 × 44 in.
Philbrook Museum of Art, Tulsa, Oklahoma, Gift of
Laura A. Clubb, 1947.8.44
Image © 2012 Philbrook Museum of Art, Inc., Tulsa,
Oklahoma

CAT. 67
Eastman Johnson
*A Ride for Liberty—The Fugitive Slaves,
March 2, 1862*, 1862
oil on board, 21 ½ × 26 in.
Virginia Museum of Fine Arts, Richmond, The Paul
Mellon Collection, 85.644
Photo by Katherine Wetzel, © Virginia Museum of
Fine Arts

CAT. 68
Edward Lamson Henry
Presentation of the Colors 1864, 1869
oil on board, 25 × 34 in.
The Union League Club of New York
Image © The Metropolitan Museum of Art

CAT. 69
Eastman Johnson
Christmas-Time, The Blodgett Family, 1864
oil on canvas, 30 × 25 in.
The Metropolitan Museum of Art, Gift of Mr. and
Mrs. Stephen Whitney Blodgett, 1983 (1983.486)
Image © The Metropolitan Museum of Art

CAT. 70
Eastman Johnson
The Lord Is My Shepherd, 1863
oil on wood, 16 ⅝ × 13 ⅛ in.
Smithsonian American Art Museum, Gift of
Mrs. Francis P. Garvan 1979.5.13

CAT. 71
Winslow Homer
The Bright Side, 1865
oil on canvas, 12 ¾ × 17 in.
Fine Arts Museums of San Francisco, Gift of
Mr. and Mrs. John D. Rockefeller 3rd, 1979.7.56

CAT. 72
Winslow Homer
Near Andersonville, 1865–1866
oil on canvas, 23 × 18 in.
Newark Museum, Gift of Mrs. Hannah Corbin Carter;
Horace K. Corbin, Jr.; Robert S. Corbin; William D.
Corbin and Mrs. Clementine Corbin Day in memory
of their parents, Hannah Stockton Corbin and Horace
Kellogg Corbin, 1966.66.354

CAT. 73
Winslow Homer
A Visit from the Old Mistress, 1876
oil on canvas, 18 × 24 in.
Smithsonian American Art Museum, Gift of William
T. Evans, 1909.7.28

CAT. 74
Winslow Homer
The Cotton Pickers, 1876
oil on canvas, 24 ¹⁄₁₆ × 38 ⅛ in.
Los Angeles County Museum of Art. Acquisition
made possible through Museum Trustees:
Robert O. Anderson, R. Stanton Avery, B. Gerald
Cantor, Edward W. Carter, Justin Dart, Charles
E. Ducommun, Camilla Chandler Frost, Julian
Ganz, Jr., Dr. Armand Hammer, Harry Lenart, Dr.
Franklin D. Murphy, Mrs. Joan Palevsky, Richard
E. Sherwood, Maynard J. Toll, and Hal B. Wallis
(M.77.68)
Digital Image © 2012 Museum Associates/LACMA
Licensed by Art Resource, NY

AFTERMATH

CAT. 75
Winslow Homer
The Veteran in a New Field, 1865
oil on canvas, 24 ⅛ × 38 ⅛ in.
The Metropolitan Museum of Art, Bequest of Miss
Adelaide Milton de Groot (1876–1967), 1967
(67.187.131)
Image © The Metropolitan Museum of Art

CAT. 76
Eastman Johnson
The Girl I Left Behind Me, about 1872
oil on canvas, 42 × 34 ⅞ in.
Smithsonian American Art Museum, Museum
purchase made possible in part by Mrs. Alexander
Hamilton Rice in memory of her husband and by
Ralph Cross Johnson, 1986.79

CAT. 77
Winslow Homer
Dressing for the Carnival, 1877
oil on canvas, 20 × 30 in.
The Metropolitan Museum of Art, Amelia B. Lazarus
Fund, 1922 (22.220)
Image © The Metropolitan Museum of Art

FIGURE ILLUSTRATIONS

INTRODUCTION

FIG I
James Hope
Battle of Antietam, September 17, 1862, 7th Maine Attacking over the Sunken Road through the Piper Cornfield, about 1862
oil on canvas, 18 ⅞ × 35 ⅞ in.
Farnsworth Art Museum, Gift of Alice Bingham Gorman, 1997.16

FIG. 2
James Hope
Bloody Lane, about 1862
oil on canvas, 19 × 26 in.
Army Art Collection, U.S. Army Center of Military History

FIG. 3
Thomas Buchanan Read
Philip Henry Sheridan (Sheridan's Ride), 1871
oil on canvas, 54 × 38 ⅞ in.
National Portrait Gallery, Smithsonian Institution; Gift of Ulysses S. Grant III, 1939, NPG.68.51

FIG. 4
Everett B. D. Fabrino Julio
The Last Meeting of Lee and Jackson, 1869
oil on canvas, 102 × 74 in.
The Museum of the Confederacy, Richmond, Virginia
Photography by Katherine Wetzel

FIG. 5
Unidentified photographer
Mark Twain (Samuel L. Clemens) (detail), 1871
wet collodion glass negative
Library of Congress, Prints and Photographs Division, LC-DIG-CWPBH-04761

FIG. 6
Constant Mayer
Recognition: North and South, 1865
oil on canvas, 68 ⅛ × 93 ½ in.
The Museum of Fine Arts, Houston, Museum purchase with funds provided by "One Great Night in November, 2011," and gift of Nancy and Richard D. Kinder in honor of Emily Ballew Neff

FIG. 7
Ole Peter Hansen Balling
John Brown, 1872
oil on canvas, 30 ⅛ × 25 ⅜ in.
National Portrait Gallery, Smithsonian Institution, NPG.74.2

FIG. 8
George Caleb Bingham
Order No. 11, 1865–70
oil on canvas, 56 ³⁄₁₆ × 79 ⁷⁄₁₆ in.
Cincinnati Art Museum, The Edwin and Virginia Irwin Memorial, 1958.515
Image courtesy the Bridgeman Art Library

FIG. 9
Masaccio
Expulsion from Paradise, 1425–1428
fresco
Brancacci Chapel, Santa Maria del Carmine, Florence, Italy
Photo credit: Scala/Art Resource, NY

FIG. 10
Petrus Christus
The Lamentation, about 1450
oil on wood, 10 × 13 ¾ in.
The Metropolitan Museum of Art, Marquand Collection, Gift of Henry G. Marquand, 1890 (91.26.12)
Image © The Metropolitan Museum of Art

FIG. 11
William D. Washington
The Burial of Latané, 1864
oil on canvas, 38 × 48 in.
The Johnson Collection

LANDSCAPES AND THE METAPHORICAL WAR

FIG. 12
Asher Durand
Kindred Spirits, 1849
oil on canvas, 44 × 36 in.
Crystal Bridges Museum of American Art, Bentonville, Arkansas
Photography by The Metropolitan Museum of Art

FIG. 13
Unidentified photographer
Martin Johnson Heade, 1860
photographic print on carte-de-visite mount, 2 ¾ × 4 in.
Miscellaneous photographs collection, Archives of American Art, Smithsonian Institution

FIG. 14
Unidentified photographer
Henry Ward Beecher, about 1855–1865
wet collodion glass negative
Library of Congress, Prints and Photographs Division, LC-DIG-CWPBH-03065

FIG. 15
Fitz Henry Lane
Approaching Storm, Owl's Head, 1860
oil on canvas, 24 × 39 ⅝ in.
Private Collection

FIG. 16
Unidentified photographer
Ralph Waldo Emerson, 1854
Photography Collection, Miriam and Ira D. Wallach Division of Art, Prints, and Photographs, The New York Public Library, Astor, Lenox and Tilden Foundations

FIG. 17
Mathew B. Brady
Frederic Edwin Church, about 1860
wet collodion glass negative
Library of Congress, Prints and Photographs Division, LC-DIG-CWPBH-02727

FIG. 18
John McNevin
Cover page from *Harper's Weekly*, August 4, 1860
wood engraving
Library of Congress, Prints and Photographs Division, LC-DIG-ds-01284

FIG. 19
Rodney Dewey
Herman Melville, about 1860
photograph
Berkshire Athenaeum, Pittsfield, Massachusetts

FIG. 20
Mathew B. Brady
Walt Whitman, about 1867
albumen silver print, 9 ⁷⁄₁₆ × 7 ⅜ in.
National Portrait Gallery, Smithsonian Institution; Gift of Mr. and Mrs. Charles Feinberg, NPG.76.96

FIG. 21
Benjamin Maxham
Henry David Thoreau, 1856
daguerreotype
The Thoreau Society Collections at the Thoreau Institute at Walden Woods

FIG. 22
Frederic Edwin Church
Twilight in the Wilderness, 1860
oil on canvas, 40 × 64 in.
The Cleveland Museum of Art, Mr. and Mrs. William H. Marlatt Fund, 1965.233
Image © The Cleveland Museum of Art

FIG. 23
Brady's National Portrait Gallery
Sanford Robinson Gifford, about 1860s
albumen silver print, carte-de-visite, 3 ⅓ × 2 ⅕ in.
The Metropolitan Museum of Art, David Hunter McAlpin Fund, 1952 (52.605)
Image © The Metropolitan Museum of Art

FIG. 24
Bobbett & Hooper, sc
Our Great Iceberg Melting Away, from *Vanity Fair*, March 9, 1861
wood engraving
Print Collection, Miriam and Ira D. Wallach Division of Art, Prints, and Photographs, The New York Public Library, Astor, Lenox and Tilden Foundations

FIG. 25
Unidentified photographer
The equestrian statue of Washington, bearing aloft the Flag of Fort Sumter, a great historical picture. Below see the heaving mass burning with devotion to the Constitution bequeathed to them as a sacred legacy by their fathers. April 20, 1861
stereograph
The New-York Historical Society, negative # ad21007

FIG. 26
Unidentified photographer
Frederic Edwin Church and Theodore Winthrop (standing), about 1860
albumen print, 6 × 4 ¾ in.
Miscellaneous photographs collection, Archives of American Art, Smithsonian Instititution

FIG. 27
Frederic Edwin Church
Our Banner in the Sky, 1861
lithographic print on paper with oil over paint, 7 ⁹⁄₁₆ × 11 ⅜ in.
Olana State Historic Site, Hudson, NY, New York State Office of Parks, Recreation and Historic Preservation, OL.1976.29

FIG. 28
Sanford Robinson Gifford
A Gorge in the Mountains (Kauterskill Clove), 1862
oil on canvas, 48 × 39 ⅞ in.
The Metropolitan Museum of Art, Bequest of Maria DeWitt Jesup, from the collection of her husband, Morris K. Jesup, 1914 (15.30.62)
Image © The Metropolitan Museum of Art

FIG. 29
Unidentified daguerreotypist
Emily Dickinson, about 1847
daguerreotype
Amherst College Archives and Special Collections

FIG. 30
Unidentified photographer
John Greenleaf Whittier, about 1840–1860
quarter- plate ambrotype
Boston Public Library, Print Department

FIG. 31
Unidentified photographer
Frederick Douglass, 1856
quarter-plate ambrotype, 4 ³⁄₁₆ × 3 ⅜ in.
National Portrait Gallery, Smithsonian Institution; Purchased with funds from an anonymous donor, NPG.74.75

FIG. 32
Julius Schrader
Baron Alexander von Humboldt, 1859
oil on canvas, 62 ½ × 54 ⅜ in.
The Metropolitan Museum of Art, Gift of H. O. Havemeyer, 1889 (89.20)
Image © The Metropolitan Museum of Art

FIG. 33
Frederic Edwin Church
Cotopaxi, 1855
oil on canvas, 28 × 42 in.
Smithsonian American Art Museum, Gift of Mrs. Frank R. McCoy 1965.12

FIG. 34
Austin Augustus Turner
Jervis McEntee, about 1860s
albumen silver print, carte-de-visite, 3 ¹¹⁄₁₆ × 2 in.
The Metropolitan Museum of Art, The Albert Ten Eyck Gardner Collection, Gift of the Centennial Committee, 1970 (1970.659.560)
Image © The Metropolitan Museum of Art

FIG. 35
Unidentified photographer
Homer Dodge Martin, about 1850–60
daguerreotype on paper, 3 ½ × 5 in.
Martin Family Archives

FIG. 36
George Gardner Rockwood
Jasper Francis Cropsey, about 1860s
albumen silver print, carte-de-visite, 3 ¹¹⁄₁₆ × 2 ³⁄₁₆ in.
The Metropolitan Museum of Art, The Albert Ten Eyck Gardner Collection, Gift of the Centennial Committee, 1970 (1970.659.175)
Image © The Metropolitan Museum of Art

FIG. 37
Unidentified artist
The Civil War in America, View from the West of Richmond, Virginia, Capital of the Confederate States—from a Sketch by Our Special Artist, from *Illustrated London News*, November 15, 1862
wood engraving
Courtesy of "The Civil War in America from the *Illustrated London News*": A Joint Project by Sandra J. Still, Emily E. Katt, Collection Management, and the Beck Center of Emory University

FIG. 38
Jasper Francis Cropsey
Richmond Hill in the Summer of 1862 (detail), 1862–1863
oil on canvas, 54 × 96 in.
Private Collection

FIG. 39
Brady's National Portrait Gallery
Picture gallery, Metropolitan Fair, N.Y.C., 1864
photograph
National Archives, photo number 111-B-2034

FIG. 40
Mathew B. Brady
Isaac Israel Hayes, about 1860–75
wet collodion glass negative
Library of Congress, Prints and Photographs Division, LC-DIG-CWPBH-00491

FIG. 41
Frederic Edwin Church
Aurora Borealis (detail), 1865
oil on canvas, 56 × 83 ½ in.
Smithsonian American Art Museum, Gift of Eleanor Blodgett, 1911.4.1

FIG. 42
Frederic Edwin Church
Aurora Borealis, Mt. Desert Island, from Bar Harbor, Maine, September 1860
brush and oil paint on cardboard, 10 ⅜ × 13 ⅞ in.
Cooper-Hewitt National Design Museum, Smithsonian Institution, Gift of Louis P. Church, 1917-4-1374
Photo by Matt Flynn, © Smithsonian Institution
Image credit: Cooper-Hewitt National Design Museum, Smithsonian Institution/Art Resource, N.Y.

FIG. 43
Thomas Nast
A Rebel General Startled in His Camp by the Beautiful and Unexpected Display of Northern Light, from *Harper's Weekly*, May 25, 1861
wood engraving
Library of Congress, Prints and Photographs Division, LC-DIG-ds-01285

FIG. 44
Frederic Edwin Church
Niagara, 1857
oil on canvas, 40 × 90 ½ in.
Corcoran Gallery of Art, Washington, D.C., Museum Purchase, Gallery Fund, 76.15

FIG. 45
Currier & Ives
The Hand-Writing on the Wall, or the Modern Belshazzar, 1862
lithograph print
American Antiquarian Society

FIG. 46
Rembrandt Harmensz van Rijn
Belshazzar's Feast, about 1636–1638
oil on canvas, 66 × 82 ⅜ in.
The National Gallery, London, Great Britain. Bought with a contribution from The Art Fund, 1964 (NG6350).
Photo © National Gallery, London/Art Resource, NY

FIG. 47
Bierstadt Brothers
Double-exposure portrait of Albert Bierstadt, about 1860s
albumen silver print, carte-de-visite, 3 ¹¹⁄₁₆ × 2 in.
The Metropolitan Museum of Art, David Hunter McAlpin Fund, 1952 (52.605)
Image © The Metropolitan Museum of Art

FIG. 48
J. E. Baker [for Armstrong and Company]
Horace Greeley, about 1872
lithograph print
Library of Congress, Prints and Photographs
Division, LC-DIG-PGA-00057

FIG. 49
James Wallace Black
Thomas Starr King, about 1860
albumen silver print, 3 ½ × 2 ¼ in.
National Portrait Gallery, Smithsonian Institution;
Gift of Frank H. Goodyear, III and Ann M. Shumard,
NPG.2011.110

FIG. 50
Unidentified photographer
Edwin Booth as Hamlet, 1863
photograph overpainted with watercolor from *Album
of Illustrated Verses*
Alexander Gallery, New York

FIG. 51
Unidentified photographer
John Frederick Kensett in his studio, about 1866
photographic print, 10 ¼ × 6 11⁄16 in.
Miscellaneous Photographs Collection, Archives of
American Art, Smithsonian Institution

THE ART OF WARTIME PHOTOGRAPHY

FIG. 52
Charles Loring Elliott
Mathew B. Brady, 1857
oil on canvas, 24 × 20 in.
The Metropolitan Museum of Art, Gift of the Friends
of Mathew Brady, 1896 (96.24)
Image © The Metropolitan Museum of Art

FIG. 53
A. Berghaus, del.
*M. B. Brady's New Photographic Gallery, Corner of
Broadway and Tenth Street, New York*, from *Frank
Leslie's Illustrated Newspaper*, January 5, 1861
wood engraving print
Library of Congress, Prints and Photographs
Division, LC-USZ62-114481

FIG. 54
Alexander Gardner
Self-Portrait, about 1864
albumen silver print, 3 ⅜ × 2 ⅛ in.
National Portrait Gallery, Smithsonian Institution,
NPG.2002.87

FIG. 55
Armstrong & Co.
Oliver Wendell Holmes, about 1879
print
Library of Congress, Prints and Photographs
Division, LC-DIG-PGA-00066

FIG. 56
Unidentified photographer
*Alexander Gardner's Photographic Gallery, 7ᵗʰ &
D Street, NW, Washington, D.C.*, about 1863
wet collodion glass negative
Library of Congress, Prints and Photographs
Division, LC-DIG-CWPBH-05229

FIG. 57
Philp and Solomons
Timothy O'Sullivan, about 1870
albumen silver print, 3 7⁄16 × 2 3⁄16 in.
National Portrait Gallery, Smithsonian Institution;
Gift of Larry J. West, NPG.2007.95

FIG. 58
Alexander Gardner
*A Sharpshooter's Last Sleep, Gettysburg,
Pennsylvania*, July 1863
albumen print
Library of Congress, Prints and Photographs
Division, LC-DIG-PPMSCA-12561

FIG. 59
Timothy H. O'Sullivan
*"Rocks could not save him at the Battle of
Gettysburg,"* July 1863
wet collodion glass negative, stereograph
Library of Congress, Prints and Photographs
Division, LC-DIG-CWPB-00875

FIG. 60
Mathew B. Brady
Wounded Trees at Gettysburg, 1863
photographic print on stereo card
Library of Congress, Prints and Photographs
Division, LC-DIG-Stereo-1S02672

FIG. 61
Mathew B. Brady
*Woods in which Gen. J. F. Reynolds Was Killed,
Gettysburg, Pennsylvania*, 1863
photograph
National Archives, Washington, D.C., Photo number
111-B-111

FIG. 62
Timothy H. O'Sullivan,
The Field Where General Reynolds Fell, Gettysburg,
July 1863
wet collodion glass negative, stereograph
Library of Congress, Prints and Photographs
Division, LC-DIG-CWPB-00849

FIG. 63
Alexander Gardner
Abraham Lincoln, November 8, 1863
photographic print
Library of Congress, Prints and Photographs
Division, LC-DIG-ppmsca-19301

FIG. 64
Alfred R. Waud, del.
Frontispiece from *Gardner's Photographic Sketch
Book of the War*, 1866
lithograph
Library of Congress, Prints and Photographs Division,
LC-DIG-PPMSCA-12834

FIG. 65
Mathew B. Brady
George N. Barnard, about 1865
albumen silver print, 3 ⅜ × 2 5⁄16 in.
National Portrait Gallery, Smithsonian Institution;
Gift of Larry J. West, NPG.2007.18

FIG. 66
George N. Barnard
William Tecumseh Sherman, 1864
wet collodion glass negative, stereograph
Library of Congress, Prints and Photographs Division,
LC-DIG-CWPB-03379

FIG. 67
George N. Barnard
Chattanooga Valley from Lookout Mountain No. 2,
1864
albumen print from *Barnard's Photographic Views of
the Sherman Campaign*, about 1866
Hargrett Rare Book and Manuscript Library/University
of Georgia Libraries

FIG. 68
Thomas Cole
*View from Mount Holyoke, Northampton,
Massachusetts, after a Thunderstorm—The Oxbow*,
1836
oil on canvas, 51 ½ × 76 in.
The Metropolitan Museum of Art, Gift of Mrs. Russell
Sage, 1908 (08.228)
Image © the Metropolitan Museum of Art

FIG. 69
George N. Barnard
*Destroying the Railroad just before the "March to
the Sea," Atlanta*, 1864
wet collodion glass negative, stereograph
Library of Congress, Prints and Photographs Division,
LC-DIG-CWPB-03394

FIG. 70
George N. Barnard
South Bank of the Chattahoochie, GA, 1864
albumen print from *Barnard's Photographic Views of
the Sherman Campaign*, about 1866
Hargrett Rare Book and Manuscript Library/University
of Georgia Libraries

FIG. 71
George N. Barnard
The Potter House, Atlanta, 1864
albumen print from *Barnard's Photographic Views of the Sherman Campaign*, about 1866
Hargrett Rare Book and Manuscript Library/University of Georgia Libraries

THE HUMAN FACE OF WAR

FIG. 72
Edward Lamson Henry
Departing for the Seat of War from New Jersey, 1869
oil on panel, 10 ¼ × 15 ¾ in.
New York State Military Museum, New York State Division of Military and Naval Affairs

FIG. 73
Unidentified artist(s)
Camp Cameron, Georgetown, D.C., The Encampment of the Seventh Regiment New York State Militia (top) and *Service by Rev. Dr. Weston, Chaplain of the Seventh Regiment, at Camp Cameron, on Sunday May 5, 1861— Sketched by Our Special Artist*
both from *Harper's Weekly*, May 25, 1861
wood engravings
Library of Congress

FIG. 74
Winslow Homer
The Advance Guard of the Grand Army of the United States Crossing the Long Bridge over the Potomac, at 2 a.m. on May 24, 1861, from *Harper's Weekly*, June 8, 1861
wood engraving on paper, 9 ¼ × 13 ¼ in.
Smithsonian American Art Museum, The Ray Austrian Collection, Gift of Beatrice L. Austrian, Caryl A. Austrian and James A. Austrian 1996.63.43

FIG. 75
Unidentified photographer
Sanford R. Gifford during the American Civil War, about 1861
photograph, 4 ¾ × 3 ⅛ in.
Sanford Robinson Gifford papers, Archives of American Art, Smithsonian Institution

FIG. 76
Unidentified photographer
Conrad Wise Chapman, about 1865
albumen print
Library of Virginia

FIG. 77
Unidentified photographer
General Pierre G. T. Beauregard, about 1860–1870
wet collodion glass negative
Library of Congress, Prints and Photographs Division, LC-dig-cwpb-05515

FIG. 78
John Ross Key
Bombardment of Fort Sumter, Siege of Charleston Harbor, 1863, 1865
oil on canvas, 29 × 69 in.
Greenville County Museum of Art, Museum purchase with funds donated by Suzanne Cochrane Austell; Dorothy Hipp Gunter; Buck and Minor Mickel; Dorothy P. Peace; John I. Smith Charities; Ball Unimark Plastics; Elliott, Davis & Co., CPAs First Union National Bank of South Carolina; Michelin Tire Corporation; 1988 Museum Antiques Show Benefactors; 1989 Collectors Group

FIG. 79
Bierstadt Brothers
Picket Guard and prisoners, near Lewinsville, Va., 1861
stereograph
Collection of Leonard A. Walle

FIG. 80
Dodge, Collier and Perkins
Picket guard on the ale[rt], near Lewinsville, Va., 1861
stereograph
Robert N. Dennis Collection of Stereoscopic Views, Miriam and Ira D. Wallach Division of Art, Prints, and Photographs, The New York Public Library, Astor, Lenox and Tilden Foundations

FIG. 81
Napoleon Sarony
Winslow Homer taken in N.Y., 1880, 1880
albumen print, 5 ⅞ × 4 ¼ in.
Bowdoin College Museum of Art, Brunswick, Maine, Gift of the Homer Family, 1964.69.179.4

FIG. 82
Winslow Homer
The Army of the Potomac—A Sharp-shooter on Picket Duty, from *Harper's Weekly*, November 15, 1862
wood engraving on paper, 9 ⅛ × 13 ¾ in.
Smithsonian American Art Museum, The Ray Austrian Collection, Gift of Beatrice L. Austrian, Caryl A. Austrian and James A. Austrian, 1996.63.50

FIG. 83
Winslow Homer
Page four of a Winslow Homer letter to George G. Briggs (detail), February 19, 1896
Winslow Homer Collection, Archives of American Art, Smithsonian Institution

FIG. 84
Mathew B. Brady
Major General Nelson A. Miles, about 1860–1865
wet collodion glass negative
Library of Congress, Prints and Photographs Division, LC-DIG-CWPB-06148

FIG. 85
Unidentified Artist
The Brier-Wood Pipe, from *Vanity Fair*, July 6, 1861
wood engraving
Smithsonian Institution Libraries, Washington, D.C.

FIG. 86
Alexander Gardner
Gathered together for burial after the Battle of Antietam, about 1862
photographic print on stereo card
Library of Congress, Prints and Photographs Division, LC-DIG-Stereo-1S02944

FIG. 87
Unidentified photographer
Battlefield of the "Wilderness"—Views in the woods in the Federal lines on north side of Orange Plank Road, about 1864–1865
photographic print
Library of Congress, Prints and Photographs Division LC-USZC4-7957

FIG. 88
Unidentified photographer
Edward Lamson Henry dressed as a coachman, about 1873
tintype
New York State Museum, Albany, N.Y.

FIG. 89
Unidentified photographer
General Francis Barlow, about 1855–1865
wet collodion glass negative
Library of Congress, Prints and Photographs Division LC-DIG-CWPBH-01160

ABOLITION AND EMANCIPATION

FIG. 90
Harry Fenn, illustrator
J. A. Bogert, engraver
Under the Natural Bridge, from *Picturesque America* (New York: D. Appleton, 1872)
wood engraving
Smithsonian Institution Libraries, Washington, D.C.

FIG. 91
Unidentified photographer
Harriet Beecher Stowe, about 1865
albumen silver print, 3 ⅜ × 2 3/16 in.
National Portrait Gallery, Smithsonian Institution, NPG.2006.57

FIG. 92
Harriet Beecher Stowe
Frontispiece from *Uncle Tom's Cabin; or, Life among the Lowly*, 1852
steel engraving
The Lilly Library, Indiana University, Bloomington, Indiana

FIG. 93
William Notman
Robert S. Duncanson, artist, Montreal, QC, 1864,
1864
silver salts on paper mounted on paper, albumen
process, 3 5⁄16 × 2 3⁄16 in.
McCord Museum, McGill University, Purchase from
Associated Screen News Ltd., I-11978.1
Image © McCord Museum

FIG. 94
Robert S. Duncanson
View of Cincinnati from Covington, KY,
about 1851
oil on canvas, 25 × 36 in.
Cincinnati Museum Center, Cincinnati Historical
Society Library

FIG. 95
J. W. Steel, engraver
View of Cincinnati, Ohio, from *Graham's
Magazine*, vol. 32, no. 6 (June 1848)
steel engraving
Smithsonian Institution Libraries, Washington, D.C.

FIG. 96
Thomas Waterman Wood
Southern Cornfields, 1861
oil on canvas, 27 × 40 in.
T. W. Wood Gallery, Montpelier, Vermont

FIG. 97
Eastman Johnson
Self Portrait, 1863
oil on millboard, 15 ½ × 12 in.
The Art Institute of Chicago, Gift of Mrs. Arthur
Meeker, 1924.126
Photography © The Art Institute of Chicago

FIG. 98
Currier & Ives
The Home of Washington, Mount Vernon, Va.,
about 1856–1872
hand-colored lithograph print
Library of Congress, Prints and Photographs
Division, LC-USZC4-3302

FIG. 99
John Adams Whipple
Henry Brooks Adams, Quincy, 1858
salted paper print, 5 5⁄8 × 4 5⁄16 in.
Harvard Art Museums/Fogg Museum, Transfer
from the Carpenter Center for the Visual Arts, Gift of
Arthur S. Eldredge, 2.2002.2052
Photo: Imaging Department © President and Fellows
of Harvard College

FIG. 100
Eastman Johnson
Negro Life at the South (detail), 1859
oil on linen, 37 × 46 in.
The New-York Historical Society, The Robert L.
Stuart Collection, S-225

FIG. 101
Samuel S. Osgood
Mary Boykin Chesnut, 1856
oil on canvas adhered to masonite, 48 × 30 in.
Private Collection
Photo credit: Private Collection/Art Resource, NY

FIG. 102
Gilbert Studios, Washington, D.C.
Harriet Jacobs, 1894
gold-toned albumen print
Private Collection

FIG. 103
Dion Boucicault
Frontispiece from *The Octoroon; or, Life in
Louisiana*, 1859
steel engraving
Colby College Special Collections, Waterville, Maine

FIG. 104
Unidentified photographer
Thomas Moran at age 18, 1855, Philadelphia, PA.,
1855
photograph, 10 × 8 in.
Courtesy of the East Hampton Library, Long Island
Collection

FIG. 105
Thomas Cole
The Course of Empire: Desolation, 1836
oil on canvas, 39 ¼ × 63 ¼ in.
The New-York Historical Society, 1858.5

FIG. 106
Mathew B. Brady
George Perkins Marsh, about 1850
half-plate gold-toned daguerreotype
Library of Congress, Prints and Photographs
Division, LC-USZ62-109923

fig. 107
Brady National Photographic Art Gallery
General Benjamin Butler, about 1855–65
wet collodion glass negative
Library of Congress, Prints and Photographs
Division, LC-DIG-CWPBH-00894

FIG. 108
U.S. Mint, Obverse: James B. Longacre, Reverse:
Anthony C. Paquet
"Liberty" twenty dollar coin, 1860
National Numismatic Collection, Division of Political
History, National Museum of American History,
Smithsonian Institution, 1985.0441.1927

FIG. 109
Unidentified artist
*Presentation of Colors to the 20th U.S. Colored
Infantry, Col. Bartram, at the Union League Club
House, N.Y., March 5,* from *Frank Leslie's Illustrated
Newspaper*, March 26, 1864
engraving
Smithsonian Institution Libraries, Washington, D.C.

FIG. 110
Thomas Waterman Wood
*A Bit of War History: The Contraband, The
Recruit,* and *The Veteran*, 1866
oil on canvas, 28 ¼ × 20 ¼ in. each
The Metropolitan Museum of Art, Gift of Charles
Stewart Smith, 1884 (84.12a-c)
Images © The Metropolitan Museum of Art

FIG. 111
Edwin White
Thoughts of Liberia, Emancipation, 1861
oil on canvas, 18 × 21 in.
The New-York Historical Society, S-200

FIG. 112
Thomas Baker, arranger
Sheet music cover for *The Song of the
Contrabands:* "*O Let My People Go,*" 1861
Library of Congress

FIG. 113
Winslow Homer
A Bivouac Fire on the Potomac, from *Harper's
Weekly*, December 21, 1861
wood engraving on paper, 13 ¾ × 20 ¼ in.
Smithsonian American Art Museum, The Ray
Austrian Collection, Gift of Beatrice L. Austrian, Caryl
A. Austrian and James A. Austrian, 1996.63.114

FIG. 114
Emily Sartain
Albion Tourgée, 1870
steel engraving, 12 × 9 ½ in.
Tourgée Papers at the Chautauqua County Historical
Society, Westfield, N.Y.

AFTERMATH

FIG. 115
John Singer Sargent
Henry James, 1913
oil on canvas, 33 ½ × 26 ½ in.
National Portrait Gallery, London, NPG1767
Image © National Portrait Gallery, London

FIG. 116
Timothy H. O'Sullivan
*Battlefield of Cedar Mountain House riddled
with cannon balls in which Gen. Winder was
killed*, August 1862
wet collodion glass stereograph negative
Library of Congress, Prints and Photographs
Division, LC-dig-cwpb-03557

FIG. 117
Silas Selleck
Clarence King and the Field Party of 1864, 1864
albumen silver print, 8 1⁄16 × 6 1⁄8 in.
National Portrait Gallery, Smithsonian Institution,
NPG.92.61

FIG. 118
Timothy H. O'Sullivan
Limestone Cañon, Humboldt Mountains,
Nevada, 1868
albumen photographic print
Library of Congress, Prints and Photographs
Division, LC-DIG-ppmsca-11898

FIG. 119
Timothy H. O'Sullivan
Steamboat Springs, Nevada, 1867
albumen photographic print
Library of Congress, Prints and Photographs
Division, LC-DIG-ppmsca-11884

FIG. 120
Unidentified photographer
Frederick Law Olmsted, about 1860
photograph
Courtesy of the National Park Service, Frederick Law
Olmsted National Historic Site

FIG. 121
Emanuel Leutze
Westward the Course of Empire Takes Its Way,
1861
stereochromy, 20 × 30 ft.
Architect of the Capitol

FIG. 122
George Inness
Gray Day, Goochland, 1884
oil on plywood panel, 18 ⅛ × 24 in.
The Phillips Collection, Washington, D.C., Acquired
1917

FIG. 123
James Gardner
Breaking Camp, Brandy Station, Virginia,
May 1864
albumen photographic print
Library of Congress, Prints and Photographs
Division, LC-DIG-ppmsca-12584

INDEX

THE CIVIL WAR
AND *American Art*

Chief of Publications: Theresa J. Slowik
Editor: Tiffany D. Farrell
Designer: Jessica L. Hawkins
Researcher: Barbaranne E. Mocella Liakos
Permissions Coordinator: Emma Stratton

 Smithsonian American Art Museum

The Smithsonian American Art Museum is home to one of the largest collections of American art in the world. Its holdings—more than 41,000 works—tell the story of America through the visual arts and represent the most inclusive collection of American art in any museum today. It is the nation's first federal art collection, predating the 1846 founding of the Smithsonian Institution. The museum celebrates the exceptional creativity of the nation's artists whose insights into history, society, and the individual reveal the essence of the American experience.

For more information or a catalog of publications, write:
Office of Publications
Smithsonian American Art Museum
MRC 970, PO Box 37012
Washington, DC 20013-7012

Visit the museum's website at AmericanArt.si.edu.

First published in 2012 by the Smithsonian American Art Museum
in association with:
Yale University Press
PO Box 209040
New Haven, CT 06520-9040
yalebooks.com/art

10 9 8 7 6 5 4 3 2 1

Published in conjunction with the exhibition of the same name, on view at the Smithsonian American Art Museum in Washington, D.C., from November 16, 2012 through April 28, 2013.

The exhibition will travel to:

The Metropolitan Museum of Art
New York City
May 21 – September 2, 2013

Printed and bound by Artegrafica in Verona, Italy.

Library of Congress
Cataloging-in-Publication Data

Harvey, Eleanor Jones.
	The Civil War and American art / Eleanor Jones Harvey.
		pages cm
	Published in conjunction with the exhibition of the same name, on view at the Smithsonian American Art Museum in Washington, D.C., from November 16, 2012 through April 28, 2013, and at the Metropolitan Museum of Art, New York City, from May 21–September 2, 2013.

ISBN 978-0-300-13733-5 (hardback)
ISBN 978-0-937311-98-1 (soft cover)

1. Art, American—19th century—Themes, motives—Exhibitions.
2. United States—History—Civil War, 1861–1865—Art and the war—Exhibitions.
3. Art and society—United States—History—19th century—Exhibitions.
I. Smithsonian American Art Museum. II. Metropolitan Museum of Art (New York, N.Y.) III. Title.

	N6510.H37 2012
	740.973'074753—dc23
			2012029342

Cover: Sanford Robinson Gifford, *The Camp of the Seventh Regiment near Frederick, Maryland* (detail), 1863. See cat. 38, p. 126

Frontispiece: Winslow Homer, *The Veteran in a New Field* (detail), 1865. See cat. 75, p. 227

Pages iv–v : Sanford Robinson Gifford, *A Coming Storm* (detail), 1863, retouched and redated in 1880. See cat. 11, p. 64

Page vi: Winslow Homer, *The Cotton Pickers* (detail), 1876. See cat. 74, p. 222

Page viii: Albert Bierstadt, *Guerrilla Warfare, Civil War* (detail), 1862. See cat. 50, p. 147

Page x: Conrad Wise Chapman, *The Flag of Sumter, Oct 20 1863* (detail), 1863–1864. See cat. 42, p. 136

Page xviii: Edward Lamson Henry, *The Old Westover House* (detail), 1869. See cat. 56, p. 163

Page 16: Frederic Edwin Church, *Cotopaxi* (detail), 1862. See cat. 6, p. 42

Page 72: George N. Barnard, *Battle Field of New Hope Church, Georgia No. 2* (detail), 1866. See cat. 28, p. 105

Page 112: Winslow Homer, *Home, Sweet Home* (detail), about 1863. See cat. 52, p. 153

Page 172: Eastman Johnson, *The Lord Is My Shepherd* (detail), 1863. See cat. 70, p. 212

Page 224: Winslow Homer, *Dressing for the Carnival* (detail), 1877. See cat. 77, p. 232